FABERGÉ

FABERGÉ
IMPERIAL CRAFTSMAN AND HIS WORLD

DR GÉZA VON HABSBURG

WITH CONTRIBUTIONS BY ALEXANDER VON SOLODKOFF, DR ROBERT BIANCHI

BOOTH-CLIBBORN EDITIONS

EDITORIAL NOTE

Entries are signed with the initials of the contributors, as follows:

LAZ L.A. Zavadskaya
TTK T.T. Korshunova
OK O.G. Kostjuk
LAY L.A. Yakovleva
EAA E.A. Ansimova
ML M.N. Lopato
MAD M.A. Dobrovolskaya
OGZ O.G. Zimina

Dr Géza von Habsburg and Alexander von Solodkoff have written all other entries.

Bibliographic citations and exhibition references in the text and at the foot of entries
refer to the Bibliography, which is organized as follows: general bibliography (books
and exhibitions), Fabergé bibliography (books, articles and exhibitions) and a
bibliography for other workmasters (books, articles and exhibitions).

Dimensions are given in imperial measurements, followed by their metric equivalents;
height precedes width.

Russian names and words have been transliterated with the primary aim of being
accessible to a general readership. Where personal or place names have acquired a
standard accepted transliteration these are given as such.

Inscriptions have been translated from the original text.

First published in 2000 by Booth-Clibborn Editions
12 Percy Street
London W1T 1DW
United Kingdom
www.booth-clibborn-editions.com

© Booth-Clibborn Editions 2000
© Broughton International, Inc. 2000
© The Forbes Magazine Collection, New York 2000
© The State Hermitage Museum, St. Petersburg 2000
© The State Museums of the Moscow Kremlin 2000
© A La Vieille Russie, Inc.

Text © 2000 Géza von Habsburg, Alexander von Solodkoff, Robert Steven Bianchi,
Christian Bolin, Alain Boucheron, J. Alastair Duncan, Marina Lopato, Tatiana Muntyan,
Eric Nussbaum, Mark A. Schaffer, Valentin Skurlov, Ulla Tillander-Godenhielm,
Larissa Zavadskaya

Art Direction: Robbie Mahoney
Design: Robbie Mahoney and Christopher Wilson
Translation: Frank Althaus
Editors: Booth-Clibborn team

ISBN 1-86154-164-3

Printed and bound in Hong Kong

CONTENTS

ACKNOWLEDGEMENTS

The planning of this exhibition has taken well over two years. A large number of lenders and collaborators must be thanked for their involvement.

The largest single lender to the exhibition, contributing 136 art objects and drawings, is the Hermitage Museum, St. Petersburg, whose Director, Dr Mikhail Piotrovsky, has shown his customary graciousness, generosity and understanding. His Deputy, Dr Vladimir Matveyev, Chief Curator, patiently spent tedious hours dealing with the voluminous paperwork at a time when the Hermitage was under political attack. Dr Marina Lopato, Curator of Western Applied Arts, efficiently co-ordinated the multi-departmental contributions of the Hermitage, adding voluminous object descriptions as well as a scholarly article for the catalog. Her colleague, Larissa Zavadskaya, Curator of Russian Applied Arts, kindly provided similar assistance and scholarship with regard to the silver production of St. Petersburg 1830–1850. Mme Irina Rodimtseva, Director of the Kremlin Armory Museum, lent three of her museum's magnificent Imperial Easter Eggs together with a selection of the treasures for which her museum is celebrated, a group small in size, yet of great importance. Armory Museum Fabergé Curator Tatiana Muntyan supplied descriptions of these treasures, a highly informative article on one of Fabergé's fascinating *Prix Courants* and another on the family of Feodor Rückert. The Forbes Magazine Collection, without the participation of which no Fabergé exhibition is complete, loaned five Imperial Eggs and a large array of other masterpieces. Christopher Forbes, Vice-President of The Forbes Magazine, has been exceedingly encouraging from the very beginning. Margaret Kelly-Trombly, Director of the Forbes Magazine Collection was full of generous understanding when the list of loans grew incessantly. Robin Tromeur, Curator, was replaced halfway through the project by Gabrielle Heimann; both were enormously helpful in answering questions about the minutiae of hallmarks.

Many colleagues have been exceedingly generous with their time. Ulla Tillander-Godenhielm helped secure elusive loans from Finland and contributed greatly to the catalog's scholarship and an essay on her grandfather's firm. Valentin V. Skurlov, the well-known Fabergé archivist in St. Petersburg, was instrumental in researching a number of the exhibition pieces, and also provided an article on the tantalizing question of hallmarks. A. Kenneth Snowman, an old friend and doyen of the Fabergé community, and his eminently gifted colleague and specialist, Geoffrey Munn, most generously provided loans from Wartski, London, and from some of the firm's clients. Paul and Peter Schaffer of A La Vieille Russie, New York, kindly lent objects owned by their firm, and also helped secure loans from their clients. Dr Mark A. Schaffer, representing a new generation of Fabergé specialists, provided an article on Henrik Wigström.

M. Eric Nussbaum, the highly knowledgeable Director of the Cartier Collection, Geneva, has, as always, been most generous with his time, writing a chapter on Cartier and Russia, and lending some of Cartier's most excellent creations dating from his "Russian" period. M. Alain Boucheron wrote an essay on his eminent ancestor. He and M. Michel Tonnelot of Boucheron, Paris, have made it possible through substantial loans, to present Frédéric Boucheron, Fabergé's contemporary, in the best possible light. Christian Bolin of Bolin Jewelers, Stockholm, kindly supplied an article on his firm's history. Ex-Christie's colleague Alastair Duncan provided a most illuminating essay on L.C. Tiffany and Fabergé, and helped secure loans of passionate Louis Comfort Tiffany collector, Eric Streiner. Ralph Esmerian, the well-known and much-admired Art Nouveau collector, was most helpful with advice and loans. Gerard Hill, Director of the Russian Department at Sotheby's and Alice M. Ilich, another Fabergé specialist and former colleague, both kindly helped to contact owners of rare Fabergé desiderata. Christie's helped with obtaining photographs.

Three major lenders should be singled out for particular thanks: Mr John Traina, owner of the greatest collection of Fabergé cigarette-cases; the Woolf family, who among many other treasures, own the finest collection of Fabergé animals after HM the Queen; and André Ruzhnikov, Palo Alto dealer and collector, who contributed much of the Russian silver and *cloisonné* enamel, have all agreed to part with approximately 100 of their cherished works of art for a year.

In addition to the lenders listed separately, the organizers would like to especially acknowledge loans from: HM King Gustav XVI Adolf of Sweden; Their Graces the Duke and Duchess of Westminster and The Hon. Simon Howard.

Particular praise is due to James Broughton, President of Broughton International, organizer of such blockbuster exhibitions as *Catherine the Great: Treasures of the Kremlin*, and *Nicholas & Alexandra*. His vision alone has permitted Fabergé to take place. The project cost him countless troubled and no doubt sleepless hours, and a host of problems, conquered only by his dogged perseverance. It has been a great pleasure and privilege to work with him. Last but not least, Dr Robert Bianchi, the highly capable and indefatigable Director of Academic and Curatorial Affairs at Broughton International has brought his exemplary efficiency to bear on this monumental project. In exemplary fashion, he has absorbed the entire Fabergé literature, providing an original and personal rendering of the history of the House of Fabergé for the catalog.

Géza von Habsburg
Alexander von Solodkoff
Co-curators of *Fabergé*

Generous help and advice from the following has also contributed to making the exhibition and the catalog possible:

Dr Fernando Cantù, Stephen R. Dale, Leonid Dorst, Iouri Golbraikh, Francis Hazeel, Moritz Landgraf von Hessen, Michael Hubel, Michael Kamidian, Dr Edward Kasinec and Dr Davies (New York Public Library, Slavic Division), Dr David Khalili, Princess Nina Lobanov-Rostovsky, Donata Herzogin zu Mecklenburg von Solodkoff, Natacha Offenstadt, Y. Jack Rabinovich, Pehr Wallin, Elsebeth Welander-Bergren, Helga Wieser-Nielsen, Alan Younger and Catherine Purcell of Wartski.

The Hermitage Collection Keepers: L.A. Zavadskaya (LAZ), T.T. Korshunova (TTK), O.G. Kostjuk (OK), L.A. Yakovleva (LAY), E.A. Anisimova (EEA), M.N. Lopato (ML), M.A. Dobrovolskaya (MAD), O.G. Zimina (OGZ).

PREFACE

The concept for this exhibition and associated book was born in 1993 in connection with the *Fabergé: Imperial Jeweler* exhibition held in St. Petersburg, Paris and London. Dr Michael Piotrovsky, Director of the State Hermitage Museum, appropriately wrote in his foreword to the catalog, "Objects bearing the Fabergé name perfectly combine the personal tastes and talents of the founder of the jewelry firm and its masters. Personal and group efforts were brought together without sacrificing individuality. The style rightfully bears the name of Fabergé, but proudly standing behind that name, unforgotten, are those masters who created it." The present exhibition, as a sign of our democratic times, is mainly dedicated to these craftsmen and their workshops. For once, as opposed to all previous exhibitions, the limelight is not solely focused on the great artist Peter Carl Fabergé himself. We are all by now aware of the master choreographer who orchestrated the production of over 150,000 objects, jewels and articles of silver, created in more than a dozen workshops by hundreds of craftsmen active in St. Petersburg, Moscow, Odessa and Kiev. This time, however, a concerted effort is made to identify the styles of his craftsmen, their idiosyncrasies and individualities, and to establish how much artistic leeway and independence each workshop possessed.

Since the archives of the firm are missing, there is little concrete evidence concerning the artistic genesis of an idea, its invention in the mind of the master. It may be safely surmised that most of the inventions in the realm of *objets de fantaisie*, initially at least, were due to Peter Carl, his brother, Agathon, and later, to Carl's four sons. Only a handful of rough sketches by Fabergé family members survive where thousands must have existed. Following preliminary brain-storming, sketches would be rendered precisely, with numerous variations, thanks to a well-staffed design studio headed, after the death of brother Agathon, by the Swiss François Birbaum. The chosen design then landed on the workbench of the executing craftsman. Virtually none of these final designs survive, as they were mostly scrapped following completion. Many rejected designs were filed by the Imperial Cabinet and are today to be found at the Hermitage.

A leading question raised by this exhibition and book is: were the individual artisans or workmasters nothing but slavish executors? We think not. We cannot imagine that the celebrated Michael Perchin, who was awarded a personal Bronze Medal at the *Paris Exposition Universelle*, and his assistant and brilliant successor, Henrik Wigström, would have served in such a subservient role. There is no doubt that, as the main workshops began to assert their technical mastery, they simultaneously acquired increasing artistic independence. This logical, even if hypothetical, development must have gone hand in hand with the fact that Fabergé was ever more involved with the management of his vast enterprise, the largest of its kind in existence at the time. Supplying the needs of his Russian clients, the London branch and those of his teams of salesmen traveling annually to Paris, Rome, the Côte d'Azur and the Far East stretched the firm's workshops to their utmost capacity, obliging Fabergé to farm out a growing number of commissions to indigenous outworkers or even to workshops abroad. This exhibition is also a partial attempt to address the question of such outworkers and other suppliers and their relationship to the House of Fabergé.

The exhibition's main theme is an individual presentation of each one of Fabergé's workshops. We learn that the firm's first head workmaster, Erik Kollin, considered as but a goldworker, also produced the *objets d'art* hitherto associated with the tenure of his successor. The remaining ateliers are presented in order: the first jewelry workshop of August Holmström; the goldsmithing atelier of August Hollming, each with over thirty exhibits; and the firm's most brilliant head workmaster, Michael Perchin, with over 120

items. Further workshops presented are those of the chief frame-makers Anders Nevalainen and Hjalmar Armfeldt; Victor Aarne and Feodor Afanasiev, all specialist studios. The lesser St. Petersburg workshops are grouped: Reimer, Soloviev, Thielemann, Gorianov and Ringe; and the outworkers: Lundell, Niukkanen and Schramm. Over one hundred items from the firm's most prolific workshop, that of the last head workmaster, Henrik Wigström, round off the presentation of the St. Petersburg ateliers. One hundred animal sculptures, flowers and figures illustrate the virtuoso handling of semi-precious stones by the firm.

Perhaps the greatest surprise comes with a substantial group of sixty-five highly sophisticated *objets de fantaisie* produced by Fabergé's Moscow workshop. This atelier, hitherto ignored, reveals itself equal in technical excellence to those of the leading St. Petersburg masters. Indeed, in some cases its readily recognizable, original designs surpass those of the better-known workshops in Russia's capital.

In the eyes of the general public, the obtainment of the *Légion d'honneur*, of the Order of St. Stanislav, Second Class and St. Anne, Third Class, the title of Supplier to the Court and Court Jeweler, all apparently put Fabergé on a pedestal by himself. The scholarship in this volume shows that Fabergé was by no means unique in this respect. Others, too, received the *Légion d'honneur* in 1900, including Boucheron, Ovchinnikov and Tiffany, as well as Lalique, who advanced to Commander of the Order. Dozens of Grand Prix and Gold Medals were awarded to contemporaries, and titles of Court Supplier and/or Court Jeweler were bestowed on numerous of Fabergé's competitors in St. Petersburg.

To show that the artist was not working in an artistic vacuum, the exhibition places Fabergé in the context of European applied arts of the eighteenth and nineteenth centuries. This is demonstrated by a group of twenty loans from the treasury of the Hermitage Museum, all eighteenth-century objects known to the Russian master, and which, directly or indirectly, inspired him in his work. Russian silversmiths of the nineteenth century, both from the generation preceding Fabergé and from among his own contemporaries, are well represented in the exhibition. Fabergé's influence in St. Petersburg was such that his competitors all lived under his spell. This exhibition assembles over eighty objects by Adler, Blanc, Britzin, Hahn, Koechli, Tillander, Rosen, Sumin and the Third Artel. They show how most local craftsmen and workshops assimilated Fabergé's style. Only Hahn and Blanc, Koechli and Tillander created valid styles of their own.

One of Fabergé's few known prejudices serves as an amusing *point de départ* to an art-historical foray into the field of his foreign competitors. His condescending dictum, "Tiffany, Cartier and Boucheron . . . are people of commerce, not artist jewelers", is an excuse to present the art of his three competitors not only as dealers in diamonds and pearls. Thirty select jewels and *objets d'art* by each of these firms allows the present-day public to judge for itself. From among the numerous remaining great Parisian *bijoutiers*, only Lalique is shown, who was, like Fabergé, in a class by himself.

Such a vast and ambitious undertaking must always remain a work in progress. One of the aims of this exhibition is to inspire viewers and readers to further research these questions and thereby contribute to the greater understanding of the world of Fabergé.

Géza von Habsburg
Chief Curator of *Fabergé*

LENDERS TO THE EXHIBITION

HM KING CARL XVI GUSTAV OF SWEDEN
THEIR GRACES THE DUKE AND DUCHESS OF WESTMINSTER

A La Vieille Russie, New York
Boucheron Joailliers, Paris
Mr and Mrs David Braver
The Cartier Museum, Geneva
The Castle Howard Collection
Mr Leonid Dorst
The G. Eriksson Collection
Ermitage Ltd., London
Mr Ralph Esmerian
The Forbes Magazine Collection, New York
Sammlung Adulf P. Goop
Herr Klaus Hansen
The Hermitage State Museum, St. Petersburg
The Hubel Collection
M. Michel Kamidian
The Khalili Family Trust
Mr and Mrs Michael Kofman
The Kremlin Armory Museum, Moscow
Collection Sylvie and Pierre Mirabaud
Chevalier Maurice F. Mizzi
Ms. Natasha Offenstadt
Joan and Melissa Rivers
Mr and Mrs Louis Rosendin
Mr André Ruzhnikov, Palo Alto
Mr Eric Streiner
Ms Ulla Tillander-Godenhielm
Mr John Traina
Mr Trevor Traina
Ms Thérèse Wallin
Wartski, London
Mr and Mrs Harold Whitbeck
Ms Helga Wieser-Nielsen
The Woolf Family Collection
And numerous private collectors who wish to remain anonymous

CHRONOLOGY

1800
Peter Fabergé, Carl Fabergé's grandfather, moves to Pernau (Livonia) from Schwedt-an-der-Oder and marries Marie Luise Elsner

1811
Birth of Paris goldsmith/jeweler Alexis Falize (d.1898)

1812
Birth of Charles Lewis Tiffany (d.1902) founder of New York firm manufacturing and retailing goldsmiths, silversmiths and jewelers

1814
Birth of Gustav Fabergé, Carl Fabergé's father

1815
Fossin *père*, head workmaster at gold-smith/jewelers Etienne Nitot, takes over firm (later Chaumet)

1820
Birth of celebrated Muscovite silversmith and enameler Pavel A. Ovchinnikov

1821
Birth of St. Petersburg jeweler Leopold C. Zeftigen.
Firm of French goldsmiths/jewelers Aucoc founded in Paris

1823
Birth of Paris jeweler Eugène Fontenay (d.1887), celebrated for his copies of archeological jewelry

1824
Birth of Italian jeweler Alessandro Castellani (d.1883), also known for his copies of Etruscan jewelry

1825
Birth of St. Petersburg goldsmith Julius Keibel (maker of orders and decorations)

1828
Birth of Paris Art Nouveau jeweler Alphonse Fouquet (d.1911)

1829
Birth of Italian jeweler Augusto Castellani (d.1914)

c. **1830**
Gustav Fabergé moves to St. Petersburg; is apprenticed to goldsmiths Andreas Spiegel and Johann Wilhelm Keibel

1830
Birth of jeweler I. A. Gunst (supplied Gustav Fabergé and Sazikov)

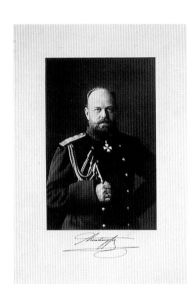

Birth of Paris jeweler Fréderic Boucheron
Jeweler Jean-Baptiste Fossin awarded *brevet du roi*.
Paris jeweler Alexis Falize apprenticed to Mellerio

1831
Arrival of Swedish jeweler/silversmith Carl-Edward Bolin in St. Petersburg

1833
Birth of Fabergé silversmith Stefan Wäkeva (d.1910)

1835
St. Petersburg jeweler Heinrich Wilhelm Kämmerer appointed "Appraiser to the Imperial Cabinet".
Carl Edward Bolin head of firm in St. Petersburg

1836
Birth of Fabergé head workmaster Erik Kollin (d.1901).
Henrik-Konrad Bolin joins his brother in St. Petersburg.
Birth of St. Petersburg goldsmith/jeweler Carl-August Hahn

1837
Nicholas I awards the title of "Court Manufacturer" to the silversmith Ignaty P. Sazikov.
Birth of St. Petersburg goldsmith Alexander E. Tillander.
C. L. Tiffany in New York in partnership with J. B. Young, opens fancy goods and stationery shop

1838
Birth of St. Petersburg goldsmith/jeweler Friedrich-Christian Koechli.
Paris jeweler Alexis Falize opens own workshop in Paris

1839
St. Petersburg jewelers W. Kämmerer and Carl Bolin appointed "Court Jewelers"
Birth of St. Petersburg jeweler Nicholas Nichols-Ewing.
Paris jeweler François-Désire Froment-Meurice (1802–1855) exhibits jewelry in the gothic taste

1840
St. Petersburg jeweler Alexander Kordes appointed "Court Jeweler"

1841
Gustav Fabergé awarded title of Master Goldsmith.
S. Gubkin founds silver factory in Moscow.
St. Petersburg goldsmith Ivan Keibel appointed "Court Goldsmith".
Birth of St. Petersburg goldsmith/jeweler Friedrich-Christian Koechli.

Tiffany enlarges premises to include jewelry, porcelain, glass, clocks and cutlery.
Birth of Edward VII of England

1842
Gustav Fabergé opens a shop at 12 Bolshaya Morskaya; after two further moves, ends at 16 Bolshaya Morskaya.
Arrival of Fabergé silversmith Stefan Wäkaeva in St. Petersburg.
Silversmith Ignaty P. Sazikov opens St. Petersburg branch

1843
Birth of David Andersen, Norwegian silversmith and enameler

1844
Silversmiths William Plinke and Constantin Nichols, owners of the famous shop "Nichols & Plinke" become "Merchants of the First Guild"

1845
Birth of Moscow silversmith and enameler Orest F. Kurljukov.
Silversmith Samuel Arndt opens workshop in St. Petersburg.
Birth of Alexander III of Russia

1846
Birth of Peter Carl Fabergé.
Birth of stone-carver and sculptor C. F. Woerffel, collaborator with Fabergé.
Silversmith Sazikov (Moscow branch) appointed "Supplier to the Court"

1847
Fabergé silversmith Stefan Wäkeva begins apprenticeship.
Paris jeweler Eugène Fontenay sets up independent workshop.
Louis-François Cartier opens a jewelry store in Paris.
Tiffany & Young move to 271 Broadway

1848
Goldsmith/jeweler A. E. Tillander settles in St. Petersburg.
Birth of American jeweler and glassmaker Louis Comfort Tiffany (d.1933).
Paris jeweler Jean Mellerio in Madrid

1849
Firm of goldsmiths "Morosov" founded by Ivan Y. Morosov in St. Petersburg.
Silversmith Sazikov awarded large silver medal for exhibits at St. Petersburg and Moscow Industrial Exhibitons.
F. Solntsev first volume of "Antiquities of the Russian State" (d.1853)

1850
Tiffany, Reed & Co. open in Paris at Rue Richelieu

1851

Birth of Fabergé silversmith Julius Rappoport (d.1917).
Jeweler Carl Bolin named "Appraiser to the Imperial Cabinet".
Silversmith P.A. Ovchinnikov opens workshop in Moscow.
Great Exhibition in London: Sazikov shows his silver sculpture "Dmitri Donskoi" to great acclaim; receives Grand Gold Medal (First Class); Bolin exhibits jewelry valued at £40,000 and Froment-Meurice exhibits Renaissance-style jewelry.
Designer Edward C. Moore begins to work for Tiffany, New York

1852

Henriek-Konrad Bolin moves to Moscow and joins Englishman Shanks and founds "English Shop, Shanks & Bolin".
St. Petersburg jeweler Alexander Breitfus awarded Honorary Heriditary Citizenship.
St. Petersburg jeweler Yannash awarded Gold Medal with diamonds "For Diligence".
Silversmith Vassilij S. Semyonov founds firm in Moscow

1853

"Shanks & Bolin" appointed "Suppliers to the Court".
Goldsmith Andrej K. Adler founds workshop in St. Petersburg.
P.A. Ovchinnikov founds firm in Moscow
Name of Tiffany & Young changed to Tiffany & Co.

1853–6

Crimean War

1854

Birth of Fabergé jewelery workmaster August Hollming (d.1914).
Paris silversmith Louis Aucoc succeeds his father Casimir as head of the firm.
Birth of Paris jeweler Joseph Chaumet (d.1928)

1855

Goldsmith and Fabergé supplier Anders Mickelson arrives in St. Petersburg.
World Fair, Paris.
Death of Paris goldsmith/jeweler F. D. Froment Meurice.
Death of Nicholas I.
Coronation of Alexander II

1856

Hardstone carver A. K. Denison-Uralski founds workshop

1857

August Wilhelm Holmström opens workshop in St. Petersburg and becomes Gustav Fabergé's chief jeweler.

Silversmith Sazikov (St. Petersburg branch) appointed "Supplier to the Court"

1858

Firm of Boucheron founded by Fréderic Boucheron in Paris (d.1902).
Jules Debut appointed designer (until 1879)

1859

St. Petersburg jeweler Leopold Zeftigen appointed "Supplier to the Court".
St. Petersburg goldsmith I. Keibel awarded Order of St. Stanislav and Hereditary Honorary Citizenship.
French jeweler Louis François Cartier opens shop in Paris.
Ivan Goncharov's masterpiece Oblomov is published.
Birth of Wilhelm II

1860

Gustav Fabergé moves to Dresden.
Leaves shop in the hands of Hiskias Pendin and V. A. Zaiantkovski.
Birth of Fabergé head workmaster Michael Perchin (d.1903).
Silversmith Ivan P. Chlebnikov opens workshop in St. Petersburg.
Napoleon III acquires famous Campana collection of Etruscan jewels

1861

Carl Fabergé is confirmed in Dresden.
Begins his commercial schooling.
St. Petersburg jeweler Adolf-Leopold Zeftigen appointed "Appraiser to the Cabinet".
Italian jeweler Carlo Giuliano opens workshop in London.
Alexander II abolishes serfdom

1861–4

Fabergé travels through Western Europe, visits Germany, Italy, France with St. Petersburg jeweler Julius Butz

1862

Birth of Agathon, Fabergé's brother, in Dresden.
Birth of Fabergé third and last head workmaster Henrik Wigström (d.1923).
Jewelers Castellani show gold granulated jewels in the Etruscan style at the London International Exhibition.
Mellerio exhibits at London Exhibition where prints and ceramics from Japan are shown for the first time.
Prosper Morel takes over the jewelry firm Fossin in Paris.
Birth of Paris Art Nouveau jeweler Georges Fouquet, son of Alphonse.
Turgenev: Fathers and Sons

1863

Fréderic Boucheron opens a jewelry workshop in Paris.

Paul Legrand designer at Boucheron (until 1867 and then subsequently between1870 and 1892).
Founding of the "Wanderers" movement: by 13 painters from the St. Petersburg Academy of Arts.
Christian IX crowned King of Denmark and his daughter Alexandra (1844–1925) is married to Edward, Prince of Wales

1864

Fabergé returns to St. Petersburg and joins his father's jewelry business.
Jeweler Carl-Ludwig Bolin named "Appraiser to the Imperial Cabinet"; Edward Ludwig Bolin and Oscar Friedrich Bolin take over the firm's management

1865

St. Petersburg jeweler F. Butz appointed "Supplier to the Court of the Tsarevich".
Moscow Exhibition of Industrial Goods – P. Ovchinnikov exhibits *champlevé* enamels and awarded title of "Supplier to the Court of the Tsarevich" and Honorary Citizenship of Moscow.
Death of Italian jeweler Fortunato Pio Castellani.
Jeweler Octave Loeuillard head workmaster at Boucheron, Paris (until 1875).
Birth of Gustav Gaudernack, enameler at David Andersen in Christiania (Oslo)

1866

Fabergé receives Temporary Certificate of Merchant of the 2nd Guild and begins association with the Imperial Cabinet.
St. Petersburg jeweler Ludwig Breitfus becomes Honorary Hereditary Citizen.
Silversmith Gavril P. Gratchev founds firm in St. Petersburg.
Designer and jeweler Jules Debut becomes head workmaster at Boucheron (until 1879).
Marriage of Alexander III to Princess Dagmar (1847–1928), daughter of Christian IX of Denmark, who assumes the Russian name of Maria Feodorovna

1867

Fabergé registered as member of the Merchant's Guild, no. 4321.
At the Paris World Fair Ovchinnikov exhibits a writing set; English "archeological" jewelry is much admired; Falize exhibits *cloisonné* enamel in the Japanese style; Eugène Fontenay exhibits copies of Etruscan gold and Chinese jade jewelry and is awarded a gold medal; Boucheron and Mellerio are awarded gold medals; Tiffany receives an award of merit.
Karl Marx: *Das Kapital*.
Tchaikovsky: *First Symphony*

1868

Breitful, Bolin and Zeftigen catalog crown jewels in St. Petersburg.

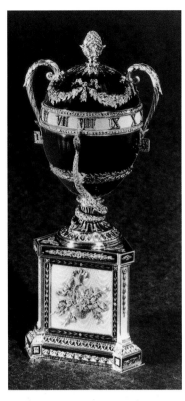

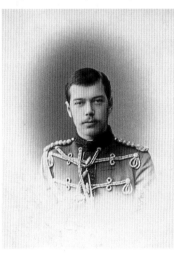

THE BLUE ENAMEL "SERPENT CLOCK EGG" of 1887 – by Fabergé, workmaster Michael Perchin, height 7¼ in. (18.5cm). H.S.H. Prince Rainier of Monaco Archive Photograph

TSAREVICH NICHOLAS ALEXANDROVICH in the Uniform of the Hussars, 1889. Photograph C. Bergamasco. Russian State Archive

Louis Rault, sculptor/engraver, silversmith and jeweler works for Boucheron (until 1875).
Tiffany's opens in London and Geneva.
Louis Comfort Tiffany travels to Paris and Spain (until 1869).
Edward C. Moore becomes chief designer and director of the silver department at Tiffany's.
Birth of Nicholas II.
Birth of Maxim Gorky

1869
Jeweler F. Butz replaces C. Breitfuss and joins Bolin and Zeftigen as "Appraiser to HM Cabinet".
Leopold Zeftigen named "Court Jeweler".
Engraver and jeweler Edward Kortes is awarded Hereditary Honorary Citizenship, the Order of St. Stanislav Third Rank and the Order of St. Anne, Second Rank; acquires a workshop.
Lapidary workshop established by Ivan Sumin in St. Petersburg.
Silversmith Ivan P. Chlebnikov founds firm in Moscow

1870
Birth of Paris Art Nouveau jeweler Eugène Feuillâtre (d.1916).
Gideon Reed of Tiffany, Paris, acquires jewelry from Boucheron for the American market.
Birth of Alexandre Benois (d.1960), founder of "World of Art" movement

1871
Firm of jewelers/silversmiths C. E. Bolin founded in Moscow.
Firm of Chlebnikov opens factory in Moscow.
Firm of Fedor A. Lorié opens in Moscow.
Feodor Dostoevsky: *The Possessed*.
Birth of Rasputin.
Wilhelm I Emperor of Germany

1872
Fabergé takes over his father's business; marries Augusta Jakobs.
Death of jeweler I. A. Gunst.
Ivan P. Chlebnikov appointed "Supplier to the Court of Grand Duke Constantin Nikolaievich".
Nemirov-Kolodkin Jewelry founded in Moscow.
Moscow Polytechnic Exhibition; silversmith Chlebnikov is awarded two large gold medals.
Birth of Sergei Diaghilev.
First Peredvizhnik exhibition.
Birth of Tsarina Alexandra Feodorovna (Princess Alix of Hessen)

1873
Stone-carver C. F. Woerffel takes over his father's business.

Jeweler C. A. Hahn founds workshop in St. Petersburg.
Silversmith Alexander N. Sokolov appointed "Court Supplier"; specializes in prizes for horse races.
Death of silversmith Gavril P. Gratchev – the business is continued by his eight sons
Ovchinnikov opens a branch in St. Petersburg.
At the World Fair in Vienna Chlebnikov, Ovchinnikov, Postnikov and Sazikov are awarded prize for "silver works made according to the national taste".
Eugène Fontenay member of the jury at the Vienna World Fair; Mellerio is awarded the large Honorary Diploma.
Leo Tolstoy: *Anna Karenina*.
Births of Feodor Chaliapin and Sergei Rachmaninoff.

1874
Birth of Eugène (Fabergé's first son); others sons are born 1876 (Agathon), 1877 (Alexander), 1884 (Nicholas).
First mention of sales by Fabergé to the Imperial Cabinet.
Jeweler Friedrich Christian Koechli founds firm in St. Petersburg.
Alfred Cartier succeeds his father as head of the Paris firm.
Jeweler and author Henri Vever (1854–1942) begins to work in his father's firm in Paris.
Muscovite patrons of the arts Savva and Elizabeth Mamontov found artistic colony at Abramtsevo including painters Vassiliy Polenov and Ilya Repin.
Modest Mussorgsky: *Boris Godunov*

1875
Jeweler Joseph Chaumet joins firm of Prosper Morel.
Boucheron exhibits at the Philadelphia International fair

1876
Famous Art Nouveau jeweler René Lalique joins Aucoc as apprentice.
Jeweler Lucien Falize succeeds his father as head of the Paris firm.
Norwegian David Andersen becomes master silversmith, opens workshop in Christiania (Olso).
Tchaikovsky: *Swan Lake*.
Philadelphia Centennial Exhibition.
Whistler: *Peacock Room*

1877
Moscow silversmith Chlebnikov appointed "Supplier to the Court of Grand Duke Vladimir Alexandrovich".

1878
Fabergé head workmaster Henrik Wigström arrives in St. Petersburg.
Firm of I. A. Marshak founded in Kiev.

Eugène Fontenay member of the jury at the Paris Exposition Universelle: Tiffany's and Fouquet awarded Gold Medals; Tiffany's receives award for "Japanesque" silver, a gold medal for jewelry, the *Légion d'honneur* and a Gold Medal from Emperor Alexander II

1879
Pavel Buhré appointed "Supplier and Regulator of Her Majesty the Empress's Clock" Jeweler Julius Butz (Fabergé's school friend and travel companion) becomes "Merchant of the Second Guild" Silversmith Andrei M. Postnikov appointed "Court Supplier".
Silversmith Sazikov awarded "State Emblem" and title of "Supplier to the Imperial Court" (he was also Supplier to the courts of Denmark, The Netherlands and Serbia).
Louis Comfort Tiffany founds Associated Artists.
Paul Legrand head workmaster at Boucheron.
Paris Art Nouveau jeweler Fouquet opens at Avenue de l'Opéra.
Tchaikovsky: *Eugene Onegin*.
Birth of Joseph Stalin

c. 1880
Moscow silversmith Ovchinnikov produces first *cloisonné* and *plique-à-jour* enamels

1880
Fabergé silversmith Julius Rappoport apprenticed in Berlin.
Jeweler Nicolas Iohanson appointed "Supplier to the Court" (until 1890).
Jeweler Nichols-Ewing appointed "Supplier to the Court" (until 1890), owned jewelery shop at 47 Bolshaya Morskaya.
Silversmiths Bros. Gratchev appointed "Suppliers to the Grand Dukes".
Partnership between Bapst and Falize (until 1892).
Church of Abramtsevo colony built and decorated by A. and V. Vasnetsov, Polenov, I. Repin and M. Nesterov

1881
Goldsmith Alexander Treiberg and silversmith Ovchinnikov appointed Suppliers to the Court.
Jeweler Julius Butz appointed "Appraiser to the Imperial Cabinet".
Death of silversmith I. Sazikov.
Assassination of Alexander II.
Coronation of Tsar Alexander III.
Death of Mussorgsky.
Jacob Tostrup produces first major piece of enamelware designed by his son, Oluf, for the wedding of crown prince Gustav of Norway

1882

Fabergé: Agathon joins his brother in St. Petersburg.

Pan-Russian Industrial exhibition in Moscow.

Exhibition of copies of Kertch hoard and first direct sale to the Imperial family.

Philip Theodor Ringe, begins work as supplier to the house of Fabergé.

Bolin awarded State Emblem at Pan-Russian Exhibition; Woerffel awarded Gold Medal.

Denisov-Uralski awarded "Honorary Mention".

Nicolas M. Rakhmanov awarded Gold Medal with ribbon of St. Stanislav; Sazikov awarded Grand Prize and "State Emblem".

Avenir I. Sumin awarded Bronze Medal for "excellent polishing of artificial and precious stones".

Carl C. Blank begins work for C. Hahn (until 1909).

Death of Julius Keibel.

Tiffany's awarded title of "Supplier to Grand Dukes Pavel, Sergej and Alexander" (brothers of Tsar Alexander III)

1883

Fabergé awarded Gold Medal and Order of St. Stanislav ribbon for his exhibits at the Pan-Russian Exhibition.

Rimsky-Korsakov's ballet: Snegurochka (The Snow Maiden) with stage settings by V. Vasnetsov performed at Mamontov's Private Opera in Moscow.

Death of Turgenev.

Death of Karl Marx

1884

Fabergé: first documented *objets d'art* (Bismarck box); Michael Perchin joins Fabergé; Henrik Wigström begins his apprenticeship with Michael Perchin; Julius Rappoport begins as silversmith in St. Petersburg (until 1917).

Firm of silversmith Ivan D. Saltykov founded in Moscow.

Paris Art Nouveau jeweler René Lalique acquires a workshop in Paris.

Louvre exhibition of the French Crown Jewels.

Budapest enamel exhibition visited by Torolf Prytz of Norway who begins to experiment with *plique-à-jour* enamel

1885

Fabergé: "First Imperial Easter Egg" (cat. 437); Michael Perchin replaces Erik Kollin as head workmaster; Fabergé awarded title of Supplier by Special Appointment to the Imperial Court; Gold Medal for exhibits at Nürnberg Fine Art Exhibition.

Death of goldsmith I.Y. Morosov; the business is taken over by his son Vladimir.

Goldsmith/jeweler C. Blank opens work-shop in St. Petersburg.

Japanese Exhibition in Paris.

René Lalique works for Cartier, Boucheron and Vever.

David Andersen produces first dated enamel work in Christiania (Oslo) with designer Harald Olsen.

Karl Marx's *Das Kapital*, vol. II is published posthumously

1886

Fabergé: "Hen with Sapphire Pendant Egg" (lost).

Clockmaker Pavel-Edward Buhré appointed "Appraiser to the Imperial Cabinet".

Silversmiths Bros. Gratchev appointed "Suppliers to the King of Denmark"

1887

Fabergé: "Serpent Clock Egg" (HRH Prince Rainier of Monaco); Moscow branch is founded with Alan Bowe as partner; Knut Oskar Pihl in charge of Fabergé Moscow jewelry workshop (until 1897); silversmith and enameler Fedor Rückert begins to work for Fabergé.

Jeweler C. Bokh named Merchant of the Second Guild.

Moscow firm of silversmith I. Sazikov taken over by I. Chlebnikov.

Eugène Fontemay publishes "Les Bijoux anciens et modernes"; dies the same year.

Sale of part of the French Crown Jewels. Tiffany buys 24 lots for $480,000.

Vassily Surikov: Boyarina Morosova, important realist painting influenced by Byzantine art.

Alexander Borodin: *Prince Igor*.

Birth of Marc Chagall

1888

Fabergé: "Cherub with Chariot Egg" (lost); Fabergé awarded Special Diploma at Nordic Exhibition in Copenhagen.

Alexander D. Ivanov, the "leading jeweler in St. Petersburg with respect to volume of precious stones" is awarded Hereditary Honorary Citizenship.

Death of Moscow silversmith Pavel A. Ovchinnikov.

P. Chlebnikov & Sons founded in Moscow.

Copenhagen museum buys *plique-à-jour* enamel kovsh by Ovchinnikov, which inspires similar Scandinavian enamels in the following decade.

Paris jeweler Alphonse Fouquet awarded the *Légion d'honneur*.

Wilhelm II Kaiser.

Rimsky-Korsakov: *Scheherazade*

1889

Fabergé: "Nécessaire Egg" (lost).

Silversmith brothers Gratchev open workshop in St. Petersburg.

Michael Gratchev awarded gold medal with ribbon of St. Stanislav for

participation in Copenhagen Exhibition.

Paris World Fair: Chlebnikov awarded gold medal; Denisov-Uralski receives award; Vever and Boucheron both obtain Grand Prix; Louis Comfort Tiffany exhibits enameled orchid brooches.

Tiffany founds Maison de l'Art Nouveau together with Samuel Bing.

Jeweler Joseph Chaumet becomes head of the firm.

Eiffel Tower.

Tchaikovsky: *Sleeping Beauty*

c. 1890–1910

Artistic colony on Talashkino estate of Princess Tenisheva

1890

Fabergé: "Danish Palaces Egg" (New Orleans); awarded title of Appraiser of the Imperial Cabinet; named Hereditary Honorary Citizen; supplies snuffboxes and other presents for Tsarevich Nicholas's cruise to India, Siam, Japan and China.

Russian avant-garde painter Mikhail Vrubel (1856–1910) meets patron of the arts Savva Mamontov.

Tchaikovsky: *Queen of Spades*

1891

Fabergé: "Pamiat Azova Egg" (Kremlin).

Moscow exhibition of French Arts and Crafts; Vever exhibits.

Birth of Sergei Prokofiev.

In Paris George Fouquet joins his father, Alphonse.

First Norwegian *plique-à-jour* enamels

1892

Fabergé: "Diamond Trellis Egg"; Fabergé, Woerffel and M. P. Ovchinnikov travel to Copenhagen for 50th Golden Anniversary of King Christian IX and Queen Louise of Denmark; Fabergé is awarded Order of St. Anne, Third Class.

Goldsmith/jeweler C. A. Hahn becomes Russian citizen.

Silversmiths Michael and Ivan G. Gratchev appointed "Appraisers to the Imperial Cabinet".

Paris Art Nouveau silversmith and jeweler Lucien Gaillard takes over his father's business.

Gustav Gaudernack employed as enameler and designer at David Andersen in Christiania (Oslo).

P. M. Tretyakov donates his gallery to the city of Moscow.

Tchaikovsky: *The Nutcracker*

1893

Fabergé: "Caucasus Egg" (New Orleans); death of Gustav Fabergé; François Birbaum joins Fabergé as chief designer where he remains until 1918.

C. F. Woerffel obtains Russian citizenship and is named merchant.

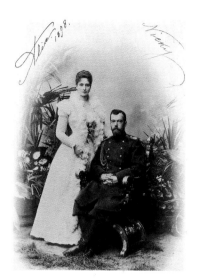

TSAR NICHOLAS II AND TSARINA ALEXANDRA FEODOROVNA 1898. Photograph K. E. von Hahn. Courtesy Alexander von Solodkoff

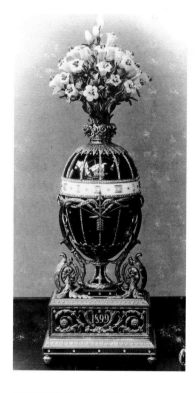

THE "MADONNA LILY EGG" of 1899 – by Fabergé, workmaster Michael Perchin, height 10½ in. (26.7cm). Kremlin Armory Museum, Moscow. Archive Photograph

Chicago World Fair: goldsmith
C. A. Hahn and the sons of silversmith
I. Sazikov are among the exhibitors;
Kiev jeweler Marshak receives an award;
silversmith A. Lubavin acquires firm of
F. E. Henrichsen and opens in
St. Petersburg.
Boucheron opens at Place Vendôme.
Lucien Hirtz becomes designer (until
1925).
Paulding Farnham becomes chief designer
and director of jewelry division at
Tiffany's.
Johan Lund chief designer at David
Andersen makes enamels for Chicago
exhibition

1894
Fabergé: "Renaissance Egg" (Forbes);
Imperial Cabinet pays 177,600 roubles for
pearl and diamond necklace given by
Nicholas to Alexandra; Eugène Fabergé
joins firm.
Title of "Court Supplier" confirmed for
goldsmith Morosov.
René Lalique exhibits under his own
name for the first time.
Louis Comfort Tiffany registers "Favrile"
trademark for his glass.
Death of Alexander III.
Wedding of Nicholas and Alexandra.
Wedding of Grand Duchess Xenia

1895
Fabergé: "Twelve Monograms Egg"
(MF – Hillwood); "Rose Bud Egg"
(AF – Forbes); death of Agathon,
Fabergé's brother; Agathon (Fabergé's son)
joins firm.
Firm of C. F. Woerffel appointed
"Supplier to the Court".
Paris Art Nouveau jeweler Georges
Fouquet become head of the firm.
René Lalique begins to show jewelry at
the Salon de la Societé des Artistes
Français; until 1912 he creates a series of
145 jewels for Callouste Gulbenkian.
Birth of Grand Duchess Olga.
Death of Engels.
Karl Marx: *Das Kapital* vol. III.
Rimsky-Korsakov: *Sadko*

1896
Fabergé: "Alexander III Egg" (MF – lost);
"Revolving Frame Egg"
(AF – Richmond).
"Renaissance Presentation Dish" (cat.
349); "Lilies-of-the-Valley Basket" (AF –
New Orleans); Fabergé participates in the
Pan-Russian Exhibition at Nizhni-
Novgorod, is awarded the State Emblem
and the Order of St. Stanislas, Second
Class.
Jeweler C. Bokh awarded Gold Medal.
Silversmiths "Bros. Gratchev" awarded
"State Emblem".
"Lubavin" awarded Gold Medal.

Goldsmith Carl August Hahn appointed
"Appraiser to the Imperial Cabinet".
Maria Semyonova head of firm in
Moscow until 1917.
René Lalique begins production of 100
jewels to be shown at the 1900
Exposition Universelle.
Louvre buys (fake) crown of Saitaphernes
made by Odessa jeweler Israel
Rouchomovsky.
Coronation of Nicholas II.
Nicholas and Alexandra visit Paris and
England.
30,000 workers strike in St. Petersburg

1897
Fabergé: "Mauve Egg" (AF – egg lost,
surprise cat. , Forbes); "Coronation Coach
Egg" (AF – Forbes); Nordic Exhibition in
Stockholm with Eugene Fabergé as
member of the Jury; Fabergé granted
Royal Warrants for the Courts of Sweden
and Norway.
Goldsmith C. A. Hahn awarded Order of
St. Stanislav, Third Rank.
Michael and Gavril Gratchev awarded
Hereditary Honorary Citizenship of
St. Petersburg.
André Falize succeeds his father Lucien as
head of the firm.
Josef Hoffmann (1870–1956) co-founder
of Vienna Secession movement.
René Lalique appointed *Chevalier de la
Légion d'honneur*.
Paris firm of jewelers Lacloche founded.
Sergej Shchukin begins to form his
collection of French modern art

1898
Fabergé: 'Pelican Egg" (MF – Richmond);
"Lilies-of-the-Valley Egg" (AF – Forbes);
"Kelch Hen Egg" (Forbes); Fabergé buys
land on Bolshaya Morskaya.
Goldsmith C. A. Hahn awarded Honorary
Hereditary Citizenship.
First Art Nouveau jewels shown by
Georges Fouquet at Paris *Salon de la
Société des Artistes Français*.
Louis Cartier joins "Alfred Cartier & fils"
in Paris.
First issue of Mir Isskustva (–1904),
the "World of Art" magazine illustrating
works by Beardsley, Burne-Jones, van de
Velde & Joseph Olbrichs.
First 'World of Art' exhibit in
St. Petersburg with paintings by the
Vasnetsovs, Levitan, Korovin, Serov,
Nesterov and Vrubel; opening of
Alexander III Museum in St. Petersburg

1899
Fabergé: "Pansy Egg" (MF – Private
Collection); "Lilies Clock Egg"
(AF – Kremlin); Kelch "Twelve Panel
Egg" (HM Queen Elizabeth II).
After working for Lalique, Art Nouveau
jeweler Eugène Feuillâtre sets up on his
own.

Boucheron opens in Moscow.
Cartier moves to 13, Rue de la Paix,
Paris.
Tiffany and Lalique glass shown at the
second "World of Art" exhibition in
St. Petersburg.
Co-founder of the Vienna Secession
movement, Joseph Olbrich, joins artist
colony on the Mathildenhöhe, Darmstadt.
100th Anniversary of Pushkin's birthday.
Tolstoy: *Resurrection*

1900
Fabergé: "Cuckoo Egg" (MF – Forbes);
"Transsiberian Railway Egg"
(AF – Kremlin); Kelch "Pine Cone Egg"
(Joan Kroc); Miniature Imperial Regalia
(Hermitage); Fabergé participates in the
Paris World Fair *hors concours* as member
of the Jury; is awarded Gold Medal and
Cross of the *Légion d'honneur*; Eugene
awarded rank and badge of a Officer of
the Académie; Agathon is awarded a Gold
Medal; Michael Perchin a Bronze Medal;
Fabergé moves to new premises on
24 Bolshaya Morskaya; Odessa branch
opened.
Silversmith Dmitri L. Smirnov appointed
"Supplier to Court".
Death of goldsmith C. A. Hahn.
Paris World Fair: stone carver
Denisov-Uralski shows amethysts;
Goldsmith/jeweler F. C. Koechli is a
member of the Jury; goldsmith Marshak
receives award; Chaumet is awarded Gold
Medal; René Lalique exhibits 100 Art
Nouveau jewels and is triumphantly
celebrated; obtains a Grand Prix and is
awarded the *Légion d'honneur*; Vever
obtains a Grand Prix; Louis Aucoc
awarded a Grand Prix in the section
Orfévrerie; Falize awarded a Grand Prix
both for *Orfévrerie* and *Bijouterie-Joaillerie*;
Feuillâtre obtains a Gold Medal; Lucien
Gaillard obtains Grand Prix for *Bijouterie-
Joaillerie*; Georges Fouquet awarded a gold
medal; Norwegian silversmith David
Andersen is awarded two Gold Medals;
his enameler Gaudernack, a Silver Medal;
Tiffany's receives two Gold Medals.
Tiffany Studios begin making metalwork
and jewelery.
Cartier opens in London at
4 New Burlington Street

1901
Fabergé: "Gatchina Egg" (MF – Walters);
"Basket of Flowers Egg"
(AF – HM Queen Elizabeth II);
Kelch "Apple Blossom Egg";
"Dutch Colony Presentation Tray".
Death of first head workmaster Erik
Kollin.
Jeweler Carl Bokh and "Bros. Gratchev"
appointed "Suppliers to the Imperial
Court".

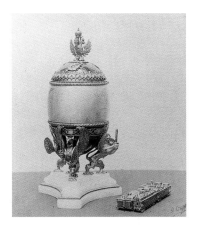

THE "TRANSSIBERIAN RAILWAY
EGG" of 1900 – by Fabergé, workmaster
Michael Perchin, height 10³⁄4 in. (27.3cm).
Kremlin Armory Museum, Moscow. Archive
Photograph)

PORTRAIT OF GRAND DUCHESSES
OLGA, TATIANA, MARIA AND
ANASTASIA, 1906. Photograph Boissonz and
Eggler. Russian State Archive

Death of Norwegian silversmith David Andersen; the business is taken over by his widow and sons.
Chekhov: *Three Sisters*.
Death of Queen Victoria and accession of King Edward VII

1902
Fabergé: "Empire Nephrite Egg" (MF – lost); "Clover Egg" (AF – Kremlin); Kelch "Rocaille Egg" (Private Collection); "Duchess of Marlborough Egg" (Forbes). Fabergé exhibits at the von Dervise Mansion; is awarded Bulgarian Commander's Cross for Civilian Services by Prince Ferdinand of Bulgaria; Eugène awarded Knight Cross of St. Alexander.
Dmitri I.
Osipov, maker of orders and medals, sells his workshop to Swiss citizen Adler.
Denisov Uralski moves to St. Petersburg and organizes a lapidary exhibition "The Urals and their Wealth".
Goldsmith/jeweler Koechli appointed "Supplier to the Court of the Empress" and "Appraiser to the Imperial Cabinet".
Cartier opens in London.
Lalique exhibits in Turin.
Death of Frédéric Boucheron; his son Louis takes over the business; at his father's death, Louis Comfort Tiffany takes the firm, becomes Art Director.
Exhibition Modern Style Architecture and Art held in Moscow

1903
Fabergé: "Danish Jubilee Egg" (MF – lost); "Peter the Great Egg" (AF – Richmond); Kelch "Bonbonnière Egg" (HM Queen Elizabeth II); Arthur Bowe opens Fabergé branch in London; death of second head workmaster Michael Perchin; Henrik Wigström third and last head workmaster; death of Fabergé's head jeweler August Holmström, who is succeeded by his son Albert.
Goldsmith/jeweler Dmitri Hahn appointed "Supplier to the Court".
Silversmith Ivan S. Britsin becomes owner of workshop in St. Petersburg (–1917).
Exhibitions of René Lalique in St. Petersburg and in London.
Paris exhibiton: Des Arts Musulmans.
Josef Hoffmann and Koloman Moser found Wiener Werkstätte.
Boucheron opens branches in London and New York.
Fifth and last *Mir Isskustva* exhibition.
200th Anniversary of the founding of St. Petersburg.
"Bojar's Ball" at the Winter Palace in St. Petersburg

1904
Fabergé: no Imperial eggs because of Russo-Japanese war; Kelch "Chanticleer Egg" (Forbes); "Pansy Flower Frame" (cat. 867); Fabergé exhibition in London.
Cartier moves to 175 New Bond Street in London.
Pierre Cartier visits Russia.
Lucien Gaillard wins first prize for jewelry at the Paris Salon.
Publication by Henri Vever of *La bijouterie française au XIXième siècle* (1904–1908). St. Louis World Fair: Tiffany exhibits sprays of gem-set enameled wild flowers; Chaumet obtains Grand Prix; Norwegian goldsmith David Andersen and his enameler Gaudernack awarded Grand Prix.
Last issue of "World of Art" magazine introducing Gauguin, Van Gogh and Cézanne to the Russian public.
Chekhov: *Cherry Orchard*.
Birth of Tsarevich Alexei.
Russo-Japanese War

1905
Fabergé: no Imperial Easter Eggs because of Russo-Japanese War.
Second exhibiton of René Lalique in London.
Lalique opens on Place Vendôme.
Chaumet moves to Place Vendôme.
Exhibition of Russian eighteenth-century portraits at the Tauride Palace in St. Petersburg with setting designed by Bakst.
Paris Exhibition of Fauve painters.
Serious disturbances in St. Petersburg.
Assassination of Grand Duke Sergei, Governor of Moscow.
Einstein: Theory of Relativity

1906
Fabergé: "Swan Egg" (MF – Sandoz); "Moscow Kremlin Egg" (AF – Kremlin); Kiev Branch is founded; Moscow partnership with Alan Bowe is dissolved; London branch is moved to 48 Dover Street.
Louis and Pierre Cartier, sons of Alfred found "Cartier frères"; Jacques Cartier takes over London branch.
Golden Fleece magazine founded in Moscow in reaction to the "World of Art".
Tsar Nicholas II opens the First State Duma

1907
Fabergé: "Cradle Egg" (MF – Private Collection); "Rose Trellis Egg" (AF – Walters Art Gallery); Youssoupov "Twenty-Fifth Anniversary Egg" (Sandoz); Youssoupov Music Box (Hillwood);
Otto Jarke named head of Moscow workshops; models of Sandringham animals commissioned.
Lyubavin appointed "Manufacturers of Silverware to the Court".

"Art Jewelry Department" established at Tiffany's.
Picasso: *Demoiselles d'Avignon*

1908
Fabergé: "Peacock Egg" (MF – Sandoz); "Alexander Palace Egg" (AF – Kremlin); Cartier opens in St. Petersburg.
Paulding Farnham resigns from Tiffany's.
First exhibition of avant-garde group Golden Fleece including works by Van Gogh and Fauve artists Matisse, Derain, Marquet and Van Dongen; also works by Mikhail Larionov and Natalia Gontcharova.
Collector Shchukin meets Picasso (acquires over 50 paintings by him over next six years).
Moussorgsky's Boris Godunov performed in Paris by Diaghilev; title role sung by Chaliapin, sets by A. Benois and A. Golovin, Russian costumes by I. Bilibin

1909
Fabergé: "Alexander III Commemorative Egg" (MF – lost); "Standard Egg" (AF – Kremlin).
Goldsmith Carl Blank becomes partner of C. Hahn.
Death of goldsmith/jeweler Friedrich-Christian Koechli.
Pierre Cartier opens in New York at 712 Fifth Avenue; London branch moved to 175 New Bond Street; St. Petersburg branch opened; hires designer Charles Jacqueau.
Diaghilev's Ballets Russes open at the Paris Théâtre du Châtelet with Pavillion d'Arminde (sets and costumes by A. Benois) and Borodin's Prince Igor and Polovtsian Dances with sets and costumes by N. Roerich, both with choreography by Fokine.
Proust begins *À la Recherche du Temps Perdu*

1910
Fabergé: "Alexander III Equestrian Egg" (MF – Kremlin); "Colonnade Egg" (AF – HM Queen Elizabeth II); Fabergé awarded title of "Jeweler to the Court" and "Manufacturing Councillor"; Kiev branch is closed.
Stone-carver Denisov-Uralski opens shop and workshop at 27 Bolshaya Morskaya Street.
Gustav Gaudernack becomes master craftsman, opens factory in Oslo.
Death of Tolstoy.
First performance of Stravinsky's *The Firebird*, sets and costumes by Bakst and Golovin.
Death of Edward VII

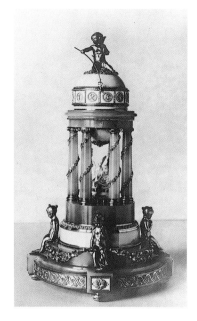

THE "COLONNADE EGG" of 1910 – by Fabergé, workmaster Henrik Wigström, height 11¼ in. (28.5cm). H. M. Queen Elizabeth II. Archive Photograph

GRAND DUCHESSES MARIA, OLGA, ANASTASIA, TATIANA, AND TSAREVICH ALEXEI 1910

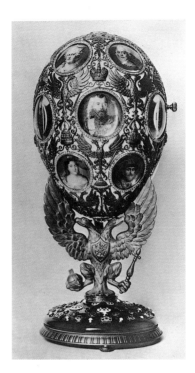

THE "ROMANOV TERCENTENARY
EGG" of 1913 – by Fabergé, workmaster
Henrik Wigström, height 7⁵⁄₁₆ in.
(18.7cm). Kremlin Armory Museum
Archive Photograph

TSAR NICHOLAS II AND
TSAREVICH ALEXEI NICOLAIEVICH
Mogilev 1916. Russian State Archive

1911

Fabergé: "Orange Tree Egg" (MF – cat.
548); "Fifteenth Anniversary Egg" (AF –
cat. 547); Renaissance Vase (HM Queen
Elizabeth II); Fabergé appointed "Court
Jeweler"; London branch is moved to 173
New Bond Street.
Death of goldsmith C. A. Hahn, C. Blank
takes over business.
Premises of Hahn taken over by Tillander
Death of goldsmith/jeweler Friedrich
F. Koechli Jr.
Paris jeweler Pierre Louis Cartier receives
St. Petersburg Merchant's Certificate.
Lalique's last jewelry exhibition.
Stravinsky: *Petrouchka* (sets and costumes
by A. Benois), danced by Karsavina and
Nijinsky.
Coronation of King George V.
Assassination of Prime Minister Stolypin

1912

Fabergé: "Napoleonic Egg"
(MF – New Orleans); "Tsarevich Egg"
(AF – Richmond).
Competition "Court Jeweler Carl
Fabergé"; first prize awarded to François
Birbaum.
Cartier opens in New York.
Exhibition *100 years of French Painting*
held in St. Petersburg.
Le Dieu Bleu ballet by Hahn, costumes by
Bakst, danced by Karsavina and Nijinsky
Debussy: *L'Après-midi d' un Faune*, sets and
costumes by Bakst

1913

Fabergé: "Winter Egg" (MF – Private
Collection); "Romanov Tercentenary
Egg" (AF – Kremlin).
Romanov Tercentenary celebration.
700, 000 workers go on strike.
Stravinsky's *Le Sacre du Printemps*, sets and
costumes by N. Roerich

1914

Fabergé: "Catherine the Great Grisaille
Egg" (MF – Hillwood); "Mosaic Egg"
(AF – H M Queen Elizabeth II); Fabergé
becomes "Merchant of the First Guild".
Cartier closes St. Petersburg office.
Death of Norwegian enameler Gustav
Gaudernack.
Rimsky-Korsakov: *Le Coq d'Or*, set
and costumes by Natalia Goncharova.
1.5 million workers go on strike in
Russia.
Outbreak of the First World War; at Battle
of Tannenberg 110,000 soldiers are killed
and 96,000 taken prisoner

1915

Fabergé: "Red Cross Egg with Portraits"
(MF – Cleveland); "Red Cross Egg with
Icon" (AF – Richmond); London shop is
closed; Fabergé petitions to exempt crafts-
men from military service.

Goldsmith C. Blank becomes Appraiser
to His Majesty's Cabinet and Hereditary
Honorary Citizen.
1.4 million Russians are killed and
970,000 are taken prisoner

1916

Fabergé: "Order of St. George Egg"
(MF – cat.); "Steel Military Egg"
(AF – Kremlin); the firm is converted
into a joint stock holding company with
a capital of 3 million roubles and six
hundred shares.
Mikimoto patent for cultured pearls.
Richard Strauss: *Till Eulenspiegel*, danced
by Nijinsky and F. Revalles.
Tsar Nicholas takes over the command
of the Russian army from Grand Duke
Nicholas.
Murder of Rasputin

1917

Fabergé: "Birch Egg" (MF – not
delivered); "Constellation Egg" (AF –
not delivered).
Committee of the Employees of the
Company C. Fabergé is formed.
Cartier acquires 653 Fifth Avenue in
exchange for a pearl necklace.
February Revolution; abdication of
Nicholas II and imprisonment of the
Imperial family at Tsarskoye Selo.
Russia becomes a Republic with a
provisional government under Prime
Minister A. Kerensky.
October Revolution

1918

Fabergé: House of Fabergé closes in
Petrograd; Fabergé flees through Finland
to Germany and then to Switzerland.
Nicholas II and his family are executed,
as are all the Grand Dukes and Grand
Duchesses living in territory held by the
Bolsheviks

1919

Treaty of Versailles

1920

Death of Carl Fabergé in La Rosiaz,
Switzerland.
Death of Grand Duchess Vladimir

1924

Brothers Eugene and Alexander, sons
of Carl Fabergé, found "Fabergé & Cie"
in Paris together with designers and
hardstone carvers Andrea Marchetti and
Giulio Guerreri

1925

Death of Augusta Fabergé.
*Exposition Internationale des Art Décoratifs
et Industriels Modernes* in Paris

1928

Death of Dowager Empress Maria
Feodorovna

1929

Carl and Augusta Fabergé are buried in
Cannes

INTRODUCTION

PETER CARL FABERGÉ
(18 MAY 1846-24 SEPTEMBER 1920)
HIS LIFE AND HIS ART

Peter Carl Fabergé, born in St. Petersburg in 1846, has been called the greatest craftsman in the age of craftsmen and is unanimously regarded as the owner of the largest jewelry firm ever to have operated anywhere on earth.[1] His name has been linked to a host of legendary creations, and rumors still persist that he himself modified a ruby cup once owned by the legendary Cleopatra the Great of Egypt.[2] These appraisals of the man and his work are all part of a commonly held myth that Fabergé, sitting at his workbench wearing a visor and using a jeweler's loop, single-handedly created the wonderful works of art on view in this exhibition. The truth of the matter is, alas, somewhat different. Although the life of Carl Fabergé is in many ways a fairy-tale succession of triumphs, it is also a tragedy which ended suddenly in exile, despair and death from a broken heart.

Contemporary physical descriptions of Fabergé are lacking, but photographs, taken at the height of his popularity, depict a man whose prominent cheekbones, aquiline nose, and bright, twinkling eyes are framed by a bushy beard and moustache. His hair was usually neatly combed behind his ears and above his neck, framing and setting off his brow and the completely bald crown of his head.

It is difficult to get a handle on Fabergé's personality and character, but a few anecdotes related primarily by those who knew and worked with him[3], can provide a limited character sketch of this extraordinary entrepreneur. Apparently very set in his ways, Fabergé was adamant about the things he hated, and writing letters topped that list. He was laconic in speech, and always got to the point as quickly as possible – he detested those who talked unnecessarily. He assiduously avoided politics as a subject of any conversation. He had little patience with legal documents, disliked studying bank accounts and sales sheets, and harbored disdain for those who would join organizations formed for the protection of some special interest or group.

He could be witty. He once told a fawning client, who was searching for square Easter Eggs which she had mistakenly thought he would be creating, that he was simply not up to such a complex task. He could enjoy a practical joke, often at his own expense. He once complained to an old friend about his habit of sending him caviar as a Christmas present. Fabergé facetiously explained that Russia had a great many other natural treasures, such as camels. The following Christmas a gaily dressed Kalmuch arrived at the door of his establishment leading a camel and bearing a letter, which read, "You asked me for a camel. I have sent one to you."[4] The beast was soon placed in good hands among other exotic creatures in the zoo of a local nobleman, Prince Wyazemski.

Fabergé hated traveling, and often did so without packing. On one occasion, he was almost prevented from checking into a fashionable hotel in Nice on the French Riviera because he had no accompanying luggage. In the end, he was recognized, and the reservation was honored. He then purchased the toiletries and clothing he needed.

He was extremely tolerant. When confronted with someone's sordid business, Fabergé would simply reply, "But men must live." He was not judgemental, but did quantify word and deed as either "silly" or "stupid" or "not silly" and "not stupid."

When the political disturbances of 1905 erupted and the streets of St. Petersburg were unsafe because of continued confrontations between protesting workers and peace-keeping Cossacks, Fabergé witnessed stray bullets hitting his premises. Not wishing to jeopardize the lives of his employees, he arranged for his workmen to remain in the safety of their own homes, and nonetheless continued to pay them.

Notes
This essay has benefited enormously through the kindness of Géza von Habsburg, to whom I here express my thanks. He has generously placed at my disposal his invaluable personal collection of photographs and has carefully read each of the text's successive drafts, making valuable suggestions and comments. I, nevertheless, take full responsibility for its present form.

1. Moncrieff (2000), p. 71.

2. Bainbridge (1949), p. ix.

3. *Ibid.*, pp. 24–37, whose account I have drawn on for the anecdotes.

4. Indeed, his wit and sense of humor are perhaps the singular characterizations of Fabergé's character which was even manifested in his creations such as the miniature salt chair which is designed as a bidet. See Snowman (1953), pp. 26, 53.

Fabergé's human, tender side, and his zest for life is revealed by his attitude towards the small children whom he would frequently sit on the floor of his sales room and allow to play with some of his precious creations. Clients would watch with mixed feelings of wonder and anxiety as their children sat amongst his exquisite, but not unbreakable, animal carvings, many of which are on view in this exhibition.

This kindly gentleman's career in jewelry, and his subsequent associations with the last two Tsars of Russia, Alexander III and Nicholas II, may be directly ascribed to his father, Gustav Fabergé, the son and only child of Peter Fabergé and his wife, Marie-Louise Elsner.[5] As a young man, Gustav Fabergé traveled to St. Petersburg where he apprenticed first with the master jeweler Andreas Ferdinand Spiegel, before transferring to the firm of Wilhelm Keibel. Keibel's firm had earlier reworked the Russian Crown Jewels in 1826. The House of Fabergé was later to create exact, miniature copies of the Imperial Regalia on the occasion of the Paris Exposition Universelle in 1900.[6]

In 1842 Gustav Fabergé married Charlotte Jungstedt, daughter of a Danish painter, and in that same year opened his own establishment in St. Petersburg at 12 Bolshaya Morskaya. The couple had a son, Peter Carl Fabergé, the subject of this exhibition, who was born on 30 May 1846. As a youth, Fabergé attended the Lutheran Gymnasium Svetaya Anna (St. Ann's School), a rigidly run German-language private school, which was one of the best and most fashionable in St. Petersburg.[7] His attendance at that institution is indicative of his father's advantaged economic position. The couple had only one other child, a second son named Agathon (1862–1895), who like his older brother Carl, joined the family's firm but died suddenly at the age of thirty-three.

In 1860 Gustav Fabergé retired and moved to Dresden, Germany, but still retained ownership of his firm. Before moving, he appointed either his partner Peter Hiskias Pendin[8] together with an individual called Zaiontchkovsky[9] managing director. In any event, Pendin was subsequently charged with training Carl in his father's firm.

As a lad, the young Carl Fabergé traveled to Frankfurt-am-Main, Germany, in order to apprentice with the House of Friedmann, a jewelry firm.[10] While there he also enrolled on courses at the local Handelsschule (Trade School) in Dresden where his studies could be monitored under the watchful eye of his father. He also undertook study trips to England, and with Julius Butz, the son of Alexander Franz Butz, a jeweler in St. Petersburg, traveled to Italy where he studied the work of Florentine enamellers and goldsmiths. The objects which Fabergé saw in museums, exhibitions, and jewelry stores during his training outside of St. Petersburg, and the styles on which he worked as an apprentice were to characterize much of his own production.

Returning to St. Petersburg, he began to work in his father's establishment. Then in 1870 Pendin died and Carl, at the age of 24, took over the complete management of his father's firm. Two years later in 1872, he married Augusta Julia Jakobs. Although his bride was not apparently a great beauty, the match was a good one as she came from an artisan's family herself, her father having served as an overseer of the imperial furniture workshops under the reign of Nicholas II's grandfather, Tsar Alexander II.

Carl's ties with Tsar Alexander III can be traced to the early 1880s, and are linked to the arrival from Dresden of his twenty-year-old younger brother, Agathon, who joined the firm. In 1882 the House of Fabergé was awarded a gold medal at the All-Russian Industrial Art Exhibition which was held in Moscow, despite the fact that this was the very first time the firm had participated in such an event. Although all of the objects shown in that exhibition were jewels, the firm was already at work on *objets de fantaisie*[11], for which the House of Fabergé was to become deservedly famous. The decision to change the firm's focus away from jewelry toward these artefacts would be resoundingly vindicated in years to come.

Fabergé's earliest, direct personal contact with the Imperial family revolves, of

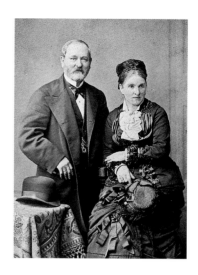

FIG I. PHOTOGRAPH OF GUSTAV AND CHARLOTTE FABERGÉ
Carl Fabergé's parents, Dresden *c.* 1860.
Archive Photograph

5. Good biographical sketches can be found in Bainbridge (1949), pp. 1–23; and in Snowman (1953), pp. 27–34.

6. Bianchi (1999A), pp. 64–65.

7. For these formative influences on Fabergé, refer to Snowman (1953), pp. 38–45.

8. Habsburg/Solodkoff (1979), p. 11.

9. Snowman (1953), p. 28.

10. *Ibid.*, pp. 38–45, is a particularly rich source of this chapter of Fabergé's life.

11. Bainbridge (1949), pp 30–31.

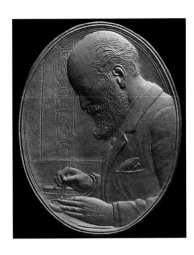

course, around the creation of the very first Imperial Easter Egg, which is discussed elsewhere in this catalog. There is however an incident which occurred around this time, but whose significance appears to have been overlooked. This is the episode of the replication of ancient works of art, particularly those wonderful gold objects which archeologists call the Kertch treasures.[12] The name derives from the huge peninsula found on the northern coast of the Black Sea, on the south coast of the Crimea, which is referred to as Kertch. In ancient times this area was colonized by Greeks, who had buried their dead with elaborate riches. Throughout the course of the nineteenth century, one tomb after another in this area had been uncovered, either by accident or design. The finds from officially sanctioned archeological excavations eventually made their way into the Imperial collections of the Hermitage, and were under the supervision of Count Sergei Stroganoff, President of the Imperial Archeological Society, himself an art historian and connoisseur.

According to Henry Charles Bainbridge's study of Fabergé, published in 1949, Count Stroganoff, after gaining the permission of Tsar Alexander III, suggested to Fabergé that he make replicas of some of these ancient gold treasures.[13] Fabergé accepted and began the project with Agathon, his younger brother, who was to become a brilliant jeweler and designer. Fabergé then enlisted the aid of artisan Erik Kollin. The significance of this event is that Fabergé, even at this early date, was organizing the work rather than creating the objects with his own hands because one now recognizes that the actual replicas of the Kertch originals were fashioned by Kollin.[14] When Fabergé submitted both the finished replicas and the originals to Alexander III, the Tsar was so taken by the fact that the one was virtually indistinguishable from the other that he decided on the spot to put on an exhibition in the Hermitage where replicas created by the House of Fabergé would be on view next to the originals in order to demonstrate the quality of their fine craftsmanship.[15] Fabergé also participated in the All-Russian Industrial Art Exhibition, in Moscow, where his work also caught the attention of Tsarina Maria, the wife of Alexander III. She purchased a set of gold cuff-links decorated with cicadas, or grasshoppers, which were considered symbols of good luck, based on originals from Kertch. In 1885, Fabergé received a gold medal at the Nuremberg Exhibition for his establishment's replicas of these very same Kertch treasures.[16]

In 1884, Carl Fabergé enlisted the assistance of Michael Evanpievich Perchin, a self-taught Russian craftsman. Perchin challenged Fabergé to see which of them could most successfully replicate a snuffbox in the Emperor's collection, created in Paris in 1777 by the renowned craftsman Joseph-Etienne Blerzy.[17] Fabergé's work was another *tour-de-force*, namely a snuffbox of gold decorated in green, red and white enamel, decorated on the lid with a miniature depicting Venus and Cupid. When Fabergé's version was subsequently presented to Alexander III, the Tsar was so taken by this particular work of art that he ordered both boxes to be displayed side by side, as he had earlier ordered be done with the originals and Fabergé's renditions of the Kertch treasures.

Alexander III became Fabergé's first publicist, extolling his virtues to one and all. The Tsar then appointed Fabergé "Supplier to the Imperial Court", a title which enabled Fabergé, along with about a dozen or so of his contemporaries similarly honored, to incorporate the double-headed imperial eagle into his firm's logo.[18] In 1890, Alexander III also conveyed the title "Appraiser to the Office of His Imperial Majesty" upon Fabergé, which made him an honorary, hereditary citizen of the empire. The relationship which Carl Fabergé had thus far cultivated with Alexander III was to be furthered and developed with his son and heir, Tsar Nicholas II.

As a result, Fabergé seamlessly integrated himself into the cultural fabric of the court of Nicholas II. Members of the Imperial Russian Court were responsible for introducing the House of Fabergé to their royal relatives abroad including members of the Danish

12. See Williams/Ogden (1994), pp. 122–198, for a selection of these antiquities and discussions of the sites in which they were found. It was not unusual to see the Muslims of the Crimea, who had chanced upon one of these tombs, to incorporate into their accessories some of these ancient objects. See Buxhoeveden (1938), p. 136. Grand Duke Constantine, an uncle of Czar Nicholas II, would often host lectures by distinguished scholars, the topics of which were the latest discoveries at Kertch. See Buxhoeveden (1938), p. 223 and Maylunas/Mironenko (1997), pp. 182, 184, for the range of his academic interests).

13. Bainbridge (1949), pp. 19–20.

14. Habsburg/Solodkoff (1979), p. 46.

15. Snowman (1953), p. 40.

16. Bainbridge (1949), pp. 19–20, 123.

17. Habsburg (1994), pp. 16–17.

18. See Andrea Marchetti's comment on the use of the double-headed eagle by the House of Fabergé, in Snowman (1953), p. 11.

monarchy and British monarchy[19], and Carl Fabergé himself was even able to forge far-flung ties with the Thai monarchy.[20]

The late 1880s witnessed both the expansion of the firm and its continued success at international exhibitions.[21] Its first branch was opened in Moscow in 1887, and a second followed three years later in Odessa, the firm having doubled its size in St. Petersburg. The House of Fabergé was awarded a special diploma at the Northern Exhibition held in Copenhagen in 1888, and was *hors concours*, "without competing", being represented on the jury.

The 1890s was a bitter-sweet time for the House of Fabergé. Two family members died within a short interval of one another. The family's patriarch, Gustav Fabergé, died in Dresden in 1893 on his seventy-ninth birthday. Within two years, Agathon, Fabergé's only sibling, died prematurely at the age of thirty-three. These losses were, perhaps, tempered by the coming-of-age of Eugène Fabergé who joined the firm in 1894. During this period of personal loss, the House of Fabergé continued to receive international honors; awarded the State Emblem at the All-Russian Industrial Art Exhibition at Nijny-Novgorod in 1896 and granted a Royal Warrant by the Court of Sweden and Norway in 1897.

The century ended spectacularly for the House of Fabergé. The firm occupied its newly erected flagship headquarters at 24 Bolshaya Morskaya in 1900. Almost as soon as its doors opened, the firm received its first American client in the person of Princess Cantacuzène (née Julia Grant, granddaughter of former US President Ulysses Simpson Grant) who had arrived in order to visit her husband's Russian domains. She had made the transatlantic journey aboard the *Narada*, the 224-foot yacht of Henry C. Walters in the company of his favorite niece, Laura Delano.[22] To these events may be added what is considered by many to be the crowning glory of Fabergé's professional career. The firm participated in the 1900 Exposition Internationale Universelle in Paris. There, for the first time ever, the public was able to see on exhibition a selection of the firm's now famous Imperial Easter Eggs. The firm had also created the miniature regalia[23] specifically for this exhibition, which marked a personal high for Fabergé himself. Although a member of the jury, he was nevertheless acclaimed Maître and received the coveted honor of being named a member of the *Légion d'Honneur*.

These events catapulted the House of Fabergé into almost every corner of the globe. American millionaires now came to St. Petersburg and patronized his establishment. These included both Consuelo Vanderbilt, the granddaughter of Cornelius Vanderbilt and Edith Rockefeller, third child of John D. Rockefeller, Sr.[24] The firm established a temporary presence in London in 1903 with the assistance of Arthur Bowe, who had earlier become a partner in the Moscow branch of the House of Fabergé. The London branch was to become permanent in 1908, and to continue in business until 1915. In 1904, objects created by the House of Fabergé were placed on public view in the United Kingdom for the first time in an exhibition arranged by Lady Paget as a charity bazaar at the Albert Hall on behalf of the Royal Hospital for Children. In this same year Fabergé himself received a personal invitation from King Chulalongkorn to visit Thailand (formerly Siam). The fame and reputation of the House of Fabergé had now been indelibly established worldwide, but what was Fabergé's contribution to that success and what role did he himself actually play within the firm?

The answers to those two questions have, in the past, been obfuscated by the commonly held belief that because Fabergé was himself a master jeweler and goldsmith, he must have come into direct physical contact with the materials which were miraculously transformed into his breathtaking creations. This belief is further compounded by many of his biographers who define Fabergé as a craftsman involved in the applied or decorative arts.[25] Such a designation, however, obscures the fact that Fabergé himself rarely, if at all, crafted any of the objects which the House of Fabergé created. Fabergé's role in the

19. These relationships were very close and somewhat complex. Tsar Nicholas II and his wife, Tsarina Alexandra, were both first cousins of King George V by virtue of the fact that the Tsarina was herself a granddaughter of Queen Victoria and the Tsar was a nephew of his mother's sister, Alexandra, Queen of England who was married to King Edward VII. For these and other dynastic links between the family of Tsar Nicholas II and Tsarina Alexandra and the other royal families of Europe, see Broughton International Inc., (1998), pp. 240–255, 295 (no. 487), 316–317 (nos. 526–527), passim.

20. The contact between the courts of Russia and Thailand (formerly Siam) was established as a result of the visit made to that country by Nicholas when he was still Tsarevich, see Broughton (1998), pp. 144–145, nos. 220–221 and p. 265, no. 436. See also Roy D. R. Betteley, in Habsburg/Solodkoff (1979), pp. 139–147; Fabergé's invitation to visit King Chulalongkorn was conveyed by Prince Chakrabong, who was being educated in Russia at the time in St. Petersburg and was serving as a pupil in the Corps des Pages. The Prince spoke Russian fluently.

21. The chronological record of events in this and the following three paragraphs are a staple of almost every book about Fabergé. See for example passages in Bainbridge (1949) and in Fabergé/ Proler/Skurlov (1997). See also Snowman (1979) and Habsburg/Soldokoff (1979).

22. Habsburg (1996), p. 27.

23. Broughton (1998), pp. 142–3, no. 208.

24. Habsburg (1996), p. 29.

25. Snowman (1953), pp. 35, 37, asks whether Fabergé ought to be considered an artist or a craftsman. He ultimately opts for the latter and habitually refers to him as "the Craftsman." And therein resides a criticism which is often leveled against Fabergé, the craftsman producing decorative arts. As the industrial revolution took hold, certain aesthetic purists developed a prejudice against the functional articles which the House of Fabergé had been creating, and formulated the axiom that decorative arts which primarily serve a utilitarian function could not be considered examples of fine art (see also the incisive comments by Habsburg/Solodkoff (1979), pp. 42–45). This brief essay is, however, not the appropriate forum in which either to challenge that criticism or formulate a viable definition of "art." Suffice it to state that several of Fabergé's contemporaries, including many artisans of Meiji Japan who were creating works of art for the booming export market concentrated in the period's world's fairs, were being subjected to the same criticism. See Bianchi (1999B), pp. 60–67.

26. Bainbridge (1949), states that "Fabergé often gave the impression that he was doing nothing at all," but that "he knew how to generate 'atmosphere'."

27. Muntian (1996) in *The World of Fabergé: Catalogue*, p. 14.

28. Habsburg (1984), pp. 24–25.

29. Sacheverell Sitwell in Bainbridge (1949), page vii.

30. Habsburg (1984), p. 23. See Buxhoeveden (1938), pp. 283–284, for the relative ease of access between St. Petersburg and Scandinavia via the Gulf of Finland.

31. Bainbrige (1949), pp. 33–34 and Fabergé/Proler/Skurlov (1992), p. 27.

32. Fabergé/Proler/Skurlov (1992), pp. 23–24.

33. Compare, for example, the photograph of the interior of the Komai atelier in Oliver Impey and Malcolm Fairley, *The Nasser D. Khalili Collection of Japanese Art II Metalwork* (1995) part I, p. 41, fig. 5 with the interior of Faberge's Moscow workshops in Snowman (1953), figs 24–26.

creative process may be profitably compared to that of a choreographer.[26] He would co-ordinate a team of designers who would submit rough sketches to be discussed. Sometimes these designs were generated by members of his firm; other times clients submitted their own designs or ideas for commissions, the Tsarina Alexandra being a case in point.[27] The more expensive a commission, the more materials were involved in the creation, and the more intense and frequent the meetings, all chaired by Fabergé who oversaw every stage of the work. These might involve presenting the client with a watercolor design, painted to scale, of the commission. Round-table discussions such as these were routine, and often took place in Fabergé's private office where extensive discussions of the plan of attack for complex objects were resolved. There are rumors that, during those sessions, he would smash to smithereens the objects which did not meet with his approval or fell short of his high standards of quality.

The size of Fabergé's workforce was indeed impressive, and at one time numbered about 500.[28] That number included about a dozen carpenters whose sole task was to manufacture the presentation cases for the works of art, as well as a number of independent artisans, who, while owning and operating their own shops, signed contracts and worked exclusively for the House of Fabergé. The majority of his craftsmen were Finns or Swedish-Finns, given the proximity of St. Petersburg to the Gulf of Finland, and this must be taken into consideration when assessing the *oeuvre* of Fabergé.[29] The predominant nationalities of his craftsmen should come as no surprise when one considers that between twenty and thirty per cent of all goldsmiths working in St. Petersburg at this time were Finns.[30]

These craftsmen worked in close proximity to one another, the spatial contiguity facilitating the collaborative effort which characterizes most of the articles of the House of Fabergé. His direct employees worked exclusively for him under contract in workshops for which he collected no rent. He also provided them with all of the necessary tools and raw materials free of charge. It seems that Fabergé paid his master craftsmen no set hourly or daily wages, but rather paid them in accordance with the profits earned from the sales of the merchandise they had created. In some ways, Fabergé's atelier appears to have been a microcosm anticipating the socialist economic system which was in theory to replace that of Tsarist Russia in later Communist workers' Utopias.[31]

As mentioned earlier, the headquarters of the House of Fabergé were eventually located in St. Petersburg at 24 Bolshaya Morskaya[32], after Fabergé, now in business for twenty-eight years, engaged the architect-designer Fabergé Schmidt in 1898. Their collaboration resulted in the erection of the pink granite, four-storey edifice, costing 416,000 roubles, which the House of Fabergé occupied in 1900. In keeping with the corporate continuity of the firm, this building was not only a home for Fabergé's family – in rooms facing the street, providing views of the city – but it was also the location of most of his craft studios. So, for example, Hollming occupied space on the first floor; Perchin then Wigström on the second; Holmström on the third; and Thielemann on the top, fourth floor. The sales room was also located on the first floor and the establishment maintained a reference library, which was almost never found in comparable workplaces of the time. Despite such spacious headquarters, the lapidary studios for cutting gems and sculpting hardstones, as well as the silver-smithing components of Fabergé's operation, were conducted off-site at other locations.

One estimate claims that several hundred individuals worked in this space at any one time. Although that estimate may be an exaggeration, one can profitably compare photographs of craftsmen working at 24 Bolshaya Morskaya with contemporary photographs taken of workshops in Meiji Japan.[33] The similarities are striking, and one cannot help but emphasize that both the Meiji artists and those working for the House of Fabergé were part of an international movement in which new technologies and

materials, born of the West's industrial revolution, were put to creative uses for the production of consumer goods of high technical and aesthetic value.

The House of Fabergé's presence along Bolshaya Morskaya was subdued, one might almost say invisible. The building itself was not advertised by any large signs, but the House of Fabergé did employ a doorman, a position still regarded by exclusive retailers as essential to their success.[34] Anyone who patronizes the trendy fashion boutiques and cosmetic emporia along Manhattan's fashionable Fifth Avenue will also recognize the importance of such an employee.[35] The entrepreneurial Fabergé recognized the value of a good doorman, and one was always at his post at 24 Bolshaya Morskaya.

Once one entered the sales room on the first floor, one realized there was virtually no interior décor. Fabergé's minimalist approach was doubtless intended to prevent architectural decorative elements competing with his merchandise. Clients soon learned that *objets de fantaisie* were always to be found on the left-hand side of the sales room while jewelry was restricted to the right-hand side.[36]

Fabergé's genius within this unique environment was his uncanny ability to recognize what his clients desired and channel the artistry of his craftsmen and the techniques at their disposal in order to fashion available material into the client's desired work of art. Fabergé acted as a mediator between what was desired and what was technically possible with the materials. His ideas for the design were conveyed to his craftsmen, and he then followed up this process by co-ordinating the efforts of specialists, each one expert in the handling of a specific material. This delicate balance between the ideal and the reality, driven by his clients' needs, explains why his *oeuvre* is so heterogeneous and why his role in the firm's creative process is best regarded as one of guiding and co-ordinating. Despite the variety of his work, the end result is so distinctive that it cannot possibly be readily confused with another atelier's creations. I would attribute this distinctive "House of Fabergé style" to Fabergé's role as a choreographer. Just as a choreographer's essence is revealed by a variety of dancers, so Fabergé's close, hands-on supervision produced objects that were unmistakably "Fabergé" artefacts. That process and its individual results are the real genius of Fabergé.

Two characteristics of his workforce facilitated the manufacturing process. First, Fabergé himself had long, professional ties with many of his master craftsmen, some of them going back to his youth when he first joined his father's firm. Fabergé was taught by Peter Hiskias Pendin. Both Pendin and August Wilhelm Holmström, who had been in the employ of Gustav Fabergé, continued to distinguish themselves under Carl Fabergé. Second, the master-craftsmen were personally interrelated.[37] For example, August Holmström's daughter, Fanny, married Knut Oscar Pihl, himself a master craftsman for Fabergé. Their daughter, Alma Theresia Pihl, distinguished herself as a designer of at least two of Fabergé's Imperial Easter Eggs. Henrik Emanuel Wigström, another master craftsman with the House of Fabergé, apprenticed under Michael Perchin. Furthermore, Perchin and his wife were Wigström's children's godparents, and Perchin bequeathed his workshop to Wigström. As these relationships demonstrate, not only were skills being passed on from one generation to another under the same roof in the House of Fabergé, but Fabergé's own *modus operandi*, the way in which his organization functioned – was also being passed on from one generation to another. The value of these family ties together with the hereditary craft skills and with Fabergé's early hands-on interaction with some of these masters cannot be underestimated. The solid foundation provided by a unique corporate continuity combined with this zealous cultivation of continued imperial support, contributed immeasurably to Fabergé's success.

The success achieved was, however, also dependent upon other factors, not the least important of which is now termed "the Fabergé Revolution." Its manifesto was issued by Fabergé himself and was based not only upon his genius as an organizer of artisans but also

34. Bainbridge (1949), pp. 3–4.

35. M. Gil Perez, the doorman at Christie's auction house in New York was recently featured in a society section of one of that city's leading newspapers, in which his contribution to the firm's image and perhaps even success, was documented. See Pollack, "Opening Doors, and More" in the *Sunday New York Times* (11 July 1999), the City Section, p. 1.

36. Bainbridge (1949), p. 4.

37. There are extended biographical sketches of these individuals in Bainbridge (1949), pp. 114–137, and more succinct versions thereof in Solodkoff et al (1989), pp. 154–159.

upon his business acumen. Here is an extract of his manifesto in his own words:

"Clearly if you compare my things with those from such firms as Tiffany, Boucheron and Cartier, of course you will find that the value of theirs is greater than of mine. As far as they are concerned, it is possible to find a necklace in stock for one-and-a-half million roubles. But of course these people are merchants and not artist-jewelers. Expensive things interest me little if the value lies merely in so many diamonds or pearls."[38]

One wonders, therefore, whether these sentiments of Fabergé are his own, or rather a reflection of the prevailing attitude of several members of the Russian aristocracy of the period, because those remarks are uncannily similar to the comments recorded on 20 July 1894 in the diary of Grand Duke Alexander Mikhailovich, called Sandro, regarded by many as Tsar Nicholas II's best friend: "Jewelry … represented, no doubt, a stupendous outlay of money, but in those days we judged the jewelry by the beauty of its design and colours, not by its value."[39]

Fabergé's biographers' insistence in referring to him as a craftsman resides in the fact that his *oeuvre* is technically faultless. His most vocal critics are forced to admit that the quality of the workmanship exhibited by his firm is, generally, superb and unsurpassed.[40] Fabergé was a stickler in this regard and always demanded the highest standards of technical accomplishment. All agree that the single most important characteristic of the House of Fabergé, what one might call its hallmark, is the meticulous quality of the work. This is nowhere more evident, for example, than in the lids which the House of Fabergé created, particularly for cigarette-cases. Their soldering is invisible so that boxes of metal appear to have been seamlessly crafted. When lidded, the hinges are invisible to the eye, a recognized characteristic of Fabergé hinges.[41] They are almost air-tight and their owners have remarked that they can even hear an audible hiss created by escaping air when these boxes are closed.

Fabergé, as a consummate craftsman, was conscious of the aesthetic changes which were being brought about by the industrial revolution. It not only introduced new technologies and new materials which he began to exploit to the fullest, but it also introduced an array of new consumer products. Towards the end of the nineteenth century, portraiture was revolutionized by photography. These photographs required picture-frames, and the House of Fabergé excelled in their manufacture. Its production was prodigious because of the importance ascribed to framed photographs of loved ones within homes.

Electricity introduced the light-bulb and required electrical lamps and shades. Louis Comfort Tiffany, a contemporary of Fabergé, manufactured lamps which relied on the extensive use of glass for shades necessary for the casting of light from the bulbs. Electricity was also harnessed for electrical bells not only to announce visitors at the door, but also to summon domestics, replacing hand-bells or other devices. As a result, the House of Fabergé created several electric bell-pushes. Clocks became more commonplace as time began to dominate one's social intercourse. Everyone admits that the hands and dials of Fabergé's clocks are clear and easy to read, and this is in keeping with Fabergé's insistence on consummately crafted products. For these reasons, the House of Fabergé produced many picture-frames, many bell-pushes, and many strut clocks. To this list can be added the countless cigarette-cases, umbrella handles, opera glasses, desk sets, ashtrays, stick match holder-strikers, and the like. It is estimated that the House of Fabergé created some 150,000 works of art.

Whereas it is true that many of these works of art are small in scale, it would be perverse simply to take the miniaturist[42] quality of Fabergé's work out of context and compare him to Benvenuto Cellini (1500–1570), the Florentine sculptor and goldsmith, as some of his contemporaries did, much to his chagrin.[43] One must emphasize that the House of Fabergé was not narrowly restricted to such miniatures, because articles created included both furniture and fashion.

38. Snowman (1998), p. 11. It is interesting to recall that François Birbaum was dismissive of some of these jewelry designs (see Hapsburg (1984), p. 12: "At first Carl learned to design and make pieces of jewelry similar to those sold in his father's shop. These jewels were later described by Franz Birbaum as "… clumsy gold bracelets …"). As time passed, the House of Fabergé, while always maintaining an impressive inventory of jewelry, nevertheless focused its goldsmithing and jeweler's talents on "*objects of fantasie*, [defined as] the product of an artist-craftsman's imagination, resulting in a small object having both artistic and functional value" Habsburg/Solodkoff (1979), p. 12.

39. Maylunas/Mironenko (1977), p. 85.

40. First strongly emphasized by Snowman, *The Art of Fabergé*, pp. 36–37, soon thereafter becoming the universal consensus about the high quality of the workmanship of objects created by the House of Fabergé. That consensus has given rise to a host of hyperbolic testimonials including the "tale about a blind man who tested Fabergé" and could determine an original because it was "beautifully put together" … and had the "right feel"." Sogg, "Fit for a Tsar". *Art and Antiques* (New York, January 2000), pp. 84–89.

41. Snowman (1953), p. 57 and Habsburg/Solodkoff (1979), p. 54.

42. The general impression of the dominant miniaturist characteristic of the *oeuvre* of the House of Fabergé often obscures the fact that articles created often included both furniture and fashion. Habsburg/Solodkoff (1979), pp. 62, 81; Muntian (1996), pp. 113–121; and Bainbridge (1949), p.8.

43. The initial discussion by Bainbridge (1949), pp. 49–56, still retains its impact.

The fate of Carl Fabergé and the fortune of the House of Fabergé, however, were linked to the fate and fortune of Russia, and particularly to those of Tsar Nicholas II, whose popularity ratings began to plummet with the outbreak of World War I in 1914. As the battles waged, the House of Fabergé directed more and more of its resources to the war effort.[44] Its craftsmen now began to produce hand grenades and medical supplies. Its silver workshops devoted their energies to the manufacture of shells and grenades. As the war dragged on, many of Fabergé's employees were drafted, and his once large workforce was reduced by about 80 per cent. He sent frantic requests to the Ministry of the Imperial Court in an effort to exempt some of his craftsmen from military service, declaring, "If they leave, it would be very difficult to carry out the Imperial commissions … if this personnel is called up for military service, then the workshop has to be immediately closed down."[45] Gold and silver were scarce, and reserved for the manufacture of military medals and badges. Steel, copper, and brass now became the materials of the hour and Fabergé and his artisans were quick to exploit their decorative effects.[46]

This is not the place to rehash the political events which eventually toppled the regime of Tsar Nicholas II.[47] It will suffice to state that having been abandoned by his high command, every ranking member of which urged his abdication, Tsar Nicholas II complied and was shortly thereafter placed under house arrest by the Bolsheviks. The Russian Revolution of 1917 had begun, and the Bolsheviks, advocating a classless society and workers' rights, gradually annulled private ownership of the means of production. It is interesting to note that Fabergé had earlier seized upon the idea of forming a workers' soviet, called the "Committee of the Employees of the Cooperative K. Fabergé"[48], composed of members of his own staff, with the expressed purpose of running the business.

In 1918, Fabergé, aware of the political situation, entrusted part of his inventory to the director of the Hermitage.[49] He doubtless harbored the hope that, when the current political unpleasantness had passed, he might yet return to claim his possessions and reopen his establishment. But the Bolsheviks eventually nationalized his company in that same year. When they entered his establishment, he asked only to be given 'ten minutes' to put on his hat and coat[50], and walked out of the door without taking anything else with him, even then consistent in his habit to travel without any luggage whatsoever.

His departure was facilitated by official diplomatic channels which enabled Fabergé, a bit earlier, to obtain a *laissez-passer* from the Imperial German Consulate General.[51] That document enabled him to apply for a diplomatic passport from Commissar Iossilevich within a fortnight, and a few days afterwards he was able to leave St. Petersburg on a diplomatic train[52], fleeing to Finland in disguise, with the help of the British embassy. One might speculate as to whether this reported assistance was in any way connected with Fabergé's association with the British royal family and the fact that he may still have had significant funds in British accounts, Bainbridge having continued to make sales privately until early January 1917.[53] Fabergé was part of an "an emigration unparalleled in history … [one in which] masses of people, equivalent to the population of a whole state, left their country … [only to become] scattered in exile all over the world."[54]

When the Russian Revolution reached Latvia in November, Fabergé, now in his seventies, proceeded to Bad-Homburg, Germany, and then on to Wiesbaden, where he was joined by his wife, Augusta, and their son, Eugène.[55] Augusta and Eugène had managed to escape from Russia and certain death, had they chosen to remain there, by crossing the border into Finland in late December 1918 on sleigh and on foot through snow-covered woods under the cover of darkness. The three then made their way to Lake Geneva in Switzerland, where, Fabergé, now seventy-four years old, died on 24 September 1920 in Lausanne from what friends and relatives called a broken heart[56]; he often exclaimed near the end, "This life is no more."[57] Augusta Fabergé, his widow, survived her husband by a

44. Bainbridge (1949), pp. 34–35.

45. Habsburg (1984), p. 80.

46. The finest article created by the House of Fabergé in response to these newly imposed conditions is doubtless the steel Military Egg. Fabergé/Proler/Skurlov (1997), pp. 230–233, no. 50.

47. These political events have been recently presented by Broughton International Inc. in light of recently released documents from the Archives of the Russian Federation in the special exhibition, *Nicholas and Alexandra: The Last Imperial Family of Tsarist Russia*. See the exhibition-related publications which include Bianchi, Nicholas and Alexander, and Broughton.

48. Habsburg/Solodkoff (1979), p. 17.

49. Habsburg (1984), p. 86.

50. Habsburg/Solodkoff (1979), p. 17.

51. Fabergé/Proler/Skurlov (1997), p. 28.

52. Bainbridge (1949), p. 34.

53. Solodkoff et al. (1984), pages 20–22. It is quite possible, of course, that these recently identified moneys, because of the way they were recorded, were not subject to Tsar Nicholas II's expectation that all Russians repatriate their foreign wealth on behalf of the war effort. See Clarke (1996), pp. 218–220.

54. Youssoupoff (1927), p. 241.

55. For a brief overview of the end of Fabergé's life, see Fabergé/Proler/Skurlov (1997), p. 28.

56. Fabergé/Proler/Skurlov (1997), p. 28: "…those who knew him said that he died from a broken heart."

57. Bainbridge (1949), p. 36, records his sentiment in this way, whereas Fabergé/Proler/Skurlov (1997), p. 28, suggest his words were, "…this is no longer a life worth living."

FIG 3. MRS CARL FABERGÉ
née Augusta Jakobs (1851–1925).
Archive Photograph

FIG 4. AGATHON FABERGÉ
(1862–1895). Photograph courtesy of
Ulla Tillander-Godenhielm

58. Bainbridge (1949), pp. 36–37.

59. Snowman (1979), p. 155, records his epitaph as:
CHARLES FABERGÉ
Joaillier de la Cour de Russie
Né 18 mai 1846 à St. Petersbourg
Décédé 24 septembre 1920 à Lausanne

60. Bainbridge (1949), p. 37.

61. For these events, see Bainbridge (1949), pp. 16–21.

62. Fabergé/Proler/Skurlov (1997), pp. 64–67; and Clarke (1996), pp. 71–83 and pp. 151–175.

63. Fabergé/Proler/Skurlov (1997), p. 64.

64. Clarke (1996), p. 80.

few years, dying in Cannes in the south of France in 1925. In May 1930 Eugène Fabergé had the remains of his father exhumed so that they could be re-interred with those of his wife in her grave in Cannes.[58] His tombstone of black, Swedish porphyry is said to have been inscribed with letters of gold[59], but Bainbridge maintains his epithet should have been, "He was never over-serious."[60]

The fate of his inventory and that of the property of his Tsar, Nicholas II, brutally murdered by the Bolsheviks with members of his family and a handful of faithful retainers in Ekaterinburg in July 1918, become intertwined somewhat earlier when Fabergé was entrusted with the care and maintenance of the jewels in the Imperial Brillyantovaya Komnata, or Diamond Room, of the Winter Palace in St. Petersburg. Doubtless at the suggestion of Fabergé, Tsar Nicholas II then agreed upon a plan to inventory the Crown Jewels.[61] Fabergé's son, Agathon, the firm's gem specialist, was entrusted with that task in 1913. Having created an inventory and having listed the Crown Jewels in order of value, the most expensive ranking at the top of the list, Agathon acquired the reputation as an expert on those Crown Jewels. After Germany declared war on Russia, Tsar Nicholas II decided to pack the Crown Jewels and other valuables housed in the Diamond Room and send them in 1914 to Moscow for safe-keeping in the event St. Petersburg should fall to invading German forces. The jewelry was packed in seven or eight packing-crates and transported to Moscow to await its fate, but Tsar Nicholas II was never able to regain possession of these treasures because he was murdered on orders from Lenin.

Between March and September 1917, the Bolshevik authorities did all in their power to collect the riches belonging to the now deposed Romanovs.[62] So, for example, eighty-four crates filled with treasures once belonging to the dowager Empress Maria in the Anichkov Palace were transported by a wagon-train of forty cars into Moscow's Kremlin Armory, allegedly for safe-keeping. Upon delivery, those in charge signed a receipt accepting the treasure which now joined the Crown Jewels, shipped there three years earlier by Tsar Nicholas II in an attempt to protect them falling into the hands of his German foes as trophy art.

Late in 1918, Fabergé reportedly obtained permission to store his inventory in the Hermitage, before he himself left Russia as a result of the Revolution. In the intervening twenty months which separate the incarceration of the Tsar and the escape of Fabergé, many of the possessions of the Tsar and other aristocratic members of the Romanov dynasty were additionally subjected to the pillaging and looting of unruly mobs who helped themselves to whatever they wished, and simultaneously destroyed palaces and priceless works of art. The government did little to prevent, let alone discourage, such acts of vandalism, which on occasion seems to have been officially sanctioned, as when the Gatchina Palace, belonging to the dowager Empress Maria, was looted by General Yudenrich's troops in 1919. This wanton destruction of Russia's rich cultural patrimony was even extended to include the homes and possessions of the advantaged. A Report by the Department for Preservation of Art and Antique Objects contains the following assessment regarding the condition of the country estate of Agathon, Fabergé's son. "This wonderful house has been completely destroyed … in fact, nothing turns out to be left; absolutely everything has been taken … everything has been turned upside down, broken, fabric and leather cut off the pieces of furniture that has remained …."[63] Recently released documents clearly reveal that Lenin, in an attempt to legalize these activities, moved ahead with plans to seize all of the remaining "official" property, both real estate and possessions, of Tsar Nicholas II, which the Bolsheviks now deemed as belonging to the state. The official declaration of that seizure was intentionally effected within days of Lenin's order to murder Tsar Nicholas II together with all the members of his immediate family and their faithful retainers at Ekaterinburg.[64] Lenin was then to establish Antikvariat in 1921 as part

of his New Economic Policy.[65] Antikvariat was the governmental department whose mandate was to administer the sales of state treasures to the West in order to obtain much-needed hard currency, which the insolvent new government desperately needed. The state treasures which were deemed the most sellable were the jewels, which the Bolsheviks were well under way in bringing together. Between 17 February and 24 March 1922, the Imperial Easter Eggs and other treasures had been combined into one collection. As a result, through the pernicious policy of Lenin's, all of the treasures of Russia, formerly belonging to Tsars, aristocrats, and the wealthy, including Fabergé objects and Crown Jewels, were now being physically intermingled. Their provenances being thus co-mingled, the objects were subsequently confused, especially in the West, and the name of Fabergé was associated with the putative fabulous treasures of the Tsars, incorrectly regarding both as one and the same.

While these events were unfolding, the Bolsheviks simultaneously began their systematic incarceration of individuals considered to be enemies of their regime. In 1919, Alexander, one of Fabergé's sons, was imprisoned by the Bolsheviks, but later managed to escape when his guards accepted the bribe offered by his wife. His brother Agathon was likewise incarcerated by the Bolsheviks, but his former familiarity with the Crown Jewels of Russia was to come back to haunt him. The Bolsheviks now required an appraiser to value those objects which they were willing to sell to the West, but there was virtually no jeweler in Russia whom the Bolsheviks could press into service in order to provide such an appraisal. They soon came to realize, however, that Agathon, the gemologist, was rotting away in one of their prisons.[66] Agathon was not only one of the only jewelers left in Russia but he was intimately familiar with the jewels which were to be laundered through Antikvariat because many of them, particularly the Imperial Easter Eggs, had been created in his father's firm and others, for instance the Crown Jewels, he had earlier cataloged and valued for the late Tsar Nicholas II. Agathon alone possessed the skills needed to obtain the necessary valuations.

He was therefore "released" from prison and forced to become complicit with this scheme. As part of his task, Agathon demanded a full-sized photograph of every piece he was asked to value.[67] Many of these photographs have survived to this day and their value to scholars in helping to identify objects is inestimable.[68] In addition, Agathon demanded that the exact weight of every precious stone and pearl be meticulously recorded in his catalog, which occupied his time from 1921 to 1923. In addition to appraising the jewelry, Agathon was also asked near the end of his task to evaluate and appraise between 18 and 20 lb. of loose diamonds which were presented to him in a pile. One wonders whether these included the diamonds the murderers had removed from the undergarments into which they had been sewn by the late Tsarina Alexandra and her daughters during the period of their incarceration. In later years, after his escape, Agathon maintained that that catalog existed in its original form as well as in one copy. In the end, the Bolsheviks found it extremely difficult to sell any of the jewels at prices approximating those established by Agathon because they were too high.

In 1928 Agathon staged a daring escape from Russia with his family, sleighing over the frozen waters of the Gulf of Finland with the guns of Kronstadt firing away, the shells landing around the fleeing gemologist. He succeeded in reaching his home in Levaschova, Finland, just over the border.

The appeal of collecting works by the House of Fabergé was, and continues to be, twofold.[69] On the one hand there is the snob appeal residing in the exclusivity of these beautifully crafted objects. On the other hand, owning an object by Fabergé provides a tangible link with one of the last resplendent monarchies of Europe, a monarchy which was suddenly eradicated by a revolution of cataclysmic proportions. In many respects,

65. Fabergé/Proler/Skurlov (1997), pp. 64–99; and Solodkoff (1989), pp. 42–48.

66. For this chapter in the life of Agathon Fabergé, the son of Fabergé, see Bainbridge (1949), p. 17.

67. Bainbridge (1949), p. 61.

68. Bainbridge (1949), p. 62: "This catalogue is the authoritative record of the jewels and is now in the possession of the Soviet authorities. I saw a copy of it in New York in 1937 in the possession of Dr Armand Hammer, and can vouch for it being a most remarkable work."

69. Curry (1995), p. 32.

Fabergé made the names of Tsar Nicholas II and his wife, Tsarina Alexandra famous; posthumously so because their names have become so intertwined with his work and the name of his firm: the stories of "Fabergé", "Nicholas" and "Alexandra" have become virtually synonymous.[70]

The link therefore between Fabergé and the culture of the courts of the last two Romanov Tsars cannot be underestimated in attempting to evaluate his work. His *oeuvre* has often been characterized as historicism, because the largest proportion of his designs appear to be based upon styles of the past.[71] This has caused some art historians to plumb the depths in order to identify the artistic antecedents of his figurines – both human and animal – of his miniature floral arrangements, and above all of his Easter Eggs.[72] Historicism, as a movement, had been current in some European circles since the middle of the nineteenth century. Its practitioners sought to borrow and imitate earlier art forms, but further refined and reworked them. The personal tastes of Alexander III gravitated toward historicism, and he delighted in Fabergé's mimetic Kertch treasures and the reinterpreted Blerzy snuffbox. Tsar Nicholas II also espoused historicism. His reign is one long pageant celebrating past Romanov triumphs from the commemoration of the Battle of Borodino to the celebration of the Tercentenary of the Romanov Dynasty.

Fabergé, whose on-site reference library was doubtless frequently consulted and contributed to his reinterpretation of earlier historical styles, recognized that historicism dominated the culture of both courts whose Tsars were his most important patrons. He naturally played to these cultural sensibilities of theirs. But like all good nineteenth-century practitioners of historicism, Fabergé reworked older styles in more refined ways. This is perhaps best illustrated by his silver production, confined in the main to his Moscow atelier. The Tercentenary of the Romanov Dynasty, celebrated in 1913, created a bull-market for silver in the so-called Old Russian style.[73] The firm rose to the occasion in order to satisfy this market, and the resulting creations are so clearly differentiated from the Old Russian-style silver of his competitors that one can, with some justification, refer to it as the firm's Romanov Tercentenary style. To dismiss summarily some of his *oeuvre* as eclectic, which some art historians have done, is to miss the point. Rather it reflects several artistic responses to his patrons' interests in historicism which dominated the culture of the courts of the last two Romanov Tsars. Fabergé's ability to work so comfortably in any number of these historical styles speaks volumes of his chameleon-like genius which enabled him to harness the creative talents of a large pool of craftsmen and guide them along the route he had selected. The results are, generally, all consummate works of art, regardless of the historical style on which they are based.

This interest in historicism has broader implications for Russian culture during the reign of Nicholas II. His wife, Tsarina Alexandra, has been described as the soul of the School of Popular Art.[74] It was her ardent desire to revive old peasant industries and to develop them and thereby raise the standards of craftsmanship, by reintroducing the beautiful old designs which had been forgotten in her own era. In order to achieve this goal, peasant girls from all over the country, as well as nuns, were enrolled in a two-year course in the school in order to learn all the branches of peasant crafts as well as the principles of design. A museum was even attached to the school, and its pupils' taste was developed through lectures delivered in front of the models exhibited there. Those who graduated from the School of Popular Art were destined to become teachers in different branches of peasant industries in village and convent schools.

Historicism has another dimension which is often overlooked in discussions of the *oeuvre* of the House of Fabergé. There are two salient characteristics of the works of art associated with Tsar Nicholas II. It is both very academic and imbued with a decidedly French flavor[75], as is a great deal of the work produced by the House of Fabergé. This

70. *Ibid.*, p. 13.

71. Habsburg/Solodkoff (1979), pp. 25–26.

72. See, in particular, the various attempts to identify the source of inspiration for his Easter Eggs, inter alia, Snowman (1953), pp. 70–73; and Fabergé/Proler/Skurlov (1997), pp. 15–19.

73. This assessment of that silver production is based upon the critique of Snowman (1953), pp. 41–43.

74. Buxhoeveden (1938), pp. 324–326.

75. Broughton (1998), catalog nos. 9, 228, 303, 304, passim.

francophile characteristic has been misunderstood by some art historians and cannot be used, as some critics have attempted, as evidence to classify Fabergé as a French craftsman.[76] It is more productive to associate this francophilism with the dominance in the nineteenth century of the French Academy in the fine arts, formulated by Poussin, perpetuated by David and Ingres, and relentlessly adhered to by numerous other French academic painters of the late nineteenth century. The art collected by and for Alexander III as well as by and for his son and successor, Nicholas II, is redolent of that academic style, which is even evident in some of the Imperial Easter Eggs created by the House of Fabergé. Whenever Imperial commissions called for the inclusion of miniatures, either in the form of portraits or tableaux, the long-established traditions of academic European portrait and history painting prevailed. Some art historians have perceptively noticed that the miniatures on the surprises of such eggs as The Napoleonic Imperial Easter Egg or those on the Danish Palace's Imperial Easter Egg are in the tradition of academic tableaux, finding their exact correspondences in monumental, royally commissioned paintings such as the unfinished series begun by Jacques-Louis David for the Luxembourg Palace which was to commemorate the reign of Napoleon Bonaparte.[77]

In the final analysis, therefore, Fabergé remained faithful to historicism to the very end, relying heavily upon the use of the styles of Louis XVI and the Empire as a counter to the Art Nouveau movement, although he does, from time to time, make concessions to that movement. His decision was conservative in the extreme, but one that was consistent, in his mind at least, with the prevailing conservative nature of the last Romanov court and the artistic policies of its last sovereign, Nicholas II, as revealed by the controversy surrounding the selection of art for the All-Russian Industrial Art Exhibition at Nizhni Novgorod in 1896.

The controversy surrounding the two canvases of Mikhail Alexandrovich Vrubel (1856–1910), namely his *Mikula Selyaninovich* and *Princess Reverie*, need not concern us here in detail except to point out that his critics deemed them too progressive for the prevailing academic tenor of Russian mainstream arbiters of taste.[78] Even Maxim Gorky, a young journalist at the time who was covering the art scene, declared that those works could not be understood by the general public but "could be appreciated only by a very limited number of connoisseurs."[79] The incident could not have been lost on Fabergé. He was the kind of choreographer who would avoid "modern dance", with its own eurythmics, in favor of the classics. And indeed the classics – his own reinterpretations of historicism – contributed to his financial success and popularity, and protected him from the kind of censure heaped upon Vrubel by Gorky. Within this context, Fabergé's reluctance to embrace more progressive art movements wholeheartedly is very understandable.

Finally, then, one cannot deny the novelty and originality of many of the creations of the House of Fabergé because Fabergé was a master of metamorphosis, capable of transforming the most mundane of utilitarian objects into creations of beauty. His designs are exceptional, the various styles in which he worked consummately mastered. All of those styles share one characteristic which Fabergé seems to have imbued into all of his works of art, namely, an undeniable and invariable liveliness.[80] If one could place a selection of his objects on a counter, intermingled with a selection of similar objects manufactured by his competitors, one would recognize at once the Fabergé items because only they possess the vitality which catches one's attention immediately. These objects still continue to cast a spell on many today, because the alpha and omega of Fabergé's success was the surprise his creations afforded their owners, whether that surprise was concealed within the shell of an Imperial Easter Egg or within one of his boxes or *bonbonnières*, whose shape and design gave no hint whatsoever of what was contained within.

76. Both Sitwell in Bainbridge (1949), pp. vi–viii; and Snowman (1953), p. 30, recognized this French character of the *oeuvre* of the House of Fabergé and went to great lengths to identify Fabergé as a Russian, rather than as a French, artist.

77. Curry (1995), p. 8.

78. For a survey of Vrubel's work, see Gray (1962), pp. 29–36 and for the controversy, Sternin (1993), pp. 89–114.

79. Sternin (1993), p. 92.

80. Snowman (1953), p. 45.

Today, when just about anything qualifies as art[81], it is refreshing to encounter the works of Fabergé, for whom quality and technical achievement were matters of concern. The *oeuvre* of the House of Fabergé has endured, and the prices that that art commands reaffirm its worth. Fabergé, contemporary of both Tchaikovsky, whose *Waltz of the Flowers* is evocative of all of his floral arrangements, and Stravinsky, whose *Firebird Suite* is contemporary with the last of his Imperial Easter Eggs, did not create art for art's sake, but rather art for the sake of men and women.[82]

Dr Robert Steven Bianchi
Director of Academic and Curatorial Affairs
Broughton International Inc

81. To wit, the recent brouhaha surrounding the exhibition, *Sensation*, mounted at The Brooklyn Museum of Art, the reverberations of which are still being felt in the art world; the reviewer M.L. wrote in *The Art Newspaper* 100 (February 2000), p. 45: "Why, to no-one's sensation, the court ruled against Giuliani in the Brooklyn Museum Law Suit."

82. Before the age of political correctness Bainbridge (1949): "This is Art, and there is no gainsay the fact, for it is in accord with the great canon: 'Art for Man's sake.'" p. 50.

I
FABERGÉ AND THE
SOURCES OF HIS ART

FABERGÉ AND THE SOURCES OF HIS ART

Peter Carl Fabergé has aptly been described as a "cultural sponge" (Snowman); indeed, much like Louis Comfort Tiffany, he absorbed the influences of all periods, past and present, including many Eastern and Western cultures, producing his own brand of historicism. All European styles are represented in his work from Ancient Greek (cat. 286), through Gothic (cat. 354), Renaissance (cat. 349, 370), Louis XIV, Louis XV or Rococo (cat. 412), Louis XVI or neo-Classical (cat. 334), Empire with the addition of Chinese (cat. 358, 712) and Japanese. Parallel to similar trends in Western Europe during the last decades of the nineteenth century, all these styles were revived by Fabergé with a marked predilection for the idiom of the Rococo and the "garland style" of Marie Antoinette. Never slavish in its adaptations, the *style Fabergé*, instantly recognizable, always remains highly original. Quickened with indigenous Russian elements, it produced extraordinary artworks such as the mount of a smoky topaz vase of 1898 (cat. 176), which is simultaneously both neo-Rococo and Art Nouveau.

Fabergé, forever interested in new trends, readily adopted the naturalistic forms of French Art Nouveau, helping to introduce it in Russia under the guise of *Mir Isskustva*, or the "World of Art" movement. Recognizing its limitations, however, Art Nouveau is but a passing phase in Fabergé's St. Petersburg *oeuvre*, appearing between 1898 and 1903, the dates of the "Lilies-of-the-Valley Egg" (Forbes) and the "Clover Egg" (Kremlin). While staunchly continuing to maintain the neo-Classical idiom preferred by his francophile clientele, Fabergé was also attracted by the unadorned forms of modernist design as espoused by the Wiener Werkstätte. Parallel to a similar development in Cartier's designs dating from around 1910 (cat. 999, 1005), some of Fabergé's work also reflects a sudden interest in geometry and sobriety (cat. 346, 459), heralding the advent of Art Deco design of the 1920s.

ANTIQUITY

Many pages have been written about Fabergé's discovery at the occasion of the Moscow All-Russian Industrial Art Exhibition of 1882, and about the success of his exhibits inspired by the archeological gold jewelry found at Kertch (fig. 1).[1] While Fabergé was fêted at home as an innovator, Greek or Etruscan gold jewels as seen through the eyes of jewelers such as Fontenay and Castellani, had been popular throughout Europe since 1860, the date of Napoleon III's acquisition of the Campana jewels. Both Castellani in England in the early 1870s and Fabergé in Russia in the early 1880s were hailed independently as the re-discoverers of the ancient art of granulation, a technique thought to be impossible to emulate. Fabergé, during his travels in Europe in the mid 1860s was apprised of this new archeological fashion, which he introduced in Russia at the first opportunity. His Kertch jewels brought Fabergé fame both at home – a Gold Medal and the Order of St. Stanislav, Third Class, and abroad – another Gold Medal at the Nuremberg International Exposition.

EIGHTEENTH-CENTURY FRANCE IN FABERGÉ'S WORK

François Birbaum's 1919 memoir is the oldest chronicle of the History of the House of Fabergé.[2] In it Birbaum, who was the chief designer of the Fabergé firm between 1893 and 1913, writes: "The Hermitage Museum with its 'Golden Treasury' served as an excellent school for the Fabergé jewelers: after the Kertch collection, they began to study jewelry of all epochs represented, especially those of the Empresses Elizabeth and

FIG I. PENCIL DRAWING OF A KERTCH JEWEL From a Fabergé jewelry album. Courtesy of Maria Lopato

Notes
1. Habsburg/Lopato (1993/4), p. 56f.

2. Fabergé/Skurlov (1992).

Catherine II, many of those articles were copied with great precision and were later used as models for the creation of new compositions … These compositions retained ancient styles but were applied to modern articles. Cigarette-cases and toilet cases took the place of snuffboxes, and instead of knick-knacks, the firm produced clocks, inkwells, ashtrays, electric bells and so forth."

This documented study of the eighteenth century had immediate repercussions in Fabergé's *oeuvre* of which not the least is his well-known copy of a Louis XVI oval snuff-box from the Imperial collections (fig. 8, cat. 371). Enameled gold Easter eggs, created as novelties by Fabergé, were already to be found in eighteenth-century precursors in the Imperial treasury in the collection of Catherine the Great (fig. 2). Fabergé's eminently popular miniature Easter eggs (cat. 628, 629) also find their origin in jeweled examples from the eighteenth century (fig. 3, 4). In a similar vein, Fabergé used a mid-eighteenth-century *nécessaire*, possibly an Easter present for Empress Elisabeth (cat. 4), as inspiration for the magnificent 1903 "Peter the Great Egg" (fig. 5); and a small George III bloodstone *bonbonnière* (cat. 5) as the starting point for the shell of the neo-Rococo "Pamiat Azova Egg" (cat. 438). Fabergé's numerous enameled gold cane and parasol handles (cat. 326, 332) are also inspired by the exquisite diamond-set cane-tops associated with Catherine the Great (cat. 7, 8). Fabergé's playful models of furniture such as his sedan chairs (cat. 432, 433), derive directly from eighteenth-century examples made in Dresden[3], or from amusing knick-knacks such as the jasper sofa-inkwell in the Imperial treasury (cat. 3).

While Fabergé and his craftsmen obviously "went to school" at the Imperial treasury, the real spiritual parent of Fabergé was Johann Melchior Dinglinger, the brilliant Saxon court goldsmith of Elector/King Augustus the Strong.[4] Dinglinger's magnificent creations were available for tourists and specialists to ogle at in the *Preziosenzimmer* and the *Juwelenzimmer* at the Green Vaults located in the Dresden Residenz. Fabergé, who lived in Dresden between 1860 and 1863, and whose father resided there until his death in 1893, was familiar with the contents of the Green Vaults, as obvious from his 1894 Renaissance Egg, a pastiche of a Renaissance-style casket by Le Roy dating from around 1700 (fig. 6). Dinglinger's virtuoso and dazzling use of hardstones, gold and enamel as shown in his eighteenth-century Kabinettstücke such as the *Bad der Diana* and the *Prunkschale mit dem kämpfenden Herkules* dating from the early eighteenth century, undoubtedly greatly impressed the young craftsman. Several objects in the style of Dinglinger are preserved in the Hermitage treasury (cat. 1, 2).

Fabergé's access to the treasury of the Hermitage allowed Carl, his brother Agathon, and the two young craftsmen Perchin and Wigström, to study closely the French and Russian eighteenth-century enameling techniques. Snuffboxes by the finest craftsmen at the Russian court – Pauzié, Scharff and Bouddé (cat. 12, 13) were examples constantly before the eyes of Fabergé and his young craftsmen. This led to experiments such as the 1884 Bismarck Box (fig. 7) and to later successes such as the 1887 Serpent Clock Egg (p. 14, fig. 4), a masterpiece of *émail en ronde bosse*. The *tour à guillocher*, introduced to Russia in the 1840s by Sazikov, was put to excellent use by Fabergé. His workshops engine-turned surfaces with a number of highly effective designs, greatly enlivening the translucent enamel surfaces that covered them. In spite of the fairly rudimentary means at his disposal, Fabergé's *guilloché* enamels attained levels of perfection well beyond the possibilities of the eighteenth century. Indeed it is recounted that the French, apprised of the intentions of a Fabergé craftsman coming to learn more about enameling refinements in Paris, were nonplussed, given the incomparable quality of Fabergé's own creations. Verbal tradition has it that Fabergé's legendary enameler N.A. Petrov was able to produce 145 different color variations, of which many can be found on two color charts that survive.[6] Fabergé's opalescent enamels, achieved with white, pale blue and pink colors, and sometimes combined with underglaze paintings *en camaïeu* or sepia[7]; or those with

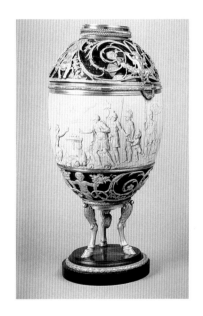

FIG 2. OVIFORM ENAMELED GOLD BRULÉ PARFUM by Jean Jacques Duc, St. Petersburg 1777, height 8¼ in. (21cm). The Hermitage Museum, St. Petersburg

3. Habsburg (1986/7), p. 69.

4. Watzdorf (1962).

5. Habsburg (1997), figs. 257 and 258.

6. London (1977), back cover.

7. St. Petersburg/Paris/London (1993/4), cat. 190.

complicated cut-out motifs in gold *paillons* (cat. 432) are without parallel in European enameling. This is also the case with the high gloss of his perfect enamel surfaces, attained through countless hours of buffing the *fondant*, or last coat of enamel, with a wooden wheel and with a shammy cloth.

HARDSTONES

Fabergé's access to the Hermitage's treasures also allowed him and his craftsmen to examine the many hardstone works accumulated by the earlier Tsars of Russia. Catherine the Great was a collector of cameos and stone carvings. Some hardstone objects of her personal property are preserved in the treasury of the Hermitage Museum. The Danish craftsman David Rudolph assembled semi-precious stone gems from Siberia and set them in snuffboxes, one of which bears the Empress's effigy.[8] Catherine's germ-carver Johann Georg Jäger, of German origin, cut her profile portrait into agates forming cameos[9], as well as into several emeralds.[10] Another German artist, Georg Heinrich König from Thuringia, who had a workshop in the Small Hermitage, was a superb modeler, stone carver and sculptor, making stone mosaics and inlays and experimenting in colored glass and wax. A circular colored glass relief, formerly in Catherine's apartments (cat. 10) may well be considered the ancestor of all those nineteenth-century composite hardstone fruit arrangements from Kolyvan and Peterhof, so eminently popular in the West. It, too, displays her portrait surmounting a still life of fruit on a table with a parrot, set in a magnificent circular enameled gold frame.

The Russian Tsars also collected hardstone objects from abroad, acquiring works of art produced by Saxon lapidaries, such as the double snuffbox shaped as two lions dating from the 1730s.[11] Few hardstone objects were as sumptuous as the exceptional agate snuffbox from the collection of Frederick the Great[12], which was added to the Imperial collections under Tsar Nicholas I. Such works, too, were known to Fabergé. During the reign of this Emperor, who was greatly interested in furthering all things Russian, and who oversaw a Renaissance of the Arts in St. Petersburg[13], many of the great hardstone vessels that decorate the Malachite Room at the Hermitage were fashioned out of grey Kalgan jasper, reddish jasper and malachite. The sheer size of these vases, carved at Ekatarinburg, is incredible, their workmanship superb. The hardstone carving facilities in Kolyvan and Peterhof produced hardstone compositions in *alto rilievo*, which were universally admired at the London Great Exhibition in 1851.

This traditional love of Russia for its hardstones set Fabergé on his quest for new means of expression. His use of semi-precious stones from Siberia and the Urals went hand in hand with his credo of eschewing costly materials. Even before the turn of the century, Fabergé had extended the use of semi-precious stones to his production of hardstone animals, often inspired by Japanese ivory Netsukes, and to a series of composite hardstone figures, using a technique which ultimately derives from Florentine *pietre dure* works of the seventeenth century.

FLOWERS

The tradition of jeweled flower bouquets reaches back into the eighteenth century. Two such bouquets are illustrated by Vever[14], both made by the Parisian Court Jeweler Bapst; one for Queen Marie Antoinette in 1788, another in 1820 for the Duchesse de Berry. Certainly the finest among these early examples is the incomparable floral bouquet by the Viennese Court Jeweler Grosser presented by Emperor Francis Stephen to his wife Maria Theresia in 1746.[15] It comprises scores of highly naturalistic flowers and insects in semi-precious stones with dried and silk leaves, standing in a rock crystal vase. Closer to home, Fabergé would have had access to the floral bouquets crafted by the Swiss jeweler Jérémie Pauzié in the 1740s (cat. 6) and flowers such as the pearl-encrusted lily by Louis-David

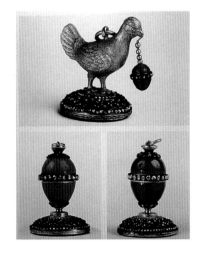
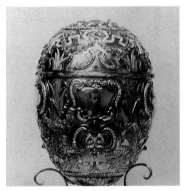

FIG 3/4. JEWELED, GUILLOCHÉ ENAMEL AND GOLD BRELOQUE shaped as a chicken with an egg – St. Petersburg *c.* 1790, height 1¼ in. (3cm). The Hermitage Museum, St. Petersburg OVIFORM JEWELED, GUILLOCHÉ ENAMEL AND GOLD BRELOQUE – St. Petersburg *c.* 1790, height 1⁵⁄₁₆ in. (3.4cm). The Hermitage Museum, St. Petersburg

FIG 5. THE "PETER THE GREAT EGG" of 1903 – by Fabergé, workmaster Michael Perchin, height 6 in. (15.2cm). The Lilian Thomas Pratt Collection, Fine Arts Museum Richmond, Virginia. Archive Photograph

FIG 6. JUXTAPOSITION of the Fabergé 1894 "Renaissance Egg" in the Forbes Magazine Collection (left) and the jeweled chalcedony casket by Le Roy, Amsterdam *c.* 1700 in the Green Vaults, Dresden (right). Photograph von Habsburg

Duval from the end of the eighteenth century.[16] Flower bouquets remained popular throughout the nineteenth century. An enameled silver-gilt bouquet of lilies-of-the-valley, roses, carnations and dahlias made by the Moscow jeweler Jahr in 1866 for Crown Princess Maria Feodorovna, was described as an "exceedingly exact and naturalistic rendition"[17], evidently a precursor of Fabergé's flower arrangements.

According to the testimony of chief designer François Birbaum, however, "the undoubted prototypes of these [hardstone flower] sculptures were Chinese and Japanese gemstone carvings." A spray of chrysanthemums from the Palace of the Chinese Emperor was brought in for repair. It was "made of corals, white nephrite and other stones, with leaves of grey nephrite and stems of square bunches of wire bound with green silk ..."[18] and set off a fashion for such virtuoso articles. In the same vein, Chinese flower arrangements in pots dating from the late eighteenth century (fig. 9) certainly influenced Fabergé. His craftsmen took this form of art to unheard-of heights, sculpting ethereally thin stems of flowers out of brittle hardstone so that flowers became even more fragile and, according to Birbaum, "a curiosity of gemstone carving instead of a work of art."

Géza von Habsburg

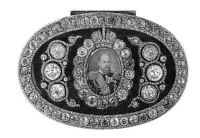

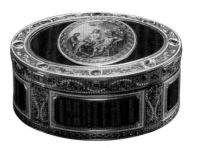

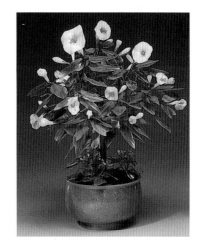

8. Cf. Pforzheim (1995/6), pp. 126–127.

9. Cf. Pforzheim (1995/6), pp. 114–115.

10. Solodkoff (1981), ill. 239.

11. Snowman (1990), pl. 609–610.

12. Op. cit., pl. 719; Baer (1993), cat. 41.

13. See chapter "Enamels".

14. See Vever (1908), I, pp. 121, 125.

15. See Museum of Natural History Vienna (1998), p. 11.

16. Munich (1986/7), cat. 657.

17. Quoted from Solodkoff (1995), p. 30f.

18. Fabergé/Skurlov (1992), pp. 42–43.

FIG 7. "THE BISMARCK BOX" a jeweled and enameled Imperial presentation snuffbox – by Fabergé, workmaster Michael Perchin, St. Petersburg 1884, length 4⅛ in. (10.5cm). Private Collection

FIG 8. LOUIS XVI SNUFFBOX enameled scarlet over a *guilloché moiré* ground, the lid applied with an enamel plaque painted with the classical scene *The Family of Darius at the Feet of Alexander* within a border of green enamel laurel – initials of Joseph-Etienne Blerzy, date letter O for 1777, Paris, charge and discharge of J.B. Fouache, a farmer-general from 1774–80, length 3¼ in. (8.3cm).
Provenance: by tradition, Catherine the Great, hence by descent to Czar Nicholas II, his son; Lansdell K. Christie, Long Island, New York
Bibliography: Snowman (1953/55), ill. plate 43; Snowman (1962/64/68/74), p. 153, ill. plate 52; Waterfield/Forbes (1978), no. 65, ill. p. 56; Snowman (1979), pp. 144–148; Schaffer (1980), p. 84; Hill (1989) p. 16; Snowman (1990), ill. plate 447.
Exhibited: Washington 1961, no. 15, cat. p. 33; New York 1968, no. 320, cat. p. 122. ill.; New York 1973, no. 16, ill. p. 61; London 1977, no. L16, cat. p. 75; Munich 1987, no. 403A, cat. ill. p. 223; New York et al. 1996/97, no. 210, cat. p. 210, ill.
The Forbes Magazine Collection, New York

FIG 9. ONE OF A PAIR OF JADE AND HARDSTONE CONVULVULUS FLOWER GROUPS Qianlong period, height 19 in. (47.5cm). Photograph courtesy of Christie's

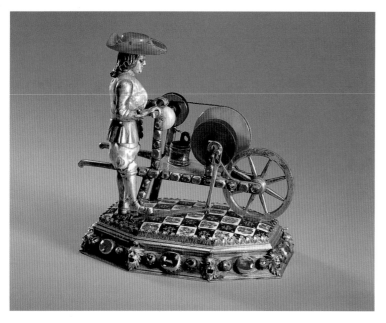

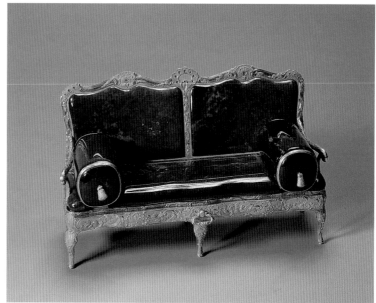

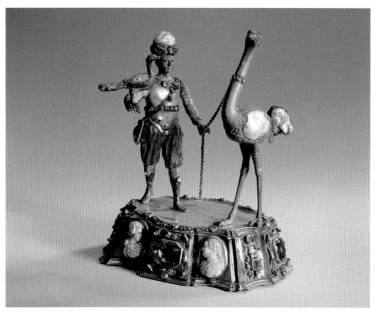

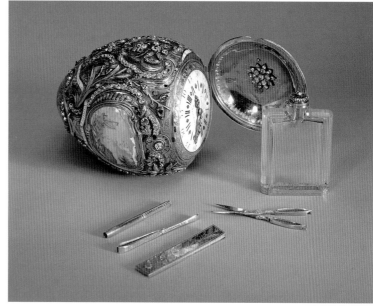

1, 2

3, 4

1. SILVER-GILT JEWELED
STATUETTE depicting a grinder sharpening
his knife – Saxony, Germany, early 18th
century, height 3½ in. (8.8cm).
Provenance: Belonged to the Gallery of Jewels
in the 19th century.
Bibliography: Lieven, 1902, p. 56.
According to tradition, while on a tour of
Germany, Peter I visited M. Dinglinger's
workshop and purchased a whole collection
of his figures. The story has been disproved, and
Dinglinger is no longer believed to have been
the maker of the statuette. However, there is no
doubt that the piece was the work of an 18th
century master from Saxony.
The Grünes Gewölbe Museum in Dresden
owns a very similar statuette, also depicting a
grinder, in this case a jeweled gold-mounted
ivory statuette by I. H. Köhler, 1708.
The State Hermitage Museum, St. Petersburg
(N 2620).
OK

2. JEWELED SILVER-GILT AND
ENAMEL FIGURINE of an ostrich and its
driver, on jeweled base – Saxony, Germany,
early 18th century, height 4⅝ in. (11.8cm),
inventory no. N. E. 2639.
Provenance: Acquired by the Gallery of Jewels
in 19th century.
Bibliography: Lieven, 1902, p. 56.
The Dresden masters were famous for their
figurines, which were characterized by the
extensive and varied use of mother-of-pearl.
The Grünes Gewölbe Museum owns a large
collection of these figurines, almost all of which
are anonymous, just as those belonging to the
Hermitage.
The State Hermitage Museum, St. Petersburg
(NE 2639).
OK

3. DESK-SET IN THE SHAPE OF A
MINIATURE DIVAN heliotrope, mother-of-
pearl – France, 18th century, unmarked, length
7⅕ in. (18.3cm).
Provenance: Acquired by the Gallery of Jewels
in 1859.
Bibliography: Ivanov, 1904, p. 155.
According to Hermitage inventories, the desk-
set was presented to Catherine II by the Polish
King Stanislaw Poniatowski on 27th June 1783.
The desk-set is carved from an exquisite piece
of polished heliotrope, underpinned with
decorated mother-of-pearl. The divan's
miniature side bolsters conceal an ink well and
sand-box, while the lower pull-out section acts
as a pen and pencil drawer.
The gold detailing helps to form the outline
of the divan and this, along with the Rococo-
style engraving are characteristic of the mid
18th century.
The State Hermitage Museum, St. Petersburg
(E 1794).
OK

4. VARICOLORED GOLD EGG
decorated with diamonds and enamel. Inside
the egg there is a clock on one side and a
nécessaire on the other.

According to legend, the clock/nécessaire was
given to Elisabeth I by representatives of the
French Court as an Easter present. The upper
lid, covering the clock, is decorated with a
diamond-studded monogram of Elisabeth I, and
bears the inscription: 'Tout Les Moments Vous
Sont … oue's [sic.].' The lower lid, which covers
the nécessaire, is decorated with the Russian
double-headed eagle bearing the Moscow coat-
of-arms on its chest, along with the sign of the
Order of St. Peter. At the centre of the piece,
beneath an enamel plate lies another inscription:
'Si vous me regarde. Je vous me Regarde. Je sera
Regarde. Née pour orner Une Couronne.' [sic.]
– assay mark of Paris of 1757–1758, indisinct
master's mark. Clock mechanism engraved with
the words: "Beeckaert No. 713, Paris"; clock
face engraved with the name: François
Beeckaert. length 3¼ in. (8.3cm).
Provenance: Diamond room, Winter Palace;
acquired by the Gallery of Jewels in the mid
19th century.
Bibliography: Lieven, 1902, p. 101.
Exhibited: Paris, 1974, No. 415; Lugano, 1986,
No. 142; Munich, 1986.
The State Hermitage Museum, St. Petersburg (E
4274).
OK

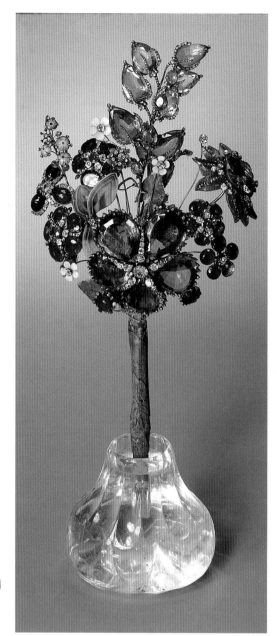

5

8. 7

6

5. HELIOTROPE EGG-SHAPED BOX
of chased and engraved gold, and heliotrope
with a hinged lid and embossed ornamentation,
the gold clasp surrounded by embossed
Rococo swirls – England, 1760s, length 4.2cm.
Provenance: Acquired in 1920 from the
Vorontsov–Dashnikov collection.
The State Hermitage Museum, St. Petersburg
(NE 10941)

6. JEWELED GOLD AND SILVER-
MOUNTED CORSAGE BOUQUET
of gold, silver, diamonds, precious and
semi-precious stones – St. Petersburg, 1740s,
attributed to J. Pauzié, unmarked, height 7²3 in.
(19.5cm).
Provenance: Listed in inventories of 1780;
the Gallery of Jewels, mid 19th century.
Bibliography: M.B. Martynova, Precious Stones
in Russian Jewellery of the 17th and 18th
Centuries, Moscow, 1974, p. 36; L. Galanina,
N. Grach, M. Tournousse Jewellery of the
Hermitage, Leningrad, 1979, p. 80.
Exhibited: Pforzheim, 1995, no. 54.
Pauzié was born in Geneva in 1716. He came
to Russia at the age of 13 with his father.
Before his death, his father apprenticed him
to the court jeweler Gravero for a seven-year
period. Pauzié stayed with him as a pupil, and
then as an assistant jeweler until 1740, when
he opened his own workshop. He soon became
a jeweler to the Court and to the Petersburg
nobility in his own right. He worked for many
years in St. Petersburg, enjoying the patronage
of the Empress Elizabeth. He also traveled
abroad to source materials and also to find
finished products to bring back to Russia.
For four years he worked together with
Louis D. Duval.
He produced snuffboxes, rings, medals and
decorative ornaments. His most prestigious
project was to design a crown for Catherine II.
In 1764, he left St. Petersburg to return to his
native Geneva, where he died in 1779, leaving
his Petersburg workshop in the hands of his
assistant jewelers. His memoirs on life and work
were published in St. Petersburg in 1870 under
the title *Russkaya Starina*.
For many years the provenance of the piece was
unclear. More recently research by
M. Tournousse [see above] points to Pauzié
as the workmaster, and M. Martynova and
L. Kuznetsova have indicated St. Petersburg as
its place of origin. The piece is thought to have
been produced between 1740–1789. The
Hermitage holds three similar bouquets, all
of which feature silver-mounted jewels and
flower-stalks bound together with gold. To
add interest to this type of composition, the
jewelers of the period frequently made use of
insect motifs (dragonflies, butterflies, beetles)
The State Hermitage Museum, St. Petersburg
(E 1864).
OK

7. DECORATIVE CANE HANDLE
with Catherine the Great's monogram,
1770s–1880s. The upper part of the handle
the *guilloché* enamel with an intricate sunburst
pattern; the center decorated with a gold and
diamond monogram of Catherine II, above
which is positioned a garlanded Imperial
Crown; rows of silver-mounted diamonds
are set a little lower down the handle –
St. Petersburg, unmarked, master unknown,
length 53¹4 in. (135.3cm).
Provenance: Transferred from the Arsenal to
Tsarskoe Selo in 1887: later acquired by the
Gallery of Jewels.
Bibliography: Lieven, 1902, p. 114.
Exhibited: Munich, 1986, no. 649.
The State Hermitage Museum, St. Petersburg
(E 2192).
OK

8. DIAMOND AND AMETHYST-SET
CANE HANDLE the upper part of the
handle featuring a garland of woven threads
with silver-mounted diamonds on an embossed
gold background; a gold border with blue-gray
guilloché enamel surrounds the garland.
The handle also features a round cabochon
amethyst, surrounded by brilliant and rose-cut
diamonds. The top of the handle is hinged and
opens to reveal a scent-flask perfume vessel
(now lost). Lower down is a ribbon in the
colors of the Order of St. George –
St. Petersburg, 1780s, no marks, master
unknown, length 51 in. (129.8cm).
Provenance: Acquired by the Gallery of Jewels
in 1859.
According to the Hermitage inventories, the
cane belonged to Catherine II and dates from
the 1780s. A similar network pattern of
guilloché enamel is to be found on snuffboxes by
Jean-Pierre Ador and I.G. Scharff (E 4497 and
E4499 respectively). These pieces have been
marked with the assay of St. Petersburg for
1781 and 1782 respectively.
The State Hermitage Museum, St. Petersburg
(E 4410).
OK

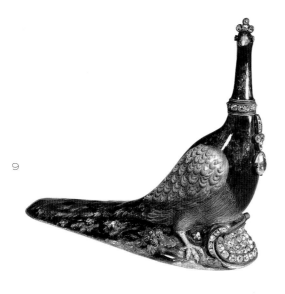

9

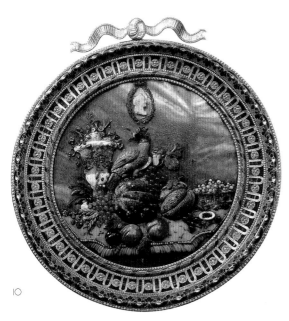

10

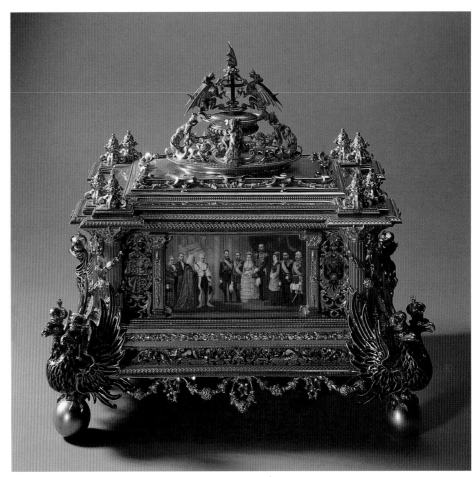

9. GOLD SCENT-FLASK IN THE SHAPE OF PEACOCK enameled,

silver-mounted diamond set engraved on base: 'St. PETERSBURG', c. 1750–60, length 3¹3 in. (8.5cm).
Provenance: Acquired by the Gallery of Jewels in the mid 19th century.
Bibliography: Lieven, 1902, p. 56.
Exhibited: Speyer, 1994, no. 226; Pforzheim, 1995, no. 116.
Although there are many examples of animal forms in late 18th century ornaments, this flask is distinct from other works of the period. The workmanship is of an extremely high standard. The enamel decoration is exquisite, the lid fastening highly intricate and the engraving on the base extremely delicate and precisely executed. The style of the engraving bears some similarity with that of snuffboxes of the late 1770s and 1780s.
The State Hermitage Museum, St. Petersburg (NE 2903).
OK

10. GOLD AND ENAMEL RELIEF

depicting fruit and a flower vase with a profile portrait of Catherine II. A decorative ribbon runs through the gold rim with a loop at the back for hanging – signature of workmaster Georg Heinrich Koenig, assay mark of St. Petersburg 1779, diameter 7¹3 in. (18.6cm).
Provenance: Displayed on the shelves of Catherine II's private rooms.
Bibliography: Lieven, 1902, p. 94; Ivanov, 1904, p. 160; C.N. Troynitskii, Georg Heinrich Koenig, Petrograd, 1921, p. 24.
Exhibited: Pforzheim, 1995, no. 132.
Georg Heinrich Koenig was born in the middle of the 18th century in Thueringen, where he studied the art of gunstock engraving, after which he came to Vienna as apprentice to a native engraver from whom he learnt the techniques of working with enamel and wax. He moved to St.Petersburg in the mid 1770s. In 1777, he became a member of the Guild of Foreign Jewelers as a master jeweler. In the 1780s he visited England. He died in St. Petersburg in 1800. Koenig is remembered as a brilliant engraver, stone-cutter and sculptor. He specialized in fireplace ornaments, vases and cameo pieces. He experimented with colored glass and wax, mosaic and various other decorative forms of insets. His chemical experiments attracted considerable interest from his peers.
He shared a workshop with K. Lebereicht in the Little Hermitage. With the help of these masters, Catherine II herself "took part in the making of pieces from enamel pastes which she added to the Tassie collection". Koenig also gave lessons to the masters of the industrial town of Tula in metalwork, especially steel. S.N. Troynitskii suggests that this plate was presented to Catherine II. G. Lieven and A. Foelkersam have both found the dish to be an authentic work by Koenig. Like much of his other work, the plate bears Koenig's engraved signature and features the use of mosaic colored glass and enamel pastes. Similar pieces by the master are detailed in archive documents.
The State Hermitage Museum, St. Petersburg (NE 1825).
OK

11. RECTANGULAR GOLD CASKET

in the Renaissance style chased with griffins, garlands, bows and extensive relief decoration, the front with enamel scene depicting Alexander II, on his right Maria Nikolaevna, the Prince of Wales and Alexei Alexandrovich and on his left the Dukes of Edinburgh and Cambridge. Other enamel plates on the casket bear the coats-of-arms of Russia, Great Britain and London. An inscription inside the casket bears the Lord Mayor's greeting to Alexander II written by the clerk of Monkton.
Surrounding the inscription are the coats-of-arms of Russia, London and several Russian towns and provinces – London, 1874, signature of workmaster J.W. Benson, length 11 in. (28cm). Inscribed: To H.I.M. Alexander II Emperor of all the Russias from the Corporation of the City of London, 18th May 1874.
Provenance: Brought from London to the Winter Palace in 1875 on the "Derzhava yacht".
Bibliography: Lieven, 1902; Ivanov, 1904, p. 161.
The golden casket was a gift to Alexander II from the City of London at his visit to London on the occasion of his daughter Maria Alexandrovna's marriage to the Duke of Edinburgh in 1874.
The State Hermitage Museum, St. Petersburg (NE 2).
OK

12

14

13

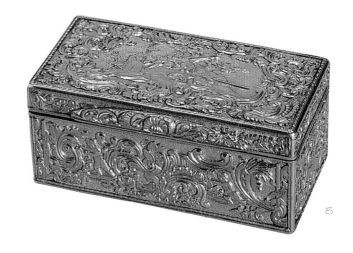

15

12. CIRCULAR DIAMOND-SET GOLD SNUFFBOX the detachable cover embellished with fruit in colored glass and enamel paste – assay mark of St. Petersburg 1778, indistinct workmaster's initials, diameter 2³⁄₄ in. (7cm).

Provenance: Acquired by the Gallery of Jewels in the mid 19th century.

Bibliography: Snowman, 1966, p. 649; Kuznetsova, 1980, p. 52; Troynitskii,1920, p. 29.
This snuffbox was identified as by I. G. Scharff on the basis of the workmaster's mark and the assay mark of St. Petersburg. A.K. Snowman dates it to 1778. (S. Troynitskii, however, has suggested it is the work of Koenig). The mosaic of colored glass and enamel pastes on the lid is typical of European jewelers of the period. The use of a dendrite-like enamel on the sides of the snuffbox is also characteristic of work of the last quarter of the 18th century.

Scharff was born in Moscow as the son of German immigrants. In 1767 he came to St. Petersburg and became an assistant jeweler. In 1772 he became a master with the Guild of Foreign Jewelers. In 1788 he was elected as a town alderman. He worked with K.G. Gebeld. There are no extant records of his whereabouts or work after 1808. He became famous for his use of diamonds. Snuffboxes constitute the main part of his work now on display in museums and private collections.

The State Hermitage Museum, St. Petersburg (NE 4465).

OK

13. OVAL ENAMELED GOLD PATCH BOX with hinged cover decorated with geometrical ornament of gold and enamel, featuring double-headed eagle, crown, orb, scepter, the monogram of Elizabeth I in diamond surround, the lid set with a mirror – by Jérémie Pauzié, St. Petersburg, unmarked, length 1³⁄₄ in. (4.3cm).

Provenance: Acquired by the Jewel Gallery in the mid 19th century.

Bibliography: Foelkersam, 1907, p. 45; Snowman, 1966, ill. p. 607; Kuznetsova, 1980, p. 45; Snowman, 1990, pl. 760.
Exhibited: Pforzheim, 1995, no. 58.
Foelkersam identified this piece as a work by Pauzié, a theory which has been undisputed since scholars agree that the work was produced in the 1750s. Noteworthy features of the piece are its geometric engravings and the combination of decorated and molded enamel in the "kozinochka" style.

A similar piece which in decorated gold, though not of such a highly regularized pattern, can be found in the Louvre's collection of work by the Parisian master Lecan, 1749–1750, (inventory number 7713). This highlights Pauzié's interest in, and knowledge of, the master jewelers in Europe. The use of cosmetic articles and patch boxes was a standard feature of court etiquette for a considerable period.

Princess Catherine (Catherine the Great) writes in her diaries of an encounter at a ball with Elizabeth I in 1750: "… the Empress greeted me with the words: 'My God, what slovenliness! Where is your beauty spot? …' at which point she took out of her pocket a box with beauty spots, and, picking one of medium size, she applied it to my face." (The Memoirs of Catherine II, Moscow, 1980, p. 113).

Patch boxes were designed in the same shape as snuffboxes with the exception of a little mirror set into the underside of the lid.

The State Hermitage Museum, St. Petersburg (NE 4452).

OK

14. DIAMOND-SET GOLD-MOUNTED BLOODSTONE PURSE in the Rococo style, the sides and main joint of the purse carved from bloodstone set in a delicate gold Rococo-style mount. The rolled-gold motifs are surrounded by silver-mounted diamonds. A double-ended writing implement (both pen and pencil) is held in loops and acts as a fastening to the purse. The lining in the purse is of pink satin, unmarked, length 3¹⁄₂ in. (8.8cm).

Provenance: Galitsyn family collection; acquired by the Gallery of Jewels in 1886.

This purse was used by Fabergé as inspiration for a similar purse in the Wernher Collection at Luton Hoo (see Habsburg 1986/7, cat. 255).

The State Hermitage Museum, St. Petersburg (NE 4796).

OK

15. RECTANGULAR GOLD-MOUNTED PLATINUM SNUFFBOX applied with gold Rococo scrolls, bucolic scenes, garlands, shells, and emblems of Love – signed J.W. Keibel, St. Petersburg mid 19th century, length 3¹⁄₂ in. (8.8cm).

Provenance: Lobanov-Rostrowsky; transferred to the Jewel Gallery 1896.

Bibliography: Foelkersam, 1907, p. 30.
Exhibited: Tokyo, 1992, No. 22; Pforzheim, 1995, no.188.
The practice of using platinum in jewelery became widespread in the second half of 19th century, following the discovery in 1825 of platinum reserves in the Urals. The suggested date is based on the highly intricate embossed ornamentation, its generous proportions, and motifs of shells, emblem of Love and garlands, all popular decorative features of the Rococo revival in the mid 19th century.

The State Hermitage Museum, St. Petersburg (E 15).

OK

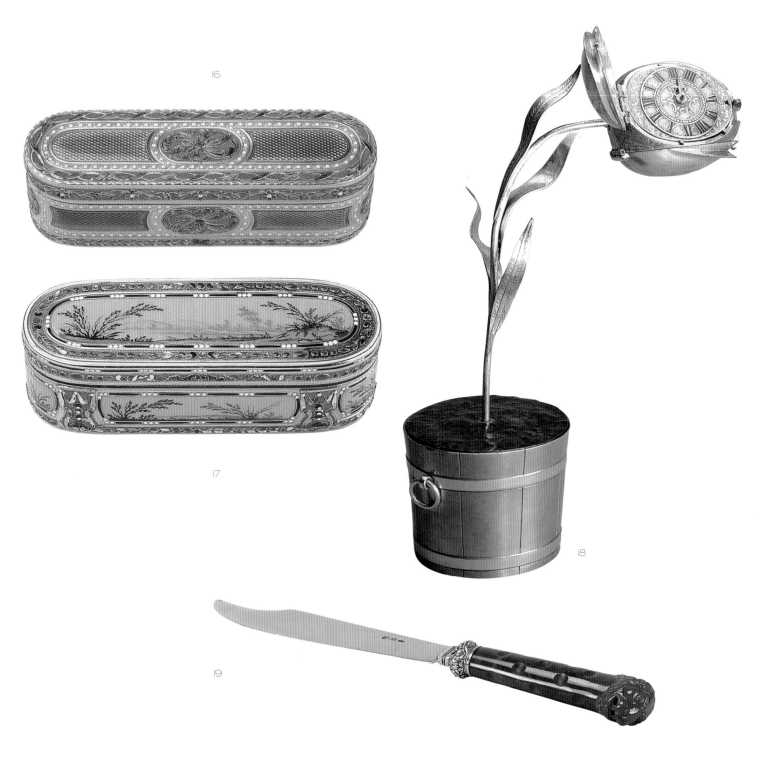

16

17

19

18

18. CLOCK SHAPED AS A TULIP IN A FLOWERPOT the silver dial placed in the center of a gilt bronze flower, the movement concealed in the flowerpot – the dial signed Jean Rousseau, France, 1660, height 6¼ in. (16cm).
Provenance: Tatishchev Collection before 1845; Collection of the Winter Palace 1845–1918.
Exhibited: Leningrad, 1971, cat 17.
Jean Rousseau (1609–1684), father of the famous Jean-Jacques Rousseau, was a fairly well-known clockmaker. This piece is based on a completely original idea to hide the mechanism in the petals of a tulip; it was particularly apt since at the time all Europe, along with Holland, was in the grip of tulip mania. Different types of boxes in the form of tulips, as well as various portrayals of these flowers, were widespread. It seems likely that similar antique objects would have been known to Fabergé, and may have served as one of his sources of inspiration

16. RUSSIAN OBLONG GOLD AND ENAMEL SNUFFBOX the cover decorated with an oval green enamel rosette flanked with blue-gray enamel panels surrounded by white enamel pellets, the border with green and red interwoven bands, the sides similarly decorated, length 3¾ in. (9.6cm).
Provenance: Collection Baron Henri de Rothschild Nr F2/79.
Private Collection

17. FRENCH OBLONG GOLD AND ENAMEL SNUFFBOX the cover painted in camaïeu sepia with a river landscape on opalescent guilloché enamel ground, the border with green enamel branches and orange and blue dots, the sides similarly decorated – initials of maker I. B., Paris 1779, length 3⅝ in. (9.2cm).
Provenance: Collection Baron Henri de Rothschild Nr. F2/81.
Private Collection

19. SILVER-GILT AND HARDSTONE PAPERKNIFE the shaded green and rust-colored agate handle carved with concave pellets and a lion's head finial, the collar cast with foliate scrolls and shells – signed J. B. Hertz, assay mark of St. Petersburg, 1841, length 11¾ in. (30cm).
Private Collection

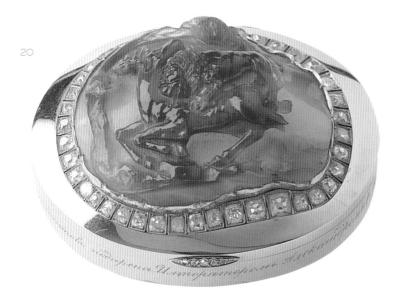

20

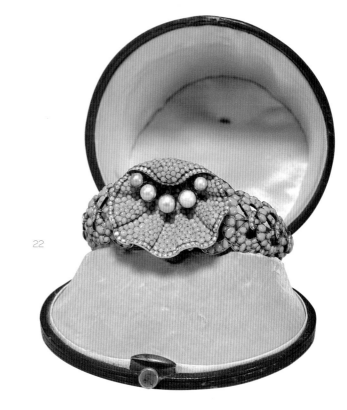

22

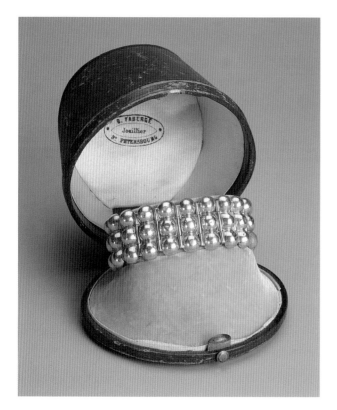

21

23

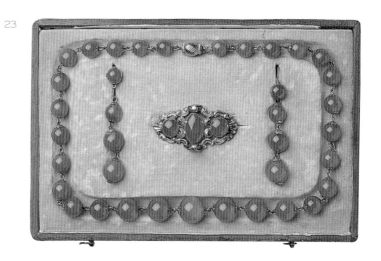

21. GOLD BRACELET consisting of three sets of 19 semi-circles – initials of workmaster François Auguste Savard, Paris, *c.* 1869, length: 7 in. (17.8cm). In original fitted case stamped with address of retailer Gustav Fabergé, Joaillier, St. Petersbourg.
Provenance: Acquired by the Hermitage in 1984.
Exhibited: Munich 1986–1987, cat. 4
Alongside items of jewellery produced by his own workshop, Gustav Fabergé sold pieces from other jewelers and imported some from abroad. In this case, the bracelet was produced by a Parisian jeweller, whose work dates from the period 1840–1870. As is evident, these various items were housed in cases marked with Gustav Fabergé's stamp.
The State Hermitage Museum, St. Petersburg (E. 17798)
ML

20. OVAL GEM-SET GOLD-MOUNTED AGATE CAMEO BOX the cover set with a cameo of a lion killing a stag surrounded by brilliant-cut diamonds, the plain gold mounts with engraved inscription and diamond-set pushpiece, the base of beveled rock crystal – initials of maker I. G., assay mark of St. Petersburg, *c.* 1840, length 2⅝ in. (6.7cm). The inscription reads: "The cameo surrounded by brilliants was given by Emperor Alexander I to Maria Antonovna Naryshkina"

22. TURQUOISE, PEARL AND SILVER BANGLE decorated frontally with a flower-head profusely set with turquoises and a central pearl – unmarked, retailed by Gustav Fabergé, *c.* 1850. Original fitted case with paper label: "(G. FAB)ERGÉ, Joaillier et Bijoutier/Grande Morskoy au coin de la Kripitskaya/maison Rouadzé No. 70/St. Petersbourg".
Exhibited: QVC 1999.
Joan and Melissa Rivers

23. GOLD-MOUNTED CORNELIAN DEMI-PARURE of twenty-nine cornelian beads with gold links and clasp; a pair of ear-pendants with three cornelian beads; and a brooch with two beads and an oval cabochon in foliate mount – initials of workmaster C. O., *c.* 1845. Original fitted case with paper label inscribed: "G. Fabergé, Joaillier et Bijoutier, Grande Morskoy, Maison Jacot N. 12, St. Petersbourg".
Exhibited: Munich 1986/7, cat. 2.
One of a small number of jewels made by an unidentified workmaster for Gustav Fabergé bearing his first address in St. Petersburg.
Wartski, London

2
GOLD AND SILVER IN
ST. PETERSBURG
1830-50

GOLD AND SILVER IN ST. PETERSBURG 1830–1850

In every era society has its own *Weltanschauung* – its own unique philosophical view of the world, which finds its voice in an artistic style. The 1820s saw important changes in both Russian and Western European art. Painters, architects and craftsmen in applied arts began to look beyond the world of antiquity as their sole source of inspiration. A new esthetic began to take root in Romanticism, based on a sense of history and a desire to portray both the seamless development of world culture and the unique nature of each of its individual episodes, rejecting a single, canonized model of beauty. In the art of Romanticism the essence of beauty had lain in the notion of unusual and diverse forms of expression, and this paved the way for artists now turning to the art and history of the Middle Ages, the Enlightenment, Ancient Rus and the Orient for inspiration. Artistic attitudes were influenced not only by painters and architects of the era, but also by writers. The world of human emotions and suffering and the cult of the domestic hearth were its ideals. This movement in artistic culture became known as eclecticism.

St. Petersburg was one of the capitals of eclecticism as an artistic style. The population of the city at the time was extremely varied. The Imperial Court, one of the most lavish in Europe, followed changing fashions keenly. The rapid development of industry in the city attracted members of the nascent bourgeoisie, who had no inhibitions in choosing artistic forms to embody their esthetic notions. By borrowing elements from the most brilliant styles of earlier periods, they considered themselves the true inheritors of the culture of the old *dvoryanstvo*, or gentry. Bourgeois culture created a widespread demand for material and spiritual well-being on the part of the mass consumer. What had formerly been accessible to the chosen few was now a way for the life for many. Mechanical production and new technologies led to an increase in volume and a reduction in cost. And the adoption of new technologies demanded not only technical skills, but also a whole new artistic approach.

The gold and silver industry in St. Petersburg came to life at almost exactly the same time as the city itself was founded. The Imperial Court, at once dazzling and extravagant, attracted the attention of both Russian and foreign jewelers and silversmiths. According to the directories of the time, there were 200 craftsmen living in the capital in 1823; by 1848 this number had grown to more than 300. They were of different nationalities and their professional training varied; each, however, sought to obtain his own circle of clients to enable him to pursue his chosen craft. Documents describing the participation of St. Petersburg craftsmen in the All-Russian Industrial Art Exhibitions of the first half of the nineteenth century shed light on certain aspects of the gold and silver industry in the capital.

From 1829 these exhibitions were held quite regularly, and every two years in St. Petersburg, Moscow or Warsaw, the latest developments in the work of Russian craftsmen went on display. Jewelers would exhibit their works alongside heavy machinery from the mining and metallurgy industry on display in the metal sections of the exhibitions. At the very first exhibition the jeweler Spiegel and the silversmiths Christian Andrej Jansen and Ivan Christian Pragst submitted their works for consideration by the public and the expert jury. All were awarded prizes for their ornaments and silver tableware.

The exhibition of 1831, held in Moscow, saw the first display of works by the young St. Petersburg silversmith Feodor Verkhovtsev. The liturgical objects created in his workshop – a mount for the New Testament, religious vessels and wedding crowns – received the Second Silver Medal. Within a few years Verkhovtsev had become one of the

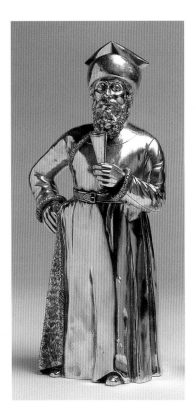

A SILVER FIGURE OF A COACHMAN
made for use as a vodka pitcher by Vaillant,
St. Petersburg, 1856 – height 12½ in. (31.8cm).
(Photo: Ermitage Ltd)

leading producers of liturgical objects. He created a book cover for a New Testament for the Cathedral of the Transfiguration and a silver shrine for Saint Arseny Konyevsky, while his jeweled icon cases and altar crosses decorated numerous cathedrals and monasteries in the diocese of St. Petersburg and Novgorod. After Feodor's death in 1867, his son Sergei Feodorovich Verkhovtsev, who had graduated from the Academy of Arts, turned the workshop into a silverware factory. On several occasions works produced at the factory were awarded prizes at All-Russian and European Industrial Art Exhibitions, right up until the factory's closure in the mid-1880s.

For several years the most famous of the capital's jewelers did not, unfortunately, pay much attention to such competitions. Thus it was only at the St. Petersburg exhibition of 1839 that the first really well-known competitors submitted their works to the expert jury. The diamond jeweller Otto Koenig and the goldsmith Johann Wilhelm Keibel were particularly commended for their diamond creations. The St. Petersburg silversmith Alexander Kordes and the Muscovite Ignaty Sazikov were beaten into second place by Sakerdon Skripitsyn from Vologda, who submitted a magnificent table service decorated with delicate niello decoration. All its constituent parts were decorated with views of Vologda and St. Petersburg, along with statistical tables concerning the Vologda Province. The service was purchased directly at the exhibition by Emperor Nicholas I.

Perhaps the most striking of the exhibitions held in Russia in the first half of the nineteenth century was the 1849 St. Petersburg Industrial Art Exhibition. Exhibitors included many of the artists who would defend the glory of the Russian silver industry at the Great Exhibition in London two years later. Members of the expert jury were presented with the arduous task of choosing between the works of the most famous Russian craftsmen. Keibel and Vaillant were awarded first prize for their "works of gold and works of diamonds and pearls framed in gold."[1] A. Borov, a merchant of the third guild, who was one of the judges on the jury, gave special mention to Sazikov and Vaillant. "The works of Sazikov and Vaillant may be described as refined in the fullest sense of the word, and some of their creations even move beyond the bounds of ordinary crafts, and stand compare with true works of art. The works of Masters Andreyev, Verkhovtsev and Borodulin are excellent examples of ordinary craftsmanship."[2] Other judges, the silversmiths A. Sukhikh, I. Bednyakov and Ya. Varlamov, in large part shared his opinion. In addition to Sazikov and Vaillant they proposed that the highest awards be given to Danila Andreyev, Vasily Ilyin and Feodor Verkhovtsev for his "silver and gilt items of superb and complex finish."[3] They proposed that second prizes be awarded to the works of Felix Shopin and Mikhail Borodulin. Eventually Sazikov and Vaillant were awarded gold medals and Verkhovtsev and Andreyev silver ones.

The Industrial Art Exhibitions of the first half of the nineteenth century showed the variety of approaches in the Russian silver industry. Alongside obvious borrowings of subject and decorative style from European art, Russian artists created works which looked not only towards Byzantine and Old Russian art, but also to the subjects of everyday life. More and more frequently artists began to decorate their works with figures dressed in national costumes or characters from Russian fairy-tales. Thanks in part to the strictness of the expert juries at All-Russian exhibitions, artists were highly self-critical. It was precisely this fact that enabled them to show their very finest works at the Great Exhibition in London.

All the most fashionable shops in St. Petersburg were situated on Nevsky Prospect and the adjoining streets. In order to attract customers, their owners would publish advertisements in newspapers such as the *St. Petersburg News*, the *Northern Bee* and *Illustration*. In 1831 Vikenty Kishkin-Zhgersky, a member of various scientific societies and foreign academies, founded the first 'Commercial Directory of the City of St. Petersburg'. He included addresses and a detailed listing of many shops and boutiques in the city. Pride

Notes

1. TsGIA, F. 18. Op. 2, d. 1358 1. 152.

2. TsGIA, F. 18. Op. 2, d. 1358 1. 152.

3. TsGIA, F. 18. Op. 2, d. 1358 1. 155.

of place was occupied by "The Great English Shop of Nicholls and Plincke", which in 1789 was situated in the house of Brigadier Vasilchikov on the corner of Nevsky Prospect. The English merchants Constantine Nicholls and Wilhelm Plincke became owners of the shop in 1804, having bought it from the previous owners, Goy and Bellis. Initially they traded only in products imported from Great Britain – fine wines, delicate silks, ribbons, toilet accessories and faience porcelain. Within a few years, however, the owners founded their own workshops, where they produced furniture, stones, bronzes, silverware and jewelry based on English designs. From the end of the 1830s the English Shop became the main supplier of silver tableware, expensive shawls and fashionable fabrics to the Imperial Court. Emperor Nicholas I liked to visit the shop in person to choose gifts for his friends and family. Count V. Sologub recalled that often "various items were ordered for the court from the English Shop: gold and silver objects, statuettes, malachite ink-wells, various fans and buckles."[4] The English Shop continued to operate in St. Petersburg until 1878.

In his section on jewelry and silverware shops, Kishkin-Zhgersky mentioned in the directory several merchants with boutiques in the famous Silver Rows near the Parliament building on Nevsky Prospect. The Silver Rows were commissioned by Emperor Alexander I and built by the merchant Sila Glazunov. At the beginning of the nineteenth century his boutique was the first and only place that dealt in the wholesale of silver. The Imperial Court and high society ordered its silver objects and silver service from Glazunov, and for a long time he had an all-powerful monopoly in the trade. Nevertheless the number of owners of silver boutiques gradually increased. They included Pavel Kudryashev, a merchant who offered tea and table services, silver samovars, toilet mirrors, boxes and baskets to high society. He began trading in 1820, but by 1840 he had abandoned the silver trade and turned instead to wood.

The jewelers Lev Breitfus and Wilhelm Kaemmerer kept diamond and gold jewelry shops on Nevsky Prospect. Both were court jewelers and acted as Appraisers to the Cabinet of his Imperial Highness. Kaemmerer was famous as a maker of military medals with diamonds, and at the Great Exhibition in London he exhibited a wreath of gold laurel leaves, a stomacher brooch set with cabochon rubies. Bogdan Breitfus suggested to Kaemmerer that he visit his shop near Siniy Bridge. Within a few years Kaemmerer too had moved to Nevsky Prospect, offering "the sale and commission of all kinds of objects: necklaces, signet and other rings, snuffboxes, stars and crosses, all in gold or silver."[5]

The directories of St. Petersburg began to offer their readers an ever increasing number of gold and silversmiths and jewelers who were able to fulfill any whim or fancy. I. N. Pushkarev, writing about St. Petersburg at the end of the 1830s, described the city's jewelers thus:

"Some of the craftsmen in gold, silver and diamonds truly deserve to be called excellent artists. To anyone who has the desire and the means to forsake thousands of loaves of bread for precious rings, necklaces and other dress ornaments, I recommend a visit to the magnificent shops of Breitfus, Keibel, Jahn and Bolin forthwith. Those who care for the grandeur of our holy cathedrals and wish to bring whatever they can to decorate holy places should pay attention to the silverworks of the honest Russian master Daniil Andreyev."[6]

On 6 February 1841 Andreyev was awarded a gold medal with the inscription "for services", to be worn around the neck with a ribbon of St. Anne. In the citation it was noted that "craftsman of the guild of silversmiths and local tradesman Daniil Andreyev, having dedicated more than ten years to mastery of the creation of liturgical objects, tableware and other silver products has today attained the highest possible level of perfection."[7] From 1845 Andreyev was entitled to call himself Silversmith to His Imperial Highness Grand Duke Alexander Nikolaevich, and to have the Imperial coat-of-arms on his shop sign.

4. The Petersburg Pages of the Count Sollogub's Memoirs with Portraits of his Contemporaries. *St. Petersburg*, (1993), p. 204.

5. K. Nistrem, The Address Book of Saint Petersburg for 1837, *St. Petersburg*, (1937), p. 45.

6. I.N. Pushkarev, Saint Petersburg under Nicholas, *St. Petersburg*, (2000), p. 584.

7. TsGIA, F. 522, Op. 1, d. 104, 1.2.

The Frenchman Jean-Baptiste Vaillant and the German Gustav Fabergé arrived in St. Petersburg at almost the same time in 1842. Both opened small shops and studios near Nevsky Prospect. Fate was to treat them kindly, for they did not get lost amidst the hundreds of other craftsmen. In 1847 *Illustration* newspaper published a drawing of a silver vase, the Imperial prize for the annual Peterhof Regatta. This fantastical composition of anchors, naiads and tritons was the work of Vaillant.[8] By 1848 he was already supplying goods to the Imperial Court, and a year later he was awarded the gold medal at an exhibition in St. Petersburg; thereafter he was frequently mentioned by St. Petersburg journalists as one of the city's most famous jewelers. His workshop contained numerous wonderful pieces of jewelery made of precious stones, including necklaces, earrings, bracelets and cuff-links, as well as a host of silver and bronze candelabras and figurines, all of which stand comparison with the works of European masters. Vaillant continued to delight Petersburgers for half a century until he left the capital in 1892, having passed his shop and studio on to another jeweler.

Gustav Fabergé did not participate in exhibitions, but was nonetheless well known by his contemporaries. Before the Christmas holidays of 1849 an unknown journalist on the St. Petersburg newspaper *Northern Bee* wrote: "Recently I saw a quite wonderful creation of diamonds, rubies and emeralds, the work of one of the city's jewellers, a young man by the name of Mr Fabergé, who has a shop in the Jacot House on Bolshaya Morskaya Street. And I must say that this work would not look out of place at a Parisian exhibition. The delicacy of the finish and the sketching is truly Parisian. G. Fabergé is an artist indeed."

Within a few decades Gustav Fabergé's son, Carl Gustavovich Fabergé, would become the pride and glory of the Russian jeweler's art.

For many years there were English, French, German and Dutch boutiques in St. Petersburg. Finally, in 1847, a shop of Russian artefacts was opened in the Engelhardt House on Nevsky Prospect. The Russian Shop was run by the Russian textile makers Guchkov, Prokhorov and Sapozhnikov, the gold thread maker Likhachev, the silversmith Sazikov and the glass-blower Maltsev. The shop had twelve different showrooms. The first and second rooms were the Likhachevs' kingdom, a land of glistening gold thread, while the third room was a showcase for Sazikov's superb gold and silver objects. Elsewhere in the shop customers could find desk accessories, linen and paper fabrics, chintzes, muslins and cashmeres.

The Russian Shop provided the opportunity to see, touch and buy everything displayed in such splendor at exhibitions. The correspondent of *Northern Bee* described his impressions as follows: "The St. Petersburg public was full of admiration for Mr Sazikov's candelabras, equal in quality to those produced in London, and his toilet accessories in the new Russian style, based on ancient designs and forms of jewelry in the Kremlin's Palace of Facets. Mr Sazikov has resurrected and firmly established in Russia the art of Benvenuto Cellini. Mr Sazikov's shop is a veritable museum of sculptures in gold and silver."[9]

The art of St. Petersburg jewelers and gold and silversmiths of the 1830s and 1840s represents a golden period in the history of Russian art. The use of advances in science and technology significantly increased the possibilities in the search for new forms and new decorative ideas. Alongside an interpretation of Western European historical styles, Russian artists showed profound respect for the history of their own national art. It was this combination that enabled the representatives of the Russian school to make their début on the international stage at the Great Exhibition in London in 1851.

Larissa Zavadskaya

8. *Northern Bee*, no. 284 of 21 December 1849.

9. *Northern Bee*, no. 255 of 12 November 1849.

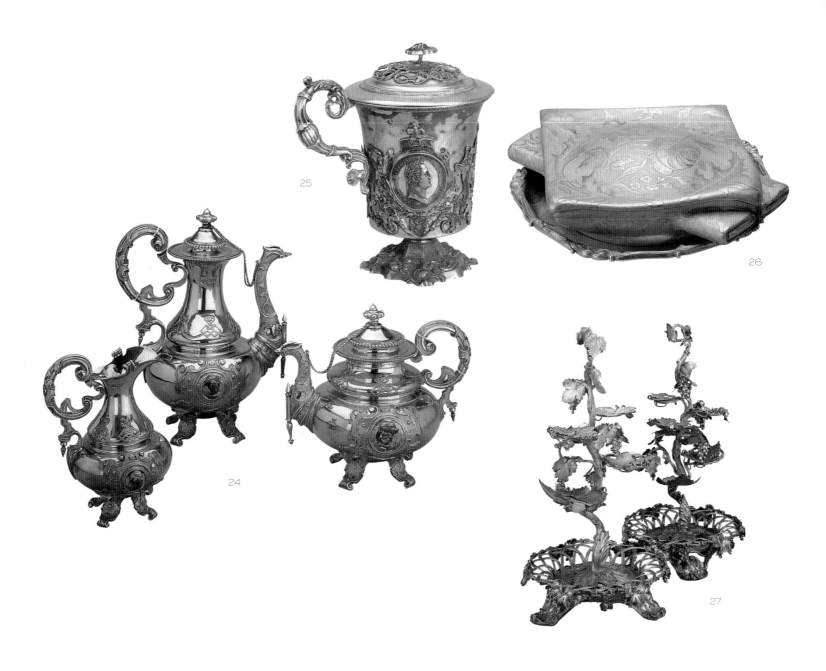

25

26

24

27

24. SILVER-GILT PART TEA AND
COFFEE-SERVICE comprising a teapot,
coffee-pot and cream-jug, each embossed with
heads of men and women in fantastic headgear
– signed with the Imperial Warrant mark of
Sazikov, assay mark of Moscow 1848, assay-
master Andrei Kovalsky, 84 (zolotnik), height of
coffee-pot 8$\frac{1}{2}$ in. (21.5cm).
Provenance: Prince Galitsyn; State Museum of
Ethnography, 1941.
Bibliography: Berniakovich, 1956, p. 29;
Berniakovich, 1977, No. 162; Postnikova-
Loseva, 1983, p. 225.
Exhibited: Historical Method 1996, cat. 25–28.
Most probably this set was ordered from
Sazikov in connection with the wedding of
Prince Nikolai Mikhailovich Galitsyn
(1820–1885) and Maria Sergeevna Sumarokova
(1832–1902), which took place on 13th January
1849.
The State Hermitage Museum (ERO – 5018-
5020).
LAZ

25. SILVER-GILT COMMEMORATIVE
TANKARD embossed with the portraits
of Emperor Nicholas I, Empress Maria
Feodorovna, Grand Duke Alexander
Nikolaevich and his wife Grand Duchess Maria
Alexandrovna, with their names engraved
beneath – signed with Cyrillic initials N.G.,
Cyrillic initials of unknown workmaster H.D.,
assay mark of Moscow 1841, assay-master
Nikolai Dubrovin, 84 (zolotnik), height 6$\frac{7}{8}$ in.
(17.5cm).
Among an assortment of silver artefacts widely
distributed in Moscow and St. Petersburg in the
1830s were a number of inexpensive but
elegant silver tankards and glasses with fine
ornamental designs in the form of classical
figures, made to imitate engravings or
embossings. With time, the character of the
decorations changed and the breadth of subjects
increased. As well as the figures of classical
dancers and cupids, historical subjects began to
appear. The magnificent wedding of the heir to
the throne took place in 1839. Obviously
tankards such as this one were made to
commemorate the event.
The State Hermitage Museum (ERO – 9037).
LAZ

26. SILVER HOT-WATER DISH FOR
TRUFFLES shaped as two folded napkins –
initials I. S., Imperial Warrant mark of Sazikov,
assay mark of Moscow 1849, assay-master
Nikolai Dubrovin, 84 (zolotnik), width 10$\frac{5}{8}$ in.
(27cm).
Provenance: Imperial Collections, Winter
Palace; State Museum of Ethnography, 1941.
Bibliography: Directory, 1849, p. 55; Review,
1850, p. 295, Holdberg, 1967, p. 202.
Exhibited: 1996, Historical Method, No. 30.
Truffles were served hot and a special cavity
was designed to hold hot water between the
outer and inner walls of the dish to keep it
warm. In 1849 a similar dish was exhibited
in the All-Russian Industrial Art Exhibition in
St. Petersburg.
The State Hermitage Museum (ERO – 5022).
LAZ

27. PAIR OF SILVER FRUIT-STANDS
from the Bobrinsky wedding service decorated
with figures of bears and beavers and chased
with vines and the family coat-of-arms – by
Karl-Johan Tegelsten, for Magasin Anglais, assay
mark of St Petersburg 1850, assay-master
Dmitri Tverskoi, 84 (zolotnik), height 19$\frac{1}{4}$ in.
(49cm).
Provenance: Counts Bobrinsky, St. Petersburg;
State Museum of the Ethnography of nations of
the USSR, 1941
Exhibited: Historical Method 1996. cat. 46–48
The ceremonial dinner service was ordered for
the wedding of Count Alexander Bobrinsky to
Countess Sophia Shuvalova. It included massive
vases for fruit and sweetmeats, coolers for wine,
salt-cellars crowned with the count's coronet,
cut-glass vessels for spices with fantastical silver
mounts. The beaver was part of Count
Bobrinsky's family crest.
The State Hermitage Museum (ERO – 4469,
4470)

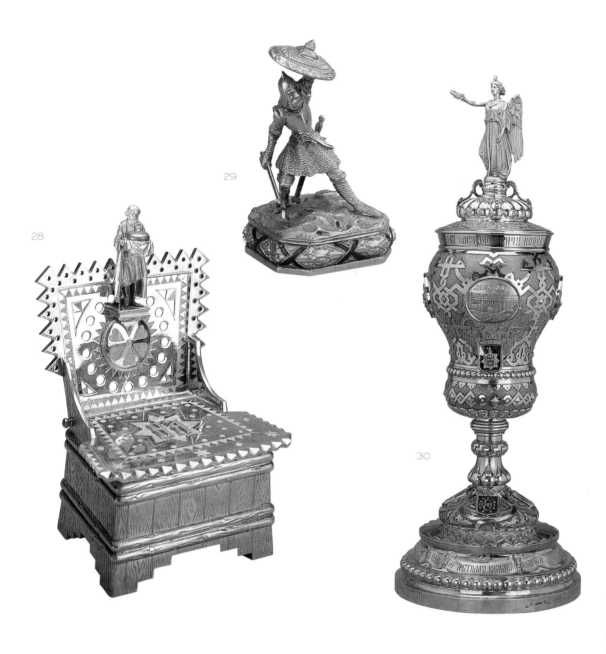

28

29

30

28. THRONE-SHAPED SILVER SALT-CELLAR
engraved with monogram "NA" and chased to imitate wood-grain, decorated with a figure of a peasant woman with a bread loaf in her hands – signed with the Imperial Warrant mark of Sazikov, assay mark of Moscow 1861, assay master Viktor Savinkov, 84 (zolotnik).
Provenance: Imperial Collections, Winter Palace; State Museum of Ethnography, 1941.
Exhibited: Historical Method 1996, cat. 56.
This silver salt-cellar was presented to Tsarevich Nicholas Alexandrovich during his travels around Russia. The offering of bread and salt to distinguished guests is an ancient Russian tradition.
The State Hermitage Museum (ERO – 3916).
LAZ

29. GOLD TABLE-SEAL SHAPED AS A RUSSIAN WARRIOR
the bloodstone matrix cut with 'Nikolai' in mirror writing – initials of workmaster Samuel Arndt, for Magasin Anglais, St. Petersburg (1850s), 56 (zolotnik).
Provenance: Imperial Collections, Winter Palace; State Museum of Ethnography, 1941.
The State Hermitage Museum (ERO – 6079).
LAZ

30. MASSIVE SILVER COMMEMORATIVE CUP AND COVER
surmounted by a winged victory figure. The body of the cup is chased with four oval enameled medallions showing the Port of Novorossia, the railway bridge, the Chamber of Commerce and of Agriculture. The base has the coats-of-arms of the provinces of Ekatarinoslav, Taurichesk and Bessarabia, and the personal coat-of-arms of P. E. Kochubei. Upper inscription: "From the grateful citizens of the Novorossiiskii region to Pavel Evstafievich Kochubei" and at the base "In commemoration of his 50th anniversary celebration, 12 March 1870" – Imperial Warrant mark of Sazikov, assay mark of St. Petersburg 1870, initials of assay master M. K., 84 (zolotnik), height 28¼ in. (72cm).
Provenance: The State Depository for valuables, 1951.
Exhibited: Historical Method 1996, cat. 60.
This impressive commemorative cup was presented to Count Kochubei on 12 March 1870 by the inhabitants of the Novorossiiskii district on his 50th anniversary as a first rank officer.
Pavel Kochubei (1801–1884), statesman; adjutant-general, member of the State Soviet. Took part in a number of military campaigns. From 1862 he was governor-general of the Novorossiiskii region and Bessarabia, commanding the troops of the Odessa military district. He did much for the economic development of southern Russia. He was also honored with the diamond-set Order of St. Andrew on the day he received this cup.
The State Hermitage Museum (ER0 – 7648)
LAZ

31

32

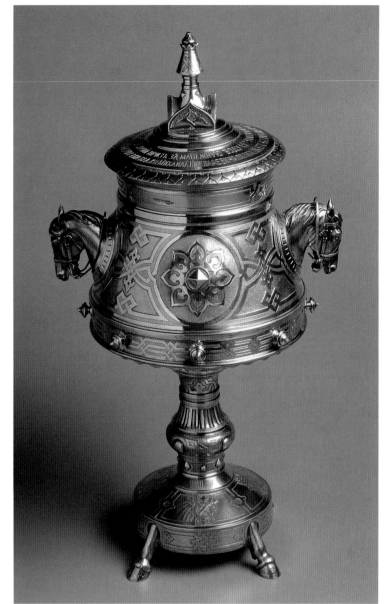

33

34

35

31. SILVER-GILT BEAKER SHAPED AS THE HEAD-GEAR OF THE HUSSARS signed with initials of Alexander Lyubavin, assay mark of St. Petersburg, c. 1870, 84 (zolotnik), height 3⁵₁₆ in. (8.4cm).
Provenance: Prince Galitsyn collection; State Museum of Ethnography, 1941.
In 1774, on the orders of the Empress Catherine II, a hussar squadron was formed, which in 1796 was reformed into a regiment. In 1818 Tsarevich Alexander Nikolaevich became its commander. When he acceded to the throne, the regiment was named the "Life-Guards of his Imperial Highness". In 1874 in St. Petersburg the regiment's centenary was commemorated. Lyubavin was commissioned to create a collection of goblets in the form of fur hats with plumes, as gifts for the officers of the regiment. The high plumes overbalance the goblets and so the glass had to be drained when filled.
The State Hermitage Museum (ERO – 4888)
LAZ

32. SILVER STIRRUP CUP SHAPED AS A DOG'S HEAD with finely chased and engraved fur, with reeded rim and gilt interior – by Nicholls and Plincke, initials of workmaster P. K., assay mark of St. Petersburg, c. 1870, height 2⁷₈ in. (7.3cm).
Private Collection courtesy A. von Solodkoff

33. SILVER TROPHY WITH HORSE-HEAD HANDLES standing on four hoofs, decorated with strapwork and turret finial – signed Sazikov, assay mark of St. Petersburg 1871, assay-master's initials Cyrillic I.E., height 17 in. (33.2cm). Inscribed: "Second prize for Exhibition Riding of the 13th Vladimir Lancers, H.I.H. Grand Duke Mikhail Nikolaevich Regiment from H.S.H. Prince Nikolai Petrovich Oldenburg".
André Ruzhnikov

34. ENAMELED GOLD PURSE DECORATED WITH THE STAR OF THE ORDER OF GEORGE – initials of workmaster Samuel Arndt, for Nichols and Plincke, St. Petersburg c. 1870, 56 (zolotnik), length 4⁵₁₆ in. (11cm).
Provenance: Winter Palace; State Museum of the Ethnography of nations of the USSR, 1941.
The purse was given by Emperor Alexander II to Count Mikhail Loris-Melikov (1825-1888), who was appointed temporary governor-general of St Petersburg, and in August 1880 became Russian Minister of the Interior. After the assasination of Emperor Alexander II in 1881 he was dismissed by Alexander III.
The State Hermitage Museum (ERO – 6114)

35. SILVER TROMPE L'OEIL BEAKER engraved to simulate a wooden pail, inscribed with the initials A. Kh. – signed with Imperial Warrant mark of Sazikov, assay mark of Moscow 1871, height 2¹₂ in. (6.5cm).
Private Collection

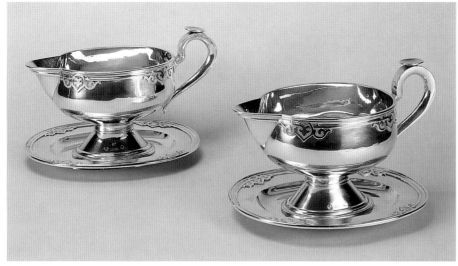

36

38

39

37

38. SILVER WRITING COMPENDIUM SHAPED AS A LOCOMOTIVE standing on a marble base, the inkwell and sandbox located in the chimneys, with a sliding door in the engine boiler inteded for pens – signed with the Imperial Warrant of Sazikov, assay mark of St. Petersburg 1871, length 17¼ in. (44cm).
Provenance: Acquired from the collection of Countess E. Shuvalova, 1925.
This unusual writing set was presumably commissioned in response to some event connected with the railway, or was presented to someone employed by the Ministry of Communications.
In the nineteenth century various models, or 'toys for adults', were extremely popular, often in the form of human figures, animals, wild beasts or birds, or prize cups in the form of ships. A model of a locomotive, however particularly one with such an obviously utilitarian purpose is exceedingly rare.
The State Hermitage Museum, St. Petersburg
ML

39. SILVER-GILT TRAY chased with the Russian and St. Petersburg coats-of-arms, the center engraved with the monogram of Tsarevich Nicholas Alexandrovich and "From the St. Petersburg Bourgeoisie" – signed I. Nordberg, assay mark of St. Petersburg 1856, assay-master Eduard Brandenburg, 84 (zolotnik), length 22 in. (56cm).
Provenance: from the Diamond Storeroom of the Wiunter Palace; State Museum of the Ethnography of nations of the USSR, 1941.
Tsarevich Nicholas Alexandrovich (1843–1865), the eldest son of the emperor Alexander II, died from a serious illness in Nice. The tray was presented to him by the Petersburg bourgeoisie after the return of the Imperial family from Moscow where they had been for the coronation ceremonies in 1856.
The State Hermitage Museum (ERO – 5421)

36. PAIR OF SILVER SAUCE BOATS AND STANDS each with capped handle and oval stand, bordered with cut-out strapwork – Imperial Warrant marks of Sazikov, initials of assay-master I. E., assay mark of St. Petersburg 1875, length 9½ in. (24cm).
Original wooden case stamped with Imperial Warrant, Moscow, St. Petersburg.
Private Collection

37. SILVER TROMPE L'OEIL SALT BOX made to resemble a loaf of bread on a folded lace napkin – Imperial Warrant mark of Pavel Ovchinnikov, assay marks of Moscow 1871, length 4½ in. (11.5cm).
Private Collection

40

40. LARGE CIRCULAR GEM-SET SILVER-GILT AND ENAMEL PRESENTATION CHARGER with white enamel crowned double-headed eagle in the center. It is applied with a ruby surrounded by emeralds, on blue enamel ground with scrolling gilt foliage, surrounded by a presentation inscription, with chased silver-gilt flutes, the chased and engraved foliage border applied with twelve coats-of-arms of Russian cities, St. George slaying the dragon of Moscow above – signed with Imperial Warrant mark of Pavel Ovchinnikov, assay mark of Moscow 1882, diameter 24³⁄4 in. (62.8cm).

The inscription reads: "On the day of the holy coronation of Emperor Alexander Alexandrovich and Empress Maria Feodorovna from the Moscow Nobility".
Tsar Alexander III was crowned in the Moscow Kremlin on 27 May 1883.
Private Collection

41

42

43

41. SILVER SALT-CELLAR SHAPED
AS A PEASANT WOMAN with a sack
of grain – initials of workmaster Grigory
Loskutov, assay mark of Moscow 1887, initials
of assay master IK, 84 (zolotnik).
Provenance: acquired by the Hermitage 1997.
The peasant theme was widely used by Russian
jewelers in the second half of the 19th century.
Writing sets in the form of peasant izbas,
lapta-bat ashtrays and cigar-cases were
extremely popular.
The State Hermitage Museum (ERO – 10095)
LAZ

42. SILVER-MOUNTED BLUE GLASS
COMMEMORATIVE KOVSH
of traditional form, the frosted exterior
inscribed on the border in Russian "in
memory of the tercentenary of the Romanov
dynasty" and with the dates '1613–1913' on
the rim, the base carved with the Romanov
coat-of-arms, with white metal handle
of upright form, chased and engraved in
pan-Slavic style with pillars, scrolls, a band of
bird and fruit and an arch, marked on the
mount – stamped 4th Artel, assay mark of
Moscow 1908–1917, length 13¾ in. (35cm).
Private Collection

43. SILVER-MOUNTED GLASS
DECANTER the bulbous vessel decorated
with horizontal banding, the mount and
handle chased with tendrils and with dragon's
head terminal holding the hinged lid – signed
Bolin, initials of workmaster K. L., assay mark
of St. Petersburg before 1899, height 5¼ in.
(13.4cm).
Private Collection

3
RUSSIAN ENAMEL

RUSSIAN ENAMEL

The earliest examples of Russian enamelware[1] date from the twelfth and thirteenth centuries to the Grand Dukedom of Kiev and were produced under the influence of Constantinople.[2] These enamels were gold plaques decorated both in *champlevé*[3] and *cloisonné*[4] enamel, stylistically related to works of art produced during what is described as the Byzantine Renaissance of the eleventh and twelfth centuries under the rule of the Paleologue emperors. In Russia this first flowering of the arts came to an abrupt end when the Mongols invaded central and southern Russia in the thirteenth century and ravaged Kiev in 1240. There ensued two centuries of artistic stagnation during which a prince of the House of Rurik founded the pricipality of Moscow.

Toward the end of the fifteenth century Prince Ivan III (1462–1505) married Sophia, a Byzantine princess of the House of Paleologue, and succeeded in wresting power from competing Rurik princes, thereby becoming the founder of Moscow's greatness. To his emblem of St. George, he added the Byzantine double-headed eagle, claiming for Moscow the role of the Third Rome, and for himself the title of Tsar or *gospodar*. During his reign the Cathedral of the Dormition was built, the church in which future Tsars were married and crowned, as well as the magnificent Cathedral of the Annunciation. The ruling house's power was consolidated both under his son and grandson, Vassili III (1505–1533) and Ivan IV (The Terrible, 1547–1584). During the reign of Ivan IV, Moscow became a truly imperial capital, open to visitors from the West.[5] Under Ivan IV and his Italian architects, the Kremlin was rebuilt.

During the sixteenth century, the arts flourished within the walls of the Kremlin, where workshops, influenced by goldsmiths from Novgorod and Pskov produced magnificent icon and gospel covers of hammered and filigree gold and *cloisonné* enamels inset with large cabochon stones.[6]

FIG I. DETAIL OF GEM-SET AND ENAMELED GOLD QUIVER
Kremlin workshops, 1627–9, length 18¾ in. (47.5cm).
The Kremlin Armory Museum, Moscow

Following the reign of Tsar Boris Godunov, the extinction of the line of the Rurik princes and a time of political disorder, Michael III ascended the throne in 1613, the first of a long line of Romanov princes who were to rule Russia for the next 300 years. The court, and with it the Kremlin workshops, regained their luster. There followed a century of great artistic activity lasting until Peter the Great transferred the seat of power to St. Petersburg in 1712. In the second half of the seventeenth century, the Moscow workshops, working for the Imperial Armory under the direction of chief armorer Bogdan Matveevich Khitrovo attained the pinnacle of their creativity. They produced gold and silver artefacts, including harnesses, quivers (fig. 1), saddlebags lavishly embellished with polychrome enamels and precious stones set on stippled ground, as well as the many exquisitely adorned liturgical implements that fill the showcases of the Kremlin Armory today.[7] These attest to the high quality of craftsmanship during this century.

Simultaneously, Solvychegodsk, the seat of the Stroganov family, became another artistic center known for its enamelware in Northern Russia. These enamels, mostly caskets and bowls, were influenced by Western examples from The Netherlands and Germany. Traditionally called 'Usolsk', they are painted with polichrome scrolling foliage and flowers on white ground.[8] Craftsmen from Solvychegodsk also worked in Moscow, producing some of the finest enamels of this genre.[9]

Peter the Great and his successors, the Tsarinas and Tsars of the eighteenth and early nineteenth century concentrated their efforts on the embellishment of the new capital, St. Petersburg. For over a century Moscow became an artistic backwater. The renaissance of the Russian arts coincides with the three decades of the reign of Nicholas I (1825–1855), whose personal interest in things Russian was a determining factor. In 1830 the director of the St. Petersburg Academy of Art, Alexei Olenin, sent the young Fedor

Solntsev to Moscow and other Russian cities to copy objects of the pre-Petrine era in the local collections. In 1836 the same Solntsev provided the designs for the restoration of the Kremlin's Terem Palace, the first instance of what has been termed as the Pan-Slavic or Old Russian style. Further early signs of this style are evident in 1837–8 in the Kremlin Service, a vast porcelain dinner service ordered by Nicholas I and produced at the Imperial Porcelain Factory in St. Petersburg, also after designs of Fedor Grigorievich Solntsev.[10] Several of Solntsev's designs are copied from known seventeenth-century originals in the Kremlin Armory. The six-volume publication of Solntsev's studies, which appeared as Antiquities of the Russian State (1846–1853), was commissioned and funded by Nicholas I.

At the same time, a rapidly growing merchant class revitalized the old capital, Moscow, providing craftsmen with many new commissions. The refurbishment of the Terem Palace set the tone for decades to come: the Old Russian style as shown in Solntsev's drawings was warmly embraced by all major silversmiths of the period, beginning with Ignatii Sazikov as early as 1851.[11] His copy of a Turkish enameled tankard from the Kremlin after a design by Solntsev was shown at the Great Exhibition in London's Crystal Palace that year (cat. 68). During the following two decades, Moscow silversmiths, Sazikov, Ovchinnikov, Khlebnikov and Gratchev embellished their works in colorful *champlevé* enamels. By the late 1870s, these old-fashioned *champlevé* enamels were slowly supplanted by *cloisonné* or filigree enamels.[12] The appearance of the two latter techniques cannot be dated with precision as few originals dating from before 1880 have survived. At first the *cloisonné* enamel decoration is sparse, appearing mainly in the form of borders on secular and liturgical implements. Gradually, however, the enamels take over the entire surface of objects.

In the last two decades of the nineteenth century, traditional Pan-Slavic enamels became exceedingly popular throughout most of Russia, except perhaps in francophile St. Petersburg. Tourists and enterprising dealers disseminated this vogue abroad. Tiffany's in New York retailed enameled wares from Russia, chiefly ordered from the Muscovite silversmith Kuzmichev (cat. 47), but also from Ivan Andreiev and others.

The first generation of craftsmen specializing in Pan-Slavic *cloisonné* enamels included, in addition to the four internationally known firms of Sazikov, Ovchinnikov, Khlebnikov and Gratchev, a number of smaller firms: Gustav Klingert, Andrei Postnikov, Maria Adler, Antip Kuzmichev and Alexander Lyubavin. All worked in a polychrome palette of predominantly turquoise, pale and dark blue, white, red, pink, green and mauve colors displayed on stippled silver-gilt ground. The lion's share of commissions went to the firm of Ovchinnikov, which specialized in presentation dishes, commemorative plaques and album covers. Ovchinnikov introduced two novel enameling techniques to Russia, *plique-à-jour* enamel[13]; and a red lacquer or varnish covering the background of objects decorated in the Japanese style.[14]

FIG 2. ENAMELED AND JEWELED GOLD PLATE by L. Konstantinov and I. Juriev, Kremlin workshops 1667, diameter 8⅝ in. The Kremlin Armory Museum, Moscow

Toward the very end of the century, coinciding with a change in assay marks from the Moscow St. George to the "kokoshnik" mark in 1899[15], palettes began to lighten up and change with the introduction of "shaded enamels". Ever larger expanses of *cloisonné* enamel covered the surfaces of the articles and were decorated with flowers and foliage in pastel colors painted in various shades, until the entire vessel was coated with enamel. This type of decoration derives ultimately from the "Usolsk" enamels of the late seventeenth century. Of the four leading firms Ovchinnikov and Khlebnikov adapted to this lighter palette. The lesser firms of Klingert, Postnikov, Kuzmichev and Lyubavin were joined by Oskar Kurlyukov, Maria Semyonova, Ivan Saltikov and Grigory Sbintnjev, all actively pursuing this new fashion. A newcomer, too, was Feodor Rückert, who had worked anonymously for Fabergé since 1882. Although a very original Moscow enameler, during the early years of his production his style and palette barely differed from those of his

competitors. *En plein* painted enamels[16] depicting Russian mythological subjects also make their appearance at this time.

At the beginning of the twentieth century, under the influence of the *Mir Isskustva* movement[17], *style moderne*, the equivalent of the German *Jugendstil* or the Austrian *Sezession* invaded Russia, diffused by the Stroganov Central School of Technical Drawing and the teachings of the artist's colony founded by Savva Mamontov at Abramtsevo.[18] The language of European Art Nouveau, now mingled with indigenous motifs, produced a highly original neo-Russian style that was successfully adopted by a small number of enamelers, becoming more and more individualized as the October Revolution drew nearer. No doubt the most outstanding of these craftsmen was Feodor Rückert, whose main retail outlet was Fabergé, but who also worked for Kurlyukov, Marshak and Ovchinnikov, as well as for his own account. The *cloisonné* enamels he made for Fabergé were highly personal, both in design and color. Coinciding approximately with the second change of assay marks in 1908, Rückert's palette darkens with the introduction of black, dark and olive green, and brown colors. His designs are distinctly influenced by the newest teachings at Abramtsevo as exemplified by the wood carvings of Elena Polenova and Alexei Zinoviev. A unique characteristic of these late enamels by Rückert is the independent role played by filigree wires twisted into tightly coiled springs and by gilded pellets, forming patterns of their own.

The flat-bottomed kovshi produced by the firm of Khlebnikov between 1908 and 1917 are also highly original with their whimsical look, lime-green colors, and exaggeratedly scalloped rims and angular animal handles. Ovchinnikov also adopted the idiom of Art Nouveau, but preferred pale pastel colors for the decoration. On the other hand, the enamels of Kurlyukov are barely affected by these momentous changes. Other enamelers followed in the wake of these leaders including the Sixth, the Eleventh, the Twentieth and the Twenty-sixth Artels (all small associations of silversmiths), Nikolai Alexeiev and Iakov Borisov. Painted enamels, many of them after celebrated works by K. Makovskii and V. Vasnetsov make their appearance on kovshi, caskets, and boxes.

In the years preceding the Revolution, there were signs that the influence of Art Nouveau was abating, with a return to more traditional forms as shown in the latest output of Ovchinnikov and Khlebnikov.

Géza von Habsburg

Notes

1. For the best study of Russian enamels (to which this author is much indebted) see Odom (1996).

2. Enamel is a transparent composition made from ground glass fused on to a metal surface. Color is obtained by adding metal oxides.

3. In *champlevé* enamels (from the French for 'raised field' or champs) enamels, designs are gouged out of the metal surface and filled with enamel.

4. *Cloisonné* enamels (from the French cloison or 'cell') are formed by soldering thin strips of metal to the surface forming cells, which are then filled with single colors of enamel and polished.

5. In 1553 the British navigator Richard Chancellor discovered a Northern passage to Moscow and the East, opening the way for merchants to sail from London passing under Scandinavia. See Oman (1961).

6. For examples of 16th-century enameling see Torre Canavese (1994), cat. 2–5.

7. For examples of 17th-century enameling see: Ibid., 8–15.

8. Usolsk enamels from Solvychegodsk are illustrated in Odom (1996), cat. 8 and 11.

9. For Mosow Usolsk enamels see Odom (1996), cat. 12 and 13.

10. For a discussion of the beginnings of the Old Russian style see Odom (1996). Also Odom (1991), p. 1–4.

11. For Sazikov see Mukhin (1992), pp. 43–51.

12. In filigree enamels, as opposed to cloisonné, the cells are formed not of metal strips, but of twisted wire.

13. *Plique-à-jour* (from the French for à jour or 'daylight') is sometimes a variant of filigree enamel or sometimes of *champlevé* enamel, but without metal backing, which causes a stained-glass window effect.

14. The same red lacquered effects were used by Tiffany's in certain of their Japanese mixed metal wares.

15. For the change of assay marks in 1896 see Anne Odom, 'The Kokoshnik Faces Left' in Habsburg/Lopato (1993), p. 443.

16. *En plein* enameling (from the French for 'in full') has come to mean large painted surfaces of opaque enamel, but can also apply to *guilloché* enamel or transparent enamel applied over an engine-turned surface.

17. For Mir Isskustva see World of Art (1991).

18. For the pioneering role of Abramtsevo and Talashkino see Anne Odom, 'Fabergé: The Moscow Workshops' in Habsburg/Lopato (1993), pp. 104–115.

RUSSIAN ENAMEL AT THE BEGINNING OF THE TWENTIETH CENTURY

The end of the nineteenth century saw the emergence of a distinctive Russian style in the applied arts. The innovations of that period were particularly marked in the development of enamel-work – while Carl Fabergé was renowned for his mastery of transparent enamel, Princess Maria Klavdievna Tenisheva (1867–1928) made inroads into work with opaque enamel and created a new palette of non-transparent colors, all of which withstood extreme temperatures and were impervious to acid. She also revived the thirteenth-century technique of "grooved" (*bas taille* and *champlevé*) enamel. Her work earned her the highest praise and regard from her contemporaries, most notably from Lalique, and she was elected a honorary member of the Society of Fine Arts and a member of the Union of Applied Arts in Paris after she had exhibited her enamelwork there from 1906 to 1908.

In 1900 Princess Tenisheva had her property of Talashkino in the Smolensk region converted into a centre for the applied arts where the various aspects of working with wood, metal, ceramic and fabrics were studied. Together with Mikhail Vrubel (1856-1910), the celebrated Russian symbolist artist who became famous not only for his paintings but also for his art works in glass and ceramics, she set up an enamel workshop for the study of metal design and finishing techniques including enamelling. Vrubel chose the staff at the school, and it was on his recommendation that Malyutin was invited to work there as director. Malyutin was granted complete freedom to work in whatever way he wished. His artistic collaboration with Vrubel was a fruitful one as it yielded an improvement both in his own work and in the students. Vrubel and Malyutin explored styles and forms of Old Russian art and reintroduced long-forgotten techniques into enameling, assisted by the Princess's large collection of old Russian artefacts. A new, distinct artistic style emerged from this enterprise, which left its mark on the work of major Russian jewelry firms, as well as on workshops and smaller studios. This, combined with Carl Fabergé's efforts, meant a huge boost in popularity of enamelwork both in Russia and abroad.

The opening of the enamel workshop of the Imperial Stroganov School in Moscow in 1902 was therefore very timely. The School had been founded in 1825 from the private funds of Count Sergei Grigoryevich Stroganov, a well-known collector, art dealer and state luminary. The Count had spent some time in France, where he had become interested in the education of craftsmen; on his return to Moscow he decided to found his own drawing school. In 1900 it met with considerable success at the World Exhibition in Paris, principally for its applied art designs and ceramic work. In 1901 the School assumed the title of "Imperial" and came under the patronage of Grand Duchess Elizaveta Feodorovna, elder sister of the Russian Empress. In the same year the School's mark with the inscription "I.S.U." (*Imperatorskoe Stroganovskoe Uchilishche*) gained the double-headed eagle, used on gold and silver articles. The double-headed eagle was the state emblem of Russia and was bestowed only on those that had received the highest awards at All-Russian Industrial Art Exhibitions, such as Bolin in 1882 and Fabergé in 1896, suppliers to the Imperial Court and organizations with the word "Imperial" in their title, an honour which could only be awarded to an organization until it had been in operation for at least fifty years.

In their first and second years, the students at the School studied "mounting" and basic enamelwork. In the third, fourth and fifth years they studied the following subjects:

FIG I. OVAL PORTRAIT STUDY OF A BEARDED MAN enamel on silver by Shilova with blue counter enamel – marked I.S.U. under Imperial Warrant, assay mark of Moscow 1908–1917, 88 (zolotnik), height 4⁵s in. (11.8cm).
Private Collection

FIG 2. PAN HOLDING HIS FLUTE AFTER MIKHAIL VRUBEL. enamel on silver by Goleva with blue counter enamel – marked I.S.U. under Imperial Warrant, assay mark of Moscow 1908–1917, 88 (zolotnik), height 4⁵s in. (11.8cm).
Private Collection

plated enamel; filigree enamel work on bronze and enamel plates; an introduction to enamel decoration of porcelain; enameling of silver and bronze articles. They worked on copies of well-known works of art or on their own compositions. In the sixth and seventh years they worked on complex compositions based on their own designs, using various different types of enamel including the most delicate. For the 300th anniversary of the reign of the Romanov dynasty a number of dishes, salt-cellars and icon-lamps in transparent enamel were produced by the workshop; these included a monumental dish with portraits of Tsar Mikhail Feodorovich and scenes from his election as Tsar. The school used this dish to make the traditional presentation of salt and bread to Emperor Nicholas II. Altogether students would complete fifty-seven hours of study in the enamel workshop in the first five years, and forty-two hours in the last three (of which fifteen were completed in the eighth year). At the same time students completed courses in the "chasing", "mounting", "electroplating" and "casting" workshops, spending 108 hours in each over the full eight-year course. Articles created in these workshops were eagerly sought after by members of the imperial family. The archives contain information on the sales of Easter Eggs and religious items created by craftsmen and students of the Stroganov School.

At the turn of the century the links between the Stroganov School and the leading Moscow jewelry firms continued to grow. At the beginning of the 1900s Feodor Rückert's two eldest sons, Pavel and Feodor, went to study at the Stroganov School. After a short time there, both returned to work in their father's studio. Rückert's work began to show marked changes in terms of geometrical composition and range of color; clearly these developments reflected the influence of the lectures in "The Stylistics of Color" given by Mikhail Vrubel at the Stroganov School and attended by the Rückert brothers. In 1910 both Mikhail Ivanov and the sons of Georgy Cheryatov entered the school, forming just two of many links between established jewelers and the school. Cheryatov was head workmaster at the firm of Lorié, a competitor of Fabergé specializing in opalescent and *plique-à-jour* enamels, while Ivanov was an artist at Fabergé's Moscow branch.

One of the school's most influential directors was Nikolai V. Globa (1859–1941) who was educated at the Academy of Arts in St. Petersburg. He was at the school from 1895 to 1917, where he was a gifted teacher and innovator in the field of arts education, and implemented a major restructuring of the school. He invited talented artists and teachers to work there, introduced new study programmes, organised art workshops and instituted annual shows of the students' works. He also opened a shop for the sale of pieces created by students, which was run directly by artists and teachers. Globa was also a strong advocate of Russian national art. He was elected to the Academy and in 1900 was appointed head of the Alexander II Industrial Art Museum, attached to the Stroganov School. He also organized the first All-Russian Competition for Industrial Art Designs in 1897 – fifteen of these were held up until 1917. In 1925 Globa traveled to an International Exhibition of Decorative Arts in Paris. He never returned to Russia, but in 1926, together with Prince Felix F. Yusupov, he established the Russian Industrial Art Institute in Paris, an organization that he headed and which counted Ivan Ya. Bilibin (1876–1942) and Mstislav V. Dobuzhinsky (1875–1957) among its teachers.

The links with the firms, which Globa helped to encourage, the numerous apprenticeships served there by students of the School, and the frequent cross-over of teachers and craftsmen between the various institutions all helped to develop and create a new Russian style in the applied arts. It achieved recognition not only in Europe, but also in America, thanks to Tiffany's, who bought large numbers of enamel objects in Russia and sold them all over America. It is also interesting to note that in 1876 the Stroganov School successfully displayed its products and designs at an exhibition in Philadelphia.

Michel Kamidian and Valentin Skurlov

FIG 3. PROFILE BUST OF A DENUDED LADY with landscape background, enamel on copper – marked I.S.U. under Imperial Warrant, height 2⅞ in. (7.3cm). Private Collection

FIG 4. GIRL IN RUSSIAN FOLK DRESS WITH BLUE SCARF standing on a meadow, enamel on silver by Afonasova with blue counter enamel – marked I.S.U. under Imperial Warrant, assay mark of Moscow 1908–1917, 88 zolotnik, height 5¾ in. (14.7cm). Private Collection

OVCHINNIKOV

The firm of Ovchinnikov was, between 1870 and the 1917 Revolution, the most important silversmith and enameler in Russia.[1] Its founder, Pavel A. Ovchinnikov (1820–1888), was a serf who was apprenticed to his brother in Moscow and obtained his liberty, getting married in 1850. With his wife's dowry he opened a workshop in 1851. In 1853 the firm's turnover was a modest 25,000 roubles, but it grew rapidly thanks to the initiatives of its founder. By 1865, at the All-Russian Industrial Art Exhibition, he was awarded the highest prize, a Gold Medal, and the title of Supplier to Tsarevich Alexander Alexandrovich (later Alexander III); later he received the Honorary Citizenship of Moscow. His many distinctions included the French *Légion d'Honneur*, the Iron Cross, the Order of St. Stanislavs (to be worn on a ribbon), the Order of Vladimir, Fourth Class, the title of Supplier to the Court of Grand Duke Michael Nikolaevich in 1878, and the title of Court Supplier in 1881.

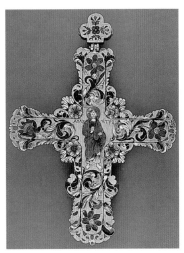

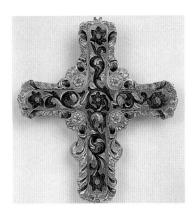

At the 1867 Paris World Fair, his large silver group commemorating the Liberation of the Serfs secured him a Silver Medal. His early sculptural works resembled those of the much celebrated Ignatii Sazikov (1796–1868), his elder by twenty-four years. They took their cue from such groups as Sazikov's *Dmitri Donskoi Wounded on the Field of Kulikovo* measuring 118 inches high and weighing 150lb., shown at the pioneering Great Exhibition of 1851 held at London's Crystal Palace. This was Sazikov's answer to the historicizing pictorial groups by Hunt & Roskill, so popular in Russia at the time. Sazikov also showed the way for the assimilation by Ovchinnikov of the Russian historical past as depicted in Fedor Solntsev's Antiquities of 1846–1853.

At the 1865 Russian exhibition the young Ovchinnikov was singled out for his enamel items – presumably *champlevé* enamels – which were regarded as a "national achievement". Their workmaster, Dillendorf, received an honorary award. He was no doubt responsible for the firm's elegant translations of peasant embroideries on to silver which were probably based on such studies as Viktor I. Butovski's "The History of Russian ornament from the X to the XVI century from ancient manuscripts" (1870); Vladimir Stasov's "Russian Folk Ornamentation" which also contained examples of embroidery (1871) and Stasov's "Samples of Russian Ornamentation" (1872) showing patterns of Russian towels. Solntsev's, Butovski's and Stasov's publications "provided a grammar of Russian ornament" that all contemporary silversmiths found useful.[2]

In 1873, Ovchinnikov's sculptor, A. Zhukovsky, received an award for work based on popular Russian themes. Both Zhukovsky and D. Chicagov provided the models for the much-admired groups of a boyar and a boyarishnia playing blind man's buff, which were exhibited at the Vienna World Fair in 1873, as well as for a dish with figures in relief depicting historical scenes from the early seventeenth century, and a silver vase ornamented in the Old Russian style.

Ovchinnikov earned much acclaim for his Gospel cover made of turquoise filigree enamel for the Church of Christ the Savior in Moscow, shown at the All-Russian Industrial Art Exhibition of 1882. At the same exhibition there is mention of a jug with "Japanese grass pattern", perhaps the first example of Ovchinnikov's red lacquer wares. The firm also showed a sculptural allegory "Memories of Slavonic Liberation I" modeled by the sculptor Lanceray.

Also in 1882, Pavel Ovchinnikov was awarded a Silver Medal for his vocational school where up to 130 apprentices were housed for five or six years and trained in an exemplary manner. Ovchinnikov's craftsmen worked daily from 7am to 9pm with a two-hour break, with double pay for working on national holidays. Bonuses were paid for outstanding craftsmanship and retired craftsmen were cared for with life-long pensions if

they had no employment. Ovchinnikov was named head of the Russian National Jewelry School for having contributed substantially to his country's undisputed international position in the world of the applied arts.

In 1873 a branch was established in St. Petersburg on 35 Bolshaya Morskaya. The firm initially employed 173 workmen, rising to 300 workmen by 1881 and was by that time the largest of its kind in Russia. Pavel Ovchinnikov was succeeded by his son Michael Pavlovich (until 1915), while his younger son Alexander was in charge of the Moscow factory. The firm maintained its pre-eminent position after Pavel's death, receiving honorary mentions at the Chicago World Fair in 1893 and at the Paris World Fair in 1900.

Géza von Habsburg

Notes
1. There is not much easily accessible literature on Ovchinnikov available for Western scholars. A basic article by Galina Smorodinova, "Pavel Ovchinnikov and the Russian Gold- and Silversmithery" in St. Petersburg (1992), pp. 57–60, provides the outline of the firm's history. In Russian, see Karina A. Orlova, "Works by the House of P. A. Ovchinnikov in the Collection of the Hermitage" in The State Hermitage, Decorative Applied Art of Russia and Western Europe (Leningrad 1986), p. 86.

2. Evgenia Kirichenko (1991).

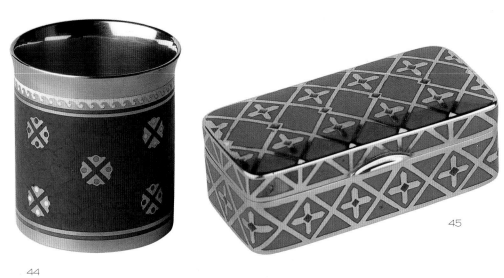

44

45

48

46

44. CYLINDRICAL GOLD AND CHAMPLEVÉ ENAMEL BEAKER
decorated with stylized flowerheads on a pale blue opaque enamel band with white enamel border – signed with Imperial Warrant mark of I. Sazikov, assay mark of St. Petersburg, *c.* 1860, 72 (zolotnik), height $1^7/16$ in. (3.6cm).
Private Collection

45. RECTANGULAR GOLD AND CHAMPLEVÉ ENAMEL BOX with a trellis of green enamel squares decorated with gold and red enamel crosses, gold pushpiece – signed with Imperial Warrant mark of I. Sazikov, assay mark of Moscow 1856, assay master A. K., 72 (zolotnik), length $2^1/16$ in. (5.2cm).
Private Collection

46. SILVER AND CHAMPLEVÉ ENAMEL CIGAR-CASE the polychrome decoration imitating peasant embroidery – initials of Andrei Bragin, assay mark of St. Petersburg before 1899, length $4^3/4$ in. (12cm).
In the late 1870s and throughout the 1880s, porcelain painters, silversmiths and enamelers were inspired by folkloristic motifs like these, transmitted through the publication of Viktor Vasnetsov's Antiquities.
André Ruzhnikov

48. CHAMPLEVÉ SILVER KOVSH OF TRADITIONAL SHAPE decorated in pale and dark blue and red hues with flowerheads and geometric motifs – signed with initials A. K. for Antip Kuzmichev, assay mark of Moscow 1891, assay master's initials A. R., length $7^1/4$ in. (18.5cm).
In spite of its late date, this kovsh and its decoration adhere to a type popular in the late 1870s/early 1880s.
André Ruzhnikov

49

 51

50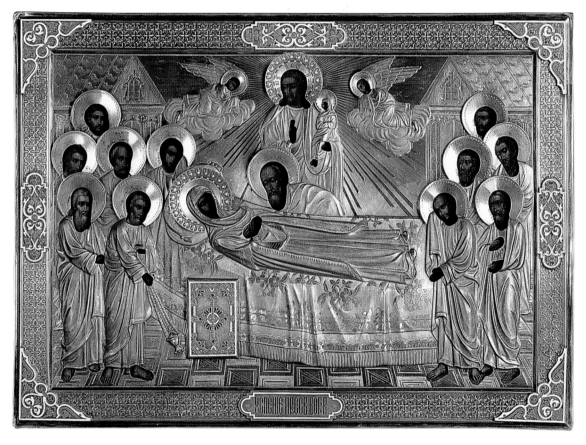

49. SILVER-GILT PLIQUE-À-JOUR
AND CLOISONNÉ ENAMEL
CIGARETTE-CASE decorated on both
sides with a stylized crowned double-headed
eagle in *plique-à-jour* enamel, surrounded by
polychrome scrolling foliage on stippled ground
– signed with Imperial Warrant mark of
Lyubavin, Moscow before 1899, length $3^5$8 in.
(9.2cm).
André Ruzhnikov

50. ICON OF THE DORMITION OF
THE HOLY VIRGIN covered in a parcel-gilt
repoussé and chased oklad, leaving only faces and
hands uncovered, with cloisonné enamel haloes
and plaques applied to the border – initials of
maker Antip Kuzmitchev, assay mark of
Moscow 1887, length $15^3$4 in.
André Ruzhnikov

51. SILVER-GILT AND SHADED
CLOISONNÉ ENAMEL CASKET with
hinged clasp, with polychrome scrolling foliage
in mainly blue, white and red hues on stippled
ground – initials of Ivan Saltikov, assay mark of
Moscow 1899, unrecorded assay master's initials
A.A., length $6^1$2 in. (16.5cm).
André Ruzhnikov

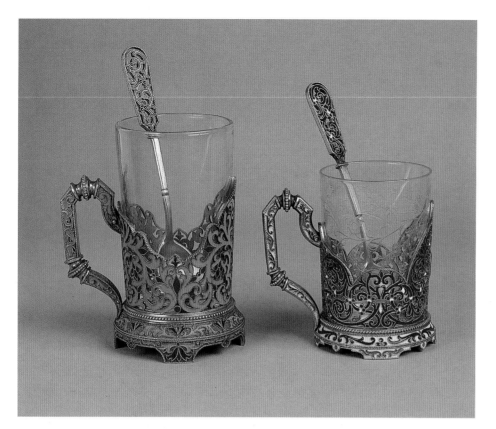

52A, 52B

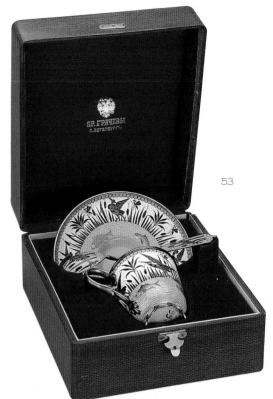

53

54

55

52A. A SILVER GILT AND
CLOISONNÉ ENAMEL TEAGLASS-
HOLDER AND SPOON decorated in
turquoise enamel with scrolling foliage –
stamped Br. Gratchev, assay mark of Moscow
before 1899, height 3¼ in. (8.5cm). Inscribed
under the base: "Henry Hugh Hanna / Anna
Sharpe Hanna / Souvenir of their visit to /
St. Petersburg, Russia, 1903".
André Ruzhnikov

52B. SILVER-GILT AND CLOISONNÉ
ENAMEL TEAGLASS-HOLDER AND
SPOON, with angular handle and scalloped
rim, decorated in dark blue enamel with
scrolling foliage – stamped Br. Gratchev, initials
of workmaster A.P., assay mark of Moscow
before 1899, height 3 in. (7.5cm). Inscribed
under the base: "Henry Hugh Hanna / Anna
Sharpe Hanna / Souvenir of their visit to /
St. Petersburg, Russia, 1903". With original
engraved teaglass.
André Ruzhnikov

53. SILVER-GILT AND PLIQUE-À-
JOUR ENAMEL TEACUP, SAUCER
AND TEASPOON decorated with figures
of birds and water plants – Imperial Warrant
mark of Gratchev, initials of workmaster A. P.,
assay mark of St. Petersburg before 1899, 88
(zolotnik).
Provenance: acquired by the State Hermitage,
1990.
The State Hermitage Museum (ERO – 9989)
LAZ

54. DESIGN IN WATERCOLOR FOR
A DISH AND SALT-CELLAR stamped
"Gratchev Br. Makers of silverware Nevski
pr. No. 34S Petersburg", 26¾×18¾ in.
(68×47.6cm). Inscribed: "650 rub".
In the center is the coat of arms of the city, on
the rim is the date 1902.
LAZ

55. DESIGN FOR GOBLET drawn by
Brodersen, stamped "Gratchev Br. Makers of
silverware Nevski pr. No. 34S Petersburg",
26¾×18⅞ in. (68×48cm). Inscribed: "Highest
approval, Baron Frederiks 24 May 1903"; on
the body of the vase: "Prize of His Imperial
Highness".
Provenance: The Imperial Cabinet;
State Museum of Ethnography, 1941.
The State Hermitage Museum
(ERO sh – 1589, 1590)
LAZ

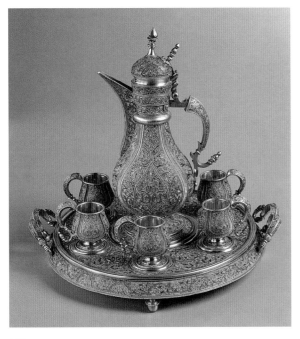

56

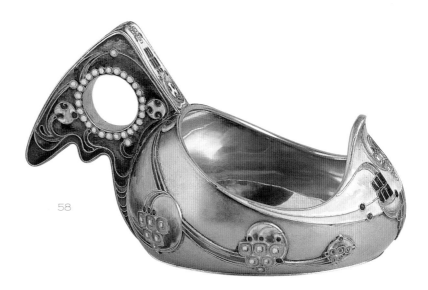

58

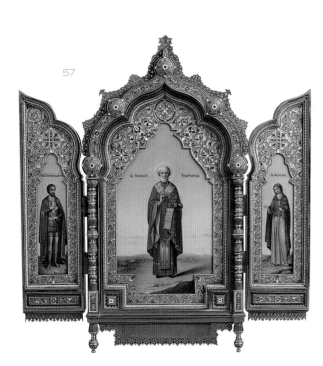

57

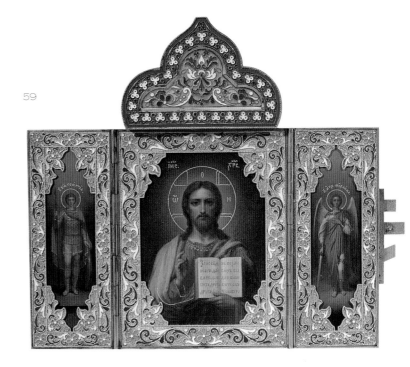

59

57. SILVER-GILT AND CLOISONNÉ ENAMEL TRIPTYCH ICON with arched top and two lateral pillars, standing on two peg feet, painted with St. Nicholas the Miracleworker (center), St. Alexander Nevsky (left) and St. Mary Magdalen (right). The oklad elaborately decorated with scrolling foliage in polychrome enamel. When closed, the doors show decorations of latticework in white, red and blue enamel, applied with four rosettes and two crosses – assay mark of Moscow 1886, height 12½ in. (31.5cm). The reverse with a presentation inscription: "To His Imperial Highness Heir Apparent Nicholas Alexandrovich from the Security Service of the Moscow Bourgeois Society, May 1886". Fitted box stamped Hammer Galleries. The saints represented are the patron saints of Tsarevich Nicholas and of his parents Tsar Alexander III and Tsarina Maria Feodorovna. The original hallmark of the maker has been obliterated. The mount can be attributed to Ivan Khlebnikov.
André Ruzhnikov

56. SILVER-GILT AND CLOISONNÉ ENAMEL COFFEE SERVICE in the Turkish style comprising a coffee pot, six mugs and a tray, each decorated in the old Pan-Slavic style with stylized flowers and scrolling foliage – stamped Gratchev, initials of workmaster A. P., assay mark of St. Petersburg before 1899, diameter of tray 11 in. (28cm). Original fitted box, the lining stamped "Silver Shop No. 8 Gratchev".
André Ruzhnikov

58. SILVER-GILT AND CLOISONNÉ ENAMEL KOVSH with flat bottom and raised, pierced handle, decorated in the neo-Russian style in lime green and red colors – stamped with Imperial Warrant mark of Khlebnikov, assay mark of Moscow 1899–1908, assay master Ivan Lebedkin, 88 (zolotnik), length 6¾ in. (13cm).
Michael and Ella Kofman Collection

59. SILVER-GILT AND SHADED CLOISONNÉ ENAMEL TRAVELING TRIPTYCH ICON with trefoil top, the central panel painted with Christ Pantocrator, the wings with St. George (left) and St. Michael (right), the interior frame decorated with stylized foliage on stippled ground, the exterior with a panel of turquoise cloisonné enamel, a Russian Orthodox cross acting as clasp, within cloisonné enamel borders – initials of Ivan Khlebnikov, assay mark of Moscow 1899–1908, assay master Yakov Lyapunov, height 7⅛ in. (18cm).
André Ruzhnikov

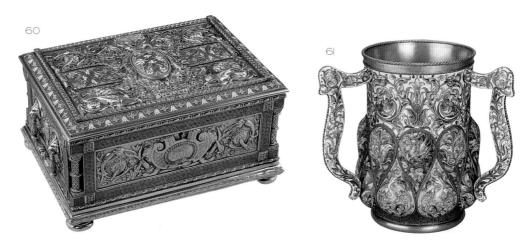

60

61

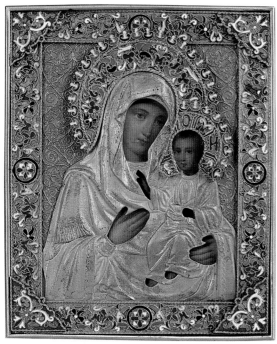

62

63

60. SILVER-GILT AND CLOISONNÉ ENAMEL CASKET with swing handles and stud feet, with cover and sides with panels of scrolling foliage, the cover also decorated with a simulated ribbon and an oval plaque in blue and white enamel, the sides with columns at the corners framed in blue enamel – stamped with the Imperial Warrant mark of Pavel Ovchinnikov, assay mark of Moscow 1887, assay master Victor Savinkov, length 10³⁄₄ in. (27.5cm).
André Ruzhnikov

61. SILVER-GILT AND SHADED CLOISONNÉ ENAMEL LOVING-CUP with three handles, decorated with pastel-colored foliage on cream ground, the lower body with two rows of tear-shaped bosses depicting swans and exotic birds – signed with Imperial Warrant mark of P. Ovchinnikov, assay mark of Moscow 1899–1908, initials of assay master Ivan Lebedkin, 84 (zolotnik), height 7⁷⁄₈ in. (20cm). Provenance: acquired by the State Hermitage, 1958.
Bibliography: Berniakovich, 1977, No. 182; Russian Enamel, 1987, No. 131.
Exhibited: Cologne 1981, cat. 91; Lugano 1986, cat. 126.
At the turn of the century, workmasters were looking for new forms, creatively reworking the inheritance of previous generations. The shape of this vase is the result of this type of search. The style of its decoration was derived from motifs of Pushkin's "Tales of King Saltan"
The State Hermitage Museum (ERO – 8873)
LAZ

62. ICON OF THE VIRGIN HODIGITRIA WITH THE CHRIST CHILD, both clad in *repoussé* and chased parcel-gilt robes, in an elaborate silver-gilt and *cloisonné* enamel oklad, the central turquoise enamel panel decorated with gilt scrolls, the haloes and frame with polychrome scrolling foliage – initials of Feodor Ovchinnikov, assay mark of Moscow 1883, Cyrillic initials of assay master V. P., height 5¹⁄₄ in. (13.5cm).
André Ruzhnikov

63. RECTANGULAR SILVER AND CLOISONNÉ ENAMEL COMMEMORATIVE PLAQUE engraved with the cruiser Rurik, with a *champlevé* enamel inscription beneath, the outer frame with squares at the corners decorated with polychrome foliage in the traditional Pan-Slavic manner – stamped with the Imperial Warrant mark of Pavel Ovchinnikov, assay mark of Moscow 1890, length 6.5 in. (16.5cm). The inscription reads: "The 20-gun armored cruiser, whose building by the Baltic Shipyard in St. Petersburg was begun on 12 May 1890, in presence of Their Imperial Majesties the Emperor and Empress, Her Majesty the Queen of Greece and His Highness General Admiral Alexei Alexandrovich." Original fitted case.
André Ruzhnikov

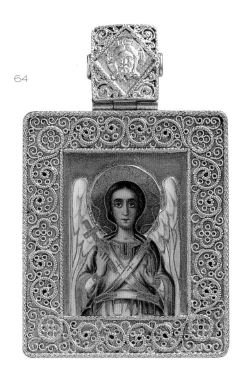

64

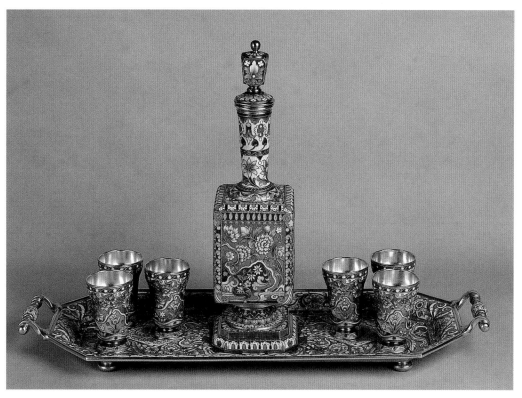

65

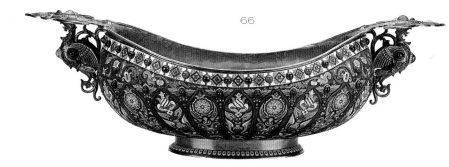

66

67

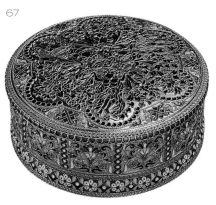

64. ENAMELED SILVER-GILT
MINIATURE ICON OF THE GUARDIAN
ANGEL, depicted frontally in blue robes, with
white wings and green halo on gold ground,
the outer frame with filigree scrolls, the reverse
with blue *champlevé* enamel inscription: "My
Keeper, God's Angel Guardian, my Keeper, save
me and protect me from all Evil", the hinged
upper part chased with the Vera Icon – signed
with Cyrillic initials P. O. for Pavel
Ovchinnikov, assay mark of Moscow
1899–1908, assay master Ivan Lebedkin, height
3 in. (7.6cm).
André Ruzhnikov

65. ENAMELED SILVER-GILT
VODKA-SET comprising a square-bodied
vodka bottle, six tapering cylindrical beakers
and an octagonal tray with scroll handles and
stud feet, all painted with pastel colored flowers
of shaded *cloisonné* enamel – signed in Cyrillic
P. Ovchinnikov, with separate Imperial Warrant
mark, assay mark of Moscow, assay master's
initials I. A., 84 (zolotnik), height of bottle
11 in. (28cm), length of tray 18 in. (46cm).
André Ruzhnikov

66. LARGE OVAL TWO-HANDLED
SILVER-GILT AND SHADED
CLOISONNÉ ENAMEL PUNCH
BOWL on low silver-gilt feet, the sides
decorated with polychrome stylized flowers
within ogee panels on gilt ground, the border
with blue rosettes on white ground, the flat
enamel handles supported by Sirin birds,
profusely set with cabochon chrysoprases,
garnets and agates, the handles with cabochon
amethysts – signed with Imperial Warrant mark
of Pavel Ovchinnikov, assay mark of Moscow
before 1899, length 29¼ in. (74.3cm).
Private Collection

67. A CIRCULAR PLIQUE-À-JOUR
AND CLOISONNÉ ENAMEL SILVER-
GILT BOX, the cover decorated in *plique-à-
jour* enamel with three nymphs with upraised
arms centering on a butterfly and surrounded
by flowers and ribbons, the sides with stylized
flowers divided by turquoise *entrelac* bands in
cloisonné enamel – signed P. Ovchinnikov, assay
mark of Moscow 1899–1908, assay master Ivan
Lebedkin, diameter 5 in. (12.7cm).
André Ruzhnikov

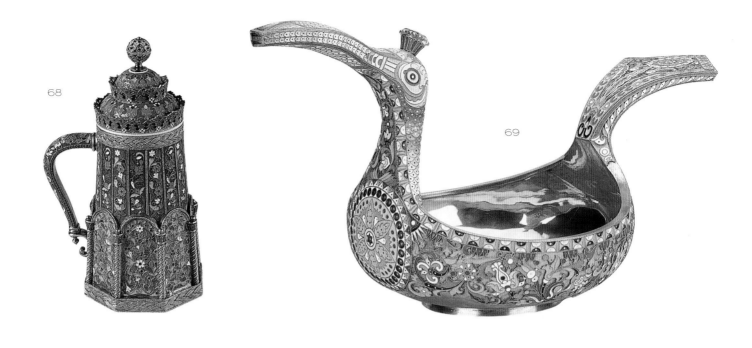

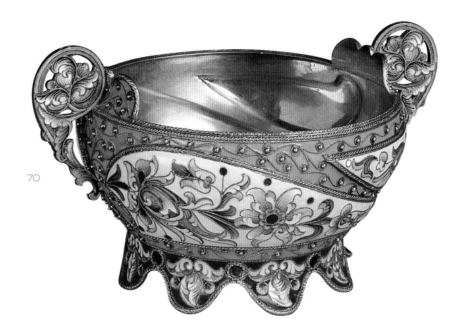

68. SILVER-GILT PLIQUE-À-JOUR
AND CLOISONNÉ ENAMEL
TANKARD of architectural design, the
octagonal lower section formed of arcades with
spiraling columns and arched tops enclosing
panels of traditional Old-Russian polychrome
enamel on stippled ground; the base with a
plique-à-jour rendering of a combat between an
eagle and a dragon; the cylindrical upper part
with bands of similar foliage on green and blue
ground; the double crown-shaped cover with
ball-shaped openwork finial – Imperial Warrant
mark of Pavel Ovchinnikov, assay mark of
Moscow 1899–1908, unrecorded assay master
A.A., height 8¼ in. (21cm).
Provenance: Marvin Greenfield Collection.
This tankard is one of a series inspired by a
Turkish 17th century tankard in the Kremlin
Armory illustrated in Feodor Solntsev's
"Antiquities" published in the 1850s (see
Baltimore, 1998, p. 294).
Private Collection

69. DUCK-SHAPED SILVER-GILT
AND CLOISONNÉ KOVSH decorated
with stylized flowers in shades of blue, green
and white, the front with a large rosette, gilt
interior, the base engraved with signature and
Petrograd 27 VII 1917 – signed with Imperial
Warrant mark of Pavel Ovchinnikov, assay mark
of Moscow 1899–1908, length 19½ in.
(49.5cm).
Private Collection

70. SILVER-GILT AND SHADED
CLOISONNÉ ENAMEL BOWL with
scroll handles and scalloped feet, decorated with
gilt scrolls on turquoise ground and with
swirling panels with shaded foliage on cream
ground – initials of Nikolai Agafanov, assay
mark of Moscow 1899–1908, assay master Ivan
Lebedkin, diameter 4 in. (10.5cm).
André Ruzhnikov

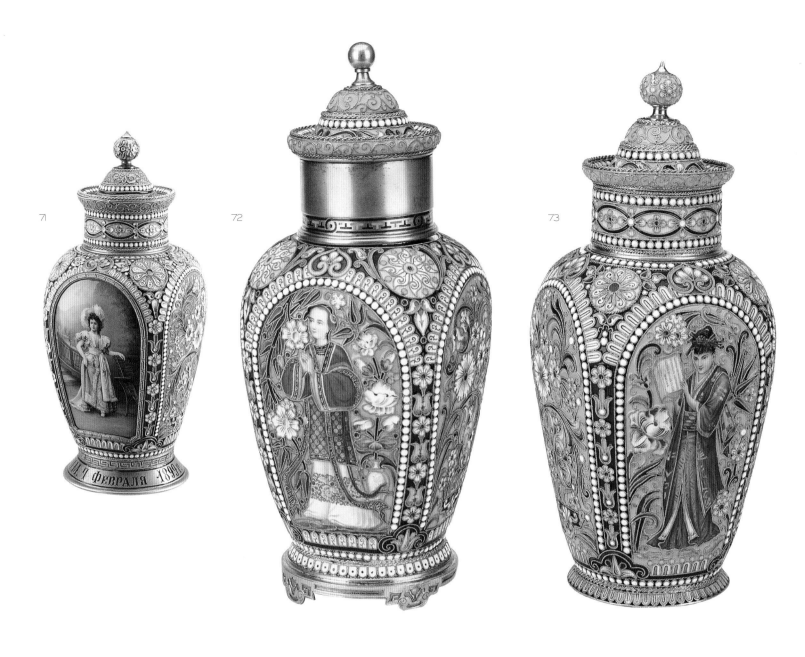

71 72 73

71. HEXAGONAL SILVER-GILT AND
CLOISONNÉ ENAMEL TEACADDY
decorated with polychrome enamel foliage,
one side with a crowned monogram MP and
the reverse with a portrait of a lady – signed
O. Kurlyukov, assay mark of Moscow,
84 (zolotnik), height 8½ in. (21.6cm).
Provenance: State Depository of Valuables, 1951
Bibliography: Russian Enamel, 1987, no. 127;
Berniakovich, 1977, no. 184.
The State Hermitage Museum (ERO – 7724)
LAZ

72. BALUSTER-SHAPED SILVER-
GILT AND SHADED CLOISONNÉ
ENAMEL TEACADDY on bracket feet
decorated with a panel of a Chinese lady in
long robes surrounded by peonies, the other
three panels with flower bouquets, silver-gilt
cylindrical neck and domed enameled cover
with ball finial – signed O. Kurlyukov, assay
mark of Moscow before 1899, height 8½ in.
(21.6cm).
Private Collection

73. BALUSTER-SHAPED SILVER-
GILT AND SHADED CLOISONNÉ
ENAMEL TEACADDY on circular base, the
sides decorated with a panel of a Chinese lady
holding a book surrounded by peonies and
further panels decorated with flowers and with
white pellet borders, the enamelled neck with
domed cover and enamelled ball finial – signed
O. Kurlyukov, assay mark of Moscow before
1899, height 8 in. (20.3cm).
Private Collection

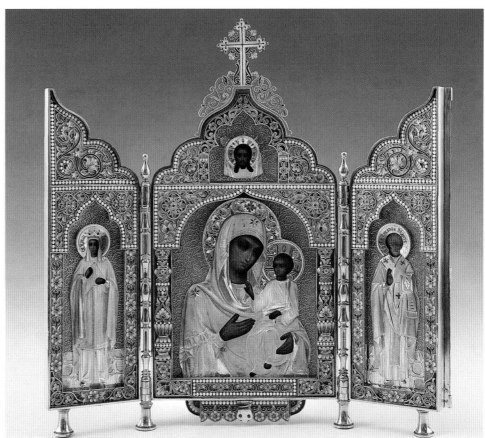

74

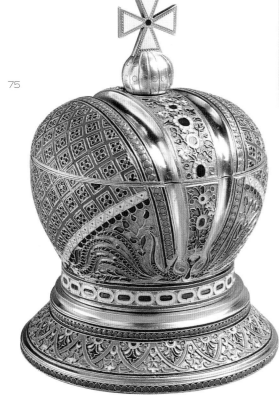

75

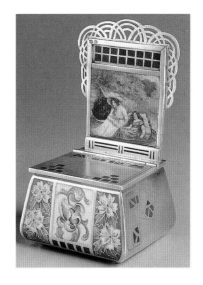

76

74. SILVER-GILT AND CLOISONNÉ
ENAMEL TRIPTYCH ICON with arched
top surmounted by a cross, standing on four
peg feet, painted with the Holy Virgin of
Iversk, flanked by St. Alexandra (left) and St.
Nicholas the Miracleworker (right) and the Vera
Icon (above), the figures clad in parcel-gilt
repoussé and chased robes shown against a
turquoise background, in an oklad elaborately
decorated in shaded enamel floral pattrens on
light blue ground – stamped O. Kurljukov,
initials of workmaster E. A., robes stamped with
Cyrillic initials IT, assay mark of Moscow
before 1899, height 12 in. (30cm).
André Ruzhnikov

75. ENAMELED SILVER, HINGED BOX
shaped as a crown decorated with cloisonné
pale-blue enamel trelliswork enclosing dark-blue
rosettes, with green foliage and with blue, white
and red flowers – signed with initials AIK for
Antip Ivanovich Kuzmichev, assay mark of
Moscow 1887, assay master Victor Savinkov,
height 4¼ in. (10.8cm).
André Ruzhnikov

76. ART NOUVEAU THRONE-
SHAPED ENAMELED SILVER SALT
BOX, its back painted en plein with a lady and
a girl in a boat, with a staircase and garden
behind, the front with stylized shaded cloisonné
enamel flowers on green and cream ground –
signed O. Kurlyukov, assay mark of Moscow
1899–1908, assay master Ivan Lebedkin, 84
(zolotnik), height 5½ in. (14cm).
André Ruzhnikov

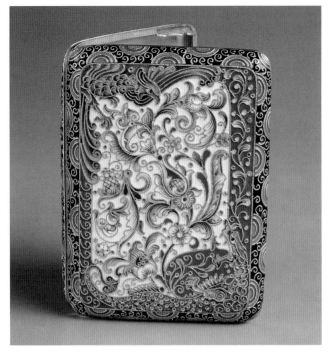

77

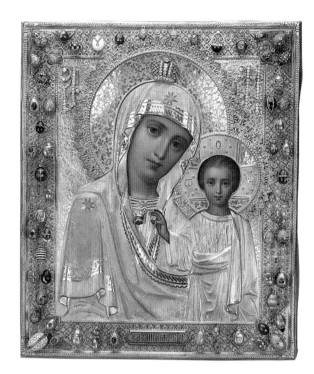

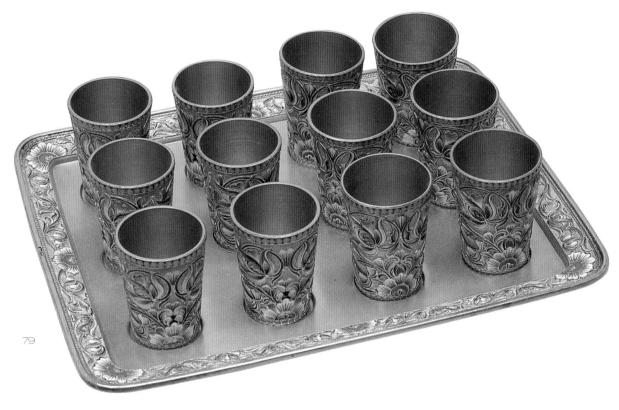

79

77. SILVER-GILT AND SHADED
CLOISONNÉ ENAMEL CIGARETTE-
CASE, the cover and base each decorated with
an eagle and a serpent and with a shaped
reserve of cream-colored enamel painted with
shaded scrolling flowers, with black and olive-
green enamel borders decorated with foliage or
stylized geometric motifs – signed with initials
of workmaster Feodor Rückert, retailed by
O. F. Kurlyukov, assay mark of Moscow 1899–
1908, assay master Ivan Lebedkin, length 3³⁄₄ in.
(9.5cm). Inscribed: "Spasibo" (thank you).
Original presentation case stamped with
Imperial Warrant of Kurlyukov, Moscow.
André Ruzhnikov

78. ICON OF THE HOLY MOTHER OF
KAZAN in a gem-set and enameled silver-gilt
oklad suspending numerous jeweled gold
miniature Easter Eggs – Imperial Warrant mark
of P. Ovchinnikov, assay mark of Moscow
1887, assay master Viktor Savinkov, 84
(zolotnik), height 12³⁄₈ in. (31.5cm); the eggs are
mostly from the Fabergé workshops.
Provenance: Museum Reserve; State Museum
of Ethnography, 1941

The icon is an interesting example of the
joint work of two leading jewelry firms –
P. Ovchinnikov and K. Fabergé. These suppliers
to the Court of the Emperor made various
objects to keep "in reserve" in case of the
Court's need. Among them were signet-rings,
clocks, brooches with the Imperial insignia and
framed icons.
The State Hermitage Museum (ERO – 6501)
LAZ

79. TWELVE SILVER-GILT AND
SHADED CLOISONNÉ ENAMEL
BEAKERS AND TRAY decorated with
pastel colored foliage on gilt stippled ground –
initials of Maria Semyonova, assay mark of
Moscow 1899–1908 assay master Ivan
Lebedkin, length of tray 9 in. (23cm).
André Ruzhnikov

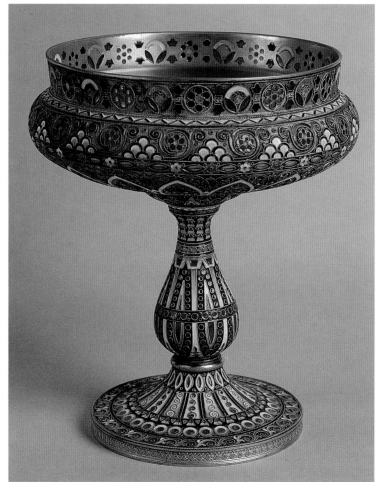

80. SILVER-GILT AND SHADED
CLOISONNÉ ENAMEL SET OF
CUTLERY comprising knife, fork and spoon,
each decorated with a stylized double-headed
eagle in pink and white hues on lime green
grounds with turquoise pellet borders – initials
of Maria Semyonova, assay mark of Moscow
1899–1908, assay master Yakov Lyapunov,
length of knife 10 in. (25cm).
André Ruzhnikov

81. OVAL ENAMELED SILVER-GILT
BOX, the cover with a panel of olive-green
guilloché enamel, the sides with pink and blue
reserves painted with shaded cloisonné enamel
foliage – signed with Cyrillic initials MS for
Maria Semyonova, assay mark of Moscow
1908–1917, length $2^5\!/_8$ in. (6.7cm).
André Ruzhnikov

82. SILVER-GILT, CLOISONNÉ AND
PLIQUE-À-JOUR ENAMEL FOOTED
VASE enameled with pale green, pink and
white geometric motifs – signed 11th Moscow
Artel, Moscow 1908–1917, height $7^1\!/_4$ in.
(18cm).
André Ruzhnikov

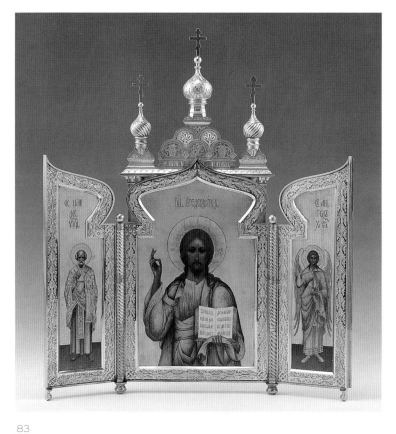

83

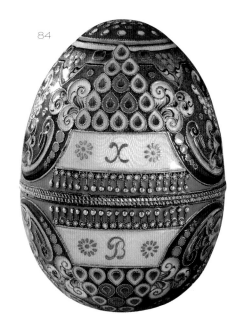

84

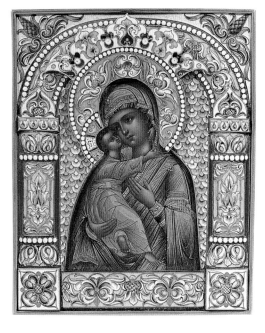

85

86

83. SILVER-MOUNTED TRIPTYCH
ICON surmounted by three onion-shaped
domes with Russian Orthodox crosses, the
center painted with Christ Pantocreator, the
wings with St. Nicholas the Miracleworker
(left) and the Guardian Angel (right) both on
gold ground, the borders chased with a floral
design – initials of Dmitri Smirnov, assay mark
of Moscow 1908-1917, height 19^{1}⁄$_{4}$ in. (49cm).
The reverse inscribed: "To His Imperial Majesty
Emperor Nicholas Alexandrovich – In Memory
of His Unforgettable Visit of the Don and
Novocherkassk / In the tumultuous year /
Dedicated to the Last Drop of Blood / Clergy
of the Don, December 4, 1914".
André Ruzhnikov

84. SILVER-GILT AND SHADED
CLOISONNÉ AND GUILLOCHÉ
ENAMEL EASTER EGG decorated with
bands of green and blue enamel and with
scrolling foliage and geometric motifs in the
neo-Russian style, with pink *guilloché* enamel
panels gilt with X and B for "Christos
Voskrese" (Christ is Risen) – 11th Artel, assay
mark of Moscow 1908–1917, 84 (zolotnik),
height 2^{13}⁄$_{16}$ in. (7.2cm).
Bibliography: Kostbare Ostereier 1998, cat. 528,
pp. 162/3, 296.
Adulf P. Goop Collection

85. ICON OF THE VIRGIN OF
VLADIMIR painted in Palekh style, in a silver-
gilt and shaded cloisonné enamel oklad
decorated with geometric motifs and stylized
foliage on pale blue and cream grounds –
Cyrillic initials of maker SB, assay mark of
Moscow 1899-1908, assay master Ivan
Lebedkin, height 5^{3}⁄$_{8}$ in. (13.5cm).
André Ruzhnikov

86. JEWELED SILVER-GILT AND
CLOISONNÉ ENAMEL SET OF
GOSPELS IN THEIR CASE comprising
four books, each with a silver-gilt and blue
filigree enamel cover embellished with white
enamel scrolls and rosettes, in a fitted case *en
suite* set with cabochon opals – stamped with
Cyrillic initials I. C. U. for Imperial Stroganov
School, assay mark of Moscow 1908–1917,
88 (zolotnik), length of case 2^{13}⁄$_{16}$ in.
Provenance: Imperial Collections; transferred to
the Kremlin Armory 1923.
Exhibited: Moscow 1992, cat. 35, ill. p. 105;
Sydney 1996, cat. 47, ill. p. 84.
Kremlin Armory Museum (KN – 178/1-5)

FEODOR IVANOVICH RÜCKERT

Numerous scholarly pages have been dedicated to the work of the famous Moscow craftsman Feodor Rückert, who worked with Carl Fabergé from 1887; of the man himself, however, hardly anything has been written. For a long time, Feodor Ivanovich's biography was something of a blank book – indeed, experts were not even sure of his date of birth. Very recently, however, it has come to light that Moscow is home to a number of Rückert's descendants, who have faithfully preserved records of their family. For many years they preferred to keep silent about their ancestor, because the family's German origins were the cause of various hardships during the First and Second World Wars. We were fortunate to meet two of Feodor Ivanovich's grandchildren, Evgenia Mikhailovna Rudnyanskaya and Zinaida Mikhailovna Shutovaya, who were kind enough to provide photographs and talk to us about their famous grandfather.

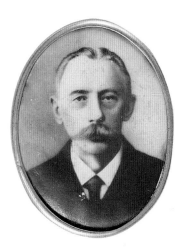

Friedrich Mauritz Rückert was born in Alsace-Lorraine in 1840, and was brought over to Russia as a fourteen-year-old by either the Yusupov or the Golitsyn family. It was while working for his new masters that Feodor met his future bride, a German seamstress called Emilie, who was born in Koenigsburg. The couple's eldest child was Adele (1870?–1938); then came Ida (1873?–1958) and Pavel (1883–1926). These children were christened Lutherans, while their brothers Feodor (1888–1942), Anatoly (1892–?) and Alexander (1895–?) were christened Orthodox, a fact which suggests that their mother was Orthodox.

After the death of his first wife, Feodor Ivanovich married Evgenia Kalistratovna Belovaya, who was related to the Smolenshchins who were daughters of the glass-blower who worked at the factory in Bolshaya Vishera. It seems likely that Feodor, Alexander and Anatoly were born to this second marriage. Rückert's second wife also bore him a son Evgeny and daughters Maria (1896?–?) and Sophia. The family still has a photograph of the married couple taken at the dacha that they rented in Rastorguevo in the summer of 1899. At the time Evgenia Kalistratovna was pregnant, and on 29 August of that year she gave birth to a daughter. This was Sophia, whose daughter Evgenia Mikhailovna Rudnyanskaya provided us with much of our information. The family was a large one, and Evgenia Kalistratovna invited her niece Maria Vasilievna Belova to come from Vishera to help her in Moscow. Evgenia Kalistratovna died in 1902, and Feodor Ivanovich asked Maria to stay with the family, since she had helped raise the children, and they were all familiar with her. Maria Vasilievna replied, however, that she would only stay in the house as its mistress and as wife of Feodor Ivanovich. At the time he was sixty-four and she was twenty-three.

The elder children were categorically opposed to the match, particularly Ida, who was several years older than her stepmother. But the marriage took place, and the Rückerts continued to live in their large house at 23/3 Vorontsovskaya Street. Feodor Ivanovich was remembered in the family as a kind and loving father and grandfather. He referred to women affectionately as "little stinkers" (Feodor Ivanovich spoke Russian with an accent). He liked to warm his back by leaning up against the large stove in the sitting-room, and the younger children and older grandchildren would run up and stand in a row along the stove with the patriarch of the family.

Feodor Ivanovich's daughters were given a good education. Adele Feodorovna, the eldest, spent many years working as a midwife in Moscow's famous Grauerman Maternity Hospital, and later worked as a governess in the family of the famous Dr Shershnyevsky-Lyuboshits. Ida taught German, performed amateur dramatics and was also an accomplished pianist. Sophia graduated from the Higher College of Trade and was also an expert enameler. All five of the sons worked in their father's workshop which, according to

FIG 1. FEODOR IVANOVICH RUCKERT

FIG 2. FEODOR IVANOVICH RUCKERT WITH HIS WIFE Evgenìa Kalistratovna at their dacha in Rastorgueva. Summer 1899.

FIG 3. FEODOR RUCKERT'S THIRD WIFE, MARIA VASILIEVNA and her children: Sophia Feodorovna and Anotoly Feodorovich in their apartment in Rückert's house on Vorontsovskaya Street.

their descendants, also employed young apprentices who lived not far off. According to Valentin Skurlov, two of the sons (and certainly Pavel) studied in the Imperial Stroganov School, but spent only a year there, since presumably it was difficult to combine their studies with work in the family business.

The family is still in possession of some ceramic models from the Stroganov School and a watercolor sketch of remarkable beauty – in all likelihood the lid of a blotting-pad. On one side is a portrait of a Sirin bird, a popular character in Russian folklore and a favorite subject of artists of the neo-Russian style. On the horizon is a formal view of the Moscow Kremlin with its many cupolas, taken from the side of the Moscow River. The same view was engraved on an enamel plate fired in the furnaces of the enamel workshop, a fragment of which is portrayed on the left side of the composition. This small work provides a unique record of the special qualities of the workshop, famous for its wonderful enamel artwork and for portraying the beauty and charm of ancient Russia. Feodor Ivanovich's granddaughters confirm that gold ornaments were also produced in the workshops. They recall that for a long time their family possessed a horseshoe brooch and a brooch in the form of an anchor and cross, both the work of their grandfather. They also recall that a local priest commissioned an enamel and pearl brooch from Rückert for his daughter-in-law Vera. The workshops were situated on the first floor of the house on Vorontsokvskaya Street.

Feodor's son Evgeny had the least involvement in the family business. He was a pianist, and used to perform alongside his sister Ida in the amateur theater attached to the gold thread factory. The theatre was set up by the famous K. Stanislavsky, who was a friend of Evgeny's, and often visited the Rückerts' house on Vorontsovskaya Street. Evgeny was also friends with the famous poet Vladimir Mayakovsky, who lived nearby, as well as Nikolai Bulganin, who was to become a leading figure in the Soviet era. All of them were guests at the hospitable Rückert home.

During the First World War only Evgeny remained in Moscow to look after the family house. In the summer of 1915 all the other members of the family were sent to Ufa and other provincial towns in Russia, from where they returned in 1916. The archives contain applications for Russian citizenship from some members of the family. Feodor Ivanovich died in 1917, and was buried in the Vvedensky Cemetery. During the Soviet period some members of the family continued to pursue their traditional trade. Thus, according to Evgenia Mikhailovna, Feodor and Sophia produced enamel badges for the Ossoviakhim workshops. Gradually, however, the family ceased to be involved in the craft, and the house with the workshop had to be abandoned. Thereafter, none of Rückert's descendants was involved in jewelry-making.

During the Second World War the Rückerts were again subject to persecution. It is known, for example, that Ida was exiled to Karaganda, while the wife of Anatoly Rückert was sacked from her job in the passport office because of her German surname. Such is the irony of fate: a name which had once brought glory to the jeweler's art in Russia became an unwelcome embarrassment in Soviet Russia. Rückert's descendants, who by now had Russian surnames, did their best to keep their origins quiet. Several of them, however, now reside in Moscow: his granddaughters Zinaida and Evgenia Mikhailovna (daughters of Sophia Feodorovna), his grandson Valentin Pavlovich (son of Pavel Feodorovich), his granddaughter Tatyana Feodorovna (daughter of Feodor Feodorovich), his grandson Evgeny Anatolyevich (son of Anatoly Feodorovich), as well as their children and grandchildren. They, together with experts in the field, are now trying to resurrect the memory of the family and the activities of the famous jeweler.

Tatiana N. Muntyan

FIG 4. STUDY FROM FEODOR RUCKERT'S STUDIO

FIG 5. FEODOR IVANOVICH RUCKERT'S SON Evgene Feodorovich Ruckert

FIG 6. FEODOR RUCKERT'S DAUGHTERS Sophia Ivanovna and Maria Ivanovna

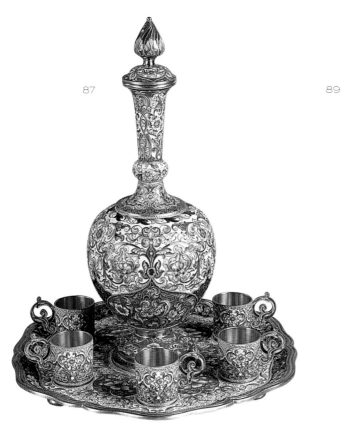

87

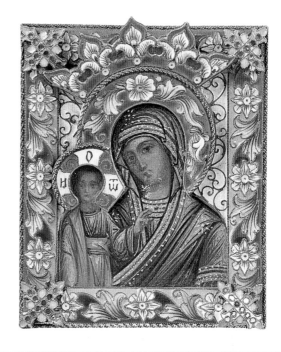

89

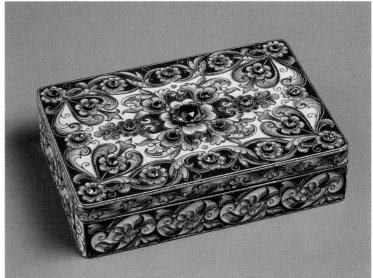

90

88

87. SILVER-GILT, SHADED
CLOISONNÉ AND PLIQUE-À-JOUR
ENAMEL VODKA SET comprising a
baluster-shaped carafe with domed cover, six
cylindrical cups with scroll handles and a
shaped circular tray on four stud feet; all
decorated with shaded scrolling flowers sprays
on cream, olive green, blue and red grounds;
the bases of the cups with similar plique-à-jour
enamel decoration – signed with Cyrillic
initials FR for Feodor Rückert, assay mark
of Moscow 1899–1908, height of flask 12 in.
(30.5cm), diameter of tray 10⅝ in. (27cm).
Provenance: Marvin Greenfield Collection.
Private Collection

88. SILVER-GILT AND SHADED
CLOISONNE ENAMEL EASTER EGG
painted *en plein* with a putto upholding a rose
garland, flanked by billing doves on pink
ground, the remainder with scrolling foliage
in pink, blue, orange and green pastel hues on
cream ground – signed O. Kurlyukov, initials
of workmaster Feodor Rückert, assay mark of
Moscow 1899–1908, 88 (zolotnik), height
3½ in. (8.9cm).
Bibliography: Kostbare Ostereier 1998, cat. 518,
pp. 156/7, 292.
When working for Kurlyukov, Rückert's style
and palette were very different from when he
worked for Fabergé.
Adulf P. Goop Collection

89. ICON OF THE VIRGIN OF KAZAN
with silver-gilt and shaded *cloisonné* enamel
oklad decorated with flowers on brick-red and
pale blue grounds – signed with Cyrillic initials
FR for Feodor Rückert, assay mark of Moscow
1899–1908, assay master Ivan Lebedkin, height
2¹³⁄₁₆ in. (7.1cm).
Michael and Ella Kofman Collection

90. RECTANGULAR GEM-SET
SILVER-GILT AND SHADED
CLOISONNÉ ENAMEL BOX each side
decorated with shaped panels with cream-
colored grounds painted with flowers and
scrolls in pastel hues, with pale blue "spades"
at each corner, with blue dark enamel borders
and seventeen pink rosettes set with façeted
citrines, amethysts and garnets – signed with
the initials of Feodor Rückert, assay mark of
Moscow 1899–1908, assay master Ivan
Lebedkin, length 3¾ in. (9.5cm).
André Ruzhnikov

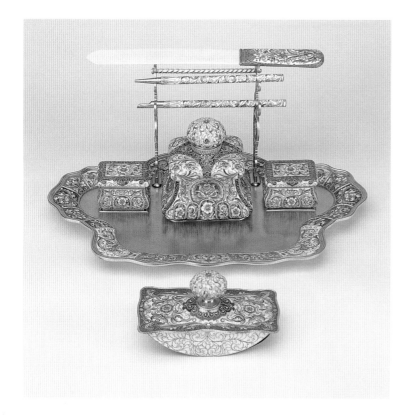

91

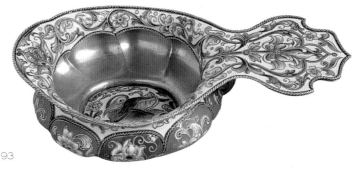

93

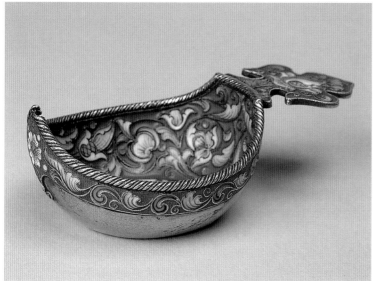

92

94

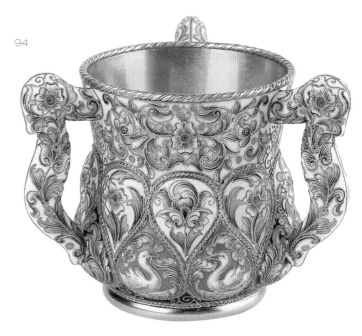

91. SILVER-GILT AND SHADED
CLOISONNÉ ENAMEL DESK SET
comprising inkwell, stamp-box and stamp
moistener on shaped tray, a blotter, a letter rack,
a pen and pencil and a paper-knife
decorated in hues of pale blue and green with
flowers and scrolling foliage on white ground,
the letter rack with a locked door surrounded
by a wooden frame and flanked with polychrome
columns decorated with flowers – initials of
workmaster Feodor Rückert, assay mark of
Moscow 1899–1908, length of tray 13¼ in.
(33.2cm), height of letter rack 6¼ in.
(15.9cm).
Private Collection

92. SILVER-GILT AND SHADED
CLOISONNÉ ENAMEL KOVSH OF
SHALLOW OVAL SHAPE with fleur-de-
lis handle, the center with stylized red double-
headed eagle on white ground, the sides with
shaded scrolling foliage on dark blue ground
and with corded rim – signed with initials of
Feodor Rückert, assay mark of Moscow
1899–1908, inventory no. 11609, length 3½ in. (9cm).
Exhibited: Sydney 1996, cat. 148, ill. p. 142.
Kremlin Armory Museum (MR 891)

93. SILVER-GILT AND SHADED
CLOISONNÉ KOVSH with fleur-de-lis
handle, the handle, interior and the outer rim
with shaded scrolling foliage on cream ground,
the bosses decorating the body with foliage on
brick-red and blue ground – initials of Feodor
Rückert, Imperial Warrant mark of retailer
Pavel Ovchinnikov, assay mark of Moscow
1899–1908, assay master Ivan Lebedkin, length
6½ in. (16.5cm).
The kovsh is an interesting example of
Rückert working for a firm other than Fabergé
using a more traditional palette.
André Ruzhnikov

94. SILVER-GILT AND SHADED
CLOISONNÉ ENAMEL LOVING-CUP
with three handles, decorated with pastel-
colored foliage on cream ground, the lower
body with two rows of tear-shaped bosses
depicting swans and exotic birds – signed with
Imperial Warrant mark of P. Ovchinnikov, assay
mark of Moscow 1899–1908, initials of assay
master Ivan Lebedkin, 84 (zolotnik), height
7⅞ in. (20cm).
Provenance: acquired by the State Hermitage,
1958.
Bibliography: Berniakovich, 1977, No. 182;
Russian Enamel, 1987, No. 131.
Exhibited: Cologne 1981, cat. 91; Lugano
1986, cat. 126.
The State Hermitage Museum (ERO–8873)
LAZ

95

96

97

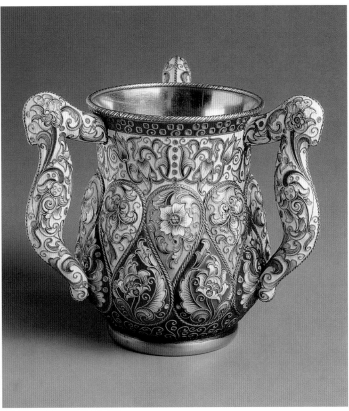

98

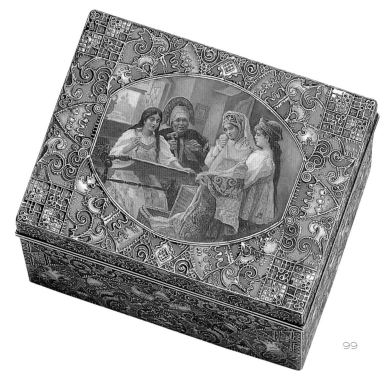

99

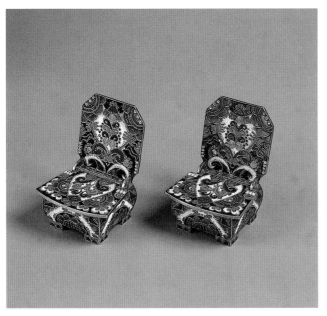

100

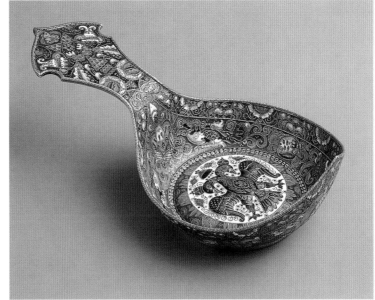

101

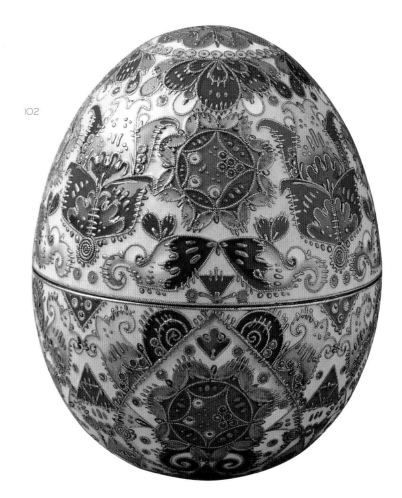

102

100. PAIR OF SILVER-GILT AND
CLOISONNÉ ENAMEL SALT BOXES
SHAPED AS CHAIR, overall decorated in
enamels and with filigree scrolls with stylized
flowers and geometric motifs on cream reserves
and in shades of pale and dark blue, brown and
black – signed with Cyrillic initials FR for
Feodor Rückert, assay mark of Moscow
1908–1917, height 3³⁄₈ in. (8.5cm).
Provenance: Marvin Greenfield Collection.
Private Collection

101. SILVER-GILT AND SHADED
CLOISONNÉ ENAMEL KOVSH styled
in the 17th century manner, of flat shape with
fleur-de-lis handle, the central boss with
a stylized double-headed eagle, a Monomakh
crown above, on cream ground, decorated on
all sides with stylized foliage and geometric
motifs – signed with initials of Feodor Rückert,
assay mark of Moscow 1908–1917, length
10³⁄₄ in. (27.2cm).
The decoration of this kovsh, with its
renaissance of designs harking back to the early
17th century, indicates a connection with the
Romanov Tercentenary festivities of 1913,
when double-headed eagles and the
Monomakh crown were frequently employed.
André Ruzhnikov

102. SILVER-GILT AND SHADED
CLOISONNÉ ENAMEL EASTER EGG
decorated with pink rosettes and blue stylized
and geometric motifs on cream-colored ground
– signed with initials of Feodor Rückert, assay
mark of Moscow 1908–1917, height 3¹⁄₂ in.
(9cm).
André Ruzhnikov

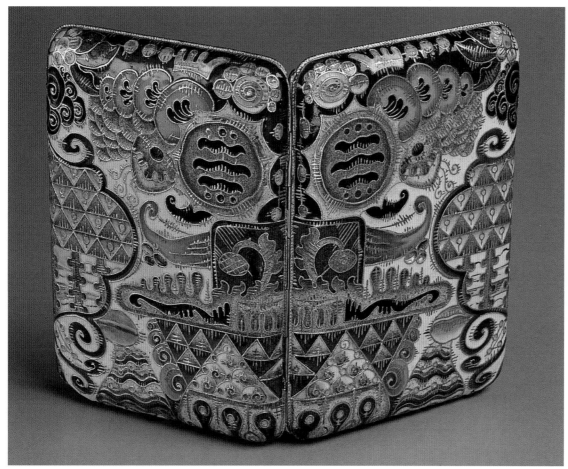

103

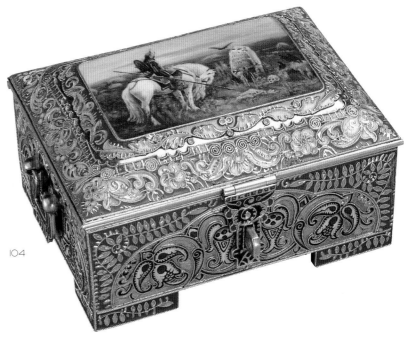

104

103. SILVER-GILT AND SHADED
CLOISONNÉ ENAMEL CIGARETTE-
CASE decorated in the neo-Russian style
with Arts and Crafts motifs on pale yellow
ground – initials of Feodor Rückert, assay mark
of Moscow 1908–1917, length 4¹5 in. (10.5cm).
A good example of the influence of the
Abramtsevo and Talashkino workshops on
Fabergé's workmaster.
André Ruzhnikov

104. SILVER-GILT AND SHADED
CLOISONNÉ ENAMEL CASKET with
domed cover, swing handles and bracket feet,
the cover inset with an en plein enamel
painting of Viktor Vasnetsov's painting "Warrior
at the Crossroads" (Tretyakov Gallery), the
cover and sides decorated with stylized flowers
and foliage on stippled gold ground – signed
with initials of Feodor Rückert, assay mark of
Moscow 1908–1917, length 3³4 in. (9.5cm).
André Ruzhnikov

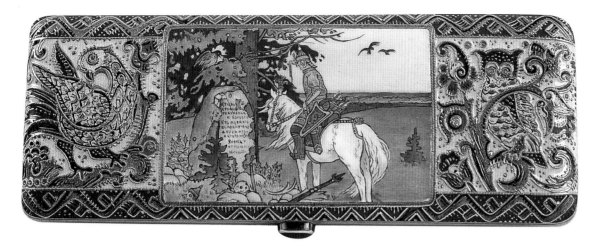

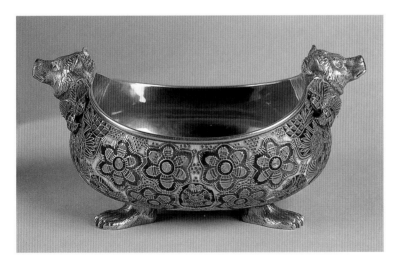

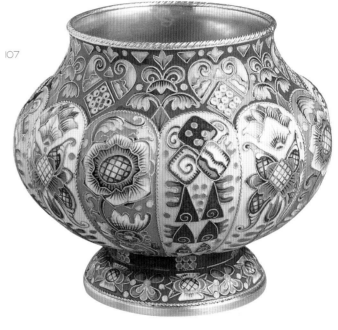

105. OBLONG SILVER-GILT AND CLOISONNÉ ENAMEL BOX the cover painted en plein with "The Warrior at the Crossroads" after I. Bilibin flanked by a stylized dove and owl on cream ground, the reverse with two fantastic birds – attributed to Feodor Rückert, assay mark of Moscow 1908–1917, length 5 in. (12.7cm). Original fitted case stamped with Imperial Warrant of V. A. Bolin, Moscow.
The firm of Bolin here acts as a retailer for a box evidently by Rückert.
André Ruzhnikov

106. OVAL SILVER-GILT AND CLOISONNÉ ENAMEL BOWL with bear-head handles and four paw feet, the body decorated with large rosettes on pink ground – signed with Cyrillic initials FR for Feodor Rückert, assay mark of Moscow 1908–1917, length 8 in. (20.2cm).
André Ruzhnikov

107. SILVER-GILT AND SHADED CLOISONNÉ ENAMEL BRATINA repoussé with tapering flutes decorated with neo-Russian motifs on cream and blue ground the foot and rim with moss green enamel grounds – signed with initials of Feodor Rückert, assay mark of Moscow 1908–1917, diameter 4¹₂ in. (11.5cm).
André Ruzhnikov

4
FABERGÉ SILVER &
CLOISONNÉ ENAMEL

FABERGÉ SILVER, MOSCOW AND ST. PETERSBURG

MOSCOW

Since the sixteenth century, Moscow has always been the center of the Russian silver production which was well organized, on a large scale, and generally of good quality. In the mid-nineteenth century, the great silversmith Ignaty Sazikov dominated the scene, introducing a figural style imbued with romantic, historical and mythological Russian themes. A so-called Pan-Slavic style ensued and was adopted by all craftsmen in the second half of the nineteenth century, diffused in particular by the important silversmithing and enameling firms of Pavel Ovchinnikov and Ivan Khlebnikov. These were Fabergé's main competitors when he opened his Moscow branch in 1887, attracted to the city for practical reasons: its lower salaries (which were 20 per cent less than in St. Petersburg); the availability of craftsmen from the many independent silversmithing firms; and its good training schools.

Fabergé's huge output of silver – tableware, retirement gifts, presentation pieces and prizes for competitions – was produced exclusively in Moscow in workshops situated in the San Galli House, 4 Bolshoi Kiselni Lane, under the management of Michael M. Chepurnov.[1] The silver department was divided into two, one section for the production of raised services and hollow-ware, the second for cast pieces such as candlesticks, sculptures and clocks. Eight craftsmen were employed solely for the engraving of coats-of-arms and monograms.[2]

The designs of the Moscow silver workshops were very eclectic, obviously dictated by the tastes of Fabergé's clientele. Commissions for St. Petersburg and clients with pro-western leanings were generally produced in the Rococo or neo-Classical styles. Local custom preferred the older Pan-Slavic or the newly fashionable neo-Russian idiom, inspired by Russian folk style, or the imported language of Art Nouveau. François Birbaum, Fabergé's head designer in St. Petersburg, would later say "The main feature that distinguished the Moscow factory from the St. Petersburg workshops is the prevalence of the Russian folk style. One can disagree with many of its peculiarities" – the absence of structured elegance and the archaic and deliberately crude execution – "but all these temporary shortcomings are offset by the originality of conception and the absence of clichés in the composition".[3] Henry Bainbridge writes of "the monumental conception and imposing splendour" of Fabergé's Moscow artefacts, of their "showy side", of their "naturalism" and of their "freedom from restraint typical of Russia".[4] This blend of old and new, of Russian and foreign, is best seen in pieces such as the Forbes "Bogatyr Kovsh" (cat. 140) or in the exuberant forms of some *cloisonné* enamelware by Feodor Rückert (cat. 103), which are Fabergé's versions of Art Nouveau. Bainbridge sees the origins of this style in the "craftsman's study of the mural decorations, documents, pieces of pottery and gold and silversmith's work of the time of Ivan the Terrible. This invention is an outstanding contribution to Russian art. The Moscow House made use of this style almost *ad infinitum* in silver works of every kind such as tankards, bratini, icons, bowls, cigarette-cases etc., and in silver work associated with Siberian stones." Fabergé's Moscow silver, when compared to the work of his competitors, is truly outstanding in quality and, often as opposed to theirs, made of metal of the heaviest gage.

Unlike St. Petersburg silver, and with very few exceptions, Fabergé's Moscow silver does not bear any workmaster's initials. When these do appear, they probably indicate manufacture by an outworker.[5]

FIG 1. FABERGÉ'S MOSCOW PREMISES AT KUZNETZKI MOST
c. 1900. Archive Photograph

FIG 2. FABERGÉ'S MOSCOW SALES ROOM with Charles Bowe, Osvald Davies, Nicolas Hobé, Otto Jarke, Lehmkuhl, George Piggott, Th. Juvé and Oliver. Archive Photograph

Notes
1. For the best account of Fabergé's Moscow workshops see Anne Odom, "Fabergé: The Moscow Workshops", in Habsburg/Lopato, (1993), pp. 104–115.

ST. PETERSBURG

The St. Petersburg silversmithing workshop was situated at 65 Ekatarinskii Canal, separate from the firm's main workshops – probably due to lack of space.

Julius Alexandrovich Rappoport (Isaac Abramovich Rappaport, 1851–1917), a native of the Datnovskii Jewish community in Kovno (Kaunas) province and Merchant of the Second Guild, converted to the Lutheran faith in the early 1890s and so changed his name. It seems he began his training in Berlin in 1880 under the silversmith Scheff, becoming master and opening his own workshop in St. Petersburg in 1883 or 1884. His workshop was first situated at 2 Spasskii pereulok, and later at 65 Ekatarinskii Canal in the house of Fabergé's sister.

Rappoport was the creator of most of Fabergé's superbly modeled animal figures, bears, rabbits (cat. 148–154), monkeys, dogs, frogs, toads (cat. 166), fish, woodcocks (cat. 164), swans (cat. 165), and various fowl, many of which were functional objects, serving as bell-pushes (cat. 156), salt and pepper shakers, clocks, wine pitchers, caviar bowls, etc. He also specialized in the silver mounts for various hardstone articles such as cigarette lighters shaped as wolves (cat. 170), match-strikers, and containers shaped as pigs or fantastic animals, frames and candlesticks. Many of his creations were silver mounts specially commissioned by or for members of the Imperial family, such as, for example, a Romanov griffin on a bowenite base (cat. 175), a smokey quartz vase (cat. 176), Gallé vases (cat. 177–179), and an Imperial presentation vase (cat.171).

Stephan Wäkaeva (1833–1910) was born in Sakkijarvi, Finland, arrived in St. Petersburg in 1843 and began his apprenticeship in 1847. Proprietor of a workshop, he supplied Fabergé with silverware, mainly tea-services, tankards and punch bowls. His two sons Konstantin (1867–1902) and Alexander (1870–1957) also worked for Fabergé, the latter taking over his father's workshop at his death in 1910. Each member of the family used his own set of initials as hallmark.

Contrary to popular belief, neither Rappoport nor the Wäkaevas were active in Moscow. This misunderstanding is due to the fact that their initials (as well as those of Anders Nevalainen) often appear in conjunction with a modified form of Fabergé's "Imperial Warrant mark", in this instance with a "separate" double-headed eagle, as opposed to the Muscovite Warrant mark which "incorporates" the eagle as part of the full Fabergé signature. It is possible that a small group of St. Petersburg masters may have been under contract to supply Moscow with specific silver, or silver-mounted, objects.

Géza von Habsburg

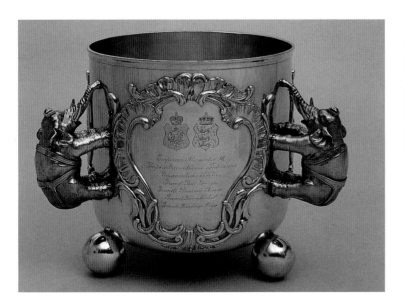

FIG 3. ONE OF A PAIR OF MONUMENTAL SILVER-GILT WINE-COOLERS presented by the related royal families of Europe to King Christian IX and Queen Louise of Denmark on the occasion of their Golden Wedding Anniversary in 1892, by Fabergé workmaster Julius Rappoport, St. Petersburg, 1892, height 13 in. (33cm). Reproduced by kind permission of HM Queen Margrethe of Denmark

FIG 4. STEPHAN WÄKAEVA Photograph courtesy of Ulla Tillander-Godenhielm

2. A Fabergé album with models for such coats-of-arms and monograms is preserved in the Fersman Mineralogical Museum, Moscow.

3. Fabergé/Skurlov (1992), p. 11.

4. Bainbridge (1966/8), pp. 132–133.

5. See Habsburg (1997), cat. 56, initials KB or HB on a pair of silver dessert plates.

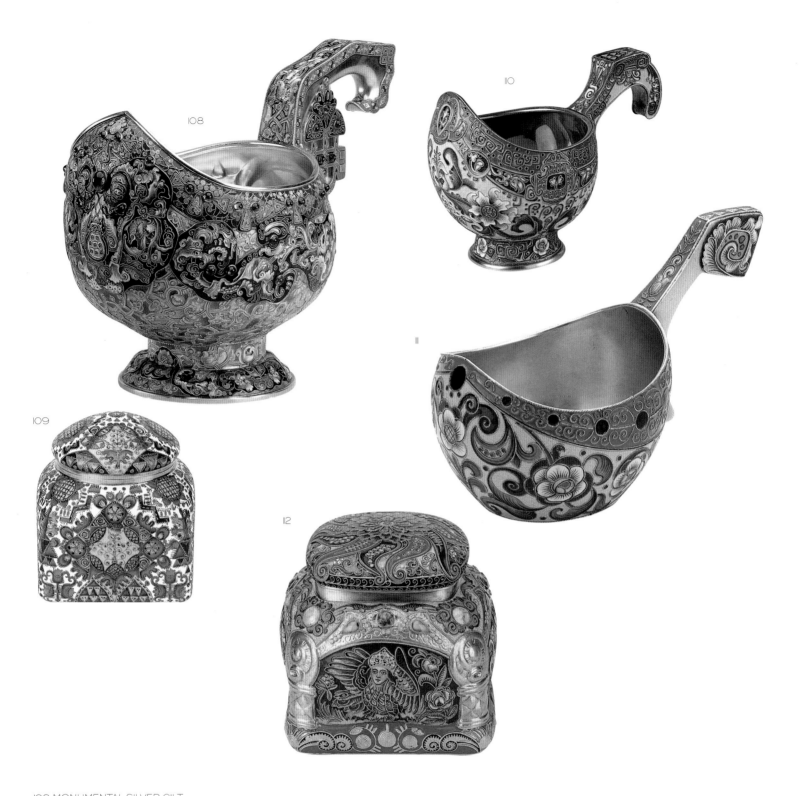

108. MONUMENTAL SILVER-GILT
AND SHADED CLOISONNÉ ENAMEL
KOVSH on raised foot with deep oval bowl
decorated with flowers in shaded hues of blue,
green and cream with similar border on dark
enamel ground, with angular enameled handle,
profusely set with cabochon amethysts – signed
with Imperial Warrant mark of Fabergé
overstriking the inititials of workmaster Feodor
Rückert, assay mark of Moscow 1899–1908,
inventory no. 22714, length 16½ in. (41.9cm).
Original fitted wooden case stamped with
Imperial Warrant, Fabergé, St. Petersburg,
Moscow, Odessa, Kiev, London and applied
with a plaque engraved with a presentation
inscription and signatures.
The presentation inscription reads: "To Ivan
Olegovich Olsen from employees of the firm
of the Nobel Brothers, May 1908".
Exhibited: St. Petersburg, Paris, London 1993,
cat no. 22.
Private Collection

109. SQUARE SILVER-GILT AND
SHADED CLOISONNÉ ENAMEL TEA
CADDY with domed hinged cover, entirely
decorated with stylized flowerheads in hues of
blue and green on white ground – signed with
Imperial Warrant mark of Fabergé overstriking
the initials of workmaster Feodor Rückert,
assay mark of Moscow 1908–1917, inventory
no. 38222, height 4 in. (10.1cm).
Private Collection

110. SILVER-GILT AND SHADED
CLOISONNÉ ENAMEL KOVSH
of traditional form decorated with fleshy green
foliage and large pink flower-heads on pale
green ground, the base, borders and handle
with filigree motifs on olive-green, blue and
other grounds – signed with Imperial Warrant
mark of Fabergé overstriking the Cyrillic
initials of workmaster Feodor Rückert, assay
mark of Moscow 1908–1917, inv no. 14383,
length 7⅛ in. (17.5cm).
Provenance: Marvin Greenfield Collection.
Private Collection

111. SILVER-GILT AND SHADED
CLOISONNÉ KOVSH painted with
polychrome scrolling flowers on cream ground,
the pale blue border with red guilloché enamel
circles, angular handle – Imperial Warrant mark
of Fabergé, assay mark of Moscow 1899–1908,
assay master Ivan Lebedkin, inventory no.
23075, length 4½ in. (11.5cm).
Private Collection

112. SQUARE SILVER-GILT AND
SHADED CLOISONNÉ ENAMEL
TEA-CADDY with domed hinged cover,
the corener with repoussé silver-gilt columns
enclosing panels of a mythical Sirin bird and
flowers in hues of blue, purple, green, olive –
signed with Imperial Warrant mark of Fabergé,
assay mark of Moscow 1899–1908, inv no.
23266, height 4¼ in. (10.8cm).
Private Collection

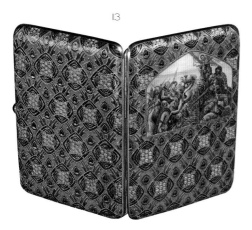

113

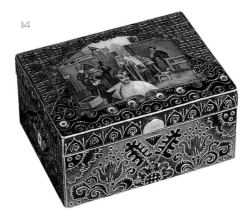

114

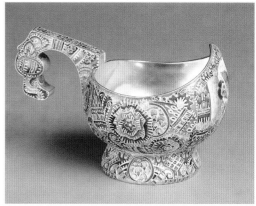

115

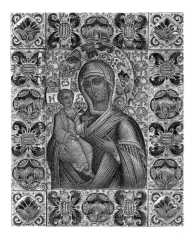

116

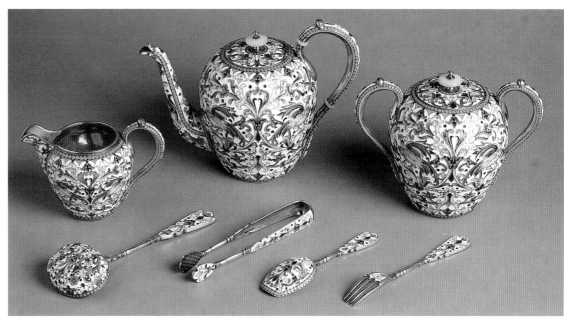

117

113. SILVER-GILT AND SHADED CLOISONNÉ ENAMEL CIGARETTE-CASE the cover painted en plein with the Battle of Chudskoie Lake, with rounded square motifs on blue ground – stamped with Imperial Warrant mark of Fabergé, assay mark of Moscow 1908–1917, length 4¹⁄₂ in. (11.5cm). André Ruzhnikov

114. RECTANGULAR SILVER-GILT AND CLOISONNÉ ENAMEL BOX the cover painted en plein with a Russian street scene in an arched reserve with trellis and scroll background, the sides with shaded cloisonné enamel Pan-Slavic foliage – stamped with Imperial Warrant mark of Fabergé, assay mark of Moscow 1908–1917, length 2³⁄₄ in. (7cm). André Ruzhnikov

115. SILVER-GILT AND CLOISONNÉ ENAMEL KOVSH the front with an en plein enamel scene of the Boyar Wedding after Makovsky, the body decorated in the Abramtsevo style mainly in dark blue and red on pale blue ground – signed with Imperial Warrant mark of Fabergé, assay mark of Moscow 1908–1917, inventory no. 23891, length 2⁵⁄₈ in. Michael and Ella Kofman Collection

116. ICON OF THE VIRGIN OF SMOLENSK with silver-gilt and *cloisonné* enamel oklad decorated in the neo-Russian style with dark and pale blue foliate motifs on gray ground – Imperial Warrant mark of Fabergé, assay mark of Moscow 1908–1917, 88 (zolotnik), inventory no. 32210, height 6¹⁄₂ in. (16.5cm). Bibliography: Hill 1989, pl. 150. Michael and Ella Kofman Collection

117. SILVER-GILT AND SHADED CLOISONNÉ ENAMEL TEA-SET comprising a teapot, covered sugar bowl, creamer, strainer, sugar tongs, fork and spoon, all decorated with stylized flowers and exotic birds mainly in blue and pink hues, on white ground – maker's initials Cyrillc I. S. for Ivan Saltikov, retailed by Fabergé, assay mark of Moscow before 1899, inventory no. 11367, height of teapot 5¹⁄₂ in. (14cm). Original fitted case with Imperial Warrant of Fabergé, St. Petersburg, Moscow. A rare instance of an enameler other than Rückert acting as a supplier to Fabergé. André Ruzhnikov

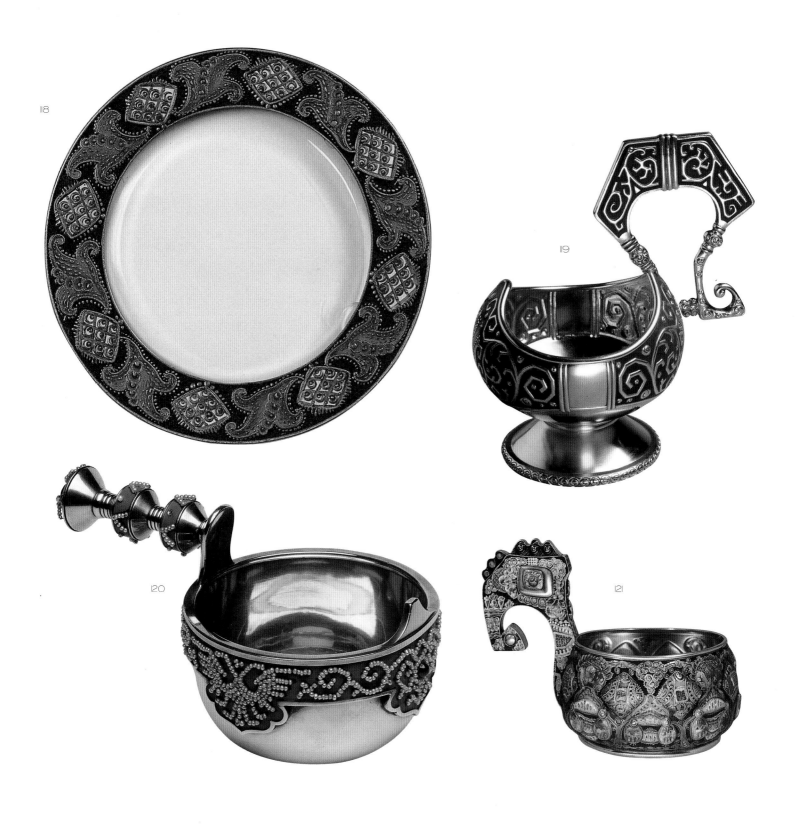

118. CIRCULAR SILVER-GILT AND
CLOISONNÉ ENAMEL FRAME in the
neo-Russian style decorated with blue foliage
and white lozenges with red dots, all on moss
green ground; wooden back and silver strut –
signed with Imperial Warrant mark of Fabergé,
(Moscow) 1908–1917, 88 (zolotnik), diameter
3⅝ in. (9.2cm).
Michael and Ella Kofman Collection

119. SILVER-GILT AND MATTE
CLOISONNÉ ENAMEL KOVSH
with high angular handle, decorated in the neo-
Russian style with raised scrolls on matte green
enamel ground – stamped with Imperial
Warrant of Fabergé, assay mark of Moscow
1908–1917, inventory no. 41110, height 6 in.
(15.2cm).
André Ruzhnikov

120. ENAMELED SILVER KOVSH
the border decorated with opaque moss green
enamel and applied with seed pearls arranged
to form stylized double-headed eagles, the
handle similarly decorated, gilt within –
stamped with Imperial Warrant mark of
Fabergé, assay mark of Moscow 1908–1917,
91 (zolotnik), length 6¹⁄₁₆ in. (15.3cm).
Wartski, London

121. LARGE SILVER-GILT AND
SHADED CLOISONNÉ ENAMEL
KOVSH with hook handle, the circular bowl
repoussé with bosses, decorated with shaded
neo-Russian designs on dark blue background
– stamped with Imperial Warrant of Fabergé,
assay mark of Moscow 1908–1917, length
11½ in. (29.2cm). Inscribed beneath:
"XXV18/31 Janvier 1912".
André Ruzhnikov

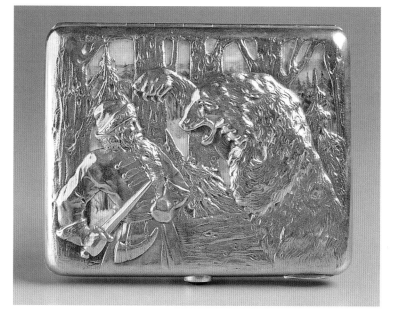

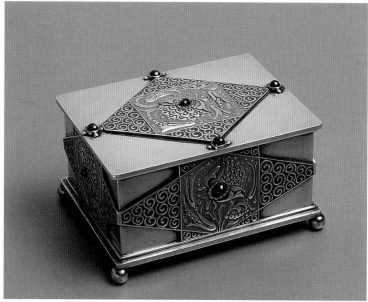

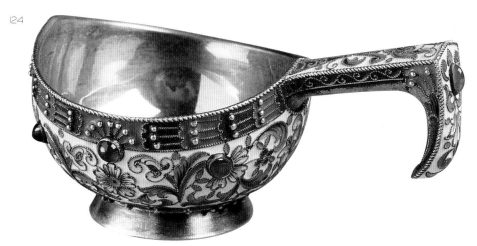

122. SILVER CIGARETTE-CASE
CHASED WITH A BEAR ATTACKING
A BOYAR with drawn dagger in a forest,
the background painted in enamel, cabochon
sapphire pushpiece – signed with Imperial
Warrant of Fabergé, assay mark of Moscow
1908–1917, length 4³⁄8 in. (11.1cm).
Bibliography: Traina 1998, p. 157 (right).
Exhibited: Hermitage 1997/8
John Traina Collection

123. RECTANGULAR GEM-SET
SILVER AND CLOISONNÉ ENAMEL
BOX the plain silver hinged cover and sides
applied with square pale blue enamel panels
within dark-blue enamel lozenges decorated
with scrolls, set with cabochon garnets and
standing on four ball feet – stamped with
Imperial Warrant mark of Fabergé, assay mark
of Moscow 1899–1908, assay master Ivan
Lebedkin, inventory no. 16217, length 4¹⁄2 in.
(10.5cm).
André Ruzhnikov

124. GEM-SET SILVER-GILT AND
SHADED CLOISONNÉ ENAMEL
KOVSH with polychrome shaded flowers and
foliage on cream-colored ground, with a band
of greenish enamel to the lip set with cabochon
garnets, the hook handle set with a cabochon
chrysoprase – stamped with Imperial Warrant
mark of Fabergé, assay mark of Moscow
1899–1908, assay master Ivan Lebedkin, length
3¹⁄2 in. (9cm).
André Ruzhnikov

125

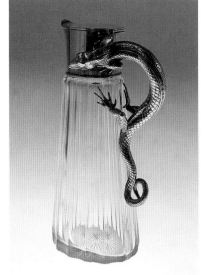

126

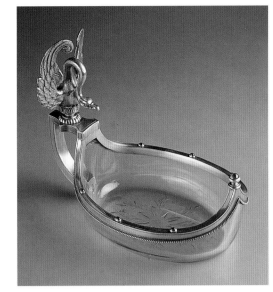

127

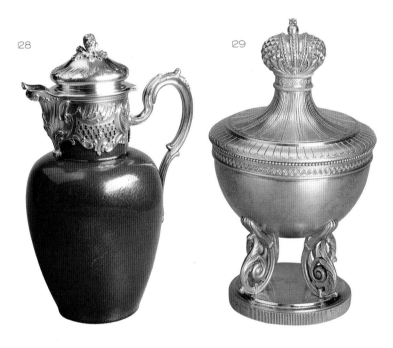

128

129

130

125. SILVER TROMPE L'OEIL
TEA CADDY realistically shaped as a large
tea parcel, the body perfectly imitating its
wrapping paper, the engraving imitating
the paper's design, on the cover "K.S. Popov
Brothers, tea from China", the base with two
large Imperial Warrants for 1894 and 1896, the
rim with a customs band for tea, and ropework
imitating string – Imperial warrant mark of
Fabergé, assay mark of Moscow before 1899,
51$_2$ × 45$_{16}$ × 31$_2$ in. (14 × 11 × 9cm).
Private Collection

126. SILVER-MOUNTED GLASS
DECANTER the tapering fluted body with a
wide silver rim and lidded cover, the handle
formed as a naturalistically cast and chased
lizard – stamped with Imperial Warrant mark
of Fabergé, assay mark of Moscow before 1899,
inventory no. 6309, height 91$_2$ in. (24cm).
André Ruzhnikov

127. GEM-SET SILVER-MOUNTED
CRYSTAL KOVSH the handle surmounted
by a swan with extended wings, the handle and
rim set with cabochon sapphires, the base
engraved with a foliate rosette – stamped with
Imperial Warrant mark of Fabergé, assay mark
of Moscow 1899–1908, assay master Ivan
Lebedkin, length 73$_4$ in. (19.5cm).
André Ruzhnikov

128. SILVER-MOUNTED BROWN
EARTHENWARE JUG the Louis XV-style
mounts chased with rocaille, scrolls and
cartouches filled with trelliswork – signed with
Imperial Warrant mark of Fabergé, assay mark
of Moscow before 1899, 84 (zolotnik), height
111$_4$ in. (28.5cm), the base stamped
C.M./Golfe-Juan am.
Michael and Ella Kofman Collection

129. SILVER SALT-CELLAR AND
COVER STANDING ON A CIRCULAR
PLINTH with three dolphin feet, the cover
surmounted by an Imperial crown – signed
with Imperial Warrant mark of Faberge, assay
mark of Moscow before 1899, 84 (zolotnik),
height 53$_4$ in. (14.5cm).
Provenance: Winter Palace; State Museum of
Ethnography, 1941.
This salt-cellar was probably made for the
coronation of Emperor Nicholas II and
Empress Alexandra Feodorovna, 1896.
The State Hermitage Museum (ERO – 3984).
LAZ

130. SILVER DINNER PLATE the rim
chased with an oak-leaf wreath, the cavetto
engraved with an Imperial double headed eagle
– stamped with Imperial Warrant mark of
Fabergé, assay mark of Moscow 1899–1908,
assay master Ivan Lebedkin, diameter 93$_4$ in.
(24.8cm). Inscribed on the reverse in Cyrillic:
"August 16, 1874–1899 from Grand Duchess
Xenia Alexandrova".
Grand Duchess Xenia (1875–1960), daughter
of Tsar Alexander III, sister of Tsar Nicholas II.
André Ruzhnikov

131

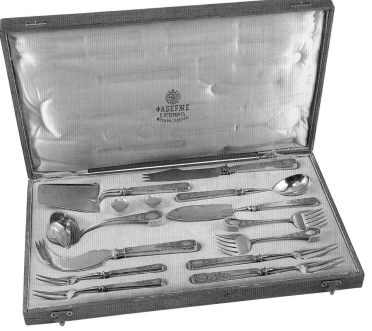

133

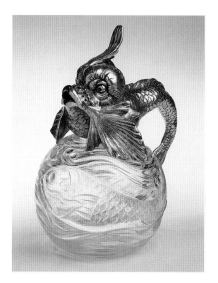

132

131. EMPIRE-STYLE SILVER DESSERT
SERVICE the handles cast and chased with
swans, wreaths and cornucopias, comprising a
cake slice, two cake forks, two knives, a butter
knife, a spoon, four serving forks and two
lemon squeezers – stamped with Imperial
Warrant mark of Fabergé, assay mark of
Moscow 1899–1908. In original fitted box with
Imperial Warrant mark, St. Petersburg, Moscow,
Odessa.
André Ruzhnikov

132. SILVER-MOUNTED CARAFE
the glass carved with a fish among waves,
the mount chased in the form of a Wolf-fish –
signed with Imperial Warrant mark of Fabergé,
assay mark of Moscow 1899–1908,
88 (zolotnik), height $7\frac{1}{8}$ in. (18cm), the glass
by Woodhall for Webb.
Wartski, London

133. SILVER-MOUNTED OAK KOVSH
with circular bowl and flat handle decorated
with neo-Russian motifs, set with three garnets
and a cabochon moonstone – stamped with
Imperial Warrant mark of Fabergé, assay mark
of Moscow 1899–1908, assay master Ivan
Lebedkin, length 6 in. (15.2cm).
Michael and Ella Kofman Collection

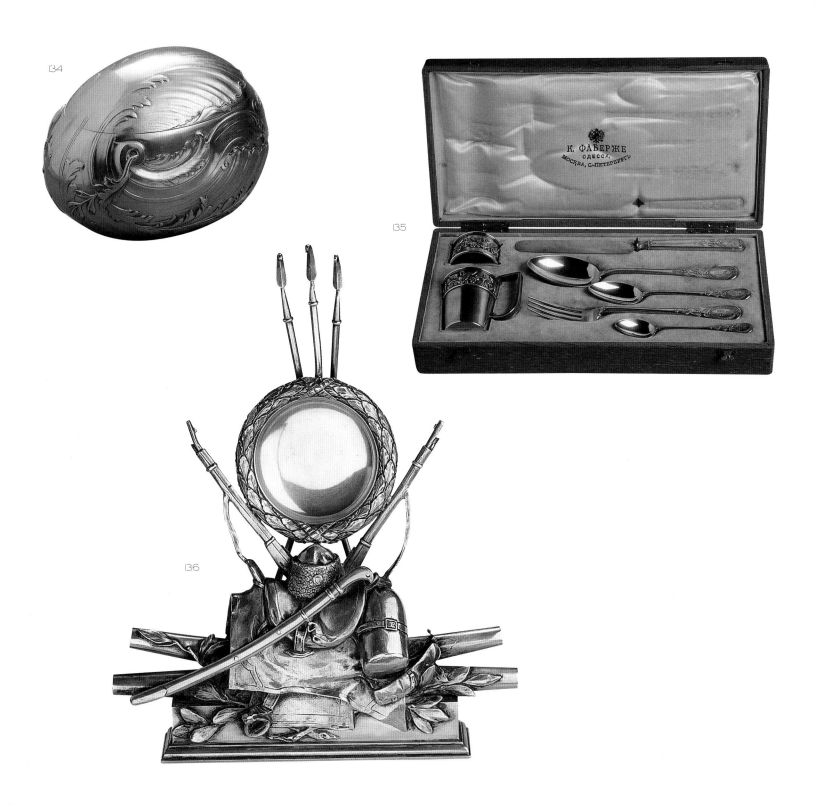

134. ROCOCO-STYLE EGG-SHAPED
SILVER BOX chased overall with rocaille,
scrolls and foliage – Imperial Warrant mark
of Fabergé, assay mark of Moscow 1890–1899,
initials of assay master Lev Oleks, 84 (zolotnik),
length 5³⁄8 in. (13.6cm).
Michael and Ella Kofman Collection

135. EMPIRE-STYLE SILVER
PICNIC-SET comprising a beaker, napkin-
ring, knife, fork and two spoons, all cast and
chased with swans, cornucopias and foliage –
stamped with Imperial Warrant mark of
Fabergé, assay mark of Moscow 1899–1908,
assay master Ivan Lebedkin, inventory nos.
21290, 21318, length of knife 8½ in. (21cm).
Original fitted box with Imperial Warrant
mark, St. Petersburg, Moscow, Odessa

136. SILVER MILITARY TROPHY AND
WATCH HOLDER on mound base with
laurel branches, a cossack's saddle in the center
with fur cap and a shashka across with two guns
behind holding a circular watch-case with
laurel border surmounted by three lances –
signed with Imperial Warrant mark of Fabergé,
assay mark of Moscow 1899–1908, assay master
Ivan Lebedkin, height 8¼ in. (21cm).
Private Collection

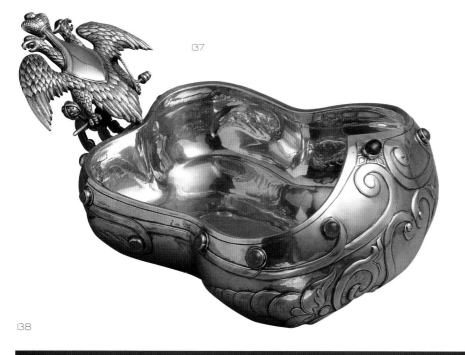

137

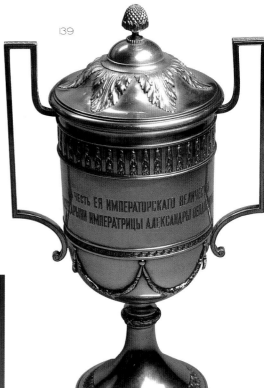

139

138

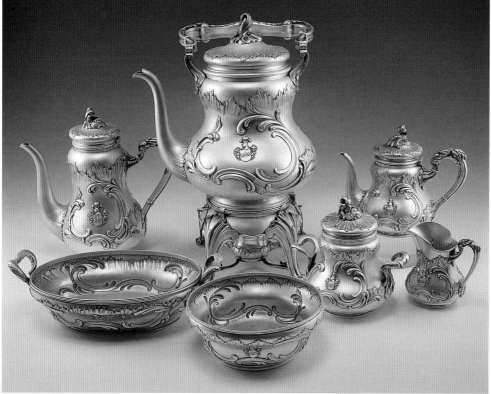

137. IMPERIAL PRESENTATION
SILVER KOVSH of quatrefoil shape, the
handle cast and chased as a Russian double-
headed eagle, the body chased with bands of
scrolls terminating under the lip in cabochon
cornelians – stamped with Imperial Warrant
mark of Fabergé, assay mark of Moscow
1899–1908, assay master Ivan Lebedkin,
length 12 in. (31cm).
André Ruzhnikov

138. SILVER TEA AND COFFEE
SERVICE OF NEO-ROCOCO
DESIGN comprising a hot-water kettle,
burner and stand, a coffee pot, tea pot, covered
sugar bowl, creamer, waste bowl and cake dish,
each chased with scrolls and rocaille and applied
with a coat-of-arms – stamped with Imperial
Warrant of Fabergé, assay mark of Moscow
1899–1908, assay master Ivan Lebedkin,
inventory no. 7751, height of coffee pot 9½ in.
(24cm).
Bibliography: Hill 1989, pl. 215; Fabergé in
America 1996/7, cat. 301.
André Ruzhnikov

139. SILVER IMPERIAL
PRESENTATION VASE-SHAPED
TROPHY in the late Georgian style, with
flaring foot, angular handles and domed cover,
the body chased with laurel swags beneath a
wide band bearing a Cyrillic inscription, with a
band of husks above, the cover with acorn finial
and acanthus-leaf decoration – stamped with
Imperial Warrant mark of Fabergé, assay mark
of Moscow 1899–1908, inventory no. 11872,
height 14½ in. (37cm). Inscribed: "In Honor of
Her Imperial Majesty Empress Alexandra
Feodorovna" and with double-headed eagle on
the reverse.
One of a large number of such trophies, part
of Fabergé's obligatory production for the
Imperial court. These were awarded mainly
as horse-racing and yachting (cf. Habsburg/
Lopato 1993/4, cat. 207) trophies.
André Ruzhnikov

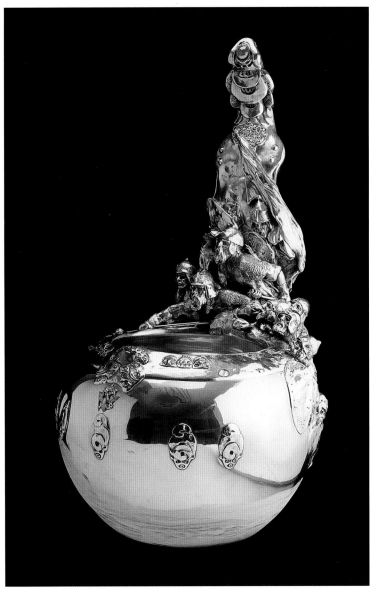

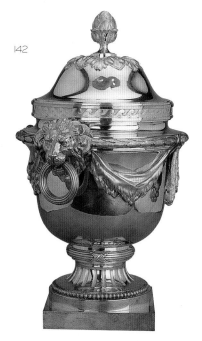

142

144

143

140

140. BOGATYR KOVSH monumental
silver-gilt and silver kovsh in the neo-Russian
style, the handle elaborately formed of ancient
Russian bogatyrs (warriors) who glance or
gesture outward to the horizon beyond –
Imperial Warrant mark of Fabergé, assay mark
of Moscow 1899–1908, assay master Ivan
Lebedkin, inventory no. 21843, height 23 in.
(58.4cm).
Provenance: Fine Art Society, London.
Bibliography: Kelly 1985, p. 12, ill.; Hill 1989,
p. 223, ill. plate no. 193; Kirichenko 1991,
p. 194, ill. opp. title page; Connaissance des Arts
1993, p. 17.
Exhibited: Virginia/Minneapolis/Chicago 1983,
cklst. no. 65, p. 15; Lugano 1987, no. 1, cat. ill.
pp. 24, 25, 39; Paris 1987, no. 1, cat. ill. pp. 20,
21, 35; New Jersey 1990, no cat.; London 1991,
no. 14, cat. pp. 3, 24, ill. pp. 24, 25, cover; Vienna
1991, cat. p. 74, ill.; St. Petersburg/Paris/
London 1993/94, no. 232, cat. p. 347, ill.
The subject recounts "The Tale of the
Armament of Igor", a late 12th-century epic
poem in which pagan Russian soldiers defeat
a young Christian Prince of Kiev and his army.
The chased silver figures clothed in chain mail
and armed with shields and maces are poised
ready to engage the enemy. A closely related
sketch for a kovsh is in the collection of the
State Hermitage Museum in St. Petersburg,
Russia.
The Forbes Magazine Collection, New York

141. TWO PARCEL-GILT SILVER
SPOONS one in the Louis XV style with
rococo scrolls, the other in the Louis XVI-style
with reed-and-tie border and laurel, gilt bowls
– signed with Imperial Warrant mark of
Fabergé, assay mark of Moscow 1908–1917,
inventory no. 4326, length 5⅞ in. (15cm).
Private Collection courtesy A. von Solodkoff

142. LOUIS XVI-STYLE VASE-SHAPED
SILVER WINE-COOLER AND COVER
with lion-head and ring handles, chased with
draperies, laurel-leaf rim, standing on a square
base with fluted and reed-and-tie foot, domed
cover with artichoke finial – signed with
Imperial warrant mark of Fabergé, assay mark
of Moscow 1908–1917, 88 (zolotnik), height
17⅛ in. (43.5cm).
Provenance: Winter Palace; State Museum of
the Ethnography of nations of the USSR, 1941.
This silver wine-cooler was probably made at
Fabergé's Moscow silver factory as part of a
service for use at the Winter Palace.
The State Hermitage Museum (ERO – 5000)
LAZ

143. SILVER-MOUNTED OAK KOVSH
with oval bowl and raised handle, the lip
and handle decorated with neo-Russian motifs,
set with three cabochon chrysoprases – stamped
with Imperial Warrant mark of Fabergé, assay
mark of Moscow 1908–1917, length 7¼ in.
Michael and Ella Kofman Collection

144. SILVER KOVCHIK the body chased
with triangular motifs studded with pellets,
the hook handle with a cabochon sapphire –
signed with Imperial Warrant mark of Fabergé,
assay mark of Moscow 1908–1917, inventory
no. 23891, length 2⅝ in. (6.7cm).
Michael and Ella Kofman Collection

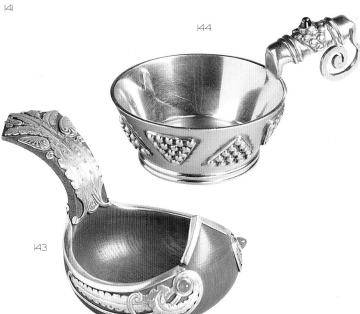

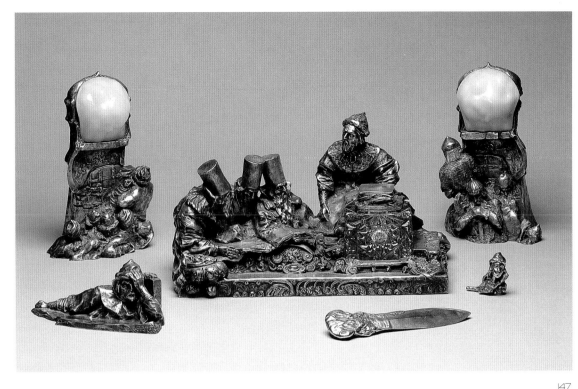

145

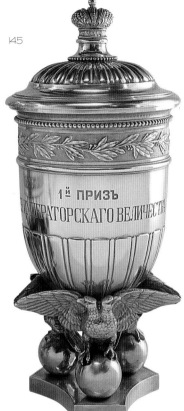

146

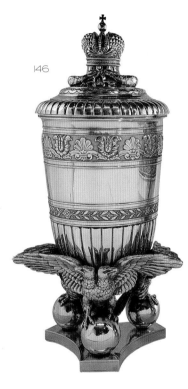

147

145. SILVER IMPERIAL PRESENTATION TROPHY OF VASE SHAPE

standing on a shaped triangular base upheld by three double-headed eagles each one perched on a sphere. The cup is chased with tapering flutes at the base, a wide band with an inscription above and a band chased with laurel leaves under the lip. The domed cover with tapering flutes surmounted by an Imperial crown – stamped with Imperial Warrant mark of Fabergé, assay mark of Moscow 1908–1917, height 13¹² in. (34cm). Inscribed: "First Prize from Her Imperial Majesty".
Exhibited: Fabergé in America 1996/7, cat. 302
André Ruzhnikov

146. SILVER IMPERIAL PRESENTATION TROPHY

similar to 145, but larger, decorated with a band of laurel leaves, an empty band for an inscription and a wide band of stylized foliate motifs beneath the lip. The cover with gadrooned rim, surmounted by an Imperial crown above two laurel swags – stamped with Imperial Warrant mark of Fabergé, assay mark of Moscow 1908–1917, height 16 in. (40.5cm).
Exhibited: Fabergé in America, 1996/7, cat. 303.
André Ruzhnikov

147. BORIS GODUNOV DESK SET

silver, rock crystal and pâte de verre desk garniture in the Neo-Russian style comprising an inkwell, a pair of lamps, a pen rest, a letter opener and a seal – inkwell: Imperial Warrant mark of Fabergé, assay mark of Moscow 1908–1917; 84 (zolotnik), inv no. 25323; letter opener: Imperial Warrant; seal: Cyrillic initials KF, assay mark of Moscow 1896–1908, 84 (zolotnik); pen rest: Imperial Warrant, assay mark of Moscow 1896–1908, 84 (zolotnik); lamps: Imperial Warrant, assay mark of Moscow 1896–1908, 84 (zolotnik), length of inkwell 16¹² in. (42cm).
Provenance: Nikolai Roerich.
Bibliography: Solodkoff 1984, ill; Hill 1989, ill. pl. no. 273.
Exhibited: Lugano 1987, no. 3, cat. 3; Paris 1987, no. 3, ill. 28, 29, 37; Vienna 1991, cat. p. 74, ill; New York et al. 1996/7, no. 230, cat. p. 235, ill.
This desk set was created for set-designer Nikolai Roerich on the occasion of the production of Rimsky-Korsakov's version of Moussorgsky's opera *Boris Godunov*. The opera, set in Russia and Poland in the late sixteenth and early seventeenth centuries, is a blend of both fiction and historical fact. It recounts the tale of Boris Godunov who after the death of Ivan the Terrible, assassinates the Tsar's son, Dimitri, and rules as regent for Ivan's feeble-minded son, Feodor. When a pretender to the throne who purports to be Dimitri incites the Russian people to overthrow Boris' regime, the Tsar is driven to madness. The desk garniture depicts Act 4, scene 2 of the opera. The inkwell portrays a group of landed nobleman who have gathered to discuss the country's fate. Their discussion is interrupted by Prince Shouisky who tells of the Tsar's fragile state of mind. The pen tray represents the distraught Boris and the hand seal, the expressionless Feodor. The lamps and letter opener represent the conflicting political forces brewing in Russia.
The Forbes Magazine Collection, New York

FABERGÉ SILVER ANIMALS

When a bell-push in the form of a silver rabbit sitting upright and set with cabochon garnet eyes was discovered recently in a private collection, the comparison with another very similar rabbit illustrated in a Fabergé exhibition catalogue[1] suggested itself. Both silver figures were authentic and had historical provenances: the first one came from the collection of Elisabeth Mavrikievna, Grand Duchess Konstantine, the second was recorded in Fabergé's London sales-ledgers as having been acquired by Mathilde Baroness Henri de Rothschild on November 11, 1913.

It is obvious that objects cast from the same mold look extremely similar. Obviously, with such a popular silver figure as the rabbit, Fabergé's workshops seem to have taken the liberty to cast several animals from one and the same mold (fig. 1). This, however, would normally not be up to the standard which Fabergé had set for his firm. We shall see later why and how all these figures differ.

Yet another silver rabbit came to light and, curiously, although looking like the model mentioned above, it was holding a carrot in its paws. This very amusing figure resembling Peter Rabbit seems to have come straight out of a children's nursery book (cat. 155).

At first, Fabergé's idea was never to be repetitive or to make objects in mass-production. However, the demand for certain endearing animal figures was apparently overwhelming. One of his mottoes was to create objects which would bring pleasure or at least be amusing. And this, the Fabergé Silver Zoo which comprised, apart from rabbits, animals such as elephants, monkeys, frogs, turkeys, dogs, woodcocks, exotic birds and many others, definitely was.

An interest in collecting Fabergé silver animals seems to have sprung up only recently. At auction sales they are now always in strong demand.[2] However, all earlier studies of Fabergé's work hardly mention the production of silver figures. This is perhaps due to the fact that castings always had the stigma of being artefacts of lesser originality. Henry C. Bainbridge in his study on Fabergé published as early as 1949[3] only states that Julius Rappoport "was a maker of large important silver pieces such as *surtouts de table*, bowls and large animals and birds. From time to time his silver birds are offered for sale in London."

FABERGÉ'S SOURCES FOR SILVER ANIMALS

Silver animal figures by Fabergé are masterpieces of silversmithry. It is perhaps of interest to find out more about their stylistic origin and sources, their historic background and how they were made at his workshops as specific, recognizable "Fabergé" objects.

As with many other technical or stylistic devices, Fabergé appears not so much the original creator but a perfectionist and innovator within an established art form. By this he was a typical example of an artist in the field of the applied arts in the late nineteenth century, a period which was dominated by the idea of eclecticism, an art form which concentrated on selecting already existing stylistic elements from previous epochs.

A sixteenth-century silversmith who already experimented with silver animal sculptures was Wenzel Jamnitzer. He was active in Nuremberg from 1534 to 1585 where he made casts from reptiles and beetles in silver and had them set on decorative objects such as caskets. This was considered by his contemporaries as highly original, as an animal was not interpreted in an artistic medium but became art in a naturalistic, life-size cast.[4] Not surprisingly, there is a silver lizard by Fabergé sitting on a leaf kept at the Hermitage Museum, St. Petersburg, similar to the Jamnitzer examples.

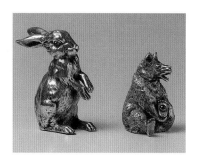

FIG I. TWO BELL-PUSHES FROM FABERGÉ'S MOSCOW BRANCH
(left) Rabbit bell-push which was acquired by Baronne Henri de Rothschild from Fabergé in 1913, (right) bear holding its paw set with a cabochon garnet.
(Private European Collection)

Also in Germany, mainly in the silver centers of Augsburg and Nuremberg, as well as in Switzerland, the production of drinking vessels in the form of animals flourished during the seventeenth century. These were chased silver, often gilt figures of animals such as stags, boars and prancing horses as well as birds. Their heads were removable and the hollow bodies could be filled with wine or beer. All these vessels lacked however, due to hollowness and the less detailed finish of the hides or plumage, the sculptural aspect which is enhanced by deep chasing of heavy silver. Again, the Hermitage Museum owns a silver falcon, dating from 1602. This apparently served Fabergé as a source of inspiration, and his workshops produced a smaller version of this proud sitting bird as a cigarette lighter (cat. 168).

During the eighteenth century it was Thomas Germain of Paris who became famous for his realistic silver animal sculptures made as parts of tureens and services. He was active from 1720 to 1748 and after his death his workshop and his casting-molds were inherited by his son François Thomas (1726–1791) who reused them as decorations on many magnificent services. His silver still lifes of game such as rabbits, boars or woodcocks were surrounded by realistic-looking vegetables. A contemporary critic of his mentioned in the *Mercure de France*, December 1750, that Germain's art not only gives a perfect rendering of nature but even successfully imitates it. This was made possible by very heavy casting in silver with subsequent extremely fine chasing of all details. It is interesting to note that during the 1880s, the time when Carl Fabergé started his activities, French eighteenth-century silver was increasingly studied and very much in demand by collectors in Europe. A first comprehensive study of the Germains in general but also describing their silver-casting process was written by Bapst and published in 1887.[5]

Silver animal sculptures were also used as decoration for dinner-services in England, especially at the end of the eighteenth century. A "Marine Service", made for the Duke of Rutland by Robert Hennell I (active from 1773–1811) in 1780 had salt-cellars set with silver crabs and shrimps. During this period, hunting, the traditional English aristocratic pursuit of chasing a fox on horseback with a pack of hounds, was already firmly established. The riders used to drink from a silver cup shaped as the head of a fox. It was realistically modeled but had no foot or base to stand on and could only be drunk in one go before setting off for the chase. This special hunting "farewell" beaker became known as a stirrup cup.

Later, around 1850, the "Magasin Anglais" which was also called the "English Shop" – a firm of silversmiths owned by Nicholls and Plincke in St. Petersburg – took up the idea of producing silver stirrup cups. They were not only shaped like a fox's head but showed a variety of animals. Samuel Arndt and a workmaster with the initials P. K. both produced series of cups shaped as horses, hares, boars, stags, roebucks, bears, oxen, dogs and even elephants. They appealed to the Russian taste which always liked a naturalistic style in decorative objects, be it imitations of woodgrain on silver cigar-boxes, the woven bark of the birch-tree on silver cups, or the ubiquitous gilt bronze figures of Russian bears used as paperweights. Arndt excelled in making the silver stirrup cups in the shape of an animal's head look very naturalistic, its fur or hide being cast in heavy silver and chased in great detail. These cups, which were also made by Sazikov, proved very popular and were doubtless sources for Fabergé's animals.[6]

Another source of inspiration for Fabergé came from Japan as European art was under the spell of *Japonisme* from about 1870. During the Meiji period (1868–1912) a large number of animal figures were produced in bronze and also in silver, often in an inlay technique using various metals.[7] They show a great love for detail which must have fascinated Fabergé as, in fact, did the Netsuke of which he had a large collection. A Japanese bronze figure of an elephant, for example, served as inspiration for Fabergé's silver elephant (cat. 183).

Notes
1. Solodkoff (1995), no. 2, p. 49.

2. Christie's London, sales catalogue, London, 17 December 1998, lot 244, "A gemset bell-push in the form of a rabbit, realistically cast, chased and engraved, Fabergé, Moscow, 6 in. long, £96,100."

3. Bainbridge (1949), p. 125.

4. Klaus Pechstein, *Der Goldschmied Wenzel Jamnitzer*, in: Wenzel Jamnitzer, exhibition catalogue (Munich 1985), p. 60 and no. 21, p. 226.

5. Germain Bapst, *Les Germains*, (Paris 1887), pp. 110 ff.

6. Solodkoff (1981), ill. 219.

7. Victor Harris, *Japanese Imperial Craftsmen. Meiji Art from the Khalili Collection*, (London 1992), p. 234, no. 239.

FABERGÉ'S ANIMAL FARM

· Crab, Dolphin, Frog, Lizard, Pike, Scorpion, Sturgeon, Toad
· Bear, Beaver, Capercaillie, Cat, Dachshund, Elephant, Fox, Horse
· Kangaroo, Monkey, Moose, Pig, Rabbit, Rhinoceros
· Falcon, Marabou Stork, Owl, Pheasant, Ruff, Swan, Turkey, Woodcock

This list just shows the variety of animal figures Fabergé produced. It is, however, incomplete as figures of other animals may still be found.

At a first glance, Fabergé animal figures distinguish themselves by a high degree of realism. Although they are miniaturized, they are finely worked in every detail. This especially applies to the treatment of the fur, hide or plumage which are all chased to the minutest feature. The engraved surface shows even the hairs of the fur or single feathers of the plumage.

The realism is enhanced by the portrayal of the characteristics of an animal. A rabbit is often shown in its typical alert position with its ears pricked, the bear as a cuddly but hairy beast. The elephant usually has the characteristic rotund features reflecting its weight. The frosted gray color of the surface helps to imitate the elephant's hide. A silver frog is partly polished as if to show the shiny wetness of its moist habitat.

Fabergé also often used the features to depict humor. The comical aspect is what makes many of these animal figures so lovable. This can be seen with the elephant seated on its heavy hindquarters and blowing its trunk, a pig happily asleep with all four legs stretched out, the frog showing its wet tongue or the rabbit nibbling a carrot. The monkey has a funny expression of surprise on its near-human face when it sees the end of its tail burning (cat. 185).

Generally, Fabergé would not be content with a simple, silver animal sculpture. Many of his items, however luxurious, needed a practical purpose to become objects for daily use. Small heavily cast vodka-cups in the shape of rotund elephants with cabochon garnet eyes (fig. 2) were not only useful but also served a decorative purpose on the dining-table.

Furthermore, Fabergé was influenced by the technical developments of the day. This was the case with photography – he produced an endless number of frames with ever varying decorations. Another technical invention was electricity and its practical use for bells. At a time when servants were increasingly found in up-and-coming households, it became fashionable to replace the handbell by an electrical bell which was activated by a bell-push linked by wires to the actual bell.

Consequently, he fitted many silver animals with a mechanism for use as bell-pushes. The eyes of the animal were usually set with red cabochon garnets, sometimes with hardstones such as green chrysoprases or the reflecting brown stone called cat's eye. These eyes served as the actual pushes which were linked to a simple electrical lever interrupter activated by a metal spring. All this was placed in the hollow cavity of the inside of the animal and covered at the bottom with black Bakelite, occasionally also a wooden or even silver plaque fixed with small silver screws. The electrical wires were led through a hole which was usually drilled into the side of the animal.

Frogs, with their protruding eyes, were used for bell-pushes, as were many rabbits. Silver pigs had the bell-push sometimes on the snout or concealed under an ear. The bushy tail of a fox or cat would also be used to hide a bell-push.

As early as 1893, Fabergé offered in his catalog "a small lamp for lighting cigarettes in the shape of a monkey".[8] This was a burner of spirit or paraffin fitted with a cotton wick. The 1893 silver monkey had the shape of a chimpanzee turning its head and looking in shock at its burning tail through which the wick was led. These *lampochki* or burners proved to be very popular with the increasing number of cigarette and cigar smokers and

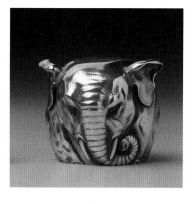

FIG 2. SILVER VODKA-CUP IN THE SHAPE OF A ROTUND ELEPHANT
its eyes set with cabochon garnets by workmaster Henrik Wigström of Fabergé's St. Petersburg workshop, 1908–1917. (Private European Collection)

8. *Fabergé Preiskurant*, (Moscow 1893), no. 50.

Fabergé looked for further ideas to develop this success. Obviously, the elongated trunk of an elephant would be ideal to conceal the wick for a burner and consequently silver burners were produced in the shape of elephants. Fabergé became very inventive in creating burners from silver animals. The frog spitting as if to catch a fly, for example, had the wick on the tip of its protruding tongue.

Large animal figures were made as water pitchers. Only a few of these, measuring about 12 inches (30cm), are known. They include a beaver from the collection of Count Bobrinsky, now at the Hermitage, St. Petersburg, a rabbit (Virginia Museum of Fine Arts, Richmond), a pheasant (Private Collection) and a dachshund (Private Collection). The Gokhran (State Depository of Valuables) in Moscow owns a large pitcher in the shape of a pig.[9]

Some animal figures were made – perhaps at the request of clients – as sculptures to decorate a table, or as paperweights. For example a large silver capercailzie stands on a circular nephrite base (fig. 4). Red marble was also used in some cases as a base or plinth. The large silver swan (cat. 165) could be used with a glass liner for flowers as a centerpiece.

A derivative of the three-dimensional sculpture of a whole animal was the use of their heads only as decorative elements. Fabergé made a number of crystal glass carafes with finials in the shape of animals. This could be the head of a monkey or, like on a set of five conical glass decanters in the Thyssen-Bornemisza collection, game birds and animals such as capercailzie, woodcock, wolf, lynx and fox.[10] More often, he made carafes with dolphins or fish as finials.

Also, but not strictly speaking belonging to the category of silver animal figures, are those composed of sandstone and silver (fig. 3). These were match-holders, and the rough surface of the sandstone was used for striking the match. To the sandstone body a silver head, feet and tail of an animal were added (cat. 182). This is the case with the pig match-holder in the Forbes Magazine Collection. The pinkish-red stone and the smiling expression of the pig gives a very humoristic effect, and this animal may be referred to as a fine example of kitsch.

A more artistic invention were the so-called exotic birds with sandstone bodies and angular grasshopper legs. They are so unrealistic that they became known as Hieronymus Bosch animals, after the Dutch sixteenth-century painter who depicted similar fantastic birds in his visions of the "Garden of Delights".[11]

THE CREATION OF SILVER ANIMALS, THEIR FABERGÉ ARTISANS AND WORKSHOPS

One of the main reasons for the superior quality of Fabergé's pieces in general is that he employed professional designers and artists for the creation of an object. This was also one of the reasons why his items had to be more expensive than those made by other contemporary jewelers.

The creation of an animal figure started with a model made by a sculptor. There were various artists who worked on these, and the most distinguished among them were the following: August Karlovich Timus, Egor (Georgi) Ivanovich Malyshev and Boris Oskarovich Froedman-Cluzel. Other designers and modelers included A. Aubert, R. Bach, A. and V. Gratchev, N. Gruenberg-Salkalns, N. Ilyina, G. Savitskii, G. Skilter and L. Strikh.

Timus, born in 1865, worked for the Imperial porcelain factory where he made a number of animal figurines. Fabergé apparently asked him to create models of animals to be copied in his workshops. Malyshev (1875–1934) graduated from the Academy of Art and also produced animal sculptures for Fabergé as well as for Denisov-Uralski. He is said to have made miniature models of the "Bronze Horseman" and other equestrian statues.[12] At the Spring Show of the Academy of St. Petersburg of 1912 he exhibited a bronze figure

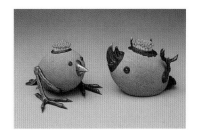

FIG 3. TWO MATCH-HOLDERS IN THE SHAPE OF SILVER-MOUNTED SAND-STONE BIRDS with cabochon garnet eyes, both by Julius Rappoport, St. Petersburg, before 1899. (Wartski Ltd., London)

9. *Mir Faberzhe*, exhibition catalogue, (Moscow-Vienna 1992), p. 234, no. 239.

10. A. Somers Cocks and Ch. Truman, *The Thyssen-Bornemisza Collection, Renaissance jewels, gold boxes and objets de vertu*, (London 1984), p. 328, no. 118.

11. Snowman (1979), p. 47.

12. Birbaum (1992), pp. 53 f. (note 18).

of a stylized chick and a relief of a sitting dog.[13]

Froedman-Cluzel was born in 1878 in St. Petersburg, studied there at the Baron Stieglitz School, at the Academy of Arts in Stockholm, in Karlsruhe, and in Paris where he exhibited at the Hébrard gallery in 1910. After 1918 he emigrated and died in Egypt during the 1950s. Froedman-Cluzel specialized not only in bronze portrait sculptures of theater and ballet artists but also in modeling animal figures. In 1907 he was chosen by Fabergé to model the animals of Sandringham which were later carved in hardstone for King Edward VII as presents for Queen Alexandra. He also made a sculpture of the King's 1896 Derby and 1897 Ascot Gold Cup winning race-horse "Persimmon" which was cast at Fabergé's workshop both in silver and in bronze in 1908.[14] According to the London Fabergé's sales ledgers, the King acquired the statue of Persimmon in oxydized silver on a nephrite base (no. 17249) on 29 October 1908 for 135 pounds sterling.

A model of an animal figure approved by Fabergé and his designers – of plaster, stone or bronze – was used by the silver or hardstone-carving artisans for creating an animal in their own working material. It was possible that an animal figure based on the same original model was made in either silver or hardstone. Two elephants and a frog from the royal collections, carved in nephrite, also appear as silver figures, all three as lighters.[15]

The production of a silver figure started with copying the original model in a "pattern" which was generally carved in wood or some other hard material. This "pattern" was then used for sandcasting. It was tightly rammed or pressed into sand or loam contained in iron frames or "casting flasks". Once the wooden pattern was extracted the remaining cavity was filled with silver.[16]

It was, however, not done as a whole but in piece molds. These parts were later not simply soldered but welded or fused together by applying extremely strong heat to attach the melting edges to each other. The seams were practically invisible through very precise workmanship. To finish a piece off, the outer surface – the fur, hide or plumage – was finely chased or chiseled by hand giving each silver figure an individual character. The description of the 1893 Fabergé catalogue and price list in fact refers to the silver animals (No. 50 and No. 53) as "chekannoy raboty" – of chased work.

An animal figure had to be hollow both to make it lighter in weight and to look more elegant. It also had to conceal the mechanism of an electrical bell or the wick and lighter fuel in it. To cast a hollow figure as a whole was not ideal although not impossible, as the cooling of a larger-size silver piece would have unequally shrunk or distorted the outline of the figure, making it twist and warp.

The artisan who most probably made the first silver animal figures was Julius Rappoport. His earliest figures date from around 1890 and he has to be credited for refining the concept of producing silver objects for decoration and everyday use.

Rappoport was born in 1851 into a Jewish family called Datnovski, in the province of Kovno. He was given the name Isaac with patronym Abramovich. After having been apprenticed in Russia and at the silver workshop of Scheff in Berlin, he became master in St. Petersburg in 1884. He registered his mark (Cyrillic) I. P. and established his own workshop at 65 Ekatarinskii Canal in a house which belonged to Fabergé's sister.

In order to establish himself as a silver merchant of greater importance – he later became a merchant of the Second Guild – he converted to Lutheranism and adopted the first names of Julius Alexandrovich in about 1890. His mark, however, remained the same although his first initial became (Cyrillic) Yu.

Around this time, he joined Fabergé's firm, a move through which he gained higher financial security as well as a larger clientele. His ideas and experience in silver production were helped by the firm's team of designers although he lost the right to sell his goods individually in his own name. He decided to retire in about 1909 and died in 1917.

However, before retiring, Rappoport wished to reward his workmen for their long

13. Niva no. 26 (June 30, 1912) p. 512.

14. Skurlov (Stockholm, 1997), pp. 34 ff. and catalogue no. 57.

15. Snowman (1953), pl. 247, 248 (nephrite elephants), and Snowman (1979), p. 70 (top ill.) no. 5 (nephrite frog) and Christie's Geneva sales catalogue (16 May 1995), lot 378, Hubel Collection, cat. 166, and Christie's Geneva sales catalogue (26 May 1993), lot 443.

16. Maryon (1971), p. 216; Cuzner (1935), p. 43.

and faithful service and left the workshop and all its equipment to them. The first Silversmith's Artel was thus formed, and the House of Fabergé decided to promote this modern experiment of a cooperative by granting the necessary credits and passing on commissions.[17]

This First Silver Artel worked from about 1909 using all production molds including the animal figures from Rappoport's stock. The Artel marked its production with the mark ICA and with the separate round Imperial warrant mark which had also been used by Rappoport, with the Fabergé stamp. This cooperative lasted, however, only a few years. This small enterprise with only some twenty participants reflected all the drawbacks of public organizations at the time: lack of solidarity, discipline and misunderstanding of mutual interests. After two or three years of internal discord, increases in the cost of production and decline in its quality, the Artel ceased to exist.[18] The exact date of closure is unknown but was most probably around 1912–13.

As was common with expensive equipment in a silversmith's workshop, the contents, with all its tools, stamps and molds, were sold on to the next silversmith. The workshop was in fact taken over by Fabergé artisan Hjalmar Armfeldt (1873–1959). He specialized more in small gold and enamel objects than in silver production and had already acquired the workshop of Victor Aarne for this purpose in 1904. However, he apparently wanted to enlarge his field of activity and as a matter of course he also received some of the patterns and molds of animal figures which he later produced with his own mark.

Having looked at the various artisans for silver animals in St. Petersburg that were all based on Rappoport, we surprisingly find that chief artisans Michael Perchin and Henrik Wigström were crafting special kinds of animals. These were the small vodka-cups in the shape of rotund-looking elephants with cabochon garnet eyes which could be turned to stand on their ears to reveal a gilt cavity for holding vodka (fig. 2).[19] As opposed to the fabrication process of hollow casts, these elephant cups were made by casting in one piece, and distinguish themselves by their heavy weight. All known examples carry the St. Petersburg assay mark of 1896–1908.

A large number of silver animal figures were produced by the Moscow branch of Fabergé. Apart from the Moscow hallmark they only carry the Imperial Warrant mark of the firm, as is usual for the Moscow silver production. This is normally a rather small mark with K. Fabergé in Cyrillic under the double-headed eagle, stamped into the silver fur or plumage and therefore often hardly visible.

Nearly all the Moscow animal figures were modeled on those made by Rappoport in St. Petersburg. It can only be assumed that Fabergé, as a firm, acquired from him the right to produce animals based on his design in Moscow, probably even using his original casting patterns. However, other patterns and molds of animals may have been created in addition by Moscow craftsmen.

It has to be kept in mind that the Moscow branch had all the facilities for silver production on a large scale and that the animal figures were increasingly in demand around 1910.

THE SALES AND SUCCESS OF FABERGÉ SILVER ANIMALS

As we have seen, the first silver animal figures were made around 1890. A fine example is the monkey – a chimpanzee – exhibited here under cat. 185 with its companion. This monkey-lighter, turning its head in astonishment towards its burning tail, became one of the most popular silver figures at Fabergé. It was also advertised in his catalog and price-list of 1893 as no. 50.

A similar monkey-lighter – a baboon holding its burning tail – was owned by the Hon. Mrs. George Keppel, the friend and confidante of King Edward VII.[20] Another is said

17. Birbaum (1992), p. 448.

18. Birbaum (1992), p. 448.

19. State Hermitage Museum, St. Petersburg, Inventory nos. ERO 8964/5.

20. Sotheby's London, sales catalog (London, 20 February 1985), lot 571 The Forbes Magazine Collection, New York

to have been in the collection of Princess Irène, the sister of Empress Alexandra Feodorovna.

A very large silver chimpanzee in a crouching position was exhibited by Fabergé at the Nordic Exhibition in Stockholm in 1897. A contemporary writer, Isabella Grin, visited the exhibition and wrote about this "marvelous monkey" which apparently received a lot of attention.[21] This figure was later shown in Fabergé's shop in St. Petersburg and can be seen in an old photograph of the premises.[22]

Although it has been said that silver animal figures appealed more to the bourgeois taste of the rich merchants of Moscow than to the aristocracy which favoured hardstone carvings, it is surprising how many silver animals were acquired by members of the Imperial family. Rumor has it that Tsar Nicholas II himself owned a large silver pitcher shaped as a sow sitting upright. It was kept in his cabinet office in the Alexander Palace of Tsarskoe Selo. This most probably is the rather strange looking – it is ugly and kitsch – pig *kryushon*, dated 1896, now kept by the Gokhran in Moscow.

From remaining archive records such as the Fabergé invoices, to the Imperial Cabinet of the sales ledgers of Fabergé's London branch, we get a picture of the cost of silver animal figures. They could fetch between 32 and 800 roubles, or in London between 2 and 135 pounds sterling, which in US currency was approximately between 9.75 and 657 dollars.

It is of course difficult to evaluate these prices today. However, comparisons within the range of Fabergé objects can be made. Desk-clocks for instance were sold for between 21 and 147 pounds sterling (between 102 and 716 US dollars).

Alexander von Solodkoff

21. Grin (Grinevskaya), Isabella, Vystavka v Stokgolme. Pis'ma turista, (St. Petersburg 1897. V.V. Skurlov, Faberzhe i Peterburgskie yuveliry, (1997), p. 568

22. Habsburg/Solodkoff (1979), ill. no. 16.

FIG 4. LARGE SILVER FIGURE OF A CAPERCAILZIE on circular nephrite base, from Fabergé's Moscow workshop. (Ermitage Ltd., London)

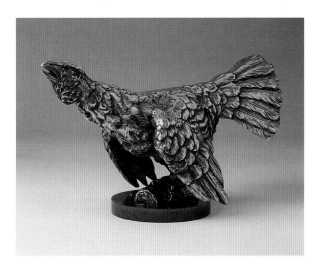

The following is a list of silver animals acquired by members of the Imperial family between 1891 and 1910. Records from the Imperial Cabinet of their payments to Fabergé are in the Russian State Archives of St. Petersburg. The list was kindly provided by Valentin V. Skurlov for this article.

Date	Artefact	Price (in roubles)	Date	Artefact	Price (in roubles)
EMPRESS MARIA FEODOROVNA			**EMPEROR NICHOLAS II**		
1891	Lighter monkey (small lamp)	150	1897	Goblet head of elephant	80
	Lighter monkey (small lamp)	150		(half with Empress)	
	Match-holder with pigeon	32	1901	Small lamp head of monkey	185
1893	Match-holder elephant	100			
	Match-holder elephant	100	**GRAND DUKE ALEXANDER MICHAELOVICH AND**		
	Match-holder elephant	50	**GRAND DUCHESS XENIA ALEXANDROVNA**		
	Lighter elephant, silver	130	1894	Bird (silver)	400
	Pheasant silver on onyx	750		Small lamp monkey	150
1892	Lighter elephant (small lamp)	210	1896	Marabou stork silver	800
	Ashtray swan	130		Penguin silver	550
	Lighter lizard (small lamp)	105	1900	Goblet with head of horse	300
1894	Match-holder elephant	100			
	Match-holder cockerel	100	**GRAND DUKE GEORGE ALEXANDROVICH**		
	Match-holder crow	75	1891	Bell-push, three chicks	180
1898	Ashtray head of elephant	80	1895	Owl	55
1899	Ashtray bat	80		Dolphin, silver	150
1901	Tcharka elephant	90	1897	Ashtray silver owl	55
	Ashtray maiolica with two silver pigeons	38	1898	Ashtray with silver snake	35
	Lighter silver bear	85		Ashtray with two silver snakes	45
1906	Cleaning and gilding of a cream-jug with monkey	5			
1908	Lighter monkey (small lamp)	160	**GRAND DUCHESS XENIA ALEXANDROVNA**		
1913	Lighter bulldog (small lamp)	180	1894	Match-holder mouse	50
				Match-holder elephant	90
EMPRESS ALEXANDRA FEODOROVNA					
1896	Ashtray silver head of monkey	150	**GRAND DUKE AND GRAND DUCHESS VLADIMIR**		
	Lighter-lamp silver monkey	100	**ALEXANDROVICH (INVENTORY OF THE PALACE)**		
	Lighter-lamp silver frog	115	1917	Pheasant silver, weight 6 pounds	500
1897	Goblet head of elephant	80		Capercailzie silver, weight 7 pounds 68 zol.	500
1901	Lamp silver monkey	185			
1906	Small lamp elephant	150			
	Duck (silver)	185			

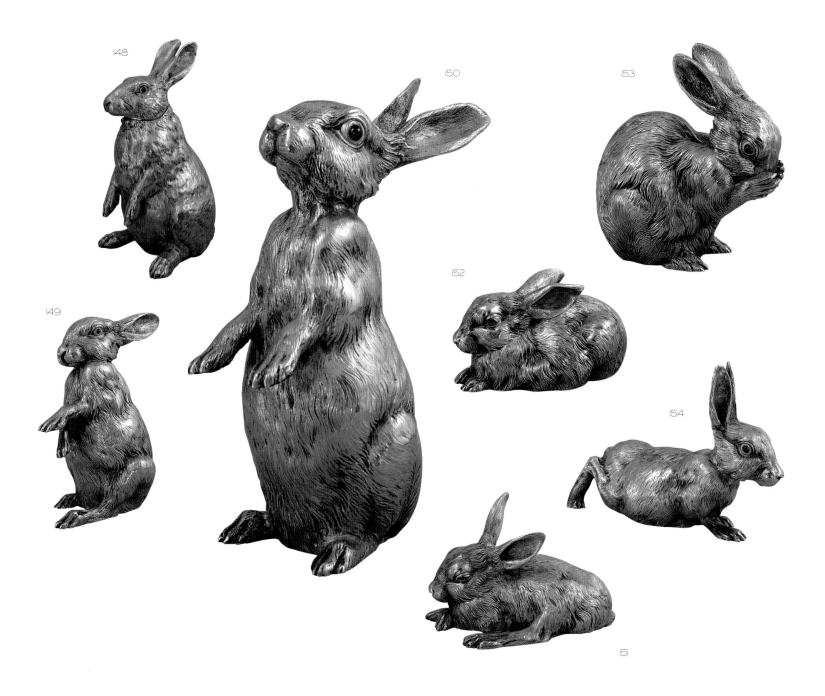

148. SILVER PITCHER SHAPED AS A
RABBIT standing on its hind quarters, with
hinged head, gilt interior and cabochon ruby
eyes – stamped with Imperial Warrant mark of
Fabergé, assay mark of Moscow 1894, assay
master A. Svetchin, 88 (zolotnik), inventory no.
4338, height 9¾ in. (25cm).

This pitcher and the six rabbits that follow were
formerly in the collection of King Ferdinand of
Bulgaria (1861–1948), one of Fabergé's most
important clients, who, according to Bainbridge
(1949, p. 27) is said to have offered Fabergé a
ministerial post in Bulgaria, to which Fabergé is
to have replied: "No, no your Majesty, not
politics, I beg of you; but minister of the
goldsmith's art, why yes, Sire, if you will it."
According to family tradition, all seven pieces
were originally contained in one large Fabergé
box, now lost. While several similar pitchers
exist, no other such group of rabbits seems to
have survived. Fabergé used the models of
several of the smaller rabbits as bell pushes, with
the cabochon ruby eyes acting as pushpieces.
Private Collection

149. SILVER FIGURE OF A RABBIT
naturalistically chased, standing upright on
its hind quarters, with left paw higher than
the right, with cabochon ruby eyes and gilt
interior – stamped with Imperial Warrant mark
of Fabergé, assay mark of Moscow before 1899,
88 (zolotnik), height 5 in. (12.8cm).
Private Collection

150. SILVER FIGURE OF A RABBIT
naturalistically chased, standing upright on its
hind quarters, peering upwards, both paws
extended, with cabochon ruby eyes and gilt
interior – stamped with Imperial Warrant mark
of Fabergé, assay mark of Moscow before 1899,
88 (zolotnik), height 5½ in. (14cm).
Private Collection

151. SILVER FIGURE OF A RABBIT
naturalistically chased, reclining with left hind
paw extended, with cabochon ruby eyes and
gilt interior – stamped with Imperial Warrant
mark of Fabergé, assay mark of Moscow before
1899, 88 (zolotnik), length 4½ in. (11.5cm).
Private Collection

152. SILVER FIGURE OF A RABBIT
naturalistically chased, in a crouching position,
with cabochon ruby eyes and gilt interior –
stamped with Imperial Warrant mark of
Fabergé, assay mark of Moscow before 1899, 88
(zolotnik), length 4¼ in. (11cm).
Private Collection

153. SILVER FIGURE OF A RABBIT
naturalistically chased, washing its face with its
front paws, with cabochon ruby eyes and gilt
interior – stamped with Imperial Warrant mark
of Fabergé, assay mark of Moscow before 1899,
88 (zolotnik), height 4 in. (10cm).
Private Collection

154. SILVER FIGURE OF A RABBIT
naturalistically chased, cautiously advancing,
with cabochon ruby eyes and gilt interior –
stamped with Imperial Warrant mark of
Fabergé, assay mark of Moscow before 1899,
88 (zolotnik), length 4¼ in. (11cm).
Private Collection

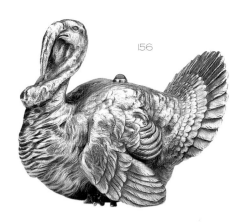

156

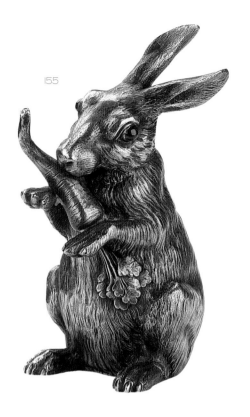

155

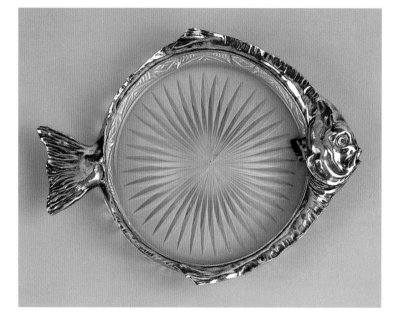

157

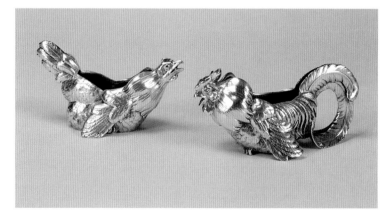

158

155. SILVER BELL-PUSH SHAPED AS A RABBIT sitting upright and nibbling a carrot held in its paws, the eyes set with cabochon garnets to be used as bell-pushes, finely chased and engraved fur – signed with Imperial Warrant mark of Fabergé, assay mark of Moscow 1899–1908, 88 (zolotnik), assay master Ivan Lebedkin, hight 5$\frac{1}{2}$ in. (12.6cm). The Hubel Collection

156. SILVER BELL-PUSH IN THE SHAPE OF A TURKEY the sitting bird with realistically modeled head and spread tail with realistically chased and engraved plumage, set with a chrysopras pushpiece – signed with Imperial Warrant mark of Fabergé, assay mark of Moscow 1899–1908, 88 (zolotnik), assay master Ivan Lebedkin, length 3$\frac{1}{8}$ in. (9.8cm). The Hubel Collection

157. SILVER-MOUNTED CUT-GLASS DISH SHAPED AS A FISH the circular glass dish with silver border molded with the head, tail and fins of a turbot – stamped with Imperial Warrant mark of Fabergé, assay mark of Moscow 1899–1908, length 7$\frac{1}{16}$ in. (18cm). Private Collection

158. PAIR OF SILVER SALTS naturalistically chased in the form of a hen and a rooster, with gilt interiors – stamped K. Fabergé, with Imperial Warrant, assay mark of Moscow before 1899, inventory nos. 4479 and 4516, length rooster 4$\frac{3}{16}$ in. (10.7cm). Private Collection

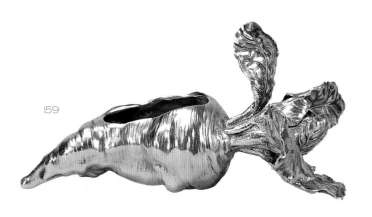

159

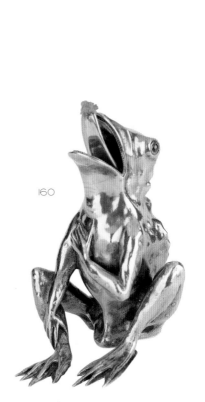

160

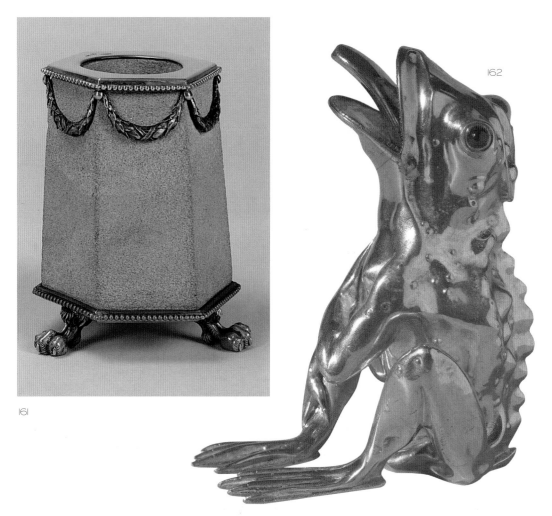

162

161

160. SILVER FROG LIGHTER
with cabochon garnet eyes sitting upright
with open mouth and protruding tongue fitted
with a wick, the base engraved with initials
C G and date 1 January 1893 – signed Fabergé,
workmaster's initials I.P. of Julius Rappoport,
assay mark of St. Petersburg before 1899,
88 (zolotnik), inventory no. 45101, height 4 in.
(10.2cm).
As this frog is not stamped with the Imperial
Warrant, it may be assumed that it was made
before Rappoport received his appointment
as warrant holder.
Private Collection

**161. SILVER-MOUNTED SANDSTONE
VESTA HOLDER** hexagonal, raised on
three claw feet – stamped K. Fabergé, initials
of workmaster Julius Rappoport, assay mark of
St. Petersburg before 1899, inventory no. 738,
height 3⅜ in. (8.5cm). Original fitted wooden
case with Imperial Warrant, St. Petersburg,
Moscow.
Private Collection

162. SILVER FROG LIGHTER
humoristically modeled as a seated frog with
one hand clasped to its chest, the wick holder
formed from the protuding tongue, set with
cabochon garnet eyes – signed K.Fabergé,
with separate Imperial Warrant, initials of
workmaster Julius Rappoport, assay mark
of St. Petersburg, 1899–1908, inventory
No. 7811, height 3¹⁵₁₆ in. (10cm).
Exhibition: St. Petersburg/Paris/London
1993/4, cat. 204, ill p. 325.
For a similar model see cat. 160.
Woolf Family Collection

159. TROMPE L'OEIL SILVER SALT
in the form of a radish with leaves and gilt
interior – signed Fabergé, initials of workmaster
Julius Rappoport, assay mark of St. Petersburg
before 1899, length 4¾ in. (12cm).
Private Collection

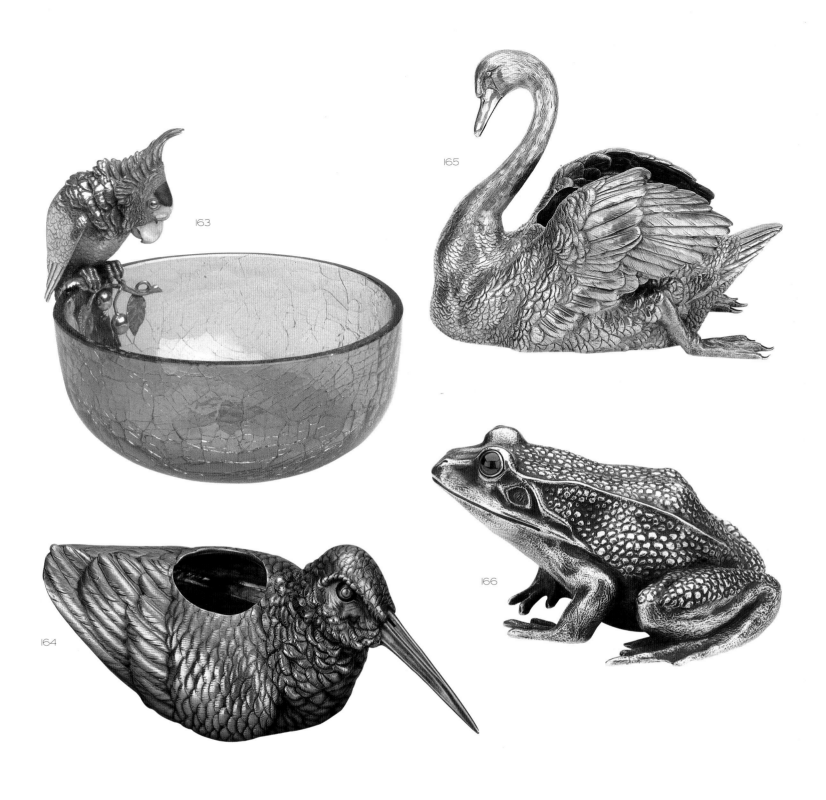

163. SILVER-MOUNTED CIRCULAR AMETHYST-COLORED CRAQUELÉ BOWL the rim applied with a cast and chased silver figure of a cockatoo perched upon a berried branch – signed K. Fabergé, with separate Imperial Warrant mark, initials of workmaster Julius Rappoport, assay master St. Petersburg 1899–1908, assay master Yakov Lyapunov, height 7¹⁄₈ in. (18cm).
The Woolf Family Collection

164. SILVER ASHTRAY SHAPED AS A WOODCOCK cast and naturalistically chased as a seated bird, with a cavity in its back – signed Fabergé, initials of workmaster Julius Rappoport, assay mark of St. Petersburg 1899–1908, 88 (zolotnik), inventory no. 3374, length 5¹⁄₂ in. (14cm).
Provenance: From the Strelninsky Palace; Central Depository of Suburban Palaces, 1956, Exhibited: Leningrad 1991, cat. 500; St. Petersburg/Paris/London 1993/4, cat. 205.
The State Hermitage Museum (ERO – 8672).
LAZ

165. SILVER CENTRE-PIECE SHAPED AS A SWAN with curved neck and spread wings, its plumage chased and engraved, with cavity to contain a glass liner – signed Fabergé with (independent) Imperial Warrant mark, initials of workmaster Julius Rappoport, assay mark of St. Petersburg 1899–1908, assay master Yakov Lyapunov, inventory no. 5948, length 9¹⁄₂ in. (24.2cm).
Provenance: Acquired by Erik Hallin, first secretary and later minister at the Swedish embassy in St. Petersburg, from Fabergé's shop between 1896 and 1901.
The Eriksson Collection

166. SILVER BELL-PUSH IN THE SHAPE OF A TOAD its eyes set with cabochon garnets, sitting in a typically alert position – initials of workmaster Julius Rappoport, assay mark of St. Petersburg 1899–1908, assay master Yakov Lyapunov, length 3³⁄₄ in. (8.5cm).
The Hubel Collection

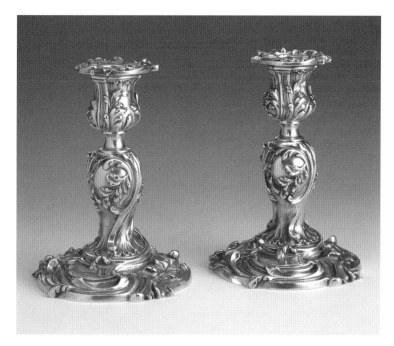

167

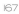

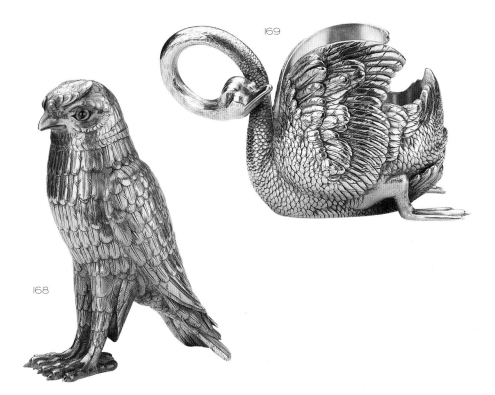

169

168

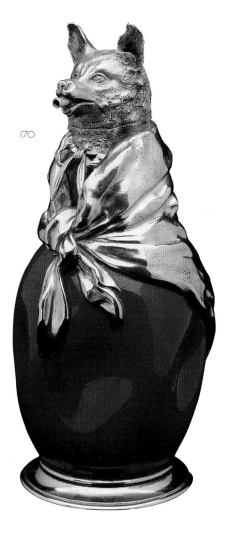

170

167. PAIR OF MASSIVE LOUIS XV-STYLE SILVER CANDLESTICKS
cast and chased with swirling foliage and scrolls, on base with conforming detachable nozzles – signed K. Fabergé, with separate Imperial Warrant mark, initials of workmaster Julius Rappoport, assay mark of St. Petersburg 1908–1917, height 6¹⁸ in. (15.5cm).
Exhibited: Lahti 1997, cat. 34, ill. p. 27.
The Woolf Family Collection

168. SILVER LIGHTER IN THE SHAPE OF A FALCON sitting straight on its legs, the grim-looking head with cabochon garnet eyes, hinged to reveal the gilt wick-holder, finely chased and engraved plumage – initials of workmaster Julius Rappoprt, assay mark of St. Petersburg before 1899, height 4³⁴ in. (11.8cm).
The Hubel Collection

169. SILVER TEAGLASS HOLDER SHAPED AS SWAN with curved neck and spread wings, chased and engraved plumage – signed Fabergé with separate Imperial Warrant mark, assay mark of St. Petersburg 1899–1908, 88 (zolotnik), assay master Yakov Lyapunov, length 5¹⁸ in. (13.2cm).
The Hubel Collection

170. BIG BAD WOLF LIGHTER silver-mounted earthenware cigar lighter formed as a big bad wolf "smoking" the lighter wick and wearing a knotted silver kerchief over a red earthenware body – Imperial Warrant mark of Fabergé, initials of workmaster Julius Rappoport, assay mark of St. Petersburg 1899–1908, 88 (zolotnik), inventory nos. 4571 and 5327, height 6¹² in. (16.5cm).
Bibliography: Habsburg/Solodkoff 1979, p. 42, ill. plate no. 50; Solodkoff 1984, p. 167, ill.; Hill 1989, p. 293, ill. plate no. 271.
Exhibitions: Lugano 1987, no. 57, cat. p. 72, ill.; Paris 1987, no. 57, cat. p. 68, ill.
The Forbes Magazine Collection, New York

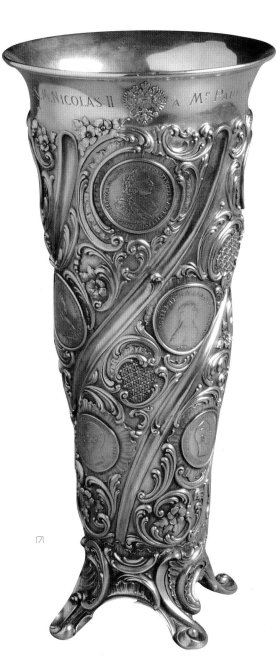

171

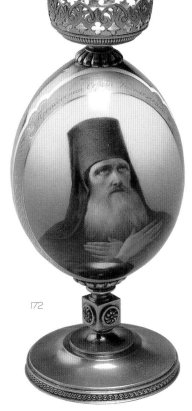

172

173

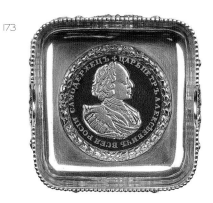

171. SILVER IMPERIAL
PRESENTATION VASE of tapering
cylindrical form cast and chased with swirling
bands of scrolling foliage and set with thirteen
silver rouble coins with the profiles of
Romanovs monarch from Peter the Great to
Alexander III, standing on four scroll and paw
feet – stamped Faberge, initials of workmaster
Julius Rappoport, assay mark of St. Petersburg
before 1899, inventory no. 2779, height 13¹₂ in.
(34.2cm). Inscribed beneath the lip: "Offert par
S. M. Nicholas II à M. Paul Nadar, Souvenir
d'Octobre 1896".
This vase must have been presented by
Nicholas II during his visit to France following
the coronation.
André Ruzhnikov

172. SILVER-MOUNTED PORCELAIN
EASTER EGG depicting St. Sergei of
Radonej, the flat circular silver foot with *entrelac*
rim, surmounted by an openwork silver candle
holder – the mount signed Fabergé, initials of
workmaster Julius Rappoport, assay mark of
St. Petersburg before 1899, 88 (zolotnik), height
6¹₄ in. (15.8cm), the egg Imperial Porcelain
Manufacture, c. 1860. Original fitted box with
Imperial Warrant, St. Petersburg, Moscow.
Bibliography: Kudriavtseva 2000.
Presumably a commission, the function of this
unique object is not clear.
Harold Whitbeck Collection

173. SQUARE SILVER AND ENAMEL
ASHTRAY set with a red enameled Peter
the Great rouble coin surrounded by chased
laurel, the sides with laurel festoons – signed
Fabergé, initials of workmaster Julius
Rappoport, assay mark of St. Peterburg before
1899, inventory no. 43551, length 2⁵₈ in.
(6.7cm).
Exhibited: Hamburg 1995, cat. no. 6.
Private Collection courtesy A. von Solodkoff

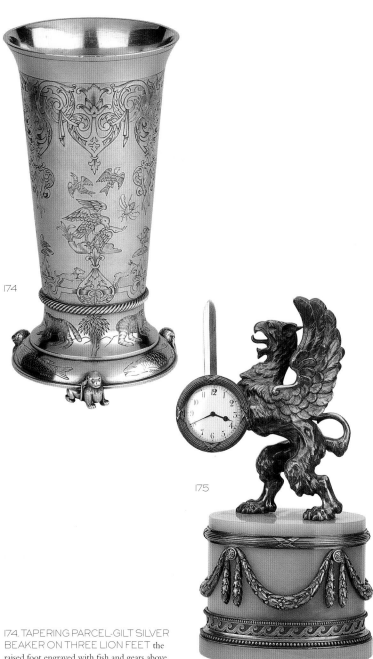

174

175

176

177

174. TAPERING PARCEL-GILT SILVER BEAKER ON THREE LION FEET the raised foot engraved with fish and gears above, the sides engraved and gilt with a central vacant cartouche flanked by hunting scenes of birds, foxes and a squirrel, with foliage and strapwork above – signed with Imperial Warrant mark of Faberge, workmaster Julius Rappoport, assay mark of St. Petersburg 88 (zolotnik), assay master Yakov Lyapunov, inventory No. 10042, height 5¹⁸ in. (13.1cm).

The shape and decoration of this beaker are inspired by 17th-century beakers made by Grigory Novgorodets in the Moscow Kremlin workshops for Patriarch Pitirim. These large beakers are still kept in the Moscow Armory Museum. See M.M. Postnikova-Loseva, in: Oruzheinaya Palata, Moskva 1954, p. 212 (ill.).
Private Collection

175. SILVER-MOUNTED BOWENITE GRIFFIN CLOCK on oval hardstone base applied with chased silver laurel garlands between waved and reed-and-tie bands, the chased and engraved heraldic griffin holding in one paw the clock and in the other a gilt sword – signed Fabergé with round Imperial Warrant mark, intials of workmster Julius Rappoport, assay mark of St. Petersburg 1899–1908, height 12¹⁴ in. (31.1cm).

The griffin holding a shield and a sword is the heraldic sign of the Romanov family.
Private Collection

176. GOLD-MOUNTED SMOKY QUARTZ VASE the tall vase carved from a single piece of quartz with a nymph, shells and dolphin, the mount decorated with Rococo scrolls and Art Nouveau plant motifs – signed Fabergé, initials of workmaster Julius Rappoport, assay mark of St. Petersburg before 1899, 88 (zolotnik), height 14⁷¹² in. (37cm).
Provenance: Imperial Collections; transferred from the Winter Palace to the Hermitage Museum, 1931.
Bibliography: Lopato 1984, pp. 43–49.
Exhibited: Leningrad 1984, cat. 23; Lugano 1986, cat. 120; Munich 1986–1987, cat. 281; Zurich, 1989, cat. 33; Leningrad 1989, cat. 65; St. Petersburg/London/Paris, cat. 55; St. Petersburg/Wilmington/Mobile 1998–2000, cat. 218.
The high quality of the engraving would suggest the work of a very talented craftsman. It is likely that this vase is the "smoke-colored topaz vase" … "presented to the Royal Court" by the director of the Peterhof Diamond Factory 23rd May 1898. Research shows that the vase was sold on 25th May and a bill of 275 roubles was presented by Fabergé just for the

mounting of the vase and for its case. The vase of smoke-colored quartz, or "topaz" as it was known at the time, was valued at 1880 roubles, the high price reflecting the length and intricacy of the work processes involved. (RGIA, f. 504, inv.1, item 2201, pages 34, 35, item 2189, page 20). It seems likely that the vase was produced by Pestu, the famous Berlin engraver, who was invited to Russia by the factory director, A.L. Gun.
The State Hermitage Museum, St. Petersburg (NE 17576).
LAZ

177. CONICAL OVERLAY GLASS VASE PARLANT by Gallé with silver mount by Fabergé, the quadruple overlay glass with opaline, pink, colorless and black hues, decorated with water-lilies and dragonflies issuing from water, everted conical silver foot chased with waves and applied with two dragonflies – the foot signed Fabergé, initials of workmaster Julius Rappoprt, assay mark of St. Petersburg before 1899, 88 (zolotnik), height 8¹¹⁶ in. (20.5cm). The glass signed and dated Emile Gallé 1892 Nancy fecit. Etched inscription around the lip: "Végetations de Symboles" and "Palmes lentes de mes désirs. Nénuphars mornes des plaisirs. Mousses froides, lianes molles … Maurice Maeterlinck"
Provenance: Probably acquired by Tsarina Alexandra Feodorovna in Darmstadt, 1896; Winter Palace, where it stood on a small work table in the office of the Tsarina; transferred to the Hermitage, 1931.
Exhibitions: Leningrad 1974, cat. 245, p. 63; St. Petersburg/Paris/London 1993/4, cat. 111; Speyer 1994, p. 126, ill. p. 127; St. Petersburg 1996, cat. 6.
Bibliography: Gallé 1900/1980. p. 340; Le Tacon 1998, p. 62, fig. 39.

Le Tacon identifies this piece as the vase exhibited at the Exposition Universelle in Paris in 1889. He also suggests that it was one of a number of works by Emile Gallé purchased by Empress Alexandra Feodorovna during her visit to her relatives in Darmstadt in 1896. As discovered by M. Lopato, the silver stand was commissioned by the Imperial Cabinet in St. Petersburg on February 21, 1898 ("Glass vase by Gallé with marsh flowers and ephemerae. Silver stand with ephemerae 70 roubles." RGIA, f. 468, inv. 32, item 1635, sheet 86). The vase is listed by N. Dementyev in 1909 (Inventory of Items belonging to their Imperial Majesties and held in the Winter Palace) as "in the style of Gallé" (Archive GE, f. 1, op.VIII g., d. 7 b, l. 59).
A verse by Maurice Maeterlinck, one of the Gallé's favourite poets, is inscribed around the lip of the vase. Gallé first used the technique of quoting poetry on his vases in 1884, thereby imparting a symbolist character to the pieces. Works of this type came to be known as "Vases parlants".
The State Hermitage Museum (23410).
EA

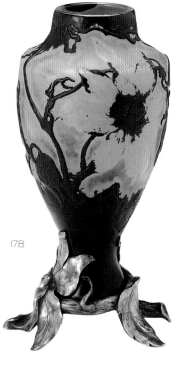

178

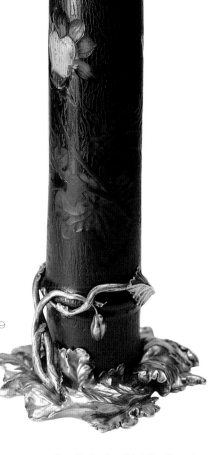

179

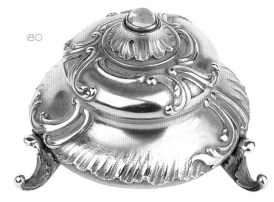

180

181

178. PEAR-SHAPED OVERLAY
GLASS VASE PARLANT by Gallé with
silver mount by Fabergé, the triple overlay vase
in pink and violet-black hues decorated with
large Clematis blooms, leaves and swirling
tendrils, the silver base applied with Clematis
leaves and tendrils – signed Fabergé, initials of
workmaster Julius Rappoport, assay mark of
St. Petersburg before 1899, 88 (zolotnik), height
7¹³₁₆ in. (19.8cm). Inscribed: "En ses creusets
le langage des fleurs et des choses muettes /
Baudelaire" Provenance: Tsarina Alexandra
Feodorovna, in her office at the Winter Palace;
transferred to the Hermitage 1931.
Exhibited: Leningrad 1974, cat. 231, p. 60; St.
Petersburg/Paris/London.
1993/4, cat. 58, p. 215; St. Petersburg 1996,
cat. 11.
Bibliography: Ivanova 1983, p. 128.
According to the inventory of 1909 this vase
stood in the office of Her Majesty in the
Winter Palace (Archive GE, f. 1, op.VIII g, d. 7
b, l. 47).
Another example of Gallé's verres parlants with

a verse from Charles Baudelaire's "Les Fleurs du
Mal" which reads "Qui plane sur la vie et
comprend sans effort / Le langage des fleurs et
des choses muettes!" Gallé took only the last
lines of a poem that expressed a complete idea.
He "does not try to 'illustrate' Baudelaire he
wants only to give us access to the medium
through which the poet helps him to see
nature" (Charpentier 1963, N 1132, p. 372).
Elena Anisimova

179. CYLINDRICAL TRIPLE OVERLAY
GLASS VASE by Gallé with silver mounts
by Fabergé, decorated with Dahlia blooms and
leaves in yellow-green and violet-brown hues,
with dark green buds and leaves in relief against
a dark background. The silver base of Dahlia
leaves and branches – signed Fabergé, initials of
workmaster Julius Rappoport, assay mark of
St. Petersburg before 1899, 88 (zolotnik), height
9¹³₁₆ in.; the glass signed Emile Gallé and a
Croix de Lorraine Provenance: The Winter
Palace 1909; transferred to the Hermitage,
1931.

Exhibited: Leningrad 1974, cat. 234, p. 61;
St. Petersburg/Paris/London 1993/4, cat. 56,
p. 213; St. Petersburg 1996, cat. 13.
Bibliography: Ivanova 1983, p. 128.
According to the inventory of 1909 this vase
stood in the Louis XVI drawing-room in the
Winter Palace (Archive GE, f. 1, op.VIII g, d. 7
b, l. 27).
The body of the vase is shaped as a bamboo
shoot with a background of Dahlia stems, leaves
and flowers. Similar vases, but on bronze stands,
can be found in the collections of the Museum
of Applied Art in Dusseldorf (Ricke 1995, Nr.
234, S.151), the Robert Zehil Gallery, Beverly
Hills (Arwas 1987, p.127) and the Museum of
the Nancy School. Another vase on a bronze
stand was reproduced in the catalog to an
exhibition in Paris in 1974 (Bloch-Darmant
1974, Abb.S.108). The following note can be
found in Fabergé's accounts presented to the
Imperial Cabinet on 21st February 1898:
"Bamboo vase by Galle. Silver stand with leaves
200 roubles." (RGIA, f. 468, inv. 32, item 1635,
sheet 86).

The State Hermitage Museum, St. Petersburg
(23411).
EA

180. CIRCULAR SILVER BELL-PUSH
ON THREE SCROLL FEET decorated
with Rococo scrolls, the pushpiece set with
a moonstone – signed Fabergé, initials of
workmaster Julius Rappoport, assay mark of
St. Petersburg 1899–1908, assay master Yakov
Lyapunov – length 2½ in. (6.3cm).
Private Collection courtesy A. von Solodkoff

181. SILVER PHOTOGRAPH FRAME
IN ROCOCO STYLE with double
aperture, wood back and silver strut – stamped
K. Fabergé and with Imperial Warrant mark,
initials of workmaster J. Rappoport, assay
mark of St. Petersburg 1899–1908,
inv no. 6132, height 7¼ in. (18.5cm).
Original fitted wooden case with Imperial
Warrant, St. Petersburg and Moscow.
Private Collection

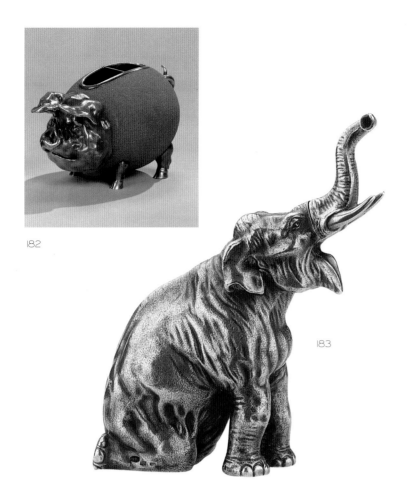

182

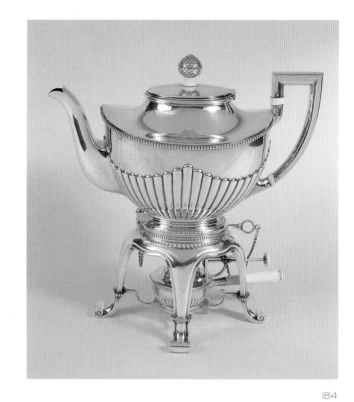

183

184

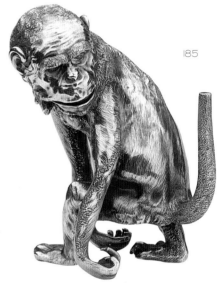

185

182. PIG MATCH HOLDER/STRIKER
silver mounted sandstone match container and
striker formed as a pig with an amusing
expressive face, the cavity in its back used for
Vesta matches, the rough surface of the body
serving to light the matches – Imperial Warrant
mark of Fabergé, maker's mark ICA for First St.
Petersburg Silver Artel, assay mark of St.
Petersburg 1908–1917, length: 6¼ in. (15.8cm).
Provenance: Ruth E. Gould, New York.
Bibliography: Habsburg/Solodkoff 1979, p. 42,
ill. no. 49; Solodkoff 1984, p. 28, ill., pp. 29, 167.
Exhibitions: Lugano 1987, no. 58, cat. p. 72, ill.;
Paris 1987, no. 58, cat. p. 68, ill.; Hamburg
1995, no. 4, cat. p. 51, ill.
The First Moscow Silver Artel (or association
of silversmiths) seems to have supplied Fabergé
regularly, if not exclusively with such objects
which bear the Artel's maker's mark and
Fabergé's mark as retailer. For a similar pig
match holder/striker with cabochon ruby-set
eyes, see ALVR 1983, no. 408, cat. p. 115, ill,
New York.
The Forbes Magazine Collection, New York

**183. SILVER LIGHTER IN THE SHAPE
OF AN ELEPHANT SITTING ON ITS
HINDQUARTERS** and proudly blowing
its twisted trunk which is detachable for use as
a wick holder, realistically undulating hide –
signed Fabergé, by the First Silver Artel ICA,
assay mark of St. Petersburg 1908–1917, 88
(zolotnik), inventory No. 23217, bearing also
later Imperial Warrant mark, hight 5⅞ in.
(14.6cm).
The model of this elephant is said to have
been inspired by a Japanese bronze of the
Meiji period. A similar elephant figure carved
in nephrite is in the Royal Collections,
cf. Snowman 1962, pl. 248.
The Hubel Collection

**184. SILVER KETTLE, STAND AND
SPIRIT LAMP** of oval section, with fluted
lower half, with artichoke finial, engraved with
monogram OM – signed K. Fabergé, separate
Imperial Warrant mark, initials of workmaster
S. Wäkaeva, assay mark of St. Petersburg
1899–1908, assay master Yakov Lyapunov, 88
(zolotnik), height 11½ in. (29.2cm).
Provenance: The initials are those of Wilhelmina
(Mina) Olsen, daughter of Fabergé client
Ludvig Nobel, wife of Hans (Ivan) Olsen,
director of a Nobel factory.
For a handsome *cloisonné* enamel kovsh given to
the same Hans Olsen by the workmen of the
Nobel factory, see cat. 108.
A La Vieille Russie

**185. SILVER LIGHTER SHAPED AS A
MONKEY** turning its head and looking in
astonishment at its tail which contains the
wick, realistically chased and engraved fur, the
head as the hinged cover for the container of
lighter fuel, with gilt interior – signed Fabergé
with separate Imperial Warrant mark, by the
First Silver Artel ICA, assay mark of
St. Petersburg 1908–1917, 88 (zolotnik), height
4½ in. (11.5cm).
The Hubel Collection

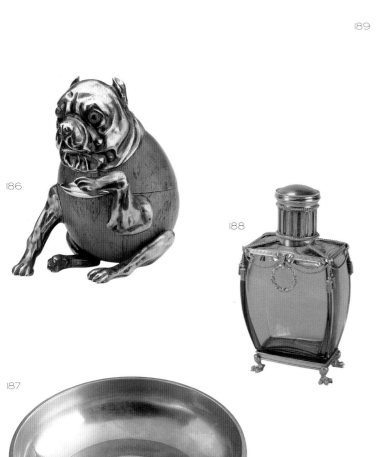

186

188

189

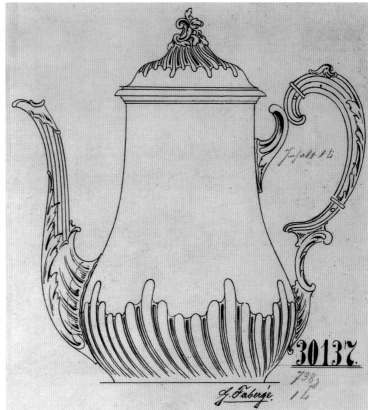

30137.

G. Fabergé.

190

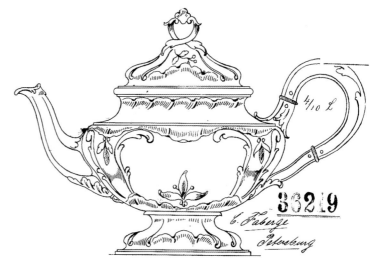

36219

C. Fabergé
Petersburg

186. SILVER-MOUNTED BURRWOOD
INKWELL in the shape of a begging pug
dog with round wooden body, opening to
reveal a silver-lined cavity, the head with
yellow and brown glass eyes, sitting upright
on its hindquarters – signed Fabergé with
(independent) Imperial Warrant mark, initials
of the First Silver Artel ICA, assay mark of
St. Petersburg 1908-1917, height 5^18 in.
(13.1cm).
The Eriksson Collection

187. PARCEL-GILT BOWL the center
inset with a silver rouble of Catherine the
Great, 1763, the outer lip chased with formal
foliage and with date 1914–1916 – signed
K. Fabergé, with Imperial Warrant mark, initials
of workmaster Alexander Wäkava, diameter
4^12 in. (11.5cm).
Bibliography: Traina 1998, p. 149 (left center).
John Traina Collection

188. GLASS TEA CADDY WITH
SILVER-GILT MOUNTS imitating smoky
quartz, the vessel comprises a tapering
rectangular section applied with Louis XVI-
style mounts – probably French c. 1900, assay
master KB, retailed by Fabergé, assay mark of
St. Petersburg 1899–1908, inventory no. 3044,
height 15.5cm. Original fitted wooden case
with Imperial Warrant, St. Petersburg.
Private Collection

189, 190. TWO FABERGÉ DRAWINGS
FOR DESIGNS OF A TEAPOT AND
COFFEE POT from the silver workshop of
Koch & Bergfeld in Bremen, Germany. Ink on
paper, laid down in an album of working
drawings by German and other Russian artists
– inscribed G. Fabergé, 30137 and C. Fabergé
Petersburg, 36219, c. 1900, the leather-bound
album 29^12 × 20 × 2^18 in. (75 × 51 × 5.5cm).
Koch & Bergfeld, a manufactory in Bremen,
Germany, specialized in silver wares such as
coffee and teasets, decorative objects and in a
large variety of cutlery. The company employed
up to 800 craftsmen around 1900, working for
clients mainly from Germany, Scandinavia,
Russia and southern Europe. Many silver items
were bought by retailers who later marked the
pieces with their own names and signatures.
This was apparently considered a normal
practice at the time, tolerated by the factory.
All major Russian firms ordered from Koch
& Bergfeld, including Fabergé, Gratchev and
Sazikov. In 246 large folio albums of designs
their names are occasionally recorded next to
the drawing of the piece they had ordered.
Bibliography: Heitmann, B.: Handwerk und
Maschinenkraft. Die Silbermanufaktur Koch
& Bergfeld in Bremen, Exhibition catalogue,
Museum.
Koch & Bergfeld, courtesy of Mr Klaus
Hansen, Kiel

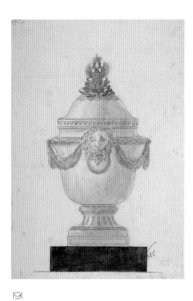

191

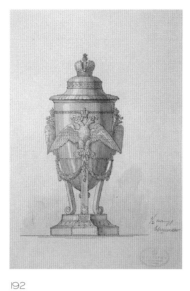

192

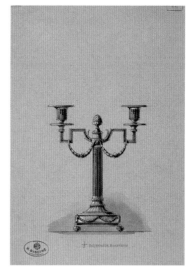

191. DESIGN IN PENCIL AND
WATERCOLOR for a silver wine-cooler
from an Imperial service – stamped
"K FABERGÉ, court jeweler,
St.Petersburg",18.V.10, 27¹⁄₈×18¹⁄₈ in.
(69×46cm).
Provenance: The Imperial Cabinet; State
Museum of Ethnography, 1941.
Exhibited: St. Petersburg/Paris/London
1993/4, cat. 306.
The wine-cooler in this sketch is drawn in the
traditions of ceremonial silver dinner services at
the time of Catherine II. The lid is topped with
a double-headed eagle leaning on an anchor.
This drawing is a variation of the actualized
plans for additions to the Winter Palace's
dinner service.
The State Hermitage Museum
(ERO sh – 1619).
LAZ

192. DESIGN IN PENCIL AND
WATERCOLOR for a silver racing trophy
– stamped "K.FABERGÉ Court jeweler
Morskaya B. S. Petersburg", 14¹⁄₁₆×9¹⁵⁄₁₆ in.
(35.7×25.2cm). Inscribed "¹⁄₂ actual size,
900 roub".
Provenance: The Imperial Cabinet;
State Museum of Ethnography, 1941.
Exhibited: St. Petersburg/Paris/London
1993/4, cat. 307.
Such trophy cups served as Imperial prizes
during various regimental reviews, naval
regattas and horse races.
The State Hermitage Museum
(ERO sh – 1593).
LAZ

193. DESIGN IN WATERCOLOR AND
GOUACHE for a two-light candlestick –
stamped "K. FABERGÉ, S. Petersburg",
18¹³⁄₁₆×11¹⁵⁄₁₆ in. (47.8×30.2cm).
Inscribed "¹⁄₂ actual size".
Provenance: The Imperial Cabinet;
State Museum of Ethnography, 1941.
This candle stick forms part of the plans for a
large silver toilet set, proposed to the Cabinet.
The State Hermitage Museum
(ERO sh – 1698).
LAZ

194. DESIGN IN PENCIL AND
WATERCOLOR for a *surtout de table* for
the ceremonial dinner service for Tsarevich
Nicholas Alexandrovich – stamped
"K. FABERGÉ", 10⁵⁄₈×14⁵⁄₁₆ in.
(27×36.4cm). Inscribed: "Empire".
Provenance: The Imperial Cabinet;
State Museum of Ethnography, 1941.
Exhibited: St. Petersburg/Paris/London
1993/4, cat. 326.
According to the Romanov tradition,
a ceremonial silver dinner service was
commissioned for the wedding of Tsarevich
Alexandrovich from the Fabergé firm. This
drawing was probably one of the variations
for the table decoration offered to the Cabinet
for their examination in 1894.
The State Hermitage Museum
(ERO sh – 1722).
LAZ

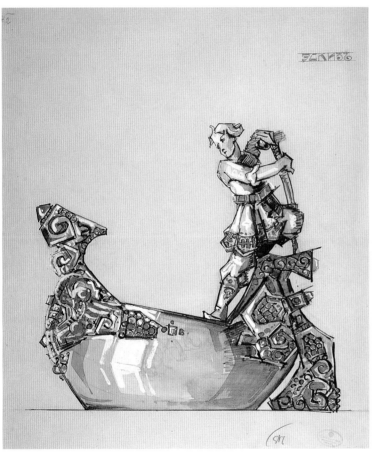

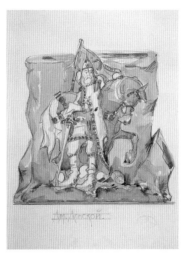

195. DESIGNS IN WATERCOLOR
AND GOUACHE for three vases from the
ceremonial dinner service of Grand Duchess
Olga Alexandrovna – signed "K. FABERGÉ",
12¼×17⁷⁄₁₆ in. (31×44.4cm).
Provenance: The Imperial Cabinet;
State Museum of Ethnography, 1941.
Exhibited: St. Petersburg/Paris/London
1993/4, cat. 330.
The wedding of Grand Princess Olga
Alexandrovna and Duke Peter Oldenburg took
place in 1901 and Fabergé made a ceremonial
dinner service for the occasion. This drawing
shows one variation of the table decoration
from the set with one large and two small
silver fruit stands with glass inserts. The large
vase is decorated with figures of Venus and
Cupid, holding a small shield with the
monogram OA beneath the Imperial crown.
The State Hermitage Museum
(ERO sh – 1719).
LAZ

196. DESIGN IN PENCIL AND
WATERCOLOR for a silver kovsh
with Russian warrior figures – stamped
"K. FABERGÉ, court jeweler St. Petersburg",
15¹⁵⁄₁₆×12¹⁵⁄₁₆ in. (40.5×32.8cm).
Provenance: The Imperial Cabinet;
State Museum of Ethnography, 1941.
Exhibited: St. Petersburg/Paris/London
1993/4, cat. 338.
For the opening of the Olympic Games in
Stockholm, a jewelers' competition was
announced to create a Russian Imperial prize
in the form of a large silver kovsh. Many
famous jewelers took part, but the winning
firm was Fabergé. The Fabergé workmasters
made a silver kovsh in the shape of an ancient
boat with the figures of Old Russian warriors.
This is now kept at the Olympic Museum in
Lausanne. This drawing is one of the variants
for this commission. The firm's workmasters
made a number of similar objects: there is a
kovsh almost identical in its design to the one

on this drawing in the Forbes Magazine
Collection.
The State Hermitage Museum
(ERO sh – 1591).
LAZ

197. DESIGN IN WATERCOLOR for a
tray and salt-cellar in the 17th-century style –
stamped "K. FABERGÉ Morskaia
B. S. Petersburg", 26³⁄₈×19½ in. (67×49.5cm).
Inscribed: "I imperially order this commission.
Baron Frederiks. 19 May 1901".
Provenance: The Imperial Cabinet; State
Museum of Ethnography, 1941
This is a modern rendition of the jeweled and
enameled dish of Tsar Michael Feodorovich in
the Kremlin Armoury Museum. The dish is
dated 12 July 1901.
The State Hermitage Museum
(ERO sh – 1598).
LAZ

198. DESIGN IN WATERCOLOR AND
GOUACHE for a silver kovsh with a figure
of Sadko – stamped "K. FABERGÉ, court
jeweler, S. Petersburg", 18.V.(19)10,
26³⁄₄×23¹³⁄₁₆ in. (68×60.5cm). Inscribed:
"Study".
Provenance: The Imperial Cabinet; State
Museum of Ethnography, 1941.
Apparently, this kovsh with the figure of the
epic hero Sadko was one of the first proposals
by Fabergé for the Olympic prize.
The State Hermitage Museum
(ERO sh – 1607).
LAZ

199. DESIGN IN PENCIL AND
WATERCOLOR for a beaker with a figure
of Dmitri Donskoi – stamped "K. FABERGÉ,
court jeweler, St. Petersburg", 20³⁄₁₆×13¹⁄₁₆ in.
(51.3×33.2cm).
Inscribed: DM Donskoi.
Provenance: The Imperial Cabinet; State
Museum of Ethnography, 1941.
The State Hermitage Museum
(ERO sh – 1603).
LAZ

5
THE MOSCOW
OBJETS D'ART

MOSCOW OBJETS D'ART

Ann Odom in her pioneering article about Fabergé's Moscow silver production[1] notes that in the vast literature on Fabergé, "scarcely ten pages have been written about his Moscow workshops." While Moscow silver has received some mention by various authors, and at least one of the Moscow jewelers has become the subject of an article,[2] nothing at all has been written about Moscow-made *objets d'art*.

Two collaborators of the great Russian craftsman, François Birbaum (1919), his chief designer, and Henry Bainbridge (1949), his London representative, both wrote somewhat disparagingly about the Moscow branch. Bainbridge went so far as to say that "the way the Moscow branch was run was an attempt to exploit the genius of Fabergé on a commercial basis".[3] Moscow silver is grudgingly lauded by them for its "high artistic value" and "its monumental conception and imposing splendor"[4] even though it is "on the showy side".[5] On the subject of the jewelry and objects made in Moscow, Birbaum wrote very condescendingly that "some branches, such as jewelry manufacture and gold and enamel work, were inferior in quantity and quality to those of St. Petersburg"[6]; and a little further: "Jewelry and gold articles were nothing to speak of, as they were mainly inferior versions of those made in St. Petersburg". Bainbridge[7] is cautiously ambiguous about Moscow-made objects, of which only three were known to him, one admittedly being the exquisite cigarette-case with a diamond-set snake in the English royal collection (fig. 1). Kenneth Snowman mentions Moscow[8] and lists its staff[9] but, apart from showing archival illustrations, makes no mention of jewelry or objects from this branch. The present author, in the exhibition *Fabergé Imperial Jeweler* (1993/4), grouped 23 items under the title of "The Moscow Workshops", of which, however, only four were objects.[10]

The Moscow branch opened in February 1887. It was headed by Alan Bowe, Fabergé's partner, between 1887 and 1907, assisted by his two brothers, Arthur and Charles. Fabergé himself called Bowe, whom he esteemed highly, as "my assistant and first manager". The showroom was located at Kuznetzki Most no. 4, the factory at no. 4, Kiselnyi Lane, San-Galli's house. The Bowes were succeeded in 1906 by Otto Jarke and later by Andrea Marchetti, a specialist in silver and gems. Fabergé's son, Alexander, took over the management of the Moscow branch between 1912 and 1918.

According to Birbaum, the Moscow factory was divided into two departments, jewelry and silver/gold, each with a manager, an assistant and a worksmaster.[11] The silver workshop was headed by Michael Chepurnov, a fine craftsman, who is listed between 1913 and 1917 as "manager" of the factory. The jewelry workshop was run by Knut Oskar Pihl between 1887 and 1897 and thereafter by the Pole Mitkevich, both described as "fine craftsmen". Several run-of-the-mill cigarette-cases bearing Pihl's signature O.P. are known (cat. 226). The combination of a maker's mark with Fabergé's Imperial Warrant classifies them among the few exceptions to the hallmarking rule in Moscow.[12]

Gustav Jahr, a Balt, is mentioned by Bainbridge as manager and craftsman of a workshop specializing in *objets d'art*, and as responsible for "very many cigarette-cases [which] were made in Moscow, in gold, silver and enamel."[13] Nothing else is known of Jahr. There was, however, a Moscow craftsman of the same name[14] from whom Cartier ordered 160 objects, of which at least fifty were supplied[15] including "table bells, paper-knives, pin-boxes, cigarette-case and ashtrays, magnifying glasses, scent bottles and parasol handles". Cartier also asked Jahr to send two palettes with his choice of enamels to Paris.

One of the objects acquired by Cartier from a certain Yahr, a photograph frame in the shape of a jeweled and enameled gold camera (cat. 990d), is strikingly similar in style and execution to an easel frame from Fabergé's Moscow workshop headed by Gustav Jahr (cat. 243). The list of objects ordered and the similarity of style would seem to indicate that

FIG I. DIAMOND-SET AND ENAMELED CIGARETTE-CASE by Fabergé, Moscow before 1899, height 3¹¹⁄₁₆ in. (9.6cm). Reproduced by kind permission of HM Queen Elizabeth II

FIG 2. JEWELED AND ENAMELED GOLD TRIPOD FRAME with miniature of Tsarina Alexandra Feorodovna – with Imperial Warrant mark of Fabergé, Moscow 1899–1908, height 5³⁄₁₆ in. (13.1cm). Photograph courtesy of The Cleveland Museum of Art, The India Minschall Collection

FIG 3. JEWELED AND ENAMELED GOLD TRIPOD FRAME with photograph of Grand Duke Michael Nicolaevich of Russia – by Fabergé, (Moscow 1899–1908), height 4⅞ in. (12.5cm). Reproduced with kind permission from HM Queen Margrethe of Denmark

Jahr and Yahr are the same person. If Jahr was a full-time employee of Fabergé, Cartier acquired far more objects from Fabergé than the few hitherto recorded (six hardstone animals in 1910 and a flower in 1911–17). On the other hand, Jahr may have been employed only part-time by Fabergé, supplying others such as Cartier, but also Ovchinnikov with *objets d'art* according to their own specifications and designs.

Since, with very few exceptions (cat. 228), no Moscow-made item ever bears a maker's hallmark, it is imprudent to make any attributions. However, it seems probable that Gustav Jahr, an accomplished goldsmith and enameler, together with a small number of technicians, may have produced all the objects bearing the Moscow hallmark. After all, setting aside the stock-in-trade silver and gold cigarette-cases, the number of Moscow-made *objets d'art* is very small – not more than a few hundred enameled pieces.

It seems worthy of note that the first objects by Fabergé to be sold in London were supplied by the Moscow branch in 1903. When the business was moved from Berners Hotel to Portman House, Grosvenor Square, under the Management of Arthur Bowe, and later moved to 32 Burlington Street, it was as a branch of the Moscow business. Only after the dissolution of the partnership with the Bowe family in 1906 did the London branch come under the management of St. Petersburg. This might mean that the majority of the objects sold in London before 1906 were *objets d'art* from Moscow.

The design of some of the objects made in Moscow is highly original, possibly originating from Fabergé's own St. Petersburg studio. Many of the best are in the Art Nouveau idiom and date from before 1899. They include the dark-blue enamel cigarette-case with diamond-set snake referred to by Bainbridge (see above), another royal-blue case with gold peonies (cat. 225 and dust jacket) and yet another with *plique-à-jour* enamel dragonflies from the collection of the Grand Dukes of Hessen (cat. 224). Possibly the most interesting of Fabergé's Moscow cigarette-cases is in the Esthetic Style, a white *guilloché* enamel box with discs in different colors within circular *cloisonnés*, each with a rose-cut diamond center. Another glorious product of the Jahrs workshop is an oval frame in bright-yellow *guilloché* with a contrasting green laurel border entwined with four-color gold flower swags (cat. 244). The quality of the gold chasing is superlative, on a par with anything produced in St. Petersburg and closely related to objects made in the workshop of Victor Aarne (cat. 691a, 692, 694).

Géza von Habsburg

Notes

1. Anne Odom, "Fabergé: The Moscow Workshops" in Habsburg/Lopato (1996/7), p. 104–114.

2. Muntian on Andrianov in Sydney (1996), pp. 26f; Stockholm (1997), p. 48f.

3. Bainbridge (1949), p. 132.

4. Fabergé/Skurlov (1992), p. 11.

5. Bainbridge (1949), p. 132f.

6. Fabergé/Skurlov, (1992), p. 11.

7. Bainbridge (1949), p. 134.

8. Snowman (1953), p. 128.

9. *Ibid.*, p. 126f.

10. Habsburg (1986), p. 342, note 12.

11. Birbaum might be mistaken, as both Bainbridge and Snowman, based on Eugene Fabergé's information, mention the silver, the jewelry and the objects departments as separate entities.

12. See chapter 7, p. 75.

13. Bainbridge (1949), p. 131.

14. Cyrillic can be read both as 'J' or 'Y'.

15. See Nadelhoffer (1984), p. 91; Judy Rudoe, *Cartier 1900–1939*, cat. 37.

200

200A

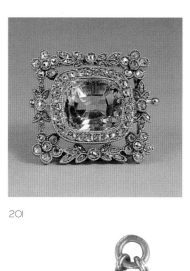

201

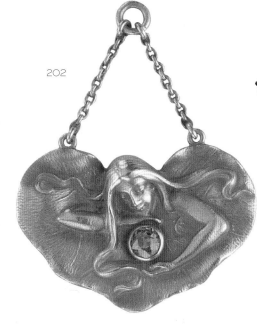

202

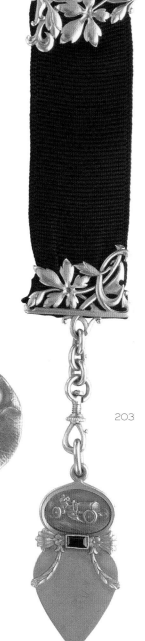

203

200. AESTHETIC MOVEMENT BROOCH decorated with disks enameled in shades of turquoise, yellow, peach, chartreuse and burnt orange on white *guilloché*, enamel ground, rose-cut diamonds border – Cyrillic initials KF for Karl Fabergé, assay mark of Moscow before 1899, 56 (zolotnik), length 1¹⁄₈ in. (2.8cm).
Exhibited: Stockholm 1997, no. 265, cat. p. 218, ill.
The pattern of this brooch (and of a related cigarette-case) was inspired by the Aesthetic Movement, an assimilation of Japanese influences into the Arts and Crafts Movement. This, and many other Muscovite objects by Fabergé, are clear evidence of the designers' skill and the technical excellence of the Moscow workmasters.
The Forbes Magazine Collection, New York

200A. AESTHETIC MOVEMENT CIGARETTE CASE an enameled gold-mounted cigarette case in the Aesthetic Style of white *guilloché* enamel decorated with discs of brightly colored enamel over *guilloché* sunburst patterns centered by diamonds, cabochon sapphire pushpiece – signed with Imperial Warrant mark of Fabergé, assay mark of Moscow before 1899, 72 (zolotnik), inventory no. 11366.
Provenance: J. Jeffs Esq.
Bibliography: Solodkoff 1984, p. 174, ill; Kelly 1985, p. 16, ill. p. 17; Wutternberg 1987, p. 1403, ill.; Habsburg 1987, no. 469, p. 238, ill., Forbes 1987, no. 7, p. 15, ill.; Forbes 1988, p. 43, ill.; Hill 1989, p. 136, ill. plate no. 95; Decker 1996, p. 56, ill.; Habsburg 1996, p. 68, ill plate 47.
Exhibited: Detroit 1984, no. 44; Munich 1986/7, no. 469, cat. p. 238; Lugano 1987, no. 99, cat. p. 97, ill.; Paris 1987, no. 99, cat. p. 93, ill.; London 1987, no cat.; Zurich 1989, no cat. 116, cat. p. 143, ill. p. 57, plate 29; New York/San Francisco et al. 1996/7, no. 259, cat. p. 253, ill.
This cigarette case is one of the most original designs from the Fabergé Moscow workshop; it is also one of the most technically accomplished. For a brooch with the same design, see cat. 200.
The Forbes Magazine Collection, New York

201. PLATINUM-MOUNTED AQUAMARINE AND DIAMOND BROOCH the faceted cushion-shaped stone set within a border of rose-cut diamonds and a similarly decorated outer foliate border – by Fabergé, unmarked, height ³⁄₄ in. (2cm), designed by Alma Pihl.
Provenance: Alma Pihl, designer at Fabergé's jewelry workshop.
Exhibited: Helsinki 1980; Helsinki 1988; Helsinki 1991; A. Tillander, Helsinki 1995; Christie's Stockholm 1996; Corcoran 1996; Stockholm 1997, cat. 239.
Note: According to her descendants, this was Alma Pihl's favorite brooch.
Private Collection courtesy of Ulla Tillander-Godenhielm, Finland

202. GOLD ART NOUVEAU PENDANT chased with a nymph leaning over a lily-pad, set with a diamond – signed with initials KF for Karl Fabergé, (Moscow) 1899-1908, width 1¹⁄₄ in. (3.2cm)
Private Collection, New York

203. ART NOUVEAU GOLD FOB KEY CHAIN on a black rep ribbon set with a single baguette sapphire, chased with a vintage racing motor-car – signed with initials KF for Karl Fabergé, assay mark of Moscow 1908–1917, inventory no. 5923, length 5¹⁄₂ in. (14cm).
Private Collection, New York

205

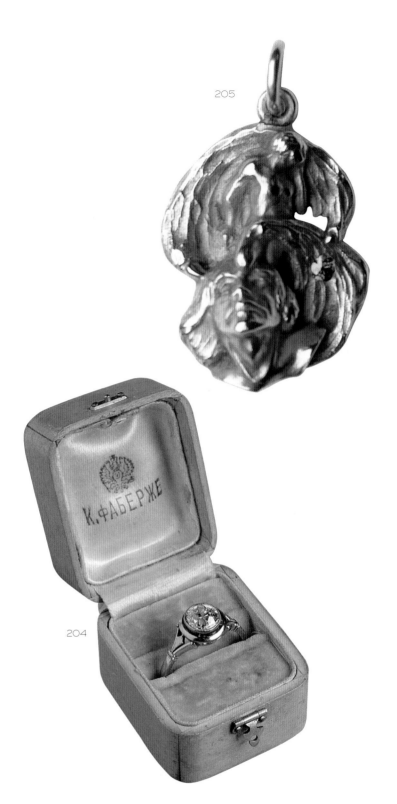

204

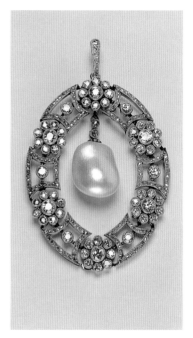

206

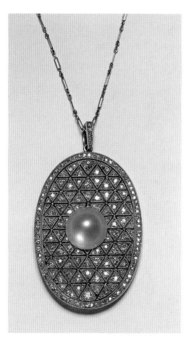

207

207. OVAL GEM-SET GOLD-
MOUNTED PLATINUM BROOCH
pendant with chain set with circular-cut
diamonds in triangular mounts, with central
pearl and rose-cut diamond border – by
Fabergé, length 2 in. (5cm).
Provenance: discovered 1990 with a group of
18 jewels in two tin boxes, all with labels of the
Fabergé firm, in 13, Solyanka Street, Moscow,
apartment no. 4, where Vladimir Stepanovich
Averkiev, a director of the firm had lived.
Eight of these jewels are in the Kremlin
Armory, the other eight in the Collection of
the Gokhran, Moscow.
Bibliography: Tatiana Muntian, "A Treasure
found in Solianka Street", in Habsburg/Lopato
1993/4, pp. 148–151; and Tatiana Muntian:
"Fabergé im Kreml" in Hamburg 1995, p. 30/1.
Exhibited: Moscow 1992, 66, ill. p. 130;
Torre Canavese 1994, cat. 33, ill. p. 97; Sydney
1996, cat. 59, ill. p. 96.
Kremlin Armory Museum (MP 11556/1–2)

205. GOLD ART NOUVEAU
PENDANT cast with a head of a man and
a male nude among drapery above it, set with
a golden yellow brilliant cut diamond, the
reverse engraved with Cyrillic initials PVG
and date 13 XII 1914 – signed with Imperial
Warrant mark of Fabergé, assay mark of
Moscow 1908–1917, length 1 in. (3.8cm).
Private Collection

206. OVAL DIAMOND-SET
PLATINUM BROOCH with a central
pendant pearl – signed Fabergé, assay mark of
Moscow, height 2 in. (5.2cm).
Provenance: acquired by the Kremlin Armory
in 1991.
The Kremlin Armory Museum

204. GOLD-MOUNTED SOLITAIRE
DIAMOND RING set with a brilliant-cut
diamond of approximately 1 ct. – Cyrillic
initials KF for Karl Fabergé, 56 (zolotnik)

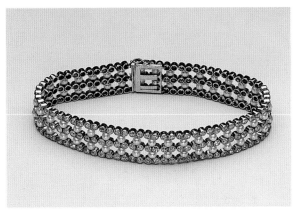

208

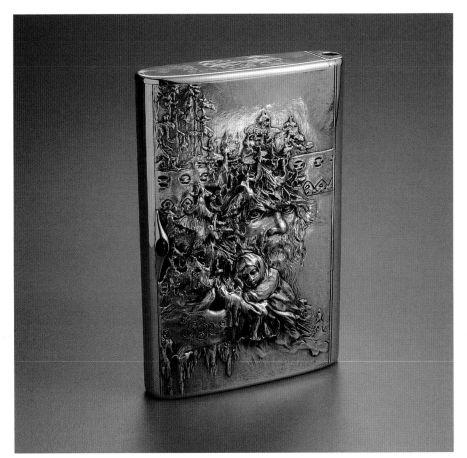

209

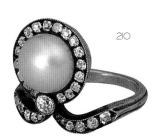

210

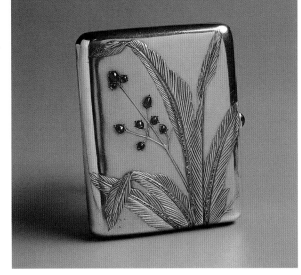

211

208. GEM-SET GOLD-MOUNTED
PLATINUM BRACELET comprising three
rows of rose-cut diamonds connected by pearls
set in platinum, with a yellow gold mount – by
Fabergé, inv no. 96174, length 7³⁄₈ in.
Exhibited: Moscow 1992, cat. 70, ill. p. 131;
Sydney 1996, cat. 68, ill. p.98.
Kremlin Armory Museum (MP – 11566)

209. LARGE SILVER TABLE
CIGARETTE BOX with match
compartment and aperture for tinder cord,
the cover chased with a scene from Russian
folklore, cabochon sapphire thumbpiece –
stamped with Imperial Warrant mark, assay
mark of Moscow 1899–1909, inventory no.
21115, length 7¹⁄₄ in. (18.5cm).
Private Collection

210. GOLD-MOUNTED PLATINUM
PEARL AND DIAMOND CLUSTER
RING – signed KF, assay mark of Moscow
1908–1917, 56 (zolotnik), inv no. 80323.
Exhibited: Moscow 1992, cat. 75, ill. p. 132;
Sydney 1996, cat. 70, ill. p.98.
Kremlin Armory Museum (MR – 11564)

211. GEM-SET SILVER CIGARETTE-
CASE chased on one side with fern fronds,
their berries set with nine cabochon rubies,
their stems with rose-cut diamonds, cabochon
sapphire pushpiece – signed with Imperial
Warrant mark, assay mark of Moscow
1899–1908, inventory no. 11429, length 3⁵⁄₈ in.
(9.2cm).
Bibliography: Traina 1998, p. 66.
John Traina Collection

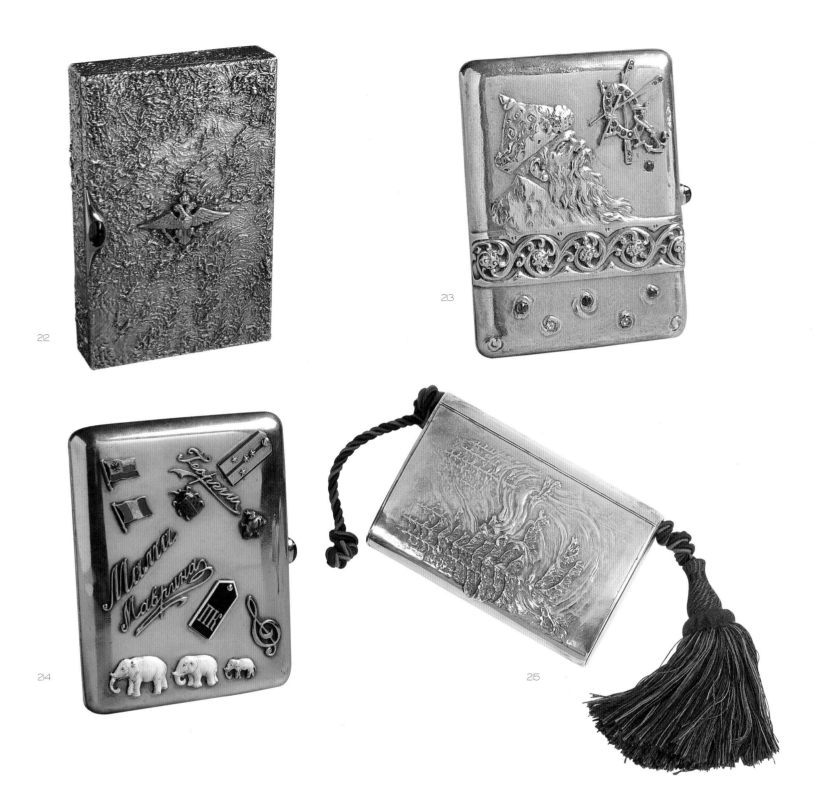

212. SAMORODOK SILVER IMPERIAL PRESENTATION CIGARETTE-CASE

the cover is applied with a gold double-headed eagle, cabochon sapphire thumpiece – stamped with Imperial Warrant, assay mark of Moscow 1908–1917, length 3⅞ in. (9.8cm). Original red leather presentation case. With presentation letter to A. Beal dated 1911: "I am desired by Prince Obolensky, on behalf of The Empress of Russia, to send you the enclosed silver case, as a Souvenir of Her Imperial Majesty's recent visit to England. Yours faithfully, T. Gordon Watson".
Bibliography: Traina 1998, p. 102 (top).
Exhibited: St. Petersburg/Paris/London 1993/4, cat. 142.
John Traina Collection

213. GEM-SET SILVER CIGARETTE-CASE IN THE OLD RUSSIAN STYLE

chased with a head of a Boyar over a band of scrolling foliage, set below with rubies, sapphires and emeralds, also applied with a gold maritime motif set with rubies and sapphires, and with cabochon sapphire pushpiece – stamped with Imperial Warrant mark of Fabergé, assay mark of Moscow 1899–1908, assay-master Ivan Lebedkin, inventory no. 21133. Inscribed: "From Comrades in Arms, Odessa, 1906".
Bibliography: Traina 1998, p. 153 (lower left)
John Traina Collection

214. SILVER SOUVENIR CIGARETTE-CASE the plain sides applied with three elephants, flags, jetons and signatures "Mama" and "Mavrika", cabochon garnet pushpiece – stamped with Imperial Warrant, assay mark of Moscow 1908–1917, inventory no. 4797, length 4 in. (10.1cm).
Bibliography: Traina, 1998, p. 80.
John Traina Collection

215. LARGE SILVER CIGAR-CASE WITH MATCH COMPARTMENT

the cover is decorated in relief with a wintery landscape with fir trees and a snowy road in the shape of the face of Father Frost, profusely set with diamond chips, gilt interior – signed with Imperial Warrant mark of Fabergé, assay mark of Moscow 1899–1908, length 7⅝ in. (19.3cm).
Private Collection courtesy A. von Solodkoff

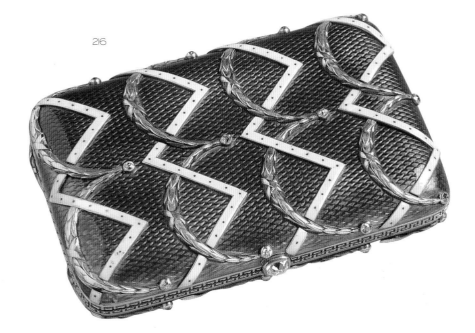

216

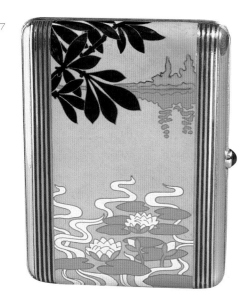

217

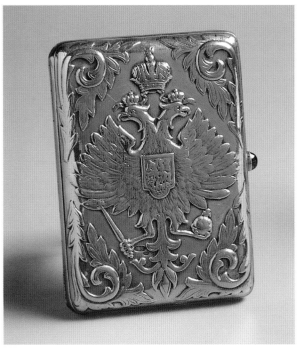

218

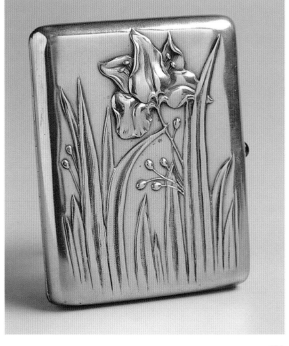

219

216. ENAMELED SILVER-GILT CIGARETTE-CASE of purple *guilloché* enamel applied with laurel swags and opaque white enamel zig-zags, rose-cut diamond pushpiece – stamped with Imperial Warrant, assay mark of Moscow before 1899, length 3¼ in. (8.2cm).
Bibliography: Traina 1998, p. 72.
Exhibited: New York 1983, cat. 195;
New York/San Francisco et al. 1996/7, cat. 364
John Traina Collection

217. ENAMELED SILVER CIGARETTE-CASE IN THE JAPANESE STYLE
painted en plein with a pale blue lake, with waterlilies in the foreground, dark foliage above, with a wooded island in the background, burnt orange enamel ribbed borders to both front and the plain silver back – stamped with Imperial Warrant mark of Fabergé, assay mark of Moscow before 1899, inventory no. 10856, length 4¼ in. (10.8cm).
An interesting and unusual case of *Japonisme* in Fabergé's firm combined with Art Nouveau elements.
André Ruzhnikov

218. BURNISHED SILVER CIGARETTE-CASE chased with an Imperial double-headed eagle, with acanthus foliage spandrels, cabochon sapphire pushpiece – stamped with Imperial Warrant, assay mark of Moscow 1908–1917, length 3⅜ in. (8.6cm).
Bibliography: Traina 1998, p. 98 (left).
John Traina Collection

219. ART NOUVEAU SILVER CIGARETTE-CASE the cover is chased with an iris and leaves, cabochon sapphire pushpiece – stamped with Imperial Warrant of Fabergé, assay mark of Moscow before 1899, length 4¼ in. (10.8cm).
Bibliography: Traina 1998, p. 124 (right).
John Traina Collection

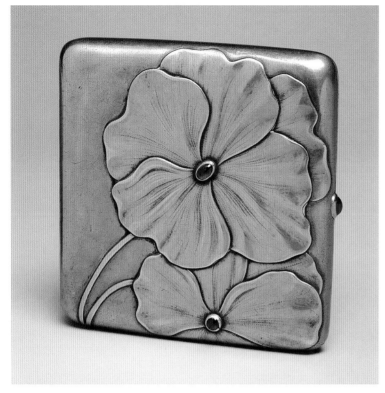

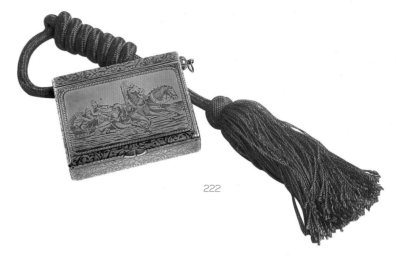

220

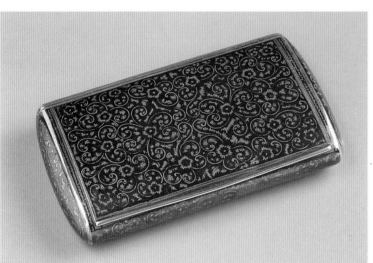

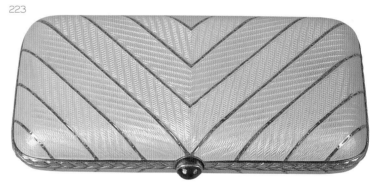

222

223

221

222. NIELLOED SILVER CIGARETTE-CASE the cover is decorated with a troika, the body with scrolling foliage, the base with an empty circular reserve – signed with Imperial Warrant mark of Fabergé, Moscow 1899–1908, length 3$\frac{1}{4}$ in. (8.3cm).
Bibliography: Bainbridge 1966/8, 119 (who describes this box as the only example of niello work in the oeuvre of Fabergé); Snowman 1953/68, pl. 94; Snowman 1979, p. 36.
Exhibited: Munich 1986/7, cat, 43.
Niello work is rare in Fabergé's *oeuvre*, but not unique. For an 18th-century style cream-jug see Snowman 1953/68, ill. 98.
Private Collection

220. ART NOUVEAU GEM-SET SILVER CIGARETTE-CASE chased with large four leaf clovers with cabochon sapphire centers, cabochon sapphire pushpiece – stamped with Imperial Warrant mark, assay mark of Moscow 1899–1908, length 3$\frac{5}{8}$ in. (9.2cm).
André Ruzhnikov

221. NIELLOED SILVER CIGARETTE-CASE with an overall decoration of scrolling foliage – signed with Imperial Warrant of Fabergé, assay mark of Moscow 1899–1908, inventory no. 16924, length 4 in. (10cm).
Bibliography: Traina 1998, p. 134.
John Traina Collection

223. ENAMELED SILVER-GILT LADY'S CIGARETTE-CASE of pale yellow *guilloché* enamel decorated with V-shaped bright-cut gold stripes, with cabochon sapphire pushpiece and palm leaf borders – signed K. Faberge, assay mark of Moscow 1899–1908, 56 (zolotnik), inventory no. 28266, length 2$\frac{7}{8}$ in. (7.3cm).
Bibliography: Snowman 1964, p. ill. 117, between pages 48 and 49.
Private Collection

131

224. ART NOUVEAU PLIQUE-À-JOUR ENAMEL AND GOLD CIGARETTE-CASE the burnished gold case decorated with four blue and white dragonflies – stamped with Imperial Warrant mark of Fabergé, assay mark of Moscow 1899–1908, inventory no. 19234, length 3¾ in. Inscribed: "For my darling Ernie from Nicky and Alix, Xmas 1900".
Provenance: Given by Tsar Nicholas II ("Nicky") and Tsarina Alexandra Feodorovna ("Alix") to Grand Duke Ernest Louis ("Ernie") of Hesse and the Rhine (1868–1937), a brother of the Russian Empress, who was married to Victoria Melita, a granddaughter of Queen Victoria.
Exhibited: Munich 1986/7, cat. 162.
A rare use of this technique by Fabergé in an exquisite design underlining the virtuosity of the Moscow workshop.
Private Collection

225. ART NOUVEAU DIAMOND-SET ENAMELED GOLD CIGARETTE-CASE of royal blue *guilloché* enamel decorated with gold branches of lotus with triple clusters of "berries" set with rose-cut diamonds and with rose-cut diamond push-piece – Imperial Warrant mark of Fabergé, assay mark of Moscow before 1899, inventory no. 14503, length 3¾ in. (9.5cm).
One of Moscow's most felicitous Art Nouveau creations together with the blue enamel case with serpent (HM Queen Elizabeth II) and the case with *plique-à-jour* dragonflies.
Private Collection

226. THREE-COLOR GOLD CIGARETTE-CASE OF CIRCULAR SECTION with two yellow gold bands engraved with scalework flanking a pink gold band similarity decorated, cabochon sapphire pushpiece – signed K. Fabergé, initials of workmaster Oskar Pihl, assay mark of Moscow before 1899, length 3⅜ in. (8.7cm).
Bibliography: Traina 1998, p. 53.
Exhibited: Corcoran 1996/7; Lahti, Finland 1997.
Oskar Pihl was apprenticed with August Holmström, became master in 1887 and headed the workshop producing objects and jewels in Fabergé's Moscow branch from 1887 to 1897. Objects signed by Oskar Pihl are scarce and it is rare to find objects made in Moscow bearing any workmaster's initials.
John Traina Collection

227. JEWELED GOLD CIGARETTE-CASE the matte cover and base are both decorated with four arrows intersecting at right angles set with diamonds and rubies, with crowned diamond-set initial "L", also set with cabochon rubies and turquoises, cabochon ruby pushpiece – stamped with Imperial Warrant, assay mark of Moscow 1899–1908, assay master Ivan Lebedkin, inventory no. 26480, length 3¾ in. (9.5cm).
Bibliography: Traina 1998, p. 78.
John Traina Collection

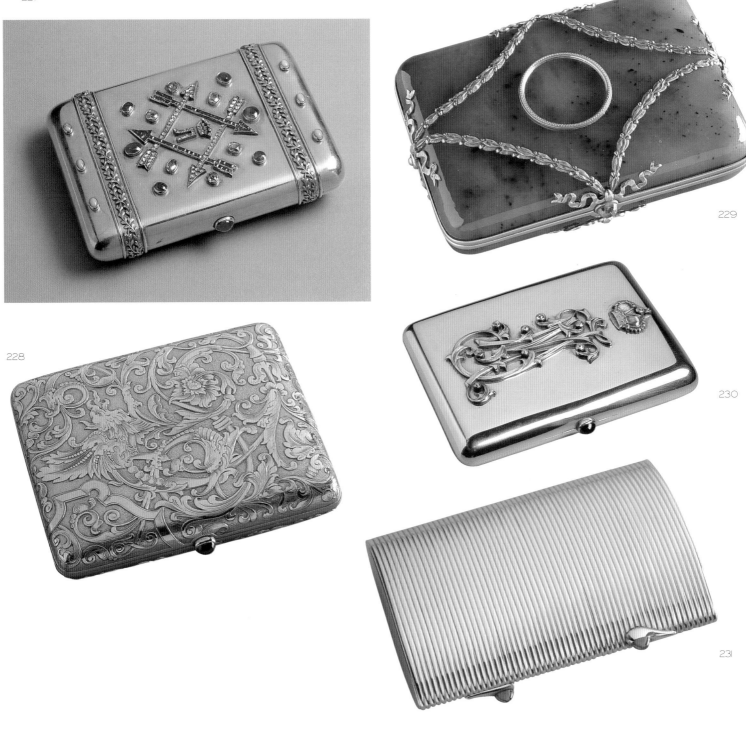

228
229
230
231

228. TWO-COLOR GOLD
CIGARETTE-CASE IN THE
RENAISSANCE STYLE the pink matte
gold body is chased with yellow gold
cartouche, scrolling acanthus foliage and
mythical birds, cabochon sapphire pushpiece –
signed with Imperial Warrant mark, initials of
workmaster Oskar Pihl, assay marks for
Moscow before 1899 and Moscow 1890,
unrecorded assay master's initials AA, inventory
no. 4803, length 3½ in. (9cm).
Bibliography: Traina 1998, p. 96 (top).
Exhibited: New York/San Francisco etc.
1996/7, cat. 368.
John Traina Collection

229. GOLD-MOUNTED NEPHRITE
CIGARETTE-CASE applied with yellow
gold laurel swags suspended from pink gold
ribbons, cabochon emerald pushpiece – initials
KF, assay mark of Moscow before 1899,
inventory no. 15726, length 3¾ in. (9.5cm).
Bibliography: Traina 1998, p. 114 (bottom).
Exhibited: New York/San Francisco etc.
1996/7, cat. 370.
John Traina Collection

230. BURNISHED-GOLD
CIGARETTE-CASE the cover is applied
with a princely monogram "MJ", the reverse
with two coats-of-arms, cabochon sapphire
pushpiece – stamped with Imperial Warrant
mark of Fabergé, assay mark of Moscow 1899-
1908, assay-master Ivan Lebedkin, inventory
no. 25678, length 3¾ in. (9.5cm).
Bibliography: Traina 1998, p. 144 (top).
John Traina Collection

231. REEDED CIGARETTE-CASE
of convex shape with two cabochon sapphire
thumbpieces – Imperial Warrant of Fabergé,
assay mark of Moscow before 1899, inventory
no. 12707, length 3½ in. (9cm).
Bibliography: Traina 1998, p. 99 (center right).
John Traina Collection

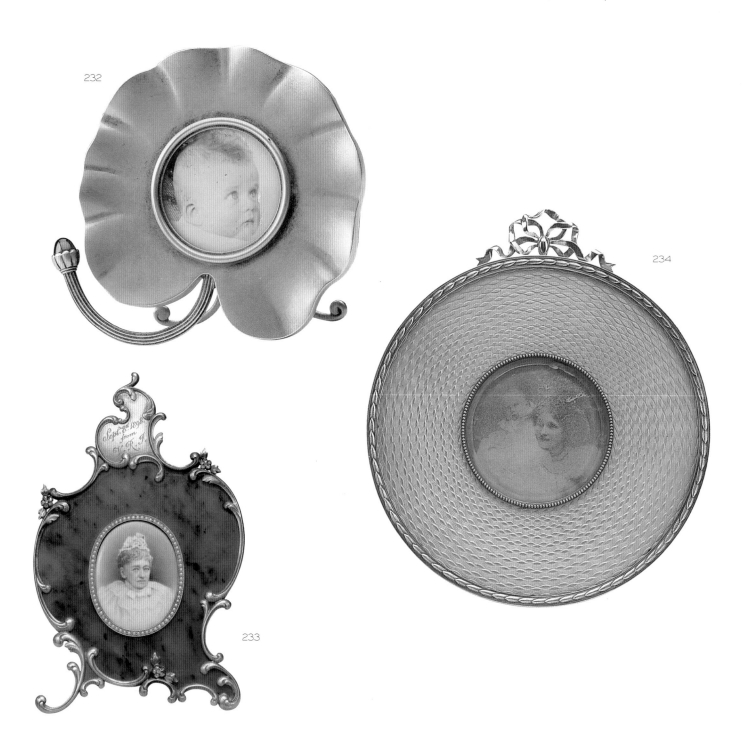

232

234

233

232. SILVER-GILT FRAME SHAPED AS A LILY-PAD with circular aperture and reeded stem with cabochon sapphire terminal – signed with Imperial warrant mark of Fabergé, assay mark of Moscow 1899–1908, inv. 15307, width 2⁷⁄₁₆ in. (6.2cm). Contains a photograph of a son of Count Sheremetiev.
Provenance: From the Fontanka house of the Count Sheremetiev; State Museum of Ethnography, 1941.
Exhibited: St. Petersburg/Paris/London 1993/4, cat. 236; Stockholm 1997, cat. 121.
The State Hermitage Museum (ERO – 6750).
LAZ

233. ROCOCO-STYLE DIAMOND-SET GOLD-MOUNTED NEPHRITE FRAME with shaped scroll border and diamond-set florets, with an oval miniature of Queen Louise of Denmark within a seed pearl border, inscribed: "September 8, 1891 VRI" – signed with Imperial Warrant mark of Fabergé, assay mark of Moscow 1899–1908, height 4³⁄₄ in. (12cm).
Provenance: Presented by Queen Louise of Denmark, mother of Tsarina Alexandra Feodorovna and of Alexandra, Princess of Wales, to her sister-in-law Queen Victoria.
Exhibited: St. Petersburg/Paris/London, 1993/4, cat. 77; QVC 1999.
Joan and Melissa Rivers

234. CIRCULAR GOLD-MOUNTED AND ENAMEL FRAME of apple-green radiating *guilloché* enamel, the bezel with pellet band, the border in two-color gold chased with laurel, with gold ribbon cresting, silver-gilt strut – signed with initials of Fabergé, Moscow before 1896, height 3³⁄₄ in. (9.8cm).
Exhibited: Hamburg 1995, cat. no. 175.
The Hubel Collection

235

236

237

238

235. DAISY-SHAPED JEWELED
ENAMELED GOLD FRAME the
aperture is surrounded by rose-cut diamonds,
with opaque white enamel petals and "A" –
shaped strut – signed with initials KF for
Fabergé, Moscow, diameter 1³⁄₈ in. (3.5cm).
Exhibited: QVC 1999.
Joan and Melissa Rivers

236. RECTANGULAR FOUR-COLOR
GOLD-MOUNTED NEPHRITE
DOUBLE FRAME the two oval apertures
have diamond-set bezels surrounded by
four-colour gold floral garlands each held by
a diamond-set ribbon tie, three gold rivets
holding the gold strut shaped in the form
of initials AB – signed K. Faberge, assay mark of
Moscow 1899–1908, assay master Ivan
Lebetkin, length 5 in. (14cm).
Private Collection

237. CIRCULAR GOLD-MOUNTED
AND ENAMEL MINIATURE FRAME
of pale mauve *guilloché* enamel with opaque
white enamel borders, gold ribbon cresting and
silver strut – signed with initials KF, assay mark
of Moscow 1899–1906, assay master Ivan
Lebedkin, inventory no. 25205, height 2¹⁄₁₆ in.
(5.2cm).
Private Collection

238. RECTANGULAR FOLDING
ENAMELED GOLD DOUBLE
PHOTOGRAPH FRAME with oval
apertures and in panels of opalescent white
guilloché enamel applied with classical
décor – Imperial Warrant mark of Fabergé,
Moscow, height 1⁷⁄₈ in. (4.7cm).
Exhibited: QVC 1999.
Joan and Melissa Rivers

239

240

241

242

239. UPRIGHT SQUARE ENAMELED
GOLD FRAME of opalescent white
guilloché enamel with palm leaf borders, ivory
back and "A"-shaped strut – signed with
initials KF for Fabergé, assay mark of Moscow
1899–1908, height 1³⁄4 in. (4.5cm).
Exhibited: QVC 1999.
Joan and Melissa Rivers

240. TRIANGULAR SILVER-GILT
AND ENAMEL FRAME with translucent
corners of red enamel over sunburst *guilloché*
enamel ground, with circular aperture, crossed
arrows and laurel wreaths at each corner,
with peg feet, wood backing and silver-gilt
strut – Imperial Warrant mark of Fabergé,
Moscow before 1899, inventory no. 4341,
height 5¹⁄4 in. (13.3cm). Original fitted
wooden case stamped with Imperial Warrant,
St. Petersburg and Moscow.
Biography: Solodkoff 1988, p. 20.
Exhibited: New York/San Francisco etc.
1996/7, cat. 315.
Louise and David Braver

241. RECTANGULAR GEM-SET
PARCEL-GILT FRAME chased with
scrolling acanthus foliage and set with four
mecca stones, two amethysts, two peridots
and twelve cabochon garnets – signed Fabergé,
initials of workmaster Hjalmar Armfeldt, assay
mark of St. Petersburg 1904–1917, assay master
R. Romanov, 88 (zolotnik), height 7¹⁄4 in.
Louise and David Braver

242. KITE-SHAPED GOLD-
MOUNTED MOSS-AGATE FRAME
cut with an oval bezel set with rose-cut
diamonds and with a profusion of quatre
couleurs gold trailing blossoms, mounted
with crossed gold thyrsus staffs terminating
in pine-cone finials, enriched with entwined
laurel bands, with gold scroll strut – signed with
Imperial Warrant mark of Fabergé, assay mark
of Moscow before 1899, height 4¹⁄4 in.
(10.7cm). Original fitted maplewood case,
stamped Fabergé with Imperial warrant,
Moscow, St.Petersburg.
Exhibitions: New York 1988 cat. 27; Zurich
1989, cat. 87, ill. p. 51 St. Petersburg/Paris/
London 1993/4, cat. 233, ill p. 348; Hamburg
1995, cat. 166, ill p. 154; London 1998.
The Woolf Family Collection

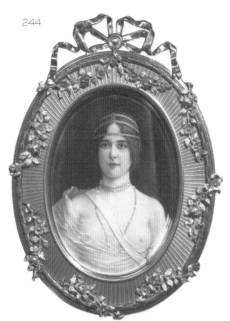

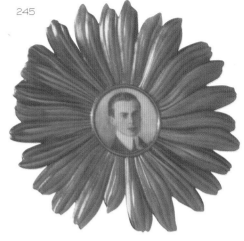

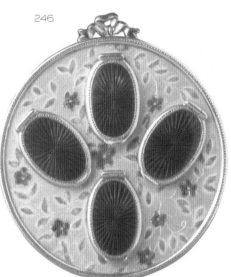

243

244

245

246

243. JEWELED AND ENAMELED
TWO COLOR GOLD EASEL
PHOTOGRAPH FRAME the rectangular
frame of opalescent enamel on a *guilloché*
sunburst ground within acanthus foliage, inset
with an oval aperture enriched with rose-cut
diamonds and flanked on either side by laurel
leaves, resting on a reeded gold easel
terminating in beaded cone feet and with
ribbon cresting – signed with initials KF, assay
mark of Moscow 1899–1908, assay master Ivan
Lebedkin, inv. 23403. Original fitted wood case
with Imperial warrant, Moscow, St. Petersburg
and Odessa.
Exhibitions: London 1977, cat. O19, ill.
p. 102; Munich 1986/1987), cat. 491, ill. p. 245;
New York 1988, cat. 22; Zurich 1989, cat. 99,
ill. p. 94; London 1992, cat. 108;
St. Petersburg/Paris/London 1993/4, cat. 234,
ill p. 348; Hamburg 1995, cat. 167, il.l p. 155;
Stockholm 1997, cat. 151, ill. p. 176; London
1998.
The Woolf Family Collection

244. OVAL ENAMELED
VARI-COLORED GOLD FRAME the
gold beaded bezel sets a panel of bright yellow
over a *guilloché* sunburst ground, with an outer
border of bright green translucent enamel
interlaced by trailing quatre couleurs rose
blossoms, enriched with ribbon cresting.
Containing a miniature on ivory of Cléo
de Mérode bust length and scantily clad,
wearing a bandeau in her hair – signed with
Imperial Warrant mark of Fabergé, assay mark
of Moscow 1896, assay master AA, height
5³₁₆ in. (13.2cm).
Exhibited: London 1977, cat. R42, ill. p. 125;
New York 1983, ill. p. 51; Munich 1986/7,
cat. 505, ill. p. 251; New York 1988, cat. 9;
Zurich 1989, cat. 86, ill. p. 51; London 1992,
cat. 128; St. Petersburg/Paris/London 1993/4,
cat. 188, ill. p. 308.
Bibliography: Snowman 1979, ill. p. 18;
Battersby 1986, p. 99–120.
The Woolf Family Collection

245. SILVER-GILT FRAME SHAPED
AS A DAISY BLOSSOM modeled with
naturalistic petals, the circular aperture with
miniature of Prince Nicholas Yusupov signed
and dated V. Zuyev 1902, the reverse engraved,
the strut shaped as a bent reeded flower stem –
signed K. Fabergé, assay mark of Moscow,
diameter 4⁵₁₆ in. (11cm).
Exhibited: Lahti 1997, cat. 1.
For another Moscow-made frame shaped as a
flower, see cat. 238.
The Woolf Family Collection

246. CIRCULAR GOLD FRAME WITH
FOUR OVAL APERTURES enameled
with flowering tendrils in translucent red and
green on yellow ground, the apertures with
oval hinged mauve enamel covers, with gold
ribbons cresting and gold strut – signed with
initials KF, assay mark of Moscow 1899–1908,
assay master Ivan Lebedkin, diameter 2 in.
(5.1cm).
Exhibited: London 19922, cat. 124;
St. Petersburg/Paris/London 1993/4, cat. 234,
ill. p. 349; Lahti 1997, cat. 23, ill. p. 21.
The Woolf Family Collection

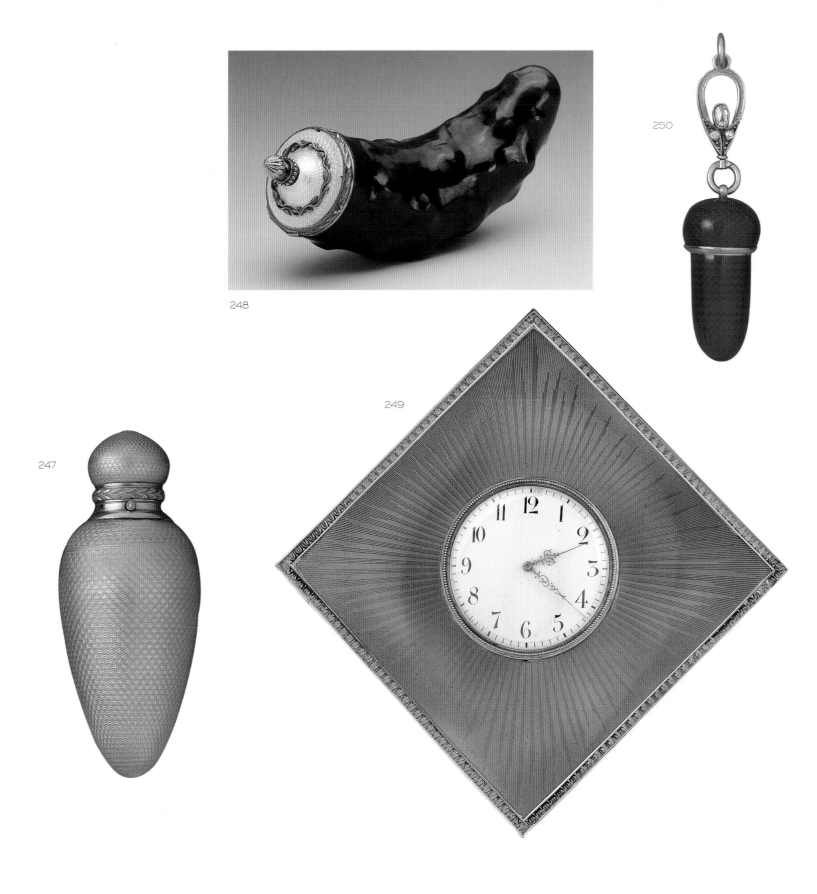

248

250

249

247

247. PEAR-SHAPED GOLD-MOUNTED ENAMELED SILVER SCENT-FLASK of pale green *guilloché* enamel, with gold laurel-leaf border and diamond pushpiece – signed with initials KF for Carl Fabergé, assay mark of Moscow 1899–1908, height 2¹¹⁄₁₈ in. (6.9cm).
Exhibited: Paris 1994, cat. 6; Hamburg 1995, cat. 42; London 1996, cat. 6.
Chevalier Maurice Mizzi Collection

248. GOLD-MOUNTED ENAMELED NEPHRITE SCENT-FLASK naturalistically shaped as a cucumber, the cover of white *guilloché* enamel with leaf border and spherical reeded gold finial – signed with initials KF for Carl Fabergé, assay mark of Moscow 1899–1908, inventory no. 2980, length 3¹⁄₈ in. (8cm).
Exhibited: Paris 1994, cat. 29; Hamburg 1995, cat. 71; London 1996, cat. 29.
Chevalier Maurice Mizzi Collection

249. SQUARE ENAMELED SILVER-GILT DESK CLOCK standing on edge, of translucent raspberry pink enamel over sunburst *guilloché* ground, the white opaque enamel dial with Arabic chapters, gold "Louis XV" hands and beaded bezel; silver strut – Imperial Warrant mark of Fabergé, assay mark of Moscow 1899–1908, height 6¹⁄₁₆ in. (15.4cm).
Exhibited: Hamburg 1995, cat. 88.
Private Collection

250. ACORN-SHAPED ENAMELED GOLD SCENT-FLASK of scarlet *guilloché* enamel, gold suspension ring set with diamonds – signed with initials KF for Carl Fabergé, assay mark of Moscow 1908–1917, height 2¹⁄₂ in. (6.3cm).
Exhibited: Paris 1994, cat. 15; Hamburg 1995, cat. 74; London 1996, cat. 15.
Chevalier Maurice Mizzi Collection

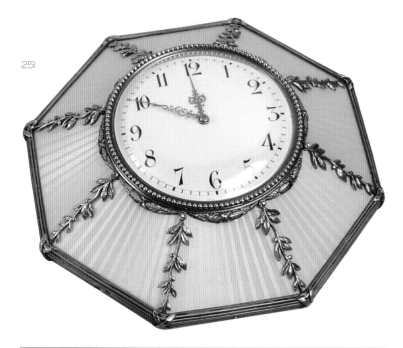

251

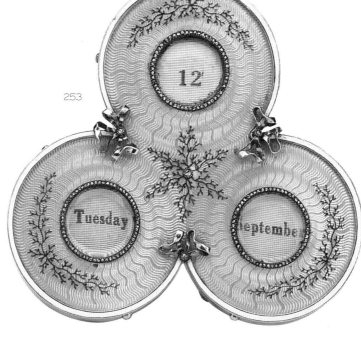

253

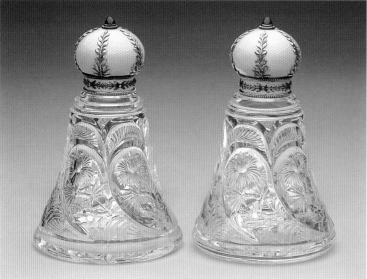

252

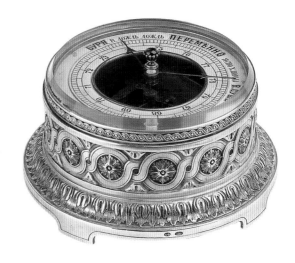

254

251. OCTAGONAL GOLD-MOUNTED ENAMELED SILVER-GILT DESK

CLOCK the downward-sloping panels of transluscent white enamel over sunburst *guilloché* ground, applied with gold laurel sprays and with reeded outer border, the white enamel dial with Arabic chapters, gold scroll hands, beaded bezel set with rose-cut diamonds suspending laurel sprays – stamped with Imperial Warrant mark of Moscow, assay mark of Moscow 1899–1908, assay master Ivan Lebedkin, 84 (zolotnik), inventory no. 26064, width 4 in. (10.1cm).
Bibliography: Snowman 1979, p. 138 (ill. lower left).
Exhibited: London 1977, cat. R 21.
Private Collection

252. PAIR OF TOILET BOTTLES

engraved with floral motifs, the domed stoppers are enameled pale blue over a *guilloché* waved pattern applied with chased gold foliage and cabochon amethyst finials – Cyrillic initials of KF for Carl Fabergé, assay mark of Moscow 1899–1908), 56 (zolotnik), height 5⅛ in. (13cm).
Bibliography: Solodkoff 1984, p. 178, ill.; Kelly 1985, ill. pp. 12, 17; Forbes 1986, ill. pp. 52-53; Forbes 1988, p. 43, ill.; Hill 1989, p. 292, ill. plate no. 259.
Exhibited: New York et al. 1996/97, no. 262, cat. p. 255, ill.
Several almost identical pairs of toilet bottles by Fabergé are known (one in the collection of Princess Margaret, Countess of Snowdon and illustrated in Snowman 1979, p. 28).
They seem to have been a Moscow speciality.
The Forbes Magazine Collection, New York

253. TREFOIL GEM-SET GOLD, SILVER-GILT AND ENAMEL

PERPETUAL CALENDAR with diamond-set bezels, decorated with three pink waved *guilloché* enamel circles painted *en camaïeu* purple with tied branches, with diamond-set gold ribbon ties, the days, weekdays, months printed on silk and moved by a rotating system, silver-gilt backing and strut – signed with Imperial Warrant mark and initials of Fabergé, assay mark of Moscow 1899–1908, inv no. 27373, height 3⅛ in. (7.9cm).
The Eriksson Collection

254. CIRCULAR SILVER-MOUNTED BAROMETER ON FOUR BRACKET

FEET the base decorated with acanthus, the sides with interlaced bands and rosettes, an entrelac band above, cabochon garnet finial – signed with Imperial Warrant mark of Fabergé, assay mark of Moscow 1899–1908, assay master Ivan Lebedkin, diameter 4⅛ in. (10.5cm).
Private Collection, courtesy A. von Solodkoff

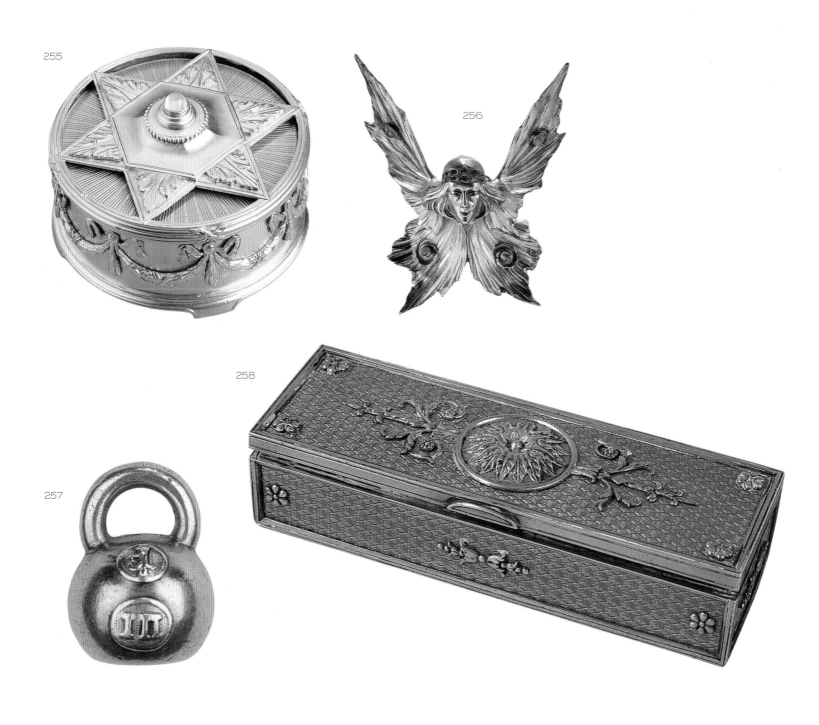

255. CYLINDRICAL ENAMELED
SILVER-GILT BELLPUSH with mauve
guilloché enamel top applied with a six-point
star chased with acanthus leaves, with a
cabochon moonstone pushpiece and chased
laurel swags to sides – signed with Imperial
Warrant mark of Fabergé, assay mark of
Moscow 1899–1908, assay master Ivan
Lebedkin, inv no. 17348, diameter 2⁵⁄₁₆ in.
(5.9cm).
Michael and Ella Kofman Collection

256. ART NOUVEAU GEM-SET
SILVER BELLPUSH shaped as a butterfly
with female head and ruby-set diadem, the
middle ruby acting as pushpiece, the wings set
with four gold-mounted cabochon emeralds –
Imperial Warrant mark of Fabergé, (Moscow),
length 5³⁄₄ in. (14.5cm).
Exhibited: New York 1983, cat. 297; Munich
1986/7, cat. 51.
Private Collection, New York

257. SILVER SEAL SHAPED AS A
WEIGHT of ball form with curved handle
and applied with eagle mark and weight
(1 Pud), matrix engraved Cyrillic Fishot –
initials K F, assay mark 88 (zolotnik), height
³⁄₄ in. (2cm).
Private Collection

258. ENAMELED SILVER STAMP
BOX WITH THREE COMPARTMENTS
of pale blue *guilloché* enamel, the cover applied
with a central rosette and paterae and rosettes –
signed with Imperial warrant mark of Fabergé,
assay mark of Moscow 1899–1908,
88 (zolotnik), inv no. 19873.
Exhibited: New York/San Francisco etc.
1996/7, cat. 328.
Private Collection

259

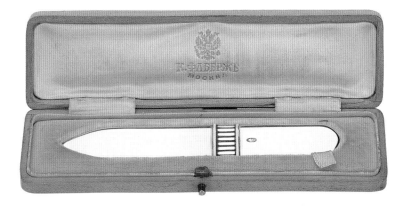

261

260

262

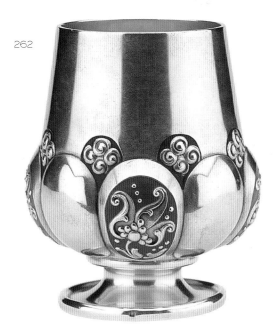

259. SILVER, GOLD AND ENAMEL
PAPER-KNIFE its blade silver on one side,
gold on the other, with a ribbed band flanked
by opaque white enamel stripes – signed with
Imperial Warrant mark of Fabergé, assay mark
of Moscow 1908–1917, length 4¹⁄₈ in. (10.5cm).
Original fitted wooden case stamped with
Imperial Warrant, Fabergé, Moscow.
Private Collection, courtesy A. von Solodkoff

260. RECTANGULAR GEM-SET
GOLD AND ENAMEL CARNET DE
BAL with raspberry enamel on starbust
guilloché ground painted with purple branches
and set with a brilliant-cut diamond in the
center, white enamel border, the reverse with
similar blue *guilloché* enamel and with pink
enamel spine – signed with (Cyrillic) initials
of Fabergé, assay mark of Moscow 1899–1908,
inv no. 28480, length 3¹⁄₂ in. (8.3cm).
Private Collection

261. TWO-COLOR REEDED GOLD
VESTA CASE decorated with bands of green
gold husks, diamond-set thumbpiece – stamped
with Imperial Warrant mark of Fabergé, assay
mark of Moscow, length 1¹⁄₄ in. (3.2cm).
André Ruzhnikov

262. TAPERING ENAMELED SILVER
BEAKER ON RAISED FOOT decorated
with round panels chased with stylized flowers
and foliage against matt green and red enamel
ground with roundels of similar foliage on
blue ground between – signed with Imperial
Warrant mark of Fabergé, assay mark of
Moscow 1908–1917, inv no. 25083, height
2⁷⁄₈ in. (7.4cm).
Private Collection

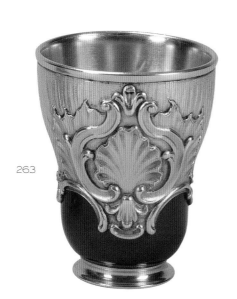

263

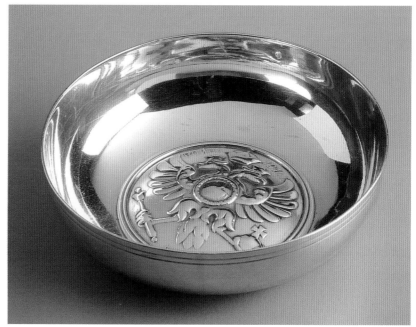

264

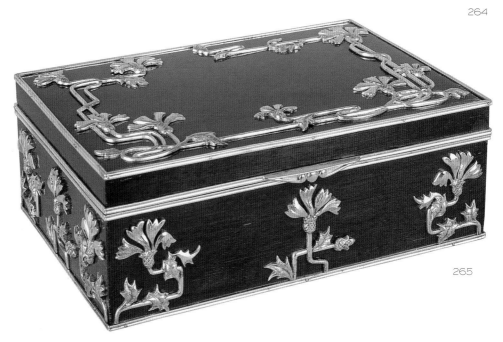

265

264. SILVER BOWL REPOUSSÉ WITH IMPERIAL DOUBLE HEADED EAGLE and with Cyrillic inscriptions: "WAR", "1914" and "K. FABERGE", two rings around the lip – stamped with Imperial Warrant mark of Fabergé, Moscow 1908–1917, diameter 4¹⁄₄ in. (10.8cm).
Bibliography: Traina 1998, p. 148 (top).
This bowl also exists in numerous examples both in copper and brass produced at a time during the War when precious metals had become rare. They are thought to have been given as drinking cups to officers during the 1914–1918 war.
John Traina Collection

263. ENAMELED SILVER BEAKER decorated in relief with rocaille scrolls and shells, the lower section enameled in translucent strawberry red over engine-turning, gilt interior – Imperial Warrant mark, assay mark of Moscow 1899–1908, height 2¹⁄₂ in. (6.5cm).
Private Collection

265. ART NOUVEAU RECTANGULAR SILVER-GILT MOUNTED PALISANDER WOOD BOX applied with chased cornflowers at top and sides, the stalks forming geometric motifs – Imperial Warrant mark of Fabergé, Moscow before 1899, 84 (zolotnik), length 5 in. (12.7cm).
Louise and David Braver

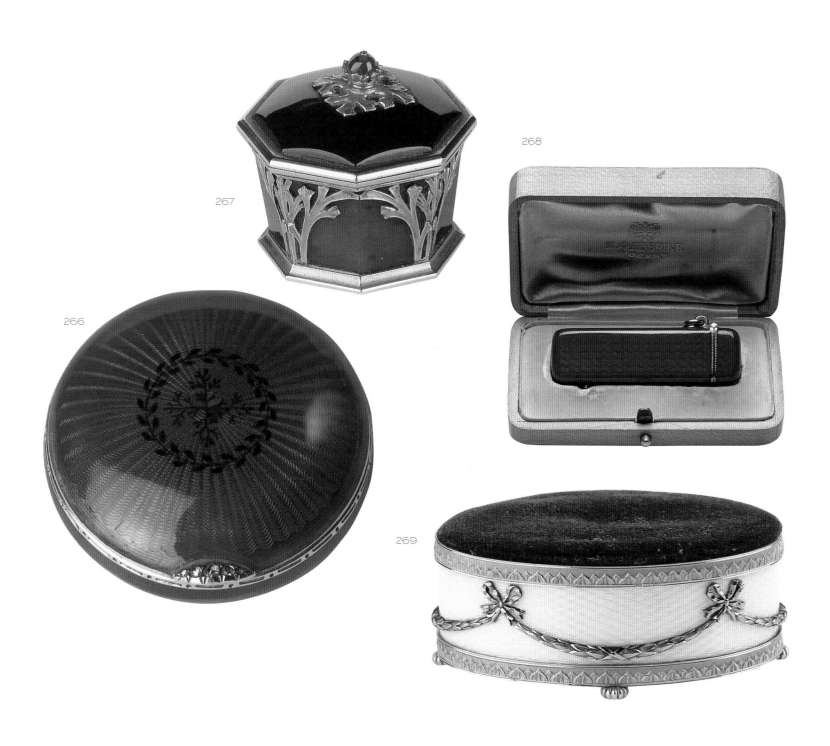

266. CIRCULAR GOLD-MOUNTED
ENAMEL PILLBOX of raspberry *guilloché*
enamel, the cover painted in the center with
a dendritic motif within laurel wreath, the
gold border with dot and dash engraving,
the thumbpiece set with rose-cut diamonds –
stamped with Imperial Warrant mark of
Fabergé, assay mark of Moscow 1899–1908,
88 (zolotnik), inv no. 30523, diameter 1^5⁄16 in.
(3.3cm).
Private Collection

267. OCTAGONAL ART NOUVEAU
GOLD-MOUNTED NEPHRITE BOX
the corners applied with chased gold stylized
branches, the base and rims with gold border,
the cover with foliage rosette and cabochon
ruby and diamond finial – maker's initials I. F,
assay mark of Moscow 1899–1908, assay master
Ivan Lebedkin, height 1^1⁄2 in. (3.8cm).
Private Collection

268. GOLD-MOUNTED AND
ENAMEL LIPSTICK HOLDER of royal
blue *guilloché* enamel with diamond-set slide
and hinged cover, gold suspension ring – signed
with initials of Fabergé, Moscow before 1896,
length 2^1⁄2 in. (5.8cm). Original fitted
maplewood case stamped with Imperial
Warrant, K. Faberge, Moscow.
Private Collection

269. OVAL GOLD-MOUNTED AND
ENAMEL NEEDLE-CUSHION on four
reeded melon feet, the side with white *guilloché*
enamel with gold stiff-leaf borders, applied with
three-color gold laurel garlands suspended from
ribbon ties, with silver base and velvet cushion
– stamped with Imperial Warrant mark and
with initials of Faberge, assay mark of Moscow
1899–1908, assay master Ivan Lebedkin, inv no.
30974, length 2^5⁄8 in. (7cm).
Private Collection

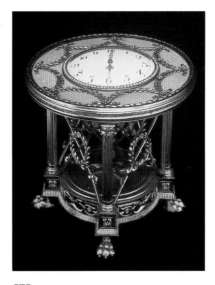

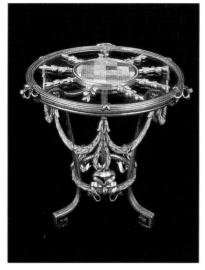

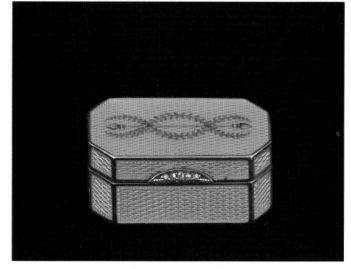

270

271

272

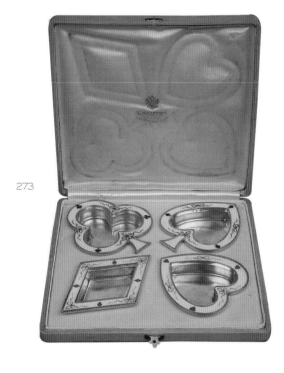

273

270. MINIATURE EMPIRE-STYLE TABLE SET WITH CLOCK with a white enamel clock face bordered by seed pearls and ringed by ribbon-tied silver-gilt laurel swags against a salmon pink enamel ground; the table's four legs are formed as fluted columns supported by chased lion paw feet – Imperial Warrant mark of Fabergé, 1899–1908, inv no. 24358, diameter 3¼ in. (8.3cm).
Bibliography: Solodkoff 1984, p. 164, ill.; Solodkoff 1986, p. 33, ill.; Kelly 1995, ill. p. 63.
Exhibited: New York 1949, no. 113, cat. p. 12; Munich 1986/87, no. 434, cat. p. 228, ill.; Lugano 1987, no. 30, cat. p. 56, ill.; Paris 1987, no. 30, cat., p. 52, ill.
Typically, Fabergé translates an *objet d'art* into an object of function. A Moscow-made table clock of comparable form is in the collection of Marjorie Meriweather Post at the Hillwood Museum, Washington DC. A second example, also from Moscow, in a private collection in Sweden is illustrated in Stockholm 1997, no. 144, cat. p. 172.
The Forbes Magazine Collection, New York

271. MINIATURE GUÉRIDON IN THE LOUIS XVI-STYLE the rock crystal top set with inlaid iridescent blue and green opals within a circular gold beaded border; nine trails of green-gold foliage radiate from the brilliant nexus towards the table's reeded gold perimeter; the legs are festooned with green-gold foliage applied with red-gold ribbons and ties – Cyrillic initials KF, assay mark for Moscow before 1899, height: 2¼ in. (5.4cm).
Bibliography: Waterfield/Forbes 1978, no. 59, ill. p. 49; Solodkoff 1984, p. 164, ill.; Kelly 1985, ill. pp. 12, 17; Forbes 1988, p. 43, ill.; Hill 1989, plate no. 249.
Exhibited: New York 1968, no. 362, p. 137, ill.; New York 1973, no. 21, ill. p. 67; New York 1983, no. 294, ill. p. 92; Lugano 1987, no. 46, cat. p. 67, ill.; Paris 1987, no. 46, cat. p. 63, ill.
The world of Fabergé's miniature sedan chairs, tables, fauteuils, chairs, even a *chaise percée*, are inspired from 18th-century objects such as a silver-gilt mounted jasper sofa in the Hermitage treasury.
The Forbes Magazine Collection, New York

272. OCTAGONAL ENAMELED GOLD VINAIGRETTE the whole enameled turquoise blue over a *guilloché* ground, the cover painted in dark green enamel with ribbon tied foliage pierced by a Thyrsos staff with pineapple finials, with diamond-set pushpiece – Cyrillic initials KF for Carl Fabergé, assay mark of Moscow. 1899–1908, initials of assay master Ivan Lebedkin, 56 (zolotnik), inv no. 8478, length ⅞ in. (2.2cm).
Bibliography: Waterfield/Forbes 1978, no. 68, p. 57, ill.; Solodkoff 1984, p. 175, ill.
Exhibited: Lugano 1987, no. 110, cat. p. 103, ill.; Paris 1987, no. 110, cat. p. 99, ill.
An almost identical box in raspberry pink enamel is in the collection of HM Queen Elizabeth.
The Forbes Magazine Collection, New York,

273. CARD SUIT ASHTRAYS set of four enameled gold-mounted silver-gilt card suit ashtrays in the shape of a heart, spade, diamond, and club respectively, the flat rims of each ashtray enameled white and painted with either black or red enamel ribbon ties and the symbol of each suit in miniature – Imperial Warrant of Fabergé, Cyrillic initials KF, assay mark of Moscow 1899–1908, 56 (zolotnik) and 84 (zolotnik), inv no. 26535, width of Diamond 3⅝ in. (9.2cm).
Provenance: Mrs. Hugh J. Chisholm, Jr.
Bibliography: Waterfield/Forbes 1978, no. 135, ill. p. 103; Solodkoff 1984, p. 179, ill.; Kelly 1985, ill. p. 19.
Exhibited: San Francisco 1964, no. 161, cat. p. 62; New York et al. 1996/97, no. 254, cat. p. 250, ill.
The Forbes Magazine Collection, New York

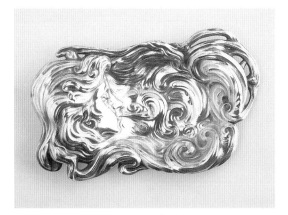

274

275

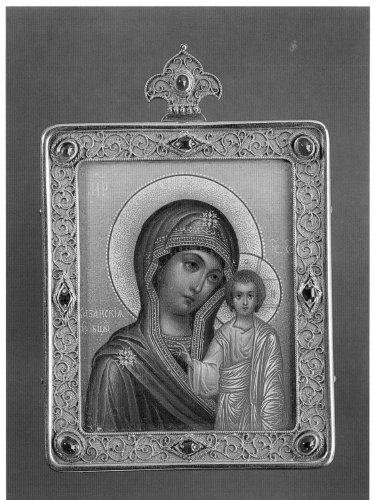

277

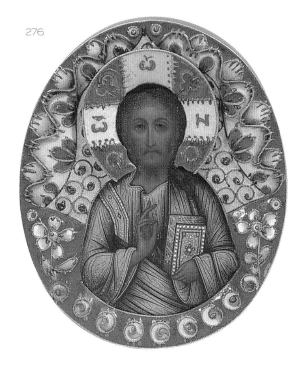

276

275. SILVER-MOUNTED WOODEN PRESENTATION CHARGER the cavetto applied with the coat-of-arms of the city of Libava (Latvia) and a Cyrillic inscription: "To their Imperial Majesties from the City of Libava 1903"; the rim applied with a siren, peacocks and birds amidst scrolling foliage set with caboch cornelians – signed with Imperial Warrant mark of Fabergé, assay mark of Moscow 1899–1908, initials of assay master Ivan Lebedkin, 84 (zolotnik), inv no. 17657, diameter 17³⁄4 in. (45cm).
Provenance: From the diamond storerooms of the Winter Palace; State Museum of Ethnography, 1941.
Exhibited: St. Petersburg/Paris/London 1993/4, cat.153.
The dish was given to the Imperial couple during their visit to Libava (now called Liepaya, Latvia). In 1903 the sea and trade port was ceremonially opened. It was planned to be the second largest trade and military port on the Baltic Sea after St. Petersburg.
The State Hermitage Museum (ERO – 5424)
LAZ

276. OVAL SILVER-GILT AND SHADED CLOISONNÉ ENAMEL TRAVELING ICON painted with Christ Pantocrator within a dark blue enamel oklad decorated with white scrolls, rosettes and "clouds" – stamped with Imperial Warrant mark of Fabergé, assay mark of Moscow 1899–1908, inv no. 29818, height 2³⁄4 in. (7cm).
André Ruzhnikov

277. JEWELED GOLD-MOUNTED ICON OF THE VIRGIN OF KAZAN the frame applied with filigree scrolls, with cabochon sapphires at the corners and rubies in between, fleur-de-lis shaped finial – stamped with Imperial Warrant mark of Fabergé, assay mark of Moscow 1908–1917, 88 (zolotnik), inv no. 24147, height 3¹³⁄16 in.(9.6cm). Original fitted case with Imperial Warrant, St. Petersburg, Moscow, Odessa, London.
Bibliography: Kostbare Ostereier 1998, cat. 600, p. 297/8.
Adulf P. Goop Collection

274. ART NOUVEAU SILVER ASHTRAY decorated with the head of a girl smoking surrounded by a silver cloud of smoke – signed with Imperial Warrant mark of Fabergé, assay mark of Moscow 1899–1908, assay master Ivan Lebedkin, length 6¹⁄16 in. (15.4cm).
Private Collection, courtesy A. von Solodkoff

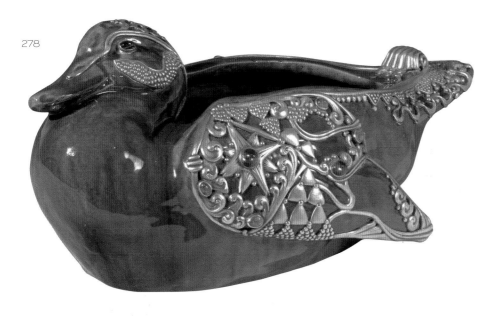

278

279

280

281

278. SILVER-MOUNTED GLAZED EARTHERNWARE BOWL shaped as a duck realistically modeled and glazed in various shades of green and brown, the wings applied with silver mounts and cabochon gemstones in the neo-Russian style, the eyes set with carbuncles – signed with Imperial Warrant mark of Fabergé, assay mark of Moscow 1908–1917, length 12⅝ in. (32.5cm).
Exhibited: New York 1997.
A small number of such ceramic animal figures created by Fabergé in the neo-Russian style are known.
The Woolf Family Collection

279. SILVER-MOUNTED WOOD KOVSH IN THE NEO-RUSSIAN STYLE the shallow circular bowl applied with silver mounts shaped as scrolls and pellets, the head of the bird with red cabochon ruby eyes suspending cabochon emerald pendants and with cabochon emerald crest – signed with Imperial Warrant of Fabergé, assay mark of Moscow 1908–1917, length 5½ in. (14cm).
Provenance: Grand Duchess Maria Pavlovna.
Exhibited: Munich 1986/7, cat. 30, ill. p. 123; Zurich 1989, cat. 41; St. Petersburg/Paris/London 1993/4, cat. 223, ill. p. 340; Stockholm 1997, cat. 160, ill. p. 182.
The Woolf Family Collection

280. SQUARE SILVER TEA CADDY OF CHINESE INSPIRATION engraved with swirling flutes and chased at the lip with rocaille ornament, the hinged cover *repoussé* and chased with a Chinese dragon, the interior with slip-on cover with a hinged loop handle – signed with Imperial warrant of Fabergé, assay mark of Moscow 1891, assay master's initials AA, height 3¹⁵⁄₁₆ in. (10cm).
Exhibited: Munich 1986/7, cat. 68, ill. p. 123; Zurich 1989, cat. 4, ill. p. 71; Hamburg 1995, cat. 68, ill. p. 123; Lahti 1997, cat. 14, ill. p. 17.
An interesting combination of Chinese and European decorative elements.
The Woolf Family Collection

281. TRIANGULAR SILVER-GILT STYLE MODERNE MILK JUG with lobed-lip and twisted tendril handle – signed with Imperial Warrant of Fabergé, assay mark of Moscow 1896, assay master ?.O. , height 2⁹⁄₁₆ in. (6.5cm).
Exhibited: New York 1983, cat. 11, ill. p. 38; Munich 1986/7, cat. 168, ill. p. 155; New York 1988, cat. 12; Zurich 1989, cat. 55, ill. p. 86; St. Petersburg/Paris/London 1993/4, cat. 223, ill. p. 340; Hamburg 1995, cat. 7, ill. p. 54; Stockholm 1997, cat. 180, ill. p. 189.
Bibliography: Snowman 1979, ill. p. 57; Habsburg/Solodkoff 1979, pl. 36.
The Woolf Family Collection

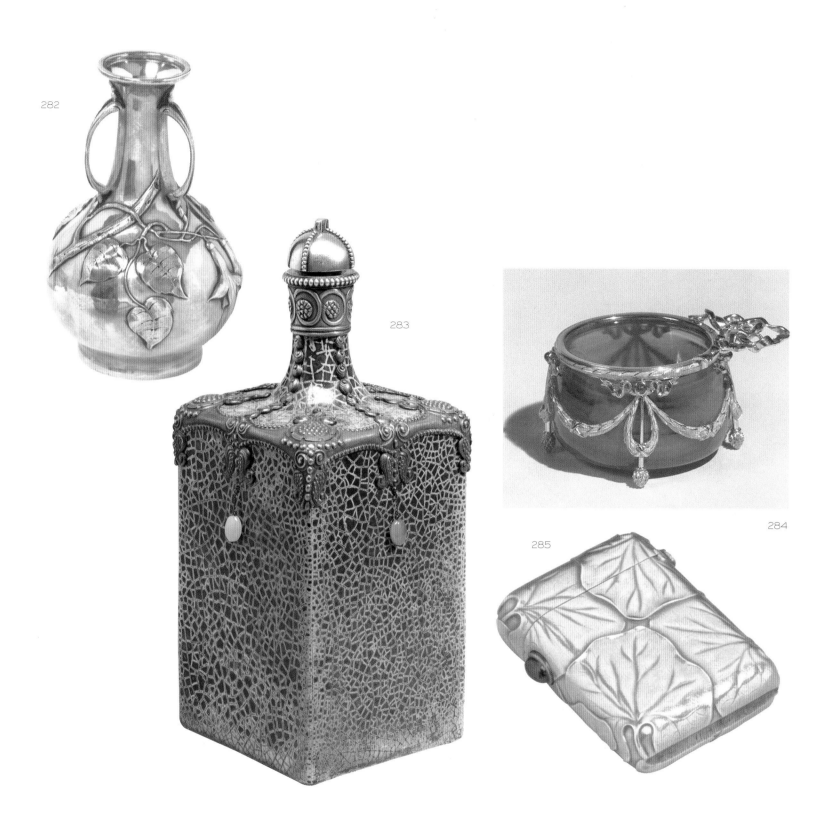

282

283

284

285

282. PARCEL-GILT VASE IN THE
PERSIAN STYLE the body *repoussé* with
an Art Nouveau design of trailing fuschia
flowers, the neck applied with three splayed
handles – signed with Imperial Warrant of
Fabergé, assay mark of Moscow before 1899,
initials of unrecorded assay master PT, height
4⁹₁₆ in. (11.6cm).
Exhibited: New York 1988, cat. 30; Zurich
1898, cat. 35, ill. p. 77; Lahti 1997, cat. 27, ill.
p. 23.
The Woolf Family Collection

283. SQUARE SILVER-MOUNTED
KRAAK-STYLE CERAMIC FLASK
the Old Russian-style mounts chased with
swirls suspending four cabochon moonstones,
with domed silver stoppper – signed with
Imperial Warrant of Fabergé, assay mark of
Moscow 1899–1908, height 9⁷₈ in. (25cm).
Exhibited: Stockholm 1997, cat. 155, ill. p. 179.
The Woolf Family Collection

284. TWO-COLOR GOLD-
MOUNTED AGATE CHARKA the
compressed hemispherical honey-colored
banded agate bowl with gold rim, four
pomegranate feet, applied with yellow gold
laurel swags with cabochon emeralds, the
handle in the form of a tied ribbons knot set
with diamonds – signed with initials KF, assay
mark of Moscow before 1899, height 1⁵₈ in.
(4.1cm).
Provenance: Grand Duchess Maria
Alexandrovna (1853-1905), sister of Tsar
Alexander III.
Exhibited: Munich 1986/7, cat. 227, ill. p. 167;
Zurich 1989, cat. 41, ill. p. 80; St. Petersburg/
Paris/London 1993/4, cat. 65, ill. p. 221.
The Woolf Family Collection

285. GOLD VESTA CASE IN
JAPANESE STYLE molded and chased
to simulate overlapping lotus leaves, with
striker at base and sapphire pushpiece – signed
with initials KF, assay mark of Moscow
1899–1908, assay master Ivan Lebedkin, length
1⁹₁₉ in. (4cm).
The Woolf Family Collection

147

6
THE HEAD
WORKMASTERS

ERIK KOLLIN

Erik Kollin (1836–1901) was born as the son of Carl Gustav Kollin, a farm laborer from Brödtorp, Pohja in Finland, and of Eva Stina Zakariasdotter of Kisko.[1] He was apprenticed in 1852 to the goldsmith Alexander Palmén at Tammisaari. In 1858 Kollin obtained a travel pass to St. Petersburg, where he was entered in the parish register of St. Katarina as a goldworker. He was employed for ten years as a journeyman in the workshop of August Holmström, who had become Master in the previous year, and had subsequently joined Gustav Fabergé as chief jeweler. Kollin became master in 1868 and opened his own workshop in 1870 at 9 Kazanskaya Street, simultaneously becoming head workmaster at Fabergé's firm for whom he worked exclusively. He held this post until 1885 or 1886, when he was replaced by Michael Perchin. For the remaining fifteen years, until his death in 1901 he worked independently, supplying Fabergé as an outworker.

During his employment with Fabergé he produced numerous *objets d'art*, mostly in yellow gold, many of them with reeded surfaces, incorporating coins, medals, tigers' claws, toucans' beaks. The workshop also mounted choice hardstone vessels – kovshi, charki and bowls – fashioned from striated agate, jadeite, purpurine (cat. 229), with elegant gold mounts. Kollin's main claim to fame are his gold replicas of jewels forming part of the Scythian gold unearthed at Kertch in the Crimea in the first half of the nineteenth century. These gold adornments, made by Greek craftsmen of 400 BC, were integrated into the Imperial collections at the Hermitage. Throughout the late 1860s and the 1870s, Fabergé's activity on behalf of the Imperial Cabinet included the repair and restoration of such treasures, no doubt with the help of his workmaster Erik Kollin. When preparing for the great All-Russian Industrial Art Exhibition of 1882 in Moscow, Fabergé received permission from the head of the Imperial Archeological Commission, Count Sergeii Stroganoff, to execute replicas of selected gold jewels. Fabergé presented two full parures in addition to a number of individual pieces. (p. 36, fig. 1) Such archeological jewels, which had become commonplace by 1860s and 1870s in Rome, London and Paris, must have been a novelty in Russia, for they were hailed by the press as something quite remarkable:

"Mr Fabergé opens a new era in the art of jewelery. We wish him all the best in his efforts to bring back into the realm of art what once used to be part of it. We hope that from now on, thanks to our renowned jeweler, the value of the objects will be measured not only by the value of precious stones, not by wealth alone, but by their artistic form as well".[2]

Fabergé, and through him his workmaster Kollin, was lauded particularly for exceptional craftsmanship and for the reintroduction of the ancient technique of granulation.[3] Thus Fabergé introduced Russia to the concept of *bijoux* (artistic jewelry) as opposed to *joaillerie* (where the value of a jewel is based on precious stones). According to the press, seven masters had worked for four months – equivalent to 10,000 working hours – on just one necklace. Fabergé was awarded a Gold Medal for his exhibits, to be worn on the ribbon of the Order of St. Stanislavs. Kollin's Kertch jewels received the same distinction – a Gold Medal – at the Nuremberg International Fine Arts Exhibition in 1885.

The artefacts produced by Kollin for Fabergé before his departure in 1886 generally bear his initials, EK, together with Fabergé's hallmark and are frequently to be found in a Fabergé box. Evidently these pre-date the change of hallmarks in 1899 (396). Objects bearing the EK mark only and produced between 1885 (his departure from Fabergé) and 1899 (date of the new hallmark) and certainly those made between 1899 and 1901 (date of his death) should be considered as the work of an independent operator, unless cased by

Notes
1. For a brief biography of Erik Kollin, as of all the workmasters, see Ulla Tillander-Godenhielm, "Personal and historical notes on Fabergé's Finnish Workmasters and Designers" in *Helsinki* (1980), pp. 28–49; and Ulla Tillander-Godenhielm, "Carl Fabergé and his Master Craftsmen" in *Stockholm* (1997), pp. 27–32.

2. Habsburg/Lopato (1993), p. 56f.

3. The Etruscan method of granulation, the invisible soldering of tiny gold globules in clusters to a metal surface, was in fact first produced in 1861/2 by the Castellani brothers Augusto and Alessandro. When shown at the 1862 International Exhibition in London, it created a sensation. The Paris jeweler Eugène Fontenay, inspired by the acquisition by Emperor Napoleon III of the 1200 pieces of Etruscan jewelry forming the collection of Cavaliere Campana in 1861, began producing gold *bijoux étrusques* soon thereafter. His exhibits at the Paris World Fair of 1867 won him great acclaim. The craze for archeological jewelry began to wane in Western Europe after 1881, the death of Arthur Castellani.

Fabergé. Certain objects bearing an EK mark only, differ markedly from anything associated with Kollin, raising the question of whether or not there was another goldsmith/jeweler with the same initials active in St. Petersburg.[4]

Géza von Habsburg

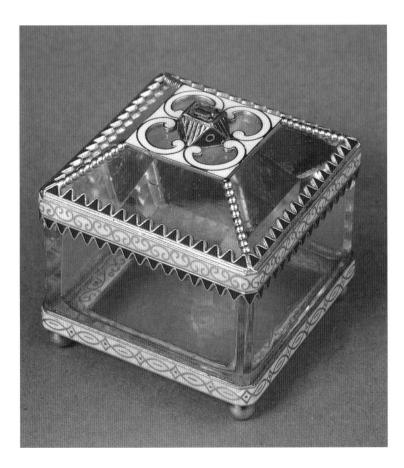

4. The Russian hallmarking system apparently did not preclude the registering of identical hallmarks by different goldsmiths. A case in point is the hallmark AT in an oval used by at least three goldsmith/jewelers – Alexander Tillander, Alexander Treiberg and Alexander Treiden.

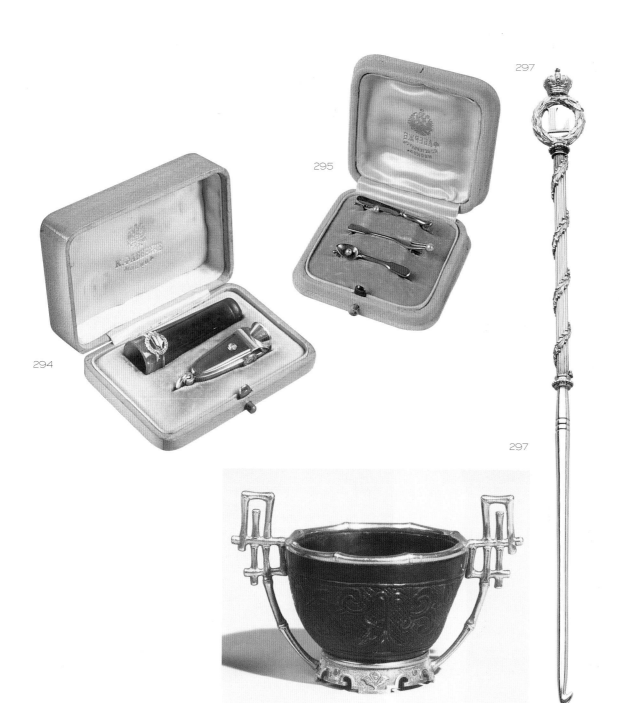

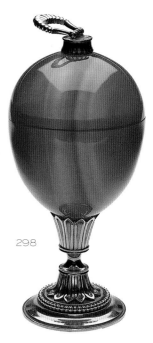

**294. GOLD-MOUNTED NEPHRITE
CHEROOT HOLDER AND CUTTER**
the cheroot holder applied with an arrow and
a circle set with rose-cut diamonds; the cutter
with a single rose-cut diamond pushpiece,
initials of workmaster Erik Kollin, inv
no. 24934. Original fitted case stamped
with "Imperial Warrant", Moscow and
monogrammed FVG.
Exhibited: London 1995, cat.10.
The Castle Howard Collection

**295. THREE MINIATURE GOLD PINS
SHAPED AS A KNIFE, FORK AND
SPOON** each set with a pearl – by Fabergé,
initials of workmaster Erik Kollin, assay mark
of St. Petersburg before 1899, inv no. 48019,
length of knife 1½ in. (3.8cm). Original fitted
suede box with Imperial Warrant mark,
St. Petersburg, Moscow.
Private Collection

**296. SILVER-GILT MOUNTED
CHINESE SHALESTONE BOWL**
the bowl carved with floral sprays, the Chinese
style silver-gilt mounts simulating bamboo –
initials of workmaster Erik Kollin, assay mark
of St. Petersburg before 1899, inv no. 57229,
width 2⅟16 in. (5.2cm).
Exhibited: New York 1988, cat. 29; London
1992, cat. 123; Lahti 1997, cat. 13, ill. p. 17;
London 1998.
A case of a Chinese object mounted by
Fabergé, the style of his mount underlining
the origin of the item.
The Woolf Family Collection

**297. QUEEN LOUISE CROCHET
HOOK** two-color reeded gold crochet hook
chased with spiraling foliage terminating in a
crowned laurel wreath encompassing an "L" –
initials of workmaster Erik August Kollin,
length 7 in. (17.7cm).
Provenance: Queen Louise of Denmark.
Exhibited: Lugano 1987, no. 80, cat. p. 85, ill.;
Paris 1987, no. 80, cat. p. 81, ill.; London 1987,
no cat.; St. Petersburg/Paris/London 1993/94,
no. 75, cat. p. 228, ill.; Stockholm 1997, no. 210,
cat. p. 201, ill.
The initial is that of Queen Louise of
Denmark. Queen Louise was the mother of
both Queen Alexandra of Great Britain and
Tsarina Maria Feodorovna.
The Forbes Magazine Collection, New York

**298. EGG-SHAPED GOLD-
MOUNTED CORNELIAN
BONBONNIÈRE** the red hardstone egg
standing on raised red-gold gadrooned and
fluted foot and with gadrooned handle-shaped
finial – signed Fabergé, initials of workmaster
Erik Kollin, assay mark of St. Petersburg
1899–1908, 56 (zolotnik), inv no. 40585,
height 4⁷⁄16 in. (11.2cm).
Provenance: Agathon Fabergé.
Exhibited: Helsinki 1980, cat. 4; Munich
1986/7, cat. 274; Helsinki 1988; Zurich 1989,
cat. 194; Helsinki 1990 and 1995; Helsinki
1991; Stockholm 1996; Lahti 1997; Stockholm
1997, cat. 83.
It is generally accepted that Erik Kollin was
replaced as head workmaster by Michael
Perchin in 1885 and that thereafter, until his
death in 1901, he continued to supply Fabergé
with *objets de vertu* bearing only his E. K. mark.
This is the only example known to the authors
of a late Kollin piece bearing Fabergé's mark.
The question of another workmaster active in
the late 1800s, possibly using the same E. K.
mark and making *objets de vertu* in gold and
guilloché enamel remains to be addressed.
Private Collection courtesy Ulla Tillander-
Godenhielm, Finland

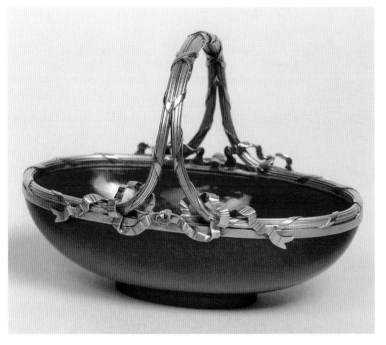

299

300

301 302

299. OVAL GOLD-MOUNTED
PURPURINE BASKET with two-color
gold reed-and-tie border and ribbons to each
side set with two faceted green garnets –
initials of workmaster Erik Kollin, assay mark of
St. Petersburg before 1899, inv no. 53836.
Original fitted case with Imperial Warrant,
St. Petersburg, Moscow.
Exhibited: Stockholm 1997, cat. 174.
A case of an *objet de fantaisie* by Kollin pre-
dating the tenure of Michael Perchin as head
workmaster.
Courtesy of A La Vieille Russie

300. GEM-SET YELLOW-GOLD
SCENT-BOTTLE SHAPED AS A
TUBE OF PAINT decorated on one side
with a floral motif set with two cabochon
rubies, three diamonds and a cabochon
sapphire – initials of workmaster Erik Kollin,
assay mark of St. Petersburg before 1899,
inv no. 49309, length 2¹⁄₁₆ in. (5.2cm).
Exhibited: Hamburg 1995, cat. 201, ill. p. 187;
Stockholm 1997, cat. 197, ill. p. 196.
The Woolf Family Collection

301. GOLD-MOUNTED TURQUOISE
SCENT-FLASK the body (probably of
Chinese origin) of flat tapering shape with
rounded shoulders, standing on a gadrooned
gold base, with gold chains suspended from
gold rings, the gadrooned stopper set with
rubies and diamonds, pearl finial – initials
of workmaster Erik Kollin, assay mark of
St. Petersburg before 1899, height 2¹⁄₄ in.
(5.9cm).
Exhibited: Paris 1994, cat. 18; Hamburg 1995,
cat. 40; London 1995, cat. 18.
Chevalier Maurice Mizzi Collection

302. GOLD-MOUNTED AGATE
SCENT-FLASK the honey-colored body
(probably of Chinese origin) of rounded form
with carved handles, standing on a gadrooned
gold base, the domed reeded and hinged cover
and with garnet finial – signed Fabergé, initials
of workmaster Erik Kollin, assay mark of
St. Petersburg before 1899, height 2¹¹⁄₁₆ in.
(6.9cm).
Exhibited: Paris 1994, 22; Hamburg 1995,
cat. 60; London 1996, cat. 22.
Chevalier Maurice Mizzi Collection

303

304

305

306

303. GOLD-MOUNTED AGATE
SCENT-FLASK the honey-colored polished
body standing on a gadrooned base, with
spherical hinged reeded gold cover set with
alternating cabochon rubies and moonstones –
initials of workmaster Erik Kollin, assay mark of
St. Petersburg before 1899, height 3³16 in.
(8.1cm).
Exhibited: Paris 1994, cat. 19; Hamburg 1995,
cat. 62; London 1996, cat. 19.
Chevalier Maurice Mizzi Collection

304. GEM-SET GOLD-MOUNTED
ROCK-CRYSTAL SCENT-FLASK OF
CIRCULAR OUTLINE the gadrooned
mount and cover set with cabochon sapphires,
the two scroll handles set with four cabochon
sapphires – initials of workmaster Erik Kollin,
assay mark of St. Petersburg before 1899, height
1¹⁷18 in. (5cm).
Exhibited: Paris 1994, cat. 21; Hamburg 1995,
cat. 64; London 1996, cat. 21.
Chevalier Maurice Mizzi Collection

305. GOLD-MOUNTED AGATE
SCENT-FLASK the rounded body
(probably of Chinese origin) of mottled
gray-black hue, the domed reeded and
hinged cover with sapphire finial – initials
of workmaster Erik Kollin, assay mark of
St. Petersburg, height 2¹⁷18 in. (7.5cm).
Exhibited: Paris 1994, cat. 17; Hamburg 1995,
cat. 61; London 1996, cat. 17.
Chevalier Maurice Mizzi Collection

306. GOLD-MOUNTED AGATE
SCENT-FLASK OF ROUNDED FORM
the plain gold mounts with a large garnet
cabochon finial – initials of workmaster Erik
Kollin, assay mark of St. Petersburg before
1899, height 2¹2 in. (6.3cm).
Exhibited: London 1994, cat. 20; Hamburg
1995, cat. 41; London 1996, cat. 20.
Chevalier Maurice Mizzi Collection

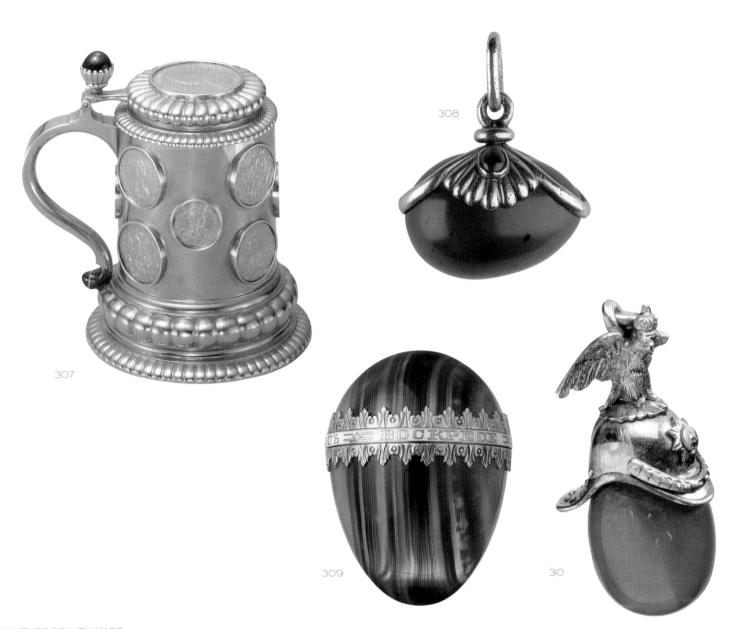

307

308

309

310

307. MINIATURE COIN TANKARD
set with a cabochon sapphire pushpiece and
decorated with five gold roubles of Catherine
the Great dated 1783, seven 5 rouble pieces
dated 1779 and one of 1758 and four 2 rouble
pieces dated 1777 – initials of workmaster Erik
Kollin, assay mark of St. Petersburg before
1899, 56 (zolotnik), height 3¼ in. (8.3cm).
Bibliography: Waterfield/Forbes 1978, pp. 95,
130, 135, ill. p. 94; Solodkoff 1984, p. 165, ill.;
Hill 1989, p. 223, plate no. 190.
Exhibited: NYCC 1973, no. 49, cat. p. 104, ill.
p. 105; London 1977, no. L6, cat. p. 72; Helsinki
1980, no. 56, cat. p. 56, ill.; Munich 1986, no.
154, cat. p. 151, ill.; Lugano 1987, no. 8, cat. p.
44, ill.; Paris 1987, no. 8, cat. p. 40, ill.; London
1987, no cat.; London 1991, no. 30, cat. p. 36,
ill. p. 37; Vienna 1991, cat. p. 61, ill.
A miniature version by Kollin of late 17th-
century/early 18th-century coin tankard such
as produced in northern and eastern Germany.
The Forbes Magazine Collection, New York

**308. GEM-SET GOLD MOUNTED
NEPHRITE EASTER EGG** the hardstone
egg horizontally mounted in fluted gold and
set with a cabochon ruby and sapphire, gold
suspension ring – workmaster's initials of Erik
Kollin, assay mark of St. Petersburg before 1899.
Private Collection

**309. GOLD-MOUNTED AGATE
EASTER EGG** the hinged stylized leaf
mount with opaque white enamel band
inscribed in Cyrillic: "Christos Woskrese" –
initials of workmaster Erik Kollin, assay mark
of St. Petersburg before 1899, 56 (zolotnik),
height 2¹⁄₁₆ in. (5.2cm).
Bibliography: Kostbare Ostereier, 1998,
cat. 601, p. 179.
A pastiche of a George III *bonbonnière* of a kind
often presented by lovers and inscribed:
"Souvenir d'Amitié".
Adulf P. Goop Collection

**310. GOLD-MOUNTED RHODONITE
CHARM SHAPED AS A CAVALIER
GUARD'S CAP** initials of workmaster EK,
56 (zolotnik), height 1 in. (2.5cm).
Provenance: The Museum Fund; State Museum
of Ethnography, 1941.
Exhibited: Orhus 1990, cat. 92.
The State Hermitage Museum (ERO – 5788)

MICHAEL PERCHIN

Michael Perchin (Michael Evanpievich Perchin, 1860–1903), was of peasant stock, born at Petrosavodsk, Olonets.[1] He was one of the few leading goldsmiths and jewelers of Russian extraction to achieve fame among Fabergé's craftsmen. Nothing is known of his early years and of his apprenticeship. Arriving in St. Petersburg, "possibly illiterate", according to François Birbaum[2], he served as a journeyman in the workshop of Erik Kollin, Fabergé's head workmaster. In 1884, aged twenty-four, he qualified as master craftsman and opened a workshop at 11 Bolshaya Morskaya, the house of architect P. P. Jacot, occupied by Gustav Fabergé between 1842 and his move to larger premises at 16 Bolshaya Morskaya.

In the same year, 1884, Henrik Wigström from Finland entered Perchin's workshop as journeyman. Under the inspirational tutelage of Carl Fabergé, Perchin, aged twenty-four, Wigström aged twenty-two and the recently arrived Agathon Fabergé, also aged twenty-two, these young craftsmen revolutionized the applied arts scene in Russia. Almost immediately, the first enameled gold objects made their appearance, probably due to Perchin's expertise. "His personality combined a tremendous capacity for work, profound knowledge of his craft and persistence in solving certain technical problems."[3] Even before his official appointment as head workmaster in 1886, Perchin signed an important Imperial presentation box for Reichskanzler Bismarck dated 1884. (p. 39, fig. 7) The box is overladen with diamonds, undoubtedly supplied by the Imperial Cabinet. The enamelwork in the round is somewhat uneven, indicating an experimental stage. There is no doubt that the studies of eighteenth-century French enameled objects in the treasury of the Hermitage by Fabergé and his craftsmen were beginning to bear fruit. According to Birbaum, "The Hermitage Museum with its 'Golden Treasury' served as an excellent school for the Fabergé jewelers: after the Kertch collection, they began to study jewelry of all the epochs represented, especially those of the Empresses Elizabeth and Catherine II, many of those articles were copied with great precision and were later used as models for the creation of new compositions."[4]

While the authorship of the First Imperial Egg (cat. 437), commissioned in 1885, is generally passed over in silence, it seems quite logical that it too was crafted by Fabergé's new team. Two years after the first egg, in 1887, the initial technical problems of enameling *en ronde bosse* (in the round) had been overcome, as demonstrated by the near-perfect execution of the "Blue Serpent Clock Egg", (p. 14 fig. 4) which is Perchin's first datable masterpiece. The craftsman's workshop mastered not only enameling, but also the chasing of gold. The quality of the *quatre couleurs* (four-color gold) swags of flowers and the precisely finished gold borders all bear the hallmarks of Fabergé later productions. Indeed, were it not for the circumstantial evidence in the archives[5], one would be tempted to date this egg to a later period. The perfection of the setting of rose-cut diamonds also seems to indicate an involvement of the Holmström jewelry workshop. As opposed to the Rococo style generally associated with Perchin's workshop, this egg, inspired by one of the numerous Louis XVI clocks with revolving dials, is an early example of the neo-Classical style in Perchin's *oeuvre*. Until 1903, all the surviving Imperial Eggs with only one exception[6], bear the hallmark of Michael Perchin's workshop.

Perchin was head workmaster at a time of some of the most glorious creations of the firm. Just how eclectic his workshop was is best demonstrated by two works of art commissioned in 1896 for the coronation of Tsar Nicholas II. One is an oval rock crystal dish, its mount designed in the neo-Renaissance style (cat. 349); the other, a lyre shaped neo-Classical clock. (cat. 334) Both styles were typical for Perchin.

Four major pieces in the Renaissance style with royal connotations also bear

FIG I. JEWELED AND GOLD-MOUNT-ED NEPHRITE PRESENTATION TRAY in the Renaissance style – by Fabergé, workmaster Michael Perchin, St. Petersburg 1901, length 13⅜ in. (34cm). Presented by the Dutch colony of St. Petersburg to Queen Wilhelmine of the Netherlands at the occasion of her coronation in 1901.
Private Collection. Photograph courtesy Christie's

FIG 2. THE KELCH "ROCAILLE EGG" of 1902 – by Fabergé, workmaster Michael Perchin, St. Petersburg 1902, length 5 in. (12.8cm)

Perchin's hallmark: the "Renaissance Egg" given by Tsar Alexander III to Maria Feodorovna in 1894 (Forbes Magazine Collection – p. 31, fig. 6); the 1896 "Revolving Miniatures Egg" in the Richmond Fine Arts Museum[7]; a nephrite tray presented by the Dutch colony of St. Petersburg at the occasion of the coronation of Queen Wilhelmine of The Netherlands in 1901 (fig. 1); and a rock crystal vase presented by Leopold de Rothschild at the occasion of the coronation of King George V.[8] The Renaissance style was evidently associated with royal gifts, but was also used for lesser objects, even during the tenure of Henrik Wigström. (cat. 351) On the other hand, neo-Rococo is considered as Perchin's trademark, to the point of being almost exclusively connected with his name. Louis XV or Rococo was the style preferred, both in Paris and St. Petersburg, throughout the 1880s and the early 1890s before the appearance of Art Nouveau. Dated objects in this style include the 1891 "Pamiat Azova Egg" (cat. 438) and the 1903 "Peter the Great Egg" (Richmond Fine Arts Museum p. 38 fig. 5[9]). The influence of Art Nouveau, newly imported from Paris, can be recognized in Perchin's work as from 1898, the date of the "Lilies of the Valley Egg" (Forbes Magazine Collection), through 1899 (1899 "Pansy Egg"[10]) and until 1903, the date of the "Clover Egg" (Moscow Kremlin Armory Museum[11]). Parallel to the French Art Nouveau style, Perchin also produced works in a typically Russian mix of Art Nouveau and Rococo. (cat. 417)

[Perchin] "was highly esteemed by the House and enjoyed rare authority over his apprentices. Over a relatively short period of time he made a considerable fortune, but had no opportunity to enjoy it, because he died in a lunatic asylum in 1903."[12] Instead of leaving his workshop to his son, Perchin left it to his senior assistant and friend, Henrik Wigström, this ensuring a continuity in its production.

Géza von Habsburg

Notes

1. For a brief biography of Perchin, see Tillander-Godenhielm (1997), p. 27f., "Carl Fabergé and his Master Craftsmen" in Carl Fabergé, Goldsmith to the Tsar, Stockholm (1997), p. 27f.

2. See Fabergé/Skurlov (1992), p. 9.

3. *Ibid.*

4. *Ibid.*

5. Fabergé/Proler/Skurlov (1997), p. 98. There have been rumors, that an almost identical pink enamel egg exists in a Californian collection. There are slight discrepancies between the blue egg and the invoice (which mentions sapphires).

6. The "Diamond Trellis Egg" is signed with the initials of workmaster August Holmström; the "Basket of Wildflowers Egg" has lost its original hallmarks.

7. See Fabergé/Proler/Skurlov (1997), p. 124.

8. The date of the coronation was 1911. The vase is marked "MP" with assay marks for 1899–1908. It was produced during Perchin's tenure *c.* 1900; see Habsburg (1996), cat. 279.

9. *Ibid.*, p. 136.

10. *Ibid.*, p. 141.

11. *Ibid.*, p. 160.

12. Fabergé/Skurlov, (1992), p. 9.

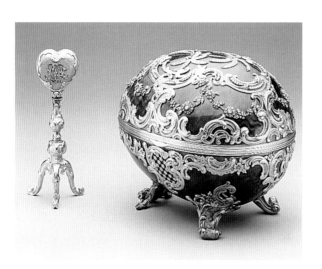

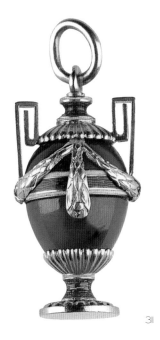

311

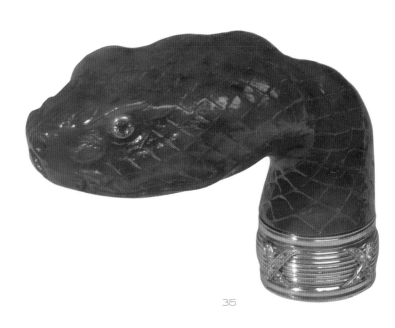

315

313

314

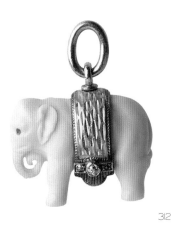

312

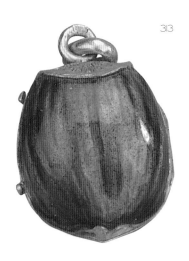

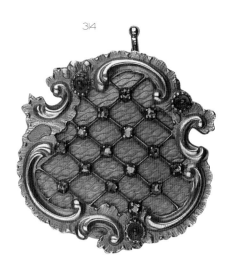

311. VASE-SHAPED GOLD AND
ENAMEL MOUNTED NEPHRITE
PENDANT the egg-shaped hardstone vase
on a raised fluted gold foot is applied with a
red and opaque white enamel band and chased
laurel garlands, with two angular handles, fluted
top and suspension ring – workmaster's initials
of Michael Perchin, assay mark of St.
Petersburg before 1899, height $^{15}_{16}$ in. (2.8cm).
Private Collection

312. GEM-SET AND ENAMEL WHITE
QUARTZ ELEPHANT PENDANT the
animal features red stone eyes covered with a
yellow *guilloché* enamel rug set with diamonds
– initials of workmaster Michael Perchin, assay
mark of St. Petersburg before 1899, length
$^{11}_{16}$ in. (1.8cm).
Private Collection

313. ENAMELED GOLD CHARM
SHAPED AS A HAZELNUT initials of
workmaster Michael Perchin, 56 (zolotnik),
height 7_8 in. (2.1cm).
Provenance: Gatchina Palace; Central
Depository for Suburban Palaces, 1956.
Exhibited: Leningrad 1974, cat. 44.
Bibliography: Russian Enamel, 1987, cat. 145

314. SHAPED GEM-SET GOLD AND
ENAMEL BROOCH in the Rococo style
with pink *guilloché* enamel, applied with a trellis
set with rose-cut diamonds, the gold border
with scrolls and shells set with three cabochon
rubies – initials of workmaster Michael
Perchin, assay mark of St. Petersburg
1899–1908, inv no. 71395, length 1 in. (2.5cm).
Private Collection

315. JEWELED GOLD-MOUNTED
CANE HANDLE shaped as a head of a
snake, naturalistically carved, with gold-
mounted diamond eyes, the reed-and-tie
mount set with rose-cut diamonds – signed
Fabergé, initials of workmaster Michael
Perchin, assay mark of St. Petersburg before
1899, height 2^3_{16} in. (5.6cm).
Exhibited: Hamburg 1995, cat. 195, ill. p. 181;
Lahti 1997, cat. 30, ill, p. 25.
The Woolf Family Collection

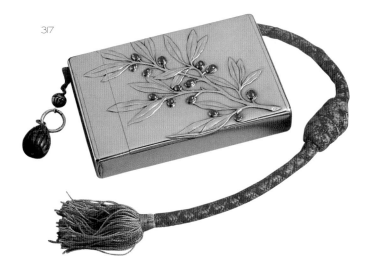

317

316

318

316. PAIR OF MINIATURE ART
NOUVEAU SILVER-MOUNTED
YELLOW CERAMIC VASES applied with
peonies in the Japanese style – signed Fabergé,
initials of workmaster Michael Perchin, St.
Petersburg before 1899, inv no. 4765, height
3¹⁵⁄₁₆ in. (10cm).
Provenance: Marchioness of Milford Haven;
Lord Ivar Mountbatten.
Exhibited: Munich 1986/7, cat. 33.
Private Collection

317. GEM-SET SILVER CIGARETTE-
CASE chased on one side with a berried
branch set with fourteen cabochon rubies, with
match compartment and tinder-cord with egg-
shaped pendant – signed Fabergé, initials of
workmaster Michael Perchin, assay mark of
St. Petersburg 1899–1904, assay master Yakov
Lyapunov, inv no. 7440, length 3¹⁵⁄₁₆ in. (10cm).
Bibliography: Traina 1998, p. 66.
It is rare to find a silver case, generally a
Moscow speciality, made by the leading
St. Petersburg workshop.
John Traina Collection

318. SILVER-MOUNTED CAMEO
GLASS by Gallé, the gray glass is overlaid in
purple and etched with iris blooms and foliage,
the silver foot and rim with applied leaves
continuing the etched design – signed Fabergé,
initials of workmaster Michael Perchin, assay
mark of St. Petersburg 1899–1908, the glass
with cameo mark "Gallé".
This is a rare instance of the head workmaster's
atelier being involved with such a commission.
Generally it was the workshop of Julius
Rappoport that mounted Gallé and ceramic
vases for Fabergé.
The Woolf Family Collection

319

320

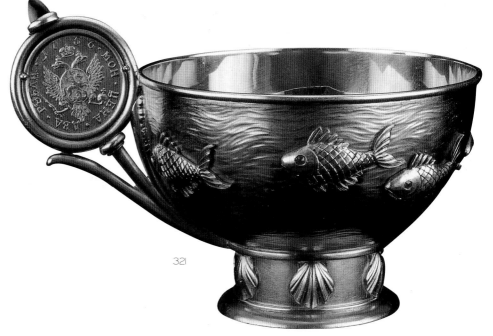

321

321. FISH CHARKA gem-set two-color gold
charka in the Japanese style chased with waves
and six goldfish with ruby-set eyes, the whole
supported by gold scallop shells and mounted
with a handle set with an Elizabeth I rouble
dated 1756 – signed Fabergé, initials of work-
master Michael Perchin, assay mark of
St. Petersburg before 1899, inv no. 43596,
length 3½ in. (8.9cm).
Bibliography: Waterfield/Forbes 1978, no. 123,
ill. p. 96; Forbes 1980, ill. p. 41; Solodkoff 1984,
p. 179; Hill 1989, plate no. 184.
Exhibited: New York 1983, no. 281, cat. p. 89;
Munich 1986/87, no. 153, cat. p. 151; Lugano
1987, no. 9, cat. p. 45; Paris 1987, no. 9, p. 41;
New York et al. 1996/97, no. 234, cat. p. 238.
The charka is similar to a bowl produced by
Martin Hall and Co. in 1880 decorated with a
fish and seaweed motif in the Japanese style
after Tiffany.
The Forbes Magazine Collection, New York

320. MINIATURE GOLD WASTE-
PAPER BASKET the sides are decorated
with alternate rays of red and yellow gold radi-
ating from white enameled gold roubles of
Empress Elizabeth and Catherine the Great –
two-color gold, enamel, roubles – signed
Fabergé, initials of workmaster Michael
Perchin, assay mark of St. Petersburg before
1899, 56 (zolotnik), inv no. 54481, height
1¾ in. (4.5cm).
Bibliography: Solodkoff 1984, p. 165; Hill
1989, plate no. 270.
Exhibited: Munich 1986/87, no. 160; Lugano
1987, no. 11, cat. p. 47; Paris 1987, no. 11,
cat. p. 43.
The Forbes Magazine Collection, New York

319. OVAL THREE-COLOR GOLD
FRAME the reeded gold border is decorated
and surmounted by a gold flame surrounded
by a laurel wreath suspending flower garlands,
with a further ribbon-tied flower garland
below, gold strut – signed Fabergé, initials of
workmaster Michael Perchin, assay mark of St.
Petersburg before 1899, height 3¼ in. (8.2cm).
Provenance: Prince George of Greece and
Denmark (1869–1957), cousin of Tsar
Nicholas II.
Exhibited: Hamburg 1995, cat. no. 163.
The Hubel Collection

322

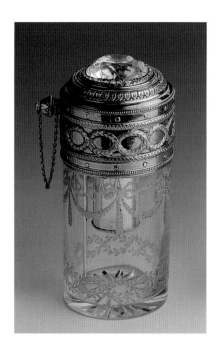

324

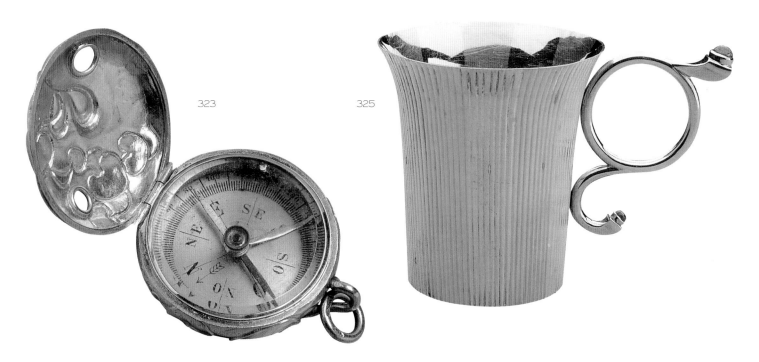

323 325

325. VODKA CUP WITH SAPPHIRES
gem-set varicolored gold vodka cup reeded
with alternating bands of red and green gold,
the scroll handle is mounted with cabochon
sapphires – signed Fabergé, initials of
workmaster Michael Perchin, assay mark of
St. Petersburg 1899–1908, 56 (zolotnik) height
1⁷8 in. (4.8cm).

322. ART NOUVEAU GEM-SET
GOLD-MOUNTED COMPASS shaped
as a watch-case *repoussé* and chased on both
sides with water lilies, the cover has two
cabochon star sapphires – signed, initials of
workmaster Michael Perchin, assay mark of
St. Petersburg 1899–1908, diameter 1¹2 in.
(3.9cm).

324. CYLINDRICAL GOLD-
MOUNTED CRYSTAL ATOMIZER the
body engraved with laurel swags, the two-color
gold mount chased with intertwining laurel
swags, with faceted rock-crystal finial as push-
piece, the nozzle attached by a chain – signed
Fabergé, initials of workmaster Michael
Perchin, assay mark of St. Petersburg
1899–1908, height 4³16 in. (10.6cm).

Provenance: HM. King Farouk (Sale, Cairo,
March 10–13, 17–20, 1957, lot 119, cat. p. 24)

Bibliography: Waterfield/Forbes 1978, no. 121,
ill. p. 96; Solodkoff 1984, p. 180.

Exhibited: New York 1973, no. 41, ill. p. 93;
Edinburgh/Aberdeen 1987, chklst. no. 39.

Provenance: Grand Duke Nicholas Nicolaevich
the Elder (1856–1929).
Private Collection

Exhibitions: Paris 1994, cat. 36; Hamburg 1995,
cat. 75; London 1996, cat. 36.

Chevalier Maurice Mizzi Collection

The Forbes Magazine Collection, New York

323. DETAIL OF ABOVE

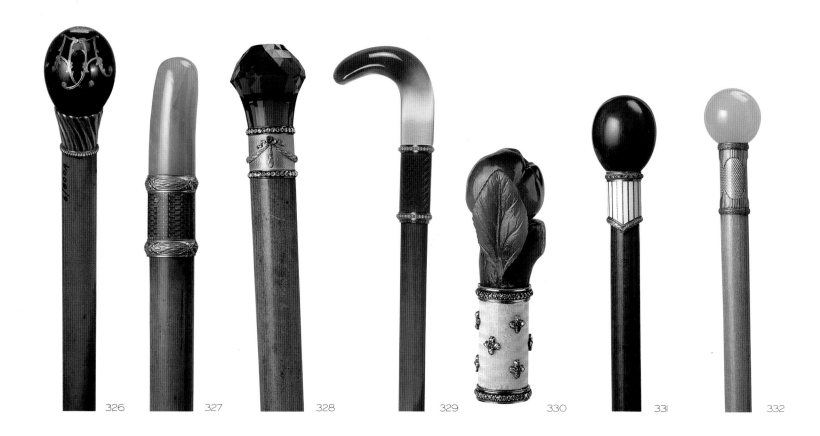

326 327 328 329 330 331 332

326. AN EGG-SHAPED, GOLD-MOUNTED BLOODSTONE CANE HANDLE inlaid in gold with crowned monogram "AA", the polished yellow gold mount spirally fluted – initials of workmaster Michael Perchin, assay mark of St. Petersburg before 1899, height of handle 2⁹⁄₁₆ in. (6.6cm). Provenance: Grand Duke Alexis Alexandrovich (1850–1908), brother of Tsar Alexander III and brother-in-law of Alfred, Duke of Edinburgh. Exhibited: Munich 1986/7, cat. 171. Private Collection

327. ENAMELED, GOLD-MOUNTED BOWENITE CANE HANDLE of cylindrical shape, the gold mount with red *guilloché* enamel band between two laurel-leaf borders – initials of workmaster Michael Perchin, assay mark of St. Petersburg before 1899, height of handle 4⁵⁄₁₆ in. (11cm). Exhibited: Munich 1986/7, cat. 172. Private Collection

328. GEM-SET, ENAMELED, GOLD-MOUNTED SMOKY QUARTZ CANE HANDLE with mushroom-shaped faceted hardstone handle, the mount of pale-green *guilloché* enamel is applied with yellow gold laurel swags suspended from cabochon rubies; rose-cut diamond borders – by Fabergé, unmarked, height of handle 2¹⁵⁄₁₆ in. (7.5cm). Exhibited: Munich 1986/7, cat. 176. Private Collection

329. GOLD-MOUTED AND ENAMELED ROCK CRYSTAL PARASOL HANDLE of orange *guilloché* enamel with seed-pearl borders – initials of workmaster Michael Perchin, assay mark of St. Petersburg before 1899, length of handle 3¹⁄₈ in. (8cm). Original felt case for handle. Private Collection

330. GEM-SET, GOLD AND ENAMEL NEPHRITE PARASOL HANDLE carved with an apple on a branch with leaves on a cylindrical opalescent white enamel mount decorated with quatrefoils set with cabochon rubies and diamonds, with diamond borders – signed Fabergé, initials of workmaster Michael Perchin, assay mark of St. Petersburg before 1899, inv no. 20579, length 2¹⁄₂ in. (6.3cm). Private Collection

331. EGG-SHAPED ENAMELED, GOLD-MOUNTED NEPHRITE CANE HANDLE the gold mount with white opaque enamel stripes, ruby and diamond-set border above, palm-leaf border below – initials of workmaster Michael Perchin, assay mark of St. Petersburg 1899–1908, height of handle 2¹¹⁄₁₆ in. (6.8cm). Exhibited: Munich 1986/7, cat. 173. Private Collection

332. SPHERICAL ENAMELED, GOLD-MOUNTED BOWENITE CANE HANDLE the reeded gold mount with mauve *guilloché* enamel reserves and with palm-leaf borders – initials of workmaster Michael Perchin, assay mark of St. Petersburg 1899–1908, height of handle 2¹³⁄₁₆ in. (7.2cm). Exhibited: Munich 1986/7, cat. 175. Private Collection

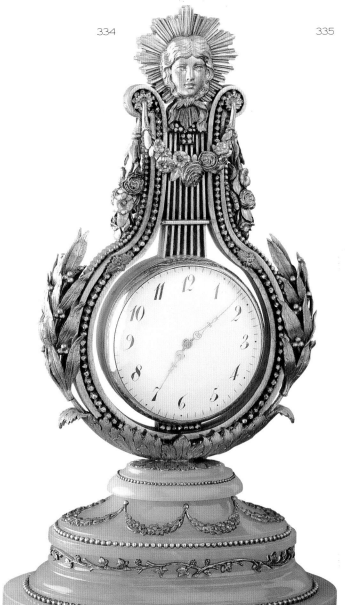

335

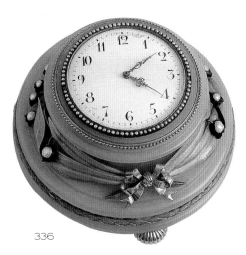

336

333

333. GEM-SET, ENAMELED, GOLD-
AND SILVER-MOUNTED
AVENTURINE QUARTZ CANE
HANDLE of knob shape, the mount with
leaves of green translucent enamel and triple
clusters of rose-cut diamonds; rose-cut dia-
mond border – signed Fabergé, initials of
workmaster Michael Perchin, assay mark of
St. Petersburg 1899–1908, assay master Yakov
Lyapunov, 56 (zolotnik), height 2¾ in. (7cm).
Trevor Traina Collection

334. QUARTZ CLOCK shaped as a lyre, set
with diamonds in gold-mounted silver-gilt and
pink aventurine, of Louis XVI design, on
stepped oval base decorated with beading, ivy
sprays and floral swags. Opaque white enamel
dial with Arabic chapters and gold "Louis XV"
hands. The lyre has outer naturalistic laurel
crown, and suspended rose swags surmounted
by the sun symbolized by Apollo's head, further
decorated with rose-cut diamonds – signed
Fabergé, initials of workmaster Michael
Perchin, assay mark of St. Petersburg before
1899, height 6¹⁵⁄₁₆ in. (17.7cm).
Exhibited: Hamburg 1995, cat. 80.
Private Collection

335. QUARTZ DESK CLOCK in square
enameled gold and silver-gilt mounted pink
aventurine, applied with gold thyrsos staffs
placed diagonally tied with ribbons, the rim of
green *guilloché* enamel set with half pearls, the
opaque white enamel dial with black Arabic
chapters, gold "Louis XV" hands and reed-and-
tie bezel – signed Fabergé, initials of
workmaster Michael Perchin, assay mark of St.
Petersburg before 1899, height 4¼ in. (10.8cm).
Exhibited: Hamburg 1995, cat. 111.
Private Collection

336. DESK CLOCK circular gold-mounted
bowenite on three gadrooned stud feet, the
white opaque enamel dial with black Arabic
chapters, gold "Louis XV" hands and seed pearl
bezel, the stepped body applied with
surrounding two-color gold lily-of-the-valley
sprays with pearl buds tied with a red gold
ribbon, with a laurel leaf band encircling the
base – signed Fabergé, initials of workmaster
Michael Perchin, assay mark of St. Petersburg
1899–1908, diameter 3⅞ in. (9.8cm).
Exhibited: Hamburg 1995, cat. 131.
Private Collection

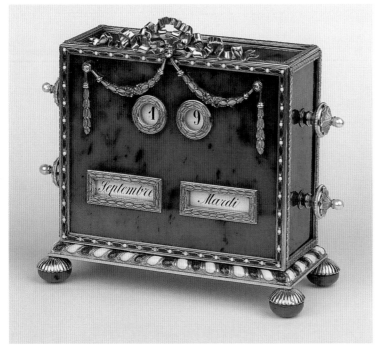

337

339

340 341 342

338

339. CARD HOLDER ON BUN FEET
rectangular two-color card holder in gold-
mounted nephrite mounted in red and green
gold and supported by four reeded red-gold
bun feet – signed Fabergé, initials of
workmaster Michael Perchin, assay mark of
St. Petersburg 1899–1908, 56 (zolotnik),
inv no. 3239, height 3 in. (7.6cm).
Bibliography: Waterfield/Forbes 1978, no. 106,
ill. p. 87; Solodkoff 1984, ill. pp. 6, 176.
Exhibited: New York et al. 1996/97, no. 289,
cat. p. 269.
The Forbes Magazine Collection, New York

341. CYLINDRICAL GEM-SET SCENT-
FLASK in gold-mounted bowenite, the
onion-shaped cover chased with swirling flutes,
Mecca-stone finial in rose-cut diamond
surround – signed Fabergé, initials of
workmaster Michael Perchin, assay mark of
St. Petersburg before 1899, height 4³⁄₁₆ in.
(10.7cm).
Exhibited: Paris 1994, cat. 37; Hamburg 1995,
cat. 56; London 1996, cat. 37.
Chevalier Maurice Mizzi Collection

337. RECTANGULAR GEM-SET
ENAMEL PERPETUAL CALENDAR
in two-colour gold-mounted nephrite with the
apertures for the date, week-day and month
with chased laurel borders surmounted by a
diamond-set ribbon tie suspending a laurel
garland, the borders and plinth with translucent
red and white enamel decoration on four
nephrite ball feet with reeded gold mounts, the
gold handles to rotate the calendar set with
pearls – signed Fabergé, initials of workmaster
Michael Perchin, assay mark of St. Petersburg
before 1899, length 4³⁄₄ in. (12.1cm).
For the Fabergé design of a desk set
comprising this perpetual calendar, see
Christie's London, sales catalogue: Designs from
the House of Carl Fabergé, 27 April 1989, no. 484.
Private Collection, courtesy A. von Solodkoff

338. RECTANGULAR GEM-SET
ENAMEL STAMP BOX in gold-mounted
nephrite en suite to the calendar carved from a
block of nephrite with three compartments for
stamps, the hardstone cover with gold chased
laurel border with red and white enamel pel-
lets, the base with similarly enameled entrelac
band with diamonds to the corners, on four
nephrite ball feet with reeded gold mounts –
signed Fabergé, initials of workmaster Michael
Perchin, assay mark of St. Petersburg before
1899, length 9³⁄₄ in. (9.4cm).
For the Fabergé design of a desk set
comprising this stamp box see 337.
Private Collection, courtesy A. von Solodkoff

340. CYLINDRICAL GEMSET SCENT-
FLASK in gold-mounted rock-crystal the
engine-turned cover (originally probably
enameled) with palm-leaf border and cabochon
moonstone finial in diamond surround –
initials of workmaster Michael Perchin, assay
mark of St. Petersburg before 1899, English
hallmark G. S., height 2⁵⁄₈ in. (6.8cm).
Exhibited: Paris 1994, cat. 11; Hamburg 1995,
cat. 50; London 1996, cat. 11.
Chevalier Maurice Mizzi Collection

342. GOLD-MOUNTED BOWENITE
CHARM shaped as a fob-seal – initials of
workmaster Michael Perchin, assay mark of
St. Petersburg 1899–1903, assay master Yakov
Lyapunov, 56 (zolotnik), 1¹⁄₈ in. (2.8cm).
Provenance: Gatchina Palace; Central
Depository for Suburban Palaces, 1956.
The State Hermitage Museum (ERO – 8425)

343

344

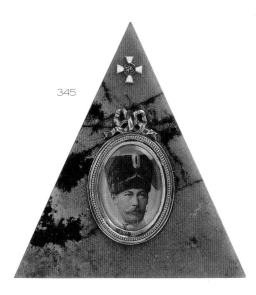

345

346

344. ROCK CRYSTAL FRAME gem-set enameled four color frame in gold-mounted rock crystal etched with a band of notched ornament and applied with four-color gold floral swags suspended above from a chased gold, diamond and ruby-set basket of flowers sculpted in the round, and below by a pink enamel ribbon with a cabochon ruby knot and diamond-set tassel also sculpted in the round – initials of workmaster Michael Perchin, assay mark of St. Petersburg 1899–1908, assay-master Yakov Lyapunov, 56 (zolotnik), inv no. 5956, height 4 in. (10cm). The frame now contains a photograph of Grand Duchess Maria, third daughter of Tsar Nicholas II and Tsarina Alexandra.
Bibliography: Waterfield/Forbes 1978, no. 72, ill. p. 64, 143; Kelly 1982/83, ill. no. 16; Solodkoff 1984, ill. p. 171; Forbes 1986, p. 52; Hill 1989, ill. pl. 141.
Exhibited: New York 1949, no. 179, cat. p. 18, ill.; Munich 1986/87, no. 285, cat. p. 190, ill.; Lugano 1987, no. 32, cat. p. 58; Paris 1987, no. 32, cat. p. 54; Stockholm 1997, no. 114, cat. p. 153.
The Forbes Magazine Collection, New York

343. RECTANGULAR THREE-COLOR GOLD AND ENAMEL ROCK CRYSTAL FRAME the bezel of red *guilloché* enamel, the rock crystal panel divided by four gold Thyrsos staffs applied with symbols of music and decorated with flower garlands suspended from cabochon rubies, gold openwork strut – signed Fabergé, initials of workmaster Michael Perchin, assay mark of St. Petersburg before 1899, inv no. 51860, height 3⁷⁄₁₆ in. (8.8cm).
The portrait is that of Grand Duke Frederick Francis III of Mecklenburg-Schwerin.
Exhibited: Hamburg 1995, cat. no. 153.
Private Collection, courtesy A. von Solodkoff

345. TRIANGULAR SILVER-MOUNTED RHODONITE FRAME the oval reeded bezel surmounted by a ribbon tie and applied with an enameled badge of the Order of St. George, with silver strut – signed Fabergé, initials of workmaster Michael Perchin, assay mark of St. Petersburg before 1899, height 3¹⁄₈ in. (8cm).
The photograph shows a portrait of Grand Duke Frederick Francis III of Mecklenburg-Schwerin.
Exhibited: Hamburg 1995, cat. no. 154.
Private Collection, courtesy A. von Solodkoff

346. GOLD-MOUNTED AND ENAMELED NEPHRITE PAPERKNIFE the oblong hardstone blade with pink *guilloché* enamel handle, its angular border set with rose-cut diamonds – signed Fabergé, initials of workmaster Michael Perchin, assay mark of St. Petersburg before 1899, inv no. 3913, length 9¹⁄₂ in. (24.1cm).
Original wooden case stamped with Imperial Warrant, Fabergé, St. Petersburg, Moscow.
Private Collection

347

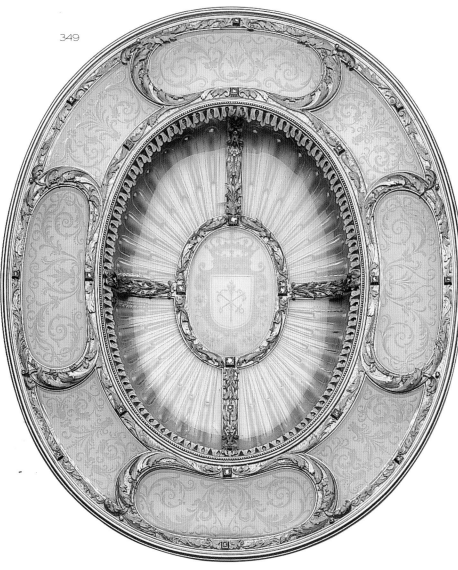

349

348

351

347. LARGE GOLD-MOUNTED
NEPHRITE PAPERKNIFE the oblong
hardstone blade with rounded edges, the
handle applied with three-color gold
openwork lambrequin decoration enclosing a
vase filled with flowers and foliate branches –
initials of workmaster Michael Perchin, assay
mark of St. Petersburg before 1899, inv no.
9165, length 9⁷⁄₈ in. (25cm).
Private Collection

348. GOLD-MOUNTED AND
ENAMELED CITRINE CIGARETTE-
CASE of oval section, the body carved with
alternating bands of narrow and wide flutes,
the mounts of white *guilloché* enamel and green
enamel leaves, cabochon sapphire thumbpiece
– initials of workmaster Michael Perchin, assay
mark of St. Petersburg before 1899, length
3⁵⁄₈ in. (9.2cm)
Bibliography: Traina 1998, p. 121.
John Traina Collection

349. OVAL GEM-SET, ENAMELED,
SILVER-GILT MOUNTED ROCK
CRYSTAL DISH in the Renaissance style set
with thirteen rock crystal panels engraved with
scrolls, the centre engraved with the coat of
arms of the city of Saint Petersburg – signed
Fabergé, Saint Petersburg, initials of
workmaster Michael Perchin, assay mark of
St. Petersburg before 1899, 88 (zolotnik),
15³⁄₄ × 13 in. (40 × 34cm). The reverse inscribed
"A gift from the nobility of the Saint
Petersburg district, 1896".
Provenance: Diamond Room at the Winter
Palace; acquired by the Hermitage on
15 June 1922.

Bibliography: Lopato, 1984, pp. 43–49.
Exhibited: Lugano, 1986, cat. 118; Munich
1986–1987, cat. 282; Zurich, 1989, cat. 22;
Leningrad 1989, cat. 42; Saint
Petersburg/Paris/London 1993–1994, cat. 11;
Saint Petersburg/Wilmington/Mobile
1998–2000, cat. 209.
The dish was presented by the St. Petersburg
nobility to the royal couple on 14 May 1896 at
the coronation of Nicholas II. This beautiful
dish is one of Fabergé's best pieces in the Late
Renaissance style. The masterly engraving on
layers of rock crystal is particularly noteworthy,
and is reminiscent of the 17th-century dishes
displayed in the Kremlin Armory, and of a
similar piece at the Kunsthistorisches
Museum, Vienna.

351. SQUARE GEM-SET ENAMEL
AND GOLD-MOUNTED NEPHRITE
BOX the cover decorated in the Renaissance
style with red and blue enamel scrolls and
white enamel strapwork, the center with a large
rose-cut diamond – signed Fabergé, initials of
workmaster Michael Perchin, assay mark of
St. Petersburg before 1899, length
1⁹⁄₁₆ in. (4cm).
Bibliography: Solodkoff 1988, p. 15 and p. 74
Exhibited: Hamburg 1995, cat. no. 186.
Private Collection, courtesy of A. von Solodkoff

352

353

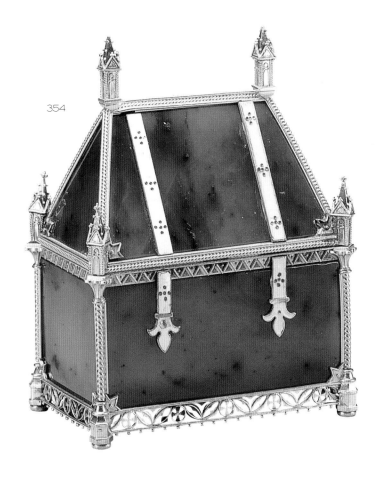

354

352. RECTANGULAR GEM-SET, GOLD-MOUNTED NEPHRITE BOX
the cover with bevelled sides, the fleur-de-lis shaped hinges and clasp set with rose-cut diamonds and cabochon rubies, the rim set with rose-cut diamonds and trimmed with red and white enamel band – signed Fabergé, initials of workmaster Michael Perchin, assay mark of St. Petersburg before 1899, length 1⁷₈ in. (4.7cm).
Exhibited: New York et al., 1996/7, cat. 343; QVC 1999.
Joan and Melissa Rivers

353. RECTANGULAR TWO-COLOR GOLD-MOUNTED AGATE DISH the translucent striated agate carved with rounded corners, the gold border chased with *entrelac* bands – initials of workmaster Michael Perchin, assay mark of St. Petersburg before 1899, inv no. 42673, length 3¹₁₆ in. (7.8cm).
Private Collection, courtesy A. von Solodkoff

354. MINIATURE RELIQUARY IN THE GOTHIC STYLE accented by two white enamel bands embellished with red enamel cross-shaped pellets, the high pitched detachable lid capped by gold mounted finials shaped as turrets – signed Fabergé, initials of workmaster Michael Perchin, assay mark of St. Petersburg before 1899, inv no. 57995, length 2¹₈ in. (5.5cm).
Bibliography: Solodkoff 1984, p. 164, ill.; Solodkoff 1988, p. 13.
Exhibited: Munich 1986/87, no. 246, ill. p. 172; Lugano 1987, no. 49, cat. p. 68; Paris 1987, no. 49, cat. p. 64.
This reliquary is a rare example of an *objet d'art* in the Gothic style in Fabergé's oeuvre. Several major commissions in this style were executed by the firm, including a huge silver service for the industrialist Alexander Kelch costing 125,000 roubles, over twice the price paid by Tsar Nicholas II for similar services made for the weddings of Grand Duchesses Olga and Xenia.
The Forbes Magazine Collection, New York

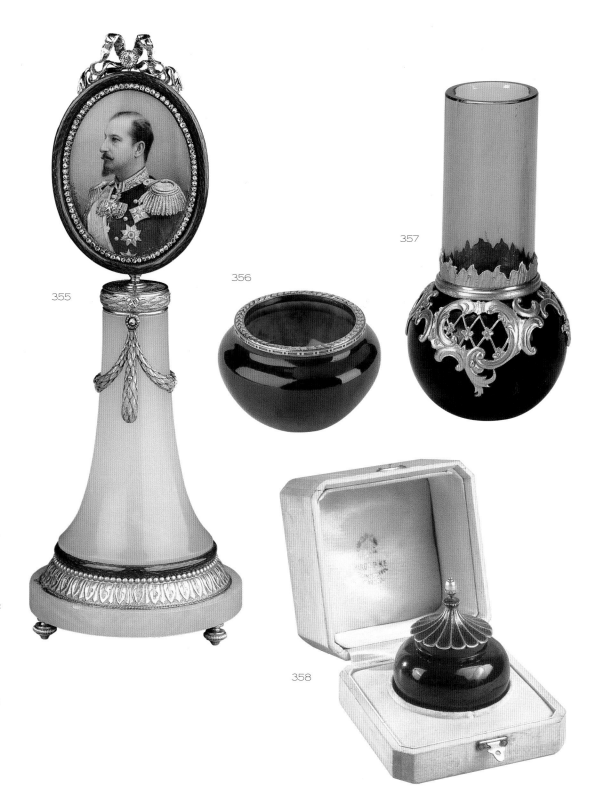

355. GEM-SET ENAMEL AND TWO-COLOR GOLD MOUNTED OVAL MINIATURE of Ferdinand I of Bulgaria wearing the uniform of a general, signed *Zehngraf*, surrounded by rose-cut diamonds and a band of red *guilloché* enamel, surmounted by a diamond-set gold ribbon cresting, on a trumpet-shaped gold-mounted bowenite base applied with diamond-set laurel festoons, the circular base with bands of chased gold laurel leaves and red enamel, on three gold toupie feet – signed Fabergé, initials of workmaster Michael Perchin, assay mark of St. Petersburg before 1899, height 5⁵⁄₁₆ in. (13.5cm).
Provenance: The Collection of the Princes of Thurn and Taxis, Schloss St. Emmeram, Regensburg Inv number: St. E 708.
Ferdinand (1861–1949) was the son of Prince August of Saxe-Coburg and Gotha-Kohary and Princess Clementine d'Orleans, daughter of King Louis Philippe of France. In 1887 he accepted his election as hereditary Prince of Bulgaria. In 1908 he was able to proclaim himself Tsar of the Bulgarians. He was known for his exuberant taste in jewelry and *objets d'art*, many of which were supplied to him by Fabergé during his frequent visits to St. Petersburg. After the First World War he abdicated in favour of his eldest son Boris, Prince of Tirnovo, and retired to Coburg.
Johannes Zehngraf (1857–1908) studied at the Academy of Copenhagen, his native city, and later became chief miniature painter for Fabergé specializing in fine quality portraits of the European aristocracy.
Private Collection, courtesy A. von Solodkoff

356. SMALL CIRCULAR GOLD-MOUNTED NEPHRITE VASE the bulbous hardstone bowl with two-color gold mounts chased with laurel, initials of Michael Perchin, assay mark of St. Petersburg, assay-master Yakov Lyapunov, inv no. 3929, diameter 1³⁄₄ in. (4.5cm).
Provenance: Collection of Sir Charles Clore.
Private Collection

357. GOLD-MOUNTED SMOKY QUARTZ SPECIMEN VASE the mounts chased with rocaille motifs – initials of workmaster M. Perchin, assay mark of St. Petersburg before 1899, inv no. 51542, height 3 in. (7.5cm). Original fitted case with Imperial Warrant, St. Petersburg, Moscow.
Private Collection

358. GOLD-MOUNTED ENAMELED NEPHRITE GUM-POT of compressed spherical shape, the cover of pagoda shape decorated with tapering bands of red *guilloché* enamel, the pearl finial on a rose-cut diamond mount – initials of workmaster Michael Perchin, St. Petersburg before 1899, height 2¹⁄₂ in. (6.3cm). Original fitted case stamped with Imperial Warrant, St. Petersburg, Moscow.
Exhibited: London 1995, cat. 14.
The Castle Howard Collection

359

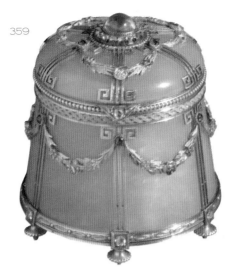

360

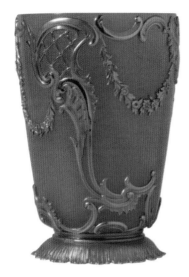

361

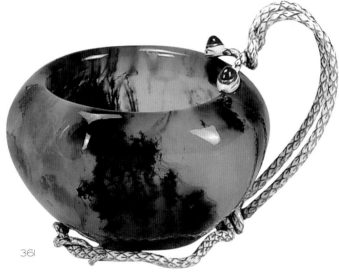

362

359. JEWELED FOUR-COLOR GOLD-MOUNTED BOWENITE GUM-POT the cylindrical body of slightly tapering shape, standing on six stud feet, the domed hinged cover with a cabochon moonstone finial within diamond setting and further gold decoration, the body applied with six pilasters enriched with diamonds and cabochon rubies suspending four-color gold swags – signed Fabergé, initials of workmaster Michael Perchin, assay mark of St. Petersburg before 1899, height 2¹⁸ in. (5.5.cm).
Exhibited: Munich 1986/7, cat. 244, ill. p. 171; New York 1988, cat. 2, cover ill.; Zurich 1989, cat. 15, ill. p. 48; St. Petersburg/Paris/London 1993/4, cat. 250, ill. p. 356; Hamburg 1995, cat. 203, ill. p. 189; Stockholm 1997, cat. 93, ill. p. 139.
The Woolf Family Collection

360. LOUIS XV-STYLE GOLD-MOUNTED BOWENITE BEAKER of tapering cylindrical shape, the body applied with a yellow-gold cagework of Rococo scrolls and floral swags, the everted gold foot chased with rocaille – signed Fabergé, initials of workmaster Michael Perchin, assay mark of St. Petersburg before 1899, height 3¹⁴ in. (8.2cm). Fitted case stamped Hammer, New York, Palm Beach.
Exhibited: Munich 1986/7, cat. 243, ill. p. 171; New York 1988, cat. 3, cover ill.; Zurich 1989, cat. 42, ill. p. 80; St. Petersburg/Paris/London 1993/4, cat. 251, ill. p. 356.
Bibliography: Connaissance des Arts Hors Série 1993, ill. p. 20.
The Woolf Family Collection

361. JEWELED, ENAMELED, GOLD-MOUNTED MOSS AGATE CHARKA the shaped hemispherical moss agate body mounted with two opaque white enameled gold snakes, entwined to form the foot and handle, each head set with a cabochon ruby – signed Fabergé, initials of workmaster Michael Perchin, assay mark of St. Petersburg 1899–1908, length 3¹⁸ in. (8cm). Original velvet and silk-lined wooden box, stamped with Imperial Warrant, St. Petersburg Moscow, Odessa.
Provenance: Miss Yznaga, sister of the Duchess of Manchester.
Private Collection

362. OWL BELL PUSH two-color gold-mounted tigers' eye and nephrite bell-push formed as an owl's head with a spray of gold holly mounted underneath the bird's curved beak, the tigers' eyes' pupils serving as push pieces – signed Fabergé, initials of workmaster Michael Perchin, assay mark of St. Petersburg 1899–1908, assay master Yakov Lyapunov, 56 (zolotnik), length: 2³⁸ in. (6cm).
Provenance: Countess Mona Bismarck.
Bibliography: Solodkoff 1984, p. 166.
Exhibited: New York 1973, no. 30, ill. p. 81; Munich 1986/87, no. 247, cat. p. 172; Lugano 1987, no. 61, cat. p. 74; Paris 1987, no. 61, cat. p. 20.
An exact replica by Cartier of this owl bell-push exists.
The Forbes Magazine Collection, New York

364

365

363

366

363. SILVER-GILT AND ENAMEL
HARDSTONE WEATHER-FROG
BELL-PUSH on three ball feet, the circular
base with a band of red *guilloché* enamel
between laurel and pellet bands surmounted by
a bell-shaped rock crystal cover revealing a
nephrite frog with diamond eyes sitting on a
ladder, with silver-gilt calyx and cabochon
garnet finial – signed Fabergé, initials of
workmaster Michael Perchin, assay mark of
St. Petersburg 1899–1908, inv no. 3605, height
3¼ in. (8.3cm).
Provenance: sold to the Imperial Cabinet on
1 December 1900, described as: Electrical bell,
nephrite frog, "glass" of rock crystal with red
enamel, one garnet and two roses, no. 3605
(1/2) 125 roubles (CSH Archive, f. 468 op. 14,
del 210) Given by Tsar Nicholas II to his
cousin Prince George of Greece and Denmark
(1869–1957).
Exhibited: St. Petersburg/Paris/London
1993–4, cat. no. 104; Hamburg 1995, cat no.
191; Stockholm 1997, cat. no. 195.
The Hubel Collection

364. SILVER-GILT MOUNTED
ENAMEL AND HARDSTONE
DOUBLE BELL-PUSH with tortoises on
four reeded melon feet with shaped bowenite
base applied with ribbon-and-tie band, with
two circular red *guilloché* enamel plaques above,
each set with a tortoise in dark grey and white
agate, surrounded by two-color silver-gilt laurel
wreaths divided by Maenad's staffs – signed
Fabergé, initials of workmaster Michael
Perchin, assay mark of St. Petersburg
1899–1908, inv no. 2926, length 4⅜ in.
(11.2cm). Original fitted wooden case stamped
with Imperial Warrant, Fabergé, St. Petersburg,
Moscow.
Provenance: Emanuel Nobel, St. Petersburg
Exhibited: Hamburg 1995, cat. no. 190;
Stockholm 1997, cat. no. 193.
The Hubel Collection

365. GOLD-MOUNTED AND
ENAMELED HARDSTONE DOUBLE
BELL-PUSH the push-pieces shaped as two
carved hardstone turtles of differing colors
with diamond eyes, seated on a red *guilloché*
enamel see-saw. The stepped rectangular
chalcedony base on four bun feet – signed
Fabergé, initials of workmaster Michael
Perchin, assay mark of St. Petersburg
1899–1908, inv no. 5720, length 4 in. (10.2cm).
Provenance: Lord Ivar Mountbatten.
Exhibited: Munich 1986/7, cat. 208, ill. p. 162.
The Woolf Family Collection

366. GOLD-MOUNTED AGATE CUP
in the Renaissance style, the hardstone is
glass-like in appearance where the stone has
been refined to its finest and most transparent
state – signed Fabergé, initials of workmaster
Eric Kollin, assay mark of St. Petersburg, 84
(zolotnik), dimensions: length 4⁷₁₂ in. (11.7cm).
Provenance: Count Feodor Ivanovich Tolstoy;
purchased by the Hermitage Acquisitions
Department in 1984 from L.I. Tolstoy.
Exhibited: Leningrad 1989, cat. 29; Zurich
1989, cat.23.
The glass-like appearance of the agate, along
with the characteristic fake stone markings
would suggest the piece was of Chinese origin.
It was not unusual for Fabergé to create mounts
for work by other masters, whether in china,
glass, crystal or stone. This particular mount is a
delicate and graceful example of Late
Renaissance style, which complements the cup
perfectly. The result is a beautiful and entirely
harmonious piece of work.
The State Hermitage Museum, St. Petersburg
(NE 17797)

367

368

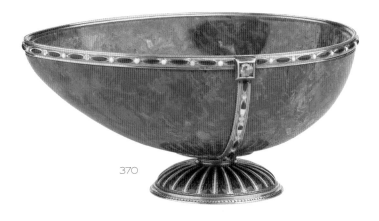

370

369

367. GOLD-MOUNTED DARK
BROWN AGATE VODKA-CUP shaped as
a negro's head with polished lips and neck,
with gold-mounted rose-cut diamond eyes and
palm-leaf border – initials of workmaster
Michael Perchin, assay mark of St. Petersburg
before 1899, length 2¹4 in. (5.7cm).
Private Collection

368. GOLD-MOUNTED SMOKY
QUARTZ EASTER EGG carved to
simulate water content and engraved inside
with "Levashovo – Pepi 28–29 May 1902",
decorated with two-color gold palmette band
– initials of workmaster Michael Perchin, assay
mark of St. Petersburg 1899–1908, assay master
Yakov Lyapunov Levashovo was the summer
house belonging to the Fabergé family.
Private Collection

369. DESIGN IN WATERCOLOR AND
GOUACHE FOR A JEWELED AND
ENAMELED GOLD-MOUNTED
NEPHRITE TRAY signed K. Fabergé,
18⁹16×25¹¹16 in. (47.2×65.3cm).
Provenance: The Imperial Cabinet; State
Museum of Ethnography, 1941
Exhibited: St. Petersburg/Paris/London
1993/4, cat. 303; Stockholm 1997, cat. 289.
On the handles, enamelled in pink, are the
cyphers of Emperor Nicholas II's and of the
German Kaiser Wilhelm. This tray may have
been intended as a present for the German
Imperial couple in 1906, date of their Silver
Wedding anniversary. A virtually identical tray,
with the cyphers of Nicholas and Alexandra,
given to them by the Nobility of the City of
St. Petersburg in 1896, is in the Forbes
Magazine Collection.
The State Hermitage Museum
(ERO sh – 1596)

370. EGG-SHAPED ENAMEL AND
GOLD-MOUNTED JASPER CUP on
circular reeded foot enameled blue with white
stripes, the red mottled hardstone held by a
gold band with blue enamel ovals and white
dots, the similarly decorated border set with
two diamonds – initials of workmaster Michael
Perchin, assay mark of St. Petersburg before
1899, London import marks for 1928, engraved
number 1907, length 3¹2 in. (9cm).
Private Collection

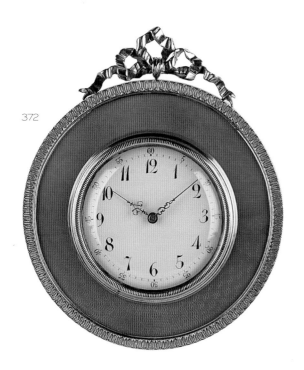

372

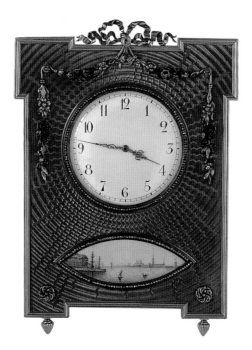

373

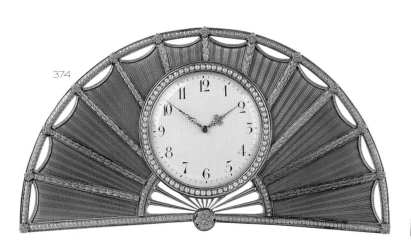

374

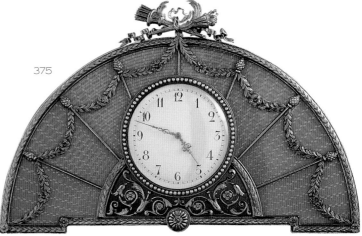

375

373. SHAPED RECTANGULAR DIAMOND-SET ENAMELED GOLD DESK CLOCK of orange translucent enamel over concentric sunburst *guilloché* ground, applied with a garland of varicolored gold and two gold rosettes in the lower corners, the opaque white enamel dial with black Arabic chapters, gold "Louis XV" hands and rose-cut diamond bezel. An elliptic aperture beneath with rose-cut diamond border is set with an enamel panel painted in camaieu rose with a view of the Mint, the Neva and the St. Peter and Paul Fortress, with ribbon cresting, reeded border and gold strut – signed Fabergé, initials of workmaster Michael Perchin, assay mark of St. Petersburg before 1899, movement signed *Henri Moser & Cie. no. 50797*, height 5⅜ in. (13.7cm).
Provenance: Lord Southborough.
Exhibited: Hamburg 1995, cat. 81.
Private Collection.

372. CIRCULAR SILVER AND PINK ENAMEL CLOCK with reeded silver bezel surrounded by a band of pink *guilloché* enamel with silver palmette border, surmounted by a ribbon cresting, silver backing and strut – signed Fabergé, initials of workmaster Michael Perchin, assay mark of St. Petersburg before 1899, height 4 in. (10.2cm).
Private Collection, courtesy A. von Solodkoff

374. FAN-SHAPED GOLD AND ENAMEL CLOCK with pearl-set bezel, the blue *guilloché* enamel fan with two-color gold ribs chased with laurel and rosettes, gold backing and strut – signed Fabergé, initials of workmaster Michael Perchin, assay mark of St. Petersburg before 1899, inv no. 49218, length 6⅛ in. (15.6cm).
Private Collection

375. SHAPED RECTANGULAR DIAMOND-SET ENAMELED GOLD DESK CLOCK of orange translucent enamel over concentric sunburst *guilloché* ground, applied with a garland of varicolored gold and two gold rosettes in the lower corners, the opaque white enamel dial with black Arabic chapters, gold "Louis XV" hands and rose-cut diamond bezel. An elliptic aperture beneath with rose-cut diamond border is set with an enamel panel painted in camaieu rose with a view of the Mint, the Neva and the St. Peter and Paul Fortress, with ribbon cresting, reeded border and gold strut – signed Fabergé, initials of workmaster Michael Perchin, assay mark of St. Petersburg before 1899, movement signed *Henri Moser & Cie. no. 50797*, height 5⅜ in. (13.7cm).
Provenance: Lord Southborough.
Exhibited: Hamburg 1995, cat. 81.
Private Collection

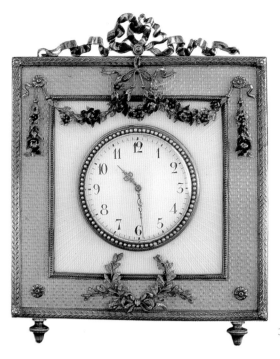

376

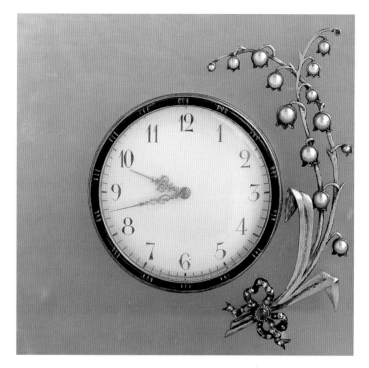

377

379

378

376. SQUARE ENAMELED GOLD-MOUNTED SILVER-GILT DESK CLOCK of white translucent enamel over sunburst *guilloché* ground and with a wide outer yellow-green *guilloché* enamel border. Applied with suspended varicolored gold flower swags above, and tied laurel sprays beneath, with ribbon cresting, peg feet, opaque white enamel dial with black Arabic chapters, gold "Louis XV" hands and seed-pearl bezel set in a panel; silver-gilt strut – signed Fabergé, initials of workmaster Michael Perchin, assay mark of St. Petersburg before 1899, inv no. 57814, height 5¹⁄₂ in. (14cm).
Exhibited: Hamburg 1995, cat. 84.
Private Collection

377. SQUARE GEM-SET, ENAMELED AND GOLD-MOUNTED BOWENITE DESK CLOCK the bowenite panel applied to the right with two lily-of-the-valley sprays with pearl buds and chased yellow gold leaves tied with a diamond and ruby-set ribbon, with opaque white enamel dial with black Arabic chapters, gold "Louis XV" hands and black *guilloché* enamel bezel with gold bands, gold case and strut – signed Fabergé, initials of workmaster Michael Perchin, assay mark of St. Petersburg before 1899, height 3¹³⁄₁₆ in. (9.7cm).
Exhibited: Hamburg 1995, cat. 96.
Private Collection

378. SQUARE ENAMELED, SILVER-GILT DESK CLOCK of translucent yellow enamel over sunburst *guilloché* ground applied overall with pearl-set scrolls, with reed-and-tie border, white opaque enamel dial with black Arabic chapters, black steel flèche hands and rocaille bezel and silver-gilt strut – signed Fabergé, initials of workmaster Michael Perchin, assay mark of St. Petersburg before 1899, height 4⁹⁄₁₆ in. (11.7cm).
Exhibited: Hamburg 1995, cat. 95.
Private Collection

379. SQUARE ENAMELED SILVER-GILT DESK CLOCK standing on its edge, of translucent mauve enamel panel over sunburst *guilloché* ground, applied with four open laurel crowns tied with ribbons, with outer stylized leaf rim, white opaque enamel dial with black Arabic chapters and gold "Louis XV" hands and interwoven bezel; silver-gilt strut – signed Fabergé, initials of workmaster Michael Perchin, assay mark of St. Petersburg before 1899, height 5¹¹⁄₁₆ in. (14.5cm).
Exhibited: Hamburg 1995, cat. 99.
Private Collection

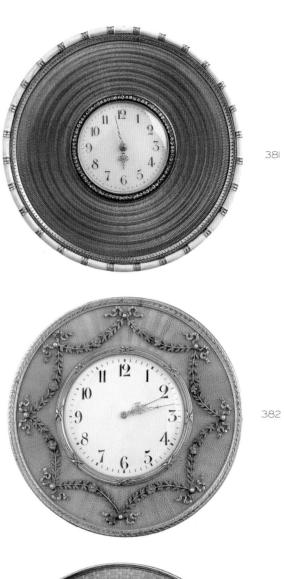

380

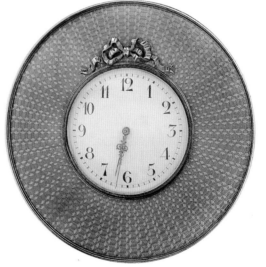

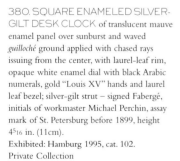

380. SQUARE ENAMELED SILVER-GILT DESK CLOCK of translucent mauve enamel panel over sunburst and waved *guilloché* ground applied with chased rays issuing from the center, with laurel-leaf rim, opaque white enamel dial with black Arabic numerals, gold "Louis XV" hands and laurel leaf bezel; silver-gilt strut – signed Fabergé, initials of workmaster Michael Perchin, assay mark of St. Petersburg before 1899, height 4⁵⁄₁₆ in. (11cm).
Exhibited: Hamburg 1995, cat. 102.
Private Collection

381. CIRCULAR DIAMOND-SET ENAMELED GOLD DESK CLOCK of translucent apricot enamel over concentric *guilloché* circles, the rim of opaque enamel tied with gold ribbons, the opaque white enamel dial with black Arabic chapters, gold "Louis XV" hands and rose-cut diamond bezel; gold strut – signed Fabergé, initials of workmaster Michael Perchin, assay mark of St. Petersburg before 1899, diameter 3 in. (7.5cm)
Exhibited: Hamburg 1995, cat. 104.
Private Collection

382. CIRCULAR GOLD-MOUNTED ENAMELED SILVER-GILT DESK CLOCK of translucent pink enamel over sunburst *guilloché* ground applied with two-color gold swags suspended from tied ribbons set with seed pearls, with laurel-leaf rim, opaque white enamel dial with black Arabic chapters and reed-and-tie bezel; silver-gilt strut – signed Fabergé, initials of workmaster Michael Perchin, assay mark of St. Petersburg before 1899, diameter 3¾ in. (9.5cm).
Exhibited: Hamburg 1995, cat. 108.
Private Collection

383. CIRCULAR ENAMELED SILVER DESK CLOCK of translucent mauve enamel over sunburst *guilloché* ground, the opaque white enamel dial with black Arabic chapters, gold "Louis XV" hands with tied ribbon cresting; silver strut – signed Fabergé, initials of workmaster Michael Perchin, assay mark of St. Petersburg before 1899, diameter 3⁷⁄₈ in. (9.8cm).
Exhibited: Hamburg 1995, cat. 109.
Private Collection

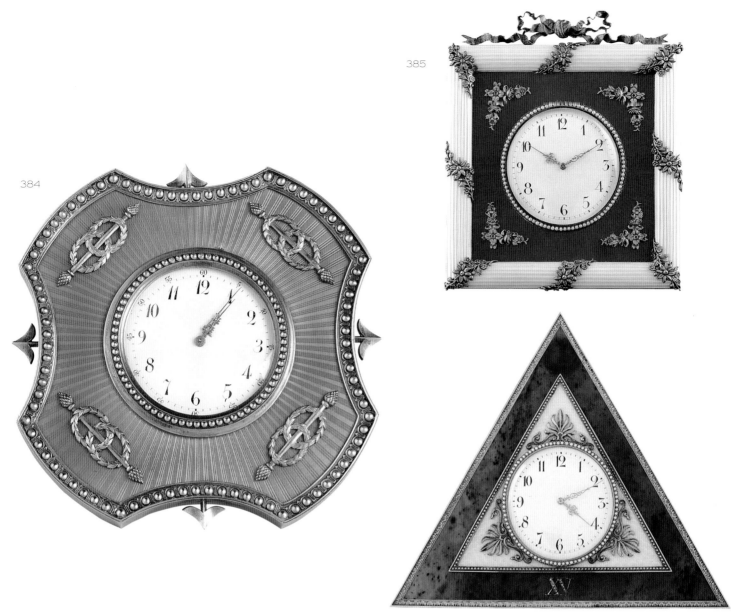

384

385

386

384. SHAPED ENAMELED SILVER-GILT DESK CLOCK of alternating convex and concave outline, with arrow heads at each concave side. Translucent pink enamel over sunburst *guilloché* ground applied with thyrsos staffs and laurel wreaths, opaque white enamel dial with Arabic chapters, gold "Louis XV" hands and beaded bezel; silver-gilt strut – signed Fabergé, initials of workmaster Michael Perchin, assay mark of St. Petersburg before 1899, height 4⅛ in. (10.5cm).
Exhibited: Hamburg 1995, cat. 115.
Private Collection

385. SQUARE ENAMELED SILVER-GILT DESK CLOCK of dark blue translucent enamel over sunburst *guilloché* ground, applied at the corners with flower sprays. The reeded border of white translucent enamel tied with a continuous flower garland. With silver-gilt ribbon cresting, white opaque enamel dial with black Arabic chapters, gold "Louis XV" hands and seed-pearl bezel, – signed Fabergé, initials of workmaster Michael Perchin, assay mark of St. Petersburg 1899–1908, inv no. 2741, height 4⅝ in. (11.8cm).
Bibliography: Solodkoff 1986, p. 10.
Exhibited: Hamburg 1995, cat. 83.
Private Collection

386. TRIANGULAR GOLD-MOUNTED ENAMELED SILVER-GILT AND NEPHRITE DESK CLOCK of white *guilloché* enamel applied with palmetto motifs and with beaded border, outer nephrite frame with diamond-set Roman numeral XV and acanthus-leaf borders, opaque white enamel dial with Arabic chapters, gold "Louis XV" hands and seed-pearl bezel; silver-gilt strut – signed Fabergé, initials of workmaster Michael Perchin, assay mark of St. Petersburg 1899–1908, inv no. 56510, height 5 in. (12.7cm).
Exhibited: Hamburg 1995, cat. 91.
Private Collection

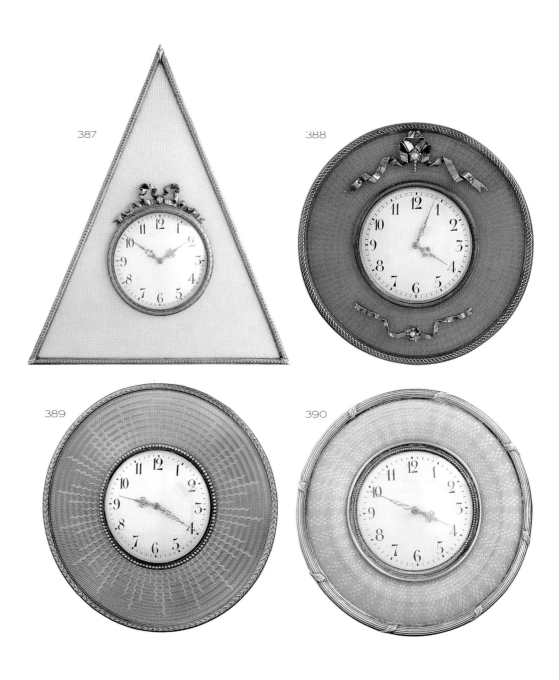

387. TRIANGULAR ENAMELED
SILVER DESK CLOCK of white *guilloché*
enamel with interwoven outer rim, opaque
white enamel dial with black Arabic chapters,
gold "Louis XV" hands, palm-leaf bezel and
tied ribbon cresting; silver strut – signed
Fabergé, initials of workmaster Michael
Perchin, assay mark of St. Petersburg
1899–1908, height 4⁵⁄₈ in. (11.8cm).
Exhibited: Hamburg 1995, cat. 92.
Private Collection

388. CIRCULAR GOLD-MOUNTED
ENAMELED SILVER DESK CLOCK
of translucent sea-green enamel over sunburst
guilloché ground applied above and beneath
with gold ribbons set with pearls, with outer
interwoven border, opaque white enamel dial
with Arabic chapters, gold "Louis XV" hands
and silver strut – signed Fabergé, initials of
workmaster Michael Perchin, assay mark of
St. Petersburg 1899–1908, diameter 4¹⁄₁₆ in.
(10.2 cm).
Exhibited: Hamburg 1995, cat. 93.
Private Collection

389. CIRCULAR ENAMELED SILVER-
GILT DESK CLOCK of green translucent
enamel over sunburst and waved *guilloché*
ground, with outer laurel-leaf rim, white
opaque enamel dial with black Arabic chapters,
gold "Louis XV" hands and pearl-set bezel;
silver strut – signed Fabergé, initials of
workmaster Michael Perchin, assay mark of
St. Petersburg 1899–1908, diameter 4¹⁄₈ in.
(10.5cm).
Exhibited: Hamburg 1995, cat. 98.
Private Collection

390. CIRCULAR ENAMELED SILVER
DESK CLOCK of translucent pale blue
enamel over sunburst and waved *guilloché*
ground, with reed-and-tie rim, opaque white
enamel dial with black Arabic chapters, gold
"Louis XV" hands and beaded bezel; silver
strut – signed Fabergé, initials of workmaster
Michael Perchin, assay mark of St. Petersburg
1899–1908, diameter 4¹⁄₁₆ in. (10.3cm).
Exhibited: Hamburg 1995, cat. 105.
Private Collection

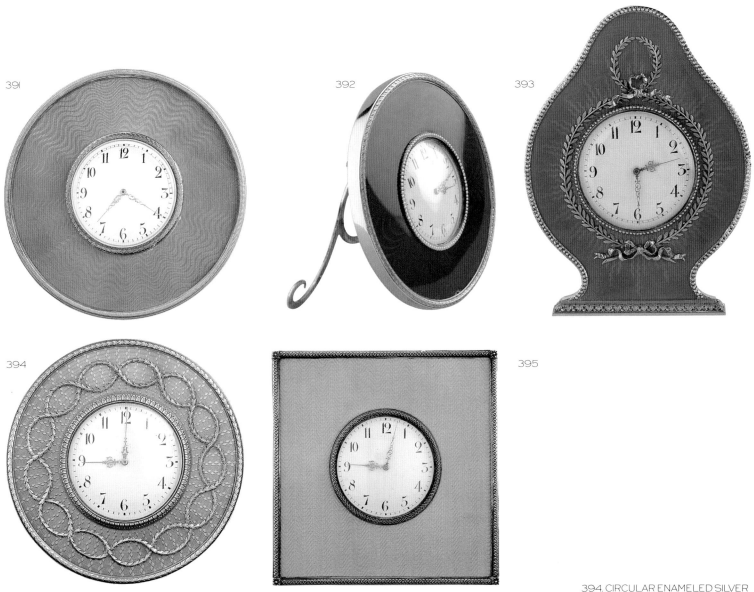

391. CIRCULAR ENAMELED SILVER-GILT DESK CLOCK of pink waved *guilloché* enamel with reeded rim, opaque white enamel dial with black Arabic chapters, gold "Louis XV" hands and foliate bezel; silver strut – signed Fabergé, initials of workmaster Michael Perchin, assay mark of St. Petersburg 1899–1908, diameter 4¹⁄₂ in. (11.5cm). Exhibited: Hamburg 1995, cat. 106. Private Collection

392. CIRCULAR ENAMELED SILVER-GILT DESK CLOCK of scarlet *guilloché* enamel with laurel leaf rim, opaque white enamel dial with black Arabic chapters, gold "Louis XV" hands and seed-pearl bezel; silver-gilt strut – signed Fabergé, initials of workmaster Michael Perchin, assay mark of St. Petersburg 1899–1908, diameter 4 in. (10.2cm). Exhibited: Hamburg 1995, cat. 113. Private Collection

393. OVAL ENAMELED, GOLD-MOUNTED SILVER-GILT DESK CLOCK of translucent pink enamel over sunburst *guilloché* ground with seed-pearl rim, white opaque enamel dial, Arabic chapters, gold "Louis XV" hands and seed-pearl bezel, applied with a surrounding laurel wreath tied with ribbons, chased acanthus-leaf base and silver-gilt strut – signed Fabergé, initials of workmaster Michael Perchin, assay mark of St. Petersburg 1899–1908, height 5¹⁄₈ in. (13cm). Exhibited: Hamburg 1995, cat. 114. Private Collection

394. CIRCULAR ENAMELED SILVER DESK CLOCK of turquoise *guilloché* enamel, applied with intertwining laurel-leaf bands, with laurel leaf rim, white opaque enamel dial with black Arabic chapters, gold "Louis XV" hands and foliate bezel; silver strut – signed Fabergé, initials of workmaster Michael Perchin, assay mark of St. Petersburg 1899–1908, diameter 4³⁄₁₆ in. (10.7cm). Exhibited: Hamburg 1995, cat. 107. Private Collection

395. SQUARE ENAMELED SILVER-GILT DESK CLOCK of lime-green moiré *guilloché* enamel, the opaque white enamel dial with Arabic chapters, gold "Louis XV" hands, bezel and rim chased with interwoven ribbons; silver-gilt strut – signed Fabergé, initials of workmaster Michael Perchin, assay mark of St. Petersburg 1899–1908, height 4¹⁄₂ in. (11.5cm). Exhibited: Hamburg 1995, cat. 117. Private Collection

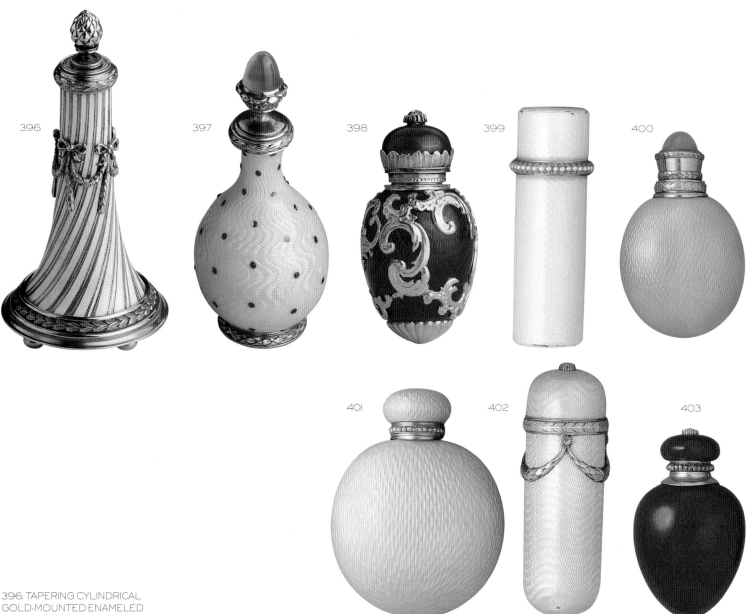

396. TAPERING CYLINDRICAL
GOLD-MOUNTED ENAMELED
SCENT-FLASK the body with alternating
swirling opaque white enamel and gold bands,
standing on ball feet, the stepped base with
laurel-wreath border, applied with chased laurel
swags suspended from tied ribbons, pine-cone
finial – signed Fabergé, initials of workmaster
Michael Perchin, assay mark of St. Petersburg
before 1899, inv no. 14265, height 3 in. (7.7cm).
Exhibited: Paris 1994, cat. 33; Hamburg 1995,
cat, 57; London 1996, cat. 33.
Chevalier Maurice Mizzi Collection

397. BALUSTER GOLD-MOUNTED
ENAMELED SILVER SCENT-FLASK
of opalescent white *guilloché* enamel with red
enamel dots, with laurel-leaf borders and
cabochon moonstone finial – initials of
workmaster Michael Perchin, assay mark of St.
Petersburg before 1899, height 2¹2 in. (6.4cm).
Exhibited: Paris 1994, cat. 24; Hamburg 1995,
cat. 58; London 1996, cat. 24.
Chevalier Maurice Mizzi Collection

398. SMALL EGG-SHAPED GOLD
AND ENAMEL SCENT-FLASK of scarlet
guilloché enamel, applied with chased gold
Rococo scrolls, the spherical cover with
diamond finial – by Fabergé, unmarked, height
1⁵16 in. (3.4cm). Original fitted case stamped
with Imperial Warrant mark, St. Petersburg
and Moscow.
Exhibited: Paris 1994, cat. 31; Hamburg 1995,
cat. 73; London 1996, cat. 31.
Chevalier Maurice Mizzi Collection

399. CYLINDRICAL GOLD-
MOUNTED ENAMELED SILVER
SCENT-FLASK of white *guilloché* enamel,
with seed pearl border – initials of workmaster
Michael Perchin, height 2¹8 in. (5.5cm).
Exhibited: Paris 1994, cat. 7; Hamburg 1995,
cat. 53; London 1996, cat. 7.
Chevalier Maurice Mizzi Collection

400. SPHERICAL ENAMELED
GOLD-MOUNTED SILVER SCENT-
FLASK of pale blue *guilloché* enamel, the
two-color gold mount chased with laurel-leaf
borders, star sapphire finial – initials of
workmaster Michael Perchin, assay mark of St.
Petersburg 1899–1908, height 2¹4 in. (5.9cm).
Exhibited: Paris 1994, cat. 16; Hamburg 1995,
cat. 36; London 1996, cat. 16.
Chevalier Maurice Mizzi Collection

401. SPHERICAL GOLD-MOUNTED
ENAMELED SILVER SCENT-FLASK
of yellow *guilloché* enamel, the gold mount set
with seed pearls – signed Fabergé, initials of
workmaster Michael Perchin, assay mark of St.
Petersburg 1899–1908, height 1¹¹18 in. (4.3cm).
Exhibited: Paris 1994, cat. 1; Hamburg 1995,
cat. 39; London 1996, cat. 1.
Chevalier Maurice Mizzi Collection

402. CYLINDRICAL GOLD-
MOUNTED ENAMELED SILVER
SCENT-FLASK of pale turquoise *guilloché*
enamel applied with two gold swags suspended
from diamonds, the laurel-leaf border and dia-
mond finial – initials of workmaster Michael
Perchin, assay mark of St. Petersburg
1899–1908, height 2³16 in. (5.6cm).
Exhibited: Paris 1994, cat. 8; Hamburg 1995,
cat. 54; London 1996, cat. 8.
Chevalier Maurice Mizzi Collection

403. EGG-SHAPED GOLD-
MOUNTED SILVER SCENT-FLASK of
scarlet *guilloché* enamel, the gold mount set
with rose-cut diamonds, diamond finial –
signed Fabergé, initials of workmaster Michael
Perchin, assay mark of St. Petersburg
1899–1908, height 2 in. (5.1cm).
Exhibitions: Paris 1994, cat. 12; Hamburg 1995,
cat. 72; London 1996, cat. 12.
Chevalier Maurice Mizzi Collection

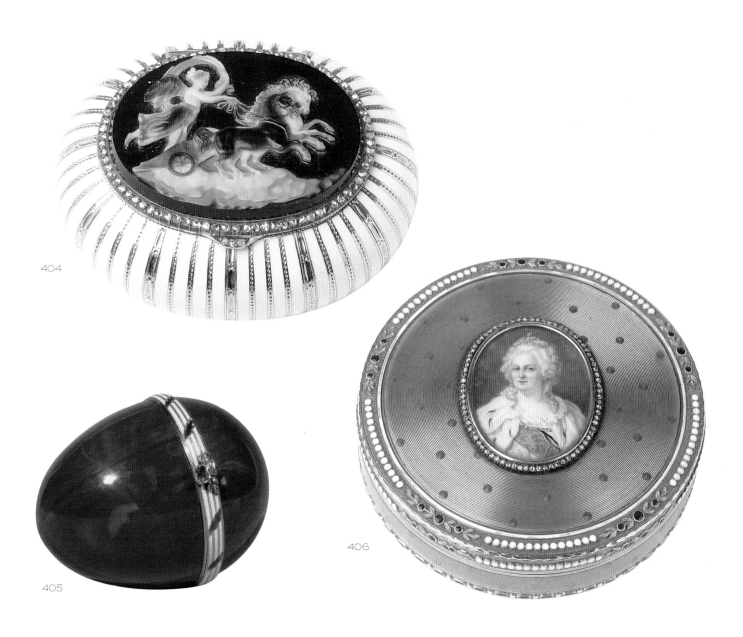

404

405

406

404. OVAL ENAMELED GOLD
BONBONNIÈRE of compressed spherical
shape, the cover set with a sardonyx cameo
carved with Aurora in her chariot within a
rose-cut diamond border, the body with
opaque white enamel bands divided by gold
stripes – signed Fabergé, initials of workmaster
Michael Perchin, assay mark of St. Petersburg
before 1899, length 2¼ in. (5.7cm).
Exhibited: London 1977, cat. R 47; Munich
1986/7, cat. 232.
Private Collection

405. EGG-SHAPED ENAMELED
GOLD-MOUNTED ORANGE
JASPER BONBONNIÈRE the hinged
gold mount with reeded opaque white enamel
band enriched with green enamel foliage at
intervals, the thumbpiece set with a
rectangular-cut emerald surmounted by rose-
cut diamonds – signed Fabergé, initials of
workmaster Michael Perchin, assay mark of
St. Petersburg before 1899, height 2⁹⁄₁₆ in.
(6.8cm). Original fitted case stamped with
Imperial Warrant, St. Petersburg, Moscow.
Exhibited: Munich 1986/7, cat. 229, ill. p. 167;
New York 1988, cat. 13; Zurich 1989, cat. 195,
ill. p. 156; St. Petersburg/Paris/London 1993/4,
cat. 252, ill. p. 357; Hamburg 1995, cat. 240, ill.
p. 217; Lahti 1997, cat. 22, ill. p. 20.
The Woolf Family Collection

406. CIRCULAR GOLD AND
ENAMEL BONBONNIÈRE the cover
with a painted portrait of Empress Catherine
the Great wearing the Small State Diamond
Crown and the sash of the Order of
St. Andrew, surrounded by rose-cut diamonds
on powder-blue guilloché enamel ground, the
border with berried green branches and white
dots, the sides and base similarly decorated –
signed Fabergé, initials of workmaster Michael
Perchin, assay mark of St. Petersburg
1899–1908, diameter 3¼ in. (8.3cm).
Private Collection

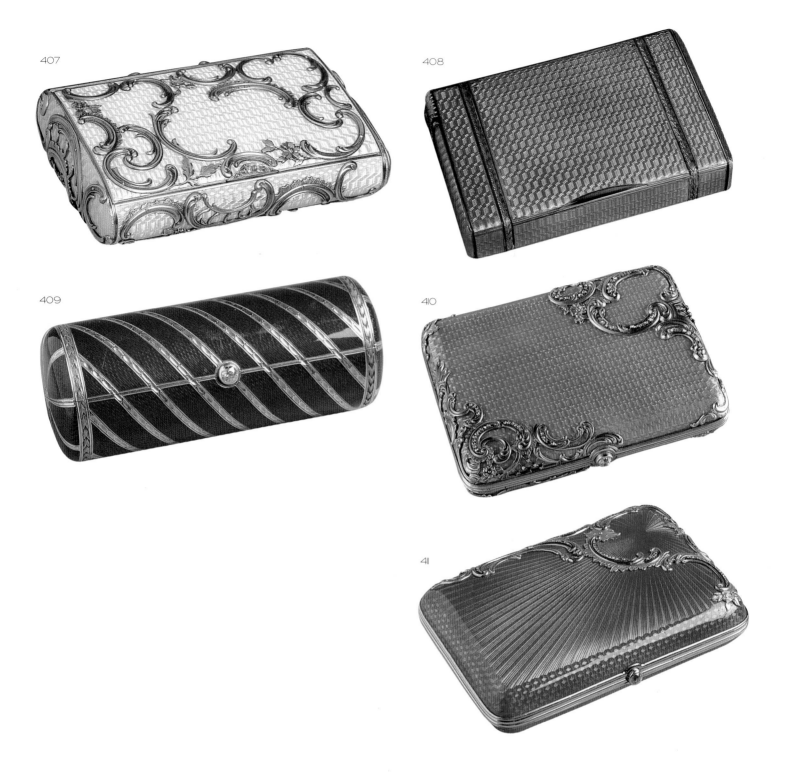

407

408

409

410

411

407. ENAMELED SILVER-GILT
CIGARETTE-CASE of neo-Rococo design,
of opalescent white *guilloché* enamel applied to
both sides with openwork decoration of scrolls,
shells and foliage, rose-cut diamond pushpiece –
signed Fabergé, initials of workmaster Michael
Perchin, assay mark of St. Petersburg before
1899, length 3½ in. (9cm).
Private Collection

408. ENAMELED GOLD CIGARETTE-
CASE with match compartment and opening
for tinder cord, of mauve *guilloché* enamel, with
palm leaf borders and plain thumpiece – signed
Fabergé, initials of workmaster Michael Perchin,
assay mark of St. Petersburg before 1899, inv no.
1727, length 3¾ in. (9.5cm).
Bibliography: Traina 1998, p. 154.
John Traina Collection

409. CYLINDRICAL ENAMELED
GOLD CIGARETTE-CASE of scarlet
guilloché enamel decorated with a continuous
swirling bright-cut gold stripe, diamond push-
piece – signed Fabergé, initials of workmaster
Michael Perchin, assay mark of St. Petersburg
before 1899, 72 (zolotnik) height 3½ in. (9cm).
Bibliography: Traina 1998, p. 147.
John Traina Collection

410. DIAMOND-SET GOLD-
MOUNTED ENAMELED SILVER-GILT
CIGARETTE-CASE of pale blue *guilloché*
enamel applied with Rococo scrolls inset with
diamonds, faceted diamond pushpiece – signed
K. Fabergé, with double headed eagle, initials
K. F., initials of workmaster Michael Perchin,
assay mark of St. Petersburg before 1899, 56
(zolotnik), length 3¾ in. (9.5cm).
Bibliography: Traina 1998, p. 109.
Exhibited: New York/San Francisco et al.
1996/7, cat. 372.
A very unusual combination of hallmarks for a
St. Petersburg case.
John Traina Collection

411. DIAMOND-SET ENAMELED
GOLD-MOUNTED SILVER-GILT
CIGARETTE CASE of neo-Rococo design,
of translucent burnt-orange enamel over
sunburst *guilloché* ground, applied to one side
with openwork decoration of scrolls and
foliage set with rose-cut diamonds, rose-cut
diamond pushpiece – signed Fabergé, initials of
workmaster Michael Perchin, assay mark of St.
Petersburg 1899–1908, length 3¾ in. (9.5cm).
Inscribed: "From Alix & Niki April 1, 1898".
Provenance: Presented by Tsarina Alexandra
Feodorovna and Tsar Nicholas II.
Private Collection

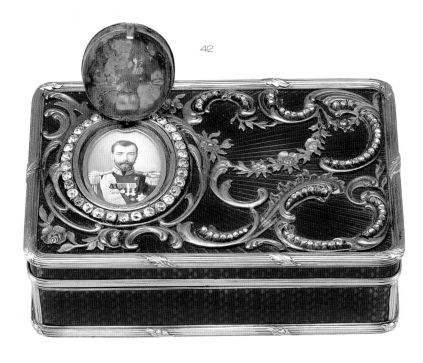

412

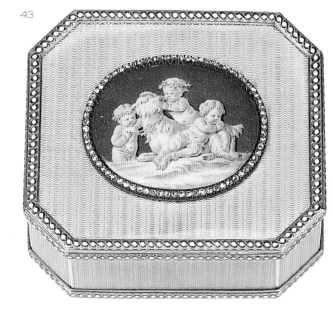

413

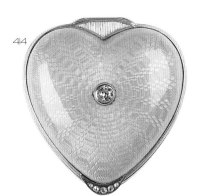

414

415

416

412. ROCAILLE BOX rectangular diamond-set enameled gold snuffbox in the Louis XV style, the cover enameled royal blue over a *guilloché* sunburst pattern applied with diamond-set rococo scrolls and gold foliage mounts, set to the left with the diamond-set crowned cipher of Tsar Nicholas II against an oval panel enameled white and bordered by diamonds. One of these gem stones conceals the release which when triggered causes the cipher to rise on a hinge concealed in the crown to reveal a miniature of the Tsar – signed Fabergé, initials of workmaster Michael Perchin, assay mark of St. Petersburg before 1899, inv no. 1111, length 3³⁄₄ in. (9.5cm).
Provenance: Jacques Zolotnitzky, Paris; Mr. H. Blum, Chicago.
Bibliography: Waterfield/Forbes 1978, no. 62, ill. p. 53; Solodkoff 1984, p. 173; Forbes 1989, p. 222; Hill 1989, ill. plate no. 117
Exhibited: New York 1968, no. 304, cat. p. 116; New York 1983, no. 215, ill. p. 79; Stockholm 1997, no. 62, cat. p. 121.
The Forbes Magazine Collection, New York

413. RECTANGULAR GEM-SET GOLD AND ENAMEL BOX with canted corners the cover of yellow *guilloché* enamel set with an oval enamel plaque painted en grisaille with putti playing with a sheep on simulated blue lapis lazuli ground, attributed to de Mailly, and surrounded by rose-cut diamonds, with blue *guilloché* and white dot borders, the sides and base similarly enameled – signed Fabergé, initials of workmaster Michael Perchin, assay mark of St. Petersburg before 1899, length 2⁷⁄₁₂ in. (6.7cm).
The Hubel Collection

414. HEART-SHAPED GEM-SET, GOLD AND SILVER-GILT ENAMELED BOX of greenish-yellow *guilloché* enamel, the cover set with a brilliant-cut diamond, the reeded gold border with diamond-set thumb-piece – signed Fabergé, initials of workmaster Michael Perchin, assay mark of St. Petersburg before 1899, inv no. 55754, length 1⁵⁄₈ in. (4.2cm).
Private Collection

415. OVAL GEM-SET ENAMELED GOLD BOX decorated with dark-blue *guilloché* enamel bands divided by gold stripes, the cover with a miniature of a girl after Greuze in a bezel set with rose-cut diamonds, the outer border set with seed pearls – signed Fabergé, initials of workmaster Michael Perchin, assay mark of St. Petersburg 1899–1908, 72 (zolotnik), length 1¹⁄₂ in. (3.8cm).
Bibliography: Snowman 1962/4, ill. 13.
Exhibited: Munich 1986/7, cat. 466.
Private Collection

416. GEM-SET ENAMELED GOLD BOX SHAPED AS A DOGE'S HAT enameled in bright translucent yellow enamel over an engraved ground of scrolls, further embellished with a ribbon of opaque white enamel set with rubies, emeralds, diamonds and pearls, with pearl finials, the hinged cover chased with rosettes and leaves against a matt ground – signed Fabergé, assay mark of St. Petersburg 1899–1908, assay master Yakov Lyapunov, inv no. 6659, height 1³⁄₈ in. (3.5cm).
Exhibited: Munich 1986/7, cat. 489, ill. p. 245; New York 1988, cat. 5; Zurich 1898, caty. 15, ill. p. 44; London 1992, cat. 126; St. Petersburg/Paris/London 1993/4, cat. 254, ill. p. 358; Stockholm 1997, cat. 1997, cat. 88, ill. p. 135; London 1998.
The Woolf Family Collection

417

418

419

417. AMATORY FRAME enameled four
color gold frame set with a rectangular panel of
salmon-pink enamel over a *guilloché* sunburst
pattern, the whole bordered by a gold egg and
dart motif, the oval aperture surrounded below
by chased green gold sprays of laurel and above
by festooned swags of flowers in four-color
gold upon which are perched two doves; a
musical trophy is suspended between the birds
from the red-gold ribbon-tied cresting; at the
base of the frame, two putti hold palms with
musical and amatory trophies about them –
signed Fabergé, initials of workmaster Michael
Perchin, assay mark of St. Petersburg before
1899, inv no. 45847, 56 (zolotnik), height
4¹8 in. (10.5cm). The frame now contains a
photograph of Tsarina Maria Feodorovna and
her sister, Queen Alexandra of England.
Bibliography: Waterfield/Forbes 1978, no. 76,
ill. p. 67, 143; Kelly 1982/83, p. 11; Solodkoff
1984, p. 171; Forbes 1986, p. 52; Habsburg
1987, cat. 495, ill. p. 246.
Exhibited: Munich 1986/87, no. 495, cat. ill.
p. 246; Lugano 1987, no. 38, cat. p. 62; Paris
1987, no. 38, cat. p. 58; New York et al.
1996/97, no. 265, cat. p. 256.
The Forbes Magazine Collection, New York

418. ENAMELED GOLD FRAME of
scarlet *guilloché* enamel with chased gold border
and ribbon cresting, ivory back and gold strut
– signed Fabergé, initials of workmaster
Michael Perchin, assay mark of St. Petersburg
before 1899, 56 (zolotnik), height 3¹2 in. (9cm).
Photograph of Grand Duchess Elizabeth
Feodorovna (1864–1918), sister of Tsarina
Alexandra Feodorovna, dressed in a nun's habit.
Provenance: H. M. Queen Louise (1889–1965)
of Sweden.
Exhibited: Stockholm 1997, cat. 119
Grand Duchess Elizabeth (born princess of
Hessen-Darmstadt) was married to Grand
Duke Sergei (1857–1905), brother of
Alexander III and Governor of Moscow. After
his assassination, she founded a monastery and
became its prioress. Queen Louise, second wife
of King Gustav V Adolf was the daughter of
Lord Louis Alexander Mountbatten, a scion of
the Grand Ducal House of Hessen-Darmstadt.
H. M. King Carl XVI Gustav of Sweden

419. SQUARE ENAMELED SILVER
FRAME the circular aperture in a panel of
pale-blue *guilloché* enamel with outer yellow
guilloché enamel border, ivory back, silver-gilt
strut – signed Fabergé, initials of workmaster
Michael Perchin, assay mark of St. Petersburg
1899–1908, 88 (zolotnik) inv no. 7725, height
2³4 in. (7cm). Contains an enamel miniature of
Grand Duchess Elizabeth Feodorovna of
Russia.
Exhibited: Munich 1986/7, cat. 427;
Stockholm 1997, cat. 120.
H. M. King Carl XVI Gustav of Sweden

420

421

422

424

420. IMPERIAL PRESENTATION FRAME large rectangular enameled gold-mounted silver-gilt Imperial frame inset with etched rock crystal panels and edged by piping enameled green with white opaque enamel ties, the square corner panels applied with diamond-set Imperial crowns; the top and bottom center roundels are embellished with the diamond-set crowned monogram of the Dowager Empress Maria Feodorovna and the Imperial eagle respectively. The circular plaques on either side of the frame feature musical, gardening and amatory trophies. The frame's elegant silver-gilt scroll strut is wrought in the form of a cursive "M" cinched by an Imperial crown. Containing a portrait of Tsar Nicholas II – signed Fabergé, initials of workmaster Michael Perchin, assay mark of St. Petersburg 1899–1908, initials of assay master Jakov Lyapunov, 88 (zolotnik), height 14⅝ in. (37.2cm).
Provenance: Tsarina Maria Feodorovna; Maurice Sandoz, Switzerland.
Bibliography: Snowman 1977, p. 53; Habsburg 1977, p. 55; Waterfield/Forbes 1978, no. 69, ill. pp. 59, 142; Kelly 1982/83, ill. pp. 8, 9; Solodkoff 1984, p. 170; Welander-Berggren 1997, p. 10.
Exhibited: New York 1961, no. 184, cat. p. 62; New York 1968, no. 322, ill. p. 123; New York 1973, no. 26, ill. p. 75; London 1977, no. L3, cat. p. 71; New York 1983, no. 90, ill. p. 52; New York et al. 1996/97, no. 266, cat. p. 257.
This is arguably the most magnificent frame made by Fabergé's firm.
The Forbes Magazine Collection, New York

421. NAVETTE-SHAPED GEM-SET SILVER-GILT AND ENAMEL TRIPLE BELL-PUSH of lime-green and white *guilloché* enamel, the domed centre with cabochon sapphire pushpiece decorated with laurel crowns and flanked by a further cabochon garnet and moonstone pushpiece, the sides applied with laurel swags, on four ball feet – signed Fabergé, initials of workmaster Michael Perchin, assay mark of St. Petersburg, inv no. 1931, length 3½ in. (8.9cm).
The Eriksson Collection

422. RECTANGULAR GOLD-MOUNTED AND ENAMEL BOWENITE BELL-PUSH on four reeded bun feet holding a curved hardstone plinth, the gold-mounted top with cabochon garnet pushpiece set in chased laurel rosette flanked by maenad's staffs and laurel branches on pink *guilloché* enamel with opaque white border – signed Fabergé, initials of workmaster Michael Perchin, assay mark of St Petersburg 1899–1903, inv no. 4390, length 2¹³⁄₁₆ in. (7.2cm).
Private Collection

423. OVAL DIAMOND-SET ENAMELED GOLD SNUFFBOX in the Louis XVI-style, enameled green over a *guilloché moiré* ground, the lid applied with a painted panel *en grisaille* of Venus and Cupid bordered in turn by diamonds, green enamel foliage and seed pearls – signed Fabergé, initials of workmaster Michael Perchin, assay mark of St. Petersburg before 1899, 72 (zolotnik), inv no. 7690, length 3¼ in. (8.3cm).
Provenance: Tsar Alexander III; Tsar Nicholas II, his son; Lansdell K. Christie, Long Island, New York.
Bibliography: Snowman 1953/55, ill. plate III; Snowman 1962/64/68/72, ill. plate IX; Snowman 1963, p. 245, ill.; Waterfield/Forbes 1978, no. 66, pp. ill. p. 56; Snowman 1979, pp. 147–148; Solodkoff 1984, ill. pp. 52, 174; Habsburg 1987, no. 403, ill. p. 223; Hill 1989, ill. plate no. 127.

423

Exhibited: Washington 1961, no. 16, ill. p. 39; New York 1962/66, L.62.8.16; New York 1968, no. 321, ill. p. 122, ill.; New York 1973, no. 17, ill. p. 61; London 1977, no. L17, cat. p. 75; Munich 1986/87 no. 403, ill. p. 233; Lugano 1987, no. 103, cat. p. 100, ill.; Paris 1987, no. 103, cat. p. 96, ill.; New York et al. 1996/97, no. 201, cat. p. 210, ill.
According to tradition, this box was created in response to Czar Alexander III's challenge that Russian craftsmen could not produce works equal to those of the French master goldsmiths of the eighteenth century. After studying the Louis XVI snuffbox by Joseph Etienne Blerzy, Fabergé workmaster Michael Perchin supervised the making of a pastiche so visibly finer (the engine-turning is more regular, the enamel less porous) that the Tsar ordered both boxes to be displayed in the Hermitage as a tribute to the extraordinary achievement of Russian craftsmanship.
The Forbes Magazine Collection, New York

424. RECTANGULAR GEM-SET TWO-COLOR GOLD AND ENAMEL CARNET DE BAL of royal-blue *guilloché* enamel with a central oval medallion of white enamel set with a brilliant-cut diamond with ribbon cresting suspended from a further diamond-set ribbon tie flanked by chased gold laurel garlands, with anthemion border, the reverse with blue *guilloché* enamel – signed Fabergé, initials of workmaster Michael Perchin, assay mark of St. Petersburg before 1899, length 3¾ in. (9.6cm).
Private Collection, courtesy A. von Solodkoff

425

426

427

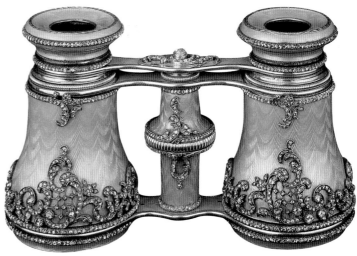

429

425. AGATE BOOK MARKER with
jeweled gold and enamel mounts, the handle
enameled in translucent orange over engine-
turning and set with a diamond, V-shaped
border – signed Fabergé, initials of workmaster
M. Perchin, assay mark of St. Petersburg before
1899, inv no. 54630, length 3¹⁄16 in. (7.9cm).
With inscribed note: "Von Xenia & Olga
bekommen in Erinnerung an Tante Minny,
November 1928, es war ein Geschenk von ihr
an Amama gewesen ML." Original fitted case
with Imperial Warrant, St. Petersburg &
Moscow.
Provenance: Presented by Grand Duchesses
Xenia and Olga as a Souvenir of Dowager
Empress Maria Feodorovna ("Minny"), their
mother. "Amama" was probably Queen Louise
of Denmark, grandmother of Princess Marie
Louise of Baden.
Private Collection

426. ENAMELED GOLD CHARM
shaped as a caricature of a bird of orange
guilloché enamel with rose-cut diamond eyes and
gold feet – initials of workmaster Michael
Perchin, assay mark of St. Petersburg before
1899, height ⁷⁄8 in. (2.1cm).
Provenance: Gatchina Palace; Central
Depository for Suburban Palaces, 1956.
Exhibited: Orhus 1990, cat. 92; Stockholm
1997, cat. 279.
The State Hermitage Museum (ERO – 8423)

**427. ROCOCO STYLE ENAMELED
SILVER-GILT VIDE-POCHES** of blue
guilloché enamel with c-scroll scalloped
borders and frontal cartouche; on four scroll
feet – signed Fabergé, initials of workmaster
Michael Perchin, St. Petersburg before 1899,
inv no. 23283, length 3³⁄4 in.
Louis and Joanne Rosendin Collection

429. ROCAILLE OPERA GLASSES
pair of diamond-set enameled gold opera
glasses in the Louis XVI-style, enameled
salmon pink over a *guilloché* swag design and
embellished with diamond-set Rococo scroll
and lattice motifs – signed Fabergé, initials of
workmaster Michael Perchin, assay master
Jakov Lyapunov, inv no. 3945, length 4¹⁄4 in.
(10.7cm).
Bibliography: Waterfield/Forbes 1978, no. 89,
ill. p. 77; Solodkoff 1984, p.168; Forbes 1986,
p. 52; Forbes 1987, no. 12, ill. p. 16; Solodkoff
1988, p. 91; Forbes 1989, p. 223; Hill 1989, ill.
plate no 254; Kelly 1994.
Exhibited: Munich 1986/87, no. 506, ill. p. 252;
Lugano 1987, no. 69, cat. p. 80, ill.; Paris 1987,
no. 69, cat. p. 76; New York et al.1996/97, no.
263, cat. p. 255.
The Forbes Magazine Collection, New York

430

431

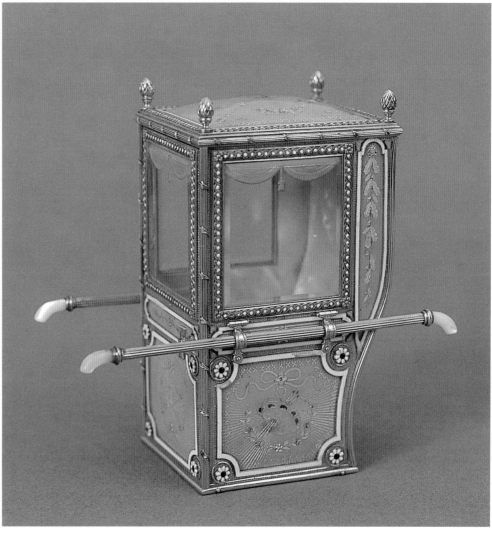

430. CYLINDRICAL GEM-SET
SILVER-GILT AND GOLD-MOUNTED
ENAMEL ÉTUI of mauve *guilloché*
enamel, the ends set with oval moss agate
plaques surrounded by rose-cut diamonds
and gold palmette border, with diamond-set
thumbpiece – signed Fabergé, initials of
workmaster Michael Perchin, assay mark of
St. Petersburg 1899–1908, assay master Yakov
Lyapunov, length 3⅝ in. (9.2cm).
Private Collection, courtesy A. von Solodkoff

431. ANGULAR GEM-SET
GOLD-MOUNTED GRAY ENAMEL
PARASOL HANDLE of luminous gray
guilloché enamel divided by rose-cut diamond-
set bands – initials of workmaster Michael
Perchin, assay mark of St. Petersburg
1899–1908, assay master Yakov Lyapunov, length
2⅜ in. (6.1cm). Original fitted felt case stamped
with Imperial Warrant and Fabergé.
Private Collection

432. ENAMELED MINIATURE GOLD
SEDAN CHAIR of Louis XVI design, with
two removable reeded gold carrying-poles with
mother-of-pearl handles and four artichoke
finials, decorated with panels of opalescent
pink enamel over starburst *guilloché* ground
with gold-leaf motifs symbolizing Love, the
Arts and Gardening, within opaque white
enamel borders, with gold column to the front,
bevelled rock-crystal windows engraved with
simulated curtains, opening to reveal a mother-
of-pearl lined interior – inscribed Fabergé,
initials of workmaster Michael Perchin, assay
mark of St. Petersburg 1899–1908, 72
(zolotnik), inv no. 2707.

Exhibited: Helsinki 1980; Helsinki 1988;
Tillander, Helsinki 1990; Helsinki 1991;
St. Petersburg/Paris/London 1993/4, cat. 253;
Stockholm 1996; Lahti 1997; Stockholm
1997, cat. 150.
Bibliography: Habsburg/Solodkoff, 1979, color
plate 89/90; Habsburg 1997, p. 77.
There is a sedan chair of identical construction
and measurements, but of differing decoration,
in Forbes Magazine Collection (cat. 433).
Private Collection, lent courtesy Ulla
Tillander-Godenhielm, Finland

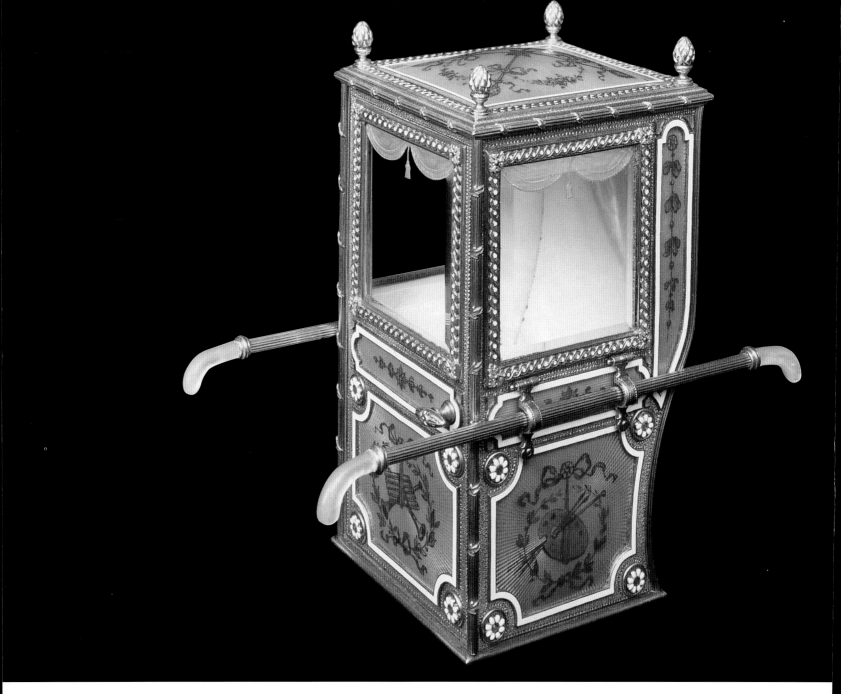

433. MINIATURE SEDAN CHAIR

enameled two-color gold, mother-of-pearl and rock crystal miniature sedan chair in the Louis XVI-style with panels of salmon pink enamel over *guilloché* sunburst patterns painted underglaze in sepia with the emblems of the Arts, Gardening, and Love; each symbol wreathed by laurel foliage suspended from ribbon swags within borders of white opaque enamel, accented by enamel rosettes with green enamel pistils at the corners; the rock crystal windows outlined with green enamel ribbons about white pellets are engraved with curtains and tassels bordering the mother-of-pearl lined interior. The fluted gold poles with mother-of-pearl handles are detachable, held by two hinged, pinned straps. The door opens by turning the handle – signed Fabergé, initials of workmaster Michael Perchin, assay mark of St. Petersburg 1899–1908, assay master Yakov Lyapunov, 72 (zolotnik), height 3½ in. (8.8cm)

Provenance: J.P. Morgan, New York; J.P. Morgan, Jr., New York, his son; Mr. and Mrs. Jack Linsky, New York; Lansdell K. Christie, Long Island, New York.

Bibliography: Snowman 1953/55, ill. no. 259; Snowman 1962/64/68/74, ill. plate L; McNab Dennis 1965, ill. p. 235.; Snowman 1977, ill. p. 38; Watts 1978; Waterfield/Forbes 1978, no. 58, ill. pp. 48, 139; Habsburg/Solodkoff 1979, ill. plate nos. 89, 90; Snowman 1979, p. 20; Solodkoff 1984, p. 164; Habsburg 1987, no. 485, p. 243; Forbes 1989, p. 223; Hill 1989, ill. plate no. 251; Booth 1990, p. 75; Kelly 1994, unpaginated; Habsburg 1996, ill. plate 49.
Exhibited: New York 1949, no. 183, cat. p. 20; New York 1951, no. 293, ill. p. 43; Washington 1961, no. 9, cat. ill. p. 30; New York 1961, no. 269, ill. p. 56; New York 1962/66, no. L.62.8.9; New York 1968, no. 357, ill. p. 135; New York 1973, no. 20, cat. ill. p. 65; London 1977, no. L14; Munich 1986/87, no. 485, ill. p. 243; Lugano 1987, no. 45, cat. p. 66, ill.; Paris 1987, no. 45, cat. pp. 6, 8, 62, ill. p. 62; New York et al.1996/97, no. 16, cat. p. 42.

For an almost identical chair decorated with varicolored gold emblems in a Scandinavian Private Collection,, see opposite page.

The Forbes Magazine Collection, New York

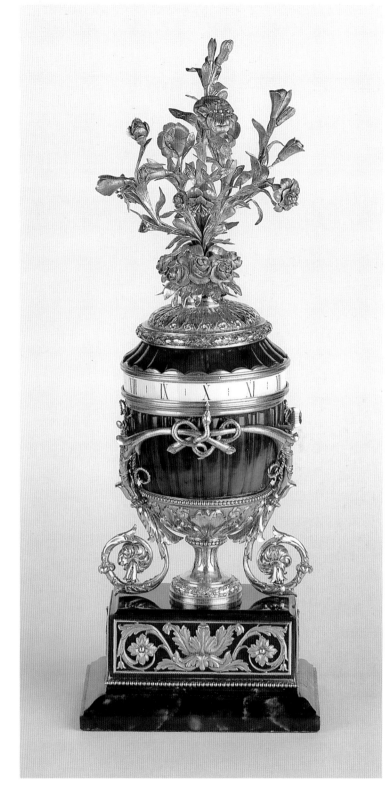

434. SILVER-GILT MOUNTED NEPHRITE MANTLE CLOCK the urn-shaped hardstone body with white enamel rotating dial with Roman chapters, the hours indicated by the head of a snake held by silver-gilt scrolls on a rectangular nephrite base decorated with scrolling foliage enclosing two rosettes, on tapering plinth, surmounted by a two-colour gilt bouquet of lilies and carnations, the rim of the vase with a cluster of roses – by Fabergé, inv no. 46822, the movement signed *Hy. Moser & Co. St. Petersbourg*, height 11 in. (28cm). Original fitted wooden case stamped with Imperial Warrant, K. Fabergé, St. Petersburg, Moscow.

Provenance: Presented to Dr. Johann Georg Metzger by Tsar Alexander III in December 1893.

The inv no. 46822 relates to a set of numbers used by the St. Petersburg workshop during the second half of the year 1893. According to the records kept in the Russian State Historical Archives (Fond 468, op. 32, d. 1623, list 4), the clock appears on a sale or return invoice to the Imperial Cabinet on 23 December 1893: *Clock jadeite, Louis XVI, Price 2,000 roubles*. The final invoice is dated 8 January 1894. (Information kindly provided by Mr. Valentin V. Skurlov).

Dr. Metzger (1838–1909), a Dutch citizen and doctor specializing in therapeutic gymnastics, famed for his use of massage treatment, was summoned by Emperor Alexander III to St. Petersburg and arrived there on 2 April, 1886 to treat the Imperial Consort. On 26 May of the same year Dr. Metzger was awarded the Order of St Stanislas for his services. Early in 1892 he was again called to St. Petersburg to treat the back injury of Grand Duchess Olga Alexandrovna who had been hurt in the Borki railway disaster on 29 October, 1888. The Imperial train had been traveling to Kharkov when two explosions severely damaged the carriages. Emperor Alexander III escaped first from the crushed dining car and held up the heavy iron roof which had collapsed to release the children and the Empress. During his second visit Dr. Metzger received a generous honorarium of 30,000 roubles as well as the clock as a present. He later received the Order of St Stanislas First Class with diamonds. Dr. Metzger's other patients included the Empress of Austria, Empress Eugenie of France, the Duke of Nassau and the Duchess of Saxe-Coburg-Gotha, (cf. Exhibition catalogue, *Dr. Johann Georg Metzger 1838–1909 en zin tijd*, Leiden, 1978).

This clock is similar in design to the Imperial Easter Egg presented to Empress Alexandra Feodorovna in 1899. This so-called Madonna Lily Egg (p. 14, fig. 4) made by workmaster Michael Perchin forms part of the collection of the Armory Museum of the Moscow Kremlin. Private Collection

434

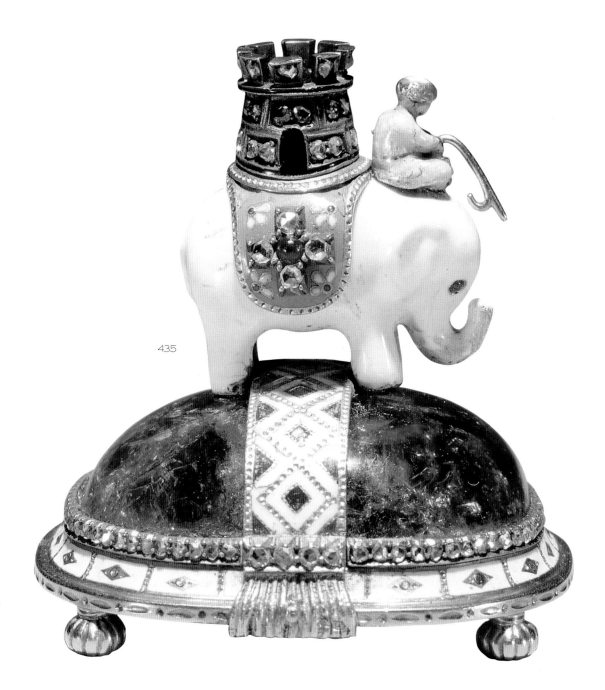

435

435. JEWELED AND ENAMELED GOLD FIGURE OF AN ELEPHANT

in the Renaissance style, the white animal with its keeper seated on its head, a diamond-set turret on its back, with diamond and ruby-studded saddle-cloth; the elephant stands on a cabochon emerald, a translucent red and opaque white enamel runner between its feet, the base with a line of rose-cut diamonds and an opaque white enamel back, standing on four stud feet, the underside engine-turned with a sunburst – engraved signature Fabergé in Cyrillic, other hallmarks illegible, height 1^{7}⁄$_{16}$ in. (3.7cm), English import marks for 1930.

Probably an emblem of the Danish royal house intended for Empress Maria Feodorovna, born Princess Dagmar of Denmark (for a very similar figure, see the elephant surmounting the lost Danish Jubilee Egg of 1903). The large cabochon emerald, the engraved signature and lack of inv no. also seem to indicate an Imperial connection, possibly a surprise contained in one of the early Easter Eggs. Its "neo-Renaissance" style best fits the Renaissance egg of 1894 (p. 38, fig. 6). The English 1930 import mark might point to a sale by the Bolsheviks to Emanuel Snoman – who from 1927 onwards traveled to Russia to acquire Russian works of art – and Fabergé. Private Collection

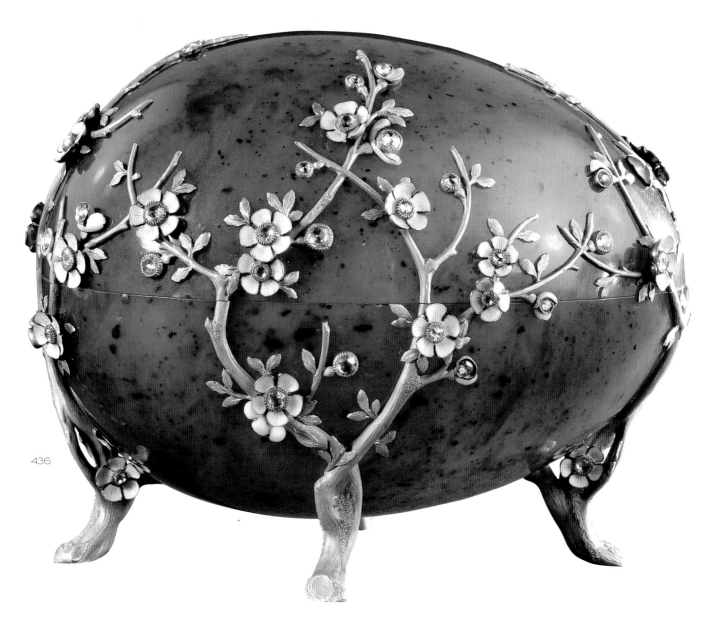

436

436. JEWELED, ENAMELED, GOLD-
MOUNTED NEPHRITE EASTER EGG

hinged, opening horizontally, standing on four
red-gold feet formed as apple-trees from which
issue red-gold branches with green-gold leaves,
pink-foiled rose-cut diamond buds and opaque
white enamel blossoms with pink-foiled rose-
cut diamond centers – engraved signature K.
Fabergé, initials of workmaster Michael
Perchin, assay mark of St. Petersburg
1899–1908, 56 (zolotnik), length 5¹2 in. (14cm).
Original fitted grey velvet case with Imperial
Warrant, St. Petersburg, Moscow, Odessa.
Provenance: Presented by Alexander Kelch
to his wife Barbara, Easter 1901; Morgan,
Paris 1920.
Exhibited: Hammer Galleries 1939; Hamburg
1995, cat. 242, pp. 220/1; Stockholm 1998,
cat. 10.
Bibliography: Snowman 1962, p. 92, ill 337;
Habsburg/Solodkoff 1979, pp. 108, 120, 158;
Solodkoff 19084, p. 42, ill p. 84; Solodkoff 1988,
pp. 39, 47; Kostbare Ostereier 1998, cat. 609, pp.
176/7, 301.

One of seven eggs made by Fabergé's
workmaster Michael Perchin for the
industrialist Alexander Ferdinandovich Kelch as
Easter presents for his immensely rich wife
Barbara, née Basanova between 1898 and 1904,
the year of their separation. Their craftmanship
equals those of the Imperial Easter Eggs. They
are generally a little larger than their Imperial
counterparts. They were sold by Barbara Kelch
following her emigration to Paris, and reap-
peared in America, where they were considered
as being of Imperial origin. Two of the Kelch
Eggs (Hen Egg, 1898, and Chantecleer Egg,
1903), are in the Forbes Magazine Collection,
one (Twelve Panel Egg, 1899) is owned by
Queen Elizabeth II, one (Pine Cone Egg,
1900) belongs to Mrs. Joan B. Kroc of San
Diego, three are in private collections.
Adulf P. Goop Collection

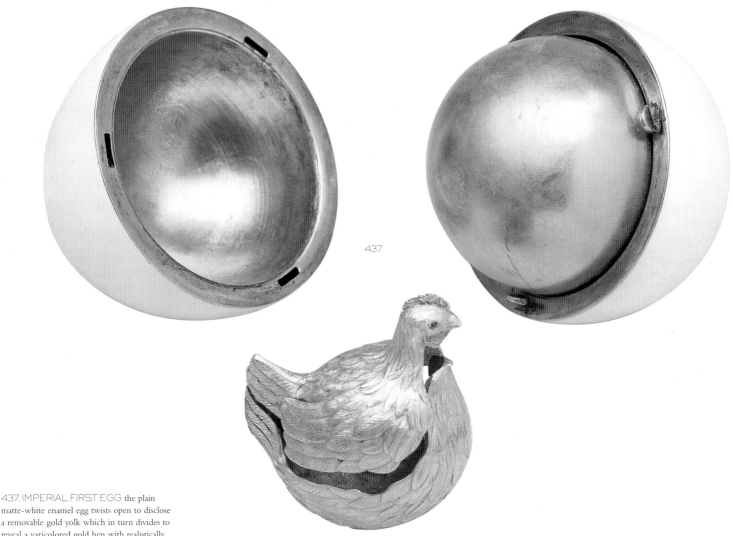

437

437. IMPERIAL FIRST EGG the plain matte-white enamel egg twists open to disclose a removable gold yolk which in turn divides to reveal a varicolored gold hen with realistically engraved feathers and ruby-set eyes. The fowl sits inside a suede and gold nest stippled to simulate straw – by Fabergé, unmarked, length of shell 2¹⁄₂ in. (6.4cm), length of hen 1³⁄₈ in. (3.5cm).

Provenance: Presented by Tsar Alexander III to Tsarina Maria Feodorovna on Easter 1885; Anon. Sale: Christie's, London, March 15, 1934, lot 55; Lady Grantchester, wife of Sir Alfred Suenson-Taylor, who was created 1st Baron Grantchester.

Bibliography: Bainbridge 1933, p. 174; Bainbridge May 1934, p. 305; Bainbridge 1949, p. 71; Snowman 1953/55, ill. nos. 280, 283; Snowman 1962/64/68/74, ill. plates 313, 316; Bainbridge 1966, p. 70; Habsburg 1977, pp. 56, 62, 72, 79; Waterfield/Forbes 1978, no. 1, ill. p. 17, 114; Forbes 1979, ill. p. 1235, plate XIV; Habsburg/Solodkoff 1979, ill. plate no. 1; Snowman 1979, ill. p. 90; Forbes 1980, ill. p. 21; Snowman 1980, p. 191; Schaffer 1980, p. 80, ill.; Swezey 1983, p. 1213; Solodkoff 1983, p. 65; Schaffer 1983, cat. pp. 8, 18, 22, 28; Lopato 1984, pp. 44, 46; Solodkoff 1984, ill. pp. 1, 54, 186; Kelly 1985, pp. 13, 14; Forbes 1986, ill. p. 54; Forbes 1988, p. 43, ill. p. 38; Solodkoff 1988, ill. pp. 23, 25; Forbes 1989, p. 220, ill.; Hill 1989, ill. plate no. 17; Booth 1990, ill. pp. 13, 108; Cerwinske 1990, ill. p. 54; Pfeffer 1990, ill. p. 17; Habsburg 1996, p. 19; Fabergé 1997, no. 1, ill. 14, 93, 234; Krog 1997, pp. 290, 296.

Exhibited: New York 1951, cat. p. 5; London 1953, no. 156, cat. p. 15; London 1977, no. O 3, cat; ill. p. 94; Helsinki 1980, cat. pp. 11, 29, 54; Munich 1986/87, no. 532, cat. ill. p. 266; Lugano 1987, no. 116, ill. pp. 106, 107; Paris 1987, no. 116, cat. pp. 6, 8, 102, ill. pp. 102, 103; Paris/London only 1993/94, cat. p. 71, ill. cover of French ed.; Stockholm 1997, cat. 1, ill. p. 73.

Originally, the surprise planned by Fabergé was a ring, similar to the rings contained in the 18th-century eggs (Rosenborg Castle Treasury, Copenhagen; Kunsthistorisches Museum, Vienna; Green Vaults, Dresden, all illustrated by Mogens Bencard, The Hen in the Egg, Amalienborg 1999) which he used as proto-types. A letter from Alexander III to his brother Grand Duke Vladimir dated 1 February 1885 requests that the surprise be changed to: "small pendant egg of some precious stone."

According to the account books of N. Petrov, Assistant Manager of His Imperial Majesty's Cabinet, the hen contained two surprises, a tiny ruby egg-shaped pendant suspended inside a diamond and ruby-set crown (their where-abouts are unknown). The account books contain a payment of 4151 roubles for this egg dated 9 April 1885.

The Forbes Magazine Collection, New York

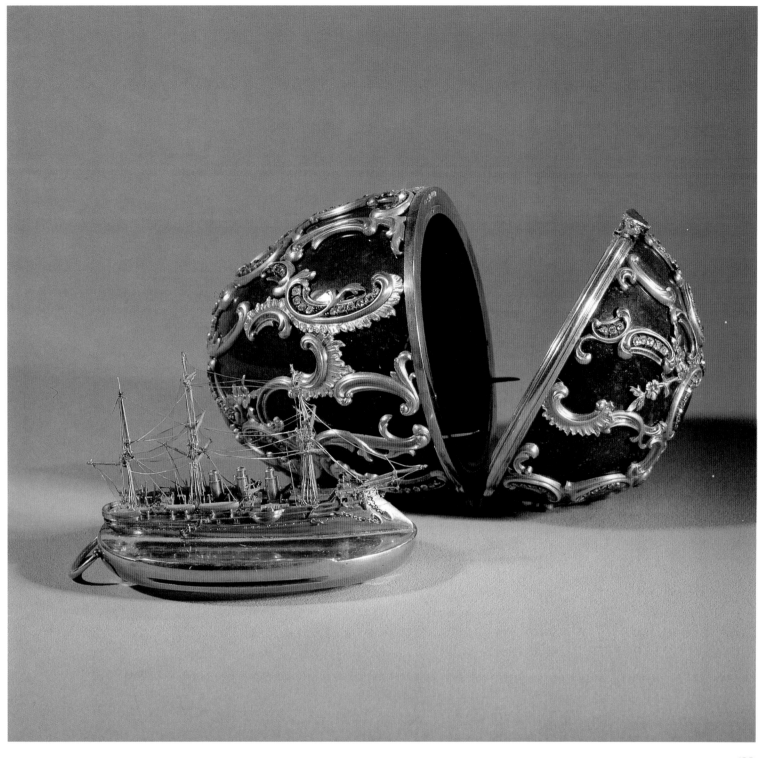

438

438. "PAMIAT AZOVA" OR "MEMORY OF AZOV" EGG of 1891, jeweled, gold-mounted bloodstone *bonbonnière* in the Louis XV style applied with cagework scrolls and rocaille set with rose-cut diamonds and with a ruby and diamond pushpiece; containing a gold and platinum model of the cruiser, with rose-cut diamond portholes, engraved: "Azov" on the stern, floating on an oval gold-mounted aquamarine engraved to simulate waves – signed Fabergé, initials of workmaster Michael Perchin, assay mark of St. Petersburg before 1899, 72 (zolotnik), length of egg $3^{11}16$ in. (9.3cm), length of cruiser $2^{3}4$ in. (7cm).
Provenance: Presented by Tsar Nicholas II to his mother Empress Maria Feodorovna, Easter 1891; transferred from the Anichkov Palace to Sovnarkom 1922.

Bibliography: Chanteclair 1900, p. 66f; Snowman 1962/4, p. 82, ill. p. 321; catalog of the Armory 1964, no. 50, p. 82; Goldberg 1967, p. 202/3; Rodimtseva 1971, p. 8, ill. 2; Habsburg/Solodkoff 1979, p. 157, no. 8; Snowman 1979, p. 91; Pfeffer 1990, ill. p. 27; Solodkoff 1984, p. 63; Forbes/Hohenzollern/Rodimtseva 1989, cat. 6; Fabergé/Proler/Skurlov 1997, no. 7, p. 106–8.
Exhibited: Paris 1900; Munich 1986/7, cat. 535, ill. p. 268; San Diego/Moscow 1989/90. cat. 2, ill.; Moscow 1992, cat. 1, ill. p. 60/1; Torre Canavese 1994, cat. 79, ill. p. 187; Sydney 1996, cat. 1, ill. p. 37.

In 1890/1 Tsarevich Nicholas and his brother George were sent on a cruise to the Far East which lasted over nine months and included China and Japan. This commemorative Easter egg was created by Fabergé in the following year. The surviving invoice dated 24 May 1891 lists the egg as costing 4,500 roubles. Although the egg is hallmarked by head workmaster Michael Perchin, the cruiser (and possibly the jeweled incrustation) is by August Holmström. When exhibited in Paris at the 1900 World Fair, the egg was criticized as overly Louis XV (and therefore old-fashioned) in style, at a time when Art Nouveau prevailed.
Kremlin Armory Museum (MR – 645/1–2)

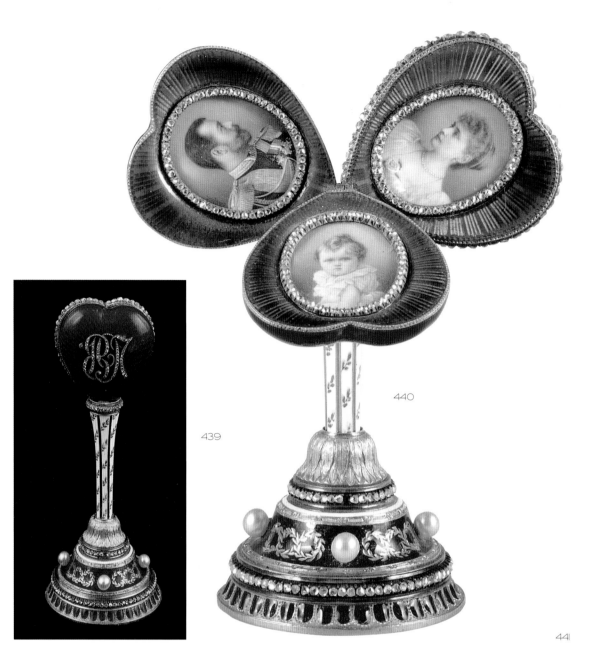

440

439

441

439. IMPERIAL HEART SURPRISE FRAME the strawberry-red enamel heart set with the date 1897 in rose-cut diamonds upon a hexagonal tapering shaft painted with spiraling green enamel foliage against an opaque white enamel ground. When the shaft is depressed, the heart opens into a three-leaf clover. Each leaf is enameled green over a *guilloché* sunburst pattern and contains a diamond-set oval aperture framing miniatures of Tsar Nicholas II, Tsarina Alexandra Feodorovna and their infant daughter Grand Duchess Olga – engraved signature K. Fabergé, height 3¼ in. closed (8.3cm)
Provenance: Presented by Tsar Nicholas II to his mother, the Dowager Empress Maria Feodorovna, Easter 1897; Lady Lydia Deterding, Paris.
Bibliography: Snowman 1968/74, no. 103, ill.; Waterfield/Forbes 1978, no. 70, ill. pp. 61, 137; Habsburg/Solodkoff 1979, plate nos. 21, 22; Kelly 1982/83, ill. no. 6, no. 7; Solodkoff 1984, ill. p. 170; Habsburg 1987, p. 243, ill.; Hill 1989, plates 138, 139; Kelly 1994, unpaginated, ill.; Fabergé 1997, ill. p. 127, 129, 234
Exhibited: Munich 1986/87, no. 486; Lugano 1987, no. 68, cat. p. 79, ill.; Paris 1987, no. 68, cat. p. 75, ill.; St. Petersburg/Paris/London 1993/94, no. 22, cat. p. 186, ill.
A recently discovered invoice for the 1897 "Mauve Easter Egg" (whereabouts unknown) confirms this frame to have been the surprise. Two further "heart" frames are known: the (pink) surprise of the 1902 Kelch "Rocaille Egg" (Stockholm 1997, cat. 11); and a (red) frame in a Swedish private collection (Stockholm 1997, cat. 128).
The Forbes Magazine Collection, New York

440. DETAIL OF ABOVE

441. DESIGN IN WATERCOLOR FOR AN EASTER EGG signed M. Perchin, 8¼×9⅝ in. (21×24.5cm).
Provenance: recently acquired by the State Hermitage Museum.
This is apparently the only surviving example of what must have been hundreds of such designs by Fabergé's second head workmaster.
The State Hermitage Museum (ERO sh – 1871)

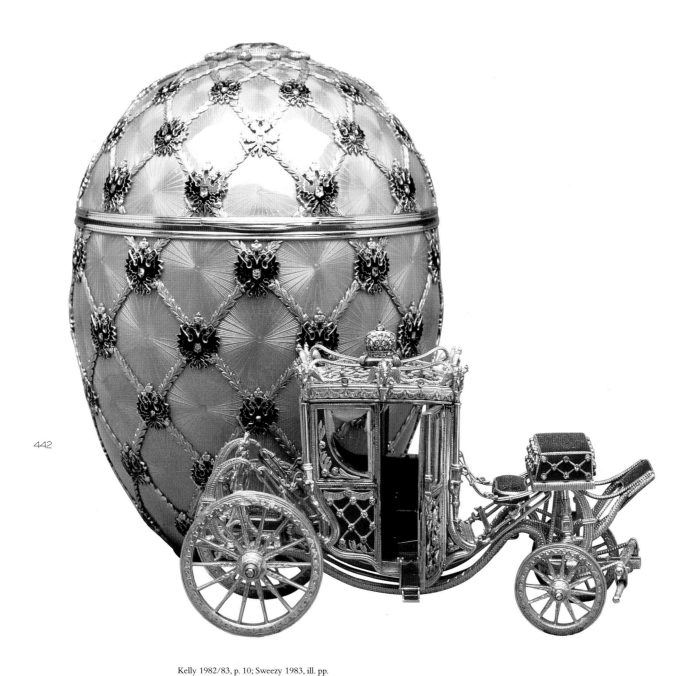

442

442. IMPERIAL CORONATION EGG
the egg is enameled a deep-gold hue over
guilloché sunburst patterns and blanketed by a
gold trellis marked by diamond-set Imperial
eagles at the intersections. At the top of the egg
is the crowned monogram of Tsarina Alexandra
Feodorovna emblazoned in rose-cut diamonds
and rubies. The date 1897 appears beneath a
smaller portrait diamond at the bottom of the
egg. When the egg is opened, the surprise
fitted inside a velvet-lined compartment is a
removable replica of a coach of gold, enamel,
diamond and rock crystal – signed Fabergé,
initials of workmaster Michael Perchin, assay
mark of St. Petersburg before 1899, 56
(zolotnik), the name Wigström is roughly
scratched on the inner surface of the shell,
length of shell 5 in. (12.7cm), length of coach
3¹¹⁄₁₆ in. (9.4cm).
Provenance: Presented by Tsar Nicholas II to
his wife, Tsarina Alexandra Feodorovna, Easter
1897; purchased by Emanuel Snowman for
Wartski, London, 1927.
Bibliography: Bainbridge 1949, ill. plate no. 58;
Snowman 1953/55, ill. plate XXIV, dust jacket;
Snowman 1962/64/68, ill. plate LXXIII;
Bainbridge 1966, ill. plate 89, dust jacket;
Waterfield 1973, p. 52, ill.; Snowman 1977, ill.
p. 51; Waterfield/Forbes 1978, ill. p. 118; Forbes
1979, ill. plate XVI; Habsburg/Solodkoff 1979,
ill. plate no. 126; Snowman 1979, p. 97, ill.;
Schaffer 1980, p. 80; Forbes 1980, ill. p. 15

Kelly 1982/83, p. 10; Sweezy 1983, ill. pp.
1210, 1211; Schaffer 1983, cat. pp. 18, 29;
Solodkoff 1984, ill. pp. 9, 74, 186; Kelly 1985,
ill. pp. 14, 15; Forbes 1986, pp. 52, 53, ill.;
Habsburg 1987, ill. p. 273; Forbes 1987, ill.
p. 14; Forbes 1988, ill. p. 37; Solodkoff 1988, ill.
p. 35, dust jacket; Forbes 1989, ill. pp. 220, 222;
Hill 1989, ill. plate nos. 31, 32; Pfeffer 1990, ill.
pp. 45, 47; Booth 1990, ill. p. 93, 110; Lopato
1991, p. 92; Habsburg/Lopato 1994, ill., p. 257;
Kelly 1994, p. 9, 10, ill.; Habsburg 1996, ill.
plate 4; Odom 1996, p. 175, ill.; Fabergé 1997,
no. 16, ill. pp. 50, 55, 131, 235; Welander-
Berggren 1997, p. 70, ill.
Exhibited: Paris 1900; von Dervise Mansion
1902; London 1935, no. 586, p. 111; London
1949, cat. 6, ill. p. 31; London 1953, no. 286,
cat. p. 25; London 1977, no. O1, Boston 1979,
ill. on cover; Helsinki 1980, cat. p. 33; Munich
1986/87, no. 539, ill. p. 273; Lugano 1987, no.
119, ill. pp. 112, 113; Paris 1987, no. 119, ill. pp.
108, 109; San Diego/Moscow 1989/90, nos. 7,
14 ill. pp. 10, 46, 47, 98; St. Petersburg/
Paris/London 1993/94, no. 110, ill. p. 257;
New York et al. 1996/97, no. 285, ill.;
Wilmington/Mobile, 1998/00, no. 397, cat.
p. 228, ill.

This is arguably the most famous of Fabergé's
eggs. It was created to commemorate the
Coronation of Nicholas II and of Alexandra on
9 May 1896 in Moscow. The shell of the egg is
a reminder of the robes worn by the Imperial
couple made of spun gold and decorated with
black double-headed eagles. The coach is a
miniature replica of the late 18th-century
coach (see Vladimir Chernyshev, "The
Hermitage 1793 Carriage" in Habsburg/
Lopato 1993/4, pp. 435–437), in which
Alexandra rode to the coronation. It was
crafted by workmaster George Stein who
labored for 15 months, 16 hours a day.
Originally an emerald pendant egg hung
inside the coach. The cost of the egg was 5,500
roubles, while the emerald pendant cost an
additional 1,000 roubles (together
approximately $3,250). The egg may be seen
as a work of collaboration between Perchin
and his gifted assistant Henrik Wigström, who
secretly scratched his name on the inside of
the shell.

The Forbes Magazine Collection, New York

HENRIK WIGSTRÖM

Henrik Immanuel Wigström (1862–1923), Fabergé's leading workmaster from 1903 to 1918, was born in Tammisaari in southern Finland, the son of a churchwarden.[1] Wigström was apprenticed at the age of ten to local jeweler Petter Madsen, who often subcontracted for retail jewelers in Russia. By the age of twenty-two, Wigström became assistant to Fabergé's chief workmaster Michael Perchin in St. Petersburg. When Perchin died prematurely in 1903, his workshop passed to Wigström. Because this workshop had become so important to the growth of the firm, Fabergé must have provided compensation to Perchin's family, which would otherwise have been disinherited for the sake of a smooth transition. The Wigström workshop was entrusted with Fabergé's most prestigious and exacting commissions, especially pieces for the Imperial family. Under Perchin, Wigström had assisted with twenty-six Imperial Eggs, and the shop created an additional twenty under his own stewardship.

The enormous growth of the House of Fabergé depended on the organization within and among the workshops. Fabergé was well ahead of his time in his use of team-based production, and the entrepreneurial and independent instincts of each shop were encouraged. At the 24 Bolshaya Morskaya building that included Fabergé's retail store, Wigström's workshop was on the second floor, and Henrik and his wife Ida lived in the same building. Craftspeople were seated at workbenches in groups, according to the nature of their work, so that goldsmiths sat together, with hardstone-mounters, gem-setters, and engravers nearby. The use of semi-manufactured pieces helped facilitate production. Other workshops occupied the same building.

Knowledge of Wigström has dramatically expanded recently with Ulla Tillander-Godenhielm's discovery of the Wigström Album. Just a few years ago, a zealous spring-cleaning revealed a dusty folio, unnoticed for eight decades, filled with extraordinarily beautiful watercolored drawings. The owner, friends and former neighbors of the Wigström family, turned to Tillander-Godenhielm: the album featured approximately 1,000 drawings of pieces actually created in Wigström's workshop.

The album served as a reference volume for the workshop, sitting on the shelf in the shop office. The drawings are neither designs, nor working drawings, but rather a record of finished works, points of comparison for ongoing and future work. Under each object is a completion date, with production number, not to be confused with the inventory number that is often scratched on the object itself once in the sales inventory. Most pieces in the album date from 1911 to 1916, with the majority from 1911 and 1913. All are drawn actual size, in pencil, pen, and watercolor, and with great accuracy as to detail and material. That so little documentary material exists from Fabergé's workshops renders these drawings especially significant.

The Wigström Album is a treat for students of Fabergé: it presents a dense cross-section of his work from a defined period of time, allowing a unique opportunity to evaluate the firm in the context of art and social history. This period was prosperous and dynamic, yet quite turbulent. In the wake of the bicentenary of the founding of St. Petersburg in 1703 and the events of the Revolution of 1905, the period covers the rapid process of industrialization in the years before the Great War, and straddles not only the anniversary of the 1812 victory over Napoleon, but also the Romanov Tercentenary of 1913. The purchasing public felt both a need for the security and comfort of the past, including mythical St. Petersburg imagery, and a desire to be part of the present. The stylistic range of Wigström's output reflects this apparent paradox. He did not imitate earlier sources, but, by allowing their influence, provided a connection with tradition, and past lifestyles.

FIG I. HENRIK WIGSTRÖM. Photograph courtesy Ulla Tillander-Godenhielm

FIG 2. THE CHILDREN OF HENRIK WIGSTRÖM. Photograph courtesy of Ulla Tillander-Godenhielm

FIG 3. WORKSHOP OF HENRIK WIGSTRÖM at 26 Bolshaya Morskaya. Archive Photograph

The album, and Wigström's work overall, displays styles from antique to Renaissance, but especially that of the Louis XVI period of the eighteenth century, with its neo-classical styling. The eighteenth century was a pinnacle of goldsmiths work, often combined with enameling: Wigström's workshop made extensive use of *guilloché* enamel, and did so with an incredibly wide palette and to exceptional levels of quality. He also used natural materials to advantage, both hardstone and wood. From turquoise to coarnelian, lapis lazuli to rock crystal, gold in four colors to *guilloché* enamel in many more, Wigström's workshop brought together many techniques and materials into practical pieces for the desk, whimsical carvings, miniature boxes, wearable Easter jewelry, all in a range of designs incorporating styles from antique to modern.

In all, the album represents about fifty different types of objects. Boxes of all types are especially prevalent, with cigarette-cases the largest single category. Although Fabergé never repeated a model, some drawings have multiple production numbers, indicating the creation of a second related object. The album reveals other details of production as well: stonework, which appears in about a third of the drawings, contains codes for the price of subcontracted lapidary work. And on half of the pieces Fabergé's signature *guilloché* enameling appears.

Many pieces in the album can be specifically associated with some of Fabergé's most famous clients, who commissioned, purchased from stock, or received as gifts, work by Fabergé in this period. Most prominent are Imperial family members, whose purchases included state gifts as well. Many non-Russians also patronized Fabergé, including foreigners on visits and those who shopped at the London branch. Foreign patronage extended to other Royal Houses, including those of Britain and Siam, and the album includes several pieces now in the Royal Collection, Thailand, recently exhibited for the first time outside Thailand at *A La Vieille Russie* and the New Orleans Museum of Art.

The number of craftsmen in Wigström's workshop diminished drastically with the outbreak of World War I. By 1918, the Revolution forced the complete closing of the House of Fabergé. Aged fifty-six, Wigström retreated almost empty-handed to his summer house, on Finnish territory, and died there in 1923.

Mark A. Schaffer. Ph.D

FIG 4. GROUP OF SEMI-MANUFACTURED OBJECTS from the personal workbench of Henrik Wigström. Photograph courtesy A La Vieille Russie

Notes
1. Tillander-Godenhielm/ P. Schaffer/Milica/Ilich/ Mark A. Schaffer (2000).

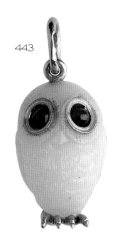
443

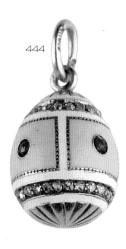
444

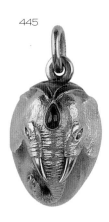
445

446

447

443. EGG-SHAPED GOLD-MOUNTED HARDSTONE OWL the white quartz engraved with plumage, gold mounted cabochon ruby eyes and gold feet and suspension ring – initials of workmaster Henrik Wigström, assay mark 1899–1908, 56 (zolotnik).
Private Collection

444. GEM-SET GOLD AND ENAMEL MINIATURE EASTER EGG the three yellow enamel panels set with cabochon rubies on opaque white enamel ground between two diamond set bands – initials of workmaster Henrik Wigström, assay mark 1908–1917, 72 (zolotnik).
Private Collection

445. GEM-SET GOLD EASTER EGG molded with the heads of two elephants and set with two oval cabochon rubies suspended from red enamel ribbons – initials of workmaster Henrik Wigström, assay mark of St. Petersburg 1903–1908, assay master Yakov Lyapunov. Original white leather case stamped "K. Fabergé" under Imperial Warrant.
Private Collection

446. ENAMELED GOLD EASTER EGG decorated with opaque white horizontal stripes and with three laurel roundels enclosing a burning red heart, a cross and the date 1916 – initials of workmaster Henrik Wigström, assay mark of St. Petersburg 1908–1917.
Provenance: Collection William Kazan.
Literature: Ghosn, Nr 163.
Private Collection

447. OVAL TWO-COLOR GOLD-MOUNTED AND ENAMEL PENDANT LOCKET of mauve *guilloché* enamel, the cover applied with classical columns and garlands surrounded by chased scrolls, the back similarly decorated, opening to reveal a miniature frame and a mirror – initials of workmaster Henrik Wigström, assay mark of St. Petersburg 1899–1908, assay master Yakov Lyapunov, height 2⁹⁄₁₆ in. (6.5cm).
Exhibited: Hamburg 1995, cat. no. 198.
Private Collection, courtesy A. von Solodkoff

448

449

448. SET OF SIX DIAMOND-SET ENAMELED SILVER-GILT STUDS of matte mauve enamel, decorated with diamond-set swirls – signed Fabergé, initials of workmaster Henrik Wigström, assay mark of St. Petersburg 1899–1908, assay master Yakov Lyapunov. Original fitted case with Imperial Warrant mark, St. Petersburg, Moscow, London.
Private Collection

449. GEM-SET GOLD AND ENAMEL ROUBLE COIN BROOCH the gold 10-Rouble coin dated 1764 with the profile portrait of Catherine the Great decorated in polychrome painted enamel and set with diamond chips – initials of workmaster Henrik Wigström, assay mark of St. Petersburg 1908–1917, diameter 1³⁄₄ in. (3.5cm).
Private Collection, courtesy A. von Solodkoff

450

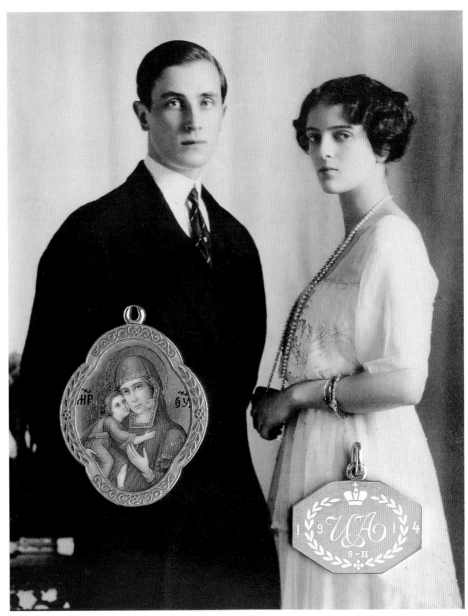

451A 451B

450. GOLD MINIATURE SAMOVAR
OF TRADITIONAL SHAPE standing on
four stud feet, with scroll handles simulating
wood handles and knob – signed Fabergé, ini-
tials of workmaster Henrik Wigström, assay
mark of St. Petersburg 1908–1917, height 3⁷₁₆
in. (8.7cm). Inscribed: "4 cups of tea – Palata
Buckhurst Park Jubilé – 9 Nov. 1933–7"
Provenance: Lady Lydia Deterding.
Bibliography: Snowman 1962/8, pl. 103;
Tillander et al. 2000, ill. p. 109.
Exhibited: Munich 1986/7, cat. 144, ill. p. 110;
New York 1988, cat. 7; Zurich 1989, cat. 60;
St. Petersburg/Paris/London 1993/4, cat. 163,
ill. p. 293; Lahti 1997, cat. 11, ill. p. 15; New
York/New Orleans 2000.
The Woolf Family Collection

451 A. THE YUSUPOV ICON a quatrefoil
gold and enamel pendant icon of the Holy
Virgin and Child of Tolga enameled and paint-
ed *en plein* on burnished gold ground, the
frame with laurel branches, rosettes and scrolls,
the reverse engraved in Russian "Bless and
Save", 9 February 1914 – engraved signature of
Fabergé, initials of workmaster Henrik
Wigström, assay mark of St. Petersburg
1908–1917, 72 (zolotnik), height 1⁵₁₆ in.
(3.4cm).
Provenance: Prince Felix Yusupov (18871967);
Princess Irina Yusupov, his daughter, later
Countess Nicholas Sheremetev (1915–1985).
Exhibited: Stockholm 1997, cat. no. 254.
The engraved date on the icon refers to the
date of the wedding of Prince Felix Yusupov,
Count Sumarokov-Elston (1887–1967), to
Princess Irina Alexandrovna of Russia
(1895–1970), eldest daughter of Grand Duke
Alexander Mikhailovich (1866–1933) and
Grand Duchess Xenia Alexandrovna
(1875–1960), daughter of Tsar Alexander III.
The wedding of Prince Felix and Princess

Irina was the last great society event before
the War, attended by the Imperial family and
the whole of St. Petersburg society. The Tsar
himself wrote in his diary on the wedding day:
"Everything went well. There were lots of.
Everyone filed through the winter garden past
Mama and the newly weds, to congratulate
them." (Maylunas, A. *et al.*: *A Lifelong Passion*,
London 1996, p.391).
After the Prince had masterminded Rasputin's
assassination "to save the Tsar and Russia" in
1916, he was exiled to central Russia where he
lived on one of the family estates. When the
Yusupovs left Russia in April 1919, aboard the
British dreadnought *Marlborough* they were able
to bring out many of their valuable
possessions – jewels, paintings, furniture and
assorted *objets d'art* (R. de Tirtoff, My Life/My
Art, New York, 1989. p. 75).
The gold icon is said to have been worn by
Prince Felix himself.
The photograph in the background showns
Prince Felix and Princess Irina Yusupov in
1914. The photograph is from the collection of
the late Countess Sheremetev.
Private Collection, courtesy A. von Solodkoff.

451 B. THE YUSUPOV JETON an
octagonal gold and enamel medallion with
suspension ring, decorated in opaque white
champlevé enamel on one side with crowned
initials of Princess Irina Alexandrovna of Russia
and the date 9/II/1914 within a laurel crown,
the reverse similarly decorated with the initials
of Prince Felix Yusupov Sumarokov-Elston –
unmarked, length 1 in. (2.6cm).
Provenance: Countess Marie Madelaine
Mordvinov, whose father was a close friend of
the Yusupov family.
Exhibited: Hamburg 1995, cat. no. 219;
Stockholm 1997, cat. no. 255.
Private Collection, courtesy A. von Solodkoff

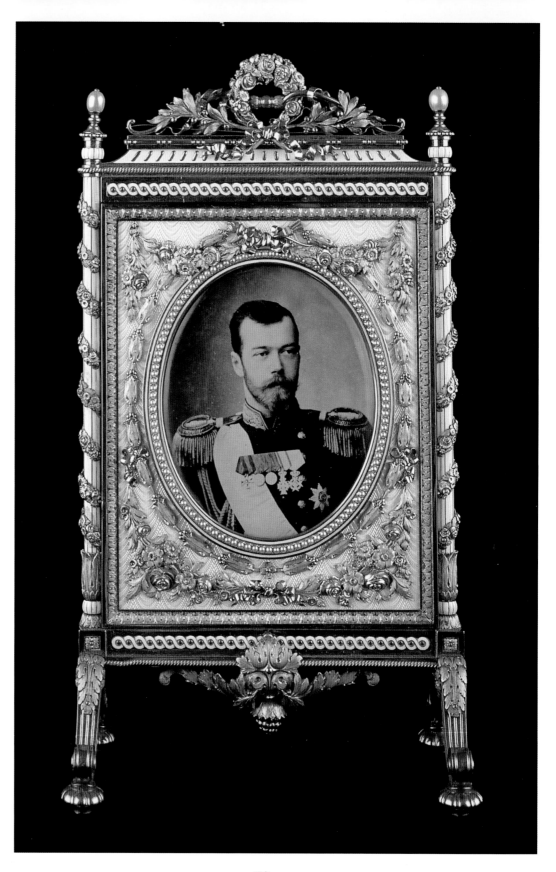

452

452. FIRE-SCREEN FRAME pearl-set
enameled varicolored double-sided frame
formed as a fire-screen surmounted by a
varicolored gold floral wreath and four sprays of
laurel. Both sides of the frame are applied with
elaborate swags of varicolored gold flowers and
garlands against a rectangular panel of translucent
pink enamel (verso) and white enamel (recto)
over a *guilloché* scalloped ground. The pearl
bordered oval aperture contains photographs of
Tsarina Alexandra (verso) and Tsar Nicholas II
(recto) – signed Fabergé, initials of workmaster
Henrik Wigström, assay mark of St. Petersburg
1908–1917, 72 (zolotnik), height 7⅛ in. (18cm).
Provenance: Maurice Sandoz, Switzerland;
Lansdell K. Christie, Long Island, New York.
Bibliography: Snowman 1962–64/68/74, ill.
plate XXVII; Waterfield/Forbes 1978, no. 71, ill.
p. 62–63; Kelly 1982/83, ill. no. 4; Schaffer 1983,
p. 17; Solodkoff 1984, p. 170, ill.; Forbes 1986, ill.
p. 55; Habsburg 1987, no. 493, ill. p. 246; Forbes
1989, p. 222, ill.; Hill 1989, p. 22; Habsburg/
Lopato 1993, no. 262, p. 364, ill.; Habsburg 1996,
ill. plate 50; Hawley 1997, ill. p. 7.
Exhibited: New York 1961, no. 183, ill. p. 68;
Washington 1961, no. 6, ill. p. 27; New York
1962/66, no. L.62.8.6; New York 1968, no. 365,
cat. p. 137, ill.; London 1977, no. L1, cat. p. 71;
Munich 1986/7, no. 492 , cat. p. 245; Lugano
1987, no. 29, cat. p. 56, ill.; Paris 1987, no. 29,
cat. p. 52, ill.; St. Petersburg/Paris/London
1993/94, no. 262, cat. p. 364, ill.; New York et al.
1996/97, no. 204, cat. p. 212, ill.
The Forbes Magazine Collection, New York

453

454

455

456

457

453. SQUARE SILVER-MOUNTED RED ENAMEL AND BOWENITE BAROMETER on four paw feet, the top with circular bezel set in a panel of red *guilloché* enamel applied with rosettes and laurel branches, with stiff-leaf border, the sides applied with a rosette within laurel crown and flanked by palmettes, cabochon garnet finial – initials of workmaster Henrik Wigström, assay mark of St. Petersburg 1899–1908, assaymaster Alexander Romanov, inv no. 12098, width 3⅝ in. (9.2cm).
The Hubel Collection

454. JEWELED ENAMELED AND GOLD-MOUNTED NEPHRITE VIDE-POCHE triangular with rounded corners and upright sides, the engine-turned gold mounts enameled in translucent strawberry red and bound by crossed bands set with rose diamonds – signed Fabergé, initials of workmaster Henrik Wigström, assay master A. Romanov, inv no. 11924, width 4¹³⁄₁₆ in. (12.3cm).
Private Collection

455. "T"-SHAPED ENAMELED, SILVER-GILT MOUNTED NEPHRITE CANE HANDLE the mount of pink *guilloché* enamel with palm-leaf borders – initials of workmaster Henrik Wigström, assay mark of St. Petersburg 1904–1908, assay master A. Romanov, width 4¹⁵⁄₁₆ in. (12.5cm).
Provenance: From a cane once belonging to King Ferdinand of Bulgaria.
Exhibited: Munich 1986/7, cat. 169.
Private Collection

456. PEAR-SHAPED GEM-SET GOLD-MOUNTED BOWENITE GUM POT carved from pale hardstone, the gold removable stalk set with a cabochon ruby – initials of workmaster Henrik Wigström, assay mark of St. Petersburg 1899–1908, assay master Yakov Lyapunov, height 2⅞ in. (7.3cm).
Provenance: From the collection of a descendant of King Christian IX of Denmark.
Exhibited: Hamburg 1995, cat. no. 202.
Bibliography: Solodkoff 1988, ill. p. 10.
The Hubel Collection

457. PRESENTATION BEAKER silver-mounted nephrite commemorative beaker applied with a silver plaque chased with the Imperial eagle and inscribed in Cyrillic "WAR/1914–1915/K. FABERGE" – initials of workmaster Henrik Wigström, assay mark St. Petersburg 1908–1917, 84 (zolotnik), height 3⅞ in. (9.8cm).
Bibliography: Hess 1980, ill. p. 45; Solodkoff 1984, ill. pp. 6, 173; Habsburg/Lopato 1994, cat. 126, p. 269, ill.
Exhibitions: St. Petersburg/Paris/London 1993/94, no. 126, cat. p. 269, ill.; New York et al. 1996/97, no. 288, ill. pp. 232, 268.
The Forbes Magazine Collection, New York

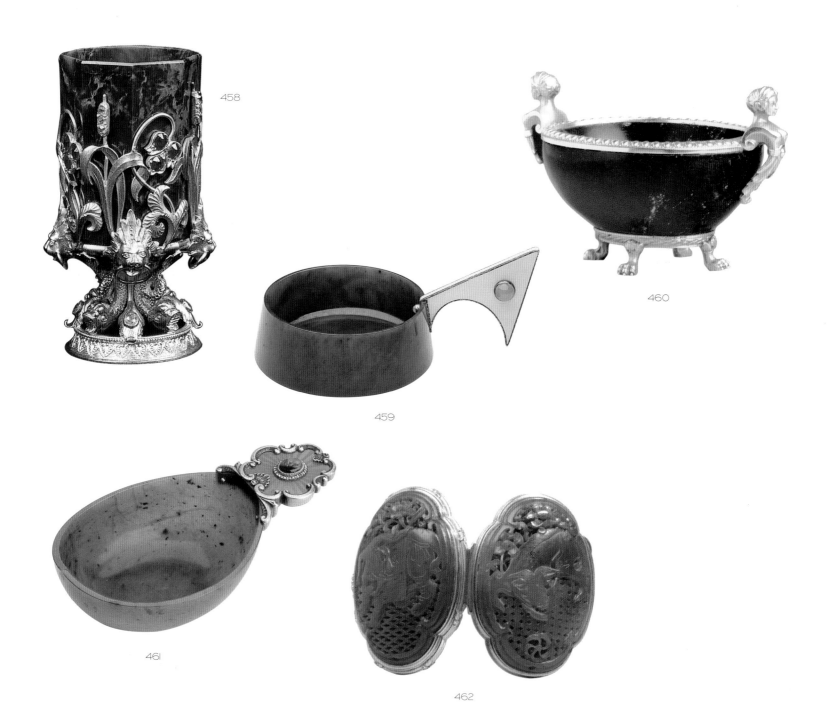

458

460

459

461

462

458. ART NOUVEAU MATCH
HOLDER octagonal Art Nouveau gem-set
gold-mounted jasper match-holder, the whole
decorated with chased gold foliage motifs set
with rubies, demantoids and lions' masks, the
gold base decorated with alternating leaf motifs
and miniature dolphins whose curled tails
support the holder – signed Fabergé, initials of
workmaster Henrik Wigström, 56 (zolotnik),
height 2⁵⁄₈ in. (6.7cm).
Literature: Waterfield/Forbes 1978, no. 133, ill.
p. 101; Solodkoff 1984, p. 179, ill.; Forbes 1986,
p. 57, ill.; Hill 1989, ill. plate no. 269; Booth
1990, p. 77, ill.
Exhibitions: New York 1973, no. 40, ill. p. 93;
Munich 1986/87, no. 240, ill. p. 169, Lugano
1987, no. 7, cat. p. 44, ill.; Paris 1987, no. 7, cat.
p. 40, ill.
The Forbes Magazine Collection, New York

459. STYLE MODERN KOVSH circular
enameled gold-mounted nephrite kovsh of
modern design, the tapering bowl with hook
handle enameled translucent white and set on
both sides with a foiled moonstone – by
Fabergé, unmarked, length 5 in. (12.7cm)
Bibliography: Waterfield/Forbes 1978, no. 126,
ill. p. 99; Solodkoff 1984, p. 179, ill.; Kelly
1985, ill. p. 12.
Exhibited: New York 1973, no. 48, ill. p. 103;
New York et al. 1996/97, no. 242, p. 242, ill.
A number of such unadorned nephrite objects
by Fabergé indicate a clear move away from
the historicizing styles of the 19th century,
heralding the clear-cut, geometric forms of
Art Deco.
The Forbes Magazine Collection, New York

460. OVAL GOLD-MOUNTED
LAPIS LAZULI BOWL in the Renaissance
style, the specimen stone body on four paw
feet with laurel band mount, the handles
formed as classical female therms, with egg and
dart rim – initials of workmaster Henrik
Wigström, assay mark of St. Petersburg
1908–1917, 72 (zolotnik), inv no. 22104,
English import marks for 1911.
Provenance: Ambassador Georges Kazan, Paris.
Bibliography: Ghosn 1996, cat. 79; Tillander et
al. 2000, ill. p. 115 and back cover.
Exhibited: New York/New Orleans 2000.
Illustrated in a surviving stock book of
Wigström's workshop (see Tillander, op. cit.).
The Woolf Family Collection

461. NEPHRITE KOVSH with silver-gilt
and enameled mount the handle set with an
oval moss agate plaque surrounded by
diamonds on pink *guilloché* enamel with silver-
gilt scroll and shell border, oval hardstone bowl
– initials of workmaster Henrik Wigström,
assay mark of St. Petersburg 1908–1917, length
4³⁄₄ in. (12.1cm).
Private Collection

462. CHINESE QUATREFOIL GOLD-
MOUNTED GREEN JADE CRICKET
CAGE the pierced panels depicting an
elephant and a tiger on either side. Transformed
into a powder compact and with a gold border
enriched with opaque white striped enamel
and foliage – signed Fabergé in Latin, initials of
workmaster Henrik Wigström, assay mark of
St. Petersburg 1908–1917, length 2⁷⁄₈ in.
(7.2cm).
Exhibited: Munich 1986/7, cat. 179, ill. p. 157;
New York 1988, cat. 11; Zurich 1989, cat. 179;
Lahti 1997, cat. 12, ill. p. 16; London 1998;
New York/New Orleans 2000.
An interesting case of a Chinese article
mounted and modified by Fabergé.
The Woolf Family Collection

463 464 465

466

463. CUBICAL ENAMELED GOLD AND ROCK CRYSTAL BOX the sides decorated in the classical style with white enamel laurel crowns and arrows bordered by *entrelac* bands, the cover and base set with engraved rock crystal plaques – signed by Fabergé, workmaster Henrik Wigström, assay mark of St. Petersburg 1908–1917, inv no. 17776, London import marks for 1911, 1³⁄₈ in. (3.5cm) square.
Private Collection

464. RECTANGULAR GOLD-MOUNTED RHODONITE BOX the hardstone panels mounted as a cage, the reeded gold mounts of the hinged cover with crossed ribbons and with green enamel squares set with rose-cut diamonds, the gold borders to sides and base with dot and dash engraving – signed (Latin) Fabergé, initials of workmaster Henrik Wigström, assay mark of St. Petersburg 1908–1917, inv no. 21807, London Import mark for 1911, length 4⁷⁄₁₆ in. (11.3cm).
Provenance: Bought from Fabergé's London branch by Lady A. Paget for £35 on 12 December 1911.
Private Collection

465. OBLONG ENAMELED, GOLD-MOUNTED NEPHRITE BOX the mount chased with laurel leaves between two stripes of opaque white enamel, set at intervals with five cabochon rubies – signed Fabergé, initials of workmaster Henrik Wigström, length 3¹⁵⁄₁₆ in. (9.8cm).
Exhibited: New York/San Franscisco et al. 1996/7, cat. 344.
Joan and Melissa Rivers

466. ENAMELED GOLD-MOUNTED RHODONITE BOX mounted *à cage*, the mounts on the cover with green enamel leaves and white pellets, the sides with opaque white enamel stripes; with diamond-set thumbpiece – signed Fabergé and Latin initials C. F., assay mark of St. Petersburg 1908–1917, 72 (zolotnik), inv no. 23331, English Import marks for 1911, length 2¼ in. (5.7cm).
Bibliography: Snowman 1962/4, pl. XIII.
Exhibited: V&A 1977, cat. R 45; Munich 1986/7, cat. 197.
Private Collection

467. NICHOLAS II NEPHRITE BOX rectangular, imperial presentation snuffbox, diamond-set gold-mounted nephrite, the cover decorated with a diamond-set trellis with, at the center, a wreath of laurel foliage enclosing a miniature by Vassily Zuiev of Tsar Nicholas II wearing the uniform of the Fourth Rifle Battalion of Guards and the Cross of the Order of St. George within a diamond-set oval border surmounted by an Imperial crown – signed Fabergé, initials of workmaster Henrik Wigström, assay mark of St. Petersburg 1908–1917, 56 (zolotnik), inv no. 4909, length 3¾ in. (9.5cm).
Provenance: Presented by Tsar Nicholas II to an unidentified personage, 1915 – 1916; Mrs. J. M. Jacques, England; Lansdell K. Christie, Long Island, New York.

Bibliography: Bainbridge 1949, ill. plate no. 125; Snowman 1953/55, ill. plate 122; Snowman 1953/55, ill. no. 122; Snowman 1962//64/68/74, ill. no. 130; McNabb Dennis 1965, p. 240, ill.; Bainbridge 1966, pl. no. 127; Waterfield/Forbes 1978, no. 63, ill. p. 55; Snowman 1979, p. 122, ill.; Solodkoff 1984, ill. pp. 26, 173; Kelly 1985, ill. p. 22; Hill 1989, ill. plate no. 118; Habsburg/Lopato 1994, cat. 146, p. 280, ill.
Exhibited: London 1949, no. 259, cat. pp. 3, 21; London 1953, no. 158, cat. p. 16; New York 1962/66, no. L.62.8.156; New York 1973, no. 13, ill. p. 55; London 1977, no. L9, cat. p. 73; New York 1983, no. 216, ill. p. 79; Petersburg/Paris/London 1993/94, no. 146, cat. p. 280, ill.; Hamburg 1995, no. 189, cat. p. 175, ill.; New York et al. 1996/97, no. 194, cat. p. 205, ill.
The Forbes Magazine Collection, New York

467

468

469

470

468. SQUARE, ENAMELED, TWO-COLOR GOLD-MOUNTED, SILVER AND NEPHRITE DESK CLOCK the opalescent white *guilloché* enamel dial painted underglaze in sepia camaieu with dendritic motifs and Arabic chapters, with gold "Louis XV" hands and chased laurel leaf bezel. Set in a square panel with chamfered corners of translucent pink enamel over sunburst *guilloché* ground bordered in opaque white. The outer nephrite frame applied with gold laurel crowns at the corners and opalescent white *guilloché* enamel panels painted in camaieu with further dendritic motifs. With opaque white enamel and gold reed-and-tie border and silver-gilt strut – signed Fabergé, initials of workmaster Henrik Wigström, assay mark of St. Petersburg 1899–1908, height 4³⁄₁₆ in. (10.7cm). Bibliography: Solodkoff 1899, p. 30; Booth 1990, p. 124.
Exhibited: Hamburg 1995, cat. 89.
Private Collection

469. RECTANGULAR, ENAMELED, GOLD AND SILVER-MOUNTED RHODONITE DESK CLOCK the opalescent white *guilloché* enamel dial with black Arabic chapters and gold "Louis XV" hands signed Fabergé and with tied laurel wreath bezel; with silver-gilt case and strut – signed Fabergé, initials of workmaster Henrik Wigström, assay mark of St. Petersburg 1908–1917, inv no. 24272, height 2¹⁵⁄₁₆ in. (7.5cm). Original fitted case stamped with Imperial Warrant, St. Petersburg, Moscow, London.
Exhibited: Hamburg 1995, cat. 112.
Private Collection

470. SILVER-MOUNTED NEPHRITE MANTLE CLOCK with arched top standing on a rectangular base with foliate silver band. The white opaque enamel dial with black Arabic chapters, gold "Louis XV" hands and laurel wreath bezel, with suspended laurel swag beneath – signed Fabergé, initials of workmaster Henrik Wigström, assay mark of St. Petersburg 1908–1917, inv no. 22437, height 5¹⁄₁₆ in. (12.8cm).
Bibliography: Solodkoff 1986, p. 15.
Exhibited: Hamburg 1995, cat. 118.
Private Collection

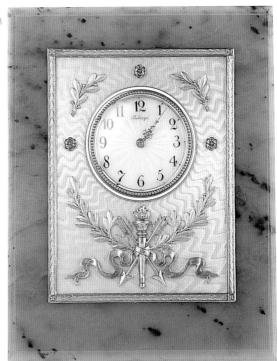

471. RECTANGULAR ENAMELED
GOLD-MOUNTED NEPHRITE
MINUTE REPEATING CLOCK mounted
à cage with chased gold laurel leaf borders, the
opalescent white *guilloché* enamel dial with
black Arabic chapters, gold "Louis XV" hands
signed C. Fabergé St. Petersburg, and with
laurel wreath bezel; cabochon garnet pushpiece
– signed Fabergé, intials of workmaster Henrik
Wigström, assay mark of St. Petersburg
1908–1917, height 5 in. (12.7cm).
Exhibited: Hamburg 1995, cat. 119.
Private Collection

472. TRAPEZOID ENAMEL AND
GOLD-MOUNTED NEPHRITE
CLOCK the dial with oyster enamel on *guil-
loché* ground signed Fabergé with reed-and-tie
bezel surrounded by an opaque white enamel
band on a nephrite panel carved with curved
borders and feet, silver-gilt backing and strut –
signed Fabergé, initials of workmaster Henrik
Wigström, assay mark of St. Petersburg
1908–1917, height 4¼ in. (10.8cm).
G. Eriksson Collection

473. RECTANGULAR TWO-COLOR
GOLD AND ENAMEL NEPHRITE
CLOCK the opalescent enameled dial signed
Fabergé with pellet and white enamel bezel on
a pink *guilloché* enamel plaque applied with a
chased gold trophy of a torch, two crossed
arrows and ribbon-tied laurel branches with
three rosettes and further laurel above, chased
laurel border, silver-gilt backing and strut –
signed Fabergé, initials of workmaster Henrik
Wigström, assay mark of St. Petersburg
1908–1917, inv no. 26414, height 4½ in.
(11.5cm).
Private Collection

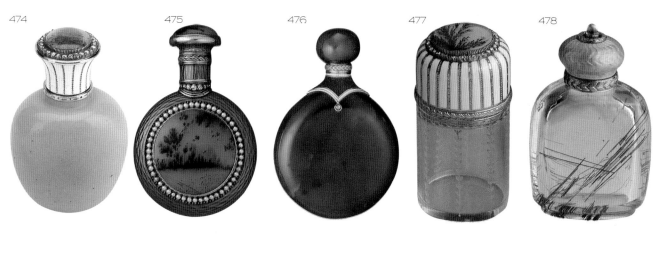

474 475 476 477 478

479

480 – 483

474. GEM-SET ENAMEL AND GOLD-
MOUNTED AGATE SCENT-BOTTLE
the rounded hardstone taken from a Chinese
snuff-bottle, the tapering cover with opaque
white enamel bands, the top with a circular
moss agate plaque surrounded by rose-cut
diamonds – initials of workmaster Henrik
Wigström, assay mark of St. Petersburg
1899–1908, assay master Yakov Lyapunov, hieght
$2^{5}16$ in. (5.8cm).
Private Collection, courtesy A. von Solodkoff

475. CIRCULAR GEMSET HARD-
STONE AND ENAMELED SILVER
SCENT-FLASK the flattened body of blue
guilloché enamel set on one side with a circular
moss agate plaque surrounded by seed pearls,
with a line of rose-cut diamonds at the neck
and moss agate finial – initials of workmaster
Henrik Wigström, assay mark of St. Petersburg
1908–1917, height $2^{1}2$ in. (6.4cm).
Exhibited: Paris 1994, cat. 5; Hamburg 1995, cat.
37; London 1996, cat. 5.
Chevalier Maurice Mizzi Collection

476. CIRCULAR GOLD-MOUNTED
ENAMELED NEPHRITE SCENT-
FLASK with spherical cover, with a collar
of red *guilloché* enamel at the neck within
opaque white borders, set with two rose-cut
diamonds – initials of workmaster Henrik
Wigström, assay mark of St. Petersburg
1908–1917, 72 (zolotnik), height $2^{15}16$ in.
(7.5cm).
Exhibited: Paris 1994, cat. 12; Hamburg 1995,
cat. 43; London 1996, cat. 12.
Chevalier Maurice Mizzi Collection

477. CYLINDRICAL GEMSET GOLD-
MOUNTED ENAMELED ROCK
CRYSTAL SCENT-FLASK engraved with
vertical lines of laurel leaves, the cover with
vertical bands of opaque white enamel and
gold and with gold laurel-leaf border, pink
foiled moss agate plaque within rose-cut
diamond border – signed Fabergé, initials of
workmaster Henrik Wigström, assay mark of
St. Petersburg 1908–1917, height $1^{13}18$ in.
(4.7cm).
Exhibited: Paris 1994, cat. 23; Hamburg 1995,
cat. 45; London 1996, cat. 23.
Chevalier Maurice Mizzi Collection

478. GOLD-MOUNTED ENAMELED
RUTILATED QUARTZ SCENT-FLASK
the flattened body with rounded shoulders
possibly of Chinese origin, the pink *guilloché*
enamel cover with chased gold laurel leaf
border and cabochon moonstone finial –
engraved signature Fabergé, initials of
workmaster Henrik Wigström, assay mark of
St. Petersburg 1908–1917, inv no. 56907,
height $2^{3}4$ in. (7cm).
Exhibited: Paris 1994, cat. 34; Hamburg 1995,
cat. 63; London 1996, cat. 34.
Chevalier Maurice Mizzi Collection

479. CYLINDRICAL GOLD-
MOUNTED CRYSTAL SCENT-FLASK
the gadrooned cover with cabochon sapphire
finial – signed Fabergé, assay mark of St.
Petersburg 1899–1908, height $2^{5}8$ in. (6.7cm).
Original fitted case stamped with Imperial
Warrant, St. Peterburg, Moscow and London.
Provenance: Queen Alexandra; Lady Duveen
of Millbank.
Exhibited: Paris 1994, cat. 38; Hamburg 1995,
cat. 65; London 1996, cat. 38.
Chevalier Maurice Mizzi Collection

480 – 483. FOUR-PIECE TOILET
SET OF CYLINDRICAL GOLD AND
GOLD-MOUNTED CRYSTAL
CONTAINERS comprising respectively two
powder boxes and two scent-bottles, their
fluted covers with cabochon sapphire finials –
retailer's mark of Fabergé, heights $1^{9}18$, $1^{13}18$
and $4^{3}18$ in. (4, 4.6 and 10.6cm).
Exhibited: Paris 1994, cat. 39–40; Hamburg
1995, cat. 66-69; London 1996, cat. 39–40.
Chevalier Maurice Mizzi Collection

484

485

486

487

488

484. GEMSET GOLD-MOUNTED POLISHED ROCK CRYSTAL CIGARETTE-CASE of oval section, the mounts set with a band of calibrated rubies between two bands of rose-cut diamonds – signed Fabergé in Cyrillic, initials C.F. in Latin script, initials of workmaster Henrik Wigström, 72 (zolotnik), London import marks for 1911, length 3³⁄₄ in. (9.5cm).
Provenance: Sold at Fabergé's London shop on 27 December 1912 to a member of the Rothschild family.
Bibliography: Traina 1998, p. 120.
John Traina Collection

485 GOLD-MOUNTED GUN-METAL CIGARETTE-CASE with match compartment, tinder cord and cabochon sapphire thumbpiece – signed Fabergé, initials of workmaster Henrik Wigström, length 3¹⁄₂ in. (9cm).
Bibliography: Traina 1998, p. 67.
John Traina Collection

486. LORGNETTE WITH OCTAGONAL LENSES with a spiraling band of green-gold laurel leaves winding itself around the pink *guilloché* enamel handle; the octagonal green-gold terminal ring is chased with husks and contains a red-gold pineapple at its center – Cyrillic initials K.F. for Carl Fabergé, assay mark of St. Petersburg 1899–1908, assay master Jakov Lyapunov 56 (zolotnik), length 6 in. (15.2cm).
Provenance: Mrs. L.D. Hirst-Broadhead.
Bibliography: Waterfield/Forbes 1978, no. 90, ill. pp. 78, 139; Solodkoff 1984, p. 169, ill.; Forbes 1989, p. 223, ill.
Exhibited: New York 1973, no. 35, cat. ill. p. 85.
The Forbes Magazine Collection, New York

487. OSTRICH FEATHER FAN diamond-set enameled gold, the engraved rock crystal handle applied with red gold mounts enameled translucent salmon pink and opaque white with a salmon pink roundel on one side, and a mirror on the reverse – signed Fabergé, initials of Henrik Wigström, 56 (zolotnik), inv no. 17348, height 20¹⁄₂ in. (52cm).
Provenance: Purchased from the Fabergé London Branch by Walter Winans, Esq. for L90 on 19 September 1908; Peter Otway Smithers, Esq.
Bibliography: Snowman 1953/55, ill. nos. 165, 166; Snowman 1962/64/68/74, ill. nos. 182, 183; Snowman 1977, p. 53, ill.; Waterfield/Forbes 1978, no. 85, ill. p. 75; Solodkoff 1984, ill. pp. 30, 169, back cover; Kelly 1985, p. 18, ill.; Forbes 1989, p. 223, ill.; Kelly 1994, unpaginated, ill.; Habsburg 1996/97, fig. 1, ill. p. 26.
Exhibited: London, 1949, no. 229, cat. p. 20; London 1953, no. 194, cat. p. 19; New York 1973, no. 34, ill. p. 85; London 1977, no. 013, p. 98 ill.
The Forbes Magazine Collection, New York

488. PAIR OF GOLD-MOUNTED AND ENAMEL LORGNETTES the tapering handle with yellow *guilloché* enamel, the finials with green enamel rectangles, opaque white enamel borders, with chased gold laurel and acanthus – signed by Fabergé, initials of workmaster Henrik Wigström, assay mark of St. Petersburg 1908–1917, length 4³⁄₈ in. (11.2cm).
Private Collection

489

493

490

492

491

489. JEWELED ENAMELED GOLD
FAN the guard of pink *guilloché* enamel
applied with scrolls and diamond-set rosettes,
the chicken-skin fan painted in the 18th
century style with ladies and gentlemen on a
terrace with an extensive landscape beyond
which is the signature van Garden and applied
with gilt paillettes, the mother-of-pearl sticks
pierced and gilt – signed Fabergé, initials of
workmaster Henrik Wigström, assay mark of
St. Petersburg 1908–1917, assay master Yakov
Lyapunov, 56 (zolotnik), length 9 in. (23cm).
Provenance: Imperial Collections, Pavlovsk
Palace; transferred to the Kremlin
Armory 1964.
Bibliography: Rodimtseva 1971, p. 3, ill. 1.
Exhibited: Moscow 1992, cat. 115, ill. 126, 126,
152/3; Torre Canavese 1994, cat. 72, ill. p. 173;
Sydney 1996, cat. 111, ill. p. 112/3.
Kremlin Armory Museum (MR – 868)

490. GEM-SET ENAMELED TWO-
COLOR GOLD CAPE-CLASP the two
lateral clasps of triangular shape, each with a
pink foiled cabochon moonstone in a rose-cut
diamond mount set in a panel of opalescent
white *guilloché* enamel applied with
intertwining green and red gold laurel sprays
and a cabochon ruby, with palm leaf borders.
The clasps are joined by a gold chain from
which there is suspended a similar triangular
pendant – signed Fabergé, initials of
workmaster Henrik Wigström, assay mark of
St. Petersburg 1899–1908, assay master Yakov
Lyapunov, overall length 5¹⁸ in. (13cm).
Original fitted case with Imperial Warrant
mark, St. Petersburg, Moscow, Odessa.
Private Collection

491. TWO-COLOR GOLD AND
ENAMEL SEAL IN THE FORM OF A
BED WARMER enameled pale blue over
guilloché ground, the circular seal with gold
borders, the enameled handle with chased gold
acanthus and laurel, the acorn shaped reeded
gold finial set with a moonstone, the matrix
engraved with initials A. K. – initials of
workmaster Henrik Wigström, assay mark of
St. Petersburg 1903–1908, inv no. 14082, length
4¹² in. (11.5cm).
Private Collection

492. GOLD-MOUNTED AND
ENAMEL THIMBLE CASE the tapering
sides decorated with opaque mauve stripes, with
white quartz base, the cover with chased gold
rosette finial set with a moonstone, gold chain
and ring attachment – workmaster's initials of
Henrik Wigström, assay mark of St. Petersburg,
56 (zolotnik), assay master Alexander Romanov,
inv no. 17965, height ¹⁵₁₆ in. (2.3cm).
Private Collection

493. FLAT EGG-SHAPED GOLD-
MOUNTED ENAMEL VESTA CASE
of red *guilloché* enamel with two-color gold
border – initials of workmaster Henrik
Wigström, assay mark of St. Petersburg, assay
master Yakov Lyapunov, 88 (zolotnik), inv no.
14759 (deleted) and 14760, length 1¹⁵₁₆ in.
4.9cm).
Private Collection

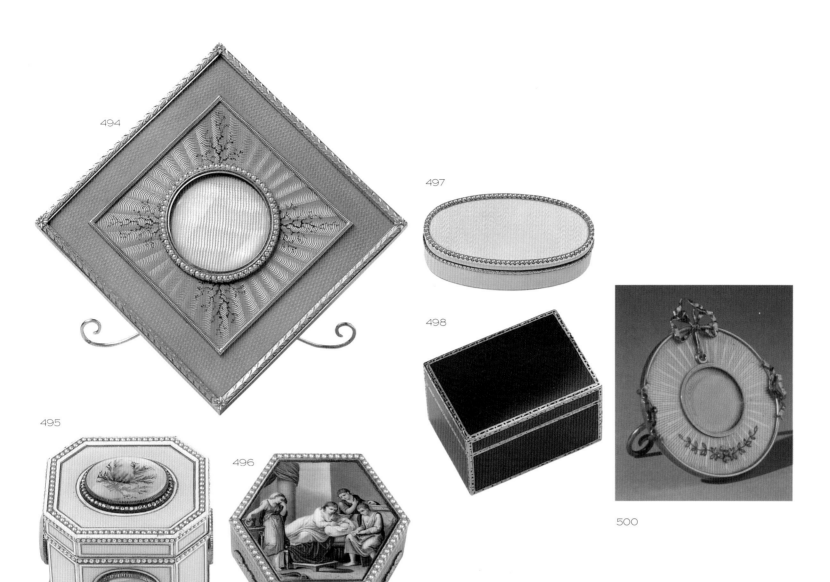

494

495

496

497

498

500

494. SQUARE PEARL-SET, TWO-COLOR GOLD AND ENAMEL FRAME standing on end, with circular split-pearl set bezel on a square green *guilloché* enamel panel painted with beige trees, surrounded by a band of pink enamel with chased gold palmette border, gold strut – signed Fabergé, initials of workmaster Henrik Wigström, assay mark of St. Petersburg 1899–1908, assay master Yakov Lyapunov, inv no. 11209, height 3³⁄4 in. (9.5cm). Original fitted hollowood case stamped with Imperial Warrant, Fabergé, St. Petersburg, Moscow, London.
Provenance: Josiane Woolf Collection.
Exhibited: Munich 1986, cat. no. 455, Hamburg 1995, cat. no. 158; Stockholm 1997, cat. no. 127.
Private Collection, courtesy A. von Solodkoff

495. OCTAGONAL GEM-SET GOLD AND ENAMEL BOX set with oval pink foiled moss agate plaques surrounded by rose-cut diamonds on opalescent white *guilloché* enamel panels, with opaque white enamel borders set with half-pearls – signed Fabergé, initials of workmaster Henrik Wigström, assay mark of St. Petersburg 1899–1908, 72 (zolotnik), inv no. 18725, length 1³⁄4 in. (4.5cm).
Private Collection

496. HEXAGONAL SILVER-GILT AND ENAMEL BOX the cover set with a Swiss early 19th-century enamel plaque painted with a scene in the antique style with half-pearl border, the green enameled sides applied with rosettes and anthemia – signed Fabergé, initials of workmaster Henrik Wigström, assay mark of St. Petersburg 1908–1917, inv no. 23640, width 2 in. (5.1cm).
Private Collection

497. OVAL PEARL-SET, GOLD-MOUNTED SILVER-GILT AND ENAMEL BOX of pink *guilloché* enamel, the hinged cover with pearl-set border – signed (Latin) Fabergé, initials of workmaster Henrik Wigström, assay mark of St. Petersburg 1908–1917, inv no. 23856, length 2⁵⁄8 in. (6.7cm).
The Hubel Collection

498. RECTANGULAR GOLD-MOUNTED SILVER-GILT AND ENAMEL BOX of red *guilloché* enamel with engraved dash-and-dot borders – signed Fabergé, initials of workmaster Henrik Wigström, assay mark of St. Petersburg 1908–1917, inv no. 23278, length 1¹⁄4 in. (3.2cm).
The Hubel Collection

500. CIRCULAR ENAMELED GOLD-MOUNTED SILVER-GILT FRAME of apple green translucent enamel over sunburst *guilloché* ground enriched with further underglaze camaïeu foliage and central rosette. The aperture with white opaque enamel bezel suspended from a gold ribbon knot set with a diamond, with further tied ribbons to the sides each set with rose-cut diamonds, with silver-gilt strut – signed Fabergé, initials of workmaster Henrik Wigström, assay mark of St. Petersburg 1908–1917, diameter 2 in. (5.1cm).
Exhibited: St. Petersburg/Paris/London 1993/4, cat. 248, ill. p. 355; Hamburg 1995, cat. 172, ill. p. 160.
The Woolf Family Collection

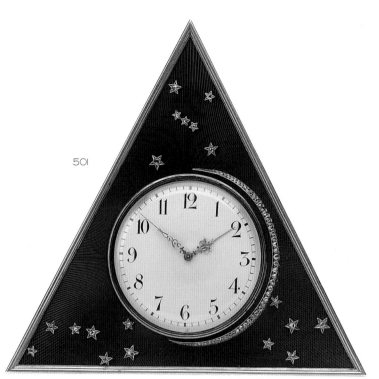

501

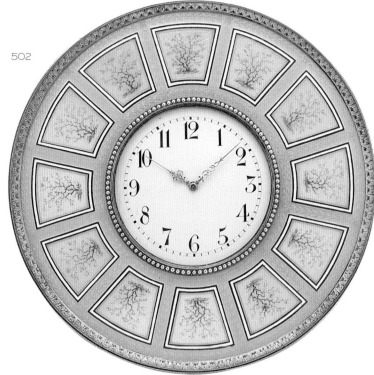

503

504

505

501. TRIANGULAR GEM-SET SILVER-GILT AND ENAMEL CLOCK of royal blue *guilloché* enamel, the dial flanked by a diamond-set crescent moon and decorated with diamond-set stars, with reeded border and silver-gilt backing and strut – signed Fabergé, initials of workmaster Henrik Wigström, assay mark of St. Petersburg 1899–1908, inv no. 13066, height 4⁵⁄₈ in. (11.8cm).
The Eriksson Collection

502. CIRCULAR GOLD-MOUNTED AND ENAMEL CLOCK the bezel set with pearls surrounded by twelve pink enamel panels painted with camaïeu purple trees, on white enamel ground lined with pale blue enamel laurel bands and rosettes, with two-color gold anthemion border, silver-gilt backing and strut – signed Fabergé, initials of workmaster Henrik Wigström, assay mark of St. Petersburg 1899–1908, assay master Alexander Romanov, inv no. 16560, diameter 5¹⁄₈ in. (13cm).
The Hubel Collection

503. SQUARE, ENAMELED, GOLD-MOUNTED, SILVER DESK CLOCK of translucent green enamel of *guilloché* ground of concentric rings further engraved with tied laurel garlands, with chased acanthus leaf rim. The opaque white enamel dial with black Arabic chapters, gold "Louis XV" hands and seed-pearl bezel, silver strut – signed Fabergé, initials of workmaster Henrik Wigström, assay mark of St. Petersburg 1899–1908, diameter 4¹⁄₈ in. (10.5cm).
Exhibited: Hamburg 1995, cat. 85.
Private Collection

504. SQUARE ENAMELED SILVER-GILT DESK CLOCK of opalescent *guilloché* enamel painted underglaze in sepia camaïeu with baskets and garlands of flowers suspended from tied ribbons, a thyrsos staff beneath, with border chased with interwoven ribbons. The opaque white enamel dial with black Arabic chapters, gold "Louis XV" hands and bezel of stylized foliage; silver strut – signed Fabergé, initials of workmaster Henrik Wigström, assay mark of St. Petersburg 1899–1908, height 4¹⁄₁₆ in. (10.3cm).
Provenance: The Josiane Woolf Collection.
Exhibited: Hamburg 1995, cat. 86.
Private Collection

505. SMALL SQUARE ENAMELED SILVER-GILT DESK CLOCK of translucent pale-blue enamel over sunburst *guilloché* ground. The opaque white enamel dial with black Arabic chapters and gold "Louis XV" hands. With stylized foliage borders and silver strut – signed Fabergé, initials of workmaster Henrik Wigström, assay mark of St. Petersburg 1899–1908, height 2⁷⁄₁₆ in. (6.2cm).
Exhibited: Hamburg 1995, cat. 103.
Private Collection

506 507 508 509

506. UPRIGHT RECTANGULAR
ENAMELED, GOLD-MOUNTED
SILVER-GILT DESK CLOCK of
translucent mauve enamel over waved sunburst
guilloché enamel, applied with laurel garlands
suspended from tied ribbons and set with rose-
cut diamonds, with laurel leaf border, the
opaque enamel dial with black Arabic chapters,
gold "Louis XV" hands and seed-pearl bezel;
silver-gilt strut – signed Fabergé, initials of
workmaster Henrik Wigström, assay mark of
St. Petersburg 1899–1908, inv no. 12253,
height 4¹⁵⁄₁₆ in. (12.7cm). Original fitted case
stamped with Imperial Warrant, St. Petersburg,
Moscow, Odessa.
Provenance: Baron Marochetti, Italian
Ambassdor to the St. Petersburg court
1886–1900.
Exhibited: Hamburg 1995, cat. 116.
Private Collection

507. UPRIGHT RECTANGULAR
ENAMELED GOLD DESK CLOCK of
apple green translucent enamel over sunburst
guilloché ground engraved with swags and a
basket of flowers, with a pale mauve outer
guilloché enamel border over engraved laurel
sprays, and with outer acanthus leaf rim. The
opalescent white *guilloché* enamel dial painted
underglaze in camaïeu sepia with a laurel
wreath, with gold "Louis XV" hands and seed-
pearl bezel – signed Fabergé, initials of
workmaster Henrik Wigström, assay mark of
St. Petersburg 1899–1908, height 6¹⁄₂ in.
(16.5cm). Original fitted case stamped with
Imperial Warrant, St. Petersburg, Moscow,
Odessa.
Provenance: Ludvig and Edla Nobel, Sweden
Exhibited: Hamburg 1995, cat. 120.
Private Collection

508. RECTANGULAR ENAMELED
SILVER DESK CLOCK of green *guilloché*
enamel, further engraved with flower swags
suspended from ribbons and a basket. The
opaque white enamel dial with black Arabic
chapters, gold "Louis XV" hands and seed-pearl
bezel; silver strut – signed Fabergé, initials of
workmaster Henrik Wigström, assay mark of
St. Petersburg 1899–1908, height 5¹⁄₈ in.
(13cm). Original fitted case stamped with
Imperial Warrant, St. Petersburg, Moscow,
Odessa.
Exhibited: Hamburg 1995, cat. 123.
Private Collection

509. RECTANGULAR ENAMELED
SILVER DESK CLOCK of raspberry
guilloché enamel engraved with suspended
flowers swags with foliate outer rim. The white
opaque enamel dial with black Arabic chapters,
gold "Louis XV" hands and seed-pearl bezel;
silver strut – signed Fabergé, initials of work-
master Henrik Wigström, assay mark of St.
Petersburg 1899–1908, height 5 in. (12.6cm).
Bibliography: Solodkoff 1988, p. 103.
Exhibited: Hamburg 1995, cat. 124.
Private Collection

511

510

512

513

513. SHAPED RECTANGULAR ENAMELED, GEM-SET, TWO-COLOR GOLD-MOUNTED SILVER DESK CLOCK of pale blue moiré *guilloché* enamel with outer acanthus leaf rim. The opalescent white *guilloché* enamel dial painted with concentric laurel leaf bands, blue Arabic chapters, gold "Louis XV" hands and seed-pearl bezel. Set in a shield-shaped pale green sunray *guilloché* enamel panel bordered by laurel leaf garlands suspended from tied ribbons and further enhanced by diamond-set rosettes; Silver-gilt strut – signed Fabergé, initials of workmaster Henrik Wigström, assay mark of St. Petersburg 1908–1917, height 6⁷⁄₈ in. (17.5cm).
Provenance: Sir Charles Clore.
Exhibited: Hamburg 1995, cat. 11.
Private Collection

510. RECTANGULAR ENAMELED SILVER-GILT DESK CLOCK of opalescent white enamel over *guilloché* sunburst and waved ground, with chased foliate rim, opaque white enamel dial, black Arabic chapters, gold "Louis XV" and seed-pearl bezel; silver-gilt strut – signed Fabergé, initials of workmaster Henrik Wigström, assay mark of St. Petersburg 1899–1908, height 5¹⁄₈ in. (13cm).
Exhibited: Hamburg 1995, cat. 125.
Private Collection

511. RECTANGULAR ENAMELED SILVER-GILT DESK CLOCK of gray *guilloché* enamel applied beneath the dial with a thyrsos staff entwined by laurels, with laurel leaf rim, white opaque enamel dial with black Roman chapters, gold "Louis XV" hands and bezel of entwined ribbons; silver strut – signed Fabergé, initials of workmaster Henrik Wigström, assay mark of St. Petersburg 1899–1908, height 5 in. (12.8cm).
Exhibited: Hamburg 1995, cat. 127.
Private Collection

512. RECTANGULAR ENAMELED SILVER DESK CLOCK of apricot *guilloché* enamel, applied beneath the dial with a thyrsos staff and laurel bands, with chased entwined ribbon rim, the white opaque enamel dial with black Arabic chapters, gold "Louis XV" hands and seed-pearl bezel; silver strut – signed Fabergé, initials of workmaster Henrik Wigström, assay mark of St. Petersburg 1899–1908, height 4¹³⁄₁₆ in. (12.2cm).
Exhibited: Hamburg 1995, cat. 129.
Private Collection

514

515

516

517

518

515. A CIRCULAR ENAMELED, GOLD-MOUNTED, SILVER-GILT DESK CLOCK of pink *guilloché* enamel painted underglaze with interweaving flower garlands in *camaïeu*, with chased foliate rim, opaque white enamel dial with black Arabic chapters, striped opaque white enamel and gold bezel tied with gold leaves; silver strut – signed Fabergé, initials of workmaster Henrik Wigström, assay mark of St. Petersburg 1908–1917, diameter 4⁵⁄₈ in. (11.7cm). Exhibited: Hamburg 1995, cat. 79.
Private Collection

514. TRIANGULAR ENAMELED SILVER DESK CLOCK vertically striped in opaque black and white enamel, with border chased with interwoven ribbons. The opalescent white *guilloché* enamel with black Arabic chapters and gold "Louis XV" hands – signed Fabergé, and with beaded bezel; silver strut – signed Fabergé, initials of workmaster Henrik Wigström, assay mark of St. Petersburg 1908–1917, height 3⁷⁄₈ in. (9.8cm).
Exhibited: Hamburg 1995, cat. 87.
The black and white color scheme and modern look of this clock heralds the art of Cartier and of the Art Déco period of the 1920s.
Private Collection

516. SMALL SQUARE ENAMELED SILVER DESK CLOCK of translucent opalescent white enamel over waved sunburst *guilloché* ground, with reeded rim. The opaque white enamel dial with black Arabic chapters and gold "Louis XV" hands – signed Fabergé; silver strut – signed Fabergé, initials of workmaster Henrik Wigström, assay mark of St. Petersburg 1908–1917, height 2¹⁄₂ in. (6.3cm).
Exhibited: Hamburg 1995, cat. 100.
Private Collection

517. SMALL SQUARE ENAMELED SILVER-GILT DESK CLOCK of pearl-gray translucent enamel over sunburst *guilloché* ground with beaded rim. The opaque white enamel dial with black Arabic chapters and gold "Louis XV" hands; silver-gilt strut – signed Fabergé in Latin characters, initials of workmaster Henrik Wigström, assay mark of St. Petersburg 1908–1917, height 2⁷⁄₁₆ in. (6.2cm).
Exhibited: Hamburg 1995, cat. 101.
Private Collection

518. SMALL SQUARE ENAMELED SILVER-GILT DESK CLOCK of translucent pink enamel over sunburst *guilloché* enamel ground with laurel leaf border. The opalescent white enamel dial with black Arabic chapters signed Fabergé, with black-steel *flèche* hands and silver-gilt strut – signed Fabergé, initials of workmaster Henrik Wigström, assay mark of St. Petersburg 1908–1917, height 2⁷⁄₁₆ in. (6.2cm).
Exhibited: Hamburg 1995, cat. 110.
Private Collection

519

520

521

521. RECTANGULAR ENAMELED, TWO-COLOR GOLD-MOUNTED, SILVER-GILT DESK CLOCK striped vertically with narrow green and wider pale mauve *guilloché* enamel bands, with chased gold acanthus rim, the opaque white enamel dial with black Arabic chapters, gold "Louis XV" hands and seed-pearl bezel; silver-gilt rim – signed Fabergé, initials of workmaster Henrik Wigström, assay mark of St. Petersburg 1908–1917, inv no. 21084, movement signed Henri Moser & Cie no. 41148, height 6⅛ in. (15.5cm).
Exhibited: Hamburg 1995, cat. 126.
Private Collection

522. RECTANGULAR ENAMELED GOLD DESK CLOCK of opalescent white enamel painted *en camaïeu mauve* with alternating bands of entwined flower garlands and laurel leaves, with acanthus leaf rim, the opaque enamel dial with black Arabic chapters, gold "Louis XV" hands, seed-pearl bezel; silver-gilt strut – signed Fabergé, initials of workmaster Henrik Wigström, assay mark of St. Petersburg 1908–1917, height 6⅛ in. (15.5cm).
Provenance: Ludvig Nobel, Sweden.
Exhibited: Hamburg 1995, 128.
Private Collection

519. UPRIGHT RECTANGULAR ENAMELED, GOLD-MOUNTED SILVER DESK CLOCK of grey-mauve moiré *guilloché* enamel, with outer beaded rim, opaque white enamel dial, black Arabic chapters, gold "Louis XV" hands and seed-pearl bezel; silver-gilt strut – signed Fabergé, initials of workmaster Henrik Wigström, assay mark of St. Petersburg 1908–1917, height 3⁵⁄₁₆ in. (8.4cm).
Exhibited: Hamburg 1995, cat. 121.
Private Collection

520. RECTANGULAR ENAMELED SILVER-GILT DESK CLOCK of light-gray *guilloché* enamel with outer foliate rim, the white opaque enamel dial with black Arabic chapters, gold "Louis XV" hands and seed-pearl rim; silver strut – signed Fabergé, initials of workmaster Henrik Wigström, assay mark of St. Petersburg 1908–1917, height 5 in. (12.7cm).
Exhibited: Hamburg 1995, cat. 122.
Private Collection

523. RECTANGULAR GOLD-MOUNTED AND ENAMEL CLOCK the oyster enamel dial signed Fabergé with pearl-set bezel on a panel of opalescent white enamel on sunburst *guilloché* ground with blue enamel borders, with chased gold laurel rim, silver-gilt backing and strut – signed Fabergé, initials of workmaster Henrik Wigström, assay mark of St. Petersburg 1908–1917, height 2½ in. (7cm). Private Collection

524. STYLE MODERNE CLOCK circular gold-mounted enameled silver table clock, the dial enameled pink over a *guilloché* waved sunburst pattern bordered by seed-pearls and set within a larger circular panel enameled blue over a *guilloché* sunburst ground enclosed by a crescent shaped panel enameled translucent white. Applied with a gold dedication plaque inscribed in Cyrillic which reads: "Murochka/on her birthday/18 May 1907/Mirra" – signed K. Fabergé, initials of workmaster Henrik Wigström, assay mark of St. Petersburg 1908–1917, 88 (zolotnik), height 5 in. (12.7cm).
Bibliography: Solodkoff 1984, p. 178, ill.; Habsburg 1996, p. 68, ill. plate 46.
Exhibited: Lugano 1987, no. 28, cat. p. 55, ill.; Paris 1987, cat. 28, p. 51, ill.; Zurich 1989, no. 106, ill. p. 53, plate 25; New York et al. 1996/97, no. 260, cat. p. 254, ill.
The Forbes Magazine Collection, New York

525. SQUARE ENAMEL AND TWO-COLOR GOLD-MOUNTED BOWENITE CLOCK the bezel surrounded by a chased gold laurel wreath with two rosettes framed by opaque white enamel bands on a carved bowenite panel, with silver backing, strut and key – signed Fabergé, initials of workmaster Henrik Wigström, assay mark of St. Petersburg 1908–1917, inv no. 26495, height 3³⁄₁₆ in. (8.1cm).
Private Collection, courtesy A. von Solodkoff

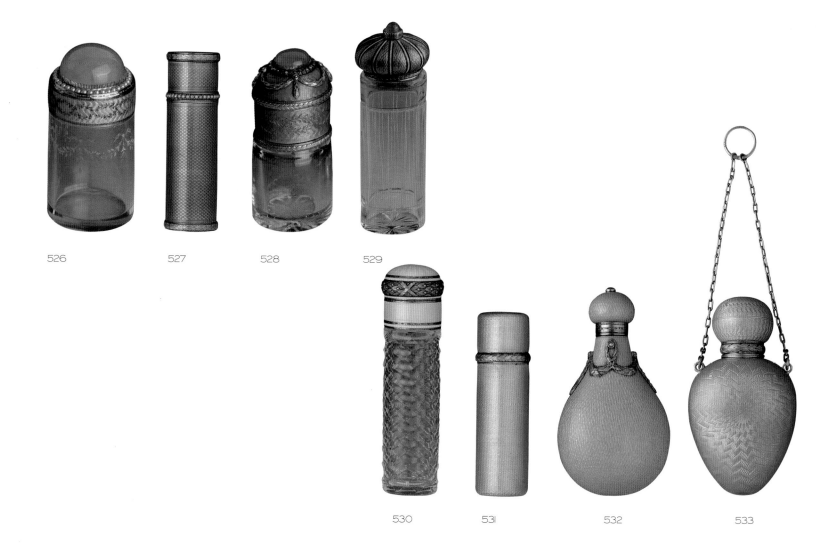

526 527 528 529

530 531 532 533

526. CYLINDRICAL GOLD AND
SILVER-MOUNTED ENAMELED
CRYSTAL SCENT-FLASK engraved with
laurel swags, with a pink *guilloché* enamel band
at the neck painted with intertwining *camaïeu*
laurel leaf sprays, large Mecca stone finial
within a seed-pearl surround – signed Fabergé,
initials of workmaster Henrik Wigström, assay
mark of St. Petersburg 1899–1908, height 2⁵⁄₈
in. (6.7cm).
Exhibited: Paris 1994, cat. 28; Hamburg 1995,
cat. 44; London 1996, cat. 28.
Chevalier Maurice Mizzi Collection

527. CYLINDRICAL GOLD-
MOUNTED ENAMELED SILVER
SCENT-FLASK of mauve *guilloché* enamel,
with a band of chased gold laurel leaves to top
and bottom and a band of seed pearls to the
cover – initials of workmaster Henrik
Wigström, assay mark of St. Petersburg
1904–1908, assaymaster A. Richter, height
2³⁄₁₆ in. (5.6cm).
Exhibited: Paris 1994, cat. 10; Hamburg 1995,
cat. 55; London, 1996, cat. 10.
Chevalier Maurice Mizzi Collection

528. CYLINDRICAL GEM-SET GOLD-
MOUNTED ENAMELED SILVER
SCENT-FLASK with green *guilloché* enamel
cover engraved with intertwining laurel sprays,
chased gold laurel leaf borders, applied laurel
swags and with pink Mecca stone finial in
rose-cut diamond surround – signed Fabergé,
initials of workmaster Henrik Wigström, assay
mark of St. Petersburg 1908–1917, height
2¹⁄₂ in. (6.4cm).
Exhibited: Paris 1994, cat. 26; Hamburg 1995,
cat. 46; London 1996, cat. 26.
Chevalier Maurice Mizzi Collection

529. CYLINDRICAL GOLD AND
SILVER-MOUNTED ENAMELED
CRYSTAL SCENT-FLASK the fluted
body with onion-shaped cover of green
guilloché and white opaque enamel, chased
laurel leaf border and pink Mecca stone finial –
signed Fabergé, initials of workmaster Henrik
Wigström, assay mark of St. Petersburg
1908–1917, height 3 in. (7.6cm).
Exhibited: Paris 1994, cat. 32; Hamburg 1995,
cat. 49; London 1996, cat. 32.
Chevalier Maurice Mizzi Collection

530. CYLINDRICAL GOLD-
MOUNTED ENAMELED CRYSTAL
SCENT-FLASK the cut crystal body with
cover of white *guilloché* enamel with a chased
laurel band with tied ribbons – signed Fabergé,
initials of workmaster Henrik Wigström, assay
mark of St. Petersburg 1908–1917, inv no.
25315, height 2¹⁵⁄₁₆ in. (7.4cm).
Exhibited: Paris 1994, cat. 13; Hamburg 1995,
cat. 51; London 1995, cat. 13.
Chevalier Maurice Mizzi Collection

531. CYLINDRICAL GOLD-MOUNTED
ENAMELED SILVER SCENT-FLASK
of pale green *guilloché* enamel, the cover with a
chased gold laurel leaf border – initials of
workmaster Henrik Wigström, assay mark of
St. Petersburg 1908–1917, height
2³⁄₁₆ in. (5.6cm).
Exhibited: Paris 1994, cat. 9; Hamburg 1995, cat.
52; London 1996 cat. 9.
Chevalier Maurice Mizzi Collection

532. PEAR-SHAPED GOLD-
MOUNTED ENAMELED SILVER
SCENT-FLASK of pink opalescent *guilloché*
enamel, with applied chased gold laurel swags
suspended from seed-pearls, pearl finial –
signed Fabergé, initials of workmaster Henrik
Wigström, assay mark of St. Petersburg
1908–1917, height 2¹⁄₄ in. (5.9cm).
Exhibited: Paris 1994, cat. 3; Hamburg 1995,
cat. 59; London 1996, cat. 3.
Chevalier Mautrice Mizzi Collection

533. EGG-SHAPED GOLD-
MOUNTED ENAMELED SILVER
SCENT-FLASK with spherical cover, of pale
blue *guilloché* enamel, with laurel-leaf border
and gold suspension chain – signed Fabergé,
initials of workmaster Henrik Wigström, assay
mark of St. Petersburg 1908–1917, height
2¹⁄₄ in. (5.8cm).
Exhibitions: Paris 1994, cat. 2; Hamburg 1995,
cat. 35; London 1996, cat. 2.
Chevalier Maurice Mizzi Collection

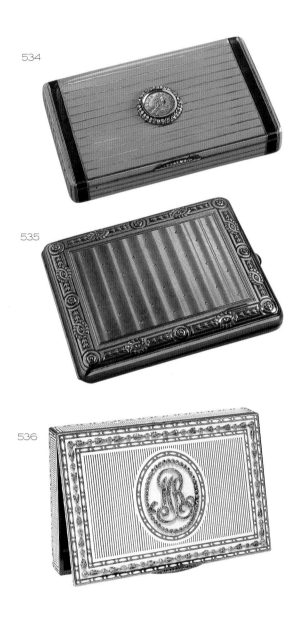

534

535

536

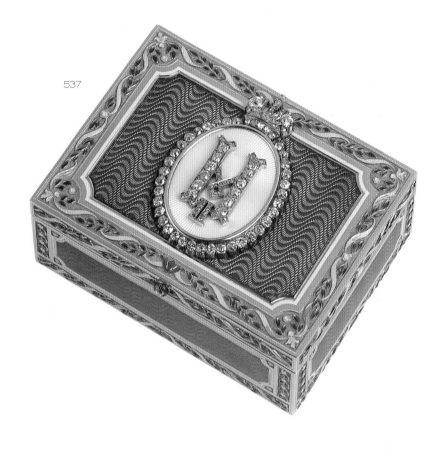

537

534. DIAMOND-SET ENAMELED GOLD CIGARETTE-CASE the cover with a poltina (50 kopeck coin) of Empress Elizabeth I, 1756, in a rose-cut diamond surround, the body with horizontal opaque turquoise enamel bands and with two vertical mauve translucent enamel borders, diamond-set thumbpiece – signed Fabergé, initials of workmaster Henrik Wigström, assay mark of St. Petersburg 1899–1904, assay master Yakov Lyapunov, length 3^716 in. (8.9cm).
Bibliography: Traina 1998, p. 89.
John Traina Collection

535. TWO-COLOR GOLD ENGINE-TURNED CIGARETTE-CASE in Louis XVI-style, with panels of moiré *guilloché* studded with pellets, with palm-leaf borders and cabochon pushpiece – signed Fabergé, initials of workmaster Henrik Wigström, assay mark of St. Petersburg 1904–1908, assay master A. Richter, inv no. 17765, length 4^14 in. (10.7cm).
Bibliography: Traina 1998, p. 94 (bottom).
Exhibited: New York/San Francisco et al. 1996/7, cat. 366.
John Traina Collection

536. JEWELED AND ENAMELED GOLD CIGARETTE-CASE with panels of opaque white enamel and gold stripes, the center with diamond-set initials "MR", with diamond-set borders, the base with an oval medallion decorated with a trophy of Love set in diamonds – signed Fabergé, initials of workmaster Henrik Wigström, assay mark of St. Petersburg 1908–1917, length 3^38 in. (8.5cm).
Exhibited: QVC 1999.
Joan and Melissa Rivers

537. RECTANGULAR GEM-SET, GOLD AND ENAMEL IMPERIAL PRESENTATION BOX the cover decorated in the Louis XVI-style with an oval white *guilloché* enamel medallion set with the initial of Tsar Nicholas II surrounded by brilliant-cut diamonds and surmounted by the Imperial crown on a powder-blue waved *guilloché* enamel panel with white rim, the border of green enamel foliage, opalescent white ribbons and pellets, the sides similarly decorated, with diamond-set thumbpiece – signed Fabergé, initials of workmaster Henrik Wigström, assay mark of St. Petersburg 1908–1917, 72 (zolotnik), length 3^18 in. (8cm). Original fitted red morocco presentation case applied with gilt Imperial eagle.
Provenance: Given by Tsar Nicholas II to Count Bourboulon, Minister and Chamberlain of King Ferdinand I of Bulgaria.
Exhibited: Stockholm 1997, cat. no. 59.
The Hubel Collection

538

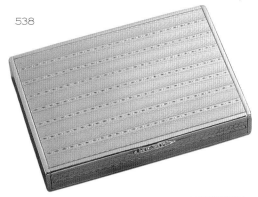

539

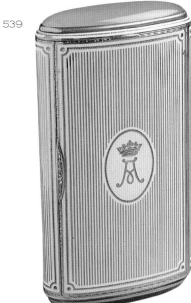

540

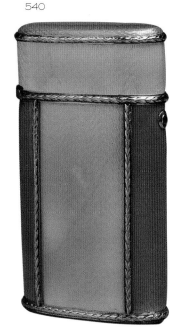

542

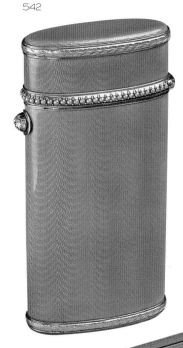

541

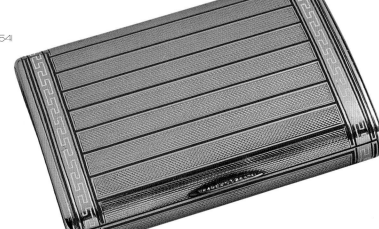

538. TWO-COLOR GOLD CIGARETTE-CASE with alternating stripes of red-gold engine-turned with waves and white gold engraved with dashes, thumbpiece set with rose-cut diamonds – signed Fabergé in Latin, C. F., initials of workmaster Henrik Wigström, 72 (zolotnik), inv no. 24403, London Import marks for 1913, length 3⅛ in. (8cm). Inscribed "Christmas 1916".
Bibliography: Traina 1998, p. 54a (top right).
John Traina Collection

539. ENAMELED GOLD CIGARETTE-CASE decorated with opaque enamel stripes, the cover with crowned initial "A.", thumbpiece set with rose-cut diamonds – signed Fabergé in Latin, initials of workmaster Henrik Wigström, assay mark of St. Petersburg 1908–1917. Inscribed "Victoria Eugenia" and "1961".
Provenance: Presented by Prince Alexander of Battenberg (1886–1960), grandson of Queen Victoria, to his sister Victoria Eugenia (1887–1969), wife of King Alfonso XIII of Spain.
Bibliography: Traina 1998, p. 59.
John Traina Collection

540. ENAMELED GOLD CIGARETTE-CASE of oval section, of mauve *guilloché* enamel with palm leaf borders and diamond-set thumbpiece – signed Fabergé, initials of workmaster Henrik Wigström, assay mark of St. Petersburg 1908–1917, 72 (zolotnik), length 3⁷⁄₁₆ in. (8.7cm).
Bibliography: Traina 1998, p. 74.
John Traina Collection

541. ENGINE-TURNED CIGARETTE-CASE decorated with blue enamel stripes, with white enamel key-pattern borders and diamond-set thumbpiece – signed Fabergé, initials of workmaster Henrik Wigström, assay mark of St. Petersburg 1908–1917, inv no. 25773, length 3⁹⁄₁₆ in. (9.1cm).
Bibliography: Traina 1998, p. 111 (left).
Exhibited: St. Petersburg 1997/8.
John Traina Collection

542. ENAMELED GOLD-MOUNTED CIGARETTE-CASE of oval section of salmon-pink translucent enamel over *guilloché* drapery ground, with seed-pearl rim, palm leaf borders and diamond pushpiece – signed Fabergé, initials of workmaster Henrik Wigström, assay mark of St. Petersburg 1908–1917, length 3¼ in. (8.2cm).
Bibliography: Traina 1998, p. 158.
John Traina Collection

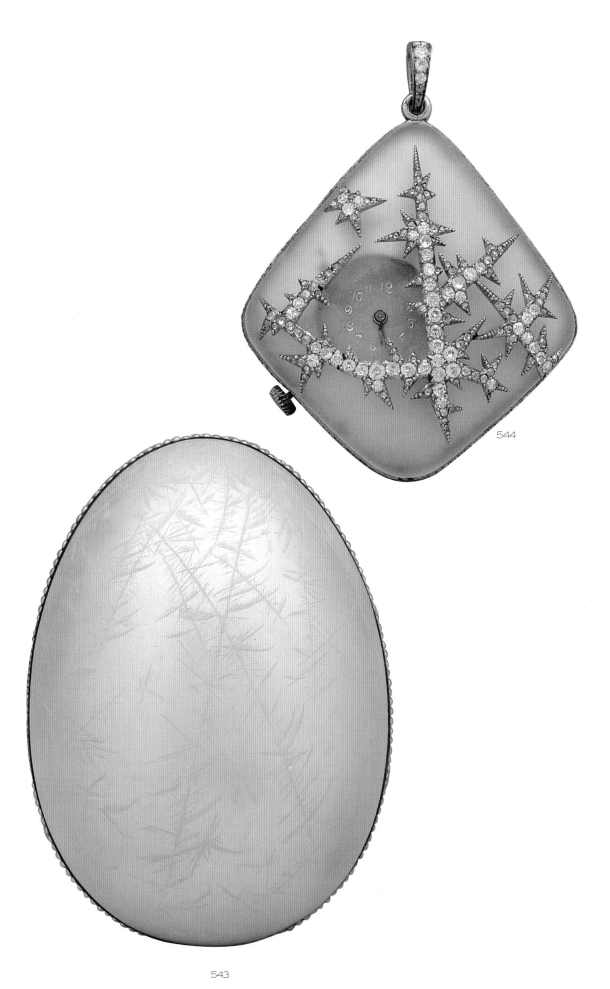

543, 544. NOBEL ICE EGG the shell is decorated in layers of transparent and silvery white translucent enamels through which a partially engraved and finely painted hoarfrost pattern peaks and with a line of seed-pearls. The egg opens to reveal a trapezoid pendant watch in a fitted velvet lined compartment with a notch for the chain. The rock crystal cover of the pendant is decorated with a tracery of platinum-mounted frost motifs set with diamonds. A watch face is seen through a transparent window in the otherwise frosted surface – unmarked, inv no. 23865 on egg; inv no. 9829(0) on watch, length 4 in. (10.2cm), watch height 2 in. (5cm).

Provenance: Dr. Emanuel Nobel; A.A. Antra, dealer, Paris; Jacques Zolotnisky, A La Vieille Russie, Paris, by 1922; Hammer Galleries, New York; Colonel Kolb, United States and thence by descent; Christie's, Geneva, May 18, 1994, lot 294; Private Collection, Zurich; Sotheby's, Geneva, November 19, 1996, lot 491; Michael Kroger, Australia.

Bibliography: Snowman 1953/55, p. 107, ill. no. 362; Snowman 1962/64/68/74, ill. no. 387; Habsburg/Solodkoff 1979, ill. plate 141; Solodkoff 1984, p. 36; Solodkoff 1988, p. 47; Booth 1990, p. 111; Fabergé et al. 1997, ill. pp. 71, 81.

Exhibited: Hammer 1939, cat. as the 'Imperial Snowflake Egg'; Hamburg 1995, no. 241, cat. pp. 218, 219, ill. pp. 218, 219; Stockholm 1997, no. 12, cat. p. 88, ill. pp. 88, 89.

Although not signed, there has never been any doubt that this egg is a creation by Fabergé. It is one of a small series of eggs made for clients other than those of the Imperial family.

The Forbes Magazine Collection, New York

543

544

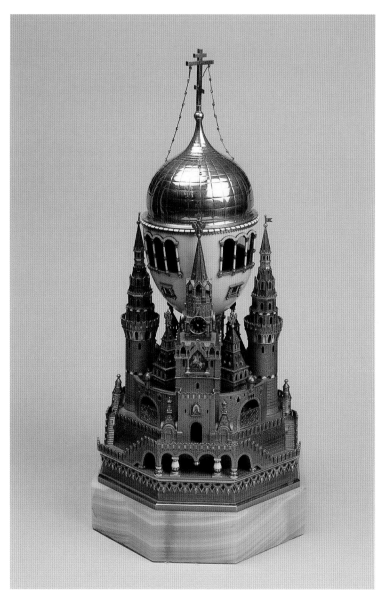

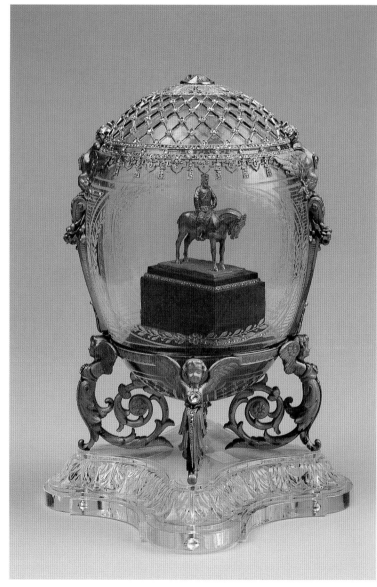

545. "USPENSKY CATHEDRAL EGG"
OR "MOSCOW KREMLIN EGG" OF
1904 an enameled gold composition centered
on the egg-shaped (removable) dome of the
Cathedral of the Assumption in the Moscow
Kremlin, in white opalescent enamel, the
interior of the church with its carpets, tiny
enameled icons and High Altar made visible
through four triple windows, surmounted by a
gold cupola; flanked by two square and two
circular stylized turrets, the former based on
the Spassky Tower, bearing the coat-of-arms of
the Russian Empire and Moscow and inset
with chiming clocks. Standing on a crenelated
gold base and octagonal onyx plinth – signed
Fabergé, dated 1904, height 14¼ in. (36.1cm).
A clockwork music box (with original key)
plays Izhe Khveruviny (Cherubim hymn), a
favorite hymn of Tsar Nicholas.
Provenance: Presented by Tsar Nicholas II to
his wife Tsarina Alexandra Feodorovna,
Easter 1906.

Bibliography: Armory 1964, p. 170;
Rodimtseva 1971, p. 14; Donova 1973, p. 180;
Snowman 1979, pp. 82/3, ill. 300; Habsburg/
Solodkoff 1979, p. 105, 158, ill. 123, no. 44; Hill
1989, pl. 45; Pfeffer 1990, ill. p. 82; Fabergé/
Proler/Skurlov 1997, cat. 30, ill. p. 170
Exhibited: New York 1979, cat. 64; Bremen
1989, cat. 80, ill. 81.
The egg commemorates the visit to Moscow
in 1903 of the Imperial couple, their first since
their coronation in 1896 and the tragic events
on the Khodynka Fields. All Russian tsars were
crowned in the Uspensky (Dormition)
Cathedral. The egg, though dated 1904, is listed
on an invoice of 7 June, 1906 as costing 11,800
roubles. Its presentation was delayed due to
the unfortunate Russo-Japanese war of 1904/5,
during which no Imperial eggs were given.
Kremlin Armory Museum (N MP – 647/1–2)

546. "ALEXANDER III
COMMEMORATIVE EGG" OF 1910 the
rock-crystal egg engraved with two tied laurel
leaf sprays, the upper half applied with
platinum trelliswork and a tasseled fringe, two
consoles shaped as crowned double-headed
eagles set with rose-cut diamonds, with a
diamond as finial concealing the date 1910 in
a rose-cut diamond surround. Standing on a
lobed and stepped quatrefoil rock crystal base
and four winged platinum therms, each ending
in an acanthus scroll. Containing a gold model
of a statue of Tsar Alexander III after P.
Troubetzkoi standing on a nephrite base
embellished with two rose-cut diamond bands
– engraved signature Fabergé, height 6¹¹⁄₈ in.
(15.5cm).
Provenance: Presented by Tsar Nicholas II to
his mother Dowager Empress Maria
Feodorovna, Easter 1910.

Bibliography: Snowman 1962/4; Armory 1964,
p. 170; Rodimtseva 1971, p. 16, ill. 9; Donova
1973, p. 180; Habsburg/Solodkoff 1979, ill.
316, pp. 105, 107; Snowman 1979, p. 90, ill.
p. 316; Solodkoff 1984, p. 96 (ill.); Solodkoff
1988, p. 27, 43 (ill.); Hill 1989, pl. 49; Pfeffer
1990, ill. p. 90; Forbes/Hohenzollern/
Rodimtseva 1989, cat.33; Fabergé/Proler/
Skurlov 1997, cat. 37, ill. p. 192/3.
Exhibited: San Diego/Moscow 1989/90,
cat. 18; Moscow 1992, cat. 8, (ill.); Sydney
1996, cat. 7, ill. p.49.
This egg commemorates the 1909 unveiling of
the controversial monumental bronze statue of
Tsar Alexander III by Prince Paul Troubetzkoi
in Znamensky Square, St. Petersburg. The egg
is listed on an invoice dated 12 July 1910 as
costing 14,700 roubles.
Kremlin Armory Museum (MR – 650/1–3)

547. IMPERIAL FIFTEENTH ANNIVERSARY EGG the opalescent and opaque white enamel egg is encased within a grid-shaped cage of gold and green enamel garlands which frame eighteen scenes painted by court miniaturist Vassily Zuiev. Some of the events of Tsar Nicholas II and Tsarina Alexandra's reign over the past fifteen years are recorded in these historical vignettes. Individual portraits of the Tsarina, her husband and their five children each set within oval-shaped apertures bordered by diamonds. The dates of Nicholas and Alexandra's wedding, 1894, and the fifteenth anniversary of the Coronation, 1911, are set beneath the portraits of the Tsarina and the Tsar respectively. Beneath a table diamond at the top of the egg is the crowned monogram of Tsarina Alexandra; the base is set with a rose-cut diamond – signed Fabergé, height 5⅛ in. (13cm).
Provenance: Presented by Tsar Nicholas II to Tsarina Alexandra Feodorovna at Easter, 1911. It stood on the middle shelf of a corner cabinet in the Tsarina's study at the Alezxander Palace
Select Literature: Bainbridge 1933, p. 174; Snowman 1953/55, ill. no. 330; Snowman 1962/64/68/74, ill. nos. 365, 366; Forbes, May 1, 1967, p. 62, ill.; Snowman 1977, p. 50, ill.; Habsburg 1977, p. 82; Waterfield/Forbes 1978, no. 6, ill. pp. 24, 25, 125, 140, 141, 142, cover; Forbes 1979, ill. plate XVIII; Habsburg/Solodkoff 1979, p. 158, ill. index plate no. 51; Snowman 1979, ill. p. 112; Forbes 1980, ill. p. 39; Swezey 1983, ill. pp. 1212, 1213; Solodkoff 1984, ill. pp. 96, 110–121, 187; Kelly 1985, p. 14, ill. opp. title page; Forbes 1986, p. 54, ill.; Solodkoff 1988, p. 45, ill.; Forbes 1988, p. 39, ill.; Forbes 1989, ill. pp. 220, 222; Hill 1989, ill. plate nos. 50, 51, title page; Pfeffer 1990, ill. pp. 93, 95; Booth 1990, p. 82, 110, ill. p. 82, 83, 110; Fabergé et al. 1997, no. 40, ill. pp. 50, 68, 201, 235, 248, 254; Schaffer 1997, p. 21, ill. fig. 11. Exhibited: New York 1962/66, no. L.67.31.2; New York no. 4, cat. pp. 3, 32, 34, 110; ill. pp. 33, 35; London 1977, no. L7, ill. p. 72, 73; Lugano 1987, no. 120, ill. pp. 114, 115; Paris 1987, no. 120, ill. pp. 110, 111; San Diego/Moscow 1989/90, nos. 19, 34; ill. pp. 70, 71, 108; St. Petersburg/Paris/London 1993/94, no. 30, ill. pp. 76, 193; Lahti 1997, cat. pp. 6-9, ill. cover, inside cover; Stockholm 1997, no. 6, ill.
The miniatures represent:
1. The procession to the Uspensky Cathedral preceding the coronation; 2. The coronation; 3. The Alexander III bridge in Paris at the opening of which Nicholas II was present; 4. Huis ten Bosch, the house in the Hague at which the first Peace Conference took place; 5. Tsar Nicholas' speech before the Duma in 1905 at the Winter Palace; 6. The Alexander III Museum; 7. The unveiling of the monument of Peter the Great in Riga; 8. The unveiling of the monument commemorating the 200th anniversary of the founding of Poltava; 9. The transfer of the relics of Saint Seraphim of Sarov to whom the family ascribed the happy event of the birth of the Tsarevich. This egg cost 16,600 roubles (approximately $8,300).
The Forbes Magazine Collection, New York

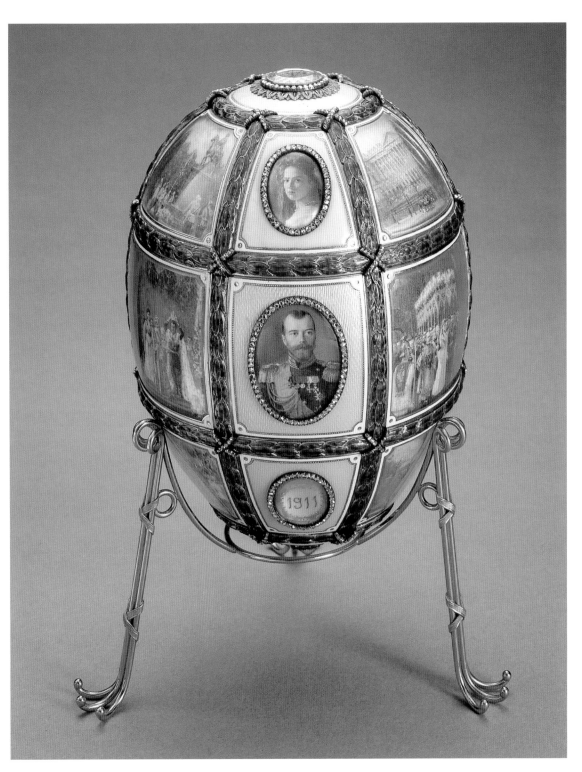

547

548. IMPERIAL ORANGE TREE EGG
the gold tree stands in a white quartz tub
applied with gold trellis and green laurel swags
suspended from rubies. The tub is filled with
hammered gold soil and stands on a nephrite
base with four nephrite posts at the corners
connected by swags of green enamel leaves and
pearls. The tree is decorated with finely
engraved nephrite leaves, citrine, amethyst,
ruby and champagne diamond 'berries' and
white enamel flowers with diamond-set pistils.
It conceals a gold winding mechanism. When
triggered by a key, a portion of the foliage at
the top of the tree rises and a feathered
nightingale emerges singing while moving its
head, wings, and beak. When the melody ends,
the bird disappears automatically – signed
Fabergé, date 1911, height: 11¾ in. (29.8cm).
Provenance: Presented by Tsar Nicholas II to
the Dowager Empress Maria Feodorovna on
Easter 1911; Anon. Sale: Sotheby's, London,
July 10, 1947 (£1,650); Wartski, London; A.G.
Hughes, England; Arthur E. Bradshaw; W.
Magalow; Maurice Sandoz, Switzerland;
Mildred Kaplan, New York (purchased Forbes
in 1966 for $35,000).
Bibliography: Bainbridge May 1934, ill. p. 305;
Snowman 1953/55, ill. nos. 334, 335; Snowman
1962/64/68/74, ill. no. 363, plate LXXVIII;
Waterfield/Forbes 1978, no. 7, ill. pp. 27, 125,
138 and cover; Forbes 1979, ill. plate XIX;
Snowman 1979, ill. p. 112; Habsburg/Solodkoff
1979, ill. plate no. 139, index plate no. 28;
Forbes 1980, ill. p. 23; Solodkoff 1984, ill. pp.
97, 187; Kelly 1985, ill. pp. 20–21; Forbes 1986,
p. 86; Habsburg 1987, ill. p. 96; Forbes 1987, p.
10; Solodkoff 1988, ill. p. 28; Forbes 1989, ill.
pp. 220, 221; Hill 1989, ill. plate no. 52, title
page; Booth 1990, ill. p. 109; Habsburg/Lopato
1993, p. 83; Kelly 1994, unpaginated, ill.;
Habsburg 1996, ill. plate 3; Fabergé 1997, no.
39, ill. pp. 68, 198, 199, 235; Welander-
Berggren 1997, p. 70, ill.
Exhibited: London 1935, no. 582, cat. p. 110;
New York 1961, no. 294, ill. p.. 93; New York
1968, cat. p. 138, ill. plate no. 369; New York
1973, no. 5, ill. cat. pp. 36, 37; London 1977,
no. L4, pp. 71–72, ill. p. 81; New York 1983,
cat. 561, ill. p. 149; Lugano 1987, no. 121, ill.
pp. 116, 117, cover; Paris 1987, no. 121, ill. pp.
112, 113; San Diego/Moscow 1989/90, nos.
20, 35, ill. pp. 18, 72, 73, 109; New York et al.
1996/97 no. 286, ill. p. 267.
This egg is inspired by French 18th-century
musical orange trees, as well as possibly, the
dome of Joseph Olbrich's 1898 Secession
Building in Vienna. Called "Orange Tree Egg",
this Easter egg is listed as a bay tree costing
12,800 roubles (approximately $6,450) in an
invoice of 9 April 1911. It was kept by the
Dowager Empress at Anichkov Palace until
1917, when it was confiscated by Kerensky's
provisional government and sent to the
Kremlin together with all the other treasures
of the Tsars.
The Forbes Magazine Collection, New York

548

549. IMPERIAL CROSS OF ST. GEORGE EGG the mat opalescent white enamel egg is under-painted with a green enamel garlanded trellis which frames St. George crosses in white and red enamel. A ribbon in the Order's colors of black and orange, encircles two medals; one mounted with the Order of the Cross of St. George (verso) and the second of silver chased with the portrait of Tsar Nicholas II in profile (recto). The badges lift to reveal painted miniatures of Tsar Nicholas and Tsarevitch Alexis. The silver crowned monogram of the Dowager Empress Maria Feodorovna surmounts the egg; the date of presentation in silver is set directly below – signed Fabergé, height 3⁵⁄₁₆ in. (8.4cm).

Provenance: Presented by Tsar Nicholas II to the Dowager Empress Maria Feodorovna on Easter 1916; Grand Duchess Xenia Alexandrovna, her daughter; Prince Vassily Romanov, her son.

Bibliography: Bainbridge 1949, p. 74; Snowman 1953/55, ill. no. 354; Snowman 1962/64/68/ 74, p. 109, ill. no. 385; Bainbridge 1966, p. 73; Forbes, February 1, 1977, p. 74, ill.; Waterfield/Forbes 1978, no. 8, ill. pp. 29, 110, 127, 140, 142; Forbes 1979, ill. plate XX; Snowman 1979, ill. p. 112; Habsburg/Solodkoff 1979, ill. plate no. 33; Forbes 1980, ill. pp. 27, 58, 59; Solodkoff 1983, p. 66; Schaffer 1983, pp. 17-18; Solodkoff 1984, ill. pp. 108, 109, 187; Kelly 1985, p. 14; Forbes 1986, ill. p. 57; Habsburg 1987, p. 98, 104; Solodkoff 1988, ill. p. 38; Forbes 1989, p. 220, ill.; Hill 1989, ill. plate no. 60; Pfeffer 1990, ill. p. 111; Booth 1990, ill. p. 104; Habsburg 1993, p. 77; Habsburg 1996, p. 35; Habsburg 1996/97, p. 231; Fabergé 1997, no. 49, ill. pp. 228, 229, 235.

Exhibited: London 1935, no. 560, cat. p. 108, ill.; London 1977, no. L12, cat. p. 74, ill.; San Diego/Moscow 1989/90, nos. 26, 45, ill. pp. 85, 114; London 1991, no. 2, ill. pp. 8, 9; Vienna 1991, cat. pp. 56, 57, ill.; Houston 1994, cat. p. 57, ill.; Hamburg 1995, no. 239, cat. p. 216, ill.; Stockholm 1997, no. 9, ill. p. 85.

A gesture to wartime austerity because of its simple silver shell, the Cross of St. George Egg presented to the Dowager Empress Marie Feodorovna on Easter 1916 commemorates the 1915 presentation of the Order of St. George Cross to Tsar Nicholas II. The Order was created by Catherine the Great to be awarded by members of the army and not the sovereign, for military bravery. Tsar Nicholas II was presented with the highest class of the Order for his leadership during the First World War. His 12 years old son Alexis, who had joined him at army headquarters, received a lower grade of the Order. This egg cost 13,347 roubles (a little more than $6,500). This last egg accompanied the Dowager Empress on her trip to Kiev in 1917, whence it was taken to the Crimea and then on to Denmark when she escaped on board the British cruiser HMS Marlborough.

The Forbes Magazine Collection, New York

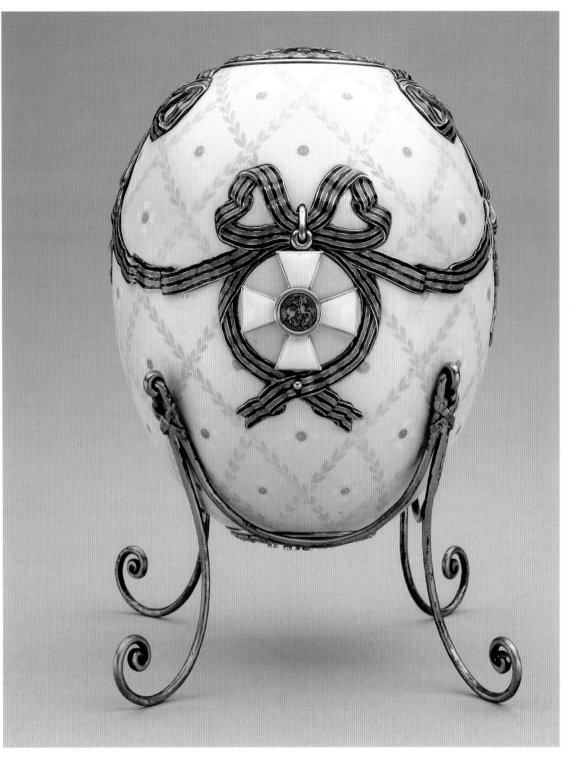

549

550, 551, 552

553

554

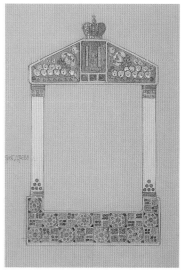

555

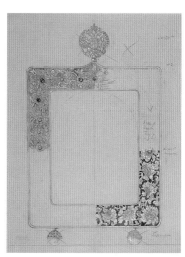

556

550. DESIGN IN PENCIL,
WATERCOLOR AND GOUACHE
FOR A FRAME stamped on both sides
"K FABERGE, S Petersburg 13 March 1909",
25³⁄₄×18¹⁄₂ in. (65.4×46.9 cm).
The State Hermitage Museum
(ERO sh – 1480)

551. DESIGN IN PENCIL AND
WATERCOLOR FOR A FRAME stamped
on both sides "K FABERGE, S Petersburg 17
Feb 1909", 64×50.5cm.
The State Hermitage Hermitage
(ERO sh – 1461)

552. DESIGN IN PENCIL,
WATERCOLOR AND GOUCHE FOR
A FRAME SHOWING VARIOUS
OPTIONS stamped "K FABERGE court
jeweller S Petersburg" (recto) and "K.
FABERGE S Petersburg. 4 March 1909"
(verso), 27¹⁄₈×19³⁄₄ in. (69×50.2cm). Inscribed:
a – white wood frame, silver gilt;
b – background beneath laurels, grey enamel;
c – in places (sky-blue, black, pink).
The State Hermitage Museum
(ERO sh – 1462)

553. DESIGN IN PENCIL AND
WATERCOLOR FOR AN IMPERIAL
PRESENTATION FRAME in *cloisonné*
enamel – stamped (recto) "K FABERGE,
S Petersburg 13 March 1909" and (verso)
"K FABERGE, 4 May 1909", 25⁹⁄₁₆×18⁷⁄₁₆ in.
(65.6×46.9cm). Inscribed: "Border wholly
without enamel and stones".
Exhibited: St. Petersburg/Paris/London
1993/4, cat. 343.
The State Hermitage Museum
(ERO sh – 1488)

554. DESIGN IN PENCIL AND
WATERCOLOR FOR A FRAME in the
neo-Classical style – stamped "K FABERGE,
S Petersburg 6 March 1909", 27⁷⁄₁₆×18¹⁄₈ in.
(69.7×46cm).
Exhibited: St. Petersburg/Paris/London
1993/4, cat. 346.
The State Hermitage Museum
(ERO sh – 1465)

555. DESIGN IN PENCIL,
WATERCOLOR AND GOUACHE FOR
AN IMPERIAL PRESENTATION
CLOISONNÉ ENAMEL FRAME
stamped "K. FABERGE, S Petersburg 13
March 1909",
25³⁄₄×18¹⁄₂ in. (65.5×47 cm). Inscribed:
"Traditonal Eagle in the frame", "no enamel
on this side", "no feet".
Exhibited: St. Petersburg/Paris/London,
1993/4, cat. 342.
The State Hermitage Museum
(ERO sh – 1489)

556. DESIGN IN PENCIL,
WATERCOLOR AND GOUACHE
FOR AN IMPERIAL PRESENTATION
CLOISONNÉ ENAMEL FRAME in the
neo-Russian style – stamped on both sides "K
FABERGE, S Petersburg 13 March 1909",
26×18⁵⁄₈ in. (66×47.3cm). Inscribed in the
left margin: "pale wood".
Exhibited: St. Petersburg/Paris/London
1993/4, cat. 345.
The State Hermitage Museum
(ERO sh – 1464)

557. DESIGN IN PENCIL,
WATERCOLOR AND GOUACHE FOR
AN IMPERIAL PRESENTATION
FRAME stamped (recto) "K FABERGE, S
Petersburg 13 March 1909" and (verso) "K
FABERGE, 4 May 1909", 25³⁄₄×18¹⁄₂ in.
(65.4×46.9cm).
Exhibited: St. Petersburg/Paris/London
1993/4, cat. 344.
The State Hermitage Museum
(ERO sh – 1470)

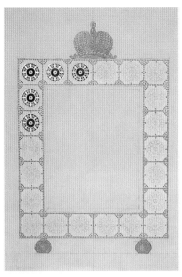

557, 558, 559

560

561

562

558. DESIGN IN WATERCOLOR
FOR A FRAME stamped "K FABERGE,
court jeweller S Petersburg", 19⁷⁄₈×13³⁄₄ in.
(50.5×35cm).
The State Hermitage Museum
(ERO sh – 1457)

559. DESIGN IN WATERCOLOR
FOR A FRAME stamped on both sides
"K FABERGE, S Petersburg 13 March 1909",
25³⁄₄×18⁵⁄₈ in. (65.5×47.2cm).
The State Hermitage Museum
(ERO sh – 1492)

560. DESIGN IN WATERCOLOR FOR
A FRAME stamped (recto) "K FABERGE,
S Petersburg 13 March 1909" and (verso)
"K FABERGE, 4 May 1909", 25³⁄₄×18¹⁄₂ in.
(65.4×47cm). Inscribed: "wood".
The State Hermitage Museum
(ERO sh – 1474)

561. DESIGN IN PENCIL,
WATERCOLOR AND GOUACHE FOR
A FRAME stamped on both sides: "K
FABERGE, S Petersburg 13 March 1909",
26³⁄₈×18⁷⁄₁₆ in. (67×46.9cm).
The State Hermitage Museum
(ERO sh – 1481)

562. DESIGN IN WATERCOLOR
FOR A FRAME stamped on both sides
"K FABERGE, S Petersburg 13 March 1909",
25⁵⁄₈×18¹⁄₂ in. (65.2×47cm).
The State Hermitage Museum
(ERO sh – 1482)

7
JEWELRY IN
ST. PETERSBURG

RUSSIAN JEWELRY 1850-1918

The Almazny (Diamond) Fond in the Kremlin Armory and the Treasury in the Hermitage Museum provides ample proof of the high level of design and Russian craftsmanship in jewelry of the eighteenth and early nineteenth centuries. Two leading foreign jewelers, the two Geneva-born craftsmen Jérémie Pauzié[1], the maker of the crown of Catherine the Great in 1762, and Louis David Duval[2], to whom we owe the "small crown of the Empress" and who was appointed Appraiser to the Imperial Cabinet, were well-known in eighteenth-century Russia. Both also created jeweled flowers for the Imperial Court, which were much in vogue throughout Europe at that time (cat. 6). Both Pauzié and yet another Swiss goldsmith, Jean-Pierre Ador[3], also made gold boxes and other *objects de vertu* for Empresses Elizabeth and Catherine the Great.

The title of Court Jeweler appears for the first time in the 1760s in connection with the newly founded Imperial Cabinet. While at that time there were few Court Jewelers, independent Suppliers to the Imperial Court were more numerous. With the exception of those listed above, few, if any, of the names are familiar: Akerblom, Blom, Bokh, Deihman, Hasselgren, Hebelt, Kepping, Kuntzendorf, Lund, and Scharff. Two names do, however, stand out: one is Andreas Roempler of Saxony, who was appointed Court Jeweler in the 1790s and Imperial Appraiser in 1823. The other is his son-in-law Gottlieb Ernst Jahn, another Court Appraiser, with whom Roempler worked in partnership. Jahn supplied an opal and diamond parure to the court on the occasion of the christening of Grand Duke Nicholas Nicolaevich (brother of Tsar Alexander II) in 1831 at a cost of 169,601 roubles, which was to remain a record price until 1894, when Fabergé supplied the future Nicholas II with a sumptuous pearl necklace at the occasion of his betrothal to Princess Alix of Hessen, the future Tsarina (see Chronology pp. 11–18).

In 1822 the jeweler Junnasch (or Jenasch), who had worked for the Cabinet since 1802, was appointed "Appraiser to the Cabinet". In 1852, the same long-lived Junnasch was awarded a gold medal decorated with diamonds and with the inscription "For Diligence" for fifty years' service. Other jewelers also obtained similar appointments: Juhn in 1829 (and 1843), and in 1835, Wilhelm Kaemmerer who became Court Jeweler in 1840.

According to the Hermitage curator Marina Lopato[4], there were three Court Jewelers employed by the Imperial Cabinet at any given time. Their activities included repairing, cleaning, adjusting, renewing and altering existing jewels, and (when new jewels were commissioned) using stones and materials supplied by the Cabinet. When supplying their own stones, jewelers were obliged to indicate their source and cost. Often this meant that only the work was paid, a relatively insignificant amount. Rarely was a jeweler permitted to charge for "the fashion", or design of a piece, which was more profitable.

In the second half of the nineteenth century, the names of Bolin, Butz and Zeftingen appear frequently in connection with orders from the Cabinet. Comparatively little is known about the two latter jewelers, as only a handful of their lesser works has survived. The Bolsheviks confiscated and then broke up virtually all the jewelry seized after the October Revolution, selling the stones piecemeal on western markets in the early 1920s.[5]

Young Carl Edvard Bolin from Sweden, who arrived in St. Petersburg in 1833 and married a daughter of the aforementioned jeweler Roempler, founded a firm of great renown.[6] He became a partner of Roempler's other son-in-law, Gottlieb Jahn, in a firm named Jahn & Bolin, which two years later became Bolin & Jahn after Jahn's death. The firm was awarded the title "Jewelers by Appointment to the Tsar" or "Imperial Jeweler" in 1839. Carl Edvard was joined by his brother Henrik Conrad in 1834, who established the Moscow branch in 1852, specializing in silver. Between 1849 and 1856 the Bolins briefly

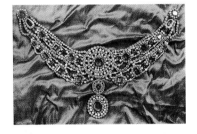

FIG I. EMERALD, PEARL AND DIAMOND ESCLAVAGE by Fabergé, made for the 1903 Costume Ball. Photograph (Fersman 1924/6 pl. 73) courtesy The New York Public Library

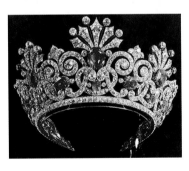

FIG 2. SAPPHIRE AND DIAMOND DIADEM by Koechli, 1890s. Photograph (Fersman 1924/6 pl. 164) courtesy The New York Public Library

joined forces with another leading St. Petersburg jeweler, Alexander F. Butz. After Butz's death the firm finally adopted the name "C. E. Bolin, Jeweler by Appointment to the Tsar". The Bolin brothers exhibited in the Crystal Palace at London's Great Exhibition of 1851, the first major international show of the industrial arts, together with the two Russian Court Jewelers, W. Kaemmerer and L. Zeftingen, and won great acclaim for the quality of their stones and their craftsmanship. Indeed it was said that "Mr. Bolin's objects, with their perfect mountings, surpassed absolutely everything else at the exhibition".[7] The Hermitage collections include over one hundred designs from C. E. Bolin's firm.[8] These show the firm's pre-eminent position in 1874 as principal suppliers of the jewels worn by the bride at the wedding of Grand Duchess Maria Alexandrovna to Alfred, Duke of Edinburgh, at a time when the young Fabergé was making his first calculated attempts at insinuating himself into the good graces of the Imperial Cabinet.

In 1870, at the All-Russian Industrial Art Exhibition in St. Petersburg, where Swiss-born jeweler Friedrich Koechli, and several lesser jewelers such as Ivan Tchichelev, Otto Kronbügel and Fuld were represented, Carl Edvard Bolin was hailed as the foremost Russian jeweler. Bolin was the only participant to be awarded an Imperial Warrant and the right to use the double-headed eagle "because of the complete purity of his work, for masterly choice of stones, and for exquisite designs during the firm's many years of existence."[9]

By comparison with the Bolins, Gustav Fabergé was a modest jeweler. He worked in Bolshaya Morskaya, the same fashionable street as the Bolins, from 1842 to 1860, but Fabergé's work did not match their quality, judging by the handful of his pieces that have survived. There is no sign of Fabergé *père* in the archives of the Imperial Cabinet; and apparently no designs of his exist suggesting more ambitious creations. Indeed, Carl Fabergé's chief designer, François Birbaum, later speaks disparagingly of Gustav's jewels as "somewhat clumsy gold bracelets, which were fashionable at the time, brooches and medallions in the form of straps with clasps … They were decorated with stones and enamels and samples can still be seen in the old drawings of the firm".[10] Compared to the important in-house activity at Bolin's, where some thirty craftsmen were employed, Gustav Fabergé seems to have operated primarily as a retailer, with a small workshop attached, headed, since 1857, by the gifted jeweler August Holmström who was joined by Wilhelm Reimer. Both of these artisans later worked for Fabergé *fils*. Until 1890, when the two Fabergé brothers began to work on their new line of *objets de fantaisie*, their jewel designs were very conservative in style.[11]

In 1889 fifty-two jewelry firms and workshops were active, employing 2,500 workers, mainly in St. Petersburg. Their output was calculated at 2,800,000 roubles. By 1893, the total value of jewels produced in Russia was estimated at seven million roubles, with imports accounting only for 809,000 roubles.

In 1882, the year of the All-Russian Industrial Art Exhibition in Moscow where Fabergé was "discovered" by the Imperial family, Bolin's work won high praise for both artistry and craftsmanship. Here, Grand Duke Vladimir Alexandrovich, husband of Maria Pavlovna, a Mecklenburg princess known for her unique collection of jewelry, acquired a diamond tiara from Bolin for 120,000 roubles. Apparently Fabergé did not submit designs for a ruby and sapphire parure for Empress Alexandra Feodorovna – a commission for which all St. Petersburg jewelers competed in 1894. Fine colored designs have survived from the submissions by Nicolas Nichols-Ewing, Friedrich Koechli, Friedrich Butz and Carl Hahn (cat. 573–594). Those of Bolin, who won another competion in 1900 can be seen on a portrait of the Empress painted by N. K. Bodarevsky (fig 3).[12]

In 1894 Fabergé's firm was preferred over all other local jewelers for two major Imperial commissions: a magnificent pearl necklace with a diamond clasp offered by

Notes

1. Solodkoff (1981), pp. 201–205.

2. *Ibid.*, p. 218.

3. *Ibid.*, pp. 188–191.

4. Lopato (1992), pp. 33–42 includes a discussion of Court Jewelers and suppliers to the Court; and Skurlov, "Index of Jewelers, Suppliers to the Imperial Court and Courts of the Grand Dukes, Appraisers of his Majesty's Cabinet, Court Jewelers" in *St. Petersburg* (1992), pp. 227–239.

5. Habsburg (1995), pp. 99ff. and 128, describes the Bolshevik sales of Imperial treasure.

6. Muntian in Ribbing (1996), p. 209.

7. *Ibid.*, (1996), p. 209.

8. Zavadskaya in Ribbing (1996), pp. 219–223.

9. Muntian in Ribbing (1996).

10. Habsburg/Lopato (1993), p. 21. This opinion seems to refer to the output of Gustav, not Carl Fabergé.

11. *Ibid.*, (1993), ill. 9–12.

12. As in the case of Fabergé, designs for works submitted, but not accepted, remained with the Imperial Cabinet. On the other hand, designs accepted, returned to the submitting firm, were, after the work of art was executed, eventually either pasted into scrapbooks, or discarded.

13. Snowman (1993), pp. 90, 99, 112, 123.

Tsarevich Nicholas Alexandrovich to his bride, Alix of Hessen, costing 177,600 roubles, and a diamond necklace given to the bride by Nicholas's parents costing 168,000 roubles. Both necklaces were the sort of thing that Fabergé was to criticize his foreign competitors for producing – in both cases there was little design involved, just strings of choice pearls or diamonds.

By this time Fabergé had overtaken all St. Petersburg firms in size and turnover, even though the Imperial family were very fair in distributing their bounty locally. They continued to provide all suppliers to the Court and Court Jewelers with commissions, apparently preferring Bolin for his jewelry designs and choice of stones. In 1894, for example, Bolin produced much of the jewelry given by Tsar Alexander III to his daughter Xenia at the occasion of her wedding to Grand Duke Alexander. In 1900, as Fabergé was beginning to eclipse all other jewelers in St. Petersburg, Bolin must have felt some annoyance when the Imperial Cabinet commissioned a magnificent parure of emeralds and diamonds for Tsarina Alexandra Feodorovna and her sister Elisabeth Feodorovna jointly from Bolin and Fabergé. Bolin admittedly made the more expensive items, the tiara and necklace and Fabergé's Moscow jewelry workshops providing the stomacher. In 1901 the Imperial Cabinet spent 339,400 roubles on three Bolin jewels; in 1908, 35,000 roubles for a sapphire and diamond necklace; in 1909 and 1910, 29,500 roubles and 24,800 roubles respectively for two pearl and diamond pendants, individual prices easily in excess of the prices for Fabergé's Imperial Easter Eggs. Such prices were small fortunes when compared to the earnings of a laborer or even the price of a good hotel room or an excellent dinner at a top St. Petersburg restaurant (up to 3 roubles or 1.53 US dollars). Tramway fares were but 5 kopeck or $2\frac{1}{2}$ cents, while cigarettes cost up to 2 kopecks (1 cent) apiece.

In 1906 Bolin and Fabergé collaborated again, trying to acquire a collection of treasures from the Imperial Court, which was up for sale in order to pay for some of the expenses of the Russo-Japanese war of 1904–5. Their joint offer of one million roubles did not suffice to retain these jewels in Russia: they were bought by a foreign jeweler, Sachs, for 1,150,000 roubles. It would appear that Bolin and Fabergé both considered closer collaboration to stave off foreign competition. The designs of some of the platinum-mounted jewelry produced by Fabergé's Holmström jewelry workshop which can be seen in their stock books of 1908–17 are superlative.[13] The gossamer diamond and sapphire necklaces, bracelets and pendants are breathtaking in their beauty and certainly on a par with the production of any contemporary jeweler, even Cartier.

Of all Russian goldsmiths or jewelers (with the exception of the Kievan jeweler Marshak who opened a branch office in Paris), only Fabergé dreamed of challenging his competitors on foreign soil. In 1903, he dispatched one of his Moscow representatives, Arthur Bowe, to open a shop in Berners Hotel in London. He was warmly received by the royal family and London society. Fabergé exhibited his creations at a charity bazaar sponsored by Queen Alexandra. Fabergé also sent salesmen each year to the Côte d'Azur, where his Russian clientele used to spend the summer, as well as occasionally to Paris and Rome.[14]

Fabergé and Cartier occupied premises next to each other on New Bond Street. Was it surprising that Cartier[15] was eyeing Fabergé's immensely rich Russian clientele? Pierre, the enterprising son of Alfred Cartier, first traveled to Russia in order to study the market and its potential in 1904 and 1905, trips which resulted in numerous orders to local hardstone carvers and goldsmiths to provide the French firm with *objets de fantaisie*, including enameled objects, all in the style of Fabergé. Indeed, Cartier thought nothing of acquiring a small number of objects from Fabergé directly and then selling them in Paris under his own name. In 1908 Louis Cartier, Pierre's eldest brother, delegated two Frenchmen, Paul Carats and M. Desbaines, to organize a first exhibition of the firm's jewels

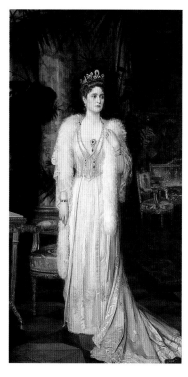

FIG 3. NICHOLAS KORNILEVICH BODAREVSKY: PORTRAIT OF EMPRESS ALEXANDRA FEODOROVNA, 1907 wearing jewelery by Bolin of 1900 – height 104 in. (268cm). Tsarskoe Selo Palace Museum

14. Habsburg/Lopato (1993), pp. 124–131.

15. Nadelhoffer (1984); and Habsburg (1996), (cat. 1986–7), pp. 335ff.

in St. Petersburg, which resulted in sales of slightly under 30,000 roubles, and in a loss for the firm. Next, in 1909, Louis Cartier traveled personally to St. Petersburg, participating in a charity bazaar organized by Grand Duchess Maria Pavlovna, who had become a major patroness of the firm.

That year the jealousy and antagonism of local jewelers reached its peak. Accusing Cartier of evading taxes and custom duties and of discrepancies in hallmarking, they succeeded in having his stock temporarily seized. Nevertheless his exhibition was a great success, with Grand Duchess Maria Pavlovna, the Dowager Empress, and several members of the Imperial family acquiring jewels from Cartier's stand. During this second season the firm's Russian sales amounted to a staggering 750,000 roubles (370,000 US dollars). Finally, in 1910, due to the intercession of his powerful patrons, but no doubt to the chagrin of his competitors Bolin and Fabergé, Cartier was awarded the coveted title of Court Jeweler. Cartier, forever in close competition with Fabergé and Bolin, strove mightily against them as jeweler, even challenging Fabergé personally by producing an Imperial Easter Egg.[16] There is no doubt that Cartier was, for more than a decade, "under the spell of Fabergé".[17] His animals, flowers and *guilloché* enamels are a clear attempt at capturing the attention of the Fabergé's Edwardian and Russian clientele (cat. 997, 998, 1002, 1007, 1613).

René Lalique[18], the greatest of Fabergé's French competitors for the title of finest craftsman, is never mentioned in connection with Fabergé. Yet his jewels, often crafted out of the humblest of materials, excel through their highly original and unique designs and their superb craftsmanship, providing a perfect parallel to Fabergé's creations. Though Lalique never sought to expand his activities beyond French frontiers, his jewels were known and highly regarded by Russian connoisseurs due to an exhibition held in St. Petersburg in 1903. The Stieglitz School in St. Petersburg had acquired several of his works in 1902 in Paris which must have been known to Fabergé and his craftsmen.

Frédéric Boucheron[19] began to prospect the Russian market in 1891, when he participated in the French section of a Moscow Exhibition. The French contingent's success led to a Franco-Russian jewelry exhibition in the following year in which Boucheron took part, opened by Grand Duke Constantin Constantinovich. In 1901 Boucheron participated in a French jewelry exhibition in St. Petersburg and in 1903 opened a branch in Moscow on the Pont des Maréchaux, close to Fabergé, under the direction of Georges Delavigne. The firm's Muscovite sales ledger covering the period of 1901 to 1906 registered sales to Dowager Empress Maria Feodorovna, Grand Duke Oldenburg, Prince Youssoupov, Queen Olga (of Greece), Grand Duke Sergei and Prince Cheremetiev. The firm's most important sale, totaling 70,000 roubles, was to Barbara Kelch, a Fabergé client. Other sales were made to Alfred de Gunzbourg, Morozoff, Poliakoff and Charitonenko, and the jeweler Tillander. Another office was temporarily opened at 26 Nevsky Prospect, St. Petersburg. The murder of Boucheron's representatives in 1911 on their return from a sales mission to Kiev set an end to Boucheron's activities and was furthermore a serious blow to the aspirations of French jewelers in Eastern Russia.

In early 1914, Fabergé threw down the gauntlet to his two main French competitors, disparagingly describing Cartier and Boucheron as "people for commerce", not artist jewelers, a class to which he thought he alone belonged.[20]

Another Parisian jeweler, Joseph Chaumet[21], also catered to the Imperial family. His main client was Grand Duchess Maria Pavlovna, but the list also includes Grand Dukes Boris, Alexis, Michael Michaelovich, and Paul Alexandrovich and Grand Duchess Xenia. A Mr Farein looked after Chaumet's business in St. Petersburg, in particular after members of the Bariatinsky, Belosselsky, Obolensky, Orloff, Cheremetiev, Shuvalov and Urusov families. Chaumet was awarded the Order of St. Anne. His main coup, however, was the commission to re-set the family jewels of Princess Xenaïde Youssoupor, the richest family in Russia in

16. Habsburg (1986), cat. 621.

17. Nadelhoffer (1984), chapter 6.

18. For Americans, the most recent exhibition of Lalique jewelry was at the Cooper-Hewitt Museum, New York, *The Jewels of Lalique*, 1998.

19. Néret (1988).

20. See Habsburg/Lopato (1993), p. 29.

21. Scarisbrick (1995), pp. 168–169.

1914 (the Youssoupors being) for the wedding of her son to a niece of the Emperor. Chaumet provided his Russian clients with kokoshnik-shaped tiaras, and numerous miniature Easter Eggs and bell-shaped charms.

In 1910, in the same year that Fabergé closed his Kievan office, Louis Cartier visited Moscow and Kiev. Through Cartier's designer, Charles Jacqeau, the French firm was able to absorb Muscovite influences into its Parisian creations. In spite of the Boucheron disaster of the previous year, Chaumet opened a boutique in Kiev in 1912, competing directly with the established local jeweler, Marshak. The branch was soon closed, however, not due to lack of clients, but to difficulties in replenishment of stock. By this time the First World War had put a stop to the French "invasion" of jewelers. With the death, emigration and incarceration of all major craftsmen, none remained in Russia to continue the centuries-old tradition of jewelry and goldsmithing. In 1922, the Bolsheviks were obliged to release Agathon Fabergé, Carl's son, from jail, when they needed an appraiser to value the loot they had amassed by confiscation, in order to begin their sales to the West.[22]

Géza von Habsburg

22. See note (5).

563

564

565

563. DESIGN IN WATERCOLOR AND
GOUACHE FOR A PALE ONYX
FRAME 13⅝×17³⁄₁₆ in. (60×43.7cm).
The Imperial Cabinet suggested to W. A. Bolin
several designs in different coloured onyx to
mark the occasion of Romanov jubilee. Among
them were winebowls, kovshes, writing sets
and photograph frames. In the designer's view,
thin plates of coloured stone were to be
decorated with superimposed silver ornament.
In this instance an Imperial crown served as a
sign of a royal gift.
Provenance: The Imperial Cabinet; State
Museum of Ethnography, 1941.
The State Hermitage Museum
(ERO sh – 1463, 1468, 1471)

564. DESIGN IN WATERCOLOR AND
GOUACHE FOR A GREEN ONYX
FRAME 23⁹⁄₁₆×18½in. (59.9×46.5 cm)

565. DESIGN IN WATERCOLOR AND
GOUACHE FOR TWO FRAMES
in red-brown and dark-green onyx –
18½×25½ in. (46.3×64cm)

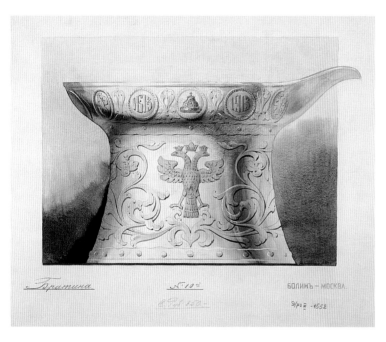

566

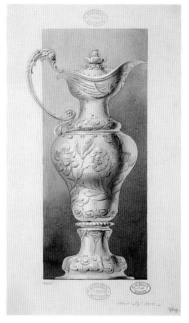

567

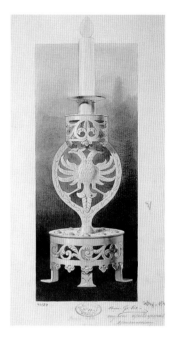

568

566. DESIGN IN WATERCOLOR AND GOUACHE FOR A WINEBOWL in the 17th-century manner – stamped BOLIN – MOSCOW, 18¼×21 in. (46.3×53.4cm). Inscribed: "winebowl No. 10, *c.* 850 roub". All Russia's jewelers started preparing early for the three-hundred year jubilee of the Romanov dynasty. Designs for items intended as gifts during the ceremonies were submitted to the Imperial Cabinet. The artists of Bolin's firm sought inspiration in the treasures of the Kremlin armory. For them royal regalia from the 'grand apparel' of the first Romanov tsar Mikhail Fedorovich became symbols of the Tercentenary: Monomach's hat, sceptre, orb, sword of State. This winebowl is decorated with a Monomach hat and state coat-of-arms of the first third of the XVIIth century. Provenance: The Imperial Cabinet; State Museum of Ethnography, 1941. The State Hermitage Museum (ERO sh – 1552)

567. DESIGN IN WATERCOLOR AND GOUACHE FOR EWER stamped K. E. Bolin, 19 February 1908, SPb 10, Morskoi B, C.E. BOLIN MOSKOU. Inscribed "no. 60, *c.* 1000 roub", 58.6×40.1cm

568. DESIGN IN WATERCOLOR AND GOUACHE FOR A CANDLESTICK stamped C.E. BOLIN MOSKOU, 18⁵⁄₁₆×9½ in. (6.5×24 cm). Inscribed: pair 850 rub., strictly adhere to the original. Provenance: The Imperial Cabinet; State Museum of Ethnography, 1941. The plans for the ceremonial silver wedding dinner service and ceremonial toilet-set were drawn up by designers of the firm for a competition which was announced by the Cabinet on the occasion of the wedding of Grand Duchess Maria Pavlovna, cousin to Emperor Nicholas II, and Prince Willhelm, second son of the Swedish Crown Prince Gustave. Bolin won this competition and received an order to make the silver part of the dowry. The State Hermitage Museum (ERO sh – 1543, 1542)

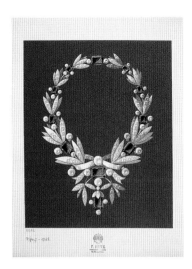

569

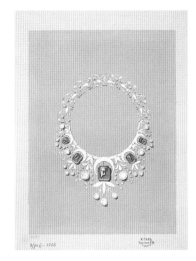

573, 574

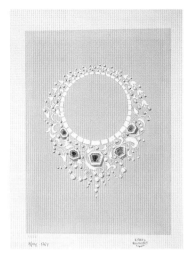

570

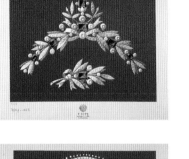

575

571

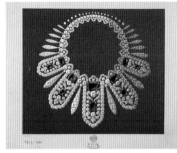

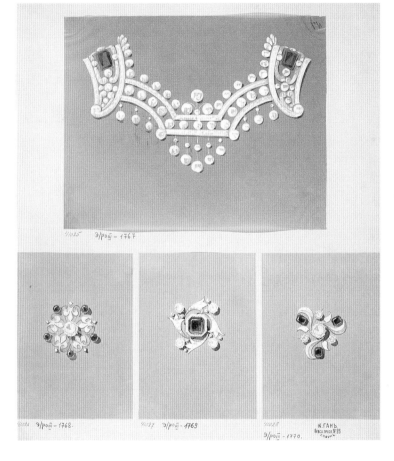

572

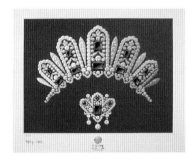

575. DESIGN IN WATERCOLOR AND
GOUACHE FOR A DIAMOND
BROOCH with 20 large emeralds –
8⁹₁₆ × 10¹⁵₁₆ in. (21.8 × 27.8cm).

DESIGN IN WATERCOLOR AND
GOUACHE FOR A BROOCH in the
form of a five-petalled rosette – 6⁵₈ × 4⁷₈ in.
(16.8 × 12.5cm).
DESIGN IN WATERCOLOR AND
GOUACHE FOR A BROOCH with an
emerald – 6⁹₁₆ × 4⁷₈ in. (16.6 × 12.5cm).

DESIGN IN WATERCOLOR AND
GOUACHE FOR A BROOCH in the
form of a five-petalled rosette – 6⁵₈ × 4⁷₈ in.
(16.8 × 12.5cm).(4), all together on one mount
stamped K HAAN, Nevskii Prospekt No 26,
S PBURG.
Provenance: The Imperial Cabinet; State
Museum of Ethnography, 1941.
The State Hermitage Museum (ERO
sh – 1764, 1766, 1767, 1768, 1769, 1770
[1767 – 1770 are all mounted on one page])

569. DESIGN IN WATERCOLOR AND
GOUACHE FOR A NECKLACE stamped
F. BUTZ Joaillier de la Cour St. Petersbourg,
17⁹₁₆ × 14⁵₁₆ in. (44.7 × 36.4cm).
Provenance: State Museum of Ethnography,
previously in His Imperial Highness's Cabinet's
collection.
State Hermitage, inv.no. ERO sh – 1761,
1760, 1763, 1762

570. DESIGN IN WATERCOLOR AND
GOUACHE FOR A RUSSIAN LAUREL
DIADEM stamped F. BUTZ Joaillier de la
Cour St. Petersbourg, 14³₈ × 17³₄ in.
(36.5 × 45cm)

571. DESIGN IN WATERCOLOR AND
GOUACHE FOR A RUSSIAN
NECKLACE stamped F. BUTZ Joaillier de la
Cour St. Petersbourg, 14⁵₁₆ × 19³₁₆ in.
(36.7 × 44.8cm)

572. DESIGN IN WATERCOLOR AND
GOUACHE FOR A KOKOSHNIK-
SHAPED DIADEM AND BROOCH
stamped F. BUTZ Joaillier de la Cour St.
Petersbourg, 14⁵₁₆ × 19³₁₆ in. (36.7 × 44.8cm).

573. DESIGN IN WATERCOLOR AND
GOUACHE FOR A NECKLACE
stamped K. HAAN, Nevskii Prospekt No. 26,
S PBURG, 20 × 15³₄ in. (50.8 × 40.3cm)

574. DESIGN IN WATERCOLOR AND
GOUACHE FOR A NECKLACE
stamped K HAAN, Nevskii Prospekt. No. 26,
S PBURG, 20 × 15³₄ in. (50.8 × 40.3cm)

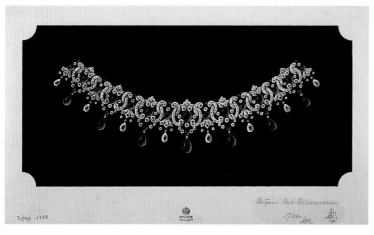
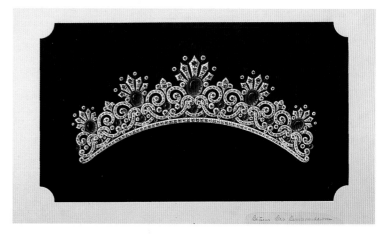

576, 577

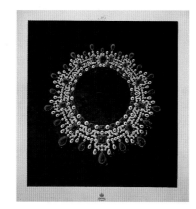
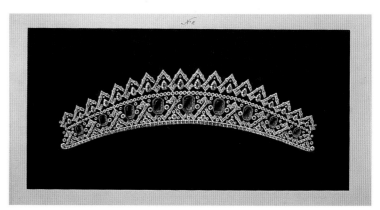

578, 579

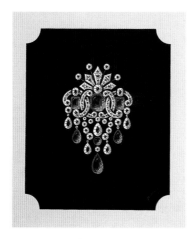
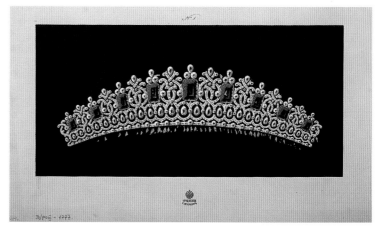

580

581

576. DESIGN WITH WATERCOLOR
AND GOUACHE FOR A NECKLACE
signed F. Koechli 94, stamped Friedr. Koechli,
St Petersburg, $11^1\!/_2 \times 20^3\!/_4$ in. (30.4×52.7cm).
Inscribed: "Chosen by their Majesties,
17 Aug. 1894"

577. DESIGN WITH WATERCOLOR
AND GOUACHE FOR A DIADEM
signed F. Koechli 94, stamped Friedr. Koechli,
St. Petersburg, $12^1\!/_2 \times 18^7\!/_8$ in. (31.7×47.9cm).
Inscribed: "Chosen by their Majesties,
17 Aug. 1894"

578. DESIGN WITH WATERCOLOR
AND GOUACHE FOR A NECKLACE
stamped Friedr. Koechli, S. Petersburg,
$18^3\!/_8 \times 17^7\!/_{16}$ in.
Provenance: The Imperial Cabinet; The State
Museum of Ethnography, 1941.
The State Hermitage Museum
(ERO sh – 1781)

579. DESIGN WITH WATERCOLOR
AND GOUACHE FOR A DIADEM
stamped Friedr. Koechli, S. Petersburg,
$12^3\!/_8 \times 20^3\!/_4$ in.
Provenance: The Imperial Cabinet; The State
Museum of Ethnography, 1941.
The State Hermitage Museum
(ERO sh – 1776)

580. DESIGN WITH WATERCOLOR
AND GOUACHE FOR A BROOCH
with seven sapphires and diamonds – signed F.
Koechli, stamped Friedr. Koechli, St.
Petersburg, $12^5\!/_{16} \times 11^1\!/_8$ in. (31.3×28.2cm)

581. DESIGN WITH WATERCOLOR
AND GOUACHE FOR A DIADEM
stamped Friedr. Koechli, S. Petersburg,
$12^5\!/_{16} \times 20^3\!/_4$ in.
Provenance: The Imperial Cabinet; The State
Museum of Ethnography, 1941.
The State Hermitage Museum
(ERO sh – 1777)

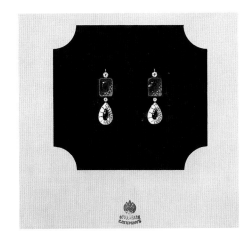

582

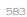

583

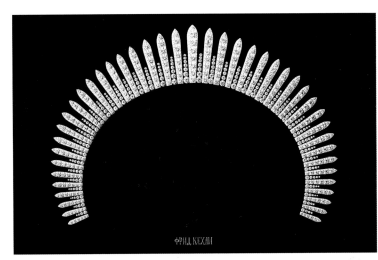

585

584

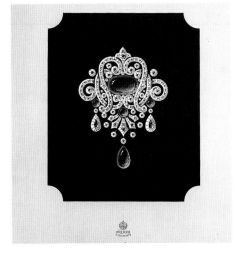

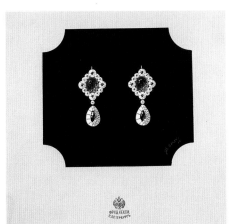

582. DESIGN WITH WATERCOLOR AND GOUACHE FOR A PAIR OF SAPPHIRE AND DIAMOND EARRINGS with sapphires and drop-shaped pendants – stamped Friedr. Koechli St. Petersburg, 8×8⁷⁸ in. (21.4×22.6cm). Provenance: The Imperial Cabinet; State Museum of Ethnography, 1941 The State Hermitage Museum (ERO sh – 1773, 1772, 1774, 1779, 1771, 1778)

583. DESIGN WITH WATERCOLOR AND GOUACHE FOR A BROOCH with five sapphires and diamonds – stamped Friedr. Koechli, St. Petersburg, 12⁵₁₆×11¹⁸ in. (31.3×28.2cm)

584. DESIGN WITH WATERCOLOR AND GOUACHE FOR A PAIR OF SAPPHIRE AND DIAMOND EARRINGS with diamond-shaped shields made of sapphires and diamonds – signed F. Koechli 94, 8×8¹⁵₁₆ in. (21.4×22.7cm)

585. DESIGN WITH WATERCOLOR AND GOUACHE FOR A NECKLACE stamped Friedr. Koechli, S. Petersburg, 11⁹₁₆×14¹₂ in. Provenance: The Imperial Cabinet; The State Museum of Ethnography, 1941. The State Hermitage Museum (ERO sh – 1784)

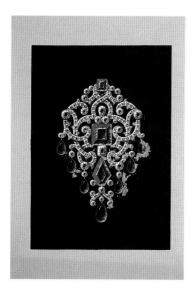

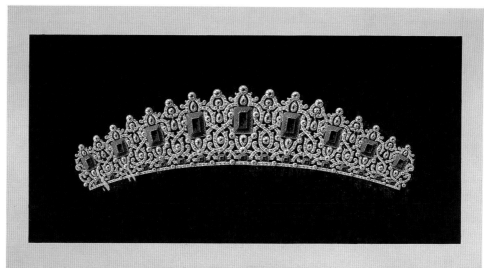

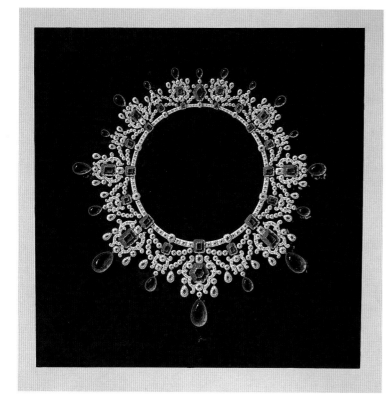

588

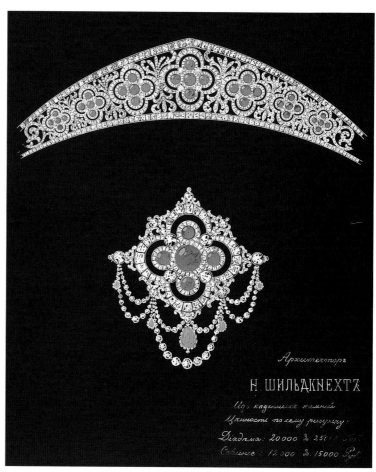

589

586. DESIGN IN WATERCOLOR AND
GOUACHE FOR A BROOCH signed
Zeftigen, 11¹¹₁₆ × 11⁹₁₆ in. (29.7 × 29.4cm).
Provenance: The Imperial Cabinet; State
Museum of Ethnography, 1941.
The State Hermitage Museum
(ERO sh – 1783, 1782, 1775)

587. DESIGN IN WATERCOLOR AND
GOUACHE FOR A DIADEM signed
Zeftigen, 8⅝ × 18¹³₁₆ in. (21.1 × 47.8cm)

588. DESIGN IN WATERCOLOR AND
GOUACHE FOR A NECKLACE signed
Zeftigen, 17⅜ × 17½ in. (44.1 × 44.3cm)

589. DESIGN IN GOUACHE FOR A
KOKOSHNIK-SHAPED DIADEM AND
BROOCH signed N. Schildknekht,
19⅛ × 15⅜ in. (48.5 × 39cm). Inscribed:
"Made of State stones".
The value according to this drawing was
20000 – 25000 roubles.
Provenance: The Imperial Cabinet; State
Museum of Ethnography, 1941.
The State Hermitage Museum
(ERO sh – 1759)

590

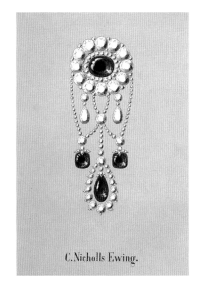

592

593

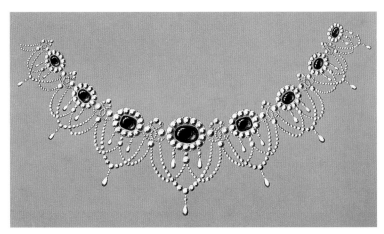

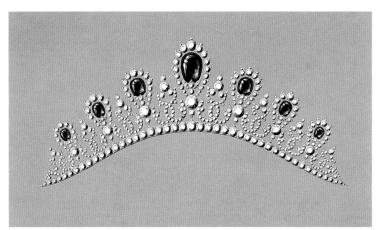

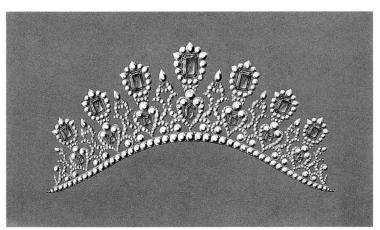

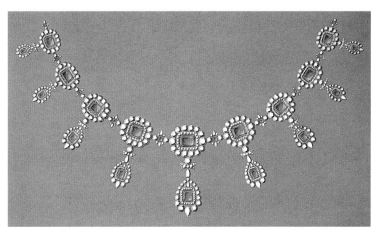

591

594

592. DESIGN WITH WATERCOLOR
AND GOUACHE FOR A PENDANT
signed Nicholls-Ewing, 9³⁄₄×6⁹⁄₁₆ in.
(24.7×16.6cm).
Provenance: The Imperial Cabinet; State
Museum of Ethnography, 1941.
The State Hermitage Museum
(ERO sh – 1790, 1791, 1788)

593. DESIGN WITH WATERCOLOR
AND GOUACHE FOR A DIADEM
signed C. Nicholls-Ewing, 13¹¹⁄₁₆×20³⁄₈ in.
(34.8×51.8cm).

590. DESIGN WITH WATERCOLOR
AND GOUACHE FOR A NECKLACE
signed Nicholls-Ewing, 13¹¹⁄₁₆×20³⁄₈ in.
(34.8×51.7cm)

591. DESIGN IN WATERCOLOR AND
GOUACHE FOR A DIADEM signed K.
Nicholls-Ewing, 12⁵⁄₈×22¹⁄₈ in. (32×56.2cm)

594. DESIGN IN WATERCOLOR AND
GOUACHE FOR A NECKLACE signed
K. Nicholls-Ewing, 17³⁄₁₆×24 in. (43.6×61cm).
Provenance: The Imperial Cabinet; State
Museum of Ethnography, 1941.
The State Hermitage Museum
(ERO sh – 1789, 1792)
N. Schildknecht

AUGUST HOLMSTRÖM

August Holmström' (1828–1903) was born in Helsinki, son of Henrik Holmström, a master bricklayer from Kirkkonummi and Maria Christina Ahlborg of Helsinki. He arrived in St. Petersburg shortly after 1840 and was apprenticed to the jeweler Herold at Butkyomov's House, Malaya Sadovaya Street, becoming journeyman in 1850 and Master in 1857. In the same year, he married Maria Sofia Welene (the marriage dissolved in 1866), daughter of a court clockmaker, and, making himself independent, acquired the workshop of goldsmith Frederik Johan Hammarström. In the following year, he was engaged as principal jeweler by Gustav Fabergé, continuing to work for his son, Carl, after 1872 until his death in 1903. In 1868, Holmström married Hilma Rosalie Sunberg, daughter of the bronzeworker Carl Johan Sunberg of Mikkeli. The workshop, which was moved to 24 Bolshaya Morskaya in 1900, was then taken over by his highly gifted son, Albert (fig. 1) (1876–1925). Another of August's eight children, Hilma Alina (fig. 2) (1875–1936), became a jewelry designer in the family workshop. Yet another daughter, Fanny (1869–1949), married Fabergé workmaster Oskar Pihl, and a granddaughter, Alma Theresia Pihl (1888–1976), worked as a designer.

There is no apparent trace of August Holmström's influence on the modest jewelry production of Gustav Fabergé, nor on the early jewelry production of the House under Peter Carl Fabergé in the 1870s and 1880s. Holmström nevertheless was responsible for some of the firm's finest jewelry creations. According to Henry Bainbridge, Holmström was the author of the surprise contained in the so-called "Pamiat Azova Egg" of 1891 (cat. 438), a miniature gold replica of the cruiser on which Tsarevich Nicholas traveled to the Far East in 1890 – "exact in every detail of guns, chains, anchor and rigging".

The first dated object of art bearing his signature is the 1892 "Diamond Trellis Egg". It seems fairly certain that the bowenite egg and its pedestal were produced in Woerffel's stone-carving factory, while the three silver putti upholding the egg must have come from Julius Rappoport's silver workshop. Holmström was responsible for the swirling diamond-set lines encasing the egg, possibly for the surprise, a gem-set ivory elephant, as well as, presumably, for the overall assembly.

Arguably the most exquisite work of art to survive from the Fabergé workshops is the "Lilies-of-the-Valley Basket" of 1899. (fig. 4) Its diamond-and-pearl-set buds were executed by August Holmström who was also was responsible for the assembly of the golden parts, possibly made in the Perchin workshop, and for the nephrite leaves probably carved by Carl Woerffel and his craftsmen.

Although they do not bear his hallmark, Holmström is certainly responsible for the miniature replicas of the Imperial Regalia begun in 1899 and exhibited at the 1900 Paris Exposition Universelle (fig. 5). The silver bases are hallmarked by Julius Rappoport, Fabergé's chief silversmith. These miniatures of the Great and Small Crowns, the Orb and Scepter were precisely described by Fabergé's son, Agathon in 1912: "The Big Crown is made of 1,083 diamonds and 245 rough rose-cut diamonds. The Small Crown out of 180 diamonds and 1,204 rough (rose) diamonds. The Orb: sixty-five diamond and 654 rough (rose) diamonds. The Scepter: one diamond and 125 rough (rose) diamonds", which comes to a total of 3,557 diamonds. According to François Birbaum[2], "the workshop was famous for its great precision and exquisite technique: such faultless gem-setting is not to be found even in the works by the best Paris jewelers. It should be noted that even if some of Holmström's works are artistically somewhat inferior to those of the Parisian masters, they always surpass them in technique, durability and finish." This exhibit won the firm great acclaim in Paris.

FIG 1. ALBERT HOLMSTRÖM
Photograph courtesy of Ulla Tillander-Godenhielm

FIG 2. HILMA ALINA HOLMSTRÖM
Photograph courtesy Ulla Tillander-Godenhielm

FIG 3. THE WORKSHOP OF AUGUST HOLMSTRÖM St. Petersburg c. 1900. Archive Photograph

Very few of August Holmström's more important jewels have withstood the vicissitudes of time, most of them having fallen prey to the Bolsheviks' devastations in the early 1920s.[3] The handful of exceptions attest to Holmström's exceptional craftsmanship. A laurel tiara belonging to the Duke and Duchess of Westminster (cat. 620), mounted in red gold and silver, shows leaves finely encrusted with minute diamonds, worthy of Birbaum's high praise. A second, unsigned, Art Nouveau tiara/necklace of cyclamens in the same collection is equally exquisitely designed and executed.[4] The remainder of the surviving jewels, made for Fabergé in August Holmström's workshop, are mostly on a small scale. Many of them are unmarked, but must be attributed to the firm's main jewelry workshop and can only be can be identified as being by Fabergé thanks to their original fitted cases.

According to François Birbaum, the Holmström workshop made jewelry only[5], although Henry Bainbridge disagrees – "he was equally successful in goldsmithery pure and simple."[6] This raises the question of the relatively small group of enameled objects which bear August Holmström's initials (cat. 595, 602). Most, but not all (cat. 603) of these are presentation boxes or cases embellished with precious stones. Holmström's Imperial presentation cigarette-cases are remarkably similar to those produced by the Hollming workshop, to the point that they seem to be interchangeable (cat. 602, 660). Does this mean that the enamelwork was Hollming's responsibility, and the jewel decoration the work of Holmström? The answer must surely be negative. But why did the workshops of Hollming and Holmström, as well as head workmaster Wigström, all produce enameled gold cases in the years between 1899 and 1908? Were all three workshops equipped to make, and capable of making, similar objects? This would contradict what we have hitherto understood as being one of the characteristics of the Fabergé workshops, namely the separation of responsibilities.

At August Holmström's death in 1903, the management of the main jewelry workshop was taken over by his highly gifted son, Albert, who was seconded by Lauri Ryynanen, a capable workmaster. Any object, therefore, bearing the post-1908 hallmark is their work. It would appear that after this date the workshop stopped making enameled cigarette-cases, although a small number of gold cases with the hallmark of Albert do exist. Sometime around 1910 platinum was introduced ("the use of platinum was an advance, as it does not tarnish, and its beautiful gray colour enhances the whiteness of diamonds"[7]), allowing for much lighter and resistant mounts. Two books of designs have miraculously survived depicting what seems to be the entire production of Albert Holmström's workshop between 1909 and 1915. While many of the designs are traditional in style, some are almost geometric and astonishingly modern in feel.[8]

The most famous artefacts produced by Albert Holmström's workshop, are the "Winter Egg" of 1913 (Private Collection) (fig. 6) and the "Mosaic Egg" of 1914 (HM the Queen), both based on clever designs by Alma Theresia Pihl, Albert's niece. The "Winter Egg" incorporates ice crystals similar to those that appear on a series of forty brooches designed by Alma Theresia for Alfred Nobel in 1911. This is arguably the most brilliant of the entire series of Imperial Easter Eggs. The "Mosaic Egg", based on a *petit point* motif of Alma Theresia, is formed of platinum latticework encrusted with tiny colored *calibré* stones, representing a *tour de force* of the jeweler's craft.

Géza von Habsburg

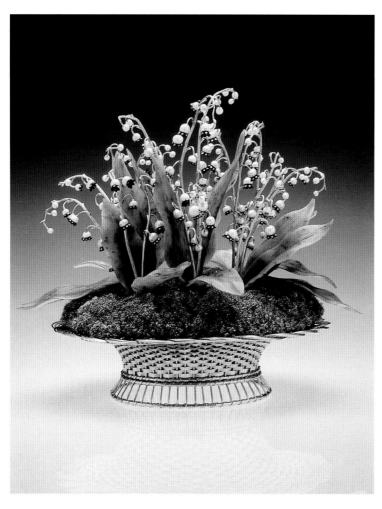

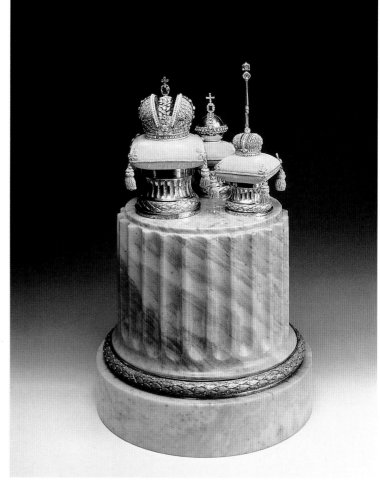

Notes

1. For a brief biography of August Holmström, cf. Ulla Tillander-Godenhielm, "Personal and Historical notes on Fabergé's Finnish Workmasters and Designers' in *Helsinki* (1980), p. 33.

2. Fabergé/Skurlov (1992), p. 6.

3. Habsburg, "When Russia Sold Its Past" in *Art & Auction*, (March 1995), pp. 94–97 and 128.

4. Munich (1986/7), cat. 131.

5. Fabergé/Skurlov (1992), p. 6.

6. Bainbridge (1949), p. 129.

7. Fabergé/Skurlov, (1992), p. 6.

8. See Snowman (1993), pp. 144, 105, 137.

FIG 4. A JEWELED HARDSTONE AND GOLD BASKET OF LILIES-OF-THE VALLEY by Fabergé, workshop of August Holmström, St. Petersburg 1896, length 8½ in. (21.5cm). New Orleans Museum of Art, Mathilda Geddings Gray Foundation Collection

FIG 5. DIAMOND-SET REPLICAS OF THE RUSSIAN CROWN JEWELS made by Fabergé's workmasters August Holmström and Julius Rappoport for the Paris 1900 Exposition Universelle. The Hermitage Museum, St. Petersburg

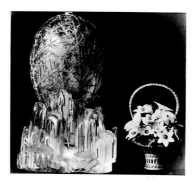

FIG 6. THE "WINTER EGG" OF 1913 A jeweled, platinum-mounted rock crystal Imperial Easter Egg – by Fabergé, workshop of Albert Holmström, St. Petersburg 1913, height 4 in. (10.2cm). Private Collection. Archive Photograph

595. CORONATION BOX diamond-set
enameled two-color gold Imperial presentation
snuffbox applied with a deep gold hued enamel
over *guilloché* sunburst patterns accented by
Imperial eagles and defined by a gold chased
trellis set with diamonds. At the center of the
box is the diamond-set crowned monogram of
Tsar Nicholas II against an oval panel
enameled white with a diamond-set border –
signed Fabergé, initials of workmaster August
Holmström, assay mark of St. Petersburg before
1899, inv no. 1067, length 3³⁄4 in. (9.5cm).
Provenance: Believed to have been presented to
Tsar Nicholas II by Tsarina Alexandra
Feodorovna, 1897; Arthur E. Bradshaw;
Lansdell K. Christie, Long Island, New York.
Bibliography: Guth 1954, p. 43, ill.; Snowman
1962/64/68/74, ill. plate I; Snowman 1963, ill.
p. 245; Snowman 1977, ill. p. 51; Waterfield/
Forbes 1978, no. 61, ill. p. 51, cover; Habsburg/
Solodkoff 1979, ill. plate no. 149; Snowman
1979, ill. p. 122; Habsburg/Solodkoff 1979, ill.
plate no. 149; Forbes 1980, p. 14; Kelly
1982/83, p. 10; Sweezy 1983, ill. p. 1211;
Solodkoff 1984, ill. pp. 27, 173; Forbes 1986,
p. 57, ill.; Forbes 1987, no. 11, p. 16, ill.; Forbes
1989, p. 222, ill.; Hill 1989, ill. plate no. 120,
title page; Habsburg/Lopato 1993, no. 105, cat.
p. 252, ill.; Habsburg 1996, ill. plate 45; Odom
1996, p. 180.
Exhibited: London 1949, no. 5, cat. pp. 3, 9;
New York 1961, no. 93, ill. p. 49; Washington
1961, no. 14, cat. p. 33, ill. opp. title page; New
York1962/6, no. L.62.8.14; New York 1973,
no. 12, ill. p. 53; London 1977, no. O14, ill. p.
81; Munich 1986/7, no. 513, ill. p. 255; Lugano
1987, no. 95, ill. pp. 94, 95; Paris 1987, no. 95,
ill. pp. 90, 91, cover; San Diego/Kremlin
1989/90, no. 27, cat. p. 86, ill.; St. Petersburg/
Paris/London 1993/94, no. 105, p. 252, ill.;
New York et al.1996/97, no. 203, cat. p. 211, ill.
The box belongs to a series of objects by the
House of Fabergé inspired by the gold ermine-
trimmed robes worn by Tsar Nicholas II and
Tsarina Alexandra Feodorovna during the 1896
coronation.
The Forbes Magazine Collection, New York

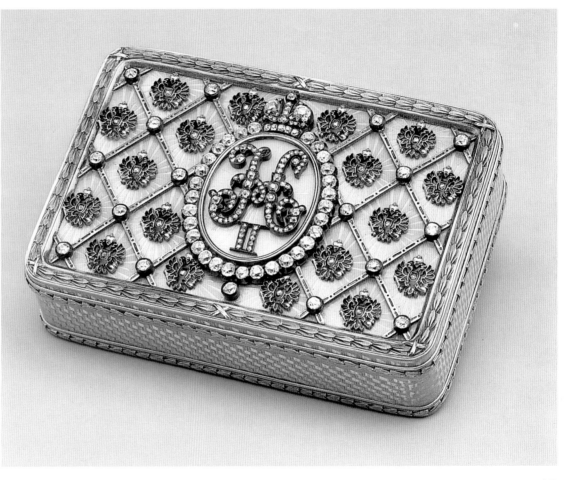

595

596

597

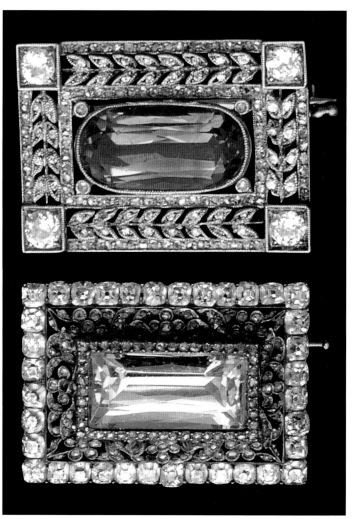

599, 598

596. GEM-SET GOLD AQUAMARINE
HEART BROOCH set with a heart-shaped
fasceted aquamarine surrounded by a band
of rose-cut diamonds and surmounted by a
diamond-set ribbon tie, with detachable pin to
be worn as pendant – signed with initials of
Fabergé, initials of workmaster August
Holmström, assay mark of St. Petersburg before
1899, height 1³⁄₈ in. (3.5cm).
Private Collection

597. TRIANGULAR GEM-SET GOLD-
MOUNTED OPAL BROOCH set with
a pale white opal surrounded by brilliant-cut
diamonds – initials of workmaster August
Homström, assay mark of St. Petersburg before
1899, inv no. 2926, width ³⁄₄ in. (1.9cm).
Private Collection

598. GOLD AND PLATINUM-
MOUNTED DIAMOND-SET
AQUAMARINE BROOCH the central
oblong aquamarine surounded by diamond-set
openwork flowers within a border of diamonds
– initials of workmaster August Holmström,
assay mark of St. Petersburg 1899–1908, 56
(zolotnik), length 1¹⁄₄ in. (3.2cm).
Exhibited: New York/San Francisco et al.
1996/7, cat. 349.
Joan and Melissa Rivers

599. RECTANGULAR DIAMOND-
SET AMETHYST BROOCH the central
oval amethyst within a frame of diamonds and
diamond-set laurel leaves, with circular cut
diamonds at each corner – initials of
workmaster August Holmström, 56 (zolotnik),
St. Petersburg, length 1 in. (2.5cm). Original
fitted case.
Exhibited: QVC 1999.
Joan and Melissa Rivers

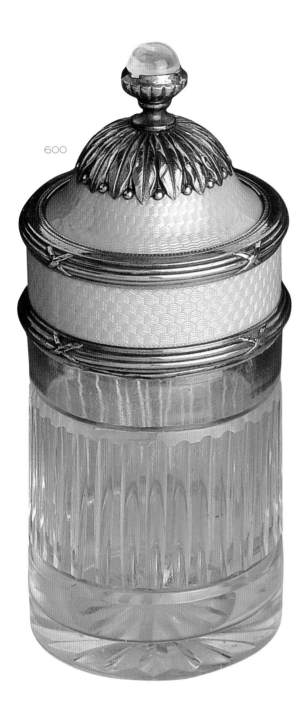

600

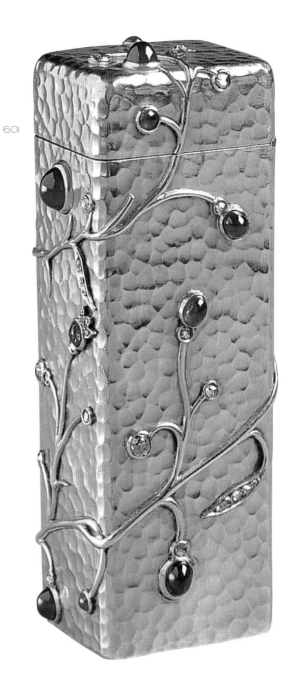

601

600. CYLINDRICAL SILVER-GILT MOUNTED ENAMELED SCENT-FLASK the fluted body with pale blue *guilloché* enamel cover with two reed-and-tie borders, cabochon moonstone finial set in a berried laurel-leaf mount – signed Fabergé, initials of workmaster August Holmström, assay mark of St. Petersburg 1899–1908, height 3⅜ in. (8.7cm).
Exhibited: Paris 1994, cat. 27; Hamburg 1995, cat. 76; London 1996, cat. 27.
Chevalier Maurice Mizzi Collection

601. IMPERIAL PRESENTATION DIAMOND-SET ENAMELED GOLD CIGARETTE-CASE of red sunburst *guilloché* enamel centered on an imperial crown set with rose-cut diamonds, diamond pushpiece – signed Fabergé, initials of workmaster August Holmström, assay mark of St. Petersburg 1899–1908, inv no.1158, length 3¾ in. (9.5cm). Original fitted red leather case with double-headed eagle.
Provenance: Presented by Tsar Nicholas II to Pavel Kaczkovsky, a high-ranking civil servant, on the eve of his coronation, May 25, 1896
Bibliography: Traina 1998, p. 60.
Exhibited: New York/San Francisco et al. 1996/7, cat. 381.
John Traina Collection

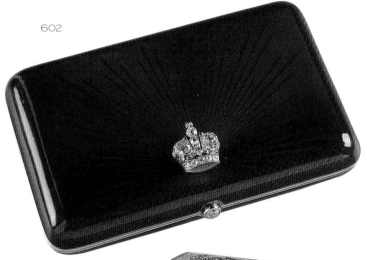

602

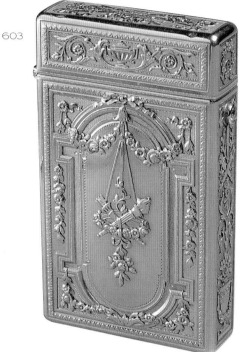

603

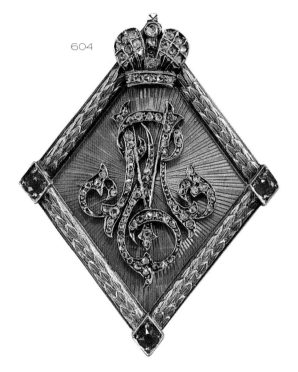

604

602. JEWELED HAMMERED-YEL-LOW-GOLD BOX applied with berried sprays set with cabochon rubies and sapphires, brilliant and rose-cut diamonds and an emerald, cabochon sapphire pushpiece – initials of workmaster August Holmström, assay mark of St. Petersburg before 1899, height 3⅛ in. (8cm).
Bibliography: Traina 1998, p. 66.
Both the Holmström and Hollming workshops specialized in hammered-gold objects.
John Traina Collection

603. FOUR-COLOR GOLD CARD-CASE in Louis XVI-style chased with an archway, with, at its center, a monogram with a royal crown above. Applied with four-color gold floral swags suspended from rosettes, all on a yellow-gold sablé ground – signed Fabergé, initials of workmaster August Holmström, assay mark of St. Petersburg before 1899, inv no. 2140, length 3⅜ in. (8.7cm).
Bibliography: Traina 1998, p. 69
A particularily fine example of a Louis XVI pastiche.
John Traina Collection

604. LOZENGE-SHAPED GEM-SET ENAMELED GOLD PENDANT/BROOCH of pink sunburst *guilloché* enamel applied with a diamond-set crowned monogram "MP", the laurel-leaf border set with three faceted rubies – signed Fabergé, initials of workmaster August Holmström, assay mark of St. Petersburg 1899–1908, assay master Yakov Lyapunov, length 1¾ in. (4.5cm).
Original fitted red leather case stamped with Imperial Warrant, St. Petersburg, Moscow.
Private Collection

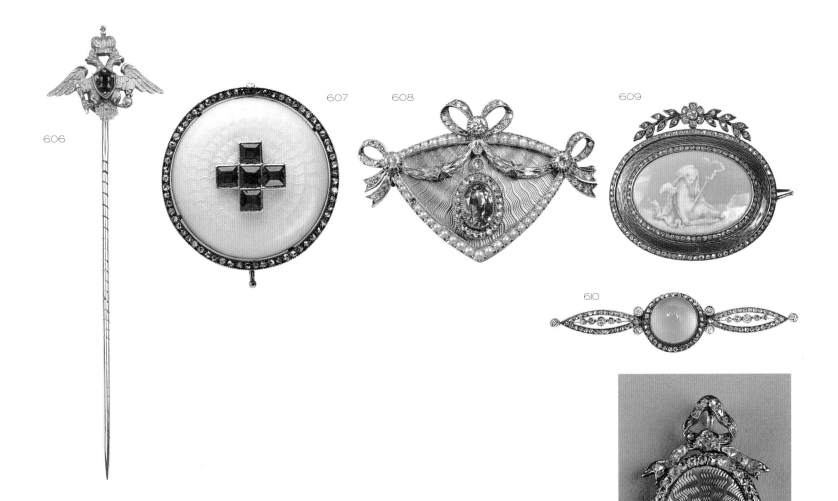

606

607

608

609

610

611

608. GEM-SET ENAMELED GOLD BROOCH of curved triangular outline centrally set with a faceted oval pink topaz in rose-cut diamond bezel, set in a panel of green *guilloché* enamel, bordered with seed pearls and applied with two laurel swags suspended from tied ribbons, set with respectively a circular diamond and numerous rose-cut diamonds – by Fabergé, workmaster's initials indistinct, assay mark of St. Petersburg 1908–1917, inv no. 85557.
Private Collection

609. GRISAILLE PIN: OVAL DIAMOND-SET ENAMELED GOLD BROOCH painted in camaieu rose with Cupid, allegorical of winter, after François Boucher, holding a torch against an opalescent pink sky – signed Fabergé, initials of workmaster Albert Holmström, 56 (zolotnik), length 1½ in. (3.8cm).
Provenance: Mrs. Ruth E. Gould, New York.
Bibliography: Solodkoff 1984, p. 100, ill.; Forbes 1986, p. 55, ill.; Forbes 1989, p. 223, ill.; Odom/Arend 1998, p. 318, ill.
Exhibited: Munich 1986/87, no. 105, cat. p. 141; Lugano 1987, no. 90, cat p. 90, ill.; Paris 1997, no. 90, cat. p. 86, ill.; St. Petersburg/Paris/London 1993/94, no. 273, cat. p. 371, ill. The image is identical to one of a series of eight grisaille enamels painted by court miniaturist Vassily Zuiev which decorate the Catherine the Great Egg presented to the Dowager Empress Maria Feodorovna on Easter 1914.
The Forbes Magazine Collection, New York

606. GEM-SET GOLD IMPERIAL PRESENTATION TIE-PIN with chased gold imperial eagle set with a ruby – initials of workmaster August Holmström, assay mark of St. Petersburg 1908–1917, inv no. 2650, width ¹³⁄₁₆ in. (2.1cm). Original fitted blue morocco case gilt with imperial eagle.
Private Collection courtesy A. von Solodkoff

607. CIRCULAR GEM-SET ENAMELED GOLD BROOCH decorated with the Red Cross set in rubies on white *guilloché* enamel ground, the border set with rose-cut diamonds – initials of workmaster August Holmström, assay mark of St Petersburg 1908–1917, diameter 1¹⁄₁₆ in. (2.7cm).
Private Collection

610. PLATINUM AND GOLD-MOUNTED CHALCEDONY AND DIAMOND BROOCH of elongated propeller shape, with a central cabochon chalcedony in a rose-cut diamond surround, further set with sixteen brilliants and rose-cut diamonds – initials of workmaster Albert Holmström, assay mark of St. Petersburg 1908–1917, 56 (zolotnik), length 2⅛ in. (5.3cm). Original fitted case stamped with Imperial Warrant, St. Petersburg, Moscow, London.
Exhibited: Zurich 1989, cat. 192 (illustrated); A. Tillander, Helsinki 1995; Christie's, Stockholm 1996; Lahti 1997; Stockholm 1997, cat. 243 (illustrated).
Bibliography: Tillander-Godenhielm 1996, p. 154.
Private Collection, lent courtesy of Ulla Tillander-Godenhielm, Finland

611. OVAL DIAMOND-SET ENAMELED GOLD LOCKET centrally set with an old mine diamond in a panel of translucent blue enamel over *guilloché* sunburst ground, bordered with rose-cut diamonds, suspended from a diamond-set bow – initials of workmaster Albert Holmström, assay mark of St. Petersburg 1899–1908, height 1¼ in. (3.2cm).
Private Collection

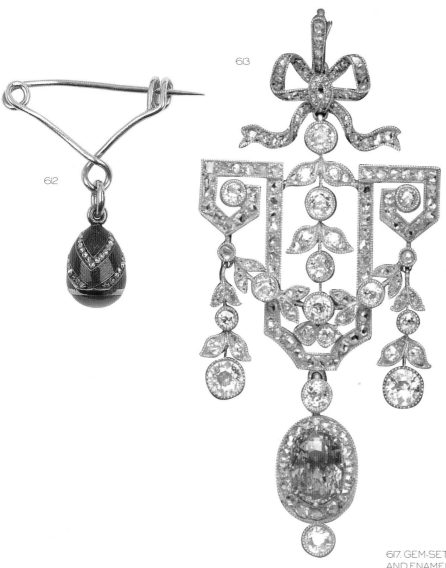

613

612

614

615

616

617

612. GEM-SET GOLD AND ENAMEL EASTER EGG PENDANT with gold safety pin brooch the egg of red *guilloché* enamel with rose-cut diamond-set chevrons and with moonstone finial – by Fabergé, apparently unmarked.

Provenance: Princess Irène of Prussia, sister of Empress Alexandra Feodorovna, described in her jewelery album: "Gold safety-pin brooch with Easter egg attached – in red enamel set with small diamonds – a moonstone at end. (From) The Grand Duchess Serge (1909)".
Private Collection courtesy A. von Solodkoff

613. GEM-SET PLATINUM AND GOLD-MOUNTED PENDANT the diamond-set ribbon tie suspending laurel garlands and angular scrolls with further garlands and an oval pink sapphire below, with platinum chain – apparently unmarked, height 2⅝ in. (6.6cm). Original fitted hollywood case stamped with Imperial Warrant, Fabergé, St. Petersburg, Moscow, Odessa.
Exhibited: Hamburg 1995, cat. no. 215.
Private Collection courtesy A. von Solodkoff

614. GEM-SET GOLD STAR SAPPHIRE PENDANT set with an oval sapphire and a brilliant-cut diamond flanked by curved rose-cut diamond-set lines, the open-work backing of the sapphire engraved with a flowerhead – by Fabergé, assay mark of St. Petersburg 1899–1908, assay master Yakov Lyapunov, inv no. 43142, length 1¹⁵⁄₁₆ in. (3.5cm).
Private Collection courtesy A. von Solodkoff

615. CIRCULAR DIAMOND-SET GOLD BROOCH enameled translucent amber and decorated with gold paillons of laurel and bound with four rose-cut diamond-set bands – signed with initials of Fabergé, assay mark of St. Petersburg before 1899, diam. 1³⁄₁₆ in. (3cm).
Private Collection

616. JEWELED RHODONITE PENDANT of tapering form carved with interlacing ellipses, the platinum mount set with rose-cut diamonds – by Fabergé, inv no. 98264, length 1⅞ in. (4.7cm).
Bibliography: Snowman 1993, p. 154.
Exhibited: Munich 1986/7, cat. 99 and p. 50.
This pendant is shown in the stock book of the Holmström jewelry workshop dated 12 May, 1914.
Private Collection

617. GEM-SET PLATINUM, GOLD AND ENAMEL SNOWFLAKE BROOCH of six-pointed star-shape design, enameled white and set with rose-cut diamonds – by Fabergé, engraved number 804, length 1¼ in. (2.9cm).
Provenance: Princess Irène of Prussia, sister of Empress Alexandra Feodorovna, described it in her jewelery album: "Brooch, white enamel snowflake of very small diamonds in center – (from) The Grand Duchess Serge, Hemmelmark, July 1913".
Private Collection

618. CIRCULAR GEM-SET GOLD AND MECCA STONE BROOCH set with a round pale blue hardstone surrounded by an open work row of rose-cut diamonds within a band of further diamonds, with diamond-set ribbon cresting – signed with initials of Fabergé, assay mark of St Petersburg 1899–1908, width 1¹⁵⁄₁₆ in. (3.4cm).
Private Collection

619. GOLD AND PLATINUM-MOUNTED STAR SAPPHIRE BROOCH the oval central stone within a border of rose-cut diamonds, surmounted by a diamond-set ribbon knot – by Fabergé, mounts illegible, length 1¼ in. (3.2cm).
Provenance: Grand Duchess Maria of Russia (1847–1909), wife of Grand Duke Vladimir Alexandrovich, brother of Tsar Alexander III, née Duchess of Mecklenburg. She was known for her great collection of jewels, many of which were by Cartier.
Exhibited: New York/San Francisco et al. 1996/7, cat. 348; QVC 1999.
Joan and Melissa Rivers

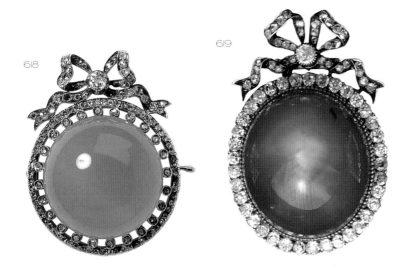

618

619

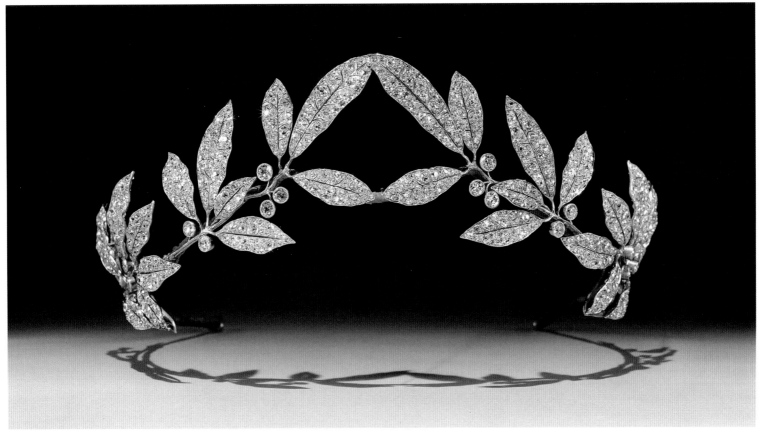

620

620. GOLD AND SILVER-MOUNTED
DIAMOND-SET TIARA shaped as a myrtle
wreath with six groups of diamond-set leaves
and diamond berries on engraved red gold
stalks – signed with initials K. F. for Carl
Fabergé, overall length 15 in. (38cm).
Provenance: Mrs Gerald Grosvenor.
Exhibited: Victoria & Albert 1977, cat Q. 1;
Wartski 1997, Stockholm 1997, cat 250.
Biblography: Snowman 1962, ill. 219.
Note: This diadem, although not signed with
the workmaster's initials, comes from the
jewelry workshop of August Holmström
(1829–1903), who was also responsible for
some of the firm's greatest jewels. These
include the Lilies of the Valley Basket of 1896
(see Fabergé in America, cat. 59; the miniature
replicas of the Imperial Regalia (see Nicholas
& Alexandra, cat. 208), which date from
c. 1900. Presumably a family commission, this
ormanent was designed as a wreath of myrtle, a
plant sacred to Venus, to be worn by future
Grosvenor brides (see Geoffrey Munn in
Wartski 1977 catalog).
Their Graces the Duke and Duchess of
Westminster

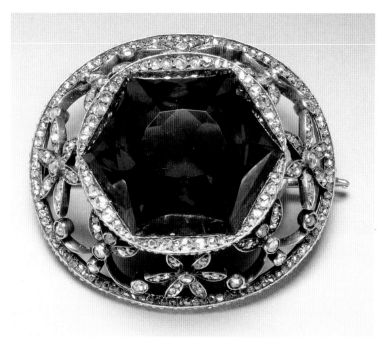

622A

622B

621

623

624

621. AMETHYST AND DIAMOND
BROOCH set with a large Siberian purple
amethyst within a white gold and diamond-set
stepped mount – Cyrillic initials K. F. for Carl
Fabergé, 56 (zolotnik), length 1⅝ in. (4.1cm).
Provenance: S.W. Ford, Inc., New York.
Exhibited: Lugano 1987, no. 89, cat. p. 90, ill.;
Paris 1987, no. 89, cat.p. 86, ill.; Houston 1994,
p. 33, ill.
The Forbes Magazine Collection, New York

622 A. GEM-SET GOLD EASTER
EGG set with a cabochon sapphire and cut by
a gold knife, the handle set with a diamond –
signed with initials K. F., assay mark
1908–1917, 56 (zolotnik).
Private Collection

622 B. GOLD AND ENAMEL EASTER
EGG decorated in black enamel with a score
of musical notes and inscribed with the
Russian text "And you will rule the World" –
signed with initials K. F. of Fabergé, assay mark
of St. Petersburg, 1899–1908, assay master
Alexander Romanov.
Private Collection

623. PAIR OF DIAMOND-SET TOR-
TOISESHELL HAIRPINS by Fabergé,
unmarked, length 3½ in. (8.9cm). Original
fitted gray suede case stamped with Imperial
Warrant, St. Petersburg, Moscow.
Private Collection

624. DIAMOND-SET AND
ENAMELED TORTOISESHELL
BARRETTE of convex shape applied with
flowerheads set with rose-cut diamonds and
with green enamel leaves – by Fabergé,
unmarked, length 3⅜ in. (8.5cm). Original
fitted box stamped with Imperial Warrant, St.
Petersburg, Moscow, London.
Courtesy of A La Vieille Russie

627

625

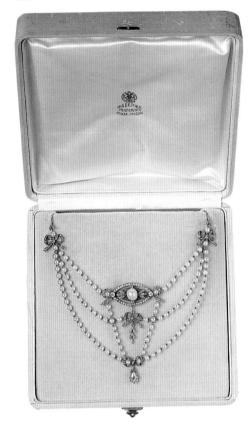

626

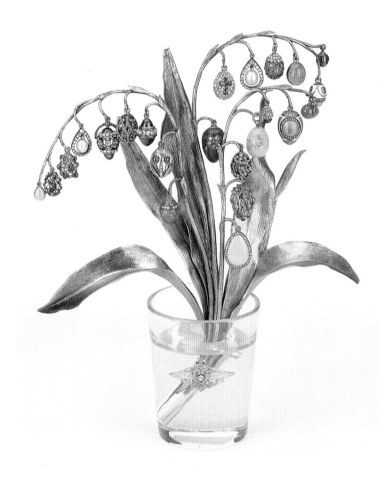

628

625. GEM-SET PEARL NECKLACE
with three rows of pearls suspended from
diamond-set ribbon ties, the central oval
diamond-set motif set with a pearl and flanked
by laurel, suspending a ribbon-tied laurel
branch, two pearl rows and a drop-shaped
diamond final, platinum chain – apparently
unmarked. Original fitted hollywood case
stamped with Imperial Warrant, Fabergé, St.
Petersburg, Moscow, London, the cover applied
with a silver plaque engraved "30 juin 1912".
Private Collection courtesy A. von Solodkoff

626. DIAMOND-SET CHALCEDONY
BROOCH of intertwined ribbon design
suspended from a bow knot, profusely set with
rose-cut diamonds, also suspended are three
pink tinted Mecca stone cabochons – initials of
workmaster Albert Holmström, assay mark of
St. Petersburg 1904–1908, assay master A.
Richter, height 2¹₂ in. (6.5cm). Original case
stamped with Imperial Warrant mark.
Joan and Melissa Rivers

627. GEM-SET PLATINUM EASTER
EGG PENDANT with a diamond-set chick
with ruby eye coming out of the broken egg-
shell – by Fabergé, apparently unmarked, c.
1900, height ¹¹₁₆ in. (1.8cm).
Exhibited: Hamburg 1995, cat. no. 233.
Private Collection courtesy A. von Solodkoff

628. GEM-SET AND ENAMEL GOLD
AND SILVER-GILT BOUQUET OF
LILIES OF THE VALLEY the three flower
branches with 23 jeweled Easter egg pendants
attributed to Fabergé, Koechli and other mak-
ers with engraved silver-gilt leaves set in a glass
vase carved to imitate water content and
applied with a gold imperial eagle – apparently
unmarked, height 8¹₂ in. (21.6cm).
Provenance: Grand Duke Paul Alexandrovitch
of Russia, son of Czar Alexander II.
Private Collection

(OVERLEAF)
629. NECKLACE WITH FIFTY-SIX
MINIATURE EASTER EGGS AND
CHARMS comprising 23 hardstone eggs,
9 enameled eggs, 8 gold eggs and 17 diverse
charms, including an Art Nouveau egg with
lilies-of-the-valley, signed with initial of
workmaster Michael Perchin and a bowenite
egg with a line of rose-cut diamonds signed
with initials of workmaster August Holmström.
Provenance: Queen Maria of Romania
Exhibited: QVC 1999.
Joan and Melissa Rivers

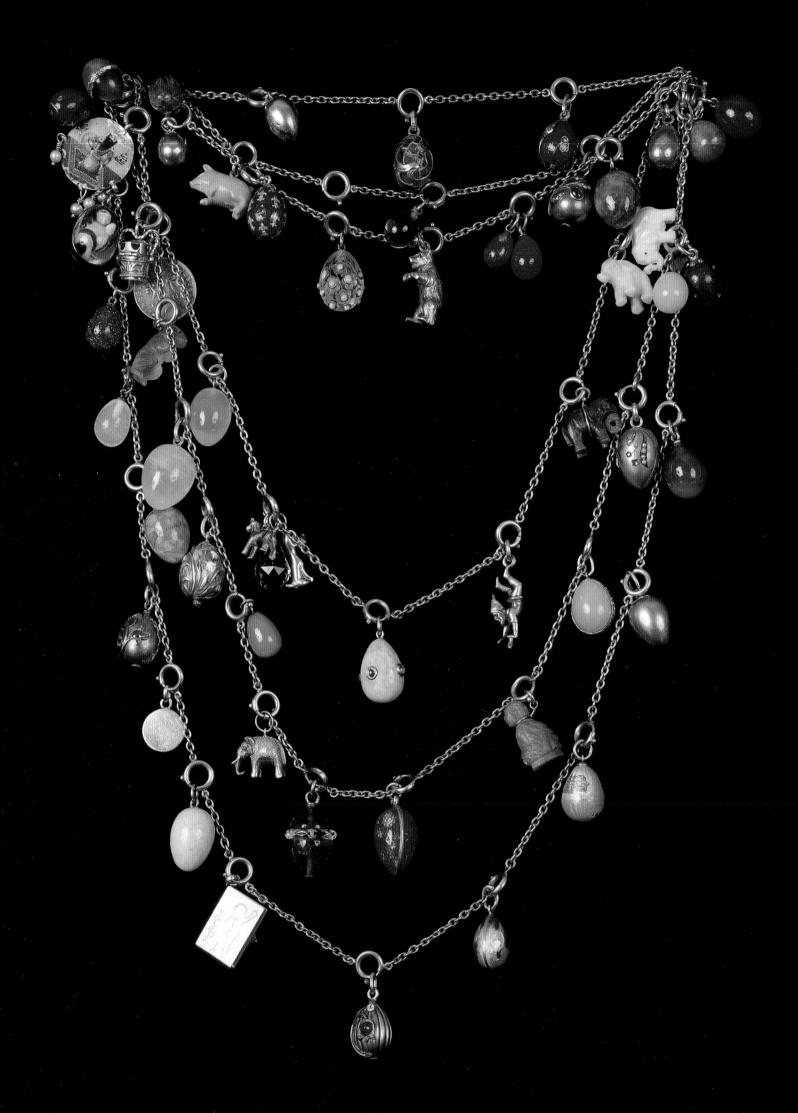

AUGUST HOLLMING

August Fredrik Hollming or Golming (1854–1913) (fig. 1), born in Loppi, Finland, was the son of a bookkeeper Anders Gustaf Hollming of Loviisa, and of Katarina Pettersson.[1] In 1870 he was apprenticed to the goldsmith Karl Fridolf Ekholm in Helsinki. Six years later, in 1876, he settled in St. Petersburg, first as a journeyman, registered at the parish of St. Mary's as a goldworker. In 1880 Hollming qualified as Master, opening a workshop at 35 Kazanskaya Street and was presumably hired by Fabergé soon after. He married Erika Gustava Abrahamsson and had three sons, of whom the eldest was August Väinö (1885–1934). In 1900 the Hollming workshop moved to 24 Bolshaya Morskaya under the same roof as Fabergé, where it was located on the third floor. After his father's death in 1913, Väinö Hollming, who had trained with his father, ran the workshop together with Otto Hanhinen, his father's long-standing assistant.

Together with Henrik Wigström, Hollming was the chief artisan of the large majority of Fabergé's cigarette-cases in silver, gold and enamel (cat.656–662). His workshop also produced a great variety of miniature Easter Eggs and small gem-set and enameled jewels such as cuff-links (cat. 639–642), brooches (cat. 636, 637, 648) and pins (cat. 646, 650). One of the finest examples of Hollming's work is an Imperial presentation box in yellow enamel in the Collection of HM the Queen Mother.[2]

FIG I. AUGUST HOLLMING Photograph courtesy of Ulla Tillander-Godenhielm

Notes
1. Ulla Tillander-Godenhielm, "Personal and Historical notes on Fabergé's Finnish Workmasters and Designers" in *Helsinki* (1980), p. 37–40.

2. Munich (1986/7), cat. 511.

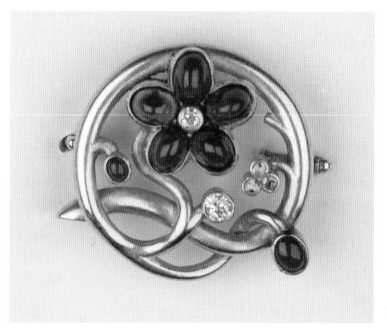

632

633

630

634

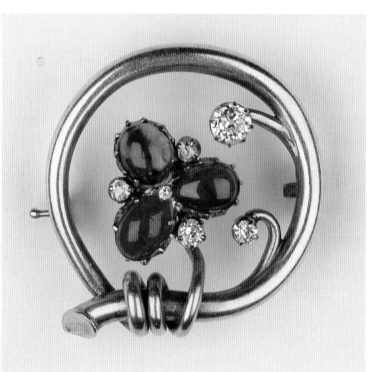

635

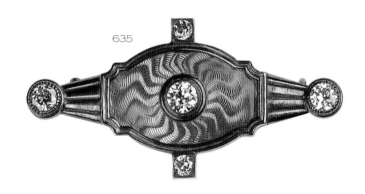

631

630. GEM-SET FLOWER BROOCH
set with five cabochon sapphires centered by a
diamond, the scrolling gold stem further set
with cabochon rubies and diamonds – initials
of workmaster August Hollming, assay mark of
St Petersburg before 1899, width 1 in. (2.5cm).
Private Collection

631. CIRCULAR GEM-SET GOLD
FLOWER BROOCH the central
flowerhead set with a cabochon ruby, sapphire
and emerald, the gold stem set with diamonds
– workmaster's initials of August Hollming,
before 1899, diam. 1⅛ in. (2.8cm).
Private Collection

632. GOLD-MOUNTED BOWENITE
CHARM shaped as an amphora – initials of
workmaster August Hollming, assay mark of
St. Petersburg 1899–1903, assay master Yakov
Lyapunov, 56 (zolotnik), height 1¼ in. (3.1cm).
Provenance: Gatchina Palace; Central
Depository for Suburban Palaces, 1956.
The State Hermitage Museum (ERO – 8418)

633. GOLD-MOUNTED HARD-
STONE CHARM shaped as a squirrel –
initials of workmaster August Hollming

634. GOLD-MOUNTED
RHODONITE MINIATURE EASTER
EGG initials of workmaster August Hollming.
The State Hermitage Museum (ERO – 5781)

635. OBLONG GEM-SET
ENAMELED GOLD BROOCH the
shaped centre with pale blue *guilloché* enamel
set with a brilliant-cut diamond, fluted gold
sides set with a further four diamonds –
workmaster's initials of August Hollming, assay
mark of St Petersburg 1899–1908, assay master
Alexander Romanov, inv no. 17204, length
1½ in. (3.8cm).
Private Collection

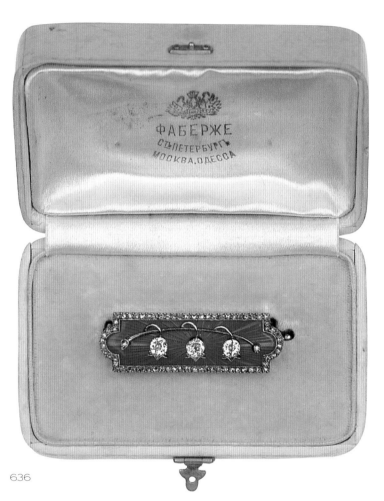

636

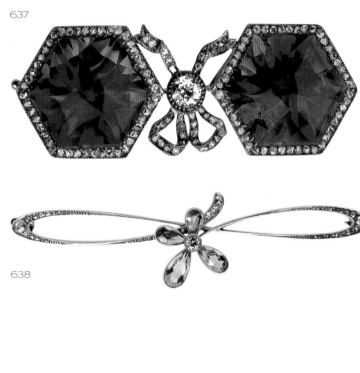

637

638

636. OBLONG DIAMOND-SET BLUE ENAMEL GOLD BROOCH decorated with a sprig of lily-of-the-valley, the three flowerheads set with brilliant cut diamonds on royal blue *guilloché* enamel ground with rose-cut diamond-set border – initials of workmaster August Hollming, assay mark of St. Petersburg 1899–1908, assay master Yakov Lyapunov, inv no. 72861, length 1½ in. (3.7cm). Original hollywood case stamped with Imperial Warrant, Fabergé, St Petersburg, Moscow, Odessa.
Private Collection

637. GEM-SET GOLD-MOUNTED DOUBLE AMETHYST BROOCH set with two hexagonal amethysts surrounded by rose-cut diamonds, a diamond set ribbon-tie with brilliant cut diamond in the center – initials of workmaster August Hollming, assay mark of St Petersburg 1899–1908, length 1¹³⁄₁₆ in. (4.7cm).
Private Collection

638. GEM-SET PERIDOT FLOWER BROOCH the flowerhead set with four oval cut peridots on a gold and diamond-set loop, the center with a brilliant-cut diamond – initials of workmaster August Hollming, assay mark of St. Petersburg 1899–1908, assay master Alexander Romanov, length 3¾ in. (9.3cm).
Private Collection

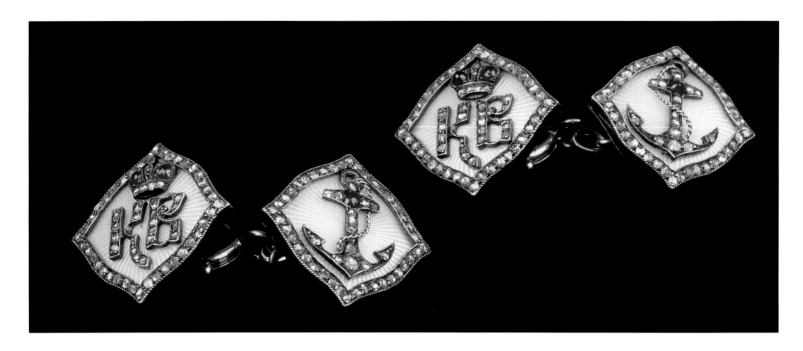

639

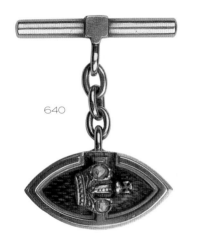
640

641

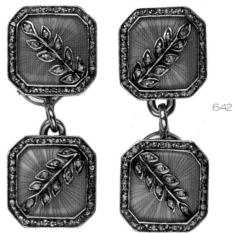

642

639. GRAND DUKE KIRILL VLADIMIROVICH CUFF-LINKS:
pair of square gem-set enameled gold Imperial presentation cuff-links each decorated with the crowned monogram of Grand Duke Kirill Vladimirovich and an anchor – Cyrillic initials K. F. for Fabergé, initials of workmaster August Frederick Hollming, assay mark of St. Petersburg 1899–1908, 56 (zolotnik), width ¾ in. (1.9cm).
Provenance: Grand Duke Kirill Vladimirovich, son of Tsar Alexander III's brother, Vladimir.
Bibliography: Waterfield/Forbes 1978, no. 98, ill. p. 81, cover; Solodkoff 1984, p. 168, ill. Kelly 1985, p. 18, ill. p. 19; Forbes 1987, no. 12, p. 16, ill.; Hill 1989, ill. title page.
Exhibited: Lugano 1987, no. 70, cat. p. 80, ill., Paris 1987, no. 70, cat. p. 76, ill.; St. Petersburg/ Paris/ London 1993/94, no. 74, cat. p. 226.
The anchors represent the Grand Duke's service as commander of the Garde Equipage, an élite corps of the Imperial Navy.
The Forbes Magazine Collection, New York

640, 641. PAIR OF GEM-SET AND ENAMEL GOLD IMPERIAL PRESENTATION CUFF-LINKS each link with the Cyrillic letter "E" enclosing a diamond-set Imperial crown on mauve *guilloché* ground, with gold chain and bar attachment – initials of workmaster August Hollming, assay mark of St. Peterburg 1899–1908, inv no. 1340, length ¾ in. (2cm). Original fitted red morocco case stamped with imperial eagle.
Provenance: Given by Tsar Nicholas II to an artist of the Imperial Hermitage Theatre ensemble. The letter "E" refers to Ermitage.
Exhibited: Hamburg 1995, cat. no. 223.
Private Collection courtesy of A. von Solodkoff

642. PAIR OF GEM-SET ENAMELED GOLD CUFF-LINKS each square link with canted corners enameled pink on *guilloché* ground with applied diamond-set laurel branches and diamond borders – workmaster's initials of August Hollming, assay mark of St. Petersburg 1899–1908.
Private Collection

643. SET OF SIX DIAMOND-SET ENAMELED GOLD STUDS of pink *guilloché* enamel with central rose-cut diamond – initials of workmaster August Hollming, assay mark of St. Petersburg 1899–1908, assay master Yakov Lyapunov, inv no. 8962. Original fitted case with Imperial Warrant mark, Moscow.
Private Collection

643

644

645

646

647

648

649

644. GEM-SET FLOWER BROOCH
SET with five pale blue oval Mecca stones to
form a flowerhead centered by a brilliant-cut
diamond, with curved diamond-set stem –
initials of workmaster August Hollming, assay
mark of St Petersburg 1899–1908, assay master
Yakov Lyapunov, length 1⁹⁄₁₆ in. (3.9cm).
Private Collection

645. PEARL-SET ENAMELED GOLD
ROUBLE COIN BROOCH the gold 5
Rouble coin dated 1764 with the gold profile
portrait of Catherine the Great on engraved
translucent red enamel background surrounded
by split-pearls – initials of workmaster August
Hollming, assay mark of St. Petersburg
1908–1917, diameter 1¹⁄₁₆ in. (2.6cm).
Private Collection courtesy A. von Solodkoff

646. ENAMELED GOLD RED
CROSS PIN decorated with a red enamel
cross on white ground within a gold framed
square standing on end and applied to a gold
safety pin – initials of workmaster August
Hollming, assay mark of St. Petersburg
1908–1917, inv no. 13109, length 1⁵⁄₈ in.
(4.8cm).
Private Collection

647. OBLONG GEM-SET AND
MAUVE ENAMEL BROOCH the center
set with a brilliant-cut diamond flanked by dia-
mond-set branches on a mauve *guilloché* enamel
panel with a border of rose-cut diamonds –
initials of workmaster August Hollming, assay
mark of St. Petersburg 1908–1917, inv no.
81409, length 1³⁄₄ in. (3.5cm).
Private Collection courtesy A. von Solodkoff

648
GEM-SET GOLD AND ENAMEL
IMPERIAL PRESENTATION BROOCH
the central imperial crown set with
two sapphires and diamonds on a hexagonal white
enamel panel flanked by openwork filigree
squares set with rose-cut diamonds – initials of
workmaster August Hollming, assay mark of
St. Petersburg 1908–1917, inv no. 3193, length
1¹⁄₄ in. (3.2cm). Original red morocco fitted
case, the cover gilt with the imperial eagle.
Exhibited: Hamburg 1995, cat. no. 213.
Private Collection courtesy A. von Solodkoff

649. CIRCULAR ENAMELED,
DIAMOND AND PEARL-SET GOLD
BROOCH/PENDANT the central disk of
pink *guilloché* enamel is bordered by a band of
opaque white enamel centrally set with a pearl
and rose-cut diamonds, surrounded by
alternating pearls and old mine diamonds –
signed Fabergé, initials of workmaster August
Hollming, assay mark of St. Petersburg
1908–1917, inv no. 81949.
Private Collection

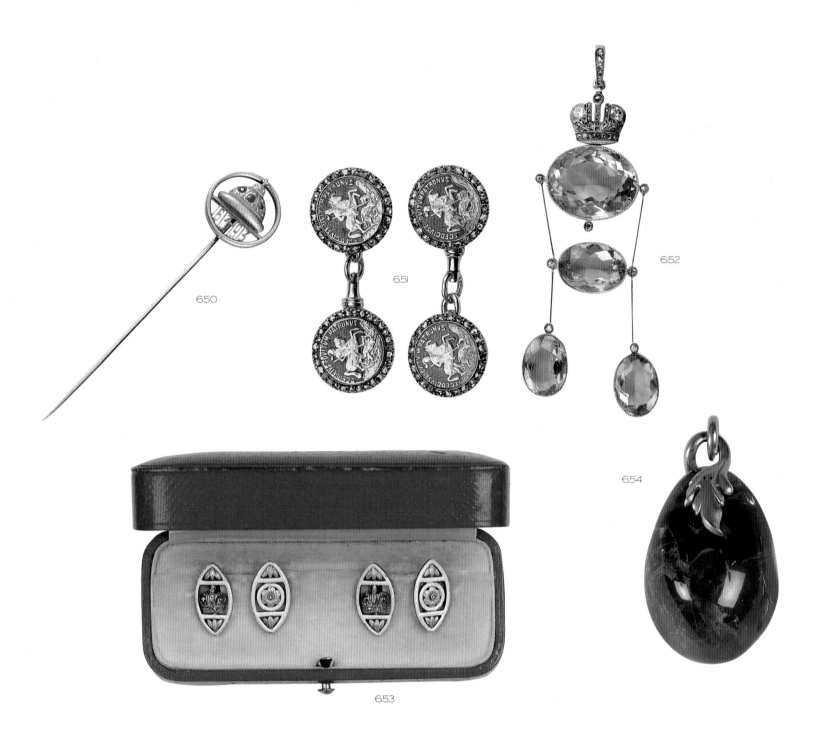

650. GEM-SET GOLD ROMANOV
TERCENTENARY IMPERIAL
PRESENTATION TIE-PIN with the
Monomakh crown set with a diamond, a
sapphire and a ruby, the dates 1613–1913
beneath, set in a gold circle – initials of
workmaster August Hollming, assay mark of
St. Petersburg 1908–1917. Original fitted real
leather presentation case stamped with gilt
imperial eagle.
Private Collection

651. PAIR OF GEM-SET RED ENAM-
ELED GOLD CUFF-LINKS with four
gold coins of St. George slaying the dragon
inscribed "St. Georgius equitum partonus"
enameled translucent red and surrounded by
rose-cut diamonds – initials of workmaster
August Hollming, assay mark of St. Petersburg
1908–1917.
Private Collection courtesy A. von Solodkoff

652. GEM-SET AMETHYST, DIA-
MOND AND GOLD IMPERIAL
PRESENTATION PENDANT with the
diamond-set imperial crown suspending four
fasceted oval amethysts on rose-cut diamond-
set links, with platinum chain – initials of
workmaster August Hollming, assay mark of
St. Petersburg 1908–1917, height 2⁷⁄₁₆ in.
(6.2cm). Original fitted red morocco case the
cover gilt with the imperial eagle.
Exhibited: Stockholm 1997, cat. no. 218.
Private Collection courtesy A. von Solodkoff

653. PAIR OF GEM-SET, GOLD AND
ENAMEL IMPERIAL PRESENTATION
CUFF-LINKS each openwork elliptical
link with imperial crown set with cabochon
sapphires and diamonds, flanked by gold leaves
surrounded by opalescent white enamel bands,
the opposite link with a white bordered rosette
set with rose-cut diamond – initials of
workmaster August Hollming, assay mark of
St. Petersburg 1908–1917, inv no. 3146, length
³⁄₄ in. (1.8cm). Original fitted red morocco case,
the cover stamped with the imperial eagle.
Exhibited: Hamburg 1995, cat. no. 227.
Private Collection courtesy A. von Solodkoff

654
GOLD-MOUNTED CABOCHON
AMETHYST PENDANT initials of
workmaster August Hollming, assay mark of
St. Petersburg, 1908–1917, length 1¹⁄₂ in.
(3.8cm). Original fitted case.
Private Collection
M.K.

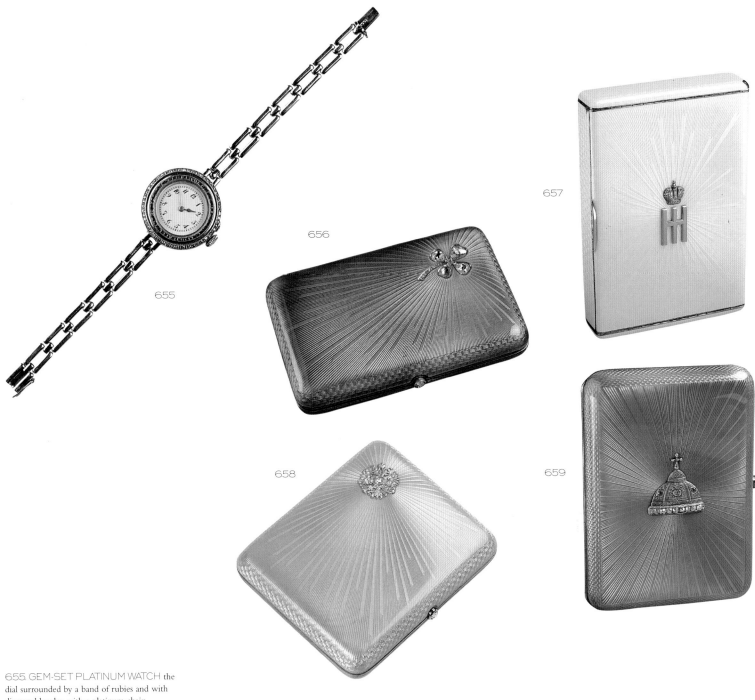

655 657

656

658 659

655. GEM-SET PLATINUM WATCH the
dial surrounded by a band of rubies and with
diamond border, with a platinum chain
bracelet – initials of workmaster August
Hollming, diameter $^{15}\!/_{16}$ in. (2.4cm).
Private Collection

656. DIAMOND-SET ENAMELED
SILVER-GILT CIGARETTE-CASE with
gray-green transparent enamel over a *guilloché*
sunburst issuing from a four-leaf clover set with
rose-cut diamonds, diamond pushpiece –
signed Fabergé, initials of workmaster August
Hollming, assay mark of St. Petersburg
1899–1904, assay master Yakov Lyapunov,
length 3¾ in. (9.5cm). Inscribed in Cyrillic
"To dear Nicky from Mama, May 6th, 1900".
Provenance: Presented to Tsar Nicholas II by
his mother Empress Maria Feodorovna on the
occasion of his 32nd birthday.
Bibliography: Traina 1998, ill. p. 50.
The gray-green color is that of his favorite
regiment, the Preobrazhensky, of which he
was Commander-in-Chief.
John Traina Collection

657. PRESENTATION ENAMELED
SILVER-GILT CIGARETTE-CASE of
opalescent pale white sunburst *guilloché*
enamel centered on crowned cypher "NN" –
signed Fabergé, initials of workmaster August
Hollming, assay mark of St. Petersburg
1908–1917, length 3¾ in. (9.5cm).
Provenance: Presented by Grand Duke Nikolai
Nikolaievich (1856–1929), the immensely tall
uncle of Nicholas II, who commanded the
Russian forces in 1914/15.
Bibliography: Traina 1998, p. 56.
John Traina Collection

658. RECTANGULAR GEM-SET
GOLD-MOUNTED SILVER-GILT AND
PINK ENAMEL CIGARETTE-CASE of
sunray *guilloché* enamel, the cover set with a
gold double-headed eagle set with a diamond,
the pushpiece with rose-cut diamond – signed
Fabergé, initials of workmaster August
Hollming, assay mark of St. Petersburg
1899–1908, length 3⅜ in. (8.6cm). Original
fitted hollywood case, the cover applied with a
gilt imperial eagle.
Provenance: Imperial present from Tsar
Nicholas II during a state visit to France.
The Hubel Collection

659. JEWELED AND ENAMELED
SILVER-GILT CIGARETTE-CASE of
steel-blue sunburst *guilloché* enamel centered on
a Monomakh crown set with rose-cut diamonds,
a ruby, sapphire and diamond, rose-cut diamond
pushpiece – signed Fabergé, initials of
workmaster August Hollming, assay mark of
St. Petersburg 1908–1917, length 3⅝ in. (9.2cm).
Biography: Traina 1998, p. 57.
Exhibited: New York/San Francisco et al.
1996/7, cat. 379.
The Monomakh crown was first used at the
coronation of Tsar Michael Romanov in 1613.
It became a symbol of Romanov rule during
the reign of Nicholas II in connection with
festivities marking the Romanov Tercentenary
in 1913.
John Traina Collection

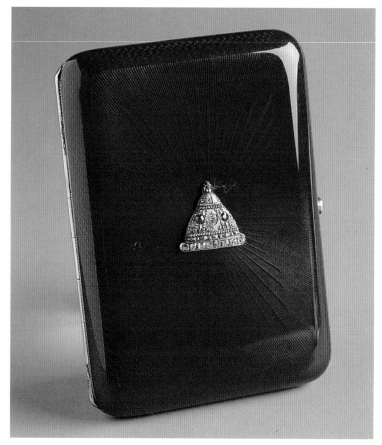

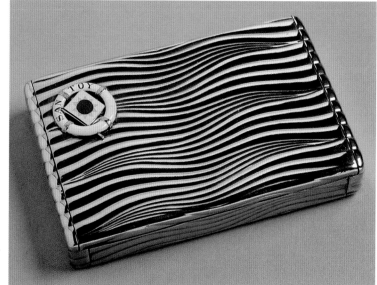

660

662

660. FABERGÉ IMPERIAL
PRESENTATION JEWELED
ENAMELED CIGARETTE-CASE of red
sunburst *guilloché* enamel centered on a
Monomakh crown set with rose-cut diamonds,
a ruby, sapphire and diamond – signed Fabergé,
initials of workmaster August Hollming, assay
mark of St. Petersburg 1908–1917, length
3³⁄₄ in. (9.5cm). Original fitted real leather case.
Provenance: Presented by Tsar Nicholas II
to the Head of the Forests of Poland to
commemorate the Romanov Tercentenary
in 1913.
Bibliography: Traina 1998, p. 61.
Exhibited: New York/San Francisco et al.
1996/7, cat. 380.
John Traina Collection

661. GEM-SET SAMORODOK GOLD
CIGARETTE-CASE randomly set with
two emeralds, rubies and diamonds, cabochon
sapphire thumbpiece – signed Fabergé, initials
of workmaster August Hollming, assay mark of
St. Petersburg 1908–1917, length 3¹⁄₂ in. (9cm).
Bibliography: Traina 1998, p. 105.
John Traina Collection

662. ENGINE-TURNED SILVER
CIGARETTE-CASE decorated with waves
and with an enameled lifebuoy inscribed San
Toy, spring loaded – signed Fabergé, initials of
workmaster August Hollming, assay mark of
St. Petersburg 1908–1917, length 3⁵⁄₈ in.
(9.2cm).
Bibliography: Traina 1998, p. 145
(lower center).
John Traina Collection

ANDERS NEVALAINEN

Anders (Anti) Juhaninpoika Nevalainen (1858–1933) (fig. 1) was born in Pielisjärvi, Finland, son of Johan Nevalainen of Kylälahti and of Margareta Waltonen.[1] Following a local apprenticeship, he traveled to St. Petersburg as a journeyman in 1874 and his name is entered in the books of the parish of St. Mary's in 1875 as a goldworker. In 1884 he married Maria Karolina Liljerot. Their five children included a son, Arvid (1897–1936), who was a clockmaker. In 1885 Nevalainen became master goldsmith, first working in the jewelry atelier of August Holmström, and soon thereafter as head of a workshop under exclusive contract with Fabergé. Following the 1917 upheaval, the family returned to Finland, where Nevalainen died in Terijoki in 1933.

The Nevalainen workshop is chiefly known for its silver-mounted frames in birchwood, palisander or lacquer (cat. 687), some of them embellished with a *guilloché* enamel border. (cat. 686) The workshop also made silver or gold cigarette-cases, (cat. 680–682); enameled silver-gilt cases with leather sleeves (cat. 678, 679); and numerous small enameled silver gilt objects – menu holders (cat. 672), vodka-cups (cat. 670) and charki (cat. 671); silver-mounted boxes (cat. 674, 676), ceramic articles (cat. 663); and covers for note-pads (cat. 668–669). His initials appear on objects made in St. Petersburg combined with the full "K. Fabergé" signature in Cyrillic, otherwise only found on Moscow-made pieces. The "K. Fabergé" mark is furthermore generally accompanied by a separate double-headed eagle punch denoting the obtention by the firm of an Imperial Warrant. The so-called Imperial Warrant mark used by Fabergé in Moscow differs from the hallmark found on St. Petersburg pieces, combining the signature "K. Fabergé" with the double-headed eagle in a single punch. This anomaly, which also appears on objects made by the silver workshops of Julius Rappoport and the Wäkeva family, has not been satisfactorily explained. Contrary to earlier belief, none of these craftsmen actually worked in Moscow. Their wares may, however, have been supplied to the Moscow branch under a special agreement.

Géza von Habsburg

FIG I. ANDERS NEVALAINEN
Photograph courtesy Ulla Tillander-Godenhielm

Notes
1. See Ulla Tillander-Godenhielm, "Personal and Historical Notes on Fabergé's Finnish Workmasters and Designers" in *Helsinki* (1980), p. 42.

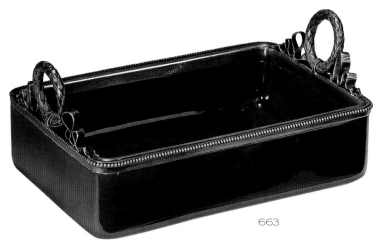

663

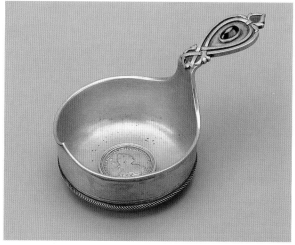

666

664

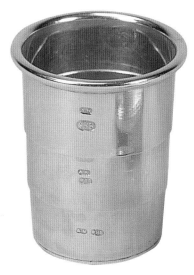

665

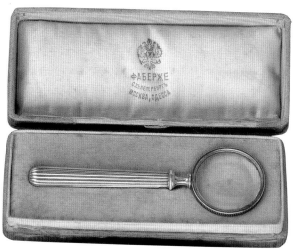

667

663. SILVER-MOUNTED CERAMIC TRAY deep rectangular brown glazed tray with silver mounts and two handles in the shape of laurel wreaths and ribbons – initials of Anders Nevalainen, assay mark of St. Petersburg before 1899, inv no. 3199, length 6¹4 in. (15.9cm).
Private Collection

664. SILVER-MOUNTED SAND-STONE MATCH-HOLDER shaped like boletus mushroom, the base with reeded silver mount, applied with a small silver frog, the top with silver-lined circular opening for matches – initials of workmaster Anders Nevalainen, assay mark of St. Petersburg before 1899, inv no. 2962, height 3¹8 in. (7.9cm).
Private Collection

665. SILVER TELESCOPIC SPIRIT CUP formed from three silver segments, the base inset with a silver 50 kopeck coin dated 1895 – initials of workmaster Anders Nevalainen, assay mark of St. Petersburg before 1899, height 1⁹16 in. (4cm). Original brown leather case stamped with Imperial Warrant.
Private Collection

666. SMALL SILVER KOVSH the handle set with an almandine, the base with silver 20 kopeck coin of Catherine the Great – initials of workmaster Anders Nevalainen, assay mark of St. Petersburg before 1899, inv no. 4011, length 4⁷16 in. (11.3cm).
Provenance: State depository of valuables, 1951.
The State Hermitage Museum (ERO – 7607)

667. SILVER MAGNIFYING GLASS with tapering reeded handle – initials of workmaster Anders Nevalainen, assay mark of St Petersburg 1899–1908, 88 (zolotnik), inv no. 13485, length 3³4 in. (9.5cm). Original gray silk case stamped with Imperial Warrant, Fabergé, St. Petersburg, Moscow, Odessa.
Private Collection

668

669

670

671

673

672

670. JEWELED SILVER AND ENAMEL MINIATURE VODKA-CUP
the barrel enameled in shaped sections with translucent cornflower blue over scaly engine-turning and oyster white divided by silver bands, beaded foot, the handle formed by entwined snakes attached to a bracket set with moonstone – stamped K. Fabergé and with Imperial Warrant, initials of workmaster Anders Nevalainen, assay mark of St. Petersburg 1899–1908, inv no. 7114, height 1⅝ in. (4.1cm).
Private Collection

671. SILVER-MOUNTED GUILLOCHÉ ENAMEL AND GEM-SET CHARKA
the handle is formed as a stylized toucan, the hemispherical bowl with salmon pink *guilloché* enamel, with silver-gilt rim on three ball feet, with mounted bear-claw beak and cabochon ruby eyes – stamped K. Fabergé, initials of workmaster Anders Nevalainen, assay mark of St. Petersburg 1899–1908, inv no. 11099; London import marks for 1909, length 3⅛ in. (8cm).
Private Collection

668. RECTANGULAR ENAMEL AND SILVER-GILT MOUNTED PALISANDER NOTE-PAD HOLDER
the mount of pale blue *guilloché* enamel decorated with laurel garlands surmounted by a ribbon tie, the sides with moonstone set, acorn finials reveal a pencil, the wooden board is applied with laurel, a beaded band and with a rosette between laurel branches – signed Fabergé with Imperial Warrant, initials of workmaster Anders Nevalainen, assay mark of St. Petersburg 1899–1908, 88 (zolotnik), inv no. 16134.
Exhibited: Helsinki, 1980, nr. 74.
Private Collection

669. RECTANGULAR SILVER-GILT, ENAMEL AND NEPHRITE NOTE-PAD HOLDER the cover with red *guilloché* enamel panel applied with a laurel wreath and four palmettes to the corners with reed-and-tie border on a nephrite plaque further applied with four rosettes, the silver-gilt hinge with artichoke finials, one hiding a pencil, on nephrite base – signed Fabergé, initials of workmaster Anders Nevalainen, assay mark of St. Petersburg 1899–1908, assay master Alexander Romanov, inv no. 12677, length 6¼ in. (15.9cm).
Private Collection courtesy A. von Solodkoff

672. PAIR OF ENAMEL SILVER-GILT MENU HOLDERS enameled in translucent rose Pompadour, Louis XVI-style mounts – stamped K. Fabergé, with Imperial Warrant, initials of workmaster A. Nevalainen, assay mark of St. Petersburg, inventory nos. 13254 and 12454, length 4 in. (10cm).
Private Collection

673. SILVER TANKARD in early 18th-century style standing on three ball feet, the cover applied with a 50-kopeck piece of Catherine the Great, the sides with three 10-kopeck coins of Empress Elizabeth I – signed K. Fabergé, initials of workmaster Anders Nevalainen, assay mark of St. Petersburg 1899–1903, assay master Yakov Lyapunov, 88 (zolotnik), height 4⅛ in. (10.5cm).
Provenance: State Valuables Depository, 1951.
Bibliography: Russian Enamel, 1987, No. 157.
Exhibited: Leningrad 1990, cat. 33.
This silver tankard repeats the shape of Russian and West European tankards of the 18th century. The tradition of decorating commemorative articles with coins and medals was a characteristic feature of Russian jewelry and metalwork from the 18th century.
The State Hermitage Museum (ERO – 7698)

674

676

675

677

674. RECTANGULAR SILVER-
MOUNTED AMARANTH BOX signed
Fabergé, initials of workmaster Anders
Nevalainen, assay mark of St. Petersburg
1899–1903, assay master Yakov Lyapunov, 84
(zolotnik), length 4¹⁵⁄₁₆ in. (12.5cm).
Provenance: State Museum of Ethnography,
1941.
Very simple in form, this box is decorated
only with a thin silver stripe. This kind of
inexpensive but elegant object allowed Fabergé
greatly to increase its circle of customers.
The State Hermitage Museum (ERO – 5388)

675. ENAMELED SILVER-GILT
TEAGLASS-HOLDER with opaque blue
enamel exterior, female therm handle, tied
laurel wreath rims, tied ribbon to the front,
oval *guilloché* enamel apertures beneath, the
based chased with stiff-leaf decoration – signed
K. Fabergé, initials of workmaster Anders
Nevalainen, assay mark of St. Petersburg
1899–1904, assay master A. Richter, inv no.
14793, height 3¹⁄₄ in. (8.5cm).
André Ruzhnikov

676. SILVER-MOUNTED
MAHOGANY BOX opening in four
directions – signed Fabergé, initials of work-
master Anders Nevalainen, assay mark of St.
Petersburg 1908–1917, length 7 in. (17.9cm).
Private Collection

677. SAMORODOK SILVER
CIGARETTE-CASE with match
compartment, tinder-cord and sapphire
thumpiece – signed K.Fabergé, with Imperial
Warrant, workmaster Anders Nevalainen, assay
mark of St. Petersburg before 1899, inv no.
4030, length 4³⁄₄ in. (12cm). Inscribed: "In steter
Dankbarkeit, Hans Tochen 18-6-18".
Bibliography: Traina 1998, p. 102 (bottom).
Exhibited: Corcoran 1996/7.
John Traina Collection

679 681 682

678. REEDED SILVER CIGARETTE-CASE set with a gold 7¹2 rouble coin with profile effigy of Tsar Nicholas II, with silver-trimmed leather case – signed K.Fabergé, initials of workmaster Anders Nevalainen, assay mark of St. Petersburg 1899–1908, assay master Yakov Lyapunov, inv no. 11222, length 4 in. (10.1cm).
Bibliography: Traina 1998, p. 71.
All of Fabergé's cigarette-cases with these leather slip covers were made in Nevalainen's workshop.
John Traina Collection

679. ENAMELED SILVER-GILT CIGARETTE-CASE of scarlet hue over a swirling *guilloché* pattern issuing from a circular-cut diamond at one corner, green leather slipcase – signed K.Fabergé, Imperial Warrant mark, initials of workmaster Anders Nevalainen, assay mark of St. Petersburg 1899–1904, assay master Yakov Lyapunov, inv no. 9831, length 3³4 in. (9.5cm).
Bibliography: Traina 1998, p. 133 (bottom).
John Traina Collection

680. RIBBED SILVER CIGARETTE-CASE the cover with four triangular panels of narrow and wide bands and an enameled rendering of St. George and the Dragon, cabochon sapphire thumpiece – signed K. Fabergé, with Imperial Warrant, initials of workmaster Anders Nevalainen, assay mark of St. Petersburg 1899–1904, assay master Yakov Lyapunov, inv no. 13726, length 4¹2 in. (11.5cm).
Bibliography: Traina 1998, p. 145 (top right).
John Traina Collection

681. SILVER CIGARETTE-CASE the wire-brushed body set with a silver 50-kopeck coin of Empress Elizabeth with red *guilloché* enamel background, cabochon sapphire pushpiece – signed K. Fabergé, initials of workmaster Anders Nevalainen, assay mark of St. Petersburg 1899–1904, assay master Yakov Lyapunov, inv no. 5992, length 3¹2 in. (9cm).
Bibliography: Traina 1998, p. 145 (bottom right).
John Traina Collection

682. ENGINE-TURNED CIGARETTE-CASE with panels of swirling flutes centered on an English gold St. George coin with red *guilloché* enamel background, with match compartment, aperture for tinder cord and red cabochon stone thumbpiece – signed K. Fabergé, with Imperial warrant, initials of workmaster Anders Nevalainen, assay mark of St. Petersburg 1899–1904, assay master Yakov Lyapunov, inv no. 13726, length 4¹2 in. (11.5cm).
Bibliography: Traina 1998, p. 145 (left).
John Traina Collection

683

685

684

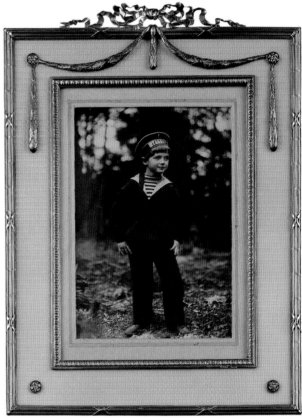

686

683. OVAL SILVER-GILT AND RED ENAMEL FRAME with a portrait of Empress Maria Feodorovna standing in a park signed V. Zuiev 1903, the bezel with a pellet band, the border of sunray *guilloché* enamel with plain rim, wooden backing and strut – signed Fabergé, initials of workmaster Anders Nevalainen, assay mark of St. Petersburg 1899–1908, height 5³⁄4 in. (14.6cm).
Provenance: Given by Empress Maria Feodorovna, honorary president of the Red Cross to Princess Alexandra Obolensky, Countess M. Chernychev-Bezobrazov.
Exhibited: St. Petersburg, Paris, London 1993, cat. no. 138; Hamburg 1995, cat. no. 157.
Private Collection courtesy A. von Solodkoff

684. TRIANGULAR ENAMELED SILVER FRAME of mauve *guilloché* enamel, the aperture with beaded bezel and ribbon cresting, outer reed-and-tie border, with wooden back and silver strut – with full signature K. Fabergé and separate Imperial Warrant mark, initials of workmaster Anders Nevalainen, assay mark of St. Petersburg 1899–1908, assay master Yakov Lyapunov, height 5³⁄4 in. (14.5cm).
Michael and Ella Kofman Collection

685. KAISER WILHELM FRAME enameled silver-gilt and hollywood frame with reed-and-tie outer border and set with a rectangular panel of pale blue enamel over a *guilloché* sunburst pattern with ribbon-tied victor laurels at the corners – Imperial Warrant mark of Fabergé, initials of workmaster Anders Johan Nevalainen, assay mark of St. Petersburg 1899–1904, initials of assay master A. Richter, 91 (zolotnik), height 11³⁄4 in. (29.9cm). Original photograph of Kaiser Wilhelm II of Germany inscribed: "William/Berlin Feb. 1909".
Provenance: Presented by Kaiser Wilhelm II to an equerry of his uncle, King Edward VII, Berlin, February 1909.
Bibliography: Waterfield/Forbes 1978, no. 81, ill. pp. 69, 143; Kelly 1982/83, pp. 9, 13; Solodkoff 1984, p. 171, ill.; Kelly 1985, p. 16, ill. pp. 12, 17; Forbes 1988, p. 43, ill.
Exhibited: Munich 1986/87, no. 460, cat. p. 235, ill.; Lugano 1987, no. 37, cat. p. 57, ill.; St. Petersburg/Paris/London 1993/94, no. 98, cat. p. 246, ill. p. 247.
Apparently, a special commission from Kaiser Wilhelm II during one of his visits to St. Petersburg, made for presentation and containing an original signed photograph.
The Forbes Magazine Collection, New York

686. PALE BLUE FRAME enameled silver, silver-gilt and hollywood frame with reed-and-tie border and set with a rectangular panel of pale blue enamel over a *guilloché* basketweave pattern with rosettes at the corners, the upper two of which are connected by a chased laurel swag suspended from the gold ribbon-tied cresting – signed Fabergé, initials of workmaster Anders Johan Nevalainen, assay mark of St. Petersburg 1899–1908, 91 (zolotnik), inv no. 15788, height 8¹⁄4 in. (21cm).
The frame now contains a postcard portrait of Tsarevich Alexis in a sailor suit with the name of the Imperial yacht "*Standart*".
Bibliography: Waterfield/Forbes 1978, no. 75, ill. pp. 66, 143; Milet/Forbes 1979, p. 44, ill.; Kelly 1982/83, ill. no. 10; Solodkoff 1984, p. 171, ill.
A sketch for a wooden frame with similar mounts is illustrated in St. Petersburg/Paris/London 1993/94, no. 346, cat. p. 419.
The Forbes Magazine Collection, New York

687

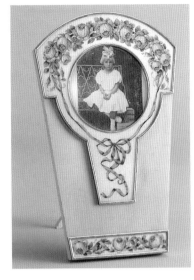

688

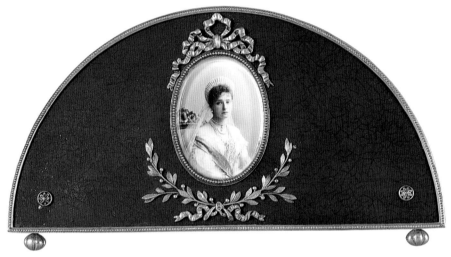

689

690

689. SEMI-CIRCULAR SILVER-GILT MOUNTED BLUE LACQUER FRAME the oval aperture surmounted by ribbon ties, with crossed laurel sprays beneath, rosettes at corners, melon and silver-gilt strut – initials of workmaster Anders Nevalainen, St. Petersburg 1899–1908, assay master Yakov Lyapunov, 3⅜ in. (8.6cm). Original photograph of Tsarina Alexandra Feodorovna.
Exhibited: New York/San Francisco et al. 1996/7, cat. 317.
Louise and David Braver

690. RECTANGULAR ENAMELED AND SILVER-MOUNTED WOODEN FRAME of two-colored wood, with a tied ribbon above the aperture, beaded bezel and wooden strut – signed Fabergé, initials of workmaster Anders Nevalainen, assay mark of St. Petersburg 1899–1908, assay master Yakov Lyapunov, 84 (zolotnik), height 13 in. (33cm). Photograph of an unknown young woman.
Provenance: Acquired by the State Hermitage, 1981.
The State Hermitage Museum (ERO – 9286)

687. LARGE RECTANGULAR SILVER-MOUNTED, NEPHRITE AND BIRCHWOOD FRAME the inner aperture with nephrite border applied with holly leaves and rosettes, with wooden back and strut – initials of workmaster Anders Nevalainen, St. Petersburg 1904–1908, assay master A. Romanov, height 12⅝ in. (32cm).
Louise and David Braver

688. RECTANGULAR ENAMELED SILVER FRAME signed Fabergé, initials of workmaster Anders Nevalainen, assay mark of St. Petersburg 1899-1908, 84 (zoltnik), inv no. 11103, height 7½ in. (19cm).
Provenance: In the Museum fund; State Museum of the Ethnography of Nations of the USSR, 1941.
The State Hermitage Museum (ERO – 6762)

VICTOR AARNE

Johan Victor Aarne (1863–1934) (fig. 1) was born in Tampere, Finland and was the son of church sexton Johan Lindström.[1] He completed his apprenticeship with Johan Erik Hellsten, a goldsmith in Tampere and became a journeyman in Hämeenlinna in 1880. For ten years, between 1880 and 1890 he worked for Fabergé in August Holmström's workshop. In 1890 he returned to Tampere to obtain his title of Master and ran his own workshop there for a year. In 1891 he returned to St. Petersburg, working exclusively for Fabergé until 1904 from his workshop at 58 Demidov Cross-Street/Ekatarinski Canal. He married Hilda Emilia Kosonen and had ten children of whom the eldest, Uuno Viktor, was also a goldsmith. After the turn of the century his workshop employed twenty journeymen and three apprentices. In 1904 Aarne sold his workshop to Hjalmar Armfeldt, a workmaster under the silversmith Anders Nevalainen, and settled in Viipuri (Vyborg), Finland, running a successful goldsmithing workshop for another thirty years. He died in Vyborg in 1934.

Aarne's speciality were exquisite miniature frames of enameled gold, many of them barely 1½ inches high.[2] They are often decorated with four-color gold swags (cat. 694, 702). Some of Aarne's frames are larger, fashioned out of silver and enamel. (cat. 703)[3] The workshop also produced fine gold cigarette-cases (cat. 705) and, more rarely, enameled gold cane handles.[4] The quality of Aarne's work was highly esteemed by Fabergé. Agathon, Fabergé's son, is reported to have said to Hjalmar Armfeldt, when he left Nevalainen to take over Aarne's workshop: "there is a great difference between Aarne and Nevalainen. We have become accustomed to having a high opinion of Aarne's firm. Can you guarantee that we shall be able to go on having such a high opinion of it?"[5]

FIG I. VICTOR AARNE Photograph courtesy Ulla Tillander-Godenhielm

Notes
1. Ulla Tillander-Godenhielm, "Personal and Historical Notes on Fabergé's Finnish Workmasters and Designers" in *Helsinki* (1980), p. 40f.

2. Habsburg (1986), cat. 423, 425, 429, 461, 519–522.

3. *Ibid.*, cat. 458, 487, 498–500.

4. *Ibid.*, cat. 483.

5. Ulla Tillander-Godenhielm in Stockholm (1997), p31.

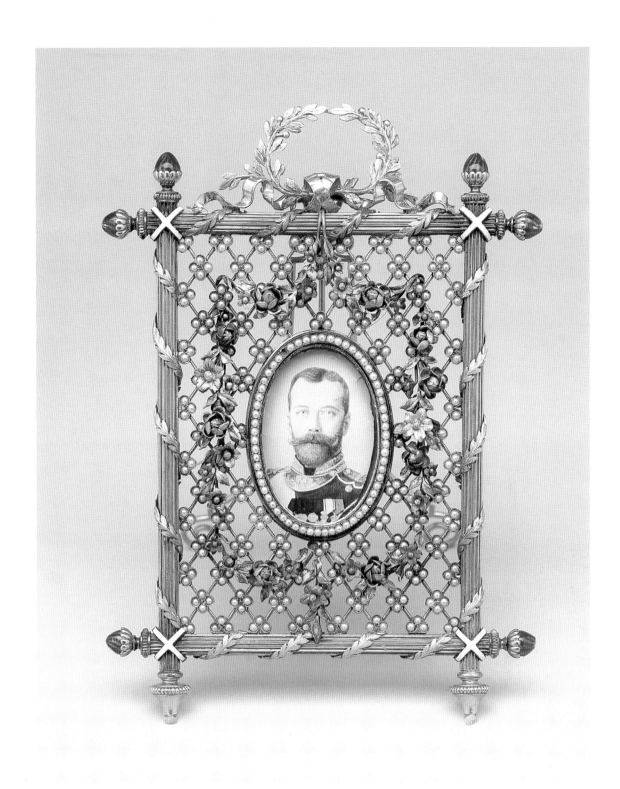

691A. ROSE TRELLIS FRAME pearl-set
and enameled varicolored gold frame with four
reeded rods with scarlet enamel flame finials
forming the perimeter, surmounted with a
ribbon-tied laurel wreath cresting; the staffs are
entwined with chased green-gold foliage and
white opaque enamel ties mark where they
overlap. Filling the frame is a gold trellis set with
quatrefoil pearl clusters at the intersections, the
whole applied with a four-color gold floral
wreath forming a rectangular surround for the
oval pearl bordered aperture – signed Fabergé,
initials of workmaster Johann Victor Aarne, assay
mark of St. Petersburg before 1899, 56
(zolotnik), inv no. 58804, height $4^{1}4$ in.
(10.8cm). The frame now contains a photograph
of Tsar Nicholas II in uniform.
Bibliography: Waterfield/Forbes 1978 no. 73, ill.
pp. 64, 143; Kelly 1982/83, ill. no. 15; Solodkoff
1984, p. 171, ill.
The Forbes Magazine Collection, New York

691B

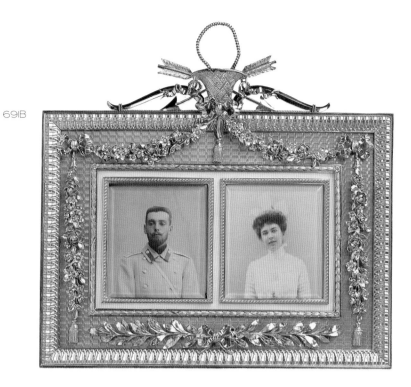

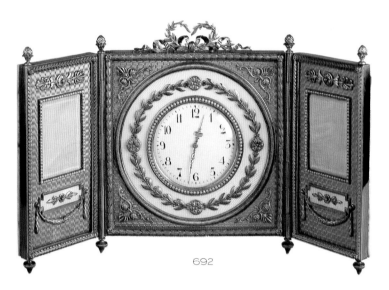

692

693

691 B. RECTANGULAR ENAMELED
SILVER-GILT DOUBLE
PHOTOGRAPH FRAME of apple green
guilloché enamel applied with flower swags
suspended from cresting, consisting of a basket
and a bow and arrow symbolizing love, with
anthemion rim, white *guilloché* enamel border to
the apertures, wooden back and silver strut –
signed Fabergé, initials of workmaster Victor
Aarne, assay mark of St. Petersburg before 1899,
inv no. 1796, length 7 in. (17.8cm).
Private Collection

692. ENAMELED SILVER-GILT
TRIPTYCH DESK CLOCK and
photograph frame of green and white *guilloché*
enamel standing on four thyrsos staffs acting as
hinges, comprising a square clock flanked by
two upright rectangular photograph frames, the
white opaque enamel dial with Arabic
chapters, gold "Louis XV" hands and seed pearl
bezel set in a circular translucent white enamel
field over sunburst *guilloché* ground applied
with a laurel wreath and rosettes, the spandrels
of apple green *guilloché* enamel applied with
anthemion and with double laurel crown
cresting; the pair of apple green *guilloché*
enamel frames with square apertures framed in
seed pearls with small white *guilloché* enamel
panels suspending laurel swags beneath; silver-
gilt back and strut – signed Fabergé, initials of
workmaster Victor Aarne, assay mark of
St. Petersburg 1899–1908, length (open)
8¼ in. (21cm).
Exhibited: Hamburg 1995, cat. 90.
The workshop of Victor Aarne occasionally
produced ambitiously complex objets d'art,
especially frames. Apple green was one of
Aarne's signature colors.
Private Collection

693. SILVER-GILT AND HOLLY-
WOOD FRAME of shaped outline with two
superimposed oval apertures, applied with
suspended floral swags, with ribbon-cresting,
wooden back and strut, standing on two stud
feet – signed Fabergé, initials of workmaster
Victor Aarne, St. Petersburg before 1899, 88
(zolotnik), height 6¾ in. (17.1cm).
Louise and David Braver

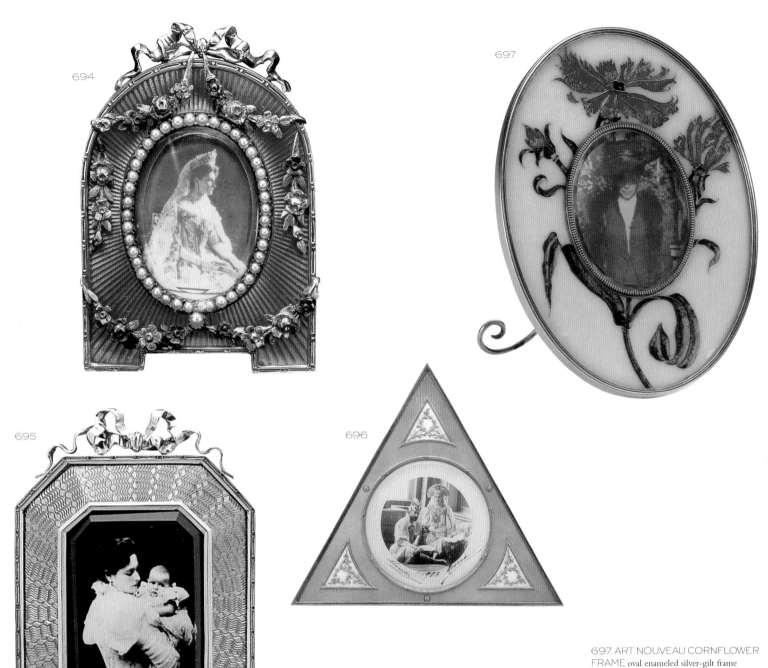

694

695

696

697

694. MINIATURE PINK FRAME gold-mounted silver gilt frame enameled deep rose over a guilloché sunburst pattern and decorated with floral swags in four-color gold, the whole surmounted by a ribbon-tied cresting – signed Fabergé, initials of workmaster Johann Victor Aarne, initials of assay master Yakov Lyapunov, 56 (zolotnik) on bottom rim, 88 (zolotnik) on strut, inv no. 3076, height 1¾ in. (4.5cm). The oval pearl bordered aperture encloses a photograph of Tsarina Alexandra in profile wearing a traditional Russian kokoshnik (crown).
Bibliography: Kelly 1982/83, ill. no. 17; Solodkoff 1984, pp. 39, 171, ill.; Habsburg 1987, p. 246, ill.; McCarthy 1993, ill. p. 16; Exhibited: Munich 1986/87, no. 494, ill. p. 246; Lugano 1987, no. 39, cat. p. 62, ill.; Paris 1987, no. 39, cat. p. 58, ill.; St. Petersburg/Paris/London, no. 29, cat. p. 184, ill.
The Forbes Magazine Collection, New York

695. MINIATURE FRAME WITH CHAMFERED EDGES
rectangular enameled silver-gilt frame with chamfered edges enameled mauve over a guilloché ground with a silver gilt ribbon-tied cresting – signed Fabergé, initials of workmaster Johann Victor Aarne, assay mark of St. Petersburg 1899–1908, 88 (zolotnik), inv no. 3083, height 2⁵⁄₁₆ in. (5.9cm). Photograph of Tsarina Alexandra Feodorovna holding her infant daughter, Grand Duchess Tatiana who was born on May 29, 1897.
Bibliography: Solodkoff 1984, p. 172, ill.; Kelly 1985, ill. pp. 12, 16; Forbes 1988, p. 43, ill.; Solodkoff 1988, p. 106, ill.
Exhibited: New York 1983, no. 75, ill. p. 73; Lugano 1987, no. 43, ill. p. 65; Paris 1987, no. 43, ill. p. 44; Stockholm 1997, no. 113, cat. p. 151, ill.
The Forbes Magazine Collection, New York

696. VANDERBILT FRAME large triangular enameled gold frame in salmon pink enamel over a guilloché sunburst pattern decorated with laurel wreath mounts at the corners – signed Fabergé, initials of workmaster Johann Victor Aarne, assay mark of St. Petersburg 1899–1908, assay master Yakov Lyapunov, 88 (zolotnik), inv no. 8631, height 11¼ in. (28.5cm). Original signed photograph of Grand Duchess Xenia, sister of Tsar Nicholas II, and her husband Grand Duke Alexander at Winter Palace Costume Ball on February 27, 1903. Provenance: Gift of the Russian Imperial Family to Grace Wilson Vanderbilt, wife of Cornelius Vanderbilt III; Mrs Cornelius Vanderbilt, Jr.
The Forbes Magazine Collection, New York

697. ART NOUVEAU CORNFLOWER FRAME oval enameled silver-gilt frame decorated with cornflowers enameled blue and green against an opaque white enamel ground – signed Fabergé, initials of workmaster Johann Victor Aarne, assay mark of St. Petersburg 1899–1908, 88 (zolotnik), inv no. 62014, height 3¼ in. (8.3cm). Period photograph of Grand Duchess Xenia. The frame is accompanied by the original penciled note of transmittal from Grand Duchess Maria Alexandrovna to her daughter Princess Alexandra zu Hohenlohe-Lagenburg which reads: "The newest style/what they call/here le dernier cri! Best wishes/for your birthday/ Sandra dear and/und ein Geschenk dazu [a gift enclosed]/Mama".
Provenance: Presented by Grand Duchess Maria Alexandrovna, daughter of Tsar Alexander II and wife of Queen Victoria's second eldest son, Alfred, Duke of Edinburgh, to her daughter Princess Alexandra zu Hohenlohe-Langenburg; Countess Mona Bismarck.
Bibliography: Solodkoff 1988, ill. p. 18
Exhibited: Lugano 1987, no. 40, cat. p. 63, ill.; Paris 1987, no. 40, cat. p. 59, ill.; Zurich 1989, no. 94, ill. p. 50, plate 19; London 1991, no. 7, ill. p. 18; Vienna 1991, cat. p. 71, ill.
Art Nouveau was, at that time, the dernier cri in St. Petersburg. Fabergé spearheaded the movement between 1898 and 1903.
The Forbes Magazine Collection, New York

699

700

701

702

703

704

699. RECTANGULAR ENAMELED SILVER-GILT PHOTOGRAPH FRAME of pink *guilloché* enamel with opaque white enamel thyrsos staff borders tied with oak leaves, the aperture with lime green enamel trim and tied ribbon cresting – signed Fabergé, initials of workmaster Victor Aarne, assay mark of St. Petersburg 1899–1908, assay master Yakov Lyapunov, width 4¼ in. (10.8cm).
The thyrsos staffs are among the decorative elements used by the Aarne workshop

700. RECTANGULAR SILVER AND RED ENAMEL FRAME of scarlet red *guilloché* enamel with silver reed-and-tie bezel applied with laurel garlands suspended from ribbon ties, a laurel wreath, ribbons and maenad's staffs below, with palmette border, wooden backing and silver strut with suspension ring – signed Fabergé, initials of workmaster Victor Aarne, assay mark of St. Petersburg 1899–1908, height 8⅜ in. (21.3cm).
The photograph taken by Princess Henry of Prussia shows her sister Grand Duchess Elizabeth Feodorovna.
Private Collection courtesy A. von Solodkoff

701. SILVER FRAME with ogival top with a border of scrolling foliage, wooden back and suspension ring – signed Fabergé, initials of workmaster Victor Aarne, assay mark of St. Petersburg 1899–1908, assay master Yakov Lyapunov, inventory number 10992, height 3¾ in. (9.5cm).
André Ruzhnikov

702. HEART-SHAPED GOLD-MOUNTED AND ENAMELED SILVER-GILT FRAME of opalescent white *guilloché* enamel, with oval laurel-and-tie bezel and outer beaded border, applied with four-color gold rose garlands suspended from ribbon cresting, with silver-gilt strut – signed Fabergé, initials of workmaster Victor Aarne, assay mark of St. Petersburg 1899–1908, assay master Yakov Lyapunov, inv no. 5243, height 2¾ in. (7cm)
Exhibited: Munich 1986/7, cat. 490, ill. p. 245; New York 1988, cat. 6; Zurich 1989, cat. 95, ill. p. 96; St. Petersburg/Paris/London 1993/4, cat. 267, ill. p. 368; Lahti 1997, cat. 32, ill. 26.
The Woolf Family Collection

703. RECTANGULAR SILVER-GILT, ENAMEL AND BIRCHWOOD PHOTOGRAPH FRAME the oval aperture with beaded border within a rectangular panel of opalescent blue *guilloché* enamel over sunray pattern, applied with laurel sprays and rosettes, with stylized leaf outer border, wooden back and silver-gilt strut – signed Fabergé, initials of workmaster, Victor Aarne, St. Petersburg 1899–1908, assay-master Yakov Lyapunov, 88 (zolotnik), height 7⅞ in. (20cm). Original signed photograph of Princess Beatrice (1884–1966) youngest daughter of Grand Duchess Maria Alexandrovna, second daughter of Tsar Alexander II; and of her husband Alfred, Duke of York, son of Queen Victoria. Her sisters were Maria, Queen of Romania; Victoria, Grand Duchess of Hessen, later Grand Duchess Kyrill of Russia; and Alexandra, Princess of Hohenlohe-Langenburg.
Louise and David Braver

704. OVAL GEM-SET ENAMELED GOLD FRAME of pale green *guilloché* enamel with pearl-set bezel, applied with gold leaf swags, four cabochon rubies and four diamonds, with ribbon cresting and gold strut – signed Fabergé, initials of workmaster Victor Aarne, assay mark of St. Petersburg 1899–1908, 56 (zolotnik), height 2 in. (5cm).
Exhibited: Helsinki 88, cat 16; St. Petersburg 1989, cat. 6; Stockholm 1997, cat. 126.

705

706

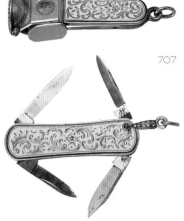

707

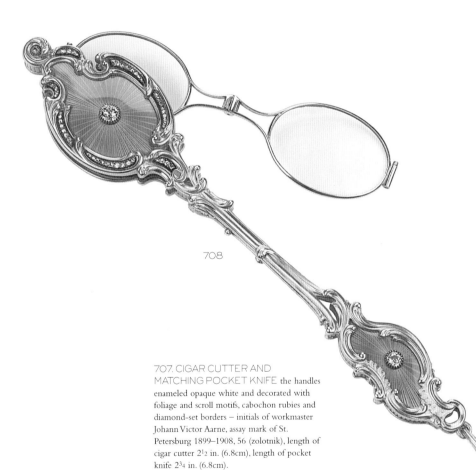

708

707. CIGAR CUTTER AND
MATCHING POCKET KNIFE the handles
enameled opaque white and decorated with
foliage and scroll motifs, cabochon rubies and
diamond-set borders – initials of workmaster
Johann Victor Aarne, assay mark of St.
Petersburg 1899–1908, 56 (zolotnik), length of
cigar cutter 2½ in. (6.8cm), length of pocket
knife 2¾ in. (6.8cm).
The Forbes Magazine Collection, New York

705. IMPERIAL PRESENTATION
REEDED GOLD CIGARETTE-CASE
cover and base with triangular panels of
engine-turning, the cover set with a gold
10-rouble coin of Nicholas II in rose-cut
diamond border, cabochon sapphire pushpiece
– signed Fabergé, initials of workmaster Victor
Aarne, assay mark of St. Petersburg before
1899, 56 (zolotnik), length 3⅝ in. (9.2cm).
Inscribed: "Presented to Lieut. J. C. Harrison
Scott Greyby H. M. the Emperor of Russia on
the occasion of his commanding the escort to
His Majesty, Ballater to Balmoral 22 Sept.,
Balmoral to Ballater 3 Oct., 1896".
Bibliography: Traina 1998, p. 99.
Exhibited: New York/San Francisco et al.
1996/7, cat. 313.
John Traina Collection

706. ART NOUVEAU GOLD-
MOUNTED PALISANDER WOOD
CIGARETTE-CASE with cabochon
emerald pushpiece – signed Fabergé, initials
of workmaster Johann Victor Aarne, assay mark
of St. Petersburg before 1899, height
3¼ in. (8.2cm).
Bibliography: Traina 1998, p. 131 (top).
Victor Aarne is primarily known for his silver-
mounted birchwood frames. Other *objets de
vertu* by him are rare.
John Traina Collection

708. GEM-SET GOLD AND ENAMEL
PAIR OF LORGNETTES decorated in
Louis XV-style with pink *guilloché* enamel
panels set with brilliant-cut diamonds within
rococo-scroll frames, the top panel hiding the
folding spectacles further set with rose-cut
diamond bands, gold suspension ring – signed
with initials K. F., initials of workmaster Victor
Aarne, assay mark of St. Petersburg before
1899. Original blue-velvet-covered wooden
case stamped with Imperial Warrant, Fabergé,
St. Petersburg.
The Eriksson Collection

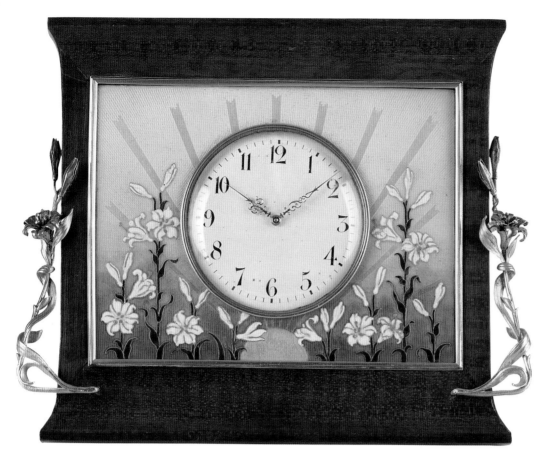

709

711

710

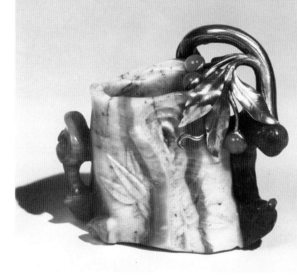

712

709. RECTANGULAR GOLD, SILVER-GILT AND ENAMEL MOUNTED MAHOGANY CLOCK decorated in Art Nouveau style with a panel enameled orange and yellow with the rising sun behind a field of white madonna lilies with green enamel leaves, set into a carved mahogany board, flanked by further curved gold stems of lilies with silver flower-heads, silver-gilt clock-case and mahogany strut – signed Fabergé, initials of workmaster Victor Aarne, assay mark of St. Petersburg 1899–1908, inv no. 5493, length 5⁵⁄₈ in. (14.3cm).
The Eriksson Collection

710. EGG-SHAPED GOLD-MOUNTED AND ENAMEL SCENT-BOTTLE of primrose yellow *guilloché* enamel with pearl-set gold band and diamond set pushpiece opening to reveal the scent-bottle with gold-mounted cork stopper – signed Fabergé, initials of workmaster Victor Aarne, assay mark of St. Petersburg 1899–1908, inv no. 6191, length 1³⁄₈ in. (3.5cm).
Private Collection

711. STANDING THERMOMETER enameled silver-gilt and maplewood thermometer set with a rectangular panel of salmon pink enamel over a *guilloché* basketweave ground, the whole surmounted by a ribbon-tied cresting – signed Fabergé, initials of workmaster Johann Victor Aarne, assay mark of St. Petersburg 1899–1908, assay master Yakov Lyapunov, 88 (zolotnik), inv no. 2833, height 4⁷⁄₈ in. (12.4cm).
Bibliography: Habsburg/Solodkoff 1979, ill. plate no. 76; Solodkoff 1984, p. 178, ill.
The Forbes Magazine Collection, New York

712. SILVER-GILT MOUNTED CHINESE JADE BRUSH POT the white and red vase is carved as a tree stump with foliage and fruit in relief, the silver-gilt handle is in the form of a foliage branch set with cabochon chrysoprases – signed Fabergé, initials of workmaster Victor Aarne, assay mark of St. Petersburg 1899–1908, assay master's initials B.A., height 3¹⁄₈ in. (8cm)
Exhibited: Munich 1986/7, cat. 67, ill. p. 123; New York 1988, cat. 14; Zurich 1989, cat. 66; Hamburg 1995, cat. 9, ill. p. 56; Stockholm 1997, cat. 192, ill. p. 193.
A Chinese brush pot mounted by Fabergé.
The Woolf Family Collection

ARMFELDT

Karl Gustaf Hjalmar Armfeldt (1873–1959) (fig. 1) was born in Artjärvi, Finland, the son of Lieutenant August Edvin Armfeldt and of Johanna Matilda Ahlroos. In 1886, aged thirteen, he was apprenticed to the Finnish silversmith Paul Sohlman in St. Petersburg at 58 Gorohovaya. He became a journeyman in 1891 and served under Fabergé's goldsmith Anders Nevalainen until 1904, when he qualified as Master, having studied at the Baron Stieglitz school from 1889 to 1904. In 1904, when he acquired the workshop of goldsmith Victor Aarne with its twenty goldsmiths and three apprentices for 8,000 roubles, Armfeldt was given to understand that the Fabergé family expected him to maintain the high standards set by his predecessor.[2] In 1895 Armfeldt married Olga Josefina Lindross. He returned to Finland in 1920 and died in Helsinki in 1959.

In the twelve years of Armfeldt's independent activity on behalf of Fabergé, he continued to produce the same line of objects as Aarne, including tiny gem-set frames[3] (cat. 728) and larger silver-mounted birchwood frames (cat. 729–731).[4] His stock-in-trade also comprised hardstone frames[5], gem-set enameled gold crucifixes[6] and silver figures on hardstone bases.[7]

Géza von Habsburg

FIG I. HJALMAR ARMFELDT
Photograph courtesy Ulla Tillander-Godenhielm

Notes

1. See Ulla Tillander-Godenhielm, "Personal and Historical Notes on Fabergé's Finnish Workmasters and Designers" in *Helsinki* (1980), p. 41f.

2. Cf. Ulla Tillander-Godenhielm, "Carl Fabergé and his Master Craftsmen", *Stockholm* (1997), p. 31.

3. Habsburg (1986), cat. 493, 523.

4. *Ibid.*, cat. 496, 497.

5. *Ibid.*, cat. 251, 446.

6. *Ibid.*, cat. 87.

7. *Ibid.*, cat. 60.

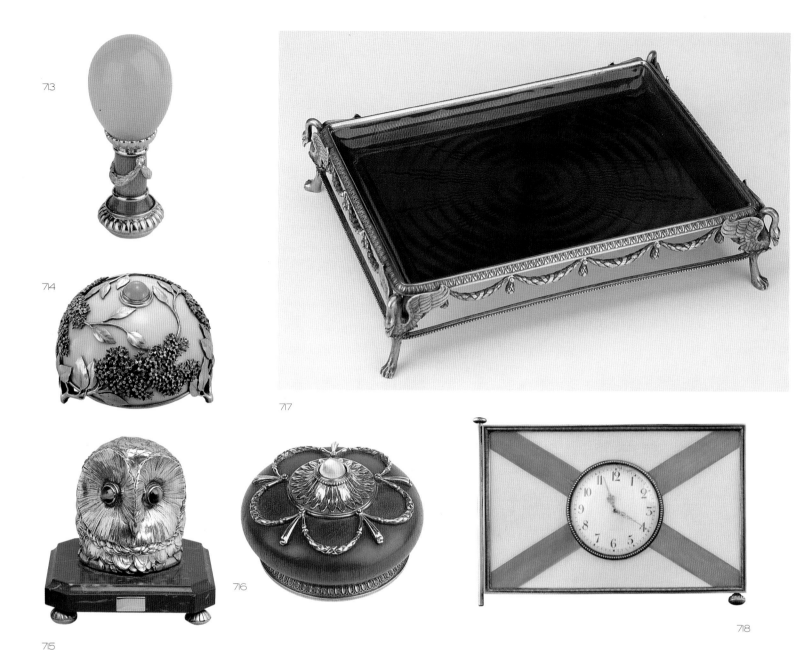

713

714

715

717

716

718

713. TWO-COLOR GOLD AND
ENAMEL BOWENITE MINIATURE
SEAL the egg-shaped hardstone handle on a
pink *guilloché* enamel column base applied with
chased gold laurel engraved with the initial
"M" – initials of workmaster Hjalmar
Armfeldt, assay mark of St. Petersburg
1899–1908, assay master Alexander Romanov,
inv no. 14768, height 1⅜ in. (3.5cm). Original
hollywood case stamped with Imperial
Warrant, Fabergé, St. Petersburg, Moscow,
London.
Provenance: Sir V. Caillard, acquired at Fabergé's
London branch on December 19, 1911.
Private Collection

714. ART NOUVEAU BELL PUSH
applied with a tracery of chased silver-gilt lilac
sprays and foliage in the Art Nouveau style,
cabochon Mecca stone pushpiece – signed
Fabergé, initials of workmaster Karl Gustav
Hjalmar Armfeldt, assay mark of St. Petersburg
1899–1904, assay master A. Richter,
88 (zolotnik), length 2¾ in. (7cm).
The Forbes Magazine Collection, New York

715. SILVER BELL-PUSH SHAPED
LIKE THE HEAD OF AN OWL with
finely chased plumage, the eyes set with cat's-
eye hardstones, on a red marble plinth on four
reeded silver melon feet – signed Fabergé,
initials of workmaster Hjalmar Armfeldt, assay
mark of St. Petersburg 1899–1908, inv no.
15363, height 4 in. (10.1cm).
Private Collection

716. CIRCULAR SILVER-MOUNTED
MAHOGANY BELL-PUSH with rounded
sides applied with chased silver swags, the
moonstone pushpiece in a silver calyx, the
silver foot rim with chased laurel – signed
Fabergé, initials of workmaster Hjalmar
Armfeldt, assay mark of St Petersburg
1899–1908, assay-master Yakov Lyapunov,
length 2½ in. (6.3cm).
Private Collection courtesy A. von Solodkoff

717. RECTANGULAR SILVER-GILT
AND ENAMEL TRAY on four lion-paw
feet, decorated with scarlet *guilloché* enamel on
waved sunray and radiating ground, the corners
with silver-gilt swans, the sides with applied
laurel garlands, stiff-leaf border – signed
Fabergé, initials of workmaster Hjalmar
Armfeldt, assay mark of St. Petersburg
1899–1908, assay master Alexander Romanov,
inv no. 14930, length 8¾ in. (22.3cm).
Private Collection

718. ENAMELED SILVER DESK
CLOCK SHAPED AS THE FLAG of the
Russian Imperial Marine, of white *guilloché*
enamel and the blue enamel cross of St.
Andrew, with reeded rim and a silver flagpole
to the left, the white opaque enamel dial with
black Arabic chapters, gold "Louis XV" hands
and seed-pearl bezel; silver strut – signed
Fabergé, initials of workmaster Hjalmar
Armfeldt, assay mark of St. Petersburg
1908–1917, height 2¹⁄16 in. (5.1cm).
Provenance: Grand Duke Alexander
Mikhailovich of Russia, Vice Admiral of the
Imperial fleet.
Bibliography: Solodkoff 1986, p. 11.
Exhibited: Hamburg 1995, cat. 130.
Private Collection

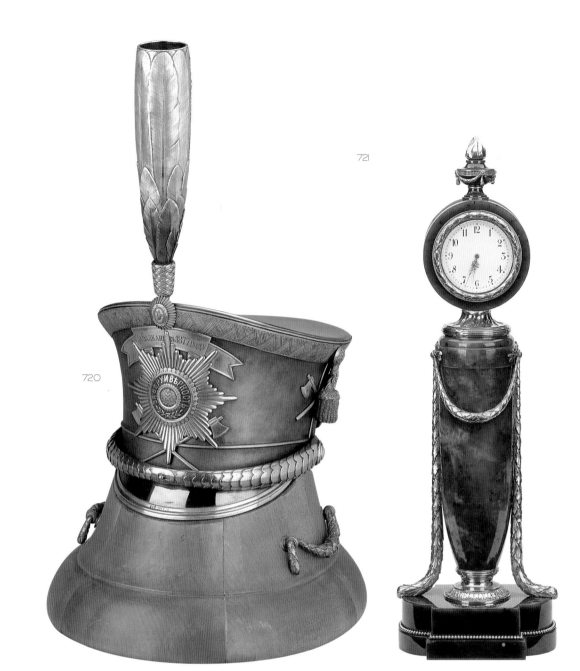

719

720

721

719. OWL-SHAPED ENAMELED GOLD SCENT-FLASK its body with opaque white enamel feathers, its face of two-colored agate, with peridot eyes and gold claws and beak – signed Fabergé, initials of workmaster Hjalmar Armfeldt, St. Petersburg 1908–1917, 72 (zolotnik), inv no. 24734, height 1⅛ in. (2.9cm). Exhibited: Paris 1994, cat. 30 (illustrated on cover); Hamburg 1995, cat. 70; London 1996, cat. 30 (illustrated as frontispiece). Chevalier Maurice Mizzi Collection

720. SILVER PUNCH-BOWL shaped as a shako of the Life Guard Sapper's Battalion the partially oxidized silver cap applied at the front with star of the Order of Andrew the Firstborn, a ribbon with the inscription "For the Balkans, 1877"; chased silver braidings, strap and tassels. The removable hollow feather plume has a separate wooden mount and can be used as a champagne glass – signed Fabergé, initials of workmaster Hjalmar Armfeldt, assay mark of St. Petersburg 1908–1917, 84 and 88 (zolotnik), height with plume 15½ in. (39.5cm).
Provenance: Silver store room of the Winter Palace; State Museum of Ethnography, 1941
Exhibitions: Leningrad 1981, cat. 502; Lugano 1986, cat. 130; St. Petersburg/Paris/ London, 1993/4, cat. 199.
The Life Guard of the sapper's batallion was formed in 1812 under the patronage of the Imperial family. In 1906, Nicholas II became its commander, and the list of officers included Tsarevich Alexei Nikolaevich, Grand Dukes Mikhail Alexandrovich, Boris Vladimirovich, Nikolai Nikolaevich and Piotr Nikolaevich. The officers presented the Emperor with this punch-bowl in the form of a shako in honour of the centenary of his batallion, 1912.
The State Hermitage Museum (ERO – 5002)

721. URN-SHAPED SILVER-MOUNTED NEPHRITE CLOCK on oblong-shaped base with nephrite urn decorated with two chased silver laurel garlands surmounted by a clock with silver laurel bezel and circular nephrite case with silver burning vase finial – signed Fabergé, initials of work-master Hjalmar Armfeldt, assay mark of St. Petersburg 1908–1917, height 15½ in. (39.4cm).
Private Collection

279

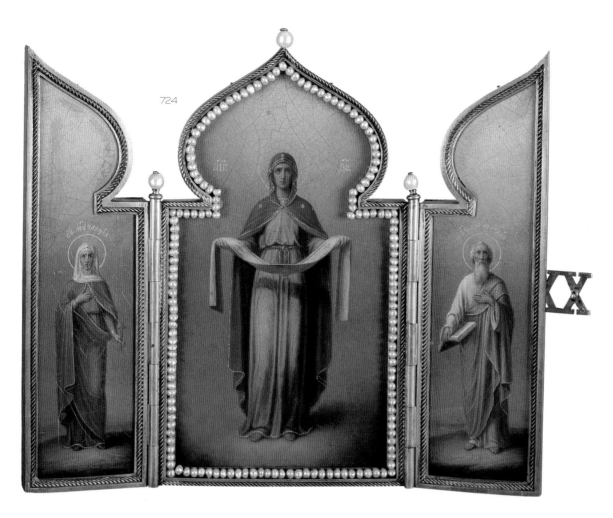

724

722

723

724. SILVER ANNIVERSARY ICON
silver-mounted tryptich icon painted with the
Virgin Mary within a seed-pearl border
flanked by St. Sophia (left) and St. Mathew
(right) – signed Fabergé, initials of workmaster
Karl Gustav Hjalmar Armfeldt, assay mark of
Moscow 1908–1917, 88 (zolotnik), length
6½ in. (16.5cm).
A penciled inscription on the back of the icon
reads: "Blessing from an old friend. Z.Y./
August 21, 1913/From Princess Zenaïde
Yusupov."
Provenance: Presented by Princess Zenaïde
Yusupov to Prince Mathias and Princess
Sophie Cantacuzène on the occasion of their
25th wedding anniversary, 1913.
Bibliography: Kelly 1982/83, ill.. no. 18;
Solodkoff 1984, p. 172, ill.; Kelly 1985, ill.
p. 12; Forbes 1988, p. 42, ill.; Habsburg/Lopato
1994, no. 192, p. 312, ill.
Exhibited: Edinburgh/Aberdeen 1987, no. 24,
ill.; London 1991, no. 11, cat. p. 22, ill.; St.
Petersburg/Paris/London 1993/94, no. 192,
ill. p. 313; New York et al. 1996/7, no. 232, cat.
p. 237, ill.
Princess Zenaïde was the mother of Prince
Felix Yusupov who was married to a niece of
Tsar Nicholas II and who helped murder
Rasputin.
The Forbes Magazine Collection, New York

**722. DOMED SILVER MECHANICAL
BELL-PUSH** engraved with laurel garlands
between bands of laurel and rosettes, with a
relief of laurel above and surmounted by a
cabochon moonstone, on ribbed circular feet,
engraved with crowned monogram "NII" and
the date 1912 – signed Fabergé, initials of
workmster Hjalmar Armfeldt, assay mark of
St. Petersburg 1908–1917, height 2⅜ in. (6cm).
The monogram is that of Tsar Nicholas II who
used this bell-push on the imperial train.
Private Collection courtesy A. von Solodkoff

**723. SILVER-GILT AND RED ENAMEL
MENU HOLDER** decorated with a red
guilloché enamel egg-shaped panel flanked by
laurel garlands and surmounted by ribbon
cresting, on bracket feet, with silver-gilt
A-shaped strut – signed Fabergé, initials of
workmaster Hjalmar Armfeldt, assay mark of
St. Petersburg 1908–1917, inv no. 23630,
height 2¼ in. (5.7cm).
The Eriksson Collection

725

726

727

726. PIVOT FRAME: RECTANGULAR
SILVER-MOUNTED DOUBLE-SIDED
OAK PIVOTING FRAME with silver bor-
ders chased with laurel and berries, the
whole secured on a vertical pivot to a reeded oak
stand surmounted by a silver
imperial eagle – signed Fabergé, initials of
workmaster Karl Gustav Hjalmar Armfeldt,
assay mark of St. Petersburg 1899–1908, 88
(zolotnik), height 10 in. (25.4cm). The
photographs are of of Tsar Nicholas II with his
cousin, the future King George V of Great
Britain (verso) and Tsarina Alexandra (recto).
Provenance: Mrs M. T. Heller, Arizona.
Bibliography: Hill 1989, ill. plate no. 135.
Exhibited: New York 1949, no. 172, cat. p. 17;
Lugano 1987, no. 35, ill. p.. 60; Paris 1987, no.
35, ill. p. 56; London 1991. no. 6, ill. p. 17;
Vienna 1991, cat. p. 66, ill.; St. Petersburg/
Paris/London 1993/94, no. 96, cat. p. 245, ill.
The close resemblance between Nicholas and
the Prince of Wales, which they cultivated, is
not surprising as their mothers, Tsarina Maria
Feodorovna and Queen Alexandra were sisters.
The Forbes Magazine Collection, New York

725. ENAMELED TWO-COLOR
GOLD FRAME set with a square panel of
vieux-rose enamel over a guilloché scalloped
ground and applied with chased laurel swags
and pendants suspended from pearls, one of
which forms the knot of the red-gold
ribbon-tied cresting – signed Fabergé, initials
of workmaster Karl Gustav Hjalmar Armfeldt,
assay mark of St. Petersburg 1899–1904, assay
master A. Richter; 56 (zolotnik) on bottom
rim, 88 (zolotnik) on strut, inv no. 14729,
height 2⁷₈ in. (7.3cm). The frame encloses a
photograph of Tsar Nicholas II in uniform.
Bibliography: Waterfield/Forbes 1978, no. 79,
ill. p. 69; Kelly 1982/83, p. 11; Solodkoff 1984,
p. 171, ill.
The Forbes Magazine Collection, New York

727. RECTANGULAR GOLD-
MOUNTED AND ENAMELED
BOWENITE FRAME the opaque white
enameled oval bezel enriched with red enamel
at intervals, inset into a rectangular bowenite
panel set with two-colour gold ribbon cresting
and swags suspended from seed-pearls, the back
with mother-of-pearl panel with hinged silver-
gilt easel strut and suspension ring – by
Fabergé, initials of workmaster Carl Gustav
Hjalmar Armfeldt, assay mark of St. Petersburg
1899–1908, height 2⁷₈ in. (7.4cm).
Exhibitions: New York 1988, cat. 24; Zurich
1989, cat. 98; Hamburg 1995, cat. 165,
ill. p. 165.
The Woolf Family Collection

728

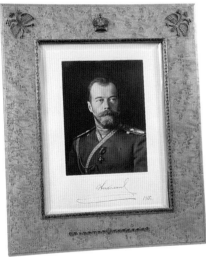

729

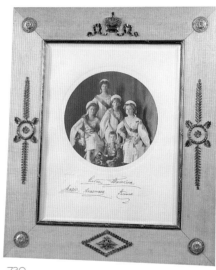

730

731

729. LARGE RECTANGULAR SILVER-GILT MOUNTED BIRCH-WOOD IMPERIAL FRAME applied with central imperial crown, a double-headed eagle in a lozenge beneath, rosettes and laurel leaf swags, and with wooden back and strut – signed Fabergé, initials of workmaster Hjalmar Armfeldt, St. Petersburg 1908–1917, 88 (zolotnik), height 17 in. (43cm). Original signed photograph of the five imperial children Grand Duchesses Olga (1895–1918); Tatiana (1897–1918); Maria (1899–1918); Anastasia (1901–1918); and of Grand Duke and Heir to the Throne Alexei (1904–1918), stamped Boissonas et Eggler, c. 1910.
Louise and David Braver

730. LARGE RECTANGULAR SILVER-MOUNTED BIRCHWOOD IMPERIAL FRAME with inner laurel-leaf wreath border, applied with Imperial crown, two stylized double-headed eagles at upper corners, with wooden back and strut – initials of workmaster Hjalmar Armfeldt, St. Petersburg 1908–1917, 88 (zolotnik), height 17½ in. (44.5cm). Original signed photograph of Tsar Nicholas II dated 1915. Original gray cardboard fitted case stamped with Imperial Warrant, St. Petersburg, Moscow and Odessa.
Louise and David Braver

728. HOUSE-SHAPED JEWELED, SILVER AND GOLD-MOUNTED WHITE AGATE FRAME applied with varicolored gold swags suspended from cabochon rubies, with mother-of-pearl back and "A"-shaped strut – initials of workmaster Hjalmar Armfeldt, assay mark of St. Petersburg 1899–1908, height 2½ in. (6.3cm)
Exhibited: QVC 1999.
Joan and Melissa Rivers

731. LARGE RECTANGULAR SILVER-MOUNTED BIRCHWOOD FRAME with inner stylized leaf border, applied with crown above and with wooden back and strut – signed Fabergé, initials of workmaster Hjalmar Armfeldt, 88 (zolotnik), height 16⅜ in. (41.6cm). Later photograph of Princess Beatrice of Great Britain.
Louise and David Braver

732

733

734

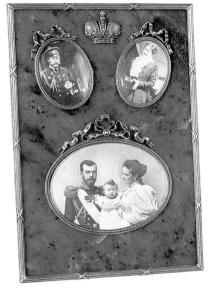

735

736

732. DOUBLE-SIDED ENAMELED SILVER PHOTOGRAPH FRAME with arched top, one side of translucent pink enamel over sunburst *guilloché* ground the reverse of white waved *guilloché* enamel – signed Fabergé, initials of workmaster Hjalmar Armfeldt, 88 (zolotnik), height 4³⁄₁₆ in. (10.4cm)
Exhibited: Leningrad 1974, cat. 41.
For another similar frame in the Peterhof Museum collection, see Habsburg/Lopato 1993/4, cat. 47.
The State Hermitage Museum (ERO – 4915)

733. RECTANGULAR SILVER-MOUNTED MAHOGANY FRAME with chased silver laurel bezel, wooden backing and strut – signed Fabergé, initials of workmaster Hjalmar Armfeldt, assay mark of St. Petersburg 1908–1917, height 13⁵⁄₈ in. (34.6cm).
The original photograph stamped Alex. Corbett, 48 Baker Street, London W., is that of Princess Victoria, daughter of King George V, with autograph signature *Victoria + Punchie*.
Private Collection courtesy A. von Solodkoff

734. RECTANGULAR SILVER-GILT AND ENAMEL MOUNTED WOODEN FRAME the bezel with reed-and-tie border surrounded by blue *guilloché* enamel with stepped outer stiff-leaf border and ribbon tie cresting on hollywood panel with wooden backing and strut – signed Fabergé, initials of workmaster Hjalmr Armfeldt, assay mark of St. Petersburg 1908–1917, height 14¹⁄₈ in. (35.2cm).
Private Collection

735. RECTANGULAR SILVER-MOUNTED NEPHRITE FRAME with a large oval aperture below and two small oval apertures above, each with beaded bezel and surmounted by ribbon cresting, an Imperial crown above, outer reed-and-tie border – signed Fabergé, initials of workmaster Hjalmar Armfeldt, assay mark of St. Petersburg 1904–1908. Assay master A. Romanov, 88 (zolotnik), height 7¹⁄₄ in.
Louise and David Braver

736. RECTANGULAR GEM-SET PARCEL-GILT FRAME chased with scrolling acanthus foliage and set with four Mecca stones, two amethysts, two peridots and twelve cabochon garnets – signed Fabergé, initials of workmaster Hjalmar Armfeldt, assay mark of St. Petersburg 1904–1917, assay master R. Romanov, 88 (zolotnik), height 7¹⁄₄ in.
Louise and David Braver

FEODOR AFANASIEV

Very little is known of the goldsmith Feodor (Fjodor) Alexeievich Afanasiev, who was apprenticed to the silversmith E. Sistonen between 1883 and 1888 and worked, presumably as a journeyman, for the jeweler K. Bokh from 1888 to 1907. Thereafter he ran a small workshop for Fabergé at 24 Bolshaya Morskaya specializing in miniature Easter Eggs (cat. 737, 739, 751), small articles made of gilded silver and *guilloché* enamel (cat. 741) and hardstone objects mounted with enameled silver-gilt mounts (cat. 746).

Géza von Habsburg

737

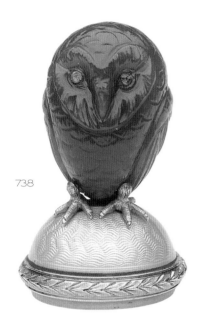

738

739

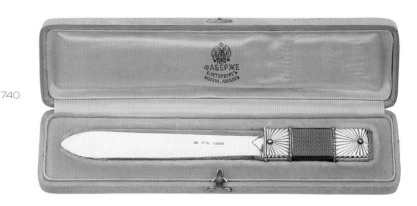

740

741

737. OVAL GEM-SET, ENAMEL AND HARDSTONE PENDANT set with a nephrite carving of a tortoise with rose-cut diamond eyes in a diamond-set oval with strawberry *guilloché* enamel border – initials of workmaster Fedor Afanasiev, assay mark of St. Petersburg before 1899, length 1¹⁄₁₆ in. (2.7cm). Private Collection

738. GOLD, ENAMEL AND AGATE OWL SEAL THE BIRD carved in hardstone with detailed plumage and set with emerald eyes, with gold feet sitting on a domed two-color gold-mounted and pale blue *guilloché* enamel seal with chased laurel border, the matrix engraved R. S. – initials of workmaster Feodor Afanasiev, assay mark of St. Petersburg 1899–1908 inv no. 20180, height 1¹⁄₄ in. (2.8cm). Private Collection

739. EGG-SHAPED AMETHYST AND GOLD PENDANT set with an amethyst carving of a chick with rose-cut diamond eyes and gold feet, sitting on an oval gold loop – initials of workmaster Feodor Afanasiev, assay mark of St. Petersburg 1908–1917. Private Collection

740. GEM-SET GOLD AND ENAMEL PAPERKNIFE the handle with a red *guilloché* enamel band with rose-cut diamond set borders flanked by gold starburst panels centered by diamonds, with plain gold blade – signed Fabergé, initials of workmaster Feodor Afanasiev, assay mark of St. Petersburg 1899–1908, inv no. 15632, length 5¹⁄₂ in. (14cm). Original fitted hollywood case stamped with Imperial Warrant, Fabergé, St. Petersburg, Moscow, London. The Hubel Collection

741. CIRCULAR GOLD-MOUNTED, SILVER-GILT AND ENAMEL BOX of raspberry red *guilloché* enamel engraved with intertwined laurel bands, chased gold palmette border, with diamond-set pushpiece – signed Fabergé, initials of workmaster Feodor Afanasiev, assay mark of St. Petersburg 1908–1917, inv no. 20239, diameter 1³⁄₈ in. (3.5cm). Provenance: Acquired by Grand Duke Michael Michailovitch at Fabergé's London branch for £8¹⁄₂ on 30 April, 1910, Lord Ivar Mountbatten. Exhibited: Hamburg 1995, cat. no. 181. Private Collection courtesy A. von Solodkoff

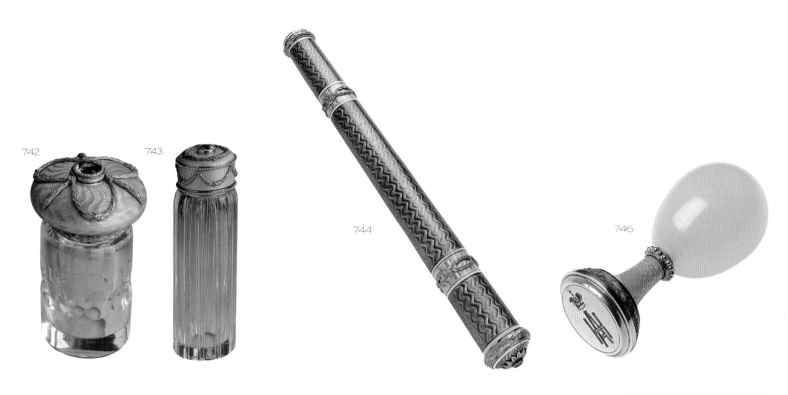

742 743

744

746

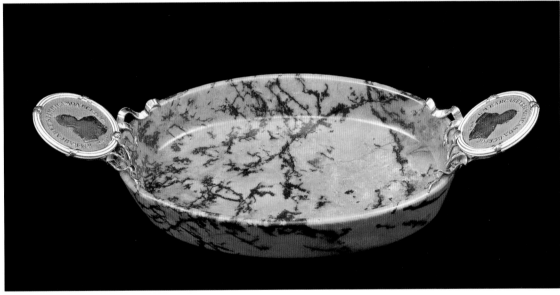

745

742. CYLINDRICAL GOLD-AND
SILVER-MOUNTED ENAMELED
CRYSTAL SCENT-FLASK the cut-crystal
body with compressed dome-shaped cover of
mauve *guilloché* enamel with chased laurel leaf
border, applied laurel swags and green citrine
finial – signed Fabergé, initials of workmaster
Feodor Afanassiev, assay mark of St. Petersburg
1908–1917, height $2^{1}8$ in. (5.4cm).
Exhibited: Paris 1994, cat. 25; Hamburg 1995,
cat. 47; London 1996, cat. 25.
Chevalier Maurice Mizzi Collection

743. CYLINDRICAL GOLD-AND
SILVER-MOUNTED ENAMELED
CRYSTAL SCENT-BOTTLE the fluted
body with pink *guilloché* enamel cover with
applied laurel swags and laurel wreath, citrine
finial – signed Fabergé, initials of workmaster
Feodor Afanasiev, assay mark of St. Petersburg
1908–1917, inv no. 19148, height $2^{15}16$ in.
(7.5cm). Original fitted case stamped with
Imperial Warrant mark, St. Petersburg,
Moscow, London.
Exhibited: Paris 1994, cat. 35; Hamburg 1995,
cat, 49; London 1996, cat. 35.
Chevalier Maurice Mizzi Collection

744. GOLD-MOUNTED SILVER-GILT
AND ENAMEL PARASOL HANDLE
of tapering cylindrical shape, decorated in gray
guilloché enamel, with chased laurel-leaf
borders, pale yellow and white guilloche
enamel bands and faceted garnet finial in
chased gold leaf mount – signed Fabergé,
initials of workmaster Feodor Afanasiev, assay
mark of St. Petersburg 1908–1917, 56
(zolotnik), inv no. 27576. In original fitted case
stamped with Fabergé's Imperial Warrant,
St. Petersburg, Moscow, London.
Exhibited: Helsinki 1988; Helsinki 1991; Lahti
1997; Stockholm 1997, cat. 207.
Private Collection courtesy of Ulla Tillander-
Godenhielm, Finland

745. RHODONITE DISH WITH
ROUBLES enameled gold-mounted
rhodonite dish with gold ribbon handles set
with two green enameled Elizabeth I roubles
dated 1751 and 1756 – initials of workmaster
Feodor Afanasiev, assay mark of St. Petersburg
1899–1908, assay master Jakov Lyapunov,
56 (zolotnik), inv no. 15871, length $6^{3}4$ in.
(17.1cm).
Provenance: Mrs Isabella Catt.
Bibliography: Waterfield/Forbes 1978, no. 127,
ill. p. 99; Snowman 1953/55, ill. no. 88;
Snowman 1962/64/68/74, ill. no. 99; Solodkoff
1984, p. 178, ill.
Exhibited: New York 1973, no. 46, ill. p. 99.
The Forbes Magazine Collection, New York

746. EGG-SHAPED GOLD-
MOUNTED BOWENITE HAND-SEAL
the tapering mount of pink *guilloché* enamel,
the base with a chased green gold laurel
wreath, the agate matrix engraved with
crowned Cyrillic letters AH – initials of
workmaster Feodor Afanasiev, inv no. 14855,
height $1^{1}4$ in. (3.2cm). Original fitted case with
Imperial Warrant mark, St. Petersburg, Moscow.
Provenance: the initials are those of Tsarevich
Alexei Nicolaevich (1904–1918), whose
personal seal this was.
Bibliography: Snowman 1979, p. 43
Exhibited: V&A 1977, cat. K 32; Munich
1986/7, cat. 127.
Private Collection

9
THE LESSER WORKMASTERS

THE LESSER WORKMASTERS

Gabriel Zachariasovich Niukkanen was registered as a goldsmith with an independent workshop at 39 Kasanskaya Street between 1898 and 1912. His main stock in trade was fine ribbed gold cigarette-cases (cat. 749)[1], some of which were destined for Imperial presentation (cat. 748a, b) and a small number of other articles – crucifixes[2], clocks (cat. 752) and Easter Eggs. (cat. 751) Virtually none of the objects bearing his Cyrillic initials are signed by Fabergé, for whom Niukkanen acted only as an occasional supplier.

Alfred Rudolfovich Thielemann was a goldsmith/jeweler of German origin, the son of Carl-Rudolf Thielemann who in 1895 ran a jewelry workshop at 11B Bolshaya Morskaya and in 1903 was chairman of the Foreign Crafts Council. Alfred Thielemann qualified as Master in St. Petersburg in 1858, and from 1880, ran a subsidiary jewelry workshop for Fabergé at 24 Bolshaya Morskaya. His initials AT, not to be confused with those of Alexander Tillander and A. Treiden, are exclusively found on small pieces of jewelry (cat. 754, 755)[3] and a large number of *jetons* or badges (cat. 753) made for the house of Fabergé. According to one source, Thielemann's son, Rudolf, ran the workshop following his father's death in 1910. Another source indicates that Fabergé took over the Thielemann workshop, putting it under the management of J. G. Nikolaiev.

Wilhelm Reimer was, like Gustav Fabergé, born in Pernau, East Germany. Indeed, his father may have been married to Gustav Fabergé's sister. Together with August Holmström, he first worked for Fabergé *père* as a jeweler, at 11B Bolshaya Morskaya. He later continued as head of a small jewelry atelier active for Fabergé *fils* until his death in 1898. Reimer's initials generally appear on small pieces of jewelry (cat. 765) without an accompanying Fabergé hallmark. The workshop was taken over by Andrei Gorianov who specialized in modest circular enameled silver frames and other small articles.[4] Gorianov's initials too, never seem to appear in conjunction with a Fabergé hallmark, which may indicate that Gorianov was not under an exclusive contract, but rather acted as an occasional supplier.

Virtually nothing is known of the St. Petersburg jeweler Eduard Wilhelm Schramm. His specialities were hammered-gold cigarette-cases embellished with cabochon sapphires and diamonds[5], more rarely *objets de vertu* such as paper knives[6] or miniature Easter Eggs.[7] His surviving *pièce de résistance* is an Art Nouveau dish encrusted with cabochon sapphires, rubies and rose-cut diamonds (cat. 758). Virtually none of these articles bear a Fabergé signature, which indicates that Schramm was an outworker, who only supplied Fabergé occasionally. The exception to this rule appears to be a modest silver-mounted birchwood cigarette-case (cat. 757), which bears both Schramm's and Fabergé's hallmarks.

There is some confusion about Karl Gustav Johanson Lundell, who it seems, was born in 1833 in Loppi, Finland, son of Johan Matson of Hallahuhta and of Gustava Lindfors. Previous authors have stated that Lundell was head workmaster in Odessa. Another source indicates that he worked exclusively in St. Petersburg and died (or possibly just arrived) there in 1856. However, a cigarette-case with his Cyrillic initials GL, the hallmark of Fabergé and the assay mark of St. Petersburg 1908–17, contradicts these theories.

The silversmith and jeweler Philipp Theodor Ringe was born in Riga in 1824 and died in 1882 in St. Petersburg, was head of a small workshop located at 12 Malaya Morskaya producing modest articles in gold and silver (cat. 760). His objects generally bear only his own initials and no Fabergé signature, which would indicate that he was but an outworker. It seems that his widow Anna, whose initials A.R. can be found on small objects dating from the turn of the century (cat. 761–3), continued as head of the

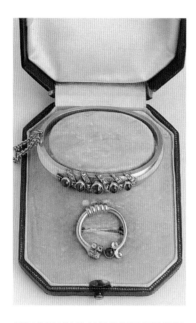

FIG I. DIAMOND AND SAPPHIRE-SET GOLD BRACELET AND BROOCH initials of workmaster Edward Schramm, St. Petersburg *c.* 1870. Original fitted case marked C.E. Bolin, St. Petersburg. Private Collection. Photograph courtesy of Christian Bolin

workshop but soon thereafter ceded it to the Finnish goldsmith Anders Mickelson (1839–1913), who worked in St. Petersburg as a journeyman from 1855 and who from 1867 ran his own workshop. He, too, should be considered as an outworker. The Ringe-Mickelson workshop was later taken over by Vladimir (Viacheslav) Soloviev whose workshop seems to have specialized in pencils both in gold (cat. 756) and silver gilt enamel. These, which all date from the last decade of Fabergé's production, were apparently in demand in London. They generally bear Soloviev's initials BC under a coat of *guilloché* enamel[8] together with Fabergé's name or initials in Latin.

Géza von Habsburg

Notes

1. Habsburg (1986), cat. 159.

2. *Ibid.*, cat. 135.

3. *Ibid.*, cat. 96, 114.

4. *Ibid.*, cat. 412.

5. *Ibid.*, cat. 147, 155, 157.

6. *Ibid.*, cat. 120.

7. *Ibid.*, cat. 528.

8. *Ibid.*, cat. 408.

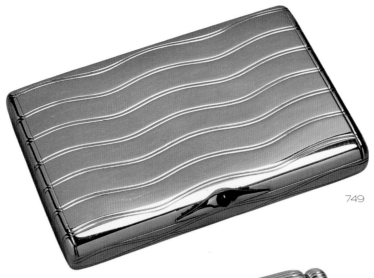

749

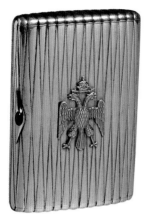

747

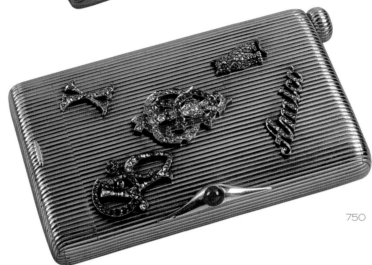

750

751

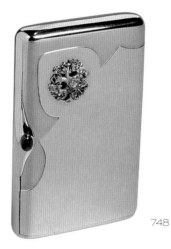

748

747. GOLD-MOUNTED SILVER IMPERIAL PRESENTATION CIGARETTE-CASE decorated with tapering flutes on either side, applied with a gold stylized double-headed eagle, with gold-mounted cabochon sapphire thumbpiece – workmaster's initials G. N. for Gabriel Niukkanen, assay mark of St. Petersburg 1908–1917, height 3⅞ in. (9.8cm).
Judging by the style of the eagle, this was a presentation case ordered for the Romanov Tercentenary.
Private Collection

748. TWO-COLOR GOLD IMPERIAL PRESENTATION CIGARETTE-CASE of burnished red gold and matte yellow gold, applied to one side with a diamond-set double-headed eagle – initials of workmaster Gabriel Niukkanen, assay mark of St. Petersburg 1899–1908, assay master Yakov Lyapunov, length 3½ in. (8.9cm). Original red leather fitted case with gilt double-headed eagle.
Private Collection

749. BURNISHED GOLD CIGARETTE-CASE engraved with sets of double waves, cabochon sapphire thumbpiece – initials of workmaster Gabriel Niukkanen, assay mark of St. Petersburg 1908–1917, length 3¾ in. (9.6cm).
Bibliography: Traina 1998, p. 55a (bottom).
Although Niukkanen's work is generally attributed to Fabergé's firm, his mark never seems to appear in conjunction with that of Fabergé. Together with E. Schramm and K. Lundell, he must be considered as an outworker who worked for Fabergé only occasionally.
John Traina Collection

750. REEDED GOLD SOUVENIR CIGARETTE-CASE the cover applied with monogram "FK" a Roman "X", a cat, another monogram and "Amico" all set with rose-cut diamonds, with match-compartment and cabochon ruby thumbpiece – initials of workmaster Gabriel Niukkanen, assay mark of St. Petersburg 1899–1904, assay master Yakov Lyapunov, length 4¼ in. (10.8cm).
Bibliography: Traina 1998, p. 79.
John Traina Collection

751. GEM-SET GOLD EASTER EGG with spider web decorated with a black enamel web centered by a diamond and with a spider set with a ruby and diamonds – initials of workmaster Gabriel Niukkanen, assay mark of St. Petersburg 1899–1908, assay master Yakov Lyapunov.
Private Collection

752

753

754

755

752. GEM-SET GOLD-MOUNTED
LAPIS LAZULI CLOCK carved from a
block of hardstone with diamond-set bezel, on
four baluster feet with stepped base with gold
pellet band, the lapis finial decorated with gold
scrolls and urn, gold cover to clock movement
– initials of workmaster Gabriel Niukanen,
assay mark of St. Petersburg 1899–1908, assay
master Yakov Lyapunov, height 3¹⁸ in. (8cm).
The Eriksson Collection

753. ENAMELED SILVER
COMMEMORATIVE BADGE shaped as
a Maltese cross with central cipher of Tsar
Nicholas II on green *guilloché* enamel ground,
inscribed and dated "Commemorating the 50th
Anniversary of the Land Reform 19 February
1861–29. March 1911", 1906 – signed Fabergé,
initials of workmaster Alfred Thielemann,
1908–1917, height 2¹⁸ in. (5.4cm)
Bibliography: S. B. Patrikyeev & A. D.
Boynovich, "Badges of Russia". Farn Moscow/
St. Petersburg 1995, p. 332, no. 12.6
(another example).
Private Collection

754. JEWELED GOLD AND
PURPURINE CAP OF MONOMACH
PENDANT designed as a miniature gold
replica of the Cap of Monomach set with
rubies and peridots above a pink-gold border
simulating mink, suspending three diamond-set
purpurine Easter eggs – initials of workmaster
Alfred Thielemann, assay mark of St. Petersburg
1908–1917.
Exhibited: Lahti 1997, cat. 4, ill. p. 5.
The Woolf Family Collection

755. GOLD-MOUNTED JEWELED
ROMANOV TERCENTENARY
BROOCH initials of workmaster Alfred
Thielemann, assay mark of St. Petersburg 1908
– 1917. Original fitted presentation case.
The State Hermitage Museum (BE 1391)

756

757

759

762

760

758

761

758. ART NOUVEAU CIRCULAR GEMSET GOLD DISH
the circular shallow gold dish with irregular rim, profusely *repoussé* and chased with scrolling foliage and rocaille enriched with sapphire, ruby and diamond blossoms and foliage against a matte ground, the center with further diamond-set floral spray – by Fabergé, initials of workmaster Eduard Schramm, assay mark of St. Petersburg before 1899, 72 (zolotnik), inv no. 24870, diameter 4¹⁄₄ in. (10.2cm).
Exhibited: London 1977, cat. 0 17, ill. p. 100; Munich 1986/7, cat. 167, ill. p. 155; New York 1988, cat. 8; Zurich 1989, cat. 30, ill. p. 75; St. Petersburg/Paris/London 1993/4, cat. 278, ill. p. 375; Stockholm 1997, cat. 165, ill. p. 184.
Among the few surviving items signed by Schramm, who seems to have worked occasionally for Fabergé, but also for Bolin, this dish takes pride of place.
The Woolf Family Collection

759. REEDED GOLD IMPERIAL PRESENTATION CIGARETTE-CASE
with alternating narrow and white bands, the cover applied to one side with a diamond-set double-headed eagle – signed Fabergé, Cyrillic initials G. L. of workmaster Gabriel Lundell, assay mark of St. Petersburg 1908–1917, length 3³⁄₄ in. (9.5cm).
Bibliography: Traina 1998, p. 138 (top).
Cf. note cat. 101.
John Traina Collection

756. TRAVELING PENCIL
reeded gold pencil holder – initials of workmaster Vladimir Soloviev, length 3 in. (7.6cm).
Bibliography: Solodkoff 1984, p. 177, ill.
Made in a workshop that specialized in gold or enameled-gold pencil holders.
The Forbes Magazine Collection, New York

757. SILVER-MOUNTED BIRCHWOOD CIGARETTE-CASE
the cover inset with a commemorative silver medal of Tsar Alexander I dated 1814, silver and cabochon ruby thumbpiece – signed Fabergé, initials of workmaster Eduard Schramm, assay mark of St. Petersburg 1908–1917, 88 (zolotnik), length 4³⁄₈ in. (11.1cm).
Bibliography: Traina 1998, p. 131 (right).
Eduard Schramm is known to have worked for Fabergé. However, it is rare to find his signature combined with that of Fabergé. As his initials generally appear alone, he may also have worked independently. His specialities were *objets de vertu* in gold.
John Traina Collection

760. TAPERING SILVER BEAKER
with reeded sides, the base inset with a gold Catherine the Great 2-rouble coin of 1785, gilt interior – initials of workmaster Theodor Ringe, St Petersburg before 1899, height 1⁷⁄₁₆ in. (3.6cm).
Private Collection

761. SILVER-MOUNTED SANDSTONE MATCH-HOLDER/STRIKER
shaped as a boletus, naturalistically modeled, standing on a gadrooned silver base, the match well lined in silver, a small silver model of a frog seated to one side – initials of workmaster Anna Ringe, assay mark of St. Petersburg before 1899, inv no. 3325, height 3⁷⁄₈ in. (10cm).
Exhibited: Hamburg 1995, cat. 10, ill. p. 57; Lahti 1997, cat. 35 ill. on back cover.
The Woolf Family Collection

762. GEM-SET GOLD-MOUNTED SILVER MINIATURE EASTER EGG
the hammered silver egg draped with a fluted gold band set with two cabochon sapphires – initials A. R. of workmaster Anna Ringe, assay mark of St. Petersburg before 1899, height ⁵⁄₈ in. (1.5cm).
The Woolf Family Collection

292

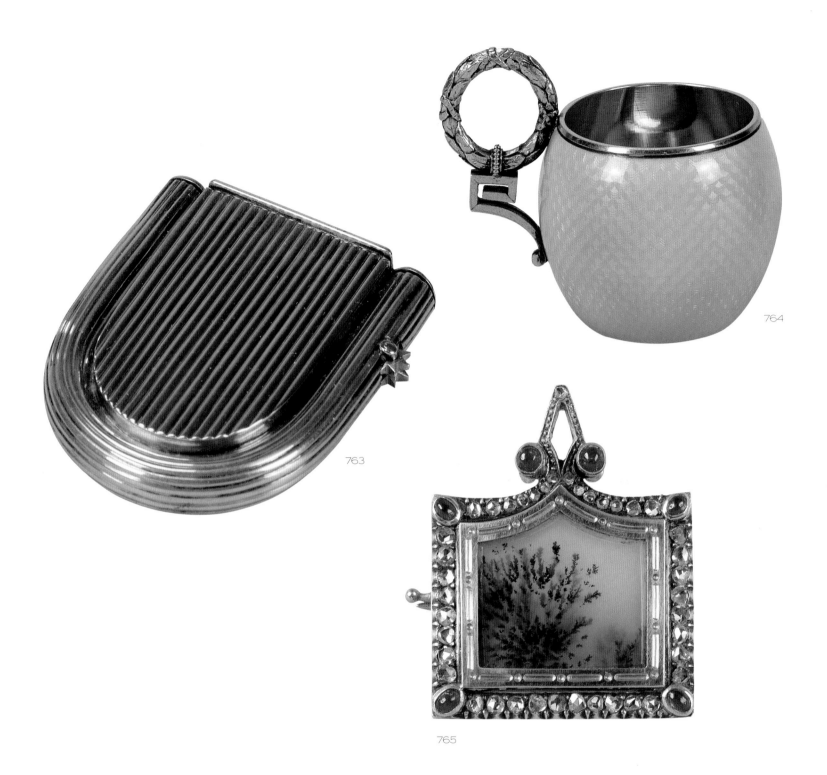

763

764

765

763. SILVER SHIELD-SHAPED
VESTA CASE initials of workmaster A. R.,
assay mark of St. Petersburg 1899–1908, assay
master A. Romanov, height 2 in. (5cm).
Original fitted wood case.
Private Collection

764. SILVER-GILT AND
TRANSLUCENT ENAMEL CORDIAL
CUP enameled translucent sky blue over a
guilloché ground, the handle in the form of a
ribbon-tied laurel wreath – Imperial Warrant
mark of Fabergé, initials of workmaster A. R.,
assay mark of St. Petersburg 1899–1908, inv no.
6888. Retailed by J. E. Caldwell & Co.,
Philadelphia, height 1¹⁄2 in. (3.8cm).
Private Collection

765. GEM-SET GOLD-MOUNTED
MOSS AGATE BROOCH with pointed
Chinese pagoda top, with rose-cut diamond
border, cabochon rubies at the angles and top
and bright-cut bezel – by Fabergé, initials of
workmaster Wilhelm Reimer, assay mark of
St. Petersburg before 1899, 56 (zolotnik),
length ¹⁵⁄16 in. (3.4cm).
Private Collection

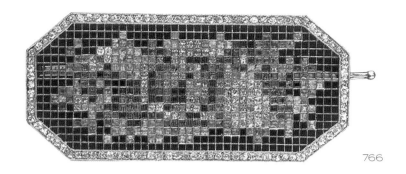

766

767

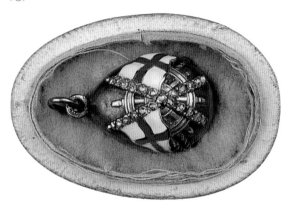

770

766. ELONGATED OCTAGONAL JEWELED PLATINUM PIN the frame set with rose-cut diamonds, supporting an openwork panel simulating *petit point* set with calibre-cut diamonds, rubies, blue and pink sapphires, topazes, demantoids, garnets and emeralds forming a floral study – by Fabergé, designed by Alma Theresa Pihl, inv no. 97142, length 1¹¹⁄₁₆ in. (4.4cm).
Bibliography: Snowman 1993, p. 142/3; Tillander 1996, ill. p. 171.
Exhibited: St. Petersburg/Paris/London 1993/4; Hamburg 1995, cat. 220, ill. p. 204; Washington 1996, ill. in brochure; Stockholm 1997, cat. 235, ill. p. 209.
This brooch is based on a design by Alma Theresa Pihl that appears in the stock book of Albert Holmström (see Snowman *op. cit.*). The same design was used for the Mosaic Egg of 1914 (HM Queen Elizabeth II).
The Woolf Family Collection

767. GEM-SET GOLD-MOUNTED ENAMEL AND SILVER EASTER EGG with two crossed enamel flags on diamond-set poles, the reverse with a gold anchor and the Cyrillic inscription "FOROS", workmasters initials of Oskar Pihl, assay mark of St. Petersburg before 1899, height 1 in. (2.5cm), original gray silk case, the lining stamped with Imperial Warrant and K Fabergé.
Foros was the name of a yacht used by the Imperial family on the Black Sea.
Private Collection

769. DOMED ENAMELED SILVER-GILT TABLE BELL of salmon pink *guilloché* enamel, applied with swags, standing on three stud feet, with cabochon moonstone pushpiece – signed Fabergé, initials of workmaster CHK, assay mark of St. Petersburg 1899–1908, assay master A. Richter, inv no. 14696, height 2¾ in. (7cm).
Private Collection

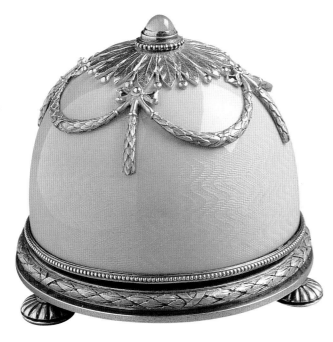

769

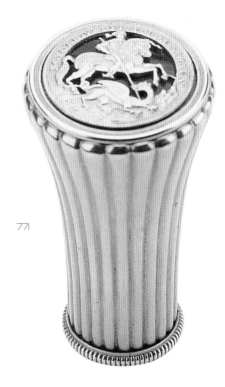

771

772

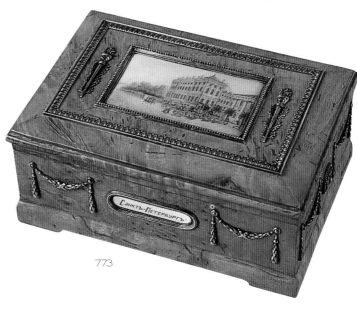

773

770. BURNISHED SILVER
CIGARETTE-CASE with match
compartment, the cover with a blue *champlevé*
enamel facsimile inscription in Cyrillic:
"Golyuba" (to my dove) – signed Fabergé,
initials K. F., assay mark of St. Petersburg
1908–1917, 88 (zolotnik), length 3³⁄₈ in.
(8.5cm).
Bibliography: Traina 1998, p. 156 (bottom).
John Traina Collection

771. TAPERING PLATINUM, GOLD
AND ENAMEL RIDING CROP
HANDLE with reeded sides, the circular top
with red *guilloché* enamel covered by an open-
work gold medallion of St. George slaying the
dragon surrounded by an inscription – assay
mark on gold only, 56 (zolotnik), inv no. 4775,
height 1¹³⁄₁₆ in. (4.6cm). Original fitted red
morocco cased stamped Fabergé, St. Petersburg,
Moscow.
Private Collection

772. PLATINUM MOUNTED ROCK-
CRYSTAL PAPERKNIFE the elliptical
blade with a platinum "ice" cap set with
rose-cut diamonds enclosing a similarly
decorated openwork snowflake on frosted rock
crystal background – unmarked, inv no. 77939
length 3 in. (7.6cm). Original fitted red
morocco case, stamped with Imperial Warrant
and K. Fabergé.
Private Collection

773. SILVER-MOUNTED
BIRCHWOOD BOX the cover inset with
an enameled view of a St. Petersburg street
scene flanked by two silver torches, with
beaded and stiff-leaf silver borders applied to
the cover, the front with an enameled plaque
inscribed in Cyrillic: "Saint Petersburg", the
sides with laurel swags – signed in full "K.
Fabergé" (St. Petersburg), 84 (zolotnik), length
6 in. (15.2cm).
Private Collection

10
LAPIDARY

NOTES ON THE LAPIDARY WORK OF THE FABERGÉ FIRM

There is no shortage of studies of the work of Fabergé; indeed, few are the jewelers who have merited such detailed attention, or to whom so many publications have been dedicated. Despite this – or perhaps because of it – questions arise concerning particular areas of Fabergé's activities. This article considers the lapidary work of the firm and attempts to explore a problem which has been compounded by the amount of lapidary work that has appeared on the market in recent years under the name of Fabergé.

In general terms it is known that the firm began to produce its own hardstone works after 1908, with the arrival of craftsmen such as P. Kremlev and P. Derbyshev. Until that time, as François Birbaum noted in his memoirs, "practically all lapidary work was carried out at the Woerffel Works in St. Petersburg and the Stern Works in Oberstein, Germany, according to designs and models produced by the firm. Stone objects were sometimes purchased from craftsmen in Ekaterinburg, and were passed on to these factories to correct any imperfections or to improve the polish. Craftsmen at the Peterhof Lapidary Works also provided their own creations, prepared by them at home during out-of-work hours." This last comment of Birbaum's is probably based more on hearsay than on the actual situation at the time. Fabergé's relations with the Peterhof Works were long-standing and close. They had an official, business-like character and were not confined to relationships with individual craftsmen.

Founded in 1725, the Imperial Peterhof Lapidary Works was the oldest of the three lapidary factories in Russia, and like the other two was the property of the Imperial family. Situated near St. Petersburg, it used mainly imported raw materials, unlike the Ekaterinburg Works, which used materials from the Urals, and the Kolyva Works, which used materials from Altai. For this reason, in addition to marble works, monumental vases, standard lamps and table lamps, a significant proportion of the factory's output consisted of lesser objects such as snuffboxes, caskets, small vases, Easter Eggs, mosaics and so on. What is more, from the very beginning of its existence the factory concentrated on the manufacture of precious stones, and in the eighteenth century was known as a "diamond mill" where "diamonds were cut and all kinds of other stones were faceted."

In 1886, the energetic and indefatigable Andrei Leontyevich Gun was appointed director, and under his stewardship the factory achieved considerable success. Gun was the first to establish links with the factories in Idar-Oberstein, which he visited regularly to purchase stones. In a short prospectus for the factory, he wrote: "The main business of the factory is the preparation of articles for Their Majesties' Court … Work at the factory is varied: without ceasing to produce its world-famous works of Florentine mosaic, the factory has increased production of objects made of jade and other hardstones, finished with gold, enamel and precious stones in a manner similar to objects produced in the sixteenth and seventeenth centuries …" The author of the factory's history added: "The areas of work at the factory are perfectly illustrated by its French title: *La Fabrique impériale des mosaïques et d'objets d'art en pierres dures.*"

Works at the Peterhof factory were created according to designs by N. Nabokov, V. Simanov, P. Kudryavtsev, Gornostaev and Baron M. Klodt. Later, two equally talented artists, V. Orlov and E. Lanceré, were invited to work there. Gun also invited the eminent Berlin engraver Pestou to come to the factory in 1887 to organise the stone-carving and engraving works. These were people who subsequently collaborated with Fabergé himself. No less famous are the names of the clients who purchased goods from both the factory and the Fabergé firm. As well as the Tsar's immediate family, of course, Grand Duke Alexei

Alexandrovich made numerous orders, particularly for jade artefacts. The sons of Grand Duke Vladimir Alexandrovich ordered whole consignments of small items as gifts for friends and relatives. Indeed, the factory was flooded with orders for exhibitions, for the private needs of the court as well as for official presentations.

It is important to note that the factory did not produce mounts for its works. Stone vases, boxes and various other accessories were sent to the jewelry firms of Bolin, Koechli, Ivanov, Ovchinnikov, Khlebnikov and Fabergé, where mounts were made for them from precious materials, often to designs by Andrei Gun himself. Documents in the archives of the Peterhof Lapidary Works show that as soon as he arrived at the factory – that is, in 1886 – Gun established close links with a number of jewelers. They included Fabergé, who was soon to become almost the most important jeweler to the Imperial Court, and who, only a year earlier had been awarded the title of Supplier to the Court, and received commissions from the Cabinet of His Imperial Majesty. The factory made good use of the firm's services. In 1888, for example, Fabergé was commissioned to "repair an Easter Egg of lapis lazuli with cut diamonds." After 1890, commissions from the factory became particularly frequent. Most significantly, Fabergé began sending a regular supply of "needle eyes", or suspension rings, to the factory, which were used to suspend "small eggs made of various stones". Between 50 and 200 of these "needle eyes" were supplied annually, at a cost of 1 to 1.25 roubles each. Thus many of the stone egg-pendants which bore the stamp of the Fabergé firm on their gold rings were not actually products of the firm itself. This does not, of course, apply to the eggs in precious metals and stones with enamels and various figured decorations, of which the firm produced a considerable number.

In addition to the above, the Peterhof factory also commissioned Fabergé to produce mounts for a number of their works made from stone. The firm carried out such commissions without fail, and always placed its own maker's mark alongside the state hallmark. Any stone object in a mount bearing the Fabergé mark thus tends to be taken as a work created entirely by the Fabergé firm. What is more, the firm was often commissioned to repair damaged objects, such as the Egg of Lapis Lazuli and Brilliants in 1888. Archive documents contain several examples of such commissions. In 1890, for example, Fabergé was commissioned to make mounts for a sphere of Egyptian jasper, a jade chest and a box made of rhodonite. In the following year he produced a mount for jade plaques made at the factory to commemorate its founding and in 1892 he created mounts for a jade chest with inlay, a jade vase and a jade egg; the mounts were priced at 148, 120 and 156 roubles respectively. In 1893 he made a mount for a jade goblet, both of which were extremely expensive: the goblet was valued at 500 roubles, its mount at 400 roubles. In 1896 Fabergé produced a "mount for a jade chest for 55 roubles" and "a stand for a jade rococo vase for 200 roubles." Fabergé's receipts for 1897 record: "Received: one plaque of petrified wood with medal, both to be mounted"; "Received: one tall rhodonite vase for finish." He used the petrified wood with metal to produce a dish in a silver setting, valued at 180 roubles, while he charged 240 roubles for work on the mount for the rhodonite vase. The same file includes reference to "mount (gold) for a jade box, 100 roubles." The box, including mount and cover, was extremely expensive at 1,200 roubles, while the mount for the jade lotka [shallow vessel] cost 175 roubles. The mount with white enamel and rose-cut diamonds for the small box of Bukharan lapis lazuli was valued at 150 roubles. The bill for the "vase of smokey topaz … presented to the Imperial Court on 25 May 1898" is of particular interest. Fabergé produced a setting and mount for 275 roubles, while the vase itself was priced at 1,880 roubles, indicative of the extremely elaborate work it entailed. The question arises here of whether this is the vase of smoky quartz mounted by Julius Rappoport in the Hermitage collection (cat. 176). Smoky quartz was often referred to as smokey topaz, and this is how it is referred to in the inventory.

Fabergé in turn also frequently commissioned the factory to carry out lapidary work. As early as 1886, he requested an ashtray of rock crystal, smokey topaz or pale jade, on which he intended to place a sea-horse of his own creation. In 1890 he purchased a number of small-scale stone items, although the accounts do not indicate specifically which. In 1891 he wrote "please supply a jade box", priced at 40 roubles.

He began to produce his own objects made from coloured stones around this time. The first important step in this direction was the creation of a jasper Easter Egg in 1891, the famous "Pamyat Azova" Egg. The bills presented to the Cabinet of His Imperial Majesty for that year include reference to rhodonite and jasper knives, goblets made of garnet, cornelian and fluorspar, a jade vase and an onyx goblet for 640 roubles. A year later, as an Easter gift for Empress Maria Feodorovna, Fabergé produced his second stone egg with an elephant and three angels, made of jadeite with rose-cut diamonds. Jadeite, jade, cornelian, topaz, rhodonite and crystal were the stones he most frequently used. At the same time he began to produce animal figurines. mainly elephants. At the end of 1891, for example, he created an "electric bell-push of jadeite with three elephants" (no. 1400) for 385 roubles. In January of the following year he produced an "electric bell-push with a jadeite elephant with a red enamel howdah on a cacholong pedestal" (no. 58837) for 120 roubles. A bill dated 1 July 1893 includes a "topaz elephant" for 65 roubles and a rhodonite and jadeite one for 45 roubles each. In 1892, on the occasion of the golden wedding anniversary of King Christian IX and Queen Louisa, their Imperial Majesties Alexander III and Maria Feodorovna took with them to Copenhagen an "elephant of smokey topaz with tower" (no. 46351, priced 165 roubles), a "jadeite elephant" for 550 roubles and two smaller jade elephants, each costing 75 roubles. The highest order in Denmark was the Royal Order of the Elephant, and before her marriage the Russian Empress had been a Danish princess. This also explains the preponderance of elephants in Fabergé's work during that year.

Indeed, Fabergé's lapidary sculpture can be said to have begun with these elephants. To judge by the bills presented to the Cabinet of His Imperial Majesty, there were few other animals and wild beasts produced by the firm during this period. Accounts for 1895 refer to a jadeite cat with rose-cut diamond eyes (75 roubles) and a jade pig with diamond eyes (67 roubles). In 1896 the firm was overwhelmed with commissions connected to the coronation of Nicholas II and they produced an assortment of familiar items: bracelets, brooches, snuffboxes, badges, goblets, vases, cups and so on. By the following year, however, the accounts contain references to a jade frog with diamond eyes (no. 53867, 115 roubles), a cornelian giraffe with rose-cut diamond eyes (no. 57942, 80 roubles), a grey chalcedony leopard with similar eyes (no. 57946, 100 roubles) and a chalcedony ass, also with rose-cut diamond eyes (no. 57948, 67 roubles). In April of the same year, Fabergé issued a bill for "a crystal glass with a flower and three brilliants" (no. 55962) for 67 roubles 50 kopecks (half price) and in 1898 the number of animal figurines produced was almost the same: a hare, two elephants of various materials, a cat, an ass and a tiger. On this occasion the eyes were all made of rubies. The objects were priced between 65 and 150 roubles. Documents covering the years from 1899–1905 list fifteen bird and animal figures: "Agate Goose (Japanese)", "Agate Fish (Japanese)" and "Agate Cockerel (Japanese)". Only the "Hare of Japanese Agate" reveals that these titles refer to Japanese agate rather than to Japanese birds or fish. Nevertheless, all of these objects made from red agate show the clear influence of oriental miniature sculpture.

The same accounts include references to only two flowers: "a rock crystal glass, four enamel violets and leaves. no. 4729, 80 roubles" from 1901, and "a rock crystal glass with pensee with opening petals, 700 roubles" from 1904 (Kremlin Armory Museum, cat. 867); yet we know the firm was already producing flowers by 1900, although more often using enamels than stone.

So until the opening of its own lapidary workshop, the Fabergé firm produced a very small quantity of stone figures, each of a quality worthy of the Imperial Court. The same products intended for sale in the firm's shop were normally bought wholesale from craftsmen at the Peterhof factory, and were then completed if necessary by the firm's own stone-carvers. This probably explains the wide range of styles and craftsmanship apparent in Fabergé's stone figures of the period.

The emergence of the firm's own stonecarvers led to the creation of human figures made from various types of stone. The skilled craftsmanship of the stonecarvers was evident not only in the sensitive choice of stone and the care of the finish, but also in the techniques they employed in fastening stones together, whereby the join was scarcely visible. These creations were relatively expensive. In a bill issued to the Cabinet of His Imperial Majesty on 8 August 1908, the following statuettes were listed: a dvornik [caretaker] (F 16462) for 545 roubles; John Bull (F 16506) for 600 roubles; a navvy (F 15991) for 480 roubles; a priest (F 16128) for 525 roubles. In November of the same year, a "Figure of a Coachman of Jade and Other Siberian Stones, No. 17050" was also sold for 600 roubles, and in December a "Figure of a Court Grenadier of Various Siberian Stones and Stamped Gold, no. 17986, 925 roubles". Six months later the firm produced a "Figure of a Carpenter from Siberian Stones" for 650 roubles and on 24 December a "Ukrainian Soldier of Various Stones and Enamels" for 700 roubles; an "Old Lady Going to the Baths, No. 20095. 600 roubles" and a "Balalaika Player of Various Stones, 850 roubles" were created before 16 April 1910. One of the most expensive figurines was "Kudinov, a Court Cossack to Her Imperial Majesty the Empress Maria Feodorovna" which, according to an account dated 22 December 1912, cost 2,300 silver roubles. This, incidentally, was not the only figurine created by Fabergé for Maria Feodorovna, and others even included "portraits." Here is a note from Grand Duke Nikolai Mikhailovich to the Empress in response to her grief at the death of her pet parrot: "I would be delighted if this parrot and cage were to meet with your approval, because old Mr Fabergé has put unheard-of effort into making the bird look like your late friend. I rather think he has succeeded. Your faithful old hound (57 years old), N. M. 28 July 1916, Grushevka Khersonskaya."

Of course, these accounts do not prove that these were the only works of carved stone produced by the Fabergé firm in the years in question. It should be remembered that they refer only to supplies to the court, and Fabergé had many other clients. For example, in photographs of the exhibition held at the home of Baron von Derwies in 1902, for example, numerous figures and vases can be seen.

Marina Lopato

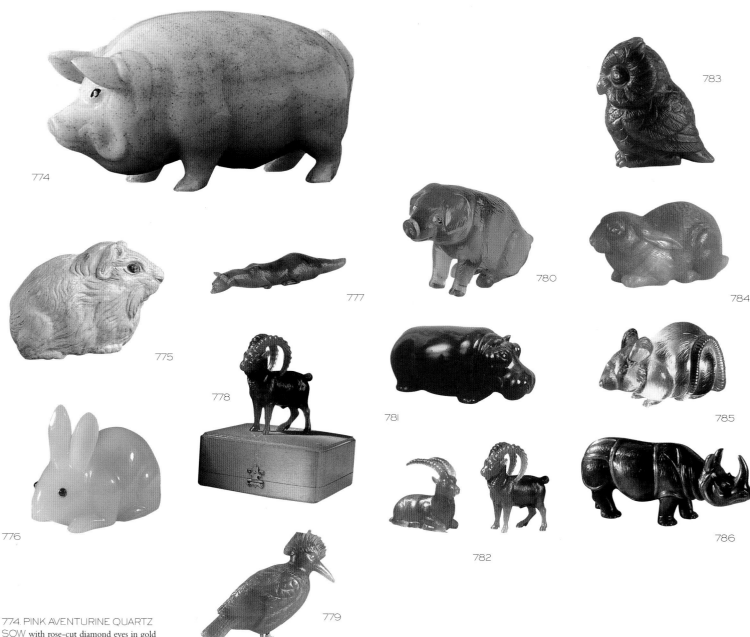

774. PINK AVENTURINE QUARTZ
SOW with rose-cut diamond eyes in gold
mounts – length 2 in. (5cm). Original fitted case
stamped with Imperial Warrant, St. Petersburg,
Moscow.
Exhibited: Munich 1986/7, cat. 298; Stockholm
1997, cat. 46.
H. M. King Carl XVI Gustav of Sweden

775. PLASTER MODEL OF A
HAMSTER by Fabergé, length 1³⁄4 in. (4.5cm).
Provenance: Henry C. Bainbridge.
A rare instance of a plaster model after a wax
model (Wartski, London) for one of Fabergé's
animal figures from the collection of the firm's
London representative.
Courtesy of À la Vieille Russie

776. WHITE QUARTZ CARVING OF A
SNOW RABBIT with cabochon ruby eyes
sitting in an alert position with raised ears –
length 1⁷⁄8 in. (4.8cm). Original dark
wooden case stamped with Imperial Warrant,
Fabergé, St. Petersburg, Moscow.
Private Collection

777. NEPHRITE CARVING OF A MINK
the crawling animal with long neck and pricked
ears, with finely carved fur – length 3¹⁄4 in.
(8.2cm). Original hollowood case stamped with
Imperial Warrant, Fabergé, Petrograd, Moscow,
London.
Private Collection

778. HONEY-COLORED AGATE
FIGURE OF A FULL-GROWN IBEX
(capra sibirica), naturalistically carved, standing
erect, its curved horn touching its back, with
rose-cut diamond eyes – height 2¹⁄4 in. (5.7cm).
Original fitted case stamped with Imperial
Warrant, St. Petersburg, Moscow, Odessa.
Bibliography: Bainbridge 1949, pl. 24.
Exhibited: London 1995, cat. 1; Stockholm
1997, cat 42.
The Castle Howard Collection

779. HONEY-COLORED AGATE
FIGURE OF A HOOPOE BIRD
naturalistically carved, with engraved gold feet
and beak and rose-cut diamond eyes – initials
of workmaster Henrik Wigström, 72 zolotnik,
height 2 in. (5.1cm). Original fitted case
stamped with Imperial Warrant, St. Petersburg,
London.
Exhibited: London 1995, cat. 5; Stockholm
1997, cat. 47.
The Castle Howard Collection

780. MINIATURE TOPAZ CARVING
OF A PIG the translucent yellow topaz body
minutely carved and set with rose-cut diamond
eyes – length ³⁄4 in. (2cm).
Private Collection

781. OBSIDIAN HIPPOPOTAMUS with
rose-cut diamond eyes – inv no. 15669
scratched on right hind leg, length 2¹⁵⁄16 in.
(7.5cm).
Exhibited: Finland 1980, p. 12, pl. 10; Corcoran
1996; Lahti 1997.
Private Collection, lent courtesy of Ulla
Tillander-Godenhielm, Finland

782. HONEY-COLORED AGATE
FIGURE OF A YOUNG IBEX (capra
sibirica), naturalistically carved, reclining, with
rose-cut diamond eyes – height 1⁷⁄8 in. (4.8cm).
Bibliography: Bainbridge 1949, pl. 24.
Exhibited: London 1995, cat. 2; Stockholm
1997, cat. 41.
The Castle Howard Collection

783. NEPHRITE FIGURE OF AN OWL
humoristically carved, with rose-cut diamond
eyes – height 1¹⁄4 in. (3.2cm).
Exhibited: London 1995, cat. 6.
The Castle Howard Collection

784. PINK QUARTZ FIGURE OF A
BELGIAN RABBIT naturalistically carved,
seated, with cabochon citrine eyes – length
2³⁄4 in. (7cm).
Exhibited: London 1995, cat. 7.
The Castle Howard Collection

785. TOPAZ FIGURE OF A RAT
naturalistically carved in transparent yellow
hardstone, in crouching position – length
1³⁄4 in. (4.4cm).
Exhibited: London 1995, cat. 8.
The Castle Howard Collection

786. FIGURE OF A BOWENITE
RHINOCEROS carved standing upright
with cabochon ruby eyes – length
6¹⁄2 in. (16.5cm).
Exhibited: London 1995, cat. 11.
Note: For the only other comparably large
(4⁵⁄8 in. 11.8cm) rhinoceros in reddish jasper in
the Walters Art Gallery, Baltimore, see Fabergé
in America, 1996/7, cat. 2.
The Castle Howard Collection

787

790

791

789

792

787. FIGURE OF A BLOODSTONE
ANTEATER with rose-cut diamond eyes –
length 2¹⁄4 in. (5.7cm).
Exhibited: London 1995, cat. 13; Stockholm
1997, cat. 44.
Note: For another pink aventurine quartz
example of this model see Habsburg
1986/7, cat. 300.
The Castle Howard Collection

789. MINUTE FIGURE OF A SMOKY
QUARTZ VOLE naturalistically carved with
rose-cut diamond eyes – ³⁄4 in. (1.9cm).
Exhibited: London 1995, cat. 15.
The Castle Howard Collection

790. CHALCEDONY FIGURE OF AN
ELEPHANT seated with raised trunk and
rose-cut diamond eyes – height 1³⁄4 in. (4.4cm).
Exhibited: London, 1995, cat. 16.
The Castle Howard Collection

791. CHALCEDONY FIGURE OF AN
ELEPHANT standing, swinging his inward
curved trunk, with rose-cut diamond eyes –
height 1³⁄4 in. (4.4cm).
Exhibited: London 1995, cat. 17.
The Castle Howard Collection

792. DIMINUTIVE AGATE FIGURE OF
A SEATED RABBIT with rose-cut
diamond eyes – by Fabergé, height ⁷⁄16 in.
(1.3cm). Original fitted case stamped with
Imperial Warrant, St. Petersburg, Moscow,
Odessa.
Private Collection

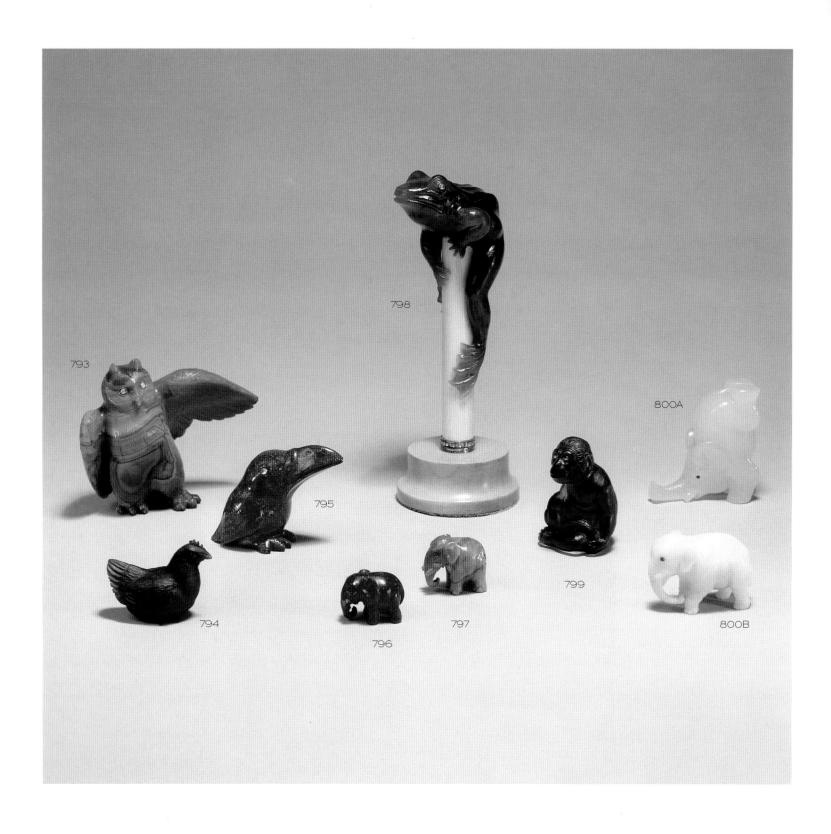

793. AGATE FIGURE OF AN OWL of
striated brownish stone with one spread wing
and rose-cut diamond eyes – by Fabergé,
height 2 in. (5cm).
Exhibited: QVC 1999.
Joan and Melissa Rivers

794. OBSIDIAN FIGURE OF A
SEATED HEN by Fabergé, height 1¼ in.
(3.1cm). Original fitted case.
Exhibited: QVC 1999.
Joan and Melissa Rivers

795. PURPURINE FIGURE OF A
TOUCAN the stylized bird with diamond
eyes – by Fabergé, height 2 in. (5cm).
Exhibited: QVC 1999.
Joan and Melissa Rivers

796. PURPURINE FIGURE OF AN
ELEPHANT by Fabergé, height ¾ in. (2cm).
Exhibited: QVC 1999.
Joan and Melissa Rivers

797. RHODONITE MINIATURE FIGURE
OF AN ELEPHANT with cabochon sapphire
eyes – by Fabergé, length ¾ in. (2cm).
Exhibited: QVC 1999.
Joan and Melissa Rivers

798. DIAMOND-SET, ENAMELED,
GOLD-MOUNTED NEPHRITE
PARASOL HANDLE surmounted by a frog,
the shaft of white *guilloché* enamel with a border
of rose-cut diamonds – by Fabergé, height
3½ in. (9cm).
Exhibited: QVC 1999.
Joan and Melissa Rivers

799. OBSIDIAN FIGURE OF A
SEATED MONKEY with rose-cut diamond
eyes – by Fabergé, height 1⅝ in. (4.1cm).
Exhibited: QVC 1999.
Joan and Melissa Rivers

800A. BOWENITE CIRCUS
ELEPHANT in a headstand with ruby eyes –
by Fabergé, height 1½ in. (3.5cm).
Exhibited: QVC 1999.
Joan and Melissa Rivers

800B. OPAL FIGURE OF A
MINIATURE ELEPHANT with ruby eyes –
by Fabergé, height 1⅛ in. (2.8cm). Original
fitted case.
Exhibited: QVC 1999.
Joan and Melissa Rivers

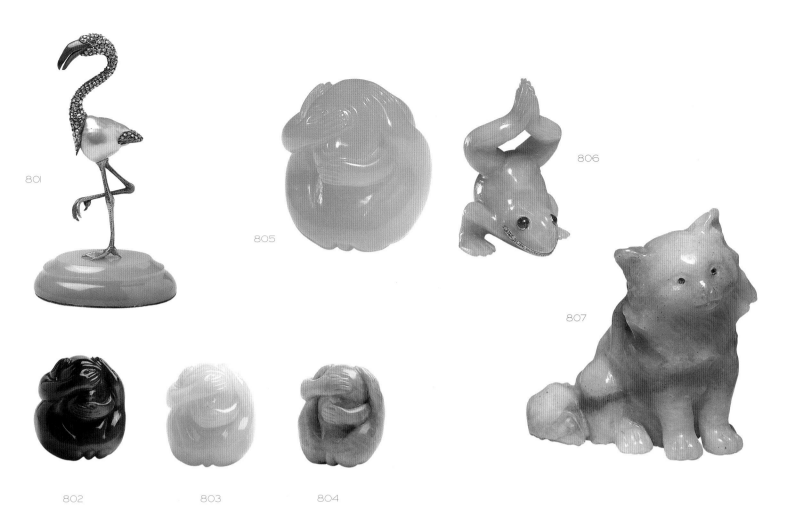

801. GEMSET FLAMINGO in the manner
of Dinglinger, the bird standing on one leg,
with baroque pearl body, diamond-encrusted
neck and tail, cabochon ruby eyes, enameled
beak and gold legs, on an oval bowenite base –
unmarked, by Fabergé, height $4^3/8$ in. (11.1cm).
Original fitted box with Imperial Warrant
mark, St. Petersburg, Moscow.
Bibliography: Snowman 1979, p. 43.
Exhibited: London 1977, cat. S 19; Munich
1986/7 cat. 342.
Private Collection

802. AMAZONITE FIGURE OF A
MYSTIC APE covering eyes, ears and mouth
– by Fabergé, height $1^1/2$ in. (3.8cm). Original
fitted case with Imperial Warrant mark,
St. Petersburg, Moscow.
Bibliography: Snowman 1962/4, pl. XXXIV;
Snowman 1979, p. 65; Munn 1987, p. 39.
Exhibited: London 1977, cat. R 27; Munich
1986/7, cat. 369.
A Fabergé version of the three mystic apes
combined in one inspired by an ivory netsuke
in the manner of Mitsuhiro, school of Osaka,
symbolizing "see no evil, hear no evil, speak no
evil" (see Habsburg 1987, p. 306).
Private Collection

803. OBSIDIAN FIGURE OF A
MYSTIC APE covering eyes, ear and mouth
– by Fabergé, height $1^1/2$ in. (3.8cm)
Bibliography: Snowman 1979, p. 65; Munn
1987, p. 39.
Exhibited: Munich 1986/7, cat. 366.
Private Collection

804. CHALCEDONY FIGURE OF A
MYSTIC APE covering eyes, ears and mouth
– by Fabergé, height $1^5/16$ in. (3.3cm).
Private Collection

805. BOWENITE FIGURE OF A
MONKEY modeled after a netsuke
symbolising "see no evil, hear no evil, speak no
evil" – by Fabergé, height $1^1/4$ in. (3.2cm).
Private Collection

806. GEM-SET JADE FIGURE OF A
FROG in a jumping position with raised hind
legs, the gold-mounted mouth set with rose-
cut diamonds and with cabochon ruby eyes –
by Fabergé, height $2^1/4$ in. (5.7cm).
Private Collection

807. AVENTURINE FIGURE OF A CAT
carved in yellow-orange hardstone with brown
stripes, the eyes set with peridots – by Fabergé,
inv no. 22992 scratched on leg, height
$2^1/4$ in. (5.7cm).
Provenance: Purchased by Lady Paget from
Fabergé in London on December 12th 1916
for L25.00 (Cost price 125 roubles)
described in the stock book as "Kitten, yellow
quartz etc.".
Evidently a portrait of Zubrovka, a favorite of
the Tsarevitch Alexei Nikolaevich. Lili Dehn
wrote in her book "The Real Tsaritsa"
(Thornton Butterworth1922) "his chief pet at
Tsarskoe was an ugly sandy and white kitten
which he once brought from G. H. Q.
Zubrovka was no respecter of palaces, and he
used to wage war with the Grand Duchess
Tatiana's bull dog, Antipo, and light-heartedly
overthrow all the family photographs in the
Tsaritsa's boudoir. But Zubrovka was a
privileged kitten, and I have often wondered
what became of him when the Imperial Family
was taken to Tobolsk."

It is a characteristic of some Fabergé animals
that they are worked underneath to show
details of the feet. This particular carving is a
good example of the technique. The
exploitation of the natural configurations of a
stone to suggest a particular animal's pelt is
characteristic of carvings in the Sandringham
collection. The lapidary who carved this cat
was probably the same as that who made the
model of King Edward VII's favorite dog, the
Norfolk Terrier, Caesar, in 1910.
For Lady Paget see Fabergé in America,
1996/7, pp. 350f .
Private Collection

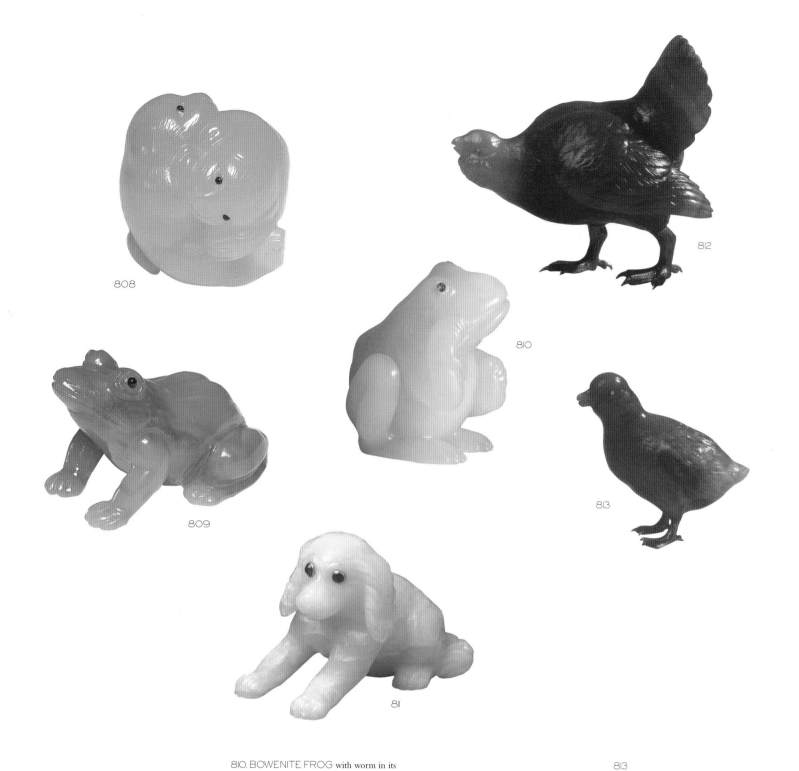

808

810

812

809

813

811

808. JADE FIGURE OF FWO FIGHTING PUPPIES of rounded shape, inspired by a netsuke, the eyes set with rubies – by Fabergé, height 1¹2 in. (3.8cm).
Private Collection

809. JADE FIGURE OF A FROG seated and with protruding eyes set with cabochon rubies – by Fabergé, length 1¹⁵16 in. (4.8cm).
Private Collection

810. BOWENITE FROG with worm in its mouth represented in the manner of a Japanese netsuke, humoristically carved seated on its hind feet and holding a worm in its mouth, set with gold-mounted cabochon ruby eyes – by Fabergé, height 2¹8 in. (5.5cm).
Exhibited: Munich 1986/7, cat. 363, ill. p. 225; New York 1988, cat. 21; Zurich 1989, cat. 148; Stockholm 1997, cat 43, ill. p. 110.
The Woolf Family Collection

811 OPAL FIGURE OF A PLAYFUL SPANIEL seated on its hind quarters with extended forelegs, set with gold-mounted cabochon ruby eyes – by Fabergé, height 1³4 in. (4.5cm). Original fitted case stamped with Imperial Warrant, St. Petersburg, Moscow, London.
Exhibited Munich 1986/1987. cat. 373, ill. p. 206; New York 1988, cat. 20; Zurich 1989, cat. 140, ill. p. 106; London 1992, cat.. 109; St. Petersburg 1993, cat. 186, ill p. 308; London 1994; Hamburg 1995, cat. 14, ill p. 60; London 1998.
The Woolf Family Collection

812. GOLD-MOUNTED AGATE FIGURE OF A CAPERCAILZIE THE STRIATED AGATE BIRD realistically carved and set with rose-cut diamond eyes, with finely chased gold feet – by Fabergé, height 2¹¹16 in. (6.9cm). Original fitted case stamped with Imperial Warrant St. Petersburg, Moscow, Odessa.
Provenance: Miss Yznaga, Paris.
Exhibited: London 1935, cat. 588B; Munich 1986/7, cat. 372, ill. p. 206; New York 1988, cat. 19; Zurich 1989, cat.155, ill. p. 60; London 1992, cat, 112; St Petersburg/Paris/London 1993/4, cat. 158, ill p. 291; Hamburg 1995, cat. 21, ill. p. 65 London 1998.
Bibliography: Habsburg/Solodkoff 1979, plate 104; Paris Match, 28th October 1993; Beaux-Arts Magazine, Hors Série 55, p. 22; Madame Figaro, Septembre, 1993.
The Woolf Family Collection

813
GOLD-MOUNTED CHALCEDONY FIGURE OF A DUCKLING realistically carved, standing on finely chased gold webbed feet, and set with diamond eyes – by Fabergé, height 1⁹18 in. (4cm). Original fitted case stamped with Imperial Warrant, St Petersburg, Moscow, Odessa.
Exhibited: London 1935, cat. 588 H; New York 1988, cat. 40; Zurich 1989, cat. 157, ill. p. 60; St. Petersburg/Paris/London 19935, cat. 157, ill p. 60; Bibliography: same or very similar to Habsburg/Solodkoff 1979, plate 104; Paris Match, October 28th 1993.
The Woolf Family Collection

814. SMOKY TOPAZ FIGURE OF A CROUCHING MOUSE realistically carved in the manner of a netsuke and set with rose-cut diamond eyes – by Fabergé, length 1⁷8 in. (4.7cm).
Exhibited: Munich 1986/1987, cat. 370, ill. p. 206; New York 1988, cat 18; Zurich 1989, cat. 150, ill. p. 107; Lahti 1997, cat. 16, ill. p.18.
The Woolf Family Collection

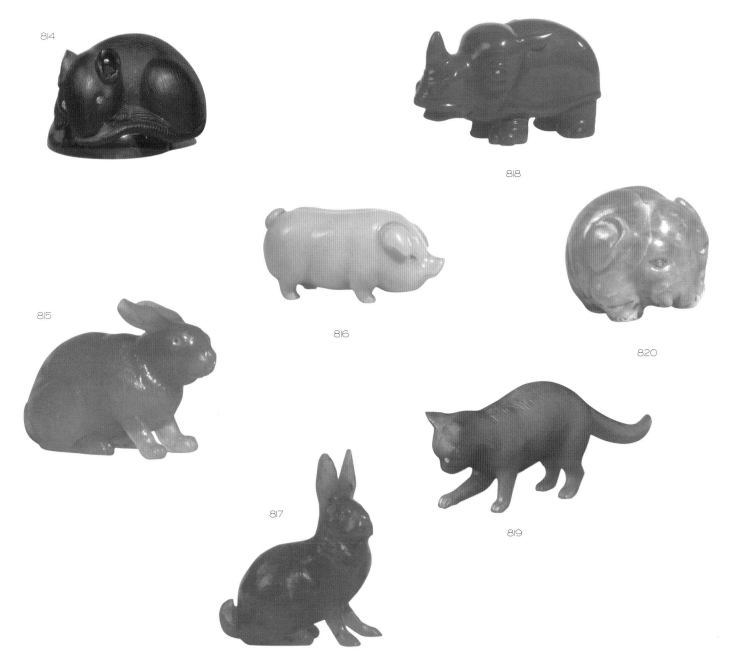

814

818

816

815

820

817

819

815. AGATE FIGURE OF A SEATED RABBIT the honey-colored red agate animal realistically carved, set with rose cut diamond eyes – by Fabergé, height 1³⁄₈ in. (3.5cm). Original fitted wood case stamped with Imperial Warrant, St. Petersburg, Moscow, Odessa.
Exhibited: London 1935, cat 588Z; New York 1988, cat. 39; Zurich 1989, cat. 142, ill. p. 107; London 1992, cat. 121; St. Petersburg/Paris/ London 1983/4 cat. 156, ill p. 290; Hamburg 1995, cat. 23, ill p. 66; Hamburg 1995, cat. 23, ill p. 66; Stockholm 1997, cat. 30, ill. p. 105; London 1998.
Bibliography: Paris Match, October 28th 1993; Madame Figaro September 25th, 1993.
The Woolf Family Collection

816. QUARTZ FIGURE OF A STAND-ING PIG the stout animal of creamy quartz, with foiled rose-cut diamond set eyes – by Fabergé, length 2 in. (5.1cm).
Exhibited: Zurich 1989, cat. 146; New York 1983.
The Woolf Family Collection

817. NEPHRITE FIGURE OF A SEATED HARE naturalistically carved, seated in an alert position with ears erect, the eyes set with rubies – by Fabergé, height 1 ⁹⁄₁₆ in. (4cm).
Exhibitions: New York 1988 cat. 37; Zurich 1989, cat. 143, ill. p. 107; London 1992, cat. 120; London 1998.
Bibliography: Possibly the same as hare Snowman 1966, plate 37; Paris Match October 28th 1993.
The Woolf Family Collection

818. GRAY KALGAN JASPER FIGURE OF A STANDING RHINOCEROS humoristically carved, the eyes set with rose cut diamonds – by Fabergé, length 2¹⁄₈ in. (5.5cm). Original fitted case stamped Imperial Warrant, St. Petersburg, Moscow.
Provenance: Edward James Collection.
Exhibited: New York 1983, cat. 90, ill. p. 66; Munich 1986/1987), cat. 320, ill. p. 197; New York 1988, cat. 36; Zurich 1989, cat. 135, ill. p. 106; London 1992, cat. 119; Hamburg 1995, cat. 29, ill p. 71; Laht 1997, cat. 19, ill. p.19; London 1998.
The Woolf Family Collection

819. HONEY-COLORED CHALCEDONY FIGURE OF A PLAYFUL CAT with one paw outstretched, the eyes set with rose cut diamonds – by Fabergé, length 2¹⁄₈ in. (5.5cm). Original fitted case stamped with Imperial Warrant, St. Petersburg, Moscow, Odessa.
Provenance: Edward James Collection.
Exhibited: New York 1983, cat. 140, ill. p. 187; Munich 1986/7, cat. 371, ill. p. 206; New York 1988, cat. 17; Zurich 1989, cat. 141, ill. p. 107; London 1992, cat. 117; St. Petersburg/Paris/ London 1993/4, cat. 157, Ill p. 290 (and used for a post-card); Hamburg 1995,cato. 22, ill p. 66.
Bibliography: Beaux-Arts Magazine; Madame Figaro, 25 septembre, 1993; Treffpunkt Tourismus, Magazine 2195, tourist report.
The Woolf Family Collection

820. RHODONITE FIGURE OF AN ELEPHANT amusingly carved as a plump pachyderm in the manner of a Japanese netsuke, with feet carved to simulate mud coating, the eyes set with demantoid garnets – by Fabergé, height 1 in. (2.5cm). Original fitted case stamped with Imperial Warrant, Petrograd, Moscow, London.
Provenance: Michael Jurivich Lermontov collection.
Exhibited: New York 1988, cat. 35; Zurich 1989, cat. 133; Lahti 1997, cat. 2, ill. p.19.
The Woolf Family Collection

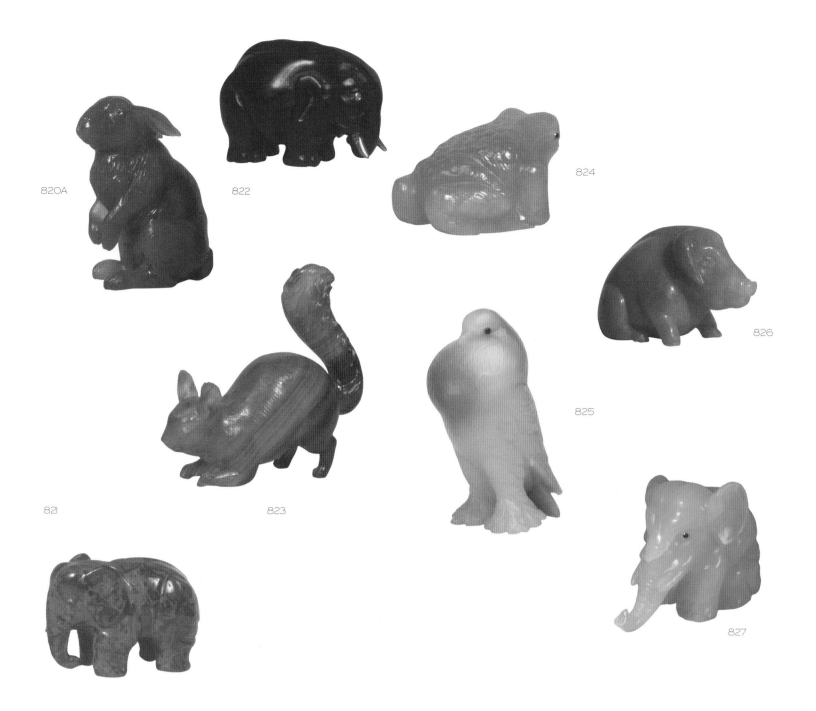

820A **820A. AGATE FIGURE OF A SEATED RABBIT** the honey-coloured red agate animal realistically carved, set with rose cut diamond eyes – by Fabergé, height 1³⁄₈ in. (3.5cm). Original fitted wood case stamped with Imperial warrant, St. Petersburg, Moscow, Odessa.
Exhibited: London 1935, cat 588Z; New York 1988, cat. 39; Zurich 1989, cat. 142, ill. p. 107; London 1992, cat. 121; St. Petersburg/Paris/ London 1983/4 cat. 156, ill p. 290; Hamburg 1995, cat. 23, ill p. 66; Stockholm 1997, cat. 30, ill. p. 105; London 1998.
Bibliography: Paris Match, October 28th 1993; Madame Figaro September 25th, 1993.
The Woolf Family Collection

821. GRAY KALGAN JASPER FIGURE OF A STANDING ELEPHANT with brown inclusions, the eyes set with demantoid garnets – by Fabergé, height 1³⁄₁₆ in. (3cm).
Exhibitions: Zurich 1989, cat. 134, ill. p. 60; Hamburg 1995, cat. 12, ill p. 58.
The Woolf Family Collection

822. OBSIDIAN FIGURE OF A STANDING ELEPHANT with gold tusks and gold-mounted rose-cut diamond eyes – signed with initials K. F. on one tusk, length 1³⁄₁₆ in. (3cm). Provenance: Collection of Queen Elizabeth of Greece; Lance Reventlow, son of Barbara Hutton.
Exhibited: New York 1988, cat. 33; St. Petersburg/Paris/London 1993/4, cat. 92, ill p. 242.
The Woolf Family Collection

823. STRIATED CORNELIAN FIGURE OF AN ALERT SQUIRREL the eyes set with rose cut diamonds – by Fabergé, height 1¹⁵⁄₁₆ in. (4.9cm). Original fitted hollywood case stamped with Imperial Warrant St. Petersburg, Moscow, Odessa.
Provenance: Miss Yznaga, sister of the Duchess of Manchester; The Sterling Trust.
Exhibitions: London 1935, cat. 588Y Munich 1986/1987, cat. 374, ill. p. 206; New York 1988, cat. 15; Zurich 1989, cat. 145, ill. p. 107; London 1992, cat. 110; St. Petersburg/Paris/ London 1993/4 cat. 160, ill p. 291; Hamburg 1995, cat. 24, ill p. 67; London 1998.
The Woolf Family Collection

824. BOWENITE FIGURE OF A SEATED FEMALE TOAD carved in the manner of a Japanese netsuke, with cabochon ruby eyes – by Fabergé, height 2 in. (5.1cm). Original fitted dark wood case stamped with Imperial Warrant.
Provenance: The Sterling Trust 1985.
Exhibited: Munich 1993/4, cat. 363, ill. p. 205; New York 1988, cat. 15; Zurich 1989, cat. 149; St. Petersburg/Paris/ London 1993/4, cat. 164, ill p. 293.
The Woolf Family Collection

825. VARICOLORED CHALCEDONY POUTER PIGEON its colors ranging from blue-gray to cream, set with cabochon ruby eyes – by Fabergé, height 2³⁄₁₆ in. (5.5cm).
Provenance: Lady Juliet Duff.
Exhibited: London 1992, cat. 113; St. Petersburg/Paris/London 1993/4, cat. 161, ill p. 292; Hamburg 1995, cat. 20, ill. p. 64; Stockholm 1997, cat. 34, ill. p. 115 and back of the book; London 1998.
Bibliography: Bainbridge, 1949, plate 76.
The Woolf Family Collection

826. AVENTURINE QUARTZ FIGURE OF A SEATED WART-HOG with rose-cut diamond eyes – by Fabergé, height 1³⁄₈ in. (3.5cm).
Exhibited: London 1992, cat. 114; Stockholm 1997, cat. 35, ill. p. 107; London 1998.
The Woolf Family Collection

827. BOWENITE FIGURE OF A SEATED ELEPHANT with trunk unfurled and gold-mounted ruby eyes – by Fabergé, height 1¹¹⁄₁₆ in. (4.3cm).
Provenance: Lord Ivar Mountbatten
Exhibited: Munich 1986/1987, cat. 330, ill. p. 199.
Bibliography: Snowman 1966, plate 37.
The Woolf Family Collection

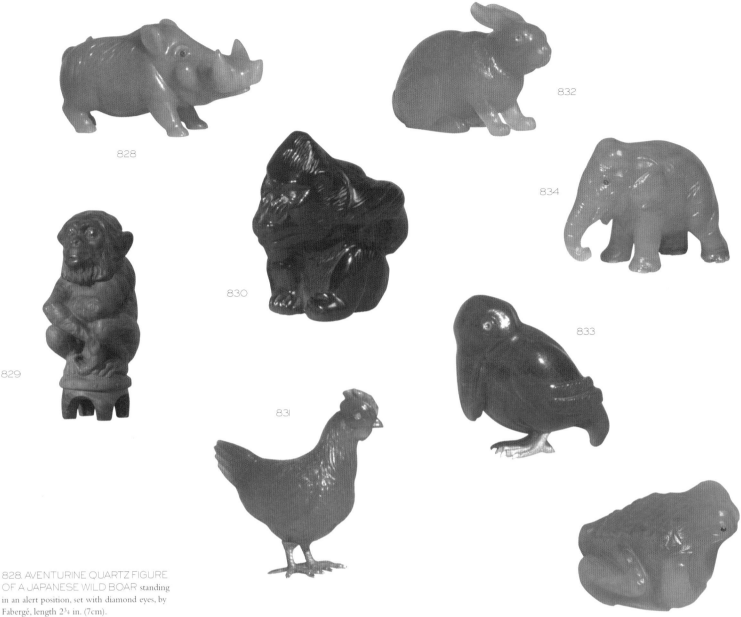

828

832

834

829

830

833

831

835

828. AVENTURINE QUARTZ FIGURE
OF A JAPANESE WILD BOAR standing
in an alert position, set with diamond eyes, by
Fabergé, length 2³⁄4 in. (7cm).
Exhibited: London 1992, cat. 115; Stockholm
1997, cat. 36, ill. p. 107; London 1998.
A very similar animal is in the Royal
Collection at Sandringham (exhibited 1985,
handlist no. 294).
The Woolf Family Collection

829. PETRIFIED WOOD FIGURE OF
A SEATED CHIMPANZEE with arms
crossed, seated on a small circus stool, set
with brilliant-cut eyes – by Fabergé, height
2¹⁄2 in. (6.3cm).
Provenance: Listed in the London sales ledgers
(1903–1915) as: Lady Paget: Chimpanzee,
petrified wood, inventory number 24223,
December 12 1915 £55, 328 roubles
Exhibited: London 1977, cat. R.36. ill p. 120;
St. Petersburg/Paris/London 1993/4, cat. 162,
ill p. 292.
Bibliography: Snowman 1979, ill. p.143; Paris
Match 28th October 1993.
The Woolf Family Collection

830. OBSIDIAN CARVING OF A
SEATED MANDRILL the polished surface
simulating the silky pelt of the animal, its eyes
set with rose cut diamonds – by Fabergé,
height 2 in. (5cm).
Exhibitions: London 1992, cat. 116; Hamburg
1995, cat. 17, ill p. 62; London 1998.
The Woolf Family Collection

831. GOLD-MOUNTED AGATE
FIGURE OF A HEN realistically carved, the
eyes set with rose-cut diamonds, the feet
chased in gold – by Fabergé, height 1³⁄8 in.
(3.5cm). Original fitted wooden case with
Imperial Warrant, St Petersburg, Moscow.
Exhibited: Hamburg 1995, cat 30, ill p. 72.
The Woolf Family Collection

832. AGATE FIGURE OF A
CROUCHING RABBIT naturalistically
carved in pale agate, its eyes set with rose cut
diamonds – by Fabergé, height 1³⁄8 in.
Exhibited: London 1992, cat. 121; Hamburg
1995, cat. 25, ill. p. 68; Stockholm 1997, cat. 29,
ill. p. 105; London 1998.
The Woolf Family Collection

833. OBSIDIAN FIGURE OF A
PELICAN CHICK carved in a humorous
vein, its eyes set with rose-cut diamonds and
the feet chased in gold – by Fabergé, height
1³⁄8 in. (3.5cm).
Exhibitied: London 1992, cat. 106; Hamburg
1995, cat. 27, ill p. 69.
The Woolf Family Collection

834. PALE-BROWN AGATE FIGURE
OF A STRIDING ELEPHANT standing
with its trunk curled inwards, set with rose cut
diamond eyes – by Fabergé, height
2²⁄8 in. (5.8cm).
Exhibitions: Hamburg 1995, cat. 33, ill p. 705.
The Woolf Family Collection

835. NEPHRITE FIGURE OF A
SEATED TOAD carving in the manner of a
netsuke, set with gold-mounted rose-cut dia-
mond eyes – by Fabergé, height 1¹⁵⁄16 in. (5cm).
Exhibitions: London 1992, cat. 107; Hamburg
1995, cat. 26, ill p. 68; London 1998.
The Woolf Family Collection

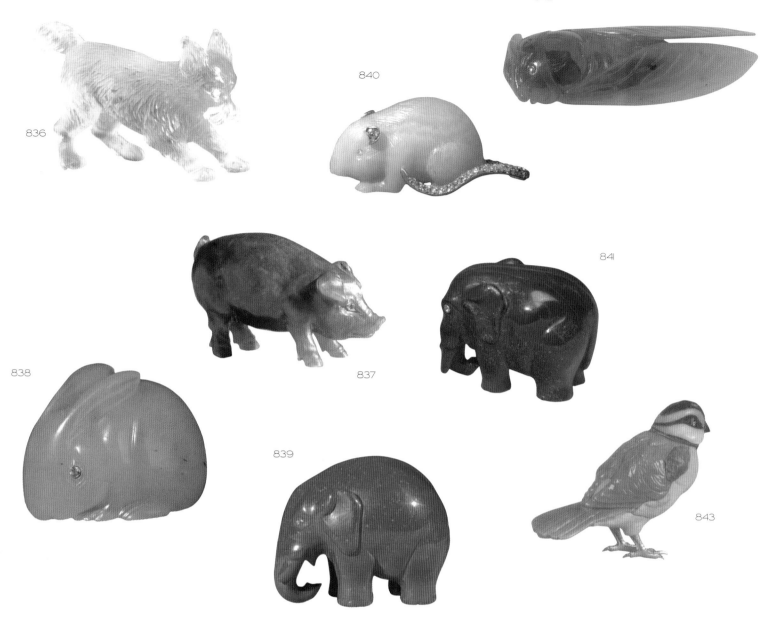

836. CITRINE FIGURE OF A
PLAYFUL SCHNAUZER its eyes set with
rose-cut diamonds – by Fabergé, length 1¹⁄₂ in.
(3.8cm). Original fitted hollywood case with
Imperial Warrant, St. Petersburg, Moscow.
Exhibited: Lahti 1997, cat. 18, ill. p.19.
The Woolf Family Collection

837. JADE FIGURE OF A STANDING
PIG set with ruby eyes – by Fabergé, height
1³⁄₄ in. (4.5cm).
The Woolf Family Collection

838. BOWENITE FIGURE OF A
SEATED RABBIT carved in the manner of
a netsuke, its eyes set with gold-mounted
yellow diamonds – by Fabergé, length 1¹³⁄₁₆ in.
(4.7cm).
The Woolf Family Collection

839. PURPURINE FIGURE OF A
STANDING ELEPHANT humoristically
carved with its trunk rolled inward, its eyes set
with rose-cut diamonds – by Fabergé, height
1³⁄₁₆ in. (3cm).
Provenance: The countess of Torby (Countess
Sophie von Merenberg, created Countess of
Torby) wife of Grand Duke Mikhail
Mikhailovich; Lord Ivar Mountbatten, 1992.
Exhibitions: London 1992, cat. 129; Stockholm
1997, cat. 32, ill. p. 107; Hamburg, 1995, cat.
32, ill. p. 74; London 1998.
The Woolf Family Collection

840. BLUE CHALCEDONY MOUSE
with pavé-set diamond tail and ears, its eyes set
with rose-cut diamonds.
Exhibitions: Stockholm 1997, cat. 31, ill. p. 105.
Bibliography: There are several similar studies of
mice, based on netsuke prototypes in the
collection of HM the Queen which are shown
on p. 70 of A. Kenneth Snowman's book "Karl
Fabergé, Goldsmith to the Imperial Court of
Russia 1979".
For a similar mouse, see Munich 1986/7,
cat 367, p. 205.
The Woolf Family Collection

841. LAPIS LAZULI FIGURE OF
STANDING ELEPHANT with gold-
mounted brilliant-cut diamond eyes – by
Fabergé, height 1⁵⁄₈ in. (4.1cm).
The Woolf Family Collection

842. SIBERIAN JADE CICADA carved in
the manner of a netsuke, set with rose-cut
diamond eyes, with realistically carved
underside – by Fabergé, length 2⁹⁄₁₆ in. (6.5cm).
Exhibitions: Lahti 1997, cat. 3, ill. p.4.
The Woolf Family Collection

843. VARICOLORED COMPOSITE
HARDSTONE FIGURE OF A BLUE TIT
its breast carved in yellow chalcedony, the tail
and wings of green bowenite, the face of
white quartzite, the crest of lapis lazuli and
the neck of onyx, with rose-cut diamond
eyes and chased gold feet – by Fabergé, height
1¹⁄₄ in. (3.2cm).
Exhibited: London 1998.
Bibliography: Connaissance des Arts, no 499,
October 1993, illustration p 133.
The Woolf Family Collection

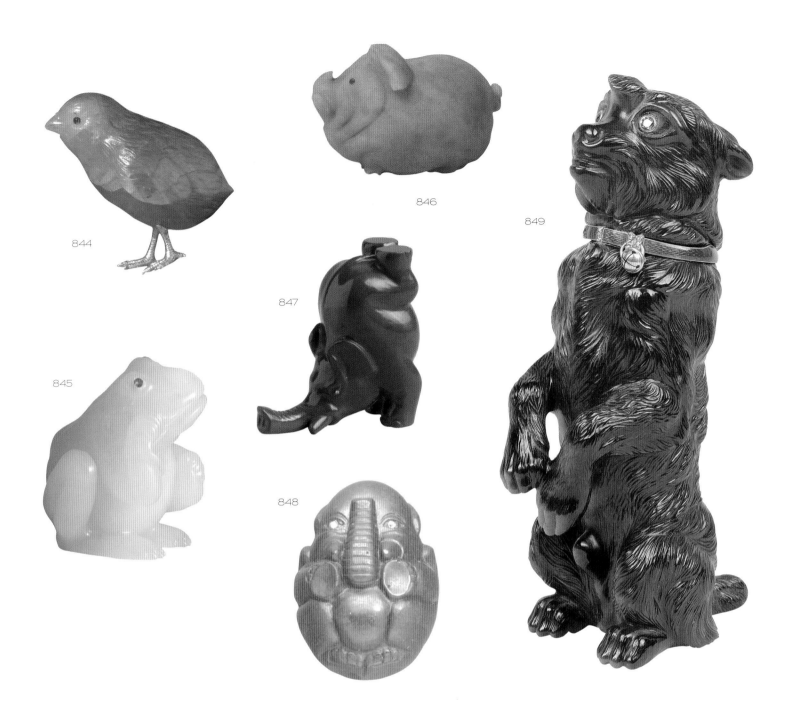

844

846

849

845

847

848

844. STRIATED TIGER'S EYE AND
QUARTZ FIGURE OF A CHICK set with
cabochon ruby eyes and chased gold feet – by
Fabergé, height 1³⁄₈ in. (3.4cm). Original
fitted case stamped with Imperial Warrant,
St. Petersburg and Moscow.
The Woolf Family Collection

845. BOWENITE FIGURE OF A
SEATED FROG humoristically carved with
head tilted upwards and its forelegs turned
inwards, set with peridot eyes – by Fabergé,
height 1⁹⁄₁₆ in. (4cm).
The Woolf Family Collection

846. AVENTURINE QUARTZ FIGURE
OF A PIG humoristically carved with inclined
head and upturned snout, exhibiting a mottled
matt surface simulating its hide, set with ruby
eyes – by Fabergé, length 2³⁄₈ in. (6cm).
Exhibited: Lahti 1997, cat. 17, ill. p.18.
The Woolf Family Collection

847. GRAY KALGAN JASPER
FIGURE OF A CIRCUS ELEPHANT
balancing on forelegs and trunk with rose-cut
diamond eyes – by Fabergé, height 1⁹⁄₁₆ in.
(4cm).
Provenance: Lady Milford Haven; Lord Ivar
Mountbatten.
Exhibited: Munich 1986/7, cat. 329.
The Woolf Family Collection

848. PURPURINE FIGURE OF A
QUASI-SPHERICAL ELEPHANT
carved in the manner of a Japenese netsuke,
with rose-cut diamond eyes – by Fabergé,
height 1³⁄₁₆ in. (3cm).
The Woolf Family Collection

849. ENAMELED GOLD-MOUNTED
OBSIDIAN FIGURE OF A BEGGING
CAIRN TERRIER seated on its hind
quarters, with gold mounted yellow diamond
eyes, red *guilloché* enamel collar with rose-cut
diamond bands and attached gold bell – by
Fabergé, unmarked, height 5¹¹⁄₁₆ in. (14.4cm).
Original fitted case with Imperial Warrant,
St. Petersburg, Moscow.
Provenance: Mme. Elisabeth Balletta.
This figure is visible on a vintage photograph
in a Fabergé album at the Fersman
Mineralogical Museum, Moscow.
Courtesy of À la Vieille Russie

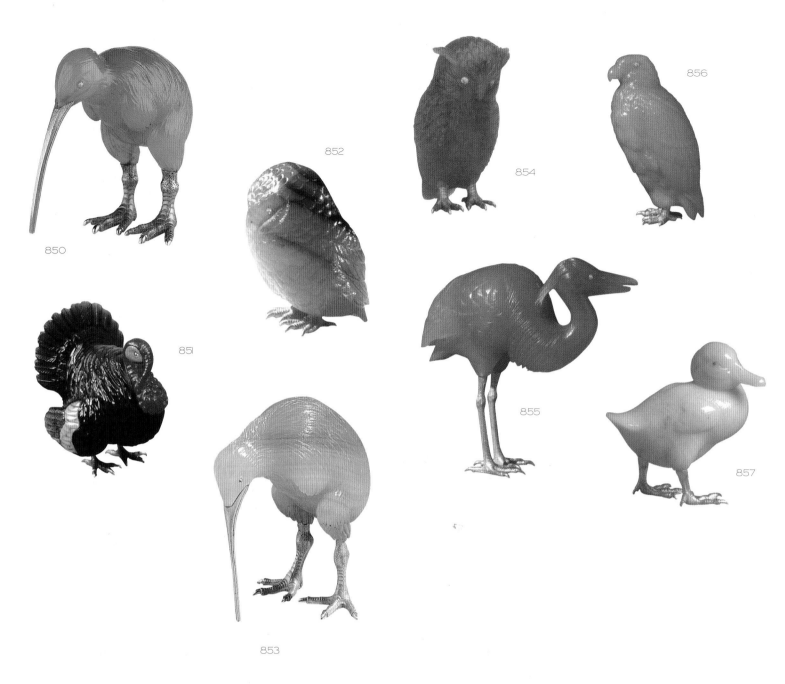

850

851

852

853

854

856

855

857

850. AGATE CARVING OF A KIWI BIRD
the gray hardstone bird carved with plumage
and set with rose-cut diamond eyes, with gold
beak and chased and engraved gold legs –
signed by Fabergé, workmaster's initials of
Michael Perchin, assay mark of St Petersburg
1899–1908, 56 (zolotnik), assay-master Yakov
Lyapunov, height 1⅝ in. (4.1cm).
Provenance: Collection of Sir Charles Clore.
Private Collection

851. GOLD-MOUNTED HARDSTONE
TURKEY naturalistically carved and
composed of an obsidian body with quartzite
feathers, a purpurine head with rose-cut
diamond eyes and gold feet – signed Fabergé,
initials of workmaster Henrik Wigström, assay
mark of St. Petersburg 1908–1917, 72
(zolotnik), height 2⅛ in. (5.3cm).
Exhibited: Helsinki 1980, cat. 78; Leningrad
1989, cat. 15; Corcoran 1996; Lahti 1997;
Stockholm 1997, cat. 52.
Private Collection, lent courtesy of Ulla
Tillander-Godenhielm, Finland

852. AGATE FIGURE OF AN OWL
naturalistically carved in varicolored hardstone,
with engraved gold feet – initials of
workmaster Henrik Wigström, 72 zolotnik,
height 1¼ in. (3.2cm).
Exhibited: Tessier 1995, cat. 9.
The Castle Howard Collection

853. LARGE GOLD-MOUNTED
AGATE FIGURE OF A KIWI with ruby
eyes and chased red-gold legs and beak –
initials of workmaster Michael Perchin, St.
Petersburg, 1899–1908, inv no. 5458, height
3¾ in. (9.5cm).
Exhibited: Houston 1994; St. Petersburg,
Florida 1995.
Courtesy of A La Vieille Russie

854. GOLD-MOUNTED AGATE
FIGURE OF AN OWL the pertly poised
long-eared owl in striated brown and mauve-
gray agate, mounted with chased gold talons
and set with brilliant-cut faceted demantoid
garnet eyes – by Fabergé, initials of workmaster
Henrik Wigström, 72 (zolotnik), height 1⅝ in.
(4.2cm).
Exhibited: Hamburg 1995, cat. 19, ill. p. 64;
Lahti 1997, cat.15, ill. p.18.
The Woolf Family Collection

855. GOLD-MOUNTED AGATE
EGRET realistically carved in an alert stance,
its legs chased in gold, its eyes set with rose-cut
diamonds – by Fabergé, initials of workmaster
Henrik Wigström, assay mark of St. Petersburg
1899–1908, assay-master Yakov Lyapunov, 72
(zoltnik), height 2¹⁵⁄₁₆ in. (6.8cm).
Provenance: General Sir Arthur Paget, thence
by direct descent.
During his career, General Sir Arthur Paget was
much in contact with Russia and the Imperial
Russian Court. The files of the Imperial
Cabinet show that nephrite vases by Fabergé
were presented to Sir Arthur Paget around
1897 at the same time as a similar presentation
to Lord Pembroke. He later received the
Russian Order of Alexander Nevski.
The Woolf Family Collection

856. GOLD-MOUNTED AGATE
EAGLE the shaded agate eagle realistically
carved in standing position with unfurled
wings, set with rose-cut diamond eyes and
finely chased gold feet – by Fabergé, initials of
workmaster Henrik Wigström, assay mark of
St. Petersburg 1908–1917, 72 (zolotnik), height
2⅜ in.
The Woolf Family Collection

857. GOLD-MOUNTED
CHALCEDONY DUCKLING realistically
carved, tilting its head to one side, its eyes set
with olivines and its gold legs finely chased –
by Fabergé, initials of workmaster Henrik
Wigström, assay mark of St. Petersburg
1899–1908, assay-master Yakov Lyapunov,
height 2½ in. (6.5cm).
Provenance: H.M. Queen Alexandra; H. M.
Queen Elisabeth II.
Exhibited: Stockholm 1997, cat. 50, ill. p. 113
Bibliography: Snowman 1979, ill. p.69.
For a very similar model see Munich 1986/7,
cat. 296.
The Woolf Family Collection

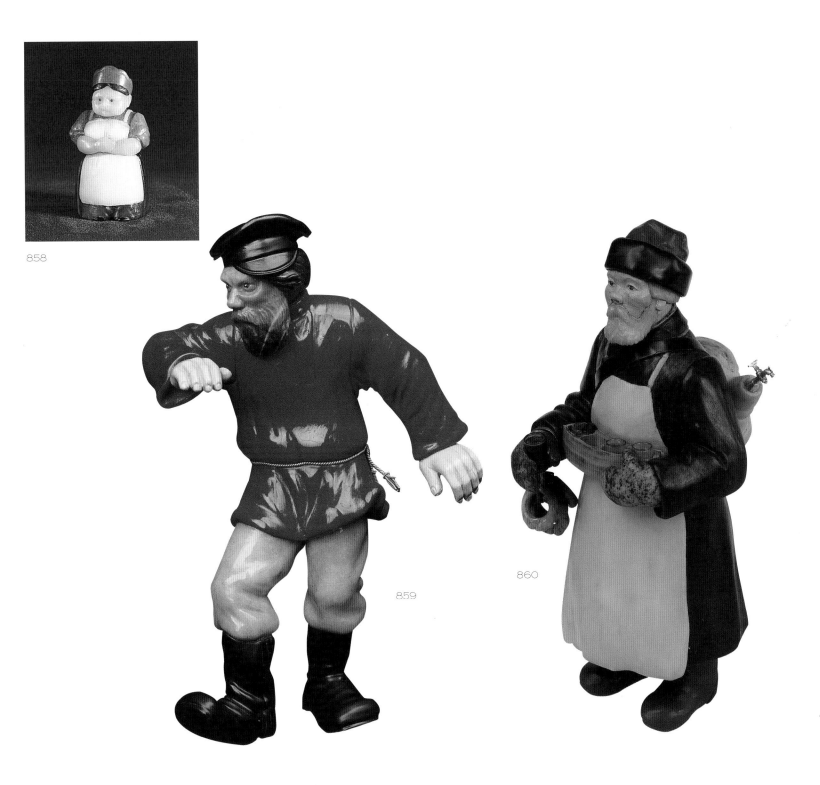

858

859

860

858. COMPOSITE HARDSTONE
FIGURE OF A WET NURSE (mamka)
with lapis-lazuli skirt, white quartz apron,
rhodonite cap and blouse, agate face and arms,
obsidian hair and sapphire eyes – by Fabergé,
height 1⁷⁄₈ in. (4.8cm).
Provenance: Imperial Collections; transferred to
the Kremlin Armory 1923.
Bibliography: Snowman 1962/4, ill. 269;
Armory 1964, p. 167; Rodimtseva 1971,
ill. p. 13.
Exhibited: Moscow 1992, cat. 61, ill. p. 125;
Sydney 1996, cat. 35, ill. p. 69; Torre Canavese
1994, cat. 66, ill. p. 160.
Kremlin Armory Museum (DK – 91)

859. DANCING MOUJIK figure of a
gold-mounted gem-set hardstone dancing
moujik represented with hat askew, right foot
and arm kicked forward and left hand swung
backward, the face carved of pink quartz, the
beard of gray jasper, with gold "rope" belt,
purpurine tunic over yellow chalcedony
trousers tucked into black marble boots –
height 5¼ in. (13.3cm).
Provenance: Lansdell K. Christie, Long Island,
New York.
Bibliography: Snowman 1963, ill. p. 249;
McNab Dennis 1965, ill. plate no. 13;
Waterfield/Forbes 1978, no. 49, ill. p. 41, cover;

Solodkoff 1984, p. 165, ill.; Habsburg 1987,
p. 86; Solodkoff 1988, p. 89; Hill 1989, ill. plate
no. 80, title page; Welander-Berggren 1997, p. 37.
Exhibited: New York 1962/66, no. L.62.8.151;
New York 1973, no. 22, ill. p. 69; London 1977,
cat. L13, p. 74; New York 1983, cat. 480, ill.
p. 134; New York et al. 1996/7, no. 195, cat.
p. 206, ill.
One of a large series of such folkloristic figures
produced by Fabergé, many of which were per-
sonally owned by Tsar Nicholas II.
The Forbes Magazine Collection, New York

860. COMPOSITE HARDSTONE
FIGURE OF A STREET VENDOR
(Raznoshik) with gray natural rock coat,
chalcedony apron, Kalgan jasper boots, obsidian
and lapis lazuli hat, gray granite mitts, marble
tea-tray, gray marble tea-urn with gold spigot,
three rock crystal glasses, smoky quartz glass in
hand, alabaster hair and beard, eosite face with
cabochon sapphire eyes – signed and dated
Fabergé 1914 under one boot, height 6¼ in.
(16cm).
Exhibited: New York 1961, cat. 285; New York
1983, cat. 199; Munich 1986/7, cat. 389.
Bibliography: Bainbridge 1962/4, pl. 100.
Private Collection

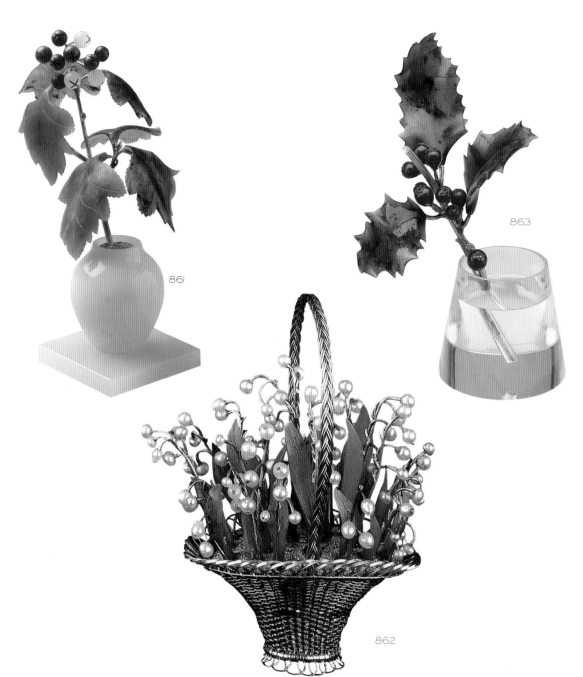

861

863

862

864

861. GOLD AND HARDSTONE
FLOWER STUDY OF A BRANCH
OF HAWTHORN the chased gold branch
with six carved undulating nephrite leaves and
fruit of purpurine, red aventurine and white
quartz, standing in a baluster-shaped white
quartz vase filled with gold soil, on square
bowenite plinth – signed Fabergé, initials of
workmaster Henrik Wigström, 72 (zolotnik),
height 5⁷⁄₁₆ in. (13.8cm).
Exhibited: Hamburg 1995, cat. no. 211.
Bibliography: Solodkoff 1988, ill. p. 103.
The Hubel Collection,
courtesy of Mr Leonid Dorst

862. MINIATURE BASKET OF LILIES
OF THE VALLEY the plaited gold wire
miniature basket filled with green gold moss
from which grow twenty-four tiny sprays
of lily of the valley with finely engraved
nephrite leaves and pearl flowers on gold stems
– signed Fabergé, initials of workmaster
Michael Perchin, St. Petersburg before 1899,
height 3ⁱ⁄₈ in. (7.9cm).
Provenance: HRH Princess Marina of Kent,
granddaughter of Tsar Alexander III's brother,
Grand Duke Vladimir Alexandrovich; Lansdell
K. Christie, Long Island, New York.
Bibliography: Snowman 1962/64/68/74, ill.
plate LXV; Snowman 1963, ill., p. 242;

Waterfield/Forbes 1978, no. 60, ill. p. 49;
Solodkoff 1984, ill.; Kelly 1985, p. 23, ill.;
Hill 1989, p. 22.
Exhibited: Washington 1961, no. 90, ill. p. 53;
New York 1962–66, no. L.62.8.90; New York
1973, no. 18, ill. p. 63 and cover; London 1977,
no. L10, ill. p. 82; New York et al.1996/97, no.
200, cat. p. 209, ill.
This study is similar to the larger Fabergé
basket of lilies of the valley which stood on the
desk of Tsarina Alexandra Feodorovna until the
1917 Revolution and is now in the collection
of the Mathilda Geddings Gray Foundation,
New Orleans Museum of Art.
The Forbes Magazine Collection, New York

863. HOLLY SPRAY gold-mounted
nephrite, purpurine and rock crystal holly
spray with gold stalk, nephrite leaves and
purpurine berries, set within a tapered rock
crystal cylindrical vase – signed Fabergé, height
4⁷⁄₈ in. (12.3cm).
Bibliography: Solodkoff 1984, p. 165, ill.;
Kelly 1985, p. 23, ill. pp. 22–23.
The Forbes Magazine Collection, New York

864. DESIGN IN GOUACHE FOR
A BROOCH IN THE FORM OF AN
ORCHID signed C. Fabergé. Inscribed
in pencil, diagonally "No".
Provenance: Acquired by the State Hermitage,
2000.
The State Hermitage Museum
(ERO sh – 1872)

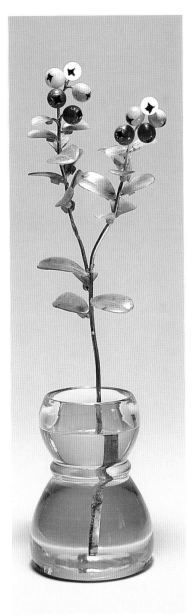

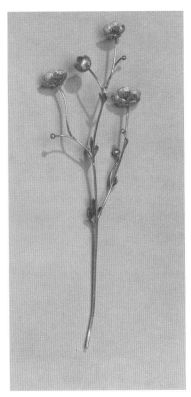

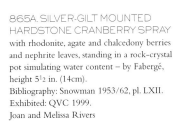

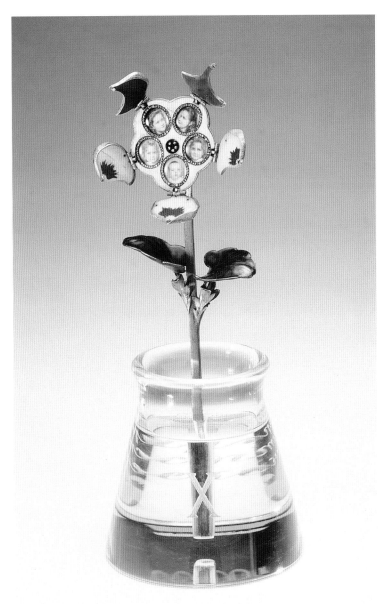

865 A

865 B. 866

865A. SILVER-GILT MOUNTED
HARDSTONE CRANBERRY SPRAY
with rhodonite, agate and chalcedony berries
and nephrite leaves, standing in a rock-crystal
pot simulating water content – by Fabergé,
height 5½ in. (14cm).
Bibliography: Snowman 1953/62, pl. LXII.
Exhibited: QVC 1999.
Joan and Melissa Rivers

865B. JEWELED, ENAMELED,
GOLD AND HARDSTONE STUDY
OF A BUTTERCUP SPRAY with
yellow-gold blossoms, diamond-set pistils and
gold stems, standing in a rock-crystal vase sim-
ulating water content – by Fabergé, height
6⅝ in. (16.8cm).
Bibliography: Snowman 1979, p82; Truman,
1977, p. 73, pl. 4.
Exhibited: London 1977, cat. 0 18; Munich
1986/7, cat. 393; Zurich 1989, cat. 167;
St. Petersburg/Paris/London 1993/4, cat. 170;
Stockholm 1997, cat. 19.
The Woolf Family Collection

866. GEM-SET ENAMELED GOLD
AND HARDSTONE STUDY OF AN
ALPINE STRAWBERRY modeled, chased
and enameled with red berries, a seed-pearl
and rose-cut diamond blossom, reeded gold
stem and two nephrite leaves, set in a rock-
crystal vase carved to simulate partial water
content – by Fabergé, unmarked, height 4¼ in.
(10.8cm).
Bibliography: Snowman 1962/4, pl. LXII,
Appendix D.
Exhibited: Hamburg 1995, cat. 395, ill. p. 217;
Stockholm 1997, cat. 17, ill. p. 93.
The Woolf Family Collection

867. JEWELED, GOLD-MOUNTED
FRAME shaped as a pansy with petals of
translucent enamel, green enamel leaves and
reeded gold stem, standing in a tapering
cylindrical rock crystal pot carved to simulate
partial water content, engraved with Roman
numeral X and the names Olga, Maria, Tatiana,
Anastasia, Alexis. The petals open to reveal
miniature portraits of the five Imperial
children, Grand Duchesses Olga, Tatiana, Maria
and Anastasia and Tsarevich Alexei framed by
rose-cut diamonds – signed Fabergé, initials
of workmaster Michael Perchin, assay mark of
St. Petersburg 1899–1908, assay-master Yakov
Lyapunov, height 6⅛ in. (15.5cm).
Provenance: Given by Tsar Nicholas II to his
wife Tsarina Alexandra Feodorovna 1904, at
the occasion of their 10th Wedding
Anniversary (November 26, 1894);
transferred to the Kremlin Armory 1922.
Bibliography: Snowman 1962/4, ill. p. 298,
p. 168; Goldberg 1967, p. 139, 212;
Armory 1964, p. 168; Rodimtseva 1971,
p. 23, ill. 14; Donova, 1973, p. 175, ill. 2.
Exhibited: Munich 1986/7, cat. 400, ill. p. 220;
Moscow 1992, cat. 44, ill.
p. 115; Sydney cat. 17, ill. p. 60.
Michael Perchin died in 1903 and his work-
shop was taken over by Henrik Wigström. This
Imperial commission, for which an invoice for
700 roubles has survived, must have been made
a year in advance of the anniversary.
Kremlin Armory Museum (MR – 564/1/2)

II
RUSSIAN
COMPETITORS

BOLIN, ST. PETERSBURG JEWELERS AND MOSCOW SILVERSMITHS

The house of Bolin is one of the oldest firms specializing in jewelry and silverware that still remains in the hands of one and the same family. The firm's archives once dated as far back as 1796, and its founder, the German-born jeweler Andreas Roempler, was established in St. Petersburg as early as 1790. In the registers of the German colony of this city he is called Master of Diamonds. He functioned as official appraiser to the Imperial Court from the early 1790s. His eldest daughter, Sofia, married Gottlieb Ernst Jahn, a reputable goldsmith, who subsequently became Roempler's partner. Jahn is known to have supplied an opal and diamond jewelry suite, comprising a tiara, necklace and bracelet, at the occasion of the christening of Grand Duke Nicolas Nicolaevich on 17 May 1834. The price of 169,601 roubles was the highest ever paid for a christening gift in the nineteenth century.

In 1833 Carl Edvard Bolin (fig. 1) arrived in St. Petersburg and began to work for Andreas Roempler. In 1834 he married Ernestine Catharina, another daughter of the recently deceased Roempler, becoming a full partner at the occasion of his marriage. The firm was henceforth named Jahn & Bolin. Brother-in-law Jahn died in 1836, leaving Bolin as partner to Jahn's widow. In 1839 the partners submitted a request to become Jewelers to the Imperial Court, which was granted. The name Jahn & Bolin prevailed for another two decades.

Bolin, an able businessman, rapidly became the most important jeweler in St. Petersburg. At the peak of his activity, he supplied more to the Imperial Court than all other jewelers put together. Towards the end of the nineteenth century some of the leading Paris houses, in particular Boucheron, established themselves in Russia, and were granted impressive commissions. From the 1890s, Bolin's main competitor was, of course, Fabergé, and although the Bolins continued to make most of the large pieces of jewelry for the Court, Fabergé surpassed Bolin in numbers and possibly also in turnover.
An example of Bolin's commissions is noted on an invoice to Tsar Nicholas II dated 19 December 1901: "(Christmas gifts?) two parures each comprising a brooch, a necklace and a bracelet, one of sapphires and diamonds, the other of pearls and diamonds". The total invoiced was the princely sum of 339,400 roubles.

In 1836 Henrik Conrad, then only sixteen years old, joined his elder brother in St. Petersburg, staying with Carl Edvard until 1852 when he opened a shop of his own in Moscow in partnership with an Englishman, James Stuart Shanks. Their shop was called Shanks & Bolin, Magasin Anglais, and was situated on the exclusive Kuznetski Most. They sold not only jewelry and silverware (this being Henrik Conrad's department) but also ladies' luxury accessories such as handbags, gloves, plumes, luxurious underwear, etc. This partnership did not last long and Henrik Conrad continued the business alone. His speciality was fine silverware which he manufactured and sold in Moscow and with which he supplied his St. Petersburg relatives. Originally the silver workshop was run by Maria Linke, and later by her son, Konstantin.

In 1864 Carl Edvard Bolin died in St. Petersburg, leaving his part of the firm in the hands of his sons Gustaf and Edward. When Henrik Conrad died in 1888 in Moscow he left everything to his three daughters. His sons, in his opinion, had received an expensive upbringing and training which was to be their sole legacy. To make it possible to continue the business, his eldest son Wilhelm James Andreevitch Bolin opened a branch for his

FIG 1. PORTRAIT OF CARL EDVARD BOLIN c. 1830. The Hermitage Museum

FIG 2. FAÇADE OF THE BOLIN HOUSE at 10 Bolshaya Morskaya, St. Petersburg, c. 1900. Russian State Archive

St. Petersburg cousins called C. E. Bolin (fig. 2). He continued on his own in Moscow, very much in the old tradition and was especially interested in silverware, bringing in young French sculptors as designers and making magnificent pieces in the somewhat overladen style of the 1880s. Eventually, he adopted the Art Nouveau style, often combining glass (Lalique), ceramics and cut crystal with silver mounts. In 1912 he took over the Moscow shop in his own name W. A. Bolin.

In St. Petersburg the two brothers, Gustaf and Edward, who in 1912 had been granted the title of hereditary noblemen with the right to bear a coat-of-arms, continued as one of the foremost jewelry houses. Sadly, Gustaf died in 1916, creating a vacuum, as neither he nor his brother Edward had any heirs wishing to take over the business. Wilhelm Bolin, who had two sons, was, of course, interested. However, the Russian revolution put an end to such plans.

Wilhelm Bolin, like his father, kept his Swedish citizenship. In 1904 he purchased a property in the south of Sweden which he visited each summer together with his family. Showing foresight, he opened a branch office in Bad Homburg in Germany in 1912 – a spa visited by the Tsar and his family. At the outbreak of World War I a great deal of stock remained in Germany. Taking advantage of his Swedish nationality, Wilhelm Bolin, whose Russian belongings and assets were confiscated by the Bolsheviks, transferred his German stock to Stockholm and opened a shop there in 1916. The firm exists today as Jewelers and Silversmiths to HM King Carl XVI Gustav.

It is deeply regrettable that none of the archives of the Bolin firm have, as yet, been found. A number of invoices from Bolin to the Imperial Court have been discovered in the Imperial Archives in St. Petersburg. There are certainly many more and research has been initiated to locate both them and Bolin's own records.

Christian Bolin

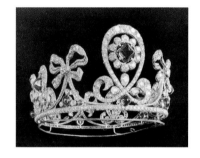

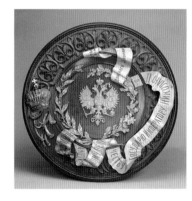

FIG 3. TIARA CREATED BY BOLIN
in 1900 for Tsarina Alexandra Feodorovna comprising 11 Colombian emeralds totaling 100 carats and diamonds totaling 225 carats. Photograph from Fersman: *Les Joyeaux du Trésor de Russie*, Moscow 1924.
Photograph courtesy of The New York Public Library

FIG 4. SILVER-GILT MOUNTED WOOD PRESENTATION CHARGER
signed Bolin, workmaster Karl Linke, Moscow 1904, diameter 27^1⁄2 in. (70cm). Inscribed: "To His Majesty and Imperial Highness, Tsar Nicholas II from the citizens of the Don province on August 16, 1904"

A. TILLANDER,
ST. PETERSBURG JEWELER

One of Imperial St. Petersburg's many jewelers, A. Tillander was a family business owned and managed by Alexander Tillander, father and son. From modest beginnings as a workshop in 1860, the firm grew to become jewelry makers of renown, with retail showrooms on Nevsky Prospekt, the main business street and one of the most desirable locations in the city.

At the outbreak of the Russian Revolution in 1917 the Tillander family returned to their native Finland where they successfully re-established the business, contriving to transfer across the border not only part of their stock of jewels but also important documents relating to the development of the firm. Among these were the company's annual reports for the years 1901–17, compiled exclusively for internal use. These unique documents paint a full and candid picture of life inside a goldsmith's firm in Imperial St. Petersburg.

The company's founder, Alexander Gustavovich Tillander (1837–1918) (fig. 1) had left Finland at the age of eleven to come to St. Petersburg as an apprentice goldsmith. By the age of twenty-two, he was an independent master goldsmith, selling his work to distinguished retailers on Nevsky Prospekt, including the court jeweler Bolin. The wide gold bangles then in vogue were to become a particular specialty of the newly-established craftsman. After a decade spent working as a subcontractor, Alexander Tillander had accumulated enough private customers to be able to establish his own successful retail premises, and by 1890 his reputation as a jewelry maker was firmly established. At the same time, his son Alexander Alexandrovich Tillander (1870–1943) completed his training as a goldsmith, having been an apprentice in his father's workshop before practising his trade in London, Paris and Dresden.

PRODUCTION AND MERCHANDIZE

Tillander was the epitome of the traditional jeweler, with a repertoire that included a wide range of jewelry, precious stones and pearls, functional pieces and *objets de fantaisie*. Every type of gold and gem-set jewelry – rings, bracelets, pins, lockets, hair ornaments, earrings, chains, cuff-links, studs, crosses and miniature Easter Eggs – was made in the firm's own workshop. Indeed for Tillander, the annual "egg trade" at Easter became something of an internal barometer of the general state of the market: when egg sales rocketed, good times were sure to follow; conversely, when the eggs languished in their display cases, a slump was equally certainly on its way.

In the early 1880s, a vogue for jewelry in the "antique" style swept Russia, prompted by sensational finds of gold jewelry in ancient Scythian tumuli on the Black Sea. Tillander's gold jewels in this style were to become house classics, and remained in production until the end of the century. Whereas Fabergé responded to the ancient Scythian finds with stunning pastiches designed by the firm's first chief workmaster Erik Kollin, Tillander's jewels were adaptations of the original models on a modest scale, and embellished with contemporary features such as gemstones and pearls. Much of this jewelry has been preserved to the present day – a reliable indication of its popularity when it was first made – and many of the pieces are still in the hands of descendants of the original St. Petersburg clients.

Another profitable line from the first decades of the firm consisted of enameled gold and silver *jetons*, or small pendants, suspended from a chain and hung over a button. Badges

FIG 1. ALEXANDER TILLANDER
Photograph courtesy Ulla Tillander-Godenhielm

FIG 2. WORKSHOP OF ALEXANDER TILLANDER Photograph courtesy Ulla Tillander-Godenhielm

of membership of a school, regiment or other organization, they were manufactured in their hundreds on a piece-work basis by specially appointed journeymen who were allotted space in the workshop.

From the last decade of the nineteenth century, the firm increased its range to include gold and silver cigarette-cases in a style influenced by Fabergé, and enameled gold or silver objects such as cups, vases, bowls and photograph frames. Both the elder Alexander Tillander and his son made regular trips to the capitals of Western Europe, especially Paris and London, in search of fresh inspiration for their work. Although they did not go so far as to imitate their distinguished colleague, the growing influence of Fabergé on tastes in St. Petersburg doubtless prompted their contemporaries to adapt their own work to the Fabergé style.

In the early years of the twentieth century, jewelry in the Louis XVI style came into fashion. The *fin-de-siècle* "garland" style, meanwhile, introduced the diamond-set platinum jewelry which was to become an important part of the firm's repertoire. This more luxurious idiom came as a direct result of the growth of the firm's clientèle, the consequence in turn of a significant change of address: in 1911, Tillander moved from its fairly modest premises in Bolshaya Morskaya, where the retail store was on the first floor, to Nevsky Prospekt, with the showroom at street level.

The decision to move premises left the Tillanders with no choice but to give up the firm's workshop, as there was no room for it next to the new showroom. Accordingly, it was sold (with its organization modeled on the system pioneered by Fabergé) to the long-serving workmaster Theodor Weibel. This decision to give up the heart of the firm was particularly difficult for its aged founder, who was always a craftsman at heart. But his son Alexander Alexandrovich, with the benefit of a more cosmopolitan education, clearly saw the possibilities of increasing the business by means of trade and export. Under its new ownership, meanwhile, the workshop continued to work exclusively for Tillander. In 1911, unexpected tragedy resulted in the Tillander firm becoming the Russian representative of the famous Paris jeweler Boucheron, when their director in Russia, G. Delavigne, and his younger son were robbed and murdered on the train from Baku to Moscow. Boucheron decided forthwith to close down the Moscow branch and transfer most of its stock to Tillander in St. Petersburg. Tillander's prestige was thus boosted, and its annual sales of Boucheron jewels were gratifying to both parties through this arrangement.

CLIENTÈLE

The annual reports list the most important customers for each year, with members of the Romanov family most prominent from 1901 until the demise of the Empire. Although Tillander had worked sporadically for the Office of his Imperial Majesty in the 1890s, these early commissions are not recorded in the annual reports. But from 1909 until the outbreak of the First World War the firm received regular orders from the Office of the Emperor, and in the years 1912 to 1915 the personal offices of both the Emperor and Empress are listed as customers.

Cigarette-boxes in gold and silver were among the popular articles made for the court in a wide range of models, all intended as imperial presentation gifts.[1] They were decorated with the emblems of the Empire, the Imperial crown or the double-headed eagle. On this matter, the requirements of the Office of His Imperial Majesty were most particular, stipulating that some were to be decorated with the "eagle of Paul I", others with the "eagle of Nicholas I", and yet others with the "contemporary eagle."[2] The majority of orders from the Office of His Imperial Majesty were for presentation jewelry however; brooches, bar-pins, coulants (small pendants), bracelets, cuff-links, and tie-pins. Each piece included the Imperial emblems in its design, and was made in gold set with

Notes
1. Detailed information on the Imperial commissions may be found in the firm's invoices to the Office of H.I.M. This research in the Imperial account books has been carried out by Valentin V. Skurlov, St. Petersburg.

2. According to Marvin Lyons, expert on Russian military history, the attractive and well-designed eagle from the reign of Alexander I and Nicholas I, which had downward-pointing wings stretched out to its sides, was redesigned after Russia's defeat in the Crimean War (1853–5), when it was concluded that downward-pointing wings symbolized defeat while those pointing upwards symbolized victory. No explanation as to why presentation objects were decorated with the "historic" eagle has so far been found.

diamonds, sapphires, rubies, aquamarines, tourmalines or apple-green demantoid garnets.

Business with the Imperial family was not always straightforward. The report for 1911 contains a note observing that "our relationship with the Office of the Empress Maria Feodorovna came to an unfortunate end because of slanders accusing us of bribery. A certain Mme Golohvastova from Nishni was behind them." Grand Duke Vladimir Alexandrovich, brother of Alexander III, was by contrast an extremely loyal customer, along with his entire family. Every year, the names of the Grand Duke, his consort Grand Duchess Maria Pavlovna, their three sons Kirill, Boris and Andrei and their daughter Helen regularly reappeared. The Vladimirovich family likewise commissioned presentation objects and jewelry decorated with their personal diamond-set ciphers. And Grand Duchess Maria Alexandrovna, only daughter of Alexander II and wife of Alfred, Duke of Edinburgh, Duke of Saxe-Coburg and Gotha, regularly placed orders for small jeweled brooches bearing her crowned monogram.

Other members of the Imperial family were more sporadic customers at Tillander. Grand Duchess Olga Alexandrovna, sister of Nicholas II, is mentioned in 1902, the year after she married Peter, Duke of Oldenburg. Grand Duke Alexei Alexandrovich, younger brother of Alexander III and Admiral-in-Chief and Supreme Commander of the Russian Imperial Fleet, placed commissions between 1900 and 1904. Grand Duke Nikolai Nikolaevich, uncle of Nicholas II and Supreme Commander of the Armed Forces, is mentioned once. The client list also includes many members of distinguished aristocratic families and the wealthy St. Petersburg business class, confirming that Tillander was now an established supplier of jewelry and *objets d'art*.

The annual reports for the years 1914 to 1917 provide dramatic reading, reflecting the tragedies of the First World War with their accounts of heavy losses among the staff, some of whom were called up for active service, while their German-born colleagues were sent to prison camps. These reports also mirror the instability and anarchy by now endemic in the renamed Russian capital of Petrograd. For the city's jewelers, the combined effect of the depreciation of the rouble and the boom in value of their merchandise initially provided a tremendous boost in business. In his report for 1916, Alexander Tillander confesses that he could not possibly declare all his turnover for fear of the punishing taxes for which the firm would become liable.

At the abdication of Nicholas II in March 1917, the Imperial family found its financial circumstances dramatically changed, as the regular allowance paid to the many Romanov households came to an abrupt end. In the spring of 1917 Grand Duchess Elizabeth Mavrikievna, widow of the literary Grand Duke Konstantin Konstantinovich, brought Tillander 300 of her jewels, asking him to sell them and make payment to her in Paris. The jewels were valued at the sum of 2.2 million francs and all was agreed when at the last minute the jeweler Charlet, the French agent for this *coup*, pulled out, and the transaction came to nothing.

Finally, on 1 September 1917, Tillander closed the shop down. As a service to regular customers the doors were kept open a few hours per week, but there was no real point in trying to do business. Finding new stock had become impossible, and the rouble was not worth the paper on which it was printed. In November of the same year, Alexander Gustavovich Tillander, now aged 80, was attacked and shot at in the street by a gang of six robbers, whose leader, later arrested, proved to be a former journeyman in the workshop. The old man heroically clung on to his briefcase, which contained jewelry belonging to customers, but the physical and psychological scars left by this assault broke his health, and he died a month later. By that time, the younger generation had already started their new life in Finland.

Ulla Tillander-Godenhielm

SOME OF FABERGÉ'S OTHER RUSSIAN COMPETITORS

Karl August Hahn (1836–1899), Austrian by birth, was a jeweler and owner of a St. Petersburg firm founded in 1873.[1] He became merchant in the following year with premises at 26 Nevsky Prospect, living at the house of the Swedish church at Konyushennaya Street. Hahn acquired Russian citizenship in 1892, exhibited at the Chicago World Fair in 1893 and was made a Hereditary Honorary Citizen in 1898. Before 1896, Hahn was commissioned to produce a replica of the "small crown of the Empress" to be worn by Tsarina Alexandra Feodorovna at the 1896 Coronation. For this well-fulfilled task he was appointed "Supplier to the Court" and "Appraiser to the Cabinet". Like Fabergé in 1889, he was awarded the Order of St. Stanislav, Third Class in 1897. Hahn was also "Supplier to the Court of Grand Duke Alexander Mikhailovich" (husband of Grand Duchess Xenia). The firm, which had an annual turnover of 100,000 roubles, employed thirty craftsmen.

After the death of Karl Hahn in 1899, his business was taken over by his widow, Adelaide, and in 1901 it passed into the hands of his son, Dmitri, Merchant of the First Guild, who was awarded the Imperial Warrant of "Supplier to the Court" in 1903. Between 1892 and 1909, the firm employed the goldsmith/jeweler Carl Carlovich Blank, who between 1909 and 1911 became a partner in the business. After Dmitri's death in 1911, the firm and premises were taken over by Alexander Tillander.

Objects made by Hahn are all of outstanding quality, equal to those produced by Fabergé. The firm specialized in Imperial presentation boxes differing markedly from those made by Fabergé. Hahn boxes, which are generally embellished with diamond-set sprays, are often of unusual outline[2] while some have no enamel decoration to the sides.[3] Hahn also produced exquisite miniature frames and full size Easter Eggs in competition with Fabergé (cat. 903).

Carl Carlovich Blank, born in 1860 in Helsingfors, Finland, joined the firm of Karl Hahn as leading jeweler and goldsmith in 1882. In 1894 he opened a workshop at 36 Gorokhovaya Street, employing eight craftsmen and three apprentices. Like Fabergé he was awarded the right to use the State Emblem following his participation in the 1896 Nijni-Novgorod exhibition. He was also named "Appraiser to His Majesty's Cabinet." In 1900 his workshop was situated at 4 Zimin Street and in 1915 at 23 Ekaterinskii Canal.

In 1894 he became Merchant of the Second Guild and in 1915, Hereditary Honorary Citizen. In 1911 he joined Hahn's son, Dmitri, as partner in the business. The firm, having run into financial difficulties, was taken over by Alexander Tillander. Thereafter Carl Blanc worked independently. Following the Revolution, Blanc returned to Finland.

Carl Blanc's initials "CB" are to be found jointly with those of Hahn on some of the firm's most outstanding productions (cat. 911, 912). Where the "CB" initials stand alone, this may denote articles made by Blanc independently. Blanc executed many commissions for the Imperial Cabinet, including badges of orders, pectoral crosses and badges for ladies-in-waiting.

Friedrich Christian Ivanovich Koechli (1837–1919), a Swiss citizen, opened a jewelry firm in St. Petersburg in 1864 and by 1874 worked at 7–10 Gorokhovaya Street, specializing in gold and diamond articles. He was probably related to another jeweler of the same name, possibly an uncle, who worked in St. Petersburg in 1849. In 1870 he received a bronze medal at the All-Russian Industrial Art Exhibition in St. Petersburg and, by 1882, he was Merchant of the Second Guild. Like Fabergé, he exhibited *hors concours* at

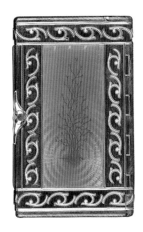

FIG I. IMPERIAL PRESENTATION GOLD, PINK, GREEN AND WHITE ENAMEL CIGARETTE-CASE by Carl Blanc, St. Petersburg, late 19th century. This case is engraved with the hand-written inscription "To dear Nicky from Mama – 6 May 1899", a birthday present to Czar Nicholas II from Empress Maria Feodorovna. (Photo: Ermitage Ltd)

Notes
1. Cf. Valentin Skurlov, "Index of jewelers: Suppliers to the Imperial Court and Courts of the Grand Dukes; Appraisers of his Majesty's Cabinet; Court Jewelers" in St. Petersburg (1992), p. 230; and Tatiana Muntian, "Index of the Workmasters and Proprietors of Jewellery Firms, Factories and Workshops" in Moscow (1996), p. 219.

2. Habsburg (1986), cat. 613.

3. *Ibid.*, cat. 614.

the Exposition Universelle in Paris in 1900 as member of the Jury and was awarded another bronze medal. In 1902 he became Supplier to the Court of Dowager Empress Maria Feodorovna. His son Theodor Friedrich, who graduated from the St. Petersburg Academy of Arts in 1890, was a sculptor and an appraiser to the Imperial Cabinet. In 1903 father and son founded the firm of "F. I. and F. F Koechli". After the death of Friedrich Koechli in 1909 and of his son in 1911, the business was discontinued. Numerous small articles of yellow-gold jewelry produced by Koechli, many of them set with cabochon sapphires, have survived (cat. 917), as well as cigarette-cases (cat. 918) and Imperial presentation boxes (cat. 914).[4]

Ivan Savelyevich Britsyn (1870–1952), a peasant from the Moscow region and later jeweler in St. Petersburg, became proprietor of a workshop at 12 Malaya Konyushennaya, active mainly between 1903 and 1917. He was undoubtedly an enterprising businessman, since he had connections with the firm of goldsmith/jeweler Marshak in Kiev and with the firm of Nobel & Co. in London, which after 1908 was run by Alan Bowe, Fabergé's former partner in Moscow between 1887 and 1908. Britsyn competed with Fabergé, specializing in *objets de vertu* such as frames (cat. 891), clocks (cat. 892), cigarette-cases (cat. 888), all embellished with *guilloché* enamels, mainly in pastel hues of pale blue, white and pink. Some special commissions found their way to the English market, in fitted cases stamped Nobel & Co.

The Third Artel consisted of a group of more than ten craftsmen, former members of the Fabergé firm. This independent St. Petersburg association, with premises at 48 Ekaterinskii Canal, competed directly with Fabergé, producing *guilloché* enamel objects – clocks, frames (cat. 875), miniature Easter Eggs (cat. 871/2), small bowls and dishes (cat. 873/4) – generally in pastel hues of apricot, strawberry, lime green, white and pale blue. Occasionally the Third Artel created exquisitely enameled objects in audacious combinations of colors (cat. 870).

Avenir Ivanovich Sumin was proprietor of a workshop specializing in the carving of stones from Siberia and the Caucasus. The workshop was originally founded by his father, Ivan, in 1869 at 46 Nevsky Prospekt. In 1882 Avenir obtained a prize for the carving of semi-precious stones at the Moscow All-Russian Industrial Art Exhibition. Sumin, who was by Imperial appointment "Supplier to the Court", had premises at 60 Nevsky Prospect. Sumin's shop offered wares in *guilloché* enamel (cat. 936) as well as finely carved animal figures in birchwood cases inspired by those of Fabergé. A nephrite monkey, formerly thought to be by Fabergé, has recently been re-attributed to Sumin, thanks to the discovery of its original fitted case (fig. 2).

Alexei Kuzmich Denisov-Uralski, a celebrated Russian stone carver, ran a workshop in 1856 with two craftsmen and a turnover of 600–800 roubles. His first distinction was an honorary testimonial for "Creative use of Ural gems in objects of art, models and collections" received at the Moscow All-Russian Industrial Art Exhibition in 1882. One of his exhibits, a map of the Urals made of semi-precious stones, was acquired by a Moscow school. Other awards included a Large Silver Medal for carvings exhibited at the 1887 Siberian Exhibition of Science and Industry in Ekaterinenburg; a prize at the 1889 Paris World Fair; and a Small Silver Medal at the 1890 Exhibition of Science and Technology held at Kazan. He exhibited amethysts at the Paris 1900 World Fair, and in 1903 founded the "Denisov (Uralski) & Co. Mining Trading Agency for distributing industrial minerals in Russia" at 42 Moika Embankment. In 1910 he transferred his shop and workshop to 27 Bolshaya Morskaya ("Ural Gems").

Denisov-Uralski frequently supplied the Court with stone carvings including a large stone parrot for the Dowager Empress (cat. 898). Pierre Cartier acquired animal carvings and a rhodonite desk-set from Denisov-Uralski following his trip to Russia in 1904.

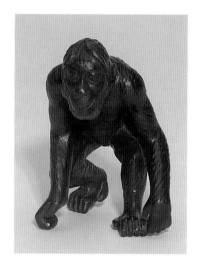

FIG 2. NEPHRITE FIGURE OF A CHIMPANZEE by Avenir Sumin, unmarked, 2⁵⁄₁₆ in. (5.8cm). Original fitted case stamped Sumin, St. Petersburg, Private Collection. Courtesy Alexander von Solodkoff

4. Habsburg (1986), cat. 313.

5. Solodkoff (1995), cat. 243.

Denisov's animals are coarser than those of Fabergé, and generally larger. Towards 1915 he produced a series of animals allegorical of the nations that participated in World War I, including a turkey composed of various hardstones 4^{1}4 inches high. These animals are today at the Perm Art Gallery.[6]

In 1880 V. Ya Finnikov occupied a workshop at 55 Moika Embankment owned by the Bolin brothers. Finnikov, who in 1897 employed fifteen craftsmen, apparently worked for several major St. Petersburg jewelers including Bolin and Hahn. He was Court Jeweler in 1908. Finikov's gold articles and jewels are of unusually modern design (cat. 901), often embellished with carved cabochon sapphires (cat. 899/900).

Andrei Karlovich Adler, the owner of Adler & Co., produced articles in gold and silver, many of them in *guilloché* enamels. His assortment included cigarette-cases (cat. 869a) and miniature Easter Eggs. His initials AA have been erroneously attributed to a fictitious workmaster "Astreyden" who was in reality A. Treiden.

Géza von Habsburg

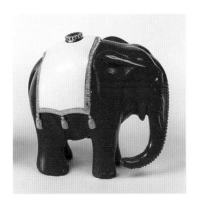

FIG 3. BELLPUSH SHAPED AS A PURPURINE ELEPHANT with silver-gilt and white enamel saddle-cloth – signed with initials IB for Ivan Britzin, 1908–1917, height 2^{13}16 in. (7.2cm). Photograph courtesy of Wartski, London

FIG 4. HARDSTONE CARICATURED FIGURE OF A FISH by Avenir Sumin, unmarked, 1^{11}16 in. (4.3cm). Original fitted case stamped A.I. Sumin, S.Pb., Nevsky 60. Private Collection

6. St. Petersburg (1992), cat. 48–52.

AN IMPERIAL RUSSIAN PRESENTATION ORDER: THE DIAMOND-SET WHITE EAGLE

Archival research in St. Petersburg has recently brought to light a magnificent and hitherto unknown Imperial Russian presentation order: the diamond-set White Eagle (cat. 868). This was a special version of the Order of the White Eagle, one of Russia's most prestigious decorations. Both badge and star are lavishly embellished with diamonds, making this one of the most impressive official awards of the former Russian Empire.

The Order of the White Eagle was originally Polish, founded by King Vladislav I in 1325 and re-established by King Augustus II in 1705. After the Polish Insurrection of 1831, the Russian Emperor Nicholas I incorporated the White Eagle with the Russian Orders. It was ranked next after the Order of St. Andrew First Called and that of St. Alexander Nevsky. The Order had one class only.

The badge of the Order is designed with the white enameled Polish eagle on a Maltese cross superimposed on the Imperial Russian Eagle, enameled in black. The badge is surmounted by the Imperial crown. The gold eight-rayed star of the Order has a center medallion with an attached cross. When awarded to non-Christians, an Imperial eagle replaced the cross.

Since the time of the Statues of the Orders of the Russian Empire, promulgated by Emperor Paul I in 1797, diamond-set Orders were only awarded for exceptional service. The White Eagle with diamonds was instituted by Alexander III in 1882, shortly after he had become Emperor of Russia. The reason for this luxurious version of the Order was no doubt the growing need for State awards, especially for diplomatic purposes. The White Eagle with diamonds was presumably never made official by an Imperial ukase. This enabled the Sovereign to sidestep the official hierarchy of chins (ranks). A recipient of the White Eagle with diamonds would not be extremely pleased being presented with this opulent Order, the hierarchy of which was not really clear.

The diamond-set Eagle came to be a rarely awarded Decoration. As few as twenty-two were presented during the reigns of Russia's two last Emperors, Alexander III and Nicholas II. Two further badges and stars of the Order were manufactured, but were never awarded. At the abdication of Nicholas II in 1917, these two remained in stock at the Office of His Imperial Majesty.

Of the total twenty-four diamond Eagles only two are known to exist to this day. Both of them have regrettably lost their provenance as they have been sold anonymously.

A glance at the list of the twenty-two recipients of the Order shows that the diamond Eagle was an award conferred on foreign dignitaries only. None of the recipients were Russian subjects. Events for bestowal of the decoration were state affairs of importance, such as visits by foreign Heads of State to Russia, visits by the Russian Sovereigns abroad, the Coronation of Nicholas II in 1896 and the Tercentary of the Romanov dynasty in 1913.

Persia was an important ally of Imperial Russia; it is therefore not surprising that the Emperor chose to honour many important Persians with gifts. Paying his respects to the new Sovereign Nicholas II in December 1894, the Extraordinary Minister and Chief of Protocol, Vajihollah Mirza, titled Amir Khan Sardar, was presented with the diamond-set Eagle. The same honor befell the Prime Minister and later Regent, Nasser-ol-Molk, in 1900, during the State visit to Peterhof of Shah Muzifa Edim. The Shah himself, at this occasion, was decorated with the diamond-set Order of St. Andrew, Russia's highest order.

The Shah, in addition, received an opulent silver bratina, the handle of which was shaped as a dragon. The bratina was made by Fabergé.

Two highly ranked members of the Shah's suite, the heir to the Persian throne, Veliagda Magomed Ali Mirza and Sultan Sadrazmin Amin-us, were decorated with diamond-set badges reminiscent of the highly esteemed Russian orders, both of which were designed to be worn at the neck in the light-blue ribbon of the Order of St. Andrew. Further down on the list of awards, during this same state visit, is a cigarette-case carved in Siberian nephrite and with a décor in gold. This was a gift to the Shah's personal physician, Dr. Hadcock. A number of signed portraits of the Emperor in gilded frames were also gifts to members of the entourage at this memorable occasion.

Bukhara was a Russian protectorate since 1868. The Emirs of Bukhara, being the local representatives of the Sovereign, were frequent recipients of Russian decorations. The Emir Said Abd-Oul-Akhad-Khan received the diamond Eagle in 1889, his son the Emir Said Mir-Alin in 1911.

The Coronation of Nicholas II and his consort Alexandra Feodorovna in 1896 was attended by representatives of all nations. The Siamese delegation was headed by the youngest son of King Chulalongkorn, Prince Chira of Siam. He was conferred with the diamond-set Order of the White Eagle in remembrance of the Coronation.

Other recipients of the diamond Eagle were the Prime Minister of Serbia, Nicola Pasic, later named The Old Fox of the Balkans, and his successor Prince Milovan Milovanovich. The Minister Plenipotentiary of Bulgaria to Russia, Major-General Stefan Georgievich Paprikov, was also presented with this fine Order.

The Emperor Nicholas II and his consort Alexandra Feodorovna were frequent visitors to the Grand Duchy of Hesse, the childhood home of the Empress. In 1911 Baron Moritz Riedesel zu Eisenbach, Chamberlain and Master of the Horse to the Grand Duke of Hesse, was decorated with the diamond Eagle. Shortly before that the Baron had been awarded a gold-mounted box with the diamond cipher of the Empress.

The manufacture of the jeweled White Eagle was entrusted to prominent St. Petersburg Court Suppliers. They were the Jewelers Carl Edvard Bolin and Carl Hahn, the latter to be succeeded by Carl Blank, long-time collaborator and head workmaster Hahn.

The Court Jewelers Bolin were the oldest of the three manufacturers, having been founded as early as 1796. The first generation of the firm, Andreas Roempler, held the title of Court Jeweler during the reigns of Paul I and Alexander I. His son-in-law, Jahn, managed the business during the reign of Nicholas I. In 1831 Jahn was commissioned to make a set of jewelery for the Empress to commemorate the birth of a son, Grand Duke Nikolai Nikolaevich. This was the century's most expensive set of jewels. During the reign of Alexander II (1855–81) the Bolin firm held its position as the foremost Court Supplier of fine jewels. The Empress's opulent tiaras, parures of gem-set jewelery of various kinds, dowries, wedding and anniversary gifts of the members of the Imperial family, were all produced in the workshops of Bolin. The close co-operation between the Office of His Imperial Majesty (the buying office of the Sovereign) and Bolin did not cease until the demise of the Empire. Russia's last Empress Alexandra Feodorovna wore a magnificent Bolin tiara richly set with pearls and diamonds for State portraits in 1907. In a more informal portrait of the same year, a painting by the artist N. K. Bodarevsky, the Empress was wearing an elegant parure by Bolin set with emeralds.

Bolin was the principal manufacturer of jeweled presentation Orders and decorations, the production of which required the jeweler's and gemsetter's expert skills. Russia's foremost Orders, in their presentation version, were made by Bolin. These included St. Andrew, St. Alexander Nevsky, the White Eagle and St. Anne First Class. Bolin was also one of the manufacturers of the diamond chiffres of the Empress's maids-of-honor. This was a significant commission as there were over 200 maids-of-honor attached

to each Empress. The firm also manufactured the miniature jeweled portraits awarded to the ladies-in-waiting and the Order of St. Catherine, presented to the most prominent ladies of the Empire.

The death of Alexander III, succeeded by the wedding and the Coronation of the Heir to the throne, Nicholas II, brought an avalanche of commissions to the jewelers' workshops. The jewelers Carl Hahn, founded in 1873, had already been an important Supplier to the Court during the previous reign. The house is known as the maker of opulent Imperial presentation snuffboxes, the traditional gift by the Sovereign to foreign *prominenti* and a prestigious award to Russian subjects of high merit. For the Coronation in 1896, Hahn was commissioned to make a diamond crown for the young Empress Alexandra Feodorovna.

At the very end of the nineteenth century, Hahn was the principal manufacturer of the diamond-set Orders, decorations and court insignia. Twelve of the total of twenty-four White Eagles with diamonds were made in his workshops. In 1892 Hahn had employed the goldsmith Carl Blank as his head workmaster. Since that year much of the Hahn production took place in Blank's workshop. Carl Blank became Hahn's partner in 1909 until 1911 when Hahn closed down as a result of the death of the owner. Blank established himself in 1911 as an independent master. His firm carried out the Imperial commissions including the diamond badges and stars of the Orders and decorations, the insignia of the lady courtiers as well as important ecclesiastical orders. The Office of H.I.M. Carl Blank was known to fulfill commissions with extreme honesty and at relatively low prices. In short, he was considered an ideal Court supplier.

Ulla Tillander-Godenhielm and Valentin V. Skurlov

Notes
The authors thank Jerzy Kalasznikow, Marvin Lyons, Victor Mihailov and Gustav A. Tammann for valuable comments.

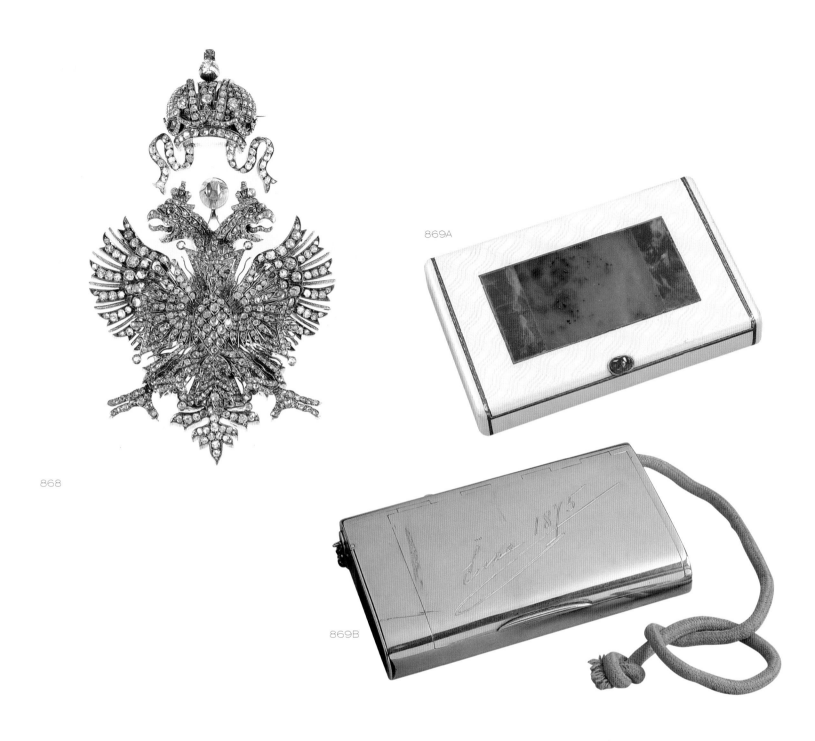

868. DIAMOND-SET IMPERIAL
PRESENTATION BADGE OF THE
ORDER OF THE WHITE EAGLE the
Polish eagle on the Maltese cross superimposed
on the Imperial Russian Eagle worked entirely
in gold and silver, the face covered with over
500 brilliant-, cushion-, and rose-cut
diamonds, the Imperial Eagle's eyes set with
rubies, the gold back engraved in imitation of
feathers and fitted with two gold retaining
bars; the Imperial Crown, a separate piece en
suite, also in gold, back fitted with a brooch
pin – height 3⅛ in. (8cm), height of crown
1½ in. (4cm).
Private Collection

869A. ENAMELED SILVER-GILT AND
HARDSTONE CIGARETTE-CASE
of white transparent enamel over intersecting
waved criss-cross bands, the cover set with
a rectangular nephrite panel flanked by two
rhodonite plaques, cabochon ruby thumbpiece
– initials of Andrei Karlovich Adler, assay mark
of St. Petersburg 1908–1917, length 3⅜ in.
(8.7cm).
Bibliography: Traina 1998, p. 52.
Until recently, the workmaster's initials A.A.
were erroneously ascribed to Astreyden, a non-
existent maker. They have been now identified
as being those of Andrei Adler by Mr Valentin
Skurlov.
John Traina Collection

869B. GOLD-MOUNTED
BURNISHED-SILVER CIGARETTE-
CASE with match compartment and tinder-
cord, the cover inlaid in gold with a facsimile
inscription "Christmas 1875", the reverse
similarly inscribed Minny – signed with initials
S. A. for Samuel Arndt, assay mark of St.
Petersburg before 1899, length 4⅛ in. (10.5cm)
Provenance: Given by Empress Maria
Feodorovna ("Minny") to her future son-in-
law, Grand Duke Alexander Alexandrovich
(1866–1933) in 1875; Prince Theodor of
Russia, his son; Prince Michael Romanov,
his son.
Bibliography: Traina 1998, p. 156 (top).
John Traina Collection

870

871 872 873 874

870. SQUARE ENAMELED SILVER-GILT DESK CLOCK decorated with alternating bands of green and blue *guilloché* enamel, the green bands engraved with rosettes, the bands separated by thin opaque white enamel bands, the central opaque white enamel dial with Roman chapters, black steel hands and subsidiary dial for seconds; silver-gilt strut – signed Third Artel, assay mark of St. Petersburg 1908–1917, height 4½ in. (11.5cm). André Ruzhnikov

871. ENAMELED GOLD MINIATURE EASTER EGG of translucent *guilloché* enamel, hinged, with a laurel leaf rim – signed Third Artel, height ¾ in. (2cm). André Ruzhnikov.

872. ENAMELED GOLD MINIATURE EASTER EGG of pale blue *guilloché* enamel, hinged, with a laurel leaf rim – attributed to the 3rd Artel, 1908–1917, height ¾ in. (2cm). André Ruzhnikov.

873. SILVER AND TRANSLUCENT PALE BLUE ENAMEL DISH stamped Third Artel, assay mark of St. Petersburg 1908–1917, width 3 in. (7.6cm). Private Collection

874. SILVER AND TRANSLUCENT OYSTER ENAMEL DISH stamped Third Artel, assay mark of St. Petersburg 1908–1917, width 3 in. (7.6cm). Private Collection

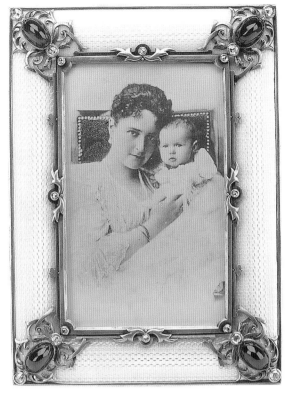

876

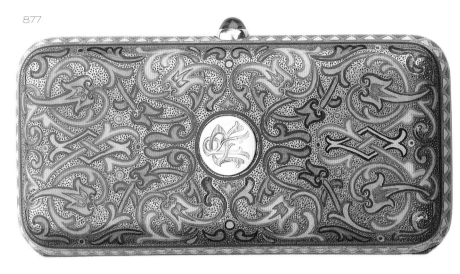

877

875

878

875. CIRCULAR ENAMELED SILVER FRAME with alternating wide band of strawberry *guilloché* enamel and narrow opaque white enamel bands, ivory back and silver strut – signed Third Artel, assay mark of St. Petersburg 1908–1917, diameter 5¼ in. (13.2cm).
This Artel, one of about twenty such independent associations, was formed of former employees of the firm of Fabergé, who set up production *c*. 1910 and specialized in articles of *guilloché* enamel.
André Ruzhnikov

876. RECTANGULAR GEM-SET GOLD AND WHITE ENAMEL FRAME the white *guilloché* enamel band with gold border, the corners with gold scrolling foliage decorated with oval cabochon garnets flanked by diamonds, gold strut and suspension ring – signed (Cyrillic) BOK, assay mark of St. Petersburg before 1899, height 4¾ in. (12.1cm).
The Eriksson Collection

877. GEM-SET ENAMELED GOLD CIGARETTE-CASE with stylized foliage in *champlevé* pink, green and blue enamel, the border with red and white triangles, the cover and base with round gold reserves engraved with monograms, cabochon sapphire pushpiece – signed (Cyrillic) BOK, assay mark of St. Petersburg 1899–1908, length 3¼ in. (8.3cm).
Private Collection

878. OCTAGONAL GEM-SET ENAMELED GOLD MEDALLION the reverse in blue sunburst *guilloché* enamel bordered by rose sprays, with photograph compartment – signed with initials K. B. for Karl Bok, 56 (zolotnik). length 1⁵⁄₁₆ in. (3.4cm).
Provenance: Acquired by the State Hermitage, 1987.
The State Hermitage Museum (ERO – 9567)

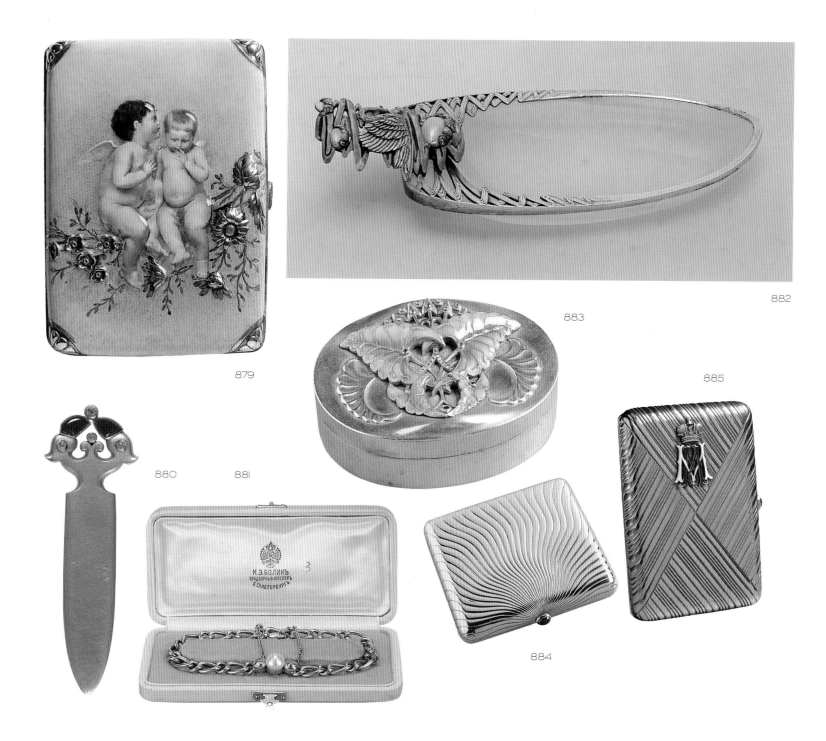

879

882

883

885

880 881

884

881. GEM-SET GOLD LINK
BRACELET set with a bouton pearl and
two circular-cut diamonds – by Bolin, initials
of workmaster A. Karpenko, assay mark of
St. Petersburg 1899–1908, assay-master Yakov
Lyapunov, 56 (zolotnik). Original fitted case
with Imperial Warrant of K. E. Bolin,
St. Petersburg.
Provenance: State depository, 1984.
Bibliography: Jewelry and silver, 1996, p. 95;
Ribbing 1996, p. 95.
The State Hermitage Museum (ERO – 9409)

882. ART NOUVEAU OVAL GEM-SET,
ENAMELED, SILVER-MOUNTED
QUARTZ BOWL the bowl of milky
white stone, the mounts chased with a swan
swimming among pearl and diamond-set water
lilies on blue enameled waves – signed Bolin,
assay mark of Moscow 1899–1908, length 8¼
in. (21cm).
Exhibited: Hamburg 1995, cat. 251.
Private Collection

883. ART NOUVEAU KIDNEY-
SHAPED GEM-SET ENAMELED
SILVER BOX the cover chased with foliage
partially enameled in green, set with rose-cut
diamonds and cabochon rubies – stamped
Bolin, assay mark of Moscow 1908–1917,
length 3⅛ in. (8cm).
Michael and Ella Kofman Collection

879. ENAMELED SILVER
CIGARETTE-CASE the cover decorated
with a relief of two cherubs sitting on a floral
garland enameled en plein on pale blue ground
– signed Shanks & Bolin, assay mark of
Moscow 1887, assay-master with initials H.K.,
length 3½ in. (8.9cm).
Private Collection

880. SAPPHIRE AND DIAMOND-SET
GOLD BOOK MARK initials of
workmaster E. Schramm, retailed by Bolin,
assay mark of St. Petersburg before 1899,
length 3½ in. (9cm). Original fitted case
stamped: "Bolin Joaillier de la Cour".
Private Collection

884. RED GOLD CIGARETTE-CASE
engine-turned with swirling flutes issuing from
a cabochon sapphire pushpiece – initials of
Andrei Bragin, assay mark of St. Petersburg
1899–1904, assay-master Yakov Lyapunov,
length 3½ in. (9cm).
Bibliography: Traina 1998, p. 54b (bottom).
Bragin's workshop is better known for its
production of cloisonné enamels.
John Traina Collection

885. TWO-COLOR GOLD
PRESENTATION CIGARETTE-CASE
cover and base each with triangular panels of
white and pink gold engine-turned with nar-
row and wide bands of flutes, applied with
crowned monogram "MM", ruby pushpiece –
initials of Andrei Bragin, assay mark of St.
Petersburg 1899–1908, length 4 in. (10.1cm).
Bibliography: Traina 1998, p. 116 (left).
John Traina Collection

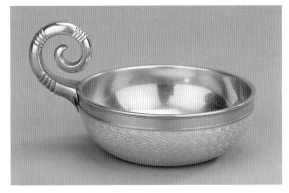

886

888

890

887

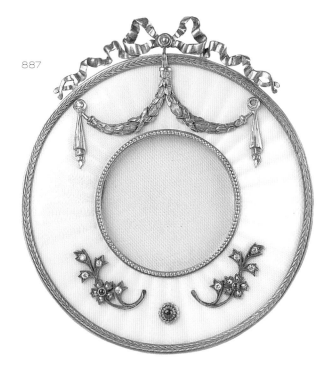

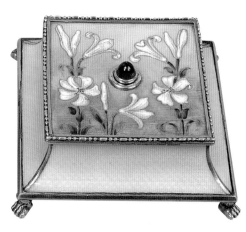

889

891

886. ENAMELED SILVER BEAKER
signed with Cyrillic initials I. B. for Ivan
Britsyn, assay mark of St. Petersburg
1908–1917, 88 (zolotnik), height 4⁷16 in.
Provenance: State Museum of the Ethnography
of Nations of the USSR, 1941.
The State Hermitage Museum (ERO – 4917)

**887. CIRCULAR GEM-SET, SILVER-
GILT, GOLD AND ENAMEL FRAME**
of opalescent white enamel applied with a
cabochon ruby flanked by ruby and diamond-
set floral branches and with laurel festoons
suspended from diamonds, with laurel border
and ribbon tie cresting, silver-gilt backing and
strut – signed with initials of Ivan Britsyn, assay
mark of St. Petersburg 1899–1908, height
4¹8 in. (10.5cm).
Private Collection

**888. AN ENAMELED SILVER-GILT
CIGARETTE-CASE** of blue *guilloché* moiré
enamel, with palm-leaf borders,
match-compartment, fitted for tinder-cord,
rose-cut diamond thumbpiece – signed
Britsyn, assay mark of St. Petersburg
1899–1908, 88 (zolotnik), length 4¹4 in.
(10.8cm).
Bibliography: Traina 1998, p. 155.
John Traina Collection

**889. ART NOUVEAU SQUARE
ENAMELED SILVER BELL-PUSH**
on paw feet, of pale blue *guilloché* enamel,
painted with green and white madonna lilies
on striped opaque pink enamel ground –
signed with Cyrillic initials I. B. for I. Britsyn,
assay mark of St. Petersburg 1904–1908, assay-
master A. Romanov, 88 (zolotnik), legth 2¹4 in.
(5.7cm).
Private Collection

**890. ENAMELED SILVER-GILT
COMBINED MINIATURE STAMP BOX
AND BLOTTER** of translucent mauve
enamel over *guilloché* sunburst, with bright-cut
borders and egg-shaped chrysoprase handle –
signed Britsyn in Cyrillic, assay mark of
St. Petersburg 1908–1917, 84 (zolotnik), length
2¹8 in. (5.4cm).
Private Collection

**891. RECTANGULAR SILVER-GILT
AND ENAMEL PHOTOGRAPH
FRAME** with arched top, with reed-and-tie
borders, the sides of pale mauve enamel over
guilloché moiré ground, white translucent
enamel over engraved floral ground above,
with tied ribbon cresting, (later) applied
Imperial crown, wood backing, silver-gilt strut
and foliate feet – signed with Cyrillic initials
I. B. for Ivan Britsyn, St. Petersburg
1908–1917, 88 (zolotnik), height 8⁷8 in.
(22.5cm).
Louise and David Braver

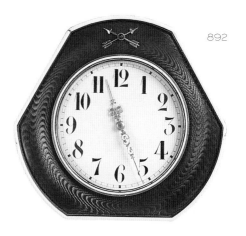

892

893

895 896

897

892. ENAMELED SILVER CLOCK
of combined circular and triangular shape,
of blue *guilloché* enamel with opaque white
enamel outer border, applied with crossed
arrows centered on a cabochon ruby; the white
enamel dial with black Arabic numerals and
gold Louis XV hands; silver strut – signed by
Cyrillic initials I. B. for Ivan Britsyn, assay mark
of St. Petersburg 1908–1917, height 3¼ in.
(8.3cm). The reverse inscribed "To Edward
from Rupert and Gwenny, Xmas 1909".
Provenance: Lord Edward Iveagh;
The Forbes Magazine Collection, New York.
Exhibited: Fabergé and the Edwardians
(Edinburgh and Aberdeen 1987), cat. 4.
Private Collection

**893. ENAMELED SILVER MATCH-
BOX** signed with Cyrillic initials of Ivan
Britsyn, assay mark of St. Petersburg
1908–1917, 88 (zolotnik), length 2¾ in. (7cm).
Provenance: Museum Reserves; State Museum
of Ethnography, 1941.
Exhibited: Leningrad 1974, cat. 40.
The State Hermitage Museum (ERO – 4918)

895. GOLD WATCH the cover engraved
with the initial "W" on a heraldic eagle, the
reverse engraved with the crowned monogram
of Empress Alexandra Feodorovna – by Paul
Buhré, St. Petersburg, *c.* 1910.
The initial "W" is that of Waldemar Prince of
Prussia, a nephew and godchild of the Empress.
He was the son of her sister, Princess Irène of
Prussia.
Private Collection courtesy A. von Solodkoff

**896. BURNISHED GOLD
CIGARETTE-CASE** the cover applied
with a foliate monogram, cabochon sapphire
pushpiece – signed Khlebnikov, initials of
workmaster C. B., assay mark of Moscow,
1899–1908, assay-master Ivan Lebedkin,
length 3¾ in. (9.5cm).
Bibliography: Traina 1998, p. 150b (top left).
John Traina Collection

**897. TWO-COLOR GOLD
CIGARETTE-CASE** with alternating
bands of pink and green gold engraved with
criss-cross lines, cabochon sapphire pushpiece –
Imperial Warrant mark of I. Khlebnikov, assay
mark of Moscow 1908–1917, length 4¼ in.
(10.9cm).
Bibliography: Traina 1998, p. 55a (top right).
The firm of Ivan Khlebnikov was a major
producer of silver cloisonné wares in the late
19th century. *Objets de vertu* by Khlebnikov
are rare.
John Traina Collection

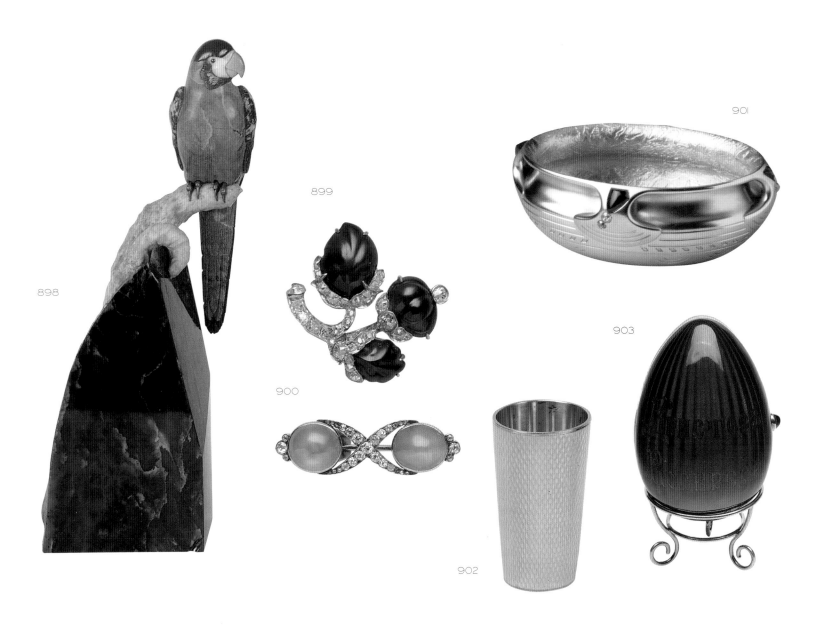

898

899

900

901

903

902

898. COMPOSITE HARDSTONE
CARVING OF A PARROT the bird with
rhodonite body mottled blue lapis plumage, its
head of obsidian and white quartz with yellow
quartz beak and cabochon ruby eyes, sitting on
a white quartz branch on tapering nephrite
base – apparently unmarked, attributed to the
firm of Denisov-Uralsky, modeled by G.
Malyshev, St. Petersburg *c.* 1914, height 13 in.
(33cm).
Provenance: Acquired by Empress Maria
Feodorovna in 1913. The original invoice Nr.
133 by A. Denisoff (Ouralski) et Co.,
St.Pétersbourg, Morskaja, 27 made out to
Empress Maria Feodorovna on 27 January
1914 details among other items of jewelry
"One parrot, various stones – 200 Roubles".
(Information kindly provided by Mr. Valentin
V. Skurlov).
Bibliography: Skurlov, V. (ed.): Fabergé and the
Jewellers of St. Petersburg, St. Petersburg 1997,
p. 384 ff., color ill.
Empress Maria Feodorovna was known to
have been very fond of parrots of which she
had owned several. She had them "portrayed"
in hardstones not only by Denisov-Uralski but
also by Fabergé. Fabergé's parrot carved in gray
jade with a purpurine tail and sitting in a silver
cage is illustrated in A. von Solodkoff, Fabergé,
London 1988, p. 81.
Private Collection

899. GEM-SET GOLD SAPPHIRE
BROOCH with three flowerheads set with
shaped carved sapphires on a diamond-set stem
– initials of V. Finikov, assay mark of
St. Petersburg before 1899, length 1¹⁸ in. (3cm)
Exhibited: Hamburg 1995, cat. no. 258.
Private Collection courtesy A. von Solodkoff

900. GEM-SET GOLD STAR
SAPPHIRE BROOCH set with two oval
sapphires linked by two crossed diamond-set
lines and flanked by further diamonds – initials
of V. Finikov, assay mark of St. Petersburg
before 1899, length 1⁹₁₆ in. (4cm).
Exhibited: Hamburg 1995, cat. no. 259.
Private Collection courtesy A. von Solodkoff

901. OVAL JEWELED GOLD BOWL
the matte exterior engraved with geometric
motifs set with irregular cabochon sapphires
and rose-cut diamonds, the interior with
Samorodok decoration – Cyrillic initials V. F.
of workmaster Vassily Finikov, assay mark of
St. Petersburg before 1899, inv no. 33099,
length 2¹⁵₁₆ in.
Exhibited: St. Petersburg (Florida) 1967;
Munich 1986/7, cat. 590, ill. p. 293.
Finikov apparently worked occasionally for
Bolin, as well as for Fabergé.
The Woolf Family Collection

902. SILVER-GILT AND ENAMEL
BEAKER painted in translucent light blue
over an engine-turned ground – stamped with
Imperial Warrant of Gratchev, assay mark of
St. Petersburg 1908–1917, height 2 in. (5cm).
Private Collection

903. ENAMELED GOLD EGG
decorated with strawberry red *guilloché*
enamel, inscribed with the motto "Christ
is Risen" on one side, and "May God protect
you" on the other, opening to reveal five
apertures surmounted with crowns and
ribbons containing photographs of members
of the Imperial Family – signed in Cyrillic K.
Hahn, initials of workmaster A. T., assay mark
of St. Petersburg before 1899, 56 (zolotnik),
height 2³⁴ in. (7cm).
Wartski, London

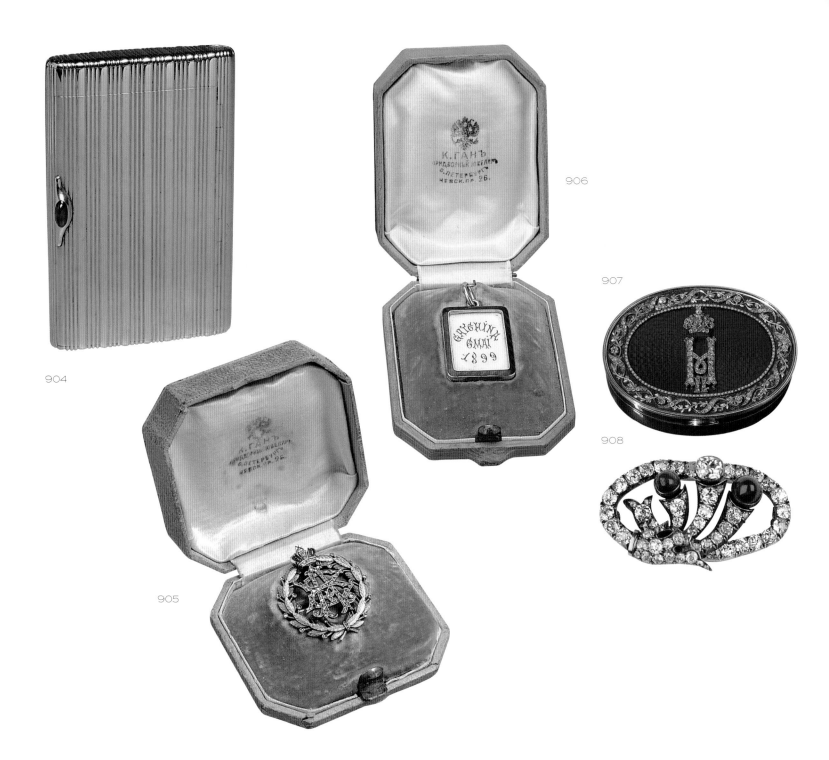

904

906

907

908

905

904. RIBBED GOLD CASE WITH MATCH COMPARTMENT engine-turned with wide and narrow flutes; cabochon sapphire thumbpiece – signed Hahn (Ghan) & Co., initials of workmaster A. T., assay mark of St. Petersburg before 1899, length 3⅜ in. (9.5cm). The interior inscribed: "From Grand Duke Georgi Alexandrovich to Lt. Gen. Hieronimus Ivanovich Stebnitsky". Provenance: Grand Duke Georgi Alexandrovich (1871–1899), son of Tsar Alexander III, was posted by his father to Abastuman in the Caucasus for health reasons. There he died of consumption. His stay in Abastuman is commemorated by Fabergé's "Caucasus Egg" of 1893. Stebnitsky was apparently second-in-command in the Caucasus.
Private Collection

905. CIRCULAR GEM-SET TWO-COLOR GOLD IMPERIAL PRESENTATION BROOCH with central diamond-set Cyrillic monogram "BA", the Imperial crown above set with rose-cut diamonds and two cabochon rubies, within two superimposed laurel wreaths of yellow and red gold with rose-cut diamond berries – by K. Hahn, initials of workmaster N. P., diameter 1¼ in. (3.2cm). Original fitted box stamped K. Hahn (Ghan), Court Jeweler, St. Petersburg, Nevsky 26.
Provenance: presented by Grand Duke Vladimir Alexandrovich (1847–1909), brother of Tsar Alexander III and husband of Duchess Maria of Mecklenburg, celebrated for her jewelry collection.
André Ruzhnikov

906. ENAMELED GOLD MEDAL inscribed Gatchina 6 May 1899 and Jiocha – initials K. G. for Karl Hahn (Gahn), diameter 1¼ in. (3.2cm). Original fitted case stamped K. Hahn.
Provenance: From Gatchina Palace; Central Depository of Suburban Palaces, 1956.
The State Hermitage Museum (ERO – 8631)

907. OVAL DIAMOND-SET ENAMELED GOLD IMPERIAL PRESENTATION BOX the cover applied with a diamond-set crowned cipher "NII" on royal blue *guilloché* enamel ground with seed pearl bezel, the sides and base of the same blue enamel, the red enamel borders with intertwining laurel leaf sprays and diamond-set ribbons – signed K. Hahn, workmaster's initials C. B. for Carl Blank, assay mark of St. Petersburg 1899–1908, 56 (zolotnik), length 3⅜ in. (8.5cm).
Provenance: Presented by Tsar Nicholas II to an unknown recipient.
Courtesy of A La Vieille Russie

908. OVAL GEM-SET GOLD BROOCH of oblong scrolling foliage design set with diamonds, the finials with a cabochon sapphire, diamond and ruby – signed with the initials C. B. of Carl Blank, assay mark of St Petersburg before 1899, width 1½ in. (3.8cm).
Private Collection

909 912

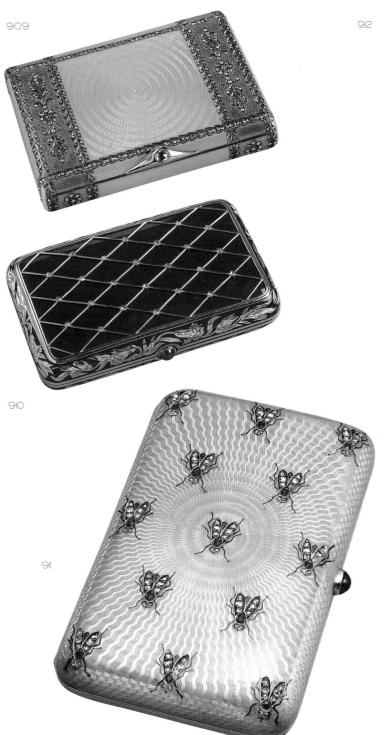

909. DIAMOND-SET ENAMELED GOLD CIGARETTE-CASE the cover and base each with a pale pink enamel band over *guilloché* sunburst pattern flanked by two bands of darker pink *guilloché* enamel applied with diamond-set floral motifs, with rose-cut diamond borders and faceted diamond thumb-piece – initials C.B. for Carl Blank, assay mark of St. Petersburg before 1899, 56 (zolotnik), length 3½ in. (9cm). Original fitted case.
Bibliography: Traina 1998, 95.
John Traina Collection

910. GEM-SET ENAMELED GOLD CIGARETTE-CASE of red *guilloché* enamel, applied with a gold trellis set with diamonds at the intersections, opaque red enamel borders decorated with gold carnations, cabochon ruby pushpiece – initials C. B. of workmaster Carl Blank, assay mark of St. Petersburg before 1899, length 3⅜ in. (8.6cm).
Bibliography: Traina 1998, p. 146.
John Traina Collection

911. BEE CIGARETTE-CASE gem-set enameled gold cigarette-case of pale green translucent enamel over a *guilloché* ground of a sunburst and concentric circles, studded with bees, each with ruby-set body, diamond wings and black enamel legs, with cabochon ruby pushpiece – by Carl Hahn, signed with initials C. B. for Carl Blank, assay mark of St. Petersburg before 1899, 56 (zolotnik), height 3½ in. (8.3cm).
Bibliography: Forbes 1999, p. 261.
A highly original design executed with great mastery.
The Forbes Magazine Collection, New York

912. CUPID FRAME diamond-set enameled gold and standing on a flat circular base embellished with red *guilloché* enamel, the baluster column decorated with gold swags and surmounted by a gold cupid upholding the circular frame. The frame has a rose-cut diamond and a red *guilloché* enamel bezel surmounted by a chased gold ribbon knot centered on a pearl and suspending laurel swags – by Carl Hahn, signed with initials C. B. for Carl Blank, assay mark of St. Petersburg before 1899, 56 (zolotnik), height 4½ in. (11.5cm). Later photograph of Tsarevich Alexis Nikolaievich.
Bibliography: Forbes 1999, p. 261.
The Forbes Magazine Collection, New York

913

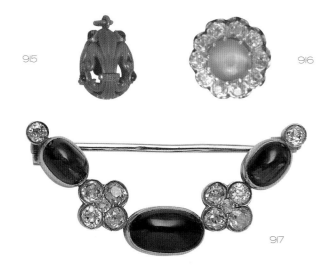

915

916

917

914

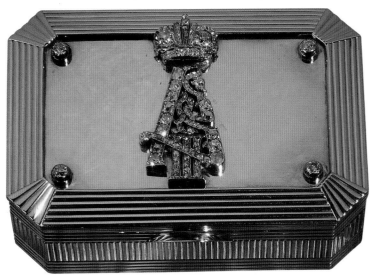

918

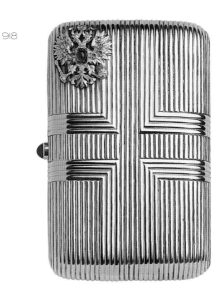

913. CIRCULAR SILVER-GILT AND ENAMEL MOUNTED BOX the hinged cover with blue *guilloché* enamel center surrounded by a white enamel band, with white composition (CHK) sides and palmette borders – signed with Cyrillic initials A. I. of Alexander Ivanov, assay mark 88 (zolotnik) 1908–1917, diameter 1⁵⁄₈ in. (4.1cm).
Private Collection

914. DIAMOND-SET GOLD IMPERIAL PRESENTATION BOX with canted corners, the burnished gold cover with a diamond-set crowned Slavonic cypher "AIII", with diamonds at the corners, with reeded borders and sides – signed by initials F. K. for Friedrich Koechli, assay mark of St. Petersburg before 1899, 56 (zolotnik), length 3¹⁄₂ in. (9cm).
Provenance: Presented by Tsar Alexander III to an unknown recipient.
Courtesy of A La Vieille Russie

915. GEM-SET GOLD MINIATURE EASTER EGG the body formed of two conjoined fleur-de-lis tied with rose-cut diamonds and set with cabochon rubies at intervals – signed with initials F. K. for Friedrich Koechli, assay mark of St. Petersburg before 1899, height ⁵⁄₈ in. (1.5cm).
Exhibited: Zurich 1989, cat. 196g; Lahti 1997, cat. 24, ill. p. 21.
The Woolf Family Collection

916. OPAL AND DIAMOND CLUSTER TIE-PIN by Friedrich Koechli, overall length 3 in. (7.6cm). Original fitted case stamped with Imperial Warrant of Friedr. Koechli, St. Petersburg.
The Woolf Family Collection

917. GEM-SET GOLD CABOCHON SAPPHIRE BROOCH set with three sapphires and two diamond-set quatrefoils in a curved line – initials of Friedrich Koechli, assay mark of St. Petersburg before 1899, length 1⁵⁄₈ in. (4.1cm).
Exhibited: Hamburg 1995, cat. no. 260.
Private Collection courtesy A. von Solodkoff

918. GEM-SET GOLD AND SILVER IMPERIAL PRESENTATION CIGARETTE-CASE the reeded silver case inlaid with gold angles to form a cross, applied with a chased gold Imperial eagle set with a cabochon sapphire, with cabochon sapphire pushpiece – signed with initials of Friedrich Koechli, assay mark of St. Petersburg before 1899, length 3⁷⁄₈ in. (9.8cm).
Private Collection courtesy A. von Solodkoff

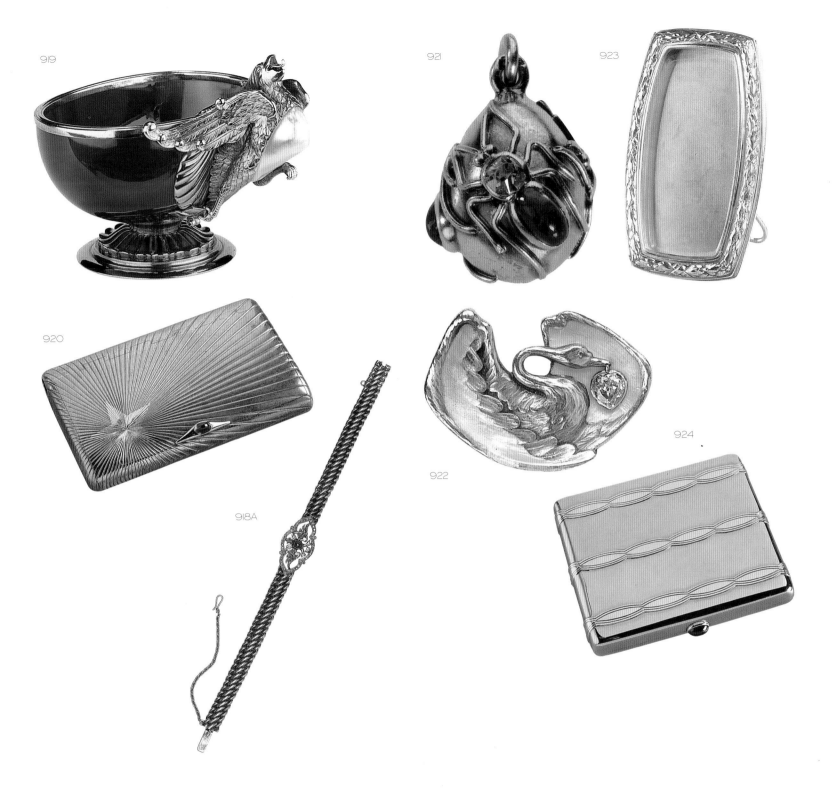

919

921

923

920

918A

922

924

918A. GEM-SET GOLD BRACELET
signed F*K for Friedrich Koechli
Kremlin Armory Museum (MR – 12951)

919. OVAL GOLD-MOUNTED PEARL-
SET AGATE CHARKA on raised gold foot
with engraved presentation inscription below,
the brown hardstone bowl with gold rim, the
handle shaped as a gold fantastic bird with
chased outspread wings, its chest applied with
a large baroque half-pearl – initials F. K.
for Frederich I. Koechli, assay mark of
St. Petersburg before 1899, height 2⅞ in.
(7.3cm).
The presentation inscription reads: "À Arthur
et Alexandre, souvenir des amis père et fils
Kandinsky 1892"

920. SILVER CIGARETTE-CASE with
a gold star to one corner from which issues
an engine-turned sunburst, gold-mounted
cabochon sapphire thumbpiece – initials of
Friedrich Koechli, assay mark of St. Petersburg
before 1899, length 3⅝ in. (9.2cm).
Bibliography: Traina 1998, p. 90.
John Traina Collection

921. GEM-SET GOLD MINIATURE
EASTER EGG applied with three spiders
each set with a brilliant-cut diamond and a
cabochon sapphire – initials F. K. for Friedrich
Koechli, assay mark of St. Petersburg
1899–1908, assay-master Yakov Lyapunov.
Bibliography: Kostbare Osterier 1998, cat. 605,
pp. 188/9, 299.
Adulf P. Goop Collection

922. GEM-SET AND ENAMELED
GOLD SWAN BROOCH the swan with
opened wings enameled opalescent blue, green
and yellow and with chased gold plumage
holding a brilliant cut diamond in its beak –
signed with initials of Feodor Lorié, assay mark
of Moscow 1899–1908, assay-master Ivan
Lebedkin, width 1⅝ in. (4.2cm).
Private Collection

923. SILVER FRAME WITH CONVEX
SIDES the border chased with a continuous
laurel wreath; silver back and strut – signed in
Cyrillic Lorié, 1908–1917, height 3⅜ in.
(8.6cm).
Michael and Ella Kofman Collection

924. BURNISHED RED-GOLD
CIGARETTE-CASE with three bands
of yellow gold intertwining braids, cabochon
sapphire pushpiece – signed Lorié, assay mark
of Moscow 1908–1917, length 3⅝ in. (9.2cm).
Bibliography: Traina 1998, p. 55a (top left).
John Traina Collection

925

926

927

928

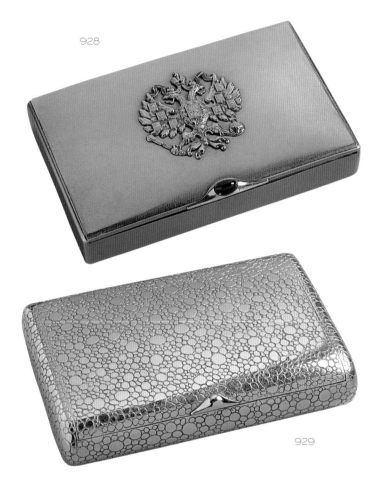

929

925. GEM-SET GOLD SCROLL
the surface imitating scales, applied with two gem-set flowers – signed with initials I. M. for Iosef Marshak, assay mark of Kiev 1908–1917, 56 (zolotnik), length 1⁷⁄₁₆ in. (3.7cm). Original fitted case stamped in Cyrillic Iosef Marshak, Kiev.
Wartski, London

926. GEMSET ENGINE-TURNED GOLD CIGARETTE-CASE with bands of narrow reeding and burnished gold, applied with an anchor set with cabochon sapphires and rose-cut diamonds, cabochon sapphire pushpiece – signed Marshak, 56 (zolotnik) length 4¼ in. (10.8cm).
Bibliography: Traina 1998, p. 149 (top).
John Traina Collection

927. IMPERIAL PRESENTATION DIAMOND-SET SAMORODOK GOLD CIGARETTE-CASE the cover applied with a diamond-set double-headed eagle, cabochon sapphire thumbpiece – Imperial Warrant mark of Ivan Morozov, assay mark of St. Petersburg 1908–1917, length 3¾ in. (9.5cm).
Bibliography: Traina 1998, p. 100 (top).
John Traina Collection

928. MATTE GOLD IMPERIAL PRESENTATION CIGARETTE-CASE the cover applied with a double-headed eagle, cabochon sapphire thumbpiece – stamped with Imperial Warrant mark of I. Morozov, workmaster's initials I. P., assay mark of St. Petersburg 1908–1917, length 3½ in. (9cm).
Bibbliography: Traina 1998, 150b (right center).
John Traina Collection

929. YELLOW-GOLD CIGARETTE-CASE engraved to simulate shagreen – initials of Nicholls and Plincke, assay mark of St. Petersburg before 1899, length 3¾ in. (9.5cm). Inscribed in French: "Capitaine F. Chevalier En Souvenir des services rendus à la Flotte Volontaire Russe".
Bibliography: Traina 1998 p. 55a (top).
Nicholls and Plincke of the Magasin Anglais, were known primarily for their production of great silver services in the mid-19th century.
John Traina Collection

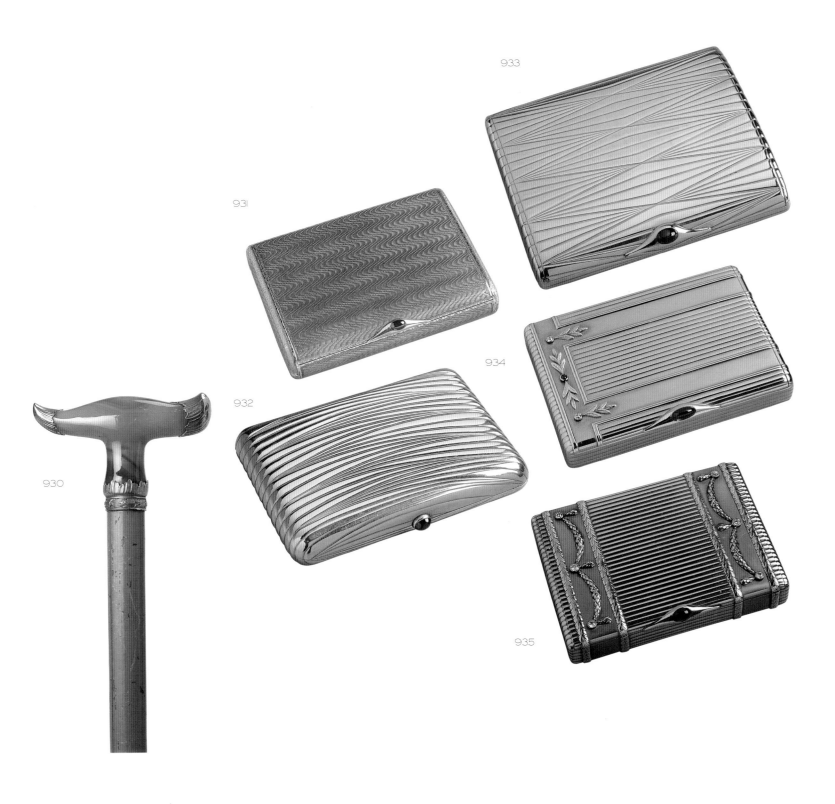

930. "T"-SHAPED GOLD-MOUNTED
AGATE CANE HANDLE with chased gold
Rococo mounts and a reed-and-tie border –
workmaster's initials Cyrillic I.P., probably for
Yakov Rosen, assay mark of St. Petersburg
before 1899, height of handle 2⁵⁄₈ in. (6.7cm).
Exhibited: Munich 1986/7, cat. 174.
Originally erroneously ascribed to Julius
Rappoport (see Munich catalog), who only
made silver objects, this cane handle is almost
certainly by Yakov Rosen. Rosen was a prolific
maker of high quality gold boxes which are
sometimes passed off as being by Fabergé. His
initials are confused with those of Fabergé's
workmaster Julius Rappoport who did not
make gold boxes.
Private Collection

931. ENAMELED SILVER-GILT
CIGARETTE-CASE of steel-gray waved
guilloché enamel with cabochon sapphire
thumbpiece – initials of Yakov Rosen, assay
mark of St. Petersburg 1908–1917, length
3³⁄₄ in. (9.5cm).
Bibliography: Traina 1998, p. 51 (bottom).
John Traina Collection

932. YELLOW-GOLD CIGARETTE-
CASE engine-turned with interlocking
curved flutes, cabochon sapphire pushpiece –
initials of Yakov Rosen, assay mark of St.
Petersburg 1908–1917, length 3³⁄₄ in. (9.5cm).
Bibliography: Traina 1998, p. 54b (right).
John Traina Collection

933. RED-GOLD CIGARETTE-CASE
engine-turned with fluted triangular motifs,
with cabochon sapphire thumbpiece – initials
of Yakov Rosen, assay mark of St. Petersburg
1908–1917, 56 (zolotnik), length 3³⁄₄ in.
Bibliography: Traina 1998, p. 52b (lower left).
Cf. note cat.
John Traina Collection

934. REEDED YELLOW-GOLD
CIGARETTE-CASE with a matte pink gold
band to each side applied with yellow gold
swags suspended from circular-cut diamonds,
cabochon sapphire thumpiece – initials of
Yakov Rosen, assay mark of St. Petersburg
1908–1917, length 3⁷⁄₈ in. (9.8cm).
Bibliography: Traina 1998, p. 94 (center).
John Traina Collection

935. GEM-SET TWO-COLOR GOLD
CIGARETTE-CASE with a match
compartment, engine-turned with panels of
flutes, chased with laurel sprays and set with
two rose-cut diamonds and a sapphire,
cabochon sapphire thumpiece – initials of
Yakov Rosen, assay mark of St. Petersburg
1908–1917, length 3³⁄₄ in. (9.5cm).
Bibliography: Traina 1998, p. 99 (top left).
John Traina Collection

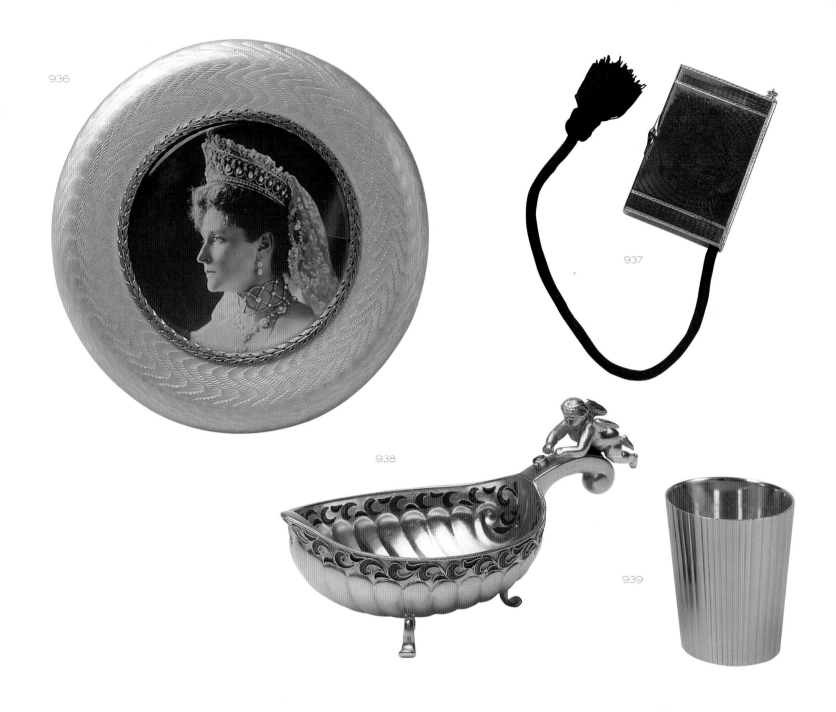

936. CIRCULAR SILVER-GILT AND
PRIMROSE-YELLOW ENAMEL
FRAME the bezel chased with laurel, the
bombé border with waved *guilloché* enamel,
shaped openwork silver-gilt strut – by Avenir
Ivanovich Sumin, assay mark of St. Petersburg,
1908–1917 – diameter 4 in. (10.2cm). Original
leather case stamped (Cyrillic) A. I. Sumin,
S.P.B., Nevsky 60.
The original photograph shows a portrait of
Empress Alexandra wearing Russian crown
jewels.
Provenance: Given by Empress Alexandra to
her sister Princess Irene, Princess Henry of
Prussia.
Exhibited: Hamburg 1995, no. 244.
Private Collection

937. IMPERIAL PRESENTATION
ENAMELED GOLD CIGARETTE-
CASE of translucent scarlet enamel over a
sunray and wavy *guilloché* pattern engraved by
hand with the Imperial Romanov double-
headed eagle emblazoned on both sides, with
match compartment, tinder cord and cabochon
sapphire thumbpiece – signed with initials A. T.
for Alexander Tillander, length 3⅝ in. (9.2cm).
Inscribed in Cyrillic "From Papa, 25 Dec.
1893, Gatchina" Provenance: Given by Tsar
Alexander to his son, Tsarevich Nicholas, on
Christmas Day, 1893.
Exhibited: Helsinki 1991; Lahti 1997.
Bibliography: Tillander-Godenhielm 1996,
Private Collection, lent courtesy Ulla
Tillander-Godenhielm

938. GEM-SET, PLIQUE-À-JOUR
ENAMEL AND GOLD KOVSH
the border ornamented with a foliate stem of
red and blue *plique-à-jour* enamel, the handle
surmounted by a gold Cupid and circular-cut
emerald – signed with initials A. T. for A.
Tillander, assay mark of St. Petersburg before
1899, 56 (zolotnik), length 2⅝ in. (6.6cm).
Wartski, London

939. TWO-COLOR GOLD VODKA-
CUP tapering cylindrical, the body vertically
reeded with alternate broader and narrower
stripes – maker's mark A. T., probably for
Alexander Tillander, assay mark of
St. Petersburg before 1899, with later French
import mark, height 1⅞ in. (4.8cm).
Private Collection

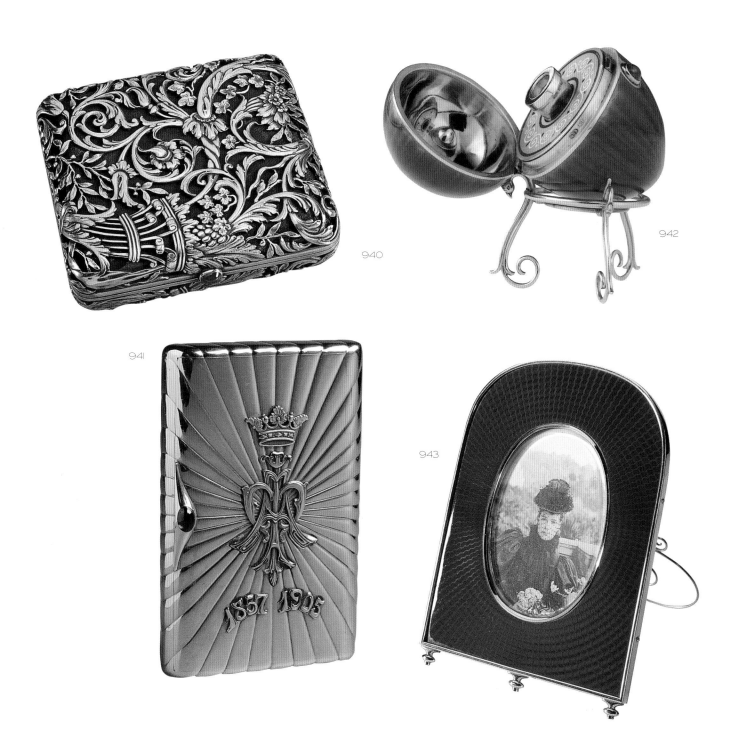

940

942

941

943

940. SILVER AND LEATHER
CIGARETTE-CASE applied with scrolling
foliage issuing from a cornucopia, sapphire
pushpiece – stamped Tillander in a lozenge,
assay mark of St. Petersburg before 1899, inv
no. 17566, length 3¼ in. (8.2cm).
Bibliography: Traina 1998, p. 73.
John Traina Collection

941. GOLD PRESENTATION
CIGARETTE-CASE engine-turned with
tapering flutes issuing from a central applied
crowned monogram "FA" and dates 1857 and
1905 beneath, the reverse with an enameled
coat-of-arms, cabochon sapphire thumbpiece –
initials of Alexander Tillander, assay mark of
St. Petersburg 1899–1904, assay-master Yakov
Lyapunov, length 4 in. (10.1cm). Inscribed with
names of 42 colleagues of the recipient Feodor
Konstantinovich Albedyll, member of a Baltic
noble family.
Bibliography: Traina 1998, p. 116 (left).
John Traina Collection

942. EGG-SHAPED ENAMELED
GOLD SCENT-FLASK of scarlet *guilloché*
enamel with a cabochon sapphire pushpiece,
opening to reveal a rock crystal flask with
opaque white enamels scrolls and blue enamel
rim – signed with initials A. T. for Alexander
Tillander, assay mark of St. Petersburg
1899–1908, height 1¾ in. (4.5cm).
Bibliography: Ghosn 1996, cat. 169; Kostbare
Ostereier 1998, cat. 701, p. 200/1.
Adulf P. Goop Collection

943. ENAMELED GOLD
PHOTOGRAPH FRAME of translucent
red enamel over a *guilloché* sunburst and wave
pattern ground, with arched top, oval aperture,
three peg feet and gold strut – initials of
Alexander Tillander, assay mark of St.
Petersburg before 1899, height 5½ in. (14cm).
Photograph of Dowager Empress Maria
Feorodovna Provenance: The Woolf Family
Collection.
Exhibited: Munich 1986/7, cat. 615.
Private Collection, Courtesy Ulla Tillander-
Godenhielm

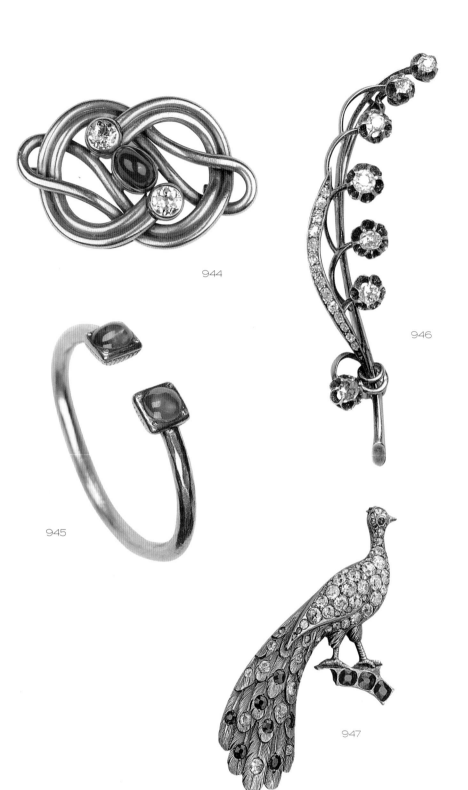

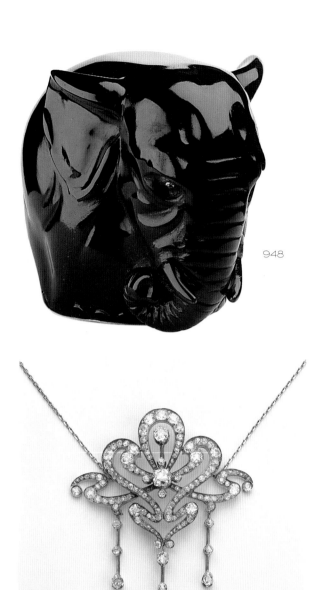

944

945

946

947

948

949

944. GEM-SET GOLD KNOT
BROOCH the reeded gold knot set with a
cabochon sapphire flanked by two diamonds –
assay mark of St Petersburg before 1899, width
1¼ in. (3.1cm).
Private Collection

945. GEM-SET GOLD SAPPHIRE
BANGLE IN THE ARCHEOLOGICAL
STYLE with two cabochon sapphires in
square gold mounts set with four rose-cut
diamonds – Russian, c. 1890, later gold
hallmark, diameter 2¹⁵⁄₁₆ in. (7.4cm).
Private Collection courtesy A. von Solodkoff

946. DIAMOND-SET LILIES-OF-THE-
VALLEY SPRAY the stem and six buds set
with rose-cut diamonds – workmaster's initials
Cyrillic G.A., assay mark of Moscow before
1899, 56 (zolotnik), length 2¼ in. (5.7cm).
Original fitted case stamped "Factory and Shop
of N.V. Nemirov-Koldkin, Moscow".
André Ruzhnikov

947. GEM-SET GOLD BROOCH
SHAPED AS A PEACOCK set with rose-
cut diamonds, rubies and sapphires – initials of
unknown workmaster SP, St. Petersburg 1880s,
56 (zolotnik), length 2⅝ in. (6.6cm).
Provenance: acquired by the State Hermitage,
1991.
The State Hermitage Museum (ERO – 9988)

948. OBSIDIAN CARVING OF AN
ELEPHANT with silver lining for use as a
beaker, the realistically modeled animal with
gold-mounted cabochon ruby eyes – initials
of maker N.P., assay mark of Moscow 1899–
1908, height 3¹⁄₁₆ in. (7.8cm).
Private Collection courtesy A. von Solodkoff

949. DIAMOND-SET GOLD
PENDANT decorated in the Art Nouveau
style with scrolls centered by a large diamond,
with three gold lines set with diamonds,
suspended, with gold chain attachment –
maker's initials A. K., assay mark of
St. Petersburg 1899–1908, length 2¾ in.
(7.1cm).
Private Collection

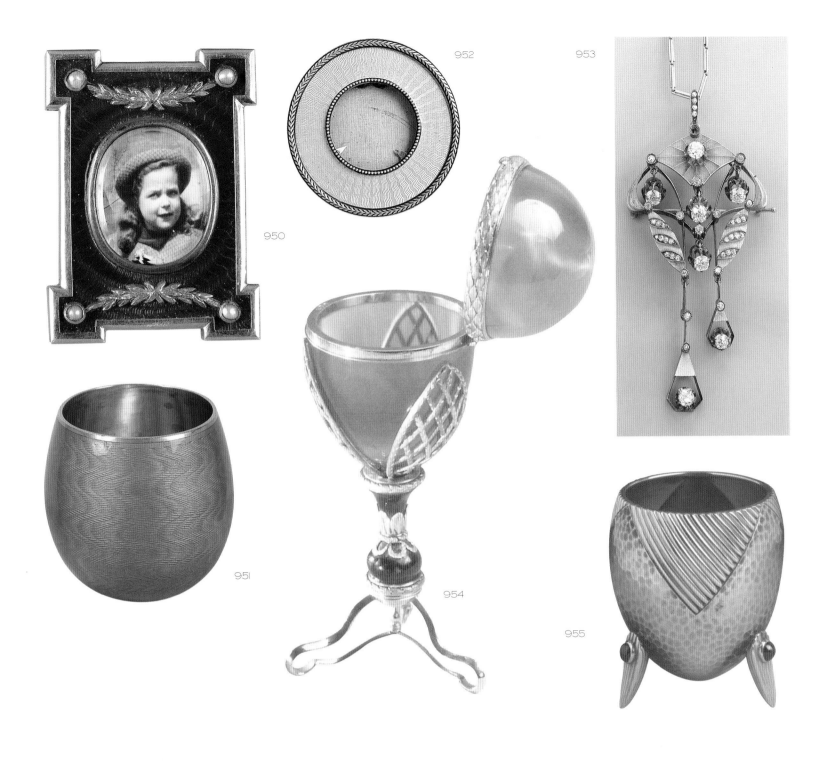

950. MINIATURE SHAPED
RECTANGULAR ENAMELED GOLD
FRAME of red *guilloché* enamel with applied
laurel swags suspended from pearls above and
below circular aperture, with gold back and
strut – workmaster's initials O. L.,
St. Petersburg, 1899–1908, assay-master Yakov
Lyapunov, height 1½ in. (3.8cm).
Louise and David Braver

951. SILVER-GILT AND GUILLOCHÉ
ENAMEL BOWL of part ovoid form,
the sides enameled in translucent bright green
over a moiré ground – initials of workmaster
indistinct, assay mark of St. Petersburg
1899–1908, inv no. 11671, height 1⁷₁₆ in.
(3.7cm).
Private Collection

952. SMALL CIRCULAR ENAMELED
AND SILVER FRAME of pale blue translu-
cent enamel over guilloché sunburst ground
with beaded bezel and laurel leaf outer border;
wooden back and silver strut – signed with
Cyrillic initials MS, 1908–1917, 88 (zolotnik),
diam 2³₁₆ in. (6 cm).
Michael and Ella Kofman Collection

953. ART NOUVEAU GEM-SET AND
ENAMELED GOLD PENDANT initials
of unknown workmaster A. O., assay mark of
Moscow 1899–1908, 56 (zolotnik), length
3⅛ in. (8cm).
Provenance: Acquired by the State Hermitage,
1997.
The State Hermitage Museum (ERO – 10053)

954. GOLD-MOUNTED AND
ENAMELED AGATE EGG standing on
a tripod base with red *guilloché* enamel baluster
shaft, the lower half applied with three
triangular openwork trelliswork panels, chased
laurel-leaf bezel – Cyrillic initials G. S.
Exhibited: London 1995, cat. 21.
The Castle Howard Collection

955. SILVER AND GOLD CUP
SHAPED AS AN AFRICAN DRUM the
hammered-silver body with triangular reeded
gold insets, three gold feet set with cabochon
garnets – Cyrillic initials of unrecorded
workmaster I. R., assay mark of St. Petersburg
before 1899, height 1⅝ in. (4.2cm)
The Woolf Family Collection

12
THE FOREIGN
COMPETITORS

THE JEWELRY OF LOUIS COMFORT TIFFANY AND CARL FABERGÉ: A COMPARATIVE STUDY

Despite the fact that Carl Fabergé and Louis Comfort Tiffany achieved worldwide celebrity for their mastery of vastly different disciplines, employing different materials and stylistic preferences, there are several interesting parallels in the work of the two artist-designers.

Included from the Streiner collection are two dozen jeweled works – both jewelry *per se* and *objets d'art* – designed by Mr Tiffany and made under his supervision during the period between 1900 and the First World War either at Tiffany Furnaces (a division of his industrial art conglomerate, Tiffany Studios) or at Tiffany & Co. In its initial stages, *c.* 1900–1902, Tiffany cloaked his experimentation in jewelry production in secrecy, a precautionary tactic which he had also pursued when he opened an enameling department in 1898 and a pottery one (*c.* 1904) at his Corona workshops. Part of this need to conceal his foray into the jewelry field lay, no doubt, in deference to his father, Charles Lewis Tiffany, the founder and president of Tiffany & Co., and his apprehension as to how he would react to his son's entry into the field in which his prestigious firm had long served as the arbiter of taste for both America's patrician families and its burgeoning *nouveau riche* merchant class. Until then, production at the two firms had not overlapped, so L. C. Tiffany's entrance into the world of jewelry required sensitivity and good timing. His father's death in 1902 eliminated the principal hurdle facing him; his election to Tiffany & Company's Board of Directors later that year consolidated his authority to proceed as he wished.[1]

FIG I. PORTRAIT OF
LOUIS COMFORT TIFFANY

Three of the Streiner pieces were created during the initial phase of Louis Comfort Tiffany's jewelry production. Two are vinaigrettes (scent bottles or atomizers) made in collaboration with the jewelry department at Tiffany & Co., who contributed the jeweled covers and collars for the Favrile glass vessels. The third is an enameled copper cloak clasp, which has the distinctive hand-wrought Arts & Crafts appearance that served as the decorative imprimatur for practically all of the enamelware produced at the Tiffany Furnaces, far removed in artistic sensibility from anything in Tiffany & Co.'s jewelry repertoire at the time. Most of L. C. Tiffany's earliest jewelry incorporates the same materials and stylistic characteristics; chased *repoussé* copper bodies superimposed with layers of polychromed enamels applied *en plein* (ie., the smooth covering of comparatively large surfaces) to render the image in the most realistic and painterly manner possible in order to eliminate the need for the *cloisons* (cells) or *champs* (fields) traditionally employed in the medium.

The remaining pieces of L. C. Tiffany jewelry lent by Mr Streiner to the exhibition were manufactured at Tiffany & Co; after Mr Tiffany had, in 1907, transferred his enamel and fledgling jewelry departments from their Tiffany Furnaces facility in Corona to the Tiffany & Co. headquarters on Fifth Avenue and 37th Street in Manhattan. These pieces, created as they had previously been under L. C. Tiffany's supervision, but now at his father's firm, bear comparison with the jewelry produced at the time at the Fabergé workshops in St. Petersburg. The reason for this is that Tiffany's designs from 1907 underwent a remarkable metamorphosis, one that brought his jewelry far closer to the medium's mainstream. Designs were formalized and simplified. Gone was the freely crafted, if not rudimentary, feel of his earlier jewelry and its faithful depiction of nature; in

Notes
1. For a history of the managerial changes at Tiffany & Co. following the death of Charles Lewis Tiffany on February 17, 1902; see Loring (1999), p. 196f and Zapata (1993), p. 73ff.

its place Tiffany started producing a more symmetrical line of personal adornments. Those familiar with the windows, lamps and other household accessories produced in such profusion at the Tiffany Studios could be forgiven if they failed to recognize that the new adornments had emanated from the same hand. Color remained the primary focus in Mr Tiffany's decorative grammar of ornament, but from 1907 nature shared his attention increasingly with an eclectic mix of historical styles, including those of Mughal India, Persia, Byzantium, ancient Egypt and Eritrea. With production now in the virtuoso hands of Tiffany & Co.'s experienced team of gold and silversmiths, lapidaries, enamelers, and chasers, Mr Tiffany no doubt saw the opportunity, if not the necessity, to improve the technical quality of his jewelry to match that of the parent company and its principal European competitors. Copper, the mainstay metal in his enameled production at Tiffany Furnaces, yielded to gold, silver and platinum, the latter a relative newcomer to the highest echelons of jewelry production. The new affiliation with Tiffany & Co. brought with it also the services of the firm's gemologist, George F. Kunz, who could counsel Tiffany on the optimum selection with which to form a color chart of stones to complement his enamels.[2]

The majority of the Streiner pieces are rendered in the revised ornamental idiom created under Mr Tiffany's supervision by a small team of his own designers at Tiffany & Co. Most prominent amongst these were Julia Munson, who had joined the enameling department shortly after its inception in 1898, Patricia Gay and Meta Overbeck. Although each brought her own idiosyncracies to the design at hand, Mr Tiffany's artistic direction dictated the style common to all of the jewelry produced under his name. This can readily be seen in the Streiner pieces; namely, the preference for natural stones over precious ones, the persistent application of enamels to introduce realistic color effects, and the use of gold, silver or platinum mounts fashioned into intricate coiled, filigreed or ropetwist patterns.[3]

The central theme of L. C. Tiffany's jewelry is his preoccupation with color and his attempt to replicate, if not to surpass, the subtle nuances or sheer intensity of nature's myriad hues and tones. To achieve the coloristic effects, he relied mainly on two materials: enamel and gemstones, used either individually or in combination. His choice of gemstones depended therefore more on their esthetic merits than on their intrinsic monetary value. In addition to a wide range of stones indigenous to the North American continent – including turquoises, amethysts, aquamarines, moonstones, onyx, topazes, opals, beryls, cornelians, Montana sapphires and demantoid garnets, to list some of his more popular varieties – Tiffany used materials such as seed and baroque pearls, coral, and his inimitable Favrile glass for his jewelry, in the same way that he incorporated fresh water pebbles into his lampshades and windows for their qualities of luminescence. Stones comprised of unconventional colorations or crystalline formations, such as fiery Mexican opals and black opals in matrix, were always sought to create novel effects. Translucent varieties were collet- or bezel-set with open backs that permitted the filtered light to glow through them when the position of the piece of jewelry shifted as the viewer's angle of vision changed. Many gems were cut *en cabochon* in preference to being faceted so that the colored light was transmitted directly, rather than fragmented.

Like Tiffany, Fabergé rarely used precious stones, being drawn rather to the inexhaustible supply of mineral deposits throughout Russia, including Siberian nephrite and jasper from the Ural mountains. In those instances when a diamond was selected for the design at hand, this was to meet the specific decorative demands of the piece rather than to enhance its financial value. The visual impact of brilliant stones such as diamonds (mostly rose-cut by Fabergé) and rubies had to be carefully harnessed to prevent them overpowering the rest of the composition, which could lead to a color imbalance.

FIG 2. TIFFANY STUDIOS EXHIBIT at the Paris World Fair, 1900

FIG 3. TIFFANY & CO. 37th Street and Fifth Avenue, *c.* 1905

2. Loring (1997), p. 40 and *Ibid.*, Zapata (1993), pp. 132–133.

3. The majority of the Streiner pieces illustrated here incorporate these characteristics of L. C. Tiffany's jewelry. Other major collections with similar examples are those of the Louis C. Tiffany Museum in Matsui, Japan, and that of Tiffany & Co., New York.

Fabergé's final choice in most instances was for semi-precious stones, including moonstones, olivines, garnets, chrysophase, jade (nephrite and jadeite), and lapis lazuli, plus a host of agates carved also by the lapidaries in his workshops into the menagerie of animal figurines that became a hallmark of the firm's output. In fact Fabergé never hesitated to employ any material, however unorthodox it may have been, if it was durable and would serve his esthetic goals.[4]

Although hailed throughout Europe as the Imperial jeweler, or jeweler to the Tsars, Fabergé did not generate a large amount of conventional jewelry in proportion to his total output. His focus was on his *objets de vertu* which, although jeweled, were not to be worn. They were, rather, *objets de fantaisie*, delectable confections that reached their pinnacle of technical ingenuity and novelty in the series of Easter Eggs commissioned by the Romanovs. His jewelry, by contrast, was often nondescript, and included a seemingly endless procession of stock-in-trade wares such as diamond-set pendants, rings, brooches, necklaces, earrings, hair combs, wrist watches and cuff-links, pieces that Fabergé collectors may not immediately associate with him. Part of the problem of identification lies in the fact that a great number of these works were mounted in platinum, for which no mark existed in Russia at the time. Many of them remained unidentified until 1986, when two of the original stock books from the firm's jewelry workshops, located at the time in St. Petersburg and headed by Albert Holmström, were discovered. These seemed to include the design of every piece of jewelry made by Fabergé between 6 March 1909, and 20 March 1915, each rendered in meticulous detail in pen and pencil, some heightened further in watercolor.[5]

One senses as one flips through the pages of the two stock books, that, for Fabergé personally, the jewelry produced by the House of Fabergé between 1909 and 1915 was somewhat commercial and perfunctory, a requisite component of the broad package which it offered its clientele and for which it was by then internationally renowned. Predictably, as for all industrial artist-designers at the time such as Tiffany, Émile Gallé and René Lalique (during his second career as a glassmaker), it was with the highest tier of artistic production, his masterworks, that Fabergé targeted the royal households of Europe and their inner circles. He knew, however, that what demanded most of his attention necessitated an artistic compromise; it was in fact the large and steady editions of less expensive and less glamorous jeweled works that financially underpinned the time-consuming and often cost-ineffective manufacture of those *chefs d'oeuvre*.

By contrast, L. C. Tiffany's designs between 1909 and 1915 today appear more interesting and charming and, ultimately, more innovative. Simply put, they come as a delightful surprise, unlike the pastiche of revivalist motifs that dominates Fabergé's jewelry designs. These designs include a predictable array of floral swags, acanthus, laurel wreathes and rocaille scrolls from the Louis XV/XVI and empire epochs, plus iconography drawn from classicism, the Renaissance and other periods of history. Until recently the full extent of Mr Tiffany's jewelry production was unknown and therefore unappreciated. He must now be credited with an even more prodigious output than was previously thought, and in a discipline for which he has been largely unknown and therefore unheralded; his devotees, initially incredulous, are now understandably enthusiastic.

In its enameling and choice of metals, however, Fabergé's work surpassed that of Tiffany and all of his competitors. Up to six layers of translucent varicolored enamels were used to provide whatever nuance or mood was desired. On occasions, paillons (particles of gold or silver leaf) were inserted under or between the layers to intensify the light as it was reflected back through the layers to the viewer, a process also used to great effect by Tiffany in the enameled wares produced at Tiffany Furnaces. These, such as vases, inkstands, trays and covered bowls, were classified in the firm's sales literature as "Fancy

FIG 4. DANDELION COIFFURE ORNAMENT created by L. C. Tiffany for the 1904 St. Louis exhibition. Reproduced from Town and Country, V, 59, 29 October, 1904

FIG 5. GRAPE NECKLACE AND DRAGONFLY by L. C. Tiffany created for the 1904 St. Louis exhibition. Reproduced from The Craftsman, VII, p. 177

4. See Snowman (1953), pp. 57–59.

5. Many of the designs are illustrated in Snowman (1993); and in the article entitled "Two Books of Revelations", by Snowman in Habsburg (1987), pp. 45–61.

Goods." The term, which described its production of de luxe household accessories, was perhaps inspired by the phrase used to identify Fabergé's most sophisticated creations: *objets de fantaisie*.

Both firms resorted on occasions to enameling's full roster of decorative techniques: *en plein*, *cloisonné*, *champlevé*, as mentioned above, and *plique-à-jour*, the process in which the metal backing is removed following the firing of the enamel to provide it with a translucent or "stained glass" appearance. Fabergé and Tiffany also mastered the difficult method of enameling curved surfaces (*en ronde bosse*), but there is a velvety feel to the surfaces of Fabergé's enamelware – achieved through hours of polishing on a wooden wheel and buffing with chamois leather – that was unsurpassed by any other maker. Fabergé embellished many of the metal surfaces beneath his enamels with engine-turned patterns created on a machine called a *tour à guillocher*. Tiffany likewise employed the *guilloché* technique – one piece by L. C. Tiffany in the Streiner collection incorporates it, although sparingly.[6]

In his choice of metals, Fabergé also provided a more sophisticated range than L. C. Tiffany. The addition of small quantities of certain minerals to yellow gold provided it with differently colored finishes, a technique borrowed from French eighteenth-century snuffbox makers, who had developed four distinct colorations (*or à quatre couleurs*). The Fabergé workshops employed up to six gold colors, which when juxtaposed in various combinations provided an infinitely subtle means of artistic expression. Silver's range of visual effects was likewise extended by burnishing, chasing, embossing, oxidizing and matting, part of Fabergé's ceaseless pursuit of novel effects.[7]

Not surprisingly, Fabergé and Tiffany shared some wealthy clients, most notably, Henry C. Walters of Baltimore, who had made his fortune from the Atlantic Coast Line, one of America's largest railroads. With an insatiable thirst for art, Walters in thirty years amassed around 22,000 works, many now housed in the Walters Art Gallery, the museum that he bequeathed to his hometown in 1931. On one of several transatlantic trips aboard his private yacht, Walters sailed up the Neva to Moscow in 1900, where he visited Fabergé's workshop and purchased a selection of enameled gold parasol handles and carved hardstone animals. In around 1930, he acquired from a Parisian dealer two prized Fabergé creations – the Gatchina Palace Egg of 1901 and the Rose Trellis Egg presented at Easter, 1907, by Tsar Nicholas II to his wife, Tsarina Alexandra Feodorovna.[8] Among Walters's known L. C. Tiffany acquisitions of the early 1900s were two pieces of jewelry that in importance relative to the artist's repertoire as a whole, measured up to his purchase of the two Imperial Eggs. The first was the gold Medusa brooch, a fearsome naturalistic interpretation of a species of jellyfish with writhing jewel-studded tentacles issuing from an opal-set body. Exhibited both at the 1904 St. Louis World Fair and the 1906 Salon of *La Société des Artistes Français* in Paris, the piece was acquired at some point by Walters – it was offered in the 1943 auction of his wife's estate, and its whereabouts are now unknown.[9] Another jewelry *tour de force* purchased by the Baltimorian was the "peacock" necklace, now in the collection of the Charles Homer Morse Museum of American Art, which appeared in a 1906 article in The International Studio, "Louis Comfort Tiffany and His Work in Artistic Jewelry."[10] The piece presents a marriage of a Byzantine jewelry form and lavish Art Nouveau imagery. Comprised of a central medallion linked to supporting lappets by pairs of rosettes, it is embellished on the obverse with peacocks and on the reverse with flamingoes.

The Vanderbilts were another American family drawn to the celebrity of both Fabergé and L. C. Tiffany. For Tiffany, the client was the family's patron, Cornelius Vanderbilt II, the railroad magnate, who in the early 1890s retained him to decorate one of the salons in his block-long residence on Fifth Avenue in New York, between 57th and

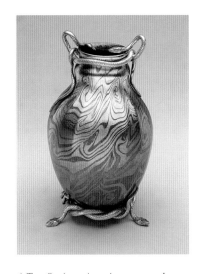

FIG 6. SILVER-GILT MOUNTED FAVRILE GLASS VASE signed LCT for Louis Comfort Tiffany, no. E408 – with snake-shaped mounts – signed Fabergé, initials of workmaster Victor Aarne, assay mark of St. Petersburg, 1908–1917, 88 (zolotnik), height 6⅜ in. (16.2cm).
The Forbes Magazine Collection, New York

6. Two Streiner pieces incorporate the *plique-à-jour* technique, an enameled gold-mounted brooch (cat. 6), and an enameled gold-mounted black opal and demantoid garnet pendant (cat. 7).

7. *Ibid.*, Habsburg (1987), pp. 89–91.

8. The Easter Egg is illustrated in Habsburg (1966), p. 36.

9. See *La Gazette de Beaux-Arts*, L'Art Décoratif aux Salons de 1906. Première série: *Bijouterie-Orfèvrerie-Ornamentation*, pls. 88 and 89; Duncan (1994), p. 240; Duncan (1989), pl. 55.

10. The International Studio, Vol. 30, No. 117 (November 1906), xxiv.

58th Streets. One of several participating interior designers, Tiffany's choice of furnishings, in its unapologetic nonconformity, was construed by the critics to be a decorating disaster. Fabergé fared better with Cornelius's granddaughter, Consuelo Vanderbilt, who on a visit to Russia in 1902 as the Duchess of Marlborough (she had married the 9th Duke in 1894) commissioned from Fabergé a pink enameled Easter Serpent Clock Egg crafted by Michael Perchin.

To reach wealthy prospective clients who had not yet searched them out, Fabergé and Tiffany were persuaded to participate in the host of international exhibitions that took place between the 1880s and the Great War. Fabergé made his début at the Nuremberg exhibition of 1885. Belatedly, Tiffany followed suite at the Columbian World Fair in Chicago in 1893, chagrined no doubt at having witnessed first-hand as a visitor to the 1889 Exposition Universelle in Paris, the Grand Prix awarded to his arch-rival, John LaFarge, for a stained-glass panel decorated with wind-blown peonies.

Surviving records indicate that Fabergé and Tiffany participated only once at the same World Fair; at the triumphal Exposition Universelle staged in the French capital in 1900, where both consolidated their reputations as master artist-designers and arbiters of taste to royalty and the super-rich, although in different arenas.[11] Selected as a member of the Jury, Fabergé was invited to participate *hors concours* as a member of both Classe 95 (*joaillerie et bijouterie*) and Classe 94 (*orfévrerie*). His display included a selection of exquisite bibelots from the Imperial Treasury, including Easter Eggs exchanged between members of the Romanov family, and miniature replicas of Imperial regalia, such as the Emperor's crown, scepter, and orb, and a selection of stomachers and diadems. Although of an irreproachable technical standard, these works by the House of Fabergé were deemed by the critics to be stylistically retardaire and therefore very much at odds with the broad trend towards modernism at the Exposition, where Lalique was judged in the fields of *bijouterie* and *orfévrerie* to be the unrivalled champion. The critic René Chanteclair, among others, considered Fabergé's attempts in the Art Nouveau idiom to be "mediocre".[12] No such historicist censure awaited L. C. Tiffany's presentation, most of which consisted of his famed Favrile glassware and exhibited in his own stand in the American pavilion. Included was a wide range of his signature household accessories: candelabra, lamps, vases, windows, etc. The few works of his that qualified as jewelry or precious works of art *per se* – notably a selection of vinaigrettes in blown glass enhanced with enameled and gem-set mounts of traditional inspiration – were created in partnership with Paulding Farnham, the chief designer of the jewelry department at Tiffany & Co., which included them in its display.[13] Both Fabergé and Tiffany were awarded the *Légion d'honneur* at the Exposition.

No doubt by 1900 mutually respectful of their respective artistic accomplishments and global stature, it is not surprising that the two houses were on occasion drawn into collaborative ventures, although none are documented in the surviving literature of either firm. Three such liaisons are known: a Tiffany glass bottle applied with Fabergé silver mounts and pearl-set cover (ex Robert Strauss collection), a glass vase with a silver peacock foot, and a glass bowl with snake mounts, now in The Forbes Magazine Collection (fig. 5).[14] Fabergé created similar silver mounts for vessels created at the time by other makers of note, including Gallé, Royal Doulton, and the Roerstrand porcelain manufactory.[15] All of these are in a vigorous Art Nouveau grammar of ornament that complement the organic decoration on the vessels they house, no doubt conveying the message from Fabergé to his critics that should he have wished to embrace the modern decorative vernacular more fully, he could readily have done so. In fairness to Fabergé, he did use Art Nouveau's naturalistic imagery at his St. Petersburg workshop between the late 1890s and 1903, a short-lived period bracketed by his designs for the Lillies-of-the-Valley Egg (1896) and the Kremlin Clover Egg (1903). At Fabergé's Moscow division, the style

11. For a detailed discussion of Fabergé's participation at the 1900 Exposition Universelle, see Habsburg/Lopato (1993), pp. 116–123.

12. *Ibid.*, p. 122.

13. Loring, Tiffany's 20th Century: A Portrait of American Style, p. 10–11, for a view of the Tiffany and Company display at the 1900 Exposition Universelle, including a selection of atomizers made in collaboration with Tiffany Studios.

14. For the Fabergé-mounted Tiffany bottle see the Hamburg Museum's Tiffany exhibition catalog, color ill. 77, and Snowman (1953), ill. 58 (shown after p. 40 of the text); for the peacock-mounted vase, see the Hamburg Museum's exhibition catalog, *ibid.*, ill. 127; and for the snake-mounted vase, see Forbes (1999), p. 146.

15. For Fabergé-mounted Gallé glassware, see Alastair Duncan, The Paris Salons, Vol. IV: Glass & Ceramics, 1998, p. 201 and Habsburg/Lopato (1993/94), cat. 56–8, pp. 214–15. For Doulton ceramics mounted by Fabergé, see Habsburg/Lopato, *ibid.*, no. 37 and 38, p. 200; and for Rorstrand porcelain with Fabergé mounts, see Habsburg/Lopato, *ibid.*, no. 2, p. 119, and no. 39, p. 201.

lingered for a while longer, especially in his silver production.

Fabergé's realm began to unravel even before the advent of the Russian Revolution and the subsequent disintegration of his élite world. For his part, Mr Tiffany was, by 1917, increasingly preoccupied with ventures other than productivity, in particular the formation of his L. C. Tiffany Foundation and the legacy that he planned would survive him. Both were consummate artist-designers who had immeasurably enriched the art of their generation, but it would take more than a half century for the extent of their contributions to bear consideration by historians, and longer still for them to be comprehended and appreciated by the public at large.

J. Alastair Duncan

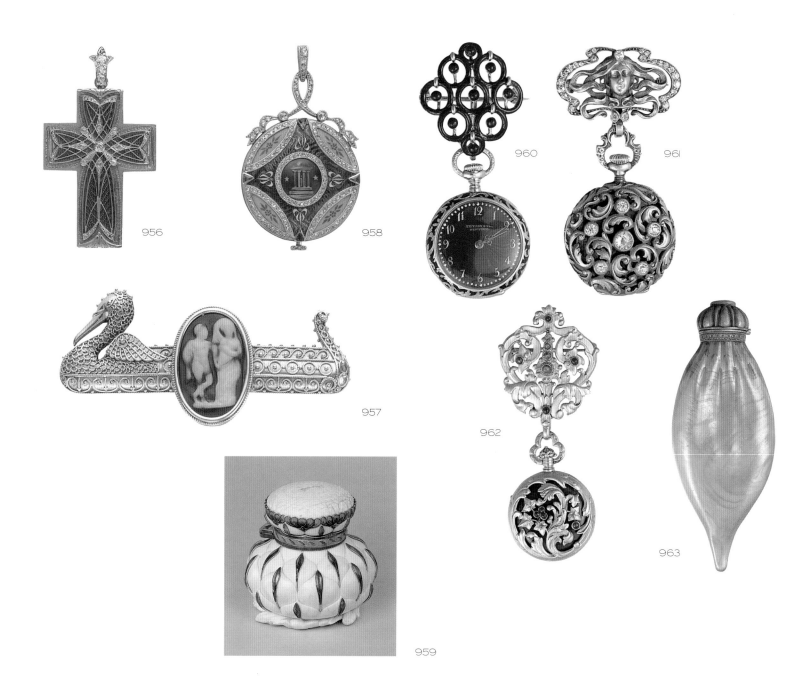

956 957 958 960 961 962 959 963

956. CROSS-SHAPED DIAMOND-SET ENAMELED GOLD PENDANT WATCH with orange Gaelic enamel arms with turquoise enamel borders, the engine-turned dial signed Tiffany, France, the reverse with applied platinum trellis set with rose-cut diamonds and a brilliant-cut diamond – workmaster Verger fils, c. 1900, height 1¹₂ in. (3.8cm).
Private Collection, New York

957. BOAT-SHAPED FILIGREE GOLD BROOCH in the archeological style with pelican-shaped prow and oval glass cameo at the center with two classical figures – signed Tiffany & Co., c. 1870, length 2¹₄ in. (5.7cm).
Private Collection, New York

958. CIRCULAR DIAMOND-SET ENAMELED PENDANT WATCH of brown Gaelic enamel, with a glass imitation cameo plaque at the center and four similar segments to the rim, the engine-turned dial signed Tiffany within brown enamel bezel – c. 1910, diameter 1¹¹₁₆ in. (2.6cm).
Private Collection, New York

959. GOLD-MOUNTED IVORY INK BOTTLE shaped as an artichoke applied with gold and green enamel leaves – signed Tiffany & Co, initials of workmaster LS in a lozenge for Le Sachet, Paris, c. 1900, height 2¹₈ in. (5.4cm).
Bibliography: Prodlow/Healey 1987, ill. 17.
Private Collection, New York

960. GEM-SET ENAMELED GOLD LAPEL WATCH chased with scrolls and decorated with translucent red enamel, the red guilloché enamel dial signed Tiffany & Co., with gold Arabic numerals and with Louis XV hands, suspended from a hexafoil openwork pin enameled in red – the movement also signed Tiffany & Co., New York, c. 1895, overall height 2³₈ in. (6cm).
Eric Streiner Collection, New York

961. GEM-SET ENAMELED GOLD LAPEL WATCH the openwork cover chased with scrolls and set with circular-cut diamonds, green guilloché enamel back, the white enamel dial signed Tiffany & Co. with gold Arabic numerals and black flèche hands, suspended from an Art Nouveau pin chased with a woman's head with flowing hair and diamond-set outer border – the movement also signed Tiffany & Co., c. 1900, overall height 3¹₄ in. (8.2cm). Original fitted leather case stamped Tiffany & Co, New York, Paris, London.
Eric Streiner Collection, New York

962. GEM-SET ENAMELED GOLD LAPEL WATCH the openwork cover chased with scrolls and set with cabochon rubies, green guilloché enamel back, the white enamel dial signed Tiffany & Co. with black Arabic numerals and steel flèche hands, chased foliate bezel set with cabochon sapphires and diamonds, suspended from a foliate chased openwork pin set with cabochon emeralds and rubies – signed Tiffany & Co., c. 1895, height 3¹₂ in. (9cm).
Eric Streiner Collection, New York

963. TEAR-SHAPED SILVER-MOUNTED FAVRILE GLASS SCENT-BOTTLE the fluted body with a domed gadrooned cover set with an oval opal – the glass signed LCT for Louis Comfort Tiffany, the mount designed by Paulding Farnham, signed Tiffany & Co., 925 (sterling), c. 1900, height 5⁷₈ in. (15cm).
Exhibited: Hamburg 1999, cat. 151.
Eric Streiner Collection, New York

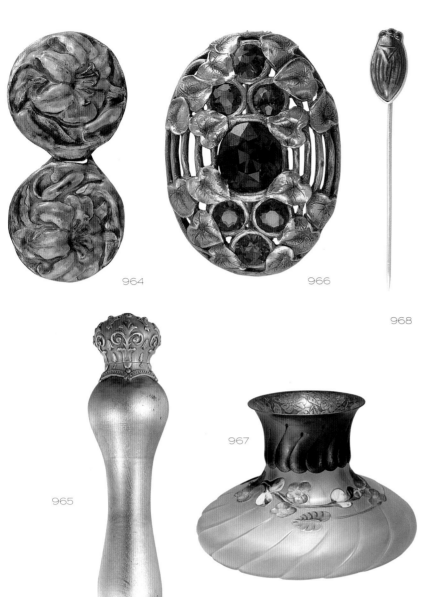

964

966

968

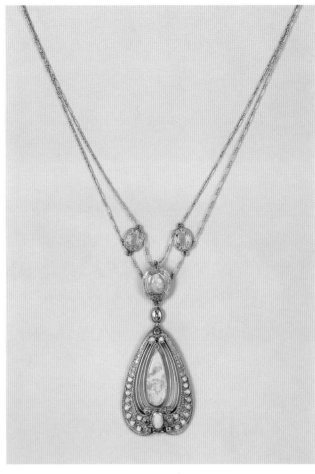

967

965

969

970

964. TIFFANY STUDIOS ENAMELED COPPER CLOAK CLASP each buckle *repoussé* and chased with a tiger lily enameled in translucent orange and with translucent green leaves – signed LCT for Louis Comfort Tiffany and numbered EL 260A, *c.* 1904, length 3⅜ in. (8.1cm).
Exhibited: Hamburg 1999, cat. 209.
Eric Streiner Collection, New York

965. GOLD-MOUNTED FAVRILE GLASS SCENT-BOTTLE OF DOUBLE BALUSTER SHAPE the domed cover chased with scrolls and set with circular-cut diamonds and with a brown diamond finial – by L. C. Tiffany, signed Tiffany & Co., *c.* 1905, height 4¾ in. (12cm).
Eric Streiner Collection, New York

966. OVAL ART NOUVEAU GOLD-MOUNTED RHODOLITE GARNET BROOCH with circular-cut stones set in chased gold foliate mounts and with chased finish to the back – by L. C. Tiffany, signed Tiffany & Co., *c.* 1908, length 1³⁄₁₆ in. (3cm).
Eric Streiner Collection, New York

967. SILVER-MOUNTED FAVRILE GLASS VASE OF COMPRESSED SPHERICAL SHAPE, the body of frosted glass carved with swirling flutes and hand-carved with flowers painted in pink and green, the mount with swirling lobes – the glass signed LCT for Louis Comfort Tiffany, Favrile 5409, the mount signed Tiffany & Co. makers, Sterling Silver, also signed with initial M for Edward C. Moore.
Listed 1908 as costing between $100 and $190.
Eric Streiner Collection, New York

968. GOLD-MOUNTED IRIDESCENT BLUE FAVRILE GLASS SCARAB TIE-PIN the glass scarab by L. C. Tiffany, signed Tiffany & Co., *c.* 1908/10, length 2½ in. (6.25cm).
Exhibited: Hamburg 1999, cat. 216.
Eric Streiner Collection, New York

969. PLATINUM AND GOLD-MOUNTED OPAL AND DEMANTOID GARNET NECKLACE suspending a pear-shaped pendant with central tear-shaped opal – by L. C. Tiffany, signed Tiffany & Co., *c.* 1910, height of pendant 2 in. (5cm).
Eric Streiner Collection, New York

970. GOLD-MOUNTED MOONSTONE NECKLACE with an irregular-cut cabochon moonstone pendant, the necklace formed of navette-shaped filigree gold elements also decorated in green *plique-à-jour* enamel – by L. C. Tiffany, signed Tiffany & Co., *c.* 1910, length 9¾ in. (24.7cm).
Eric Streiner Collection, New York

971

972

977

973

974

975

976

971. GOLD-MOUNTED NEPHRITE AND PLIQUE-À-JOUR ENAMEL NECKLACE set with oval cabochon nephrites flanked by inverted volutes in filigree work decorated in moss-green enamel – by L. C. Tiffany, signed Tiffany & Co., c. 1910, length 21 in. (53.5cm).
Eric Streiner Collection, New York

972. PLATINUM- AND GOLD-MOUNTED DIAMOND amethyst and kunzite pendant, the central kunzite surrounded by amethysts, open filigree work scroll platinum mount, yellow gold and platinum necklace – by L. C. Tiffany, signed Tiffany & Co., c. 1910, length 1½ in. (3.8cm).
Eric Streiner Collection, New York

973. OVAL GOLD-MOUNTED ENAMELED TURQUOISE BROOCH the central stone flanked by triple clusters of gray sweet-water pearls and with blue *guilloché* enamel on sterling silver above and below – by L. C. Tiffany, signed Tiffany & Co., c. 1910, length 1½ in. (3.8cm).
Eric Streiner Collection, New York

974. CIRCULAR FILIGREE GOLD VINAIGRETTE the hinged box with emerald-green jade center – by L. C. Tiffany, signed Tiffany & Co., c. 1910, diameter 1³⁄₁₆ in. (3.1cm).
Eric Streiner Collection, New York

975. PAIR OF SHAPED OVAL GOLD CUFFLINKS each chased with three fruit motifs and enameled covered with translucent orange and green enamel – by L. C. Tiffany, signed Tiffany & Co., c. 1910, length ¾ in. (2cm).
Eric Streiner Collection, New York

976. OVAL GEM-SET BROOCH set with a faceted oval topaz surrounded by cabochon fire opals – by L. C. Tiffany, signed Tiffany & Co., c. 1910, length 2⅛ in. (5.4cm).
Eric Streiner Collection, New York

977. OVAL GOLD-MOUNTED BLACK OPAL, DEMANTOID GARNET AND PLIQUE-À-JOUR ENAMEL PENDANT with a pear-shaped central stone flanked by two filigree work volutes decorated in blue-green enamel and with enameled back – by L. C. Tiffany, signed Tiffany & Co., c. 1912, length 1⅝ in. (4.2cm).
Exhibited: Hamburg 1999, cat. 218.
(Louis Comfort Tiffany, Meisterwerke des amerikanischen Jugendstils, Hamburg 1999).
Eric Streiner Collection, New York

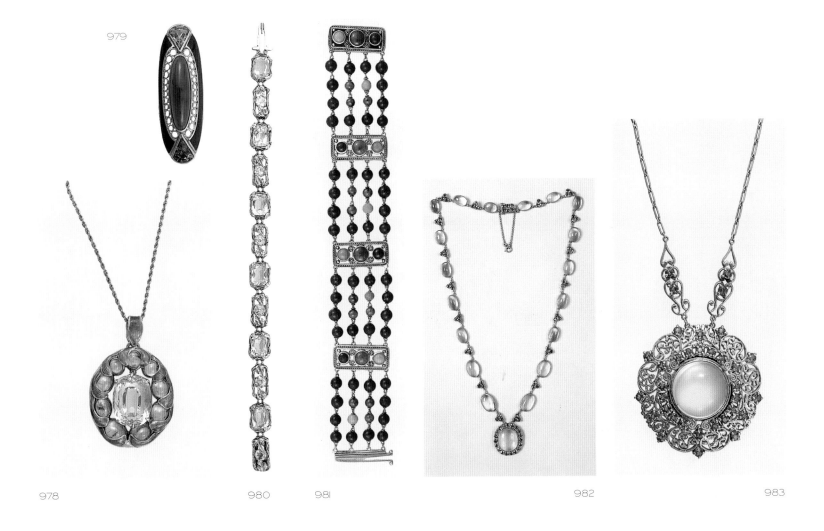

979

978 980 981 982 983

978. OVAL GOLD-MOUNTED FACETED YELLOW BERYL BROOCH set with demantoids and with green enamel leaves – by L. C. Tiffany, signed Tiffany & Co., *c.* 1912, length 1¾ in. (4.5cm). Exhibited: Hamburg 1999, cat. 219. Eric Streiner Collection, New York

979. OVAL GOLD-MOUNTED NEPHRITE, ZIRCON AND GREEN ENAMEL BROOCH, the oval nephrite in an openwork gold mount flanked by two triangular zircons and with green enamel border to match the nephrite – by L. C. Tiffany, signed Tiffany & Co., *c.* 1914, length 1½ in. (3.8cm). Eric Streiner Collection, New York

980. GOLD-MOUNTED CHRYSOBERYL AND AQUAMARINE BRACELET with alternating rectangular-cut aquamarines and circular-cut chrysoberyls in rectangular mounts, all set in corded foliate mounts – by L. C. Tiffany, signed Tiffany & Co., *c.* 1915, length 8 in. (20cm). Eric Streiner Collection, New York

981. GOLD-MOUNTED LAPIS-LAZULI, CORAL AND JADEITE BEAD BRACELET of four strands each with groups of four beads alternating with gold dividers each set with three stones – by L. C. Tiffany, signed Tiffany & Co., *c.* 1915, length 7¼ in. (18.5cm). Eric Streiner Collection, New York

982. PLATINUM-MOUNTED MOONSTONE AND MONTANA SAPPHIRE NECKLACE with a central oval cabochon moonstone surrounded by triple clusters of sapphires – by L. C. Tiffany, signed Tiffany X Co., *c.* 1915, length 20 in. (51cm). Eric Streiner Collection, New York

983. GOLD- AND PLATINUM-MOUNTED MOONSTONE AND MONTANA SAPPHIRE PENDANT AND NECKLACE the shaped circular central cabochon moonstone in an openwork scroll mount set with circular-cut sapphires, original necklace – by L. C. Tiffany, signed Tiffany & Co., *c.* 1915, length of pendant 1½ in. (3.9cm). Eric Streiner Collection, New York

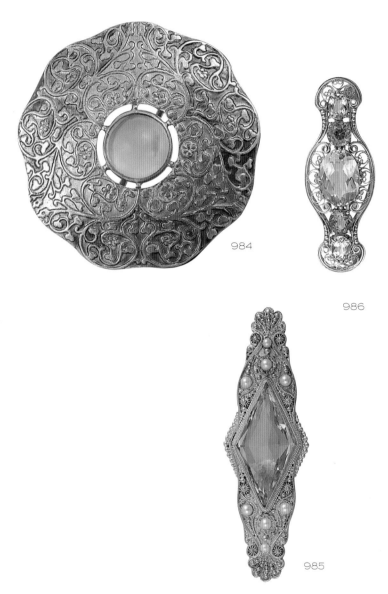

984

986

985

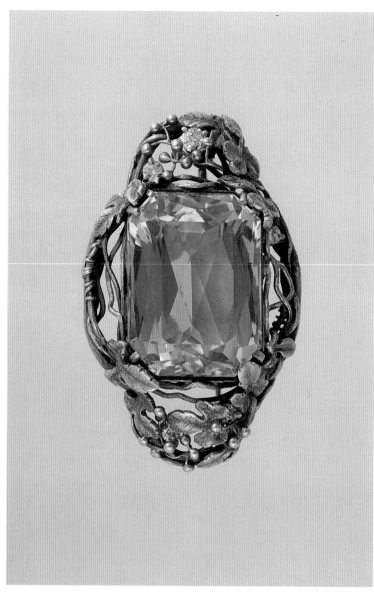

984. LOBED CIRCULAR ENAMELED AND GOLD-MOUNTED MOON-STONE PENDANT/BROOCH set in a gold scroll mount filled with gray and blue translucent enamel – by L. C. Tiffany, signed Tiffany & Co., c. 1915, diameter 1½ in. (3.8cm).
Eric Streiner Collection, New York

985. OBLONG GOLD-MOUNTED AQUAMARINE AND PEARL PIN the lozenge-shaped stone in a filigree gold mount set with white sweet water pearls, the reverse chased with scrolls – by L. C. Tiffany, signed Tiffany & Co., c. 1915, length 2⅝ in. (6.7cm)
Exhibited: Hamburg 1999, cat. 224.
Eric Streiner Collection, New York

986. ELONGATED LOBED GOLD-MOUNTED TOPAZ, APATITE AND TOURMALINE BROOCH the central oval apatite in a filigree gold mount – by L. C. Tiffany, signed Tiffany & Co., c. 1915/20, length 1¾ in. (4.5cm).
Exhibited: Hamburg 1999, cat. 222.
Eric Streiner Collection, New York

987. SHAPED OVAL GEM-SET GOLD BROOCH set with a cushion-shaped aquamarine in an openwork foliate wire-work mount set with circular-cut diamonds – by L. C. Tiffany, signed Tiffany & Co., c. 1916, length 2½ in. (6.3cm).
Eric Streiner Collection, New York

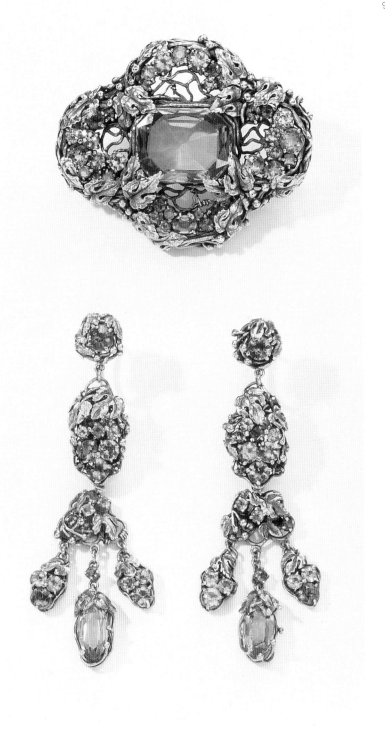

988

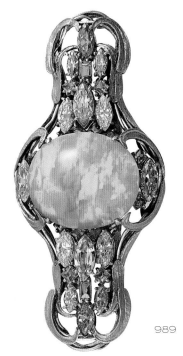

989

988. GOLD-MOUNTED TOPAZ AND MULTIGEM DEMI-PARURE of textured matte finish and with openwork of grape leaves, vines and berries, comprising a brooch and two ear pendants, the shaped quatrefoil brooch with a central topaz in a foliate gold mount set with a profusion of colored stones, the ear pendants each with three pendant topazes – by L. C. Tiffany, signed Tiffany & Co., *c.* 1917, length of brooch 1¹⁵⁄₁₆ in. (5cm), original fitted "Japanese" case by Falize.
Eric Streiner Collection, New York

989. GEM-SET GOLD- AND PLATINUM-MOUNTED BROOCH of lobed elongated shape set with a central opal and numerous navette-shaped yellow and white diamonds and emeralds – by L. C. Tiffany, signed Tiffany & Co., *c.* 1918, length 2¹⁄₄ in. (5.7cm) Exhibited: Hamburg 1999, cat. 223.
Eric Streiner Collection, New York

CARTIER'S RELATIONSHIP WITH IMPERIAL RUSSIA

Louis, the eldest of Alfred Cartier's three sons (fig. 1), was only 25 years old, and had been his father's associate at the newly opened, elegant store located at 13 rue de la Paix for only a year, when he was confronted with one of Carl Peter Fabergé's outstanding achievements. Impressed by the beauty of the fifteen traditional Easter Eggs which had been on show during the world exhibition of 1900 at the "Esplanade des Invalides" and which reflected French taste of the 1870s, he was determined to become one of Fabergé's fiercest competitors. Not by imitation, but by translating this particular style into a very individual expression, which was a lasting success well into the first decades of the twentieth century.

According to Cartier's archives, the first Russian customer was Prince Saltikov, who, in 1860, at the Cartier establishment on the Boulevard des Italiens, bought a bracelet set with emeralds on black enameled gold. This color combination, juxtaposing engraved emeralds with shiny onyx, was often used in art-deco design.

Competition actually started when Russian *emigrés*, who had established themselves in Paris and around Nice on the French Riviera after the assassination of Alexander II in Moscow in 1881, began to send gifts, such as pendant watches, small decorative clocks – *guilloché* enameled like Fabergé's – penholders, pill-boxes and perfume flasks by Cartier to relatives in Russia. Later, Cartier used to send a large selection of *objets de vertu* and jewels to the Tsar's residence at Gatchina, and Alexander III's daughters, Xenia and Olga, would choose Christmas presents for their mother.

Other members of the Russian imperial family traveled to Paris to buy jewels from Cartier, as did their relatives from the English court. It happened more than once that cousins, uncles and nephews met unexpectedly at 13 rue de la Paix. At the turn of the century, just as Russian customers delighted in jewels made in Paris, European aristocrats and representatives of New York's high society loved to decorate their interiors with all sorts of bibelots from St. Petersburg, such as hardstone carvings of naturalistic flora and fauna, photograph frames and ornaments such as table bells. These came in one of the 144 different shades of pastel colours in transparent enamel, applied in up to six layers, fired at 800°C on *guilloché* gold in a great variety of patterns.

Louis Cartier, although doubtless pleased with the great success of the sales of his jewelry – now newly set in platinum – to the Russian aristocracy, nevertheless remained intrigued by the triumph of Carl Fabergé's objects. He therefore asked his younger brother Pierre to explore the workshops of the leading purveyors to Fabergé. An intensive study of these resulted in orders made to Jahr in Moscow (who also worked for Ovchinnikov), for samples of enamel colors. Soon, the Cartier enamel colors would appear much stronger than the ones used by Fabergé, and the color combinations more daring – for instance mauve next to pink, or strong green opposed to a blue of the same strength.

Orders were placed at the lapidaries Svietchnikov, Woerffel and Sourovi, who specialized in carved animals made from hardstones from Siberia, such as lapis lazuli, agate, serpentine and rhodonite; objects came either from their stock or they were made according to Cartier's own designs. By 1907, there was an assortment of over 200 different types of animals, including the much favored ibis, owl, stork, pig and elephant. Fabergé, meanwhile, was presenting Edward VII with models of the animals at Sandringham.

Since these Cartier animals were not signed and have no reference numbers, only a preserved original box specially made with the imprint of the exact shape of an object, an exhaustive description in the Cartier registers, or a black and white photograph from the

FIG 1. PHOTOGRAPH OF ALFRED CARTIER AND HIS THREE SONS from left to right: Pierre, Louis, Alfred and Jacques, 1922. Photograph courtesy of Archives Cartier. Copyright Cartier

FIG 2. CARTIER'S IMPERIAL WARRANT 1907. Photograph courtesy of Cartier. Copyright Cartier

albums can guarantee that an item was originally traded by Cartier and not by Fabergé, to whom it might now be attributed. This problem is compounded by the possibility that two animals, purchased by Cartier directly from Fabergé – a little pig made of pink jade and a fox made of cornelian – may have survived in a collection somewhere.

At Ovchinnikov's in Moscow, best known for Byzanto-Russian *cloisonné* enamels, Cartier bought a toad in a synthetic dye called purpurine, and an obsidian elephant. Other animals were bought from a dealer named Yamanaka of Japan, who also provided ivory netsukes and bronze animals.

Cartier's flowers are easier to recognize, even without any surviving archival proof. These were usually protected by a glass case, the art-deco vase or container standing on an ivory base, with the Cartier signature cut out in a little gold plate with rounded corners, reminiscent of a Japanese print. The flower arrangements themselves are inspired by the art of Ikebana. The four decorative gold angles which hold the five-sided glass case together, are often inlaid with black or colored enamel, as on the corners of a cigarette-case, or a *nécéssaire* dating from the same years. Some of Cartier's little trees in blossom, surrounded by animals, became colorful still-lives in tiny hot-houses.

French workshops such as the Taillerie de Royat or Berquin-Varangoz (later Aristide Fournier) quickly learned to work in the Russian style and provided Paris stores with animals and flowers. Russian emigrants familiar with Fabergé's art, such as the Heyman brothers, delivered to the recently opened New York branch. To complicate matters it was known that Berquin-Varangoz also made flowers for Fabergé, as reported by Désiré Sarda, Cartier's man in St. Petersburg. Among Cartier's customers for plants and flowers, were King Alfonso XIII of Spain, and the American banker J. P. Morgan, who also bought the first model Mystery Clock by Cartier. Mystery Clocks, "marvels of the clockmaker's art" as described by the *Gazette du bon ton*, also displayed the jeweler's skill. Designed by Jacqueau and built by Maurice Coudt, they were rare masterpieces. Today, Mystery Clocks are considered to be to Cartier, what Imperial presentation Easter Eggs are to Fabergé.

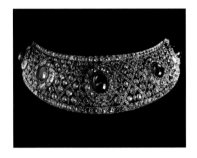

The more these hardstone animals and flowers change hands in the future, the more difficult it may become to clearly attribute an item either to Fabergé or to Cartier. This is due both to reasons already mentioned and to the extensive trading of the various products of both houses.

According to the firm's sales ledgers, on 22 April 1907 Empress Maria Feodorovna honored Cartier with a visit and bought two tie pins and two hardstone rabbits as small presents. But she expressed a wish to be able to see jewels at her own home, and encouraged Louis Cartier to organize an exhibition in St. Petersburg, which in fact was already planned for later that year at the Grand Hôtel d'Europe. Among Cartier's selection for this exhibition, was the clock in the shape of a green enameled egg on a blue enameled base, with a little star set with diamonds as the single hand, indicating the (not very precise) hour (fig. 4), all set on a rotating disc with enameled Roman numerals.

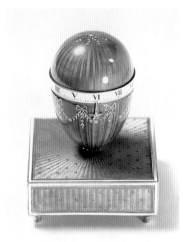

In 1907, Cartier was awarded the Imperial Warrant as purveyor to Tsar Nicolas II (fig. 2). A violet and white enameled Imperial Easter Egg, crafted in 1906 and first shown in 1910, bears the monogram of Nicolas II, and a crown of pearls and diamonds. It opens to show a photograph of the young Tsarevitch Alexei. Unsold, it was bought in 1912 by the Paris City Council, led by President Felix Roussel, to be offered to Nicolas II on the occasion of his official visit to Russia. How it survived the Revolution is not known. It is now the property of the Metropolitan Museum of Art in New York, who bought it, now with a replaced wooden base, from Laird Shield Goldsborough in 1951 (fig. 5).

Cartier's next visit to St. Petersburg took place the following year at 28 Quai de la Cour, a building next to the Hermitage which belonged to the widow of Grand Duke Vladimir, the German-born Marie of Mecklenburg-Schwerin. Not only was she one of Cartier's great admirers, she was also one of the firm's best customers, recovering, on this

FIG 3. KOKOSHNIK-SHAPED SAPPHIRE AND DIAMOND DIADEM made for Grand Duchess Maria Pavlovna, widow of Grand Duke Vladimir, 1909. Photograph courtesy of Archives Cartier. Copyright Cartier

FIG 4. ENAMELED JEWELED GOLD AND PLATINUM-MOUNTED SILVER CLOCK with revolving dial – Cartier, Paris 1907, height 3³⁄₁₆ in. (8.1cm). Collection Art de Cartier. Photo Nick Welsh

occasion, some of the money spent on jewels, by a two-month lease of 900 roubles. Like her husband, Grand Duke Vladimir, she was also a patron of the arts; she supported Serge Diaghilev, the brilliant organizer of the Russian Exhibition in Paris in 1906 and later brought famous Russian dancers like Vaslav Nijinsky, Karsavina and Ida Rubinstein to the Palais Garnier in Paris, for wonderful ballet performances such as Rimski Korsakov's *Scheherazade*, in oriental stage settings by Leon Baskt.

These ballets, their settings and costumes greatly influenced Louis Cartier and his outstanding designer Charles Jacqueau. They subsequently added polychromy to the hitherto white Garland style, and as early as 1906/1907, while many orders were still being placed by customers for jewels in the traditional Garland style they began creating jewels with a linear, geometrical look for stock.

The dominating Art Nouveau style of the turn of the century was not favored by Cartier and his designers, partly for reasons of personal taste, but also because they were excelling in the use of the newly-discovered alloy; platinum, set with diamond. In addition, they were more interested in the success of their avant-garde jewelry designs than in a style more suitable for goldsmiths. Indeed, very few items in Cartier's stock books could be characterized as Art Nouveau.

Upon the death of Grand Duke Vladimir, a son of Alexander II and former commander-in-chief of the army, his widow was granted an enormous annual pension. Thereafter, she was no longer generous to Diaghilev, but preferred to complete her collection of jewels (fig. 3), which, at the end of her life was divided among her four children. Cyril received the pearls, André all the rubies, including the tiara with the Beauharnais ruby, Helen the diamonds and Boris the emeralds. There was no descendant to receive the sapphires and the famous Cartier Kokoshnik tiara, delivered to her in Russia by Louis Cartier personally. This went to Marie, Queen of Romania and the well-known diamond bow-knot tiara with the drop pearls was bestowed on Queen Mary of England.

1908 was a bad business year for Cartier. Advice from Sarda to open a permanent shop, as Boucheron had done in Moscow in 1899, was ignored by Alfred Cartier, who was planning to open new premises in New York in 1909, to be overseen by Pierre Cartier, since Jacques, his youngest son, was in charge of the London branch which opened in 1902. Only sales exhibitions were planned for Christmas and, more importantly, for Easter.

In 1911, Louis Cartier traveled to Russia in the company of Charles Jacqueau. They visited customers and made pencil drawings for personal orders, made sketches during their visits to the Hermitage, and later translated items or patterns from the oriental-influenced Russian art into jewelry. They also visited Kiev and Moscow, were they met Ivan Morozov and were shown the avant-garde paintings owned by this extraordinary collector.

In 1913, during the celebrations of the 300th anniversary of the Romanov dynasty, despite revolutionary movements which were becoming increasingly threatening, Cartier visited many rich customers, such as Count Orlov and the faithful Grand Duchess Maria Pavlovna. One of the last jewels to be delivered by Cartier to Russia in 1914 was the rock-crystal tiara ordered for the wedding of Irina, niece of Tsar Nicolas II, to Felix Youssoupoff, whose mother, Zenaïde, owned some of the most famous pearls in the world.

After the First World War and the Russian Revolution of 1917, relations with Russian customers continued, but the channels of trade were reversed. By selling small but valuable jewels or artworks through Cartier and Fabergé many *emigrés* were able to escape and build up a new life in France or elsewhere.

Eric Nussbaum
Curator Art of Cartier Collection

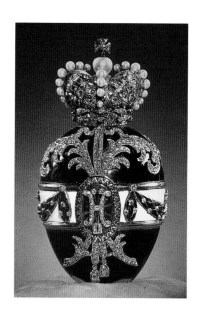

FIG 5. CARTIER'S IMPERIAL EASTER EGG a diamond-set, enameled, fluorite, platinum and gold egg with cipher of Tsar Nicholas II – by Cartier, workmasters Picq, Césard and Guesdon, Paris 1906, height 4⅛ in. (11.6cm). Exhibited by Cartier in Russia 1910, sold 1912 to the City of Paris. Presented by the Paris City Council to Tsar Nicholas II in Moscow 1912. Metropolitan Museum of Art, Bequest of Laird Shields Goldsborough, 1951. Copyright MET. Photograph courtesy of Cartier

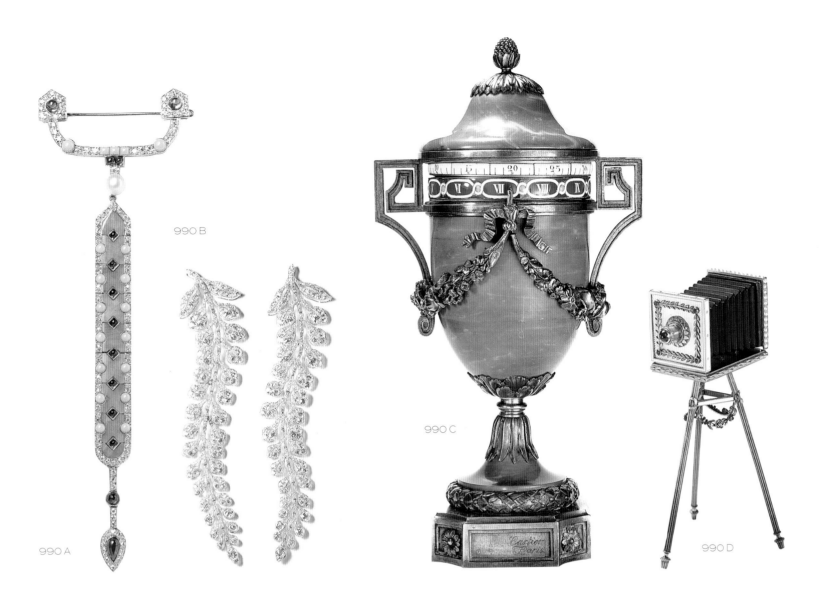

990 B

990 C

990 D

990 A

990A. PLATINUM AND DIAMOND HAIR ORNAMENT consisting of three parallel undulating ribbons millegrain-set with circular-cut diamonds – workshop: Picq, Paris 1902, width 6¹³⁄₁₆ in. (17.3cm).
Entered in Paris stock book on March 6th, 1902; sold on December 22nd, 1902. This tiara which follows the shape of the hairline, is another wholly original design by Cartier.
Art of Cartier Collection, Geneva
(Inv. HO 25 A02)

990B. "FERN SPRAY" PLATINUM AND DIAMOND ORNAMENT which may be worn as a diadem, a necklace, or an identical pair of brooches, each entirely articulated brooch formed of fifteen graduated pavé- and millegrain-set diamond double leaves – workshop: Charpentier, Paris 1903, length of each brooch 7¼ in. (18.5cm).
Provenance: Lady Ernest Cassel.
Exhibited: Tokyo 1995, cat. 53; Lausanne 1996, cat. 167; New York 1996/7, cat. 1; London 1997/8, cat. 1; Mexico 1999, p. 112; Chicago 1999/2000, cat. 1.
Entered in Cartier Paris stock book on November 20th, 1903; sold on January 28th 1904; Sir Ernest Cassel was also one of Fabergé's best clients in London.
Art of Cartier Collection, Geneva
(CL 114 A03)

990C. SILVER-GILT MOUNTED MARBLE REVOLVING MANTLE CLOCK OF LOUIS XVI DESIGN the vase-shaped gray marble body with angular silver-gilt handles, the sides applied with chased swags, with pine-cone finial in an acanthus leaf mount, the revolving dial in white, green and yellow enamel with white enamel Roman chapters on blue ground indicating the hours, with Arabic minutes above – engraved Cartier Paris, height 9¹⁄₂ in. (24cm).
Bibliography: Retrospective Louis Cartier 1976, no. 21; Barracca/Negretti/Nencini 1989, p. 33.
Exhibited: Naples 1988, cat. 133; Paris 1989/90, cat. 77; Rome 1990, cat. 41; St. Petersburg 1992, cat. 51; Tokyo, 1995, cat. 32; Lausanne 1996, cat. 54.
Entered in Cartier Paris stock book on December 15th, 1904; sold on December 19th, 1904.
Art of Cartier Collection, Geneva
(Inv. CC1 03 A04)

990D. JEWELED GOLD MINIATURE FRAME SHAPED AS A VINTAGE CAMERA on reeded tripod legs connected by gold swags and opaque white enamel stretchers, the back plate of the camera with green guilloché enamel and seed-pearl border surrounding a photograph of the Duke of Windsor as a young man, with dark wood bellows, opalescent white guilloché enamel lens plate with gold swags and opaque white enamel border, cabochon ruby lens – engraved Cartier, made by Yahr in Moscow for Cartier 1904, height 4⅛ in. (10.5cm).
Bibliography: Cologni/Mocchetti 1996, p. 51.
Exhibited: New York 1996/7, cat. 37; London 1997/8, cat. 37; Chicago 1999/2000, cat. 37.
Not recorded in stock or orders books but thought to be identical with "appareil photo B" mentioned in a letter from Cartier Paris to Yahr in February 1904 enclosing stones for specific pieces ordered by Cartier Paris.
Art of Cartier Collection, Geneva
(Inv. OV 10 A04)

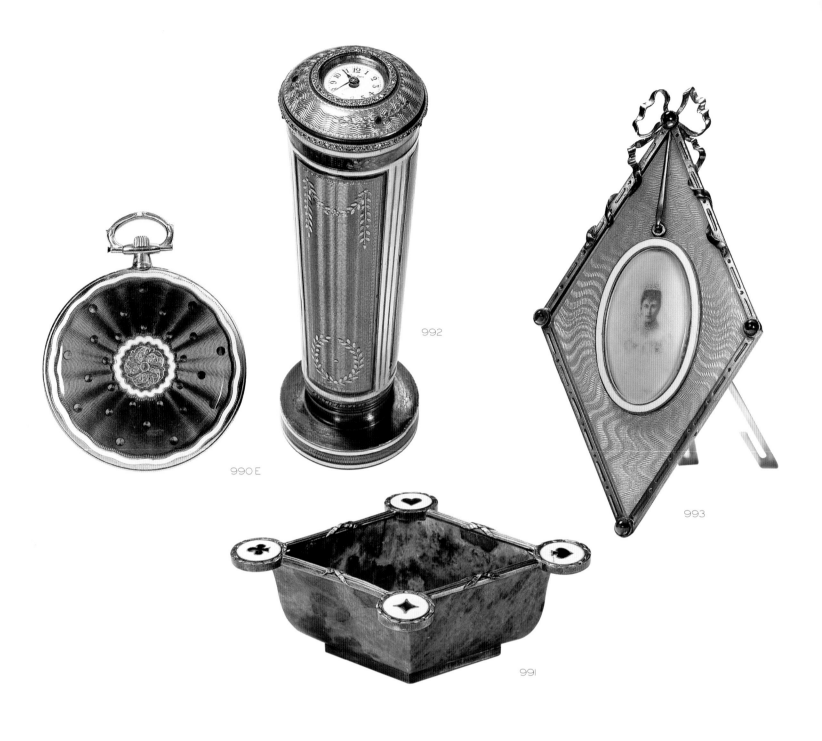

990 E

992

993

991

990E. ENAMELED YELLOW GOLD FOB-WATCH the engine-turned silvered dial with Arabic chapters in a waved white enamel bezel, dial signed Cartier, movement signed Cartier Paris Londres, the reverse of green *guilloché* enamel, with a central blue enamel flower – workshop: Jaeger/Césard, Paris 1905, diameter 1¹³⁄₁₆ in. (4.6cm).
Entered in Paris stock book on March 22nd, 1905; sold on April 4th, 1905.
The fob-watch was one of Cartier's favored creations. The two-tone green and blue enamel hues with white enamel borders are typical for Cartier.
Art of Cartier Collection, Geneva
(Inv. WPO 63 A05)

991. LOZENGE-SHAPED SILVER-GILT MOUNTED AND ENAMELED HARDSTONE CARD PLAYER'S ASHTRAY of amphibolite (zoisite), the reed-and tie rim with a white enamel disk at each corner, each decorated with a red or black card suit, silver-gilt base – engraved Cartier, Paris, workshop: Varangoz, marked KBV, Paris 1906, length 3½ in. (9cm).
Provenance: H. Rothschild.
Exhibited: Hamburg 1995, cat. 278.
Entered in Paris stock book on April 27th, 1906; sold on December 15th, 1906 to H. Rothschild.
Art of Cartier Collection, Geneva
(Inv. SA 10 A06)

992. CARTIER GEM-SET ENAMELED YELLOW-GOLD AND PLATINUM PARASOL HANDLE OF TAPERING TUBULAR FORM with panels of green and blue *guilloché* enamel within opaque white enamel borders, set with a watch at its apex within concentric diamond borders, white enamel dial with Arabic chapters and gold perlé minute indicators, rotating terminal winder, the base of the handle with a twist-off seal engraved with initials ME – engraved Cartier, Paris 1906, workshop Césard/Prevost, height 3¹⁄₁₆ in. (7.8cm).
Exhibited: Hamburg 1995, cat. 272.
Sold April 5th 1907.
Art of Cartier Collection, Geneva

993. LOZENGE-SHAPED ENAMELED AND JEWELED GOLD FRAME of pale blue *guilloché* enamel, within a yellow gold border with dot and line motifs and cabochon sapphires at each corner, surmounted by a pink-gold tied ribbon.
Containing an original photograph of Queen Mary with an oval apertures bordered in opaque white enamel – engraved Cartier Paris, Londres, workshop: Matthey, marked M & Cie, Paris 1906, height 3¹⁄₄ in. (8.2cm).
Exhibited: St. Petersburg 1992, cat. 41; Tokyo 1995, cat. 24; Lausanne 1996, cat. 36.
Entered in Paris stock book on November 3rd, 1906, sold on August 8th, 1918 to Ira Nelson Morris Esq.
Art of Cartier Collection, Geneva
(Inv. PF 08 A06)

994 A

994 B

995

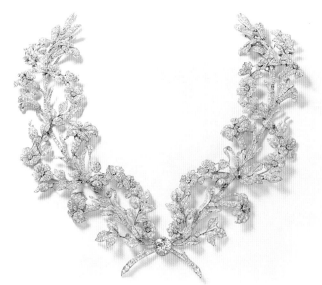

996

994A. CIRCULAR DIAMOND-SET
ENAMELED GOLD POWDER
COMPACT with pink *guilloché* enamel
panels within opaque white enamel borders
with stylized green and blue enamel flowers
and a line of rose-cut diamonds to the lip –
engraved Cartier Paris, workshop: Lavabre,
Paris 1906, diameter 2 in. (5cm).
Exhibited: Hamburg 1995, cat. 274; Lausanne
1996, cat. 42.
Entered in Paris stock book on August 20th,
1906; sold on November 3rd, 1906.
Art of Cartier Collection, Geneva
(Inv. PB 17 A06)

994B. TRIPTYCH GEM-SET
ENAMELED SILVER-GILT
COMBINED FRAME AND CLOCK
each panel of pale blue/green *guilloché*
enamel, the center with arched top and white
enamel dial with black Arabic chapters and
diamond-set hands suspended from a tied
ribbon, the sides with oval apertures for
miniatures also suspended from tied ribbons,
ivory backing – workshop: Mathey/Prévost,
marked M&Cie, Paris 1906, length 9⅛ in.
height 6 in. (15.2cm).
Bibliography: Baracca/Negretti/Nencini 1989,
p. 34; Cologni/Mocchetti 1992, p. 51.
Exhibited: St. Petersburg 1992, cat. 42; Tokyo
1995, cat. 25; Lausanne 1996, cat. 134.
Entered in Paris stock book on September 8th,
1906.
Art of Cartier Collection, Geneva
(Inv. PF 77 A06)

995. TRIANGULAR ENAMELED
SILVER-GILT TABLE CLOCK the white
enamel dial with Roman numeral chapters and
Arabic numeral seconds within a white enamel
border signed Cartier Paris Londres, set in a
panel of green *guilloché* enamel decorated with
alternating gilt vertical lines and bands of husks
– engraved Cartier Paris, workshops: Prévost
Brédillard/Césard, Paris 1906, height 4¹³⁄₁₆ in.
(12.1cm).
Exhibited: Tokyo 1995, cat. 33; Lausanne 1996,
cat. 24.
Entered in Cartier Paris stock book on
February 12th, 1906, sold on December 22nd,
1906. Cartier may well have been inspired by
dozens of such triangular enameled silver-gilt
table clocks made by Fabergé.
Art of Cartier Collection, Geneva
(Inv. CDS 61 A06)

996. PLATINUM AND DIAMOND
CORSAGE ORNAMENT with two
entirely articulated sprays of lilies entwined
with ranking wild roses which can be worn
as separate brooches, all millegrain-set with
circular- and rose-cut diamonds, with a larger
old mine diamond claw-set at the intersection
– workshop: Guesdon, Paris 1906, total length
18½ in. (47cm).
Provenance: Mrs. Townsend; Mrs. Donald
McElroy.
Bibliography: Nadelhoffer 1984, p. 55;
Cologni/Nussbaum 1996, p. 98.
Exhibited: St. Petersburg 1992, cat. 22; Tokyo
1995, cat. 57; Lausanne 1996, cat. 163; New
York 1996/7, cat. 2; London 1997/8, cat. 2;
Mexixo 1999, p. 82; Chicago 1999/2000, cat. 2
Special order of Mrs Townsend on January
2nd, 1906. An early and virtuoso use of
platinum used in a traditional 19th-century
design.
Art of Cartier Collection, Geneva
(Inv. CL 134 A06)

999

997

998

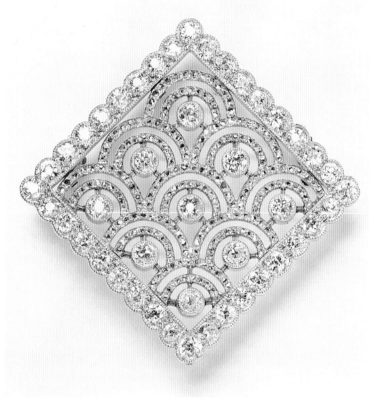

1000

997. GRANITE FIGURE OF A SEATED BULLDOG with yellow gold collar and ruby eyes – workmaster Varangoz, Paris 1907, height 2⁵⁄₈ in. (6.7cm).
Bibliography: Cologni/Mocchetti 1992, p. 64.
Exhibited: Tokyo 1995, cat. 47; Lausanne 1996, cat. 59.
Entered into Cartier, Paris stock book on November 24th, 1907, ceded to Cartier London January 20th, 1909.
Art of Cartier Collection, Geneva
(Inv. AN 07 A07)

998. ENAMELED GOLD PEN-REST SHAPED AS A BOOT-JACK with alternating tapering green *guilloché* and opaque white enamel stripes and beaded borders – engraved Cartier, workshop: Bako, Paris 1907, length 1³⁄₄ in. (4.5cm).
Provenance: Queen Alexandra of Great Britain (1844–1925), wife of King Edward VII and sister of Dowager Empress Marie Feodorovna. Entered in Paris stock book on November 13th, 1907; sold on December 19th, 1907 to Queen Alexandra. Several such pen-rests by Fabergé are known, two of them in nephrite (cf. Bainbridge 1949/77, pl. 87; Habsburg 1986/7 cat. 235). Queen Alexandra shopped frequently both at Fabergé's in London, as well as at Cartier in Paris.
Art of Cartier Collection, Geneva
(Inv. D1 17 A07)

999. DIAMOND-SET PLATINUM BROOCH SHAPED AS A TIED RIBBON the openwork mount set pavé-set with circular diamonds, and with three old-mine diamonds – engraved Cartier Paris; workshop: Lavabre, workmaster's initials HL, Paris 1907, width 1⁵⁄₁₆ in. (3.3cm).
Exhibited: Naples 1988, cat. 74; Paris 1989/90, cat. 153; Rome 1990, cat. 63; St. Petersburg 1992, cat. 82; Tokyo 1995, cat. 83; Lausanne 1996, cat. 139; New York 1996/7, cat. 20; London 1997/8, cat. 20; Mexico 199, p. 122; Chicago 1999/2000, cat. 20.
Entered in Paris stock book on February 25th, 1907; sold on March 12th, 1912. An early and very modern design showing audacious use of platinum.
Art of Cartier Collection, Geneva
(Inv. CL 23 A07)

1000. LOZENGE PLATINUM AND DIAMOND BROOCH of openwork peacock-feather design set with rose-cut diamonds and millegrain-set circular-cut diamonds, the outer frame set with circular-cut diamonds – engraved Cartier Paris Déposé, workshop: Lavabre, Paris 1907, 1¹⁄₈ in. (2.8cm) square.
Bibliography: Cologni/Nussbaum 1996, p. 81.
Exhibited: St. Petersburg 1992, cat 79; Tokyo 1995, cat. 82; Lausanne 1996, cat. 156; New York 1996/7, cat. 24; London 1997/8, cat. 24; Mexico 1999, p. 121; Chicago 1999/2000, cat. 24.
Entered in Paris stock book on April 25th 1907; sold August 3rd, 1907. Another example of a modern Cartier design dating from 1907. August Holmström at Fabergé, too, was designing modern-style jewelry pieces toward 1910.
Art of Cartier Collection, Geneva
(Inv. CL 99 A07)

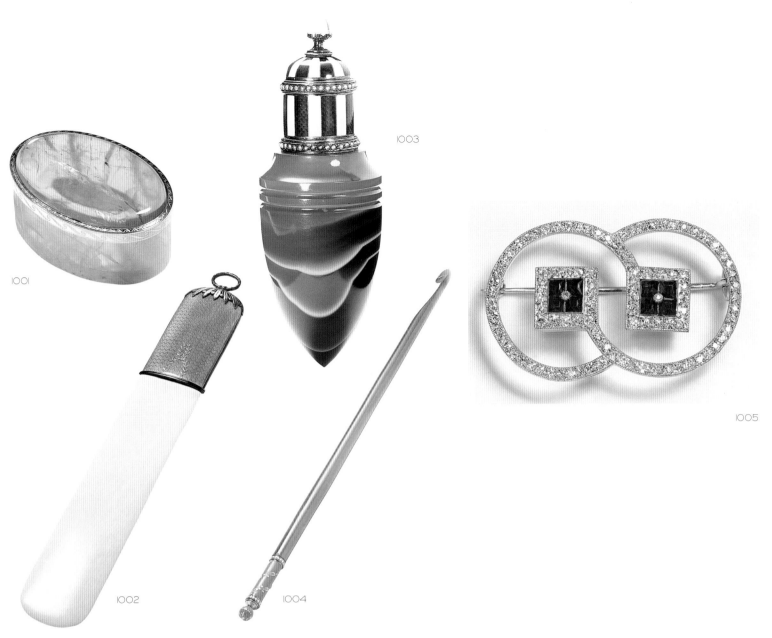

1001

1003

1002

1004

1005

1001. OVAL GOLD-MOUNTED AND ENAMELED PINK QUARTZ BOX
the mount with opaque white enamel frieze –
Paris 1908, length 1¹⁵₁₆ in. (4.9cm).
Provenance: Grand Duchess Xenia, daughter of
Tsar Alexander III and sister of Tsar Nicholas II.
Exhibited: St. Petersburg 1992; Hamburg 1995,
cat. 275; Lausanne 1996, cat. 43 ; Mexico 1999,
p. 265.
Entered in Cartier Paris stock book on
November 28th, 1908, sold July 1, 1909 to
Grand Duchess Xenia.
Art of Cartier Collection, Geneva (BS 03 A08)

1002. GOLD-MOUNTED ENAMELED SILVER AND IVORY PAPER-KNIFE
the handle of lavender *guilloché* enamel with
chased yellow-gold laurel leaf finial – work-
shop: Bako, Paris 1908, length 8¹₄ in. (21cm).
Bibliography: Retrospective Louis Cartier,
LACMA 1982, cat. 112.
Exhibited: Munich 1986/7, cat. 635; Naples
1988, cat. 46.
Entered in Paris stock book on January 9th,
1906. Cartier has adopted a popular Fabergé
design. As opposed to Cartier's ivory blade,
most of Fabergé's creations are in nephrite.
Art of Cartier Collection (DI 01 A06)

1003. DROP-SHAPED ENAMELED SILVER SCENT FLASK the cover with
alternating bands of striped green *guilloché* and
white opaque enamel within seed-pearl
borders, cabochon moonstone finial – work-
shop Mathey/Varangoz, stamped M & Cie,
Paris 1908, height 3³₄ in. (9.5cm).
Exhibited: Hamburg 1995, cat. 273; Lausanne
1996, cat. 23; Mexico 1999, p. 263.
Entered in Paris stock book on February 10th,
1908; sold on January 27th, 1912. Cartier's
version of another of Fabergé's most popular
creations, differs by its much larger format and
its elegant two-color enamel decoration.
Art of Cartier Collection, Geneva
(Inv. FK 12 A08)

1004. GOLD-MOUNTED AND ENAMELED TORTOISESHELL CROCHET HOOK the handle of yellow
gold with light blue and white enamel
imitating Wedgwood – engraved Cartier, Paris,
workshop: Stummer, Paris 1909, length 8¹₂ in.
(21.5cm).
Entered in Paris stock book on December 15th,
1909; sold on December 24th, 1909. May be
compared to a Fabergé crochet hook made for
Queen Louise of Denmark (cf. Habsburg/
Lopato 1993/4, cat. 75).
Art of Cartier Collection, Geneva
(Inv. IO 19 A09)

1005. "TWIN CIRCLE" GEM-SET PLATINUM BROOCH designed as two
intersecting circles millegrain-set with old-mine
diamonds, each circle with a square
central terminal set with similar diamonds, four
square-cut rubies and a central diamond –
engraved Cartier Paris, workmaster GA, work-
shop: Andrey, Paris 1909, length 1⁵₈ in. (4.1cm).
Exhibited: St. Petersburg 1992, cat. 84; Tokyo
1995, cat. 85; Lausanne 1996, cat. 140; New York
1996/7, cat. 22; London 1997/8, cat. 22; Mexico
1999, p. 122; Chicago 1999/2000, cat. 1.
Entered in Cartier Paris stock book on
September 6th, 1909, sold November 4th, 1912.
Another early and singularly modern design by
Cartier.
Art of Cartier Collection, Geneva
(Inv. CL 102 A09)

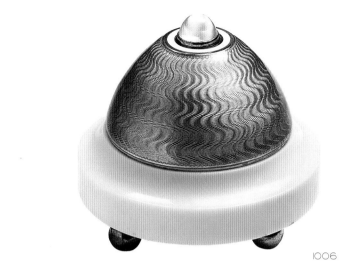

1006

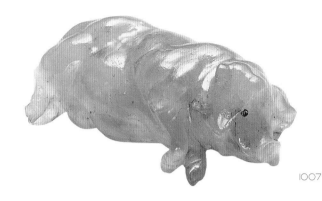

1007

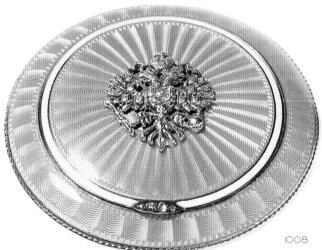

1008

1009

1006. DOMED GOLD-MOUNTED
ENAMELED SILVER AND IVORY
BELLPUSH of orange *guilloché* enamel,
standing on four ball feet and ivory base, with
cabochon moonstone push-piece in white
enamel border – engraved Cartier, Paris 1910,
height 2³⁄₈ in. (6cm).
Bibliography: Cologni/Mocchetti 1992, p. 53.
Exhibited: Tokyo 1995, cat. 29.
Cartier's version of one of Fabergé's favorite
objects, of which several hundred have
survived, is subtly different and typical for the
Paris jeweler, with the inclusion of ivory and
the tell-tale opaque white enamel border.
Entered in Paris stock book on January 22nd,
1910; sold on December 17th, 1910.
Art of Cartier Collection, Geneva
(Inv. I0 60 A10)

1007. PINK QUARTZ FIGURE OF A
RECLINING SOW with cabochon sapphire
eyes – workshop: Taillerie de Royal, Paris 1911,
length 2⁵⁄₈ in. (6.7cm). Original fitted case.
Exhibited: Munich 1986/7, cat. 632; Naples
1988, cat. 58; Rome 1990, cat. 57; St.
Petersburg 1992, cat. 71; Lausanne 1996, cat.
58; New York, 1996/7, cat. 51; London 1997/8,
cat. 51; Mexico 1999, cat. p. 265; Chicago
1999, cat. 51.
Entered in Paris stock book on November
20th, 1911, sold December 31, 1912.
Art of Cartier Collection, Geneva
(Inv. AN 01 A11)

1008. CIRCULAR DIAMOND-SET
ENAMELED YELLOW-GOLD
POWDER COMPACT of opalescent pink
guilloché enamel with opaque white enamel
border, the cover applied with a Russian
Imperial double-headed eagle with central
diamond, diamond-set thumbpiece – engraved
Cartier Paris, Londres, New York, workshop:
Lavabre, Paris 1911, diameter 1⁹⁄₁₉ in. (4cm).
Exhibited: Tokyo 1995, cat. 30; Lausanne 1996,
cat. 131; New York, 1996/7, cat. 41; London
1997/8, cat. 41; Chicago 1999/2000, cat. 41.
Entered in Cartier Paris stock book on April
27th, 1911.
Art of Cartier Collection, Geneva
(PB 17 AO6)

1009. OVOID ENAMELED YELLOW-
GOLD MAGNIFYING GLASS the case
with white opaque enamel stripe, the perlé
border enclosing a monogram GW, with two
lenses – engraved Cartier Paris Londres New
York, workshop: Lavabre, Paris 1911, length
1⁷⁄₈ in. (4.9cm).
Exhibited: St. Petersburg 1992, cat. 48.
Entered in Paris stock book on March 29th,
1911; ceded to Cartier, New York on July 31,
1912.
Art of Cartier Collection, Geneva
(Inv. 01 17 A11)

1010

1012

1011

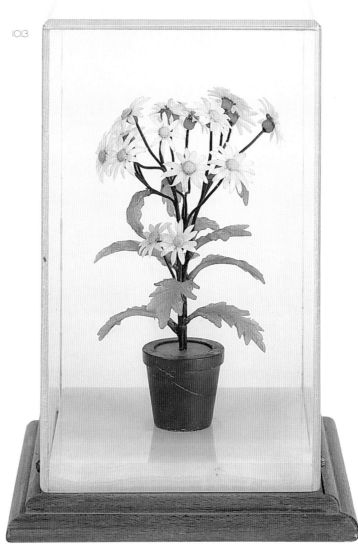

1013

1010. CIRCULAR JEWELED PLATINUM AND GOLD-MOUNTED JADE BOX of milky-green hardstone, the cover carved with flowers and butterflies, the hinge and clasp set with circular-cut diamonds, a cabochon and a square-cut ruby – engraved "Cartier Paris Londres New York", workshop: Lavabre, 1912, diameter 2⅛ in. (5.3cm).
Provenance: Countess Torby (1868–1927), morganatic wife of Grand Duke Michael Michailovich.
Exhibited: Munich 1986/7, cat. 623; Hamburg 1995, cat. 277.
Entered in Cartier Paris stock book on December 27th, 1912, sold on December 19th, 1904, to Countess Torby, morganatic wife of Grand Duke Michael Michailovich, both important clients of Fabergé, London. An interesting example of the re-use of a Chinese jade item by Cartier, which finds numerous parallels in Fabergé's oeuvre.
Art of Cartier Collection, Geneva (BS 05 A12)

1011. GEMSET PLATINUM AND JADEITE PENDANT BROOCH the U-shaped pin set with circular-cut diamonds, cabochon sapphires and turquoises, suspending an articulated jadeite panel with central collet-set cabochon sapphire line, bordered with circular-cut diamonds and cabochon turquoises, with a circular diamond and cabochon sapphire tassel suspending a sapphire and diamond drop – signed Cartier Paris, workshop: Picq, workmaster HP, Paris 1913, length 4¾ in. (12cm).
Bibliography: Nadelhoffer 1984, pl. 31.
Exhibited: Lausanne 1996, cat. 198; New York 1996/7, cat. 29; London 1997/8, cat. 29; Chicago 1999/2000, cat. 29.
Entered in Paris stock book on November 20th, 1913; sold on December 20th, 1913.
A truly avant-garde design heralding the Art Deco of the 1920s and 1930s with an early use of jadeite.
Art of Cartier Collection, Geneva (Inv. CL 193 A13)

1012. KOKOSHNIK-SHAPED GEM-SET PLATINUM-MOUNTED BLACKENED STEEL TIARA the metal band bordered with *calibré*-cut rubies, with a band of old-mine diamonds above and rose-cut diamonds below, set with thirteen pear-shaped diamonds within *calibré*-cut ruby-set frames alternating with pairs of collet-set circular-cut diamonds – workshop: Picq, stamped HP, Paris 1914, height 1⅝ in. (4.1cm), diameter 7⁷⁄₁₆ in. (18cm).
Provenance: Mme Marghiloman.
Bibliography: Cologni/Nussbaum p. 107.
Exhibited: Tokyo 1995, cat. 89; New York 1996/7, cat. 28; London 1997/8, cat. 28; Mexico 1999, p. 107; Chicago 1999/2000, cat. 28.
Special order of Mme Marghiloman. While Fabergé used blackened steel throughout the War years, mostly for cigarette-cases, Cartier's wholly original use of steel for a major jewelry commission is revolutionary.
Art of Cartier Collection, Geneva (Inv. HO 11 A14)

1013. CARTIER FLOWER STUDY OF A DAISY the flowerheads with mother-of-pearl petals and yellow composition centers with green aventurine leaves, standing in a brown jasper pot on square white quartz base, in a glass case on wooden plinth – apparently unmarked, height 7 in. (19.1cm). Original silk covered case.
Private Collection

BOUCHERON

Born in 1830, Frédéric Boucheron was apprenticed to Jules Chaise from 1844 to 1853 and worked with Tixier-Deschamps in the Palais Royal from 1853 until 1858, when he set up his own business as a retailer in the Galerie de Valois in the Palais Royal. In 1866, a year after the arrival of jeweler Georges Radius, who joined the firm as partner, Boucheron opened his own workshop. This allowed him to participate in the 1867 Paris World Fair where he obtained a Gold Medal for the first time. Together with Oscar Massin, Boucheron launched a fashion for floral jewelry. Many of his most successful creations display leaves and blossoms *en tremblant* with diamond mounts that received lavish praise for their precision. The most lavish among these were the *traines* (elongated flower-sprays) and the *devants de corsage* (heavily encrusted "stomacher brooches"). By 1875, the date of the Philadelphia Exhibition, Boucheron had established a reputation for making innovative jewelry of the highest quality which earned him the cross of the French *Légion d'honneur*.

Boucheron can be linked to Fabergé in a number of ways: his great originality and creativity as well as his highly innovative use of materials of little intrinsic value such as boxwood, rock crystal, damascened steel and ivory. Boucheron was one of the first jewelers to make use of *plique-à-jour* enamel, at first acquiring objects from Charles Riffault, who perfected and patented the technique in 1865 and who later sold the rights to Boucheron. Eclectic in his tastes, Boucheron produced exceptional works of art in the Japanese (cat. 1015/6) and Chinese styles, as well as the Gothic (cat. 1018), Renaissance (cat. 1023), and Louis XV (cat. 1022) styles. By 1893, when the business relocated to 26 Place Vendôme, Boucheron's clients included a large number of Europe's monarchs, as well as the wealthiest and most prominent heads of industry.

Boucheron's first contact with the Russian Imperial family occurred in 1871, when Tsarevich Alexander (the future Alexander III) commissioned a magnificent diamond-set *châtelaine* with his crowned cipher (fig. 1). In 1871 the firm's Paul Legrand designed a precious casket for a crown destined for the Tsar Alexander II. In 1882 Boucheron recruited Georges Delavigne with a view to seeking out new opportunities in the Russian market. The firm displayed jewelry and works of art at a Moscow exhibition of French art in 1891 and, in 1898, opened a branch in Moscow in the same street as Fabergé, Pont des Maréchaux. It was run by Delavigne, assisted by his two sons. During these years, Russian hardstones such as nephrite and jasper and other stones from the Urals appeared in Boucheron's *oeuvre*, as well as agates and rock crystals. Like Fabergé, Boucheron was producing mounts for Chinese snuff-bottles and jade objects. The firm took part in an exhibition of French goldsmith-work and jewelry in St. Petersburg in 1901. The Russian episode was to end in disaster. In 1911 Delavigne and one of his sons traveled to Kiev loaded with 500,000 roubles worth of jewelry they planned to sell at a wedding. They were both robbed and murdered in a train on their way back. Their death put an end to Boucheron's plans in Russia.

For Frédéric Boucheron, the Paris Exposition Universelle of 1900 was his swan song. He exhibited a vast quantity of magnificent jewelry and many unusual creations which attracted a great deal of notice (figs. 3–6). He was awarded the Grand Prix, a Gold Medal for his goldsmith-work, and was made Commander of the *Légion d'honneur*. Boucheron was creating works of art inspired by the eighteenth century of a comparable, if not superior, quality to those of his Russian competitor (cat. 1034). Many of his works in *guilloché* enamel were superlative, some of the "drapery effects" even surpassing what Fabergé enamelers were capable of at the time. Boucheron's ledgers and albums read like lists of Fabergé objects and include rococo frames, enameled parasol handles,

FIG 1. DIAMOND-SET GOLD CHÂTELAINE of Tsarevich Alexander Alexandrovich (future Tsar Alexander III), designed by Jules Debut, 1876. Photograph Boucheron Archive

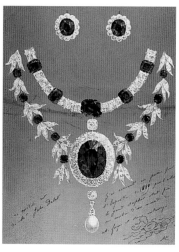

FIG 2. WATERCOLOR DESIGN for the sapphire and diamond parure of Mrs. Mackay, 1889. Photograph Boucheron Archive

thermometers, cigarette-cases in moss agate, Louis XVI snuffboxes, and agate cups. Many of the craftsmen working for Boucheron also supplied Cartier, in particular Varangoz and Jacta.

Frédéric Boucheron died in 1902 and was succeeded by his son, Louis, under whose management the firm continued its rapid ascent. In the years following the Exposition Universelle, Boucheron's client list included most of the same prestigious names found in the sales ledgers of Cartier and Fabergé, London: The Dowager Empress of Russia, various Russian grand duchesses, Queen Alexandra of England, Princess Louise, the Duchesses of Marlborough and Sutherland, Lady Paget, Princess Hatzfeldt, Lady Wernher, and eminently rich personalities such as Gulbenkian, Baronne Edmond de Rothschild, Barons Lionel and Maurice de Rothschild, Mrs John Mackay (fig. 2) and Madame Kelch. In 1903 offices were opened in London and New York. Highlights in the years preceding the October Revolution include a massive gold teaset in the Louis XVI style modeled by Lucien Hirtz for Sir Basil Sacharoff in 1909–10. The world of Diaghilev's Ballets Russes was to influence and revolutionize jewelry design in Paris profoundly, while in far-away Russia, Fabergé continued to recreate the past, both French and Russian. When, following their father's death in 1922, two of his sons opened Fabergé et Cie. in Paris, with the intention of continuing production, the world and its fashion had changed radically. The revolutionary 1925 Exposition des Arts Décoratifs marshaled in a new era in which there was no place for the elegant bibelots of Peter Carl Fabergé.

Alain Boucheron

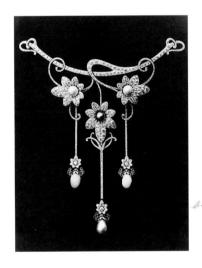 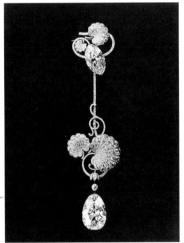

FIG 3. WATERCOLOR DESIGN by Bugnot for a pearl and diamond hair ornament, 1900. Photograph Boucheron Archive

FIG 4. WATERCOLOR DESIGN for a diamond brooch, 1900. Photograph Boucheron Archive

FIG 5. DIAMOND NECKLACE for the 1900 Exposition Universelle. Photograph Boucheron Archive

FIG 6. DIAMOND BROOCH designed by Bugnot for the 1900 Exposition Universelle. Photograph Boucheron Archive

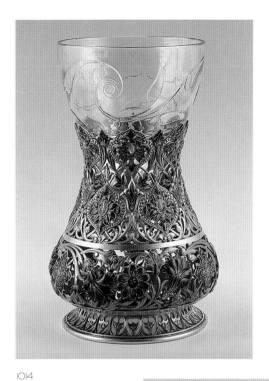

1014

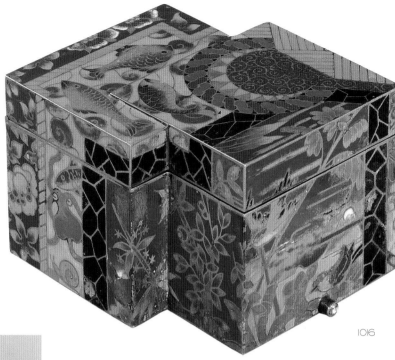

1016

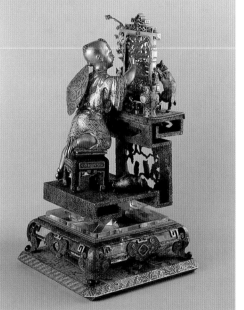

1015

1017

1014. PARCEL-GILT AND ENAMEL
VASE (VERRE À BIÈRE) of baluster shape
and foliate openwork design, with scrolling
silver foliage and enameled flowers, standing on
an openwork foot, with a foot-less engraved
glass liner – signed "Fic Boucheron", modeled
and chased by Honoré Burdoncle, enameled
by Antoine Tard, 1877, overall height 6⅝ in.
(17cm).
Bibliography: Falize 1880, p. 27; Bouilhet 1912,
vol. II, p. 152; Néret 1988, pl. 26.
Exhibited: Paris 1878; Paris 1988, cat. 55.
Example of a work of art in Boucheron's
eclectic and orientalizing style.
Collection Boucheron, Paris (Inv. 334)

1015. FIGURE OF A JAPANESE
PAINTER, OF SILVER-GILT,
CLOISONNÉ AND PLIQUE-À-JOUR
ENAMEL standing on a glass base – signed
Boucheron, designed and modeled by Paul
Legrand, 1877, height 12¾ in. (32.5cm).
Bibliography: Vever 1908, vol. III, p. 447;
Néret 1988, pl. 81.
Exhibited: Paris 1988, cat. 52; New York 1989.
An early and important example of the influ-
ence of Japanese (and Chinese) art on French
designers of the period.
Collection Boucheron, Paris (Inv. 329)

1016. ENAMELED SILVER-GILT
BONBONNIÈRE SHAPED AS TWO
INTERSECTING CUBES lavishly
decorated in polychrome cloisonné enamels
in the Japanese taste – signed "Fic Boucheron",
1880, length 4⁷⁄₁₆ in. (11.2cm).
Bibliography: Néret 1988, pl. 83.
Exhibited: Tokyo 1985; Paris 1988, cat. 79;
Limoges 1994, cat. 61.
A highly original design decorated in a manner
that became popular both in Western Europe
and in Russia in the 1880s.
Collection Boucheron, Paris (Inv. 337)

1017. CIRCULAR, DIAMOND-SET,
ENAMELED SILVER-GILT MOUNTED
CHALCEDONY DESK CLOCK the dial
with black Roman chapters and diamond-set
flèche hands and with four subsidiary dials for
the days of the week, months, and lunar phases;
signed Boucheron Paris, white and green
enamel bezel, silver strut – by Bako, 1911,
diameter 4¾ in. (12cm).
Collection Boucheron, Paris (Inv. 707)

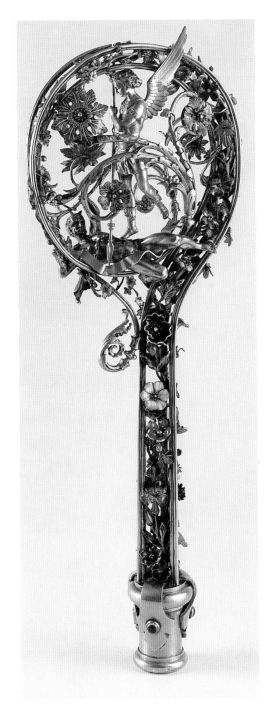

1018

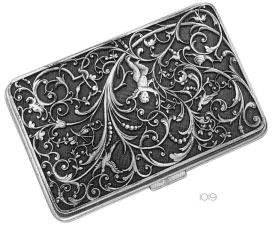

1019

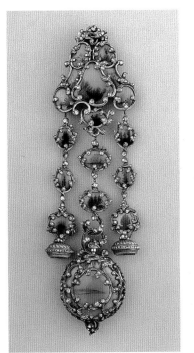

1020

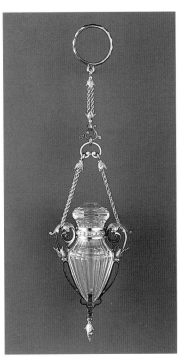

1021

1018. ENAMELED, GEM-SET, SILVER-
GILT EPISCOPAL CROZIER SHAPED
AS A SHEPHERD'S STAFF with a
figure of St. Michael Archangel defeating the
devil set within acanthus scrolls, the
surrounding enameled flowers with rose-cut
diamond centers – modeled by P. Legrand,
sculptures by E. Pascal, workmaster Kuyl, 1884,
height 17³⁄₄ in. (45cm).
Bibliography: Falize 1889/91, p. 83; Molinier,
p. 109; Bouilhet 1912, p. 288; Fouquet 1913,
p. 133; Néret 1988, pp. 23, 35, 77.
Exhibited: Paris 1889; Milan 1906; Paris 1988,
cat. 63; Limoges 1994, cat. 56.
One of Boucheron's justly most celebrated
pieces in the Gothic style.
Collection Boucheron, Paris (Inv. 414)

1019. RECTANGULAR SILVER-
MOUNTED LEATHER BOX (boîte porte-
monnaie) with applied openwork decoration
of scrolling foliage in the Renaissance manner
– signed "Fic Boucheron", workmaster Alfred
Menu, chasing by Rhone, 1885, length 3¹⁄₈ in.
(8cm).
Bibliography: Néret 1988, pl. 66.
Exhibited: Paris 1988, cat. 35.
Comparable with similar somewhat overladen
eclectic works by Fabergé's workmaster
Michael Perchin.
Collection Boucheron, Paris (Inv. 326).

1020. LOUIS XV-STYLE GOLD-
MOUNTED AND JEWELED MOSS
AGATE CHATELAINE AND WATCH
flanked by two pendant fob seals, all inset with
pink foiled dendritic agate panels in yellow-
gold mounts set with diamonds – signed "Fic
Boucheron", workmaster Charles Arfvidson,
1885, length 5¹⁄₂ in. (14cm).
Bibliography: Néret 1988, pl. 71.
Exhibited: Munich 1989/90, cat. 167.
This is an excellent example of a work of art
in a style also much favored by Fabergé in the
1880s and 1890s.
Collection Boucheron, Paris

1021. GOLD-MOUNTED ROCK-
CRYSTAL SCENT-FLASK of amphora
shape with scroll-shaped gold handles,
suspended from a gold chain – signed
"Boucheron", workmaster Alfred Menu, 1887,
overall length 6¹⁄₈ in. (15.5cm).
Bibliography: Néret 1988, pl. 56.
Exhibited: Tokyo 1985; Paris 1988, cat. 26,
ill. p. 24.
Collection A. Boucheron, Paris (n. 299)

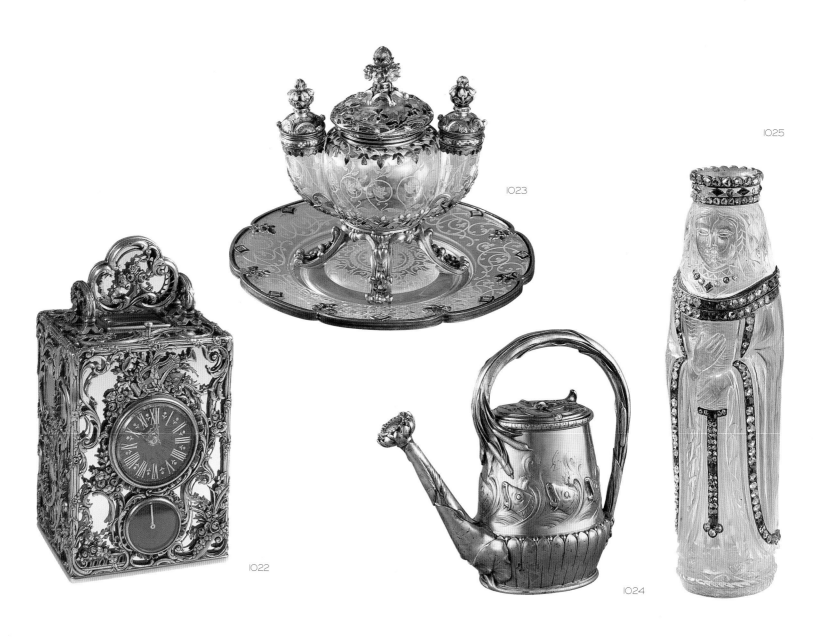

1025

1023

1022

1024

1024. MINIATURE SILVER-GILT
WATERING-CAN CHASED WITH FISH
the spout shaped as a water-lily, the handle
formed of bullrushes – signed "Fic Boucheron
Paris", modeled by Lucien Hirtz, workmaster
Mangin, 1894, height 7¼ in. (18.5cm).
Bibliography: Néret 1988, pl. 107.
Exhibited: Paris 1900; Paris 1983; Paris 1988,
cat. 59; New York 1989; Rotterdam 1992;
Gand 1992.
A highly individual design combining Louis
XVI, Japanese and Art Nouveau elements
similar to Japanese-inspired works by Tiffany,
Gorham, Ovchinnikov and Fabergé. Another
version of this item is at the Musée des Arts
Décoratifs, Paris.
Collection A. Boucheron, Paris (Inv. 358)

1022. LOUIS XV-STYLE SILVER-GILT
AND MIRROR GLASS ALARM
CLOCK the case of mirror glass encased in an
openwork chased decoration of scrolls, flowers
and instruments, the black enamel dial with
white Roman numerals – signed "Fic
Boucheron Paris", workmaster Menu, 1888,
height 5⅛ in. (13cm).
Bibliography: Néret 1988, pl. 110.
Exhibited: Paris 1988, cat. 118.
Another excellent example of a historical
interpretation, of a type favored by Fabergé's
workmaster Michael Perchin.
Collection Boucheron, Paris (Inv. 516)

1023. GOLD-MOUNTED AND
ENAMELED ROCK-CRYSTAL
INKWELL AND STAND IN THE
RENAISSANCE STYLE the rock
crystal body standing on four feet, with three
apertures, each with a hinged gold cover
decorated with *champlevé* enamel foliage –
signed "Fic Boucheron", executed by G. Le
Saché, 1893, height 3⅝ in. (9.2cm), diameter of
stand 4⅞ in. (12.5cm).
Bibliography: Néret 1988, pl. 57.
Exhibited: Tokyo 1985; Munich 1987;
Paris 1988, cat. 13, ill. p. 24; New York 1989.
Collection A. Boucheron, Paris (Inv. 276)

1025. GOLD-MOUNTED, JEWELED
ROCK-CRYSTAL SCENT-FLASK
shaped as a Medieval queen, her crown and the
seams of her robe set with rose-cut diamonds,
rubies and sapphires – signed "Fic Boucheron,
Paris", late 19th century, height 3¼ in. (8.3cm).
Bibliography: Néret 1988, pl. 61; Master
Jewelers, 1999, p. 82.
Exhibited: Tokyo 1985; Paris 1988, cat. 155, ill.
p. 25.
Collection A. Boucheron, Paris (Inv. 441)

1026

1027

1028

1029

1030

1026. "LE VENT D'AUTOMNE", a box-
wood and chicken-skin fan, the guard sculpted
with children emblematic of the wind, the leaf
painted with gilded maple foliage – sculpted by
Becker, painted by Lhévy-Dhurmer, 1900,
length 15³⁴ in. (40cm).
Bibliography: Champier 1902, p. 226; Néret
1988, pl. 116.
Exhibited: Paris 1900; Paris 1988, cat. 107;
New York 1989.
Collection A. Boucheron, Paris (Inv. 459)

1027. FRENCH GOLD, ENAMEL AND
HARDSTONE CIGARETTE CASE of
honey-colored aventurine quartz, the clasp and
hinges applied with shells of brown enamel on
green branches simulating algae, the interior
with openwork gold cigarette clip with
engraved signature "Boucheron Paris" –
maker's mark and French gold control mark,
Paris *c.* 1900, length 3⁵⁸ in. (9.2cm).
Private Collection

1028. ART NOUVEAU ENAMELED
GOLD BELT BUCKLE decorated with
two chased and enameled hydrangeas – signed
"Boucheron Paris", designed by Hirtz, work-
master Matheret, 1903, length 2¹³₁₈ in. (7.2cm).
Exhibited: Paris 1900 (Exposition Centennale,
another example); Paris 1988, cat. 95.
Collection Boucheron, Paris (Inv. 381)

1029. ENAMELED GOLD BELT-
BUCKLE shaped as two cornucopias, the
horns in green opaque enamel filled with
chased gold fruit – signed "Boucheron Paris",
designed by F. Chardon, workmaster Georges
Le Turcq, 1903, length 2³⁴ in. (7cm).
Bibliography: Néret 1988, pl. 95.
Exhibited: Paris 1908; Paris 1988, cat. 88;
New York 1989.
The belt buckle provides an interesting
comparison to Fabergé's and Cartier's examples
dating from the same period.
Collection Boucheron, Paris (Inv. 365)

1030. ENAMELED SILVER-GILT
MOUNTED BOWENITE
THERMOMETER in the Louis XVI-style,
the blue *guilloché* enamel border applied with
rose swags – signed "Boucheron Paris", by
Jacta, 1904, height 7¹⁴ in. (18.5cm).
Exhibited: Paris 1988, cat. 120.
Collection Boucheron, Paris (Inv. 586)

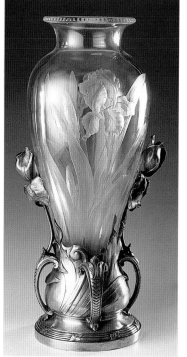

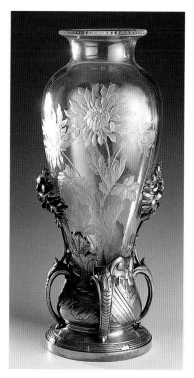

1033

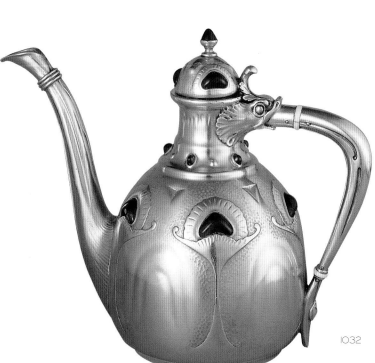

1032

1034

1031. ART NOUVEAU TRIANGULAR DIAMOND-SET ENAMELED GOLD BROOCH chased with hydrangeas with enameled petals and rose-cut diamond centers, flanked by two peacock heads, each set with three rose-cut diamonds, suspending a pear-shaped diamond – signed "Boucheron Paris", designed by Hirtz, workmaster Espinasse, 1904, height 2⅛ in. (5.3cm).
Exhibited: Paris 1900 (another example); Paris 1908; New York 1989.
Collection Boucheron, Paris (Inv. 319)

1032. ART NOUVEAU JEWELED PARCEL-GILT EWER IN THE ORIENTAL STYLE of *repoussé* and chased silver, decorated with peacock feathers and encrusted with cabochon amethysts – designed by Lucien Hirtz, executed by Mangin, 1904, height 5¹⁵⁄₁₆ in. (15cm).
Bibliography: Néret 1988, pl. 76.
Exhibited: Paris 1988, cat. 114; New York 1989.
The design is based on an Oriental rose-water sprinkler.
Collection A. Boucheron, Paris (Inv. 320)

1033. PAIR OF LARGE ART NOUVEAU SILVER-GILT MOUNTED GLASS VASES the pear-shaped glass Iris Vase engraved with irises and their leaves, in a silver-gilt mount chased with irises and their leaves issuing from four volutes; its pair, the Chrysanthemum Vase, similarly engraved with chrysanthemums and set in a silver-gilt base chased with chrysanthemums – signed "Boucheron Paris Moscow", workmaster J. A. Martel, *c.* 1905, height 20⅞ in. (53cm).
Collection Boucheron, Paris (Inv. 644/5)

1034. LOUIS XVI-STYLE OVAL ENAMELED GOLD FOLDING POCKET MIRROR enameled to imitate a pink and pale blue silk drapery, applied with a suspended varicolored trophy symbolizing Love – signed "Boucheron", workmaster Menu, 1906, height 3⅛ in. (8cm). A virtuoso use of enamel imitating pleated silk.
Collection Boucheron, Paris (Inv. 359)

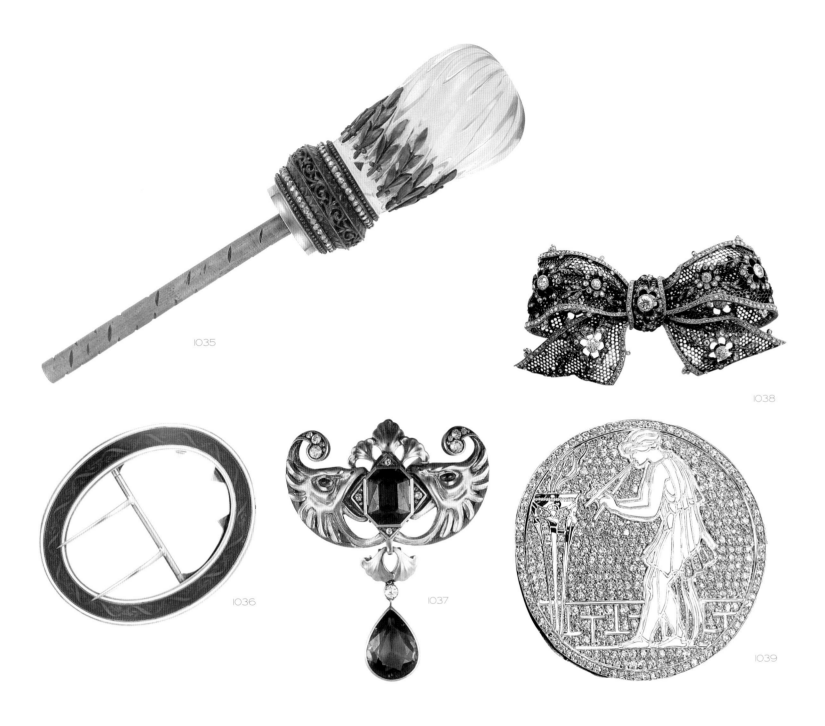

1035

1038

1036

1037

1039

1035. DIAMOND-SET GOLD-MOUNTED STEEL AND CRYSTAL PARASOL HANDLE carved with swirling flutes applied with steel husks, the chased steel mount with two lines of rose-cut diamonds – signed "Boucheron", workmaster Arfvidson, 1906, overall length 4¹³⁄16 in. (12.2cm).
Exhibited: Tokyo 1985.
Collection Boucheron, Paris

1036. OVAL ENAMELED SILVER-GILT BELT-BUCKLE of deep-purple *guilloché* enamel engraved with a continuous ribbon, with opaque white enamel borders – signed Boucheron London, 1907, height 3³⁄8 in. (8.5cm).
The belt buckle provides an interesting comparison to Cartier's very similar buckles which are usually in pastel colors of pale blue or pink.
Collection Boucheron, Paris (Inv. 479)

1037. GOLD AND PERIDOT BROOCH SHAPED AS TWO EAGLES' HEADS holding an hexagonal faceted peridot, suspending a pear-shaped peridot pendant – signed "Boucheron Paris", designed by L. Hirtz, executed by Espinasse, 1907, length 3⁵⁄8 in. (8.4cm).
Bibliography: Larousse 1985, p. 90; Néret 1988, pl. 106.
Exhibited: Paris 1988, cat. 96; Munich 1989/90, cat. 78.
Collection Boucheron, Paris (Inv. 382)

1038. GOLD-MOUNTED DIAMOND-SET PLATINUM BROOCH shaped as a tied ribbon, the blackened platinum-mesh ribbon applied with flower sprays set with diamonds, yellow-gold diamond-set borders – signed "Boucheron Paris", workmaster Lefort, 1908, length 3 in. (7.6cm).
Bibliography: Néret 1988, pl. 109; Thames & Hudson 1990, p. 83.
Exhibited: London 1908; Paris 1933; Tokyo 1985; Munich 1987; Paris 1988, cat. 104, ill. p. 29; Munich 1989/90, cat. 83.
Collection A. Boucheron, Paris (Inv. 278)

1039. CIRCULAR GOLD-MOUNTED DIAMOND-SET BROOCH in the antique style decorated in blackened and silvered gold with a nymph blowing the double flute before an altar before a pavé-set diamond ground – signed Boucheron, 1910, diameter 1¹³⁄16 in. (4.7cm).
Provenance: Elton John.
An unusually modern design and technique heralding Art Deco designs of the 1920s and 1930s.
Collection A. Boucheron, Paris (Inv. 609)

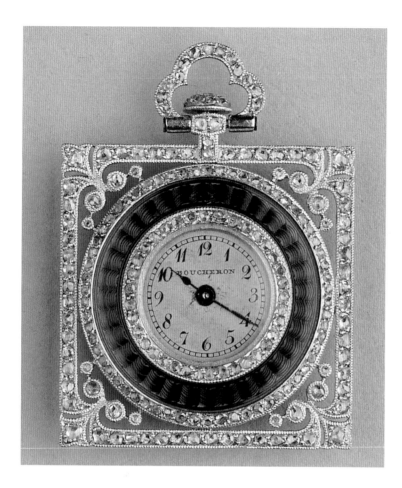

1040

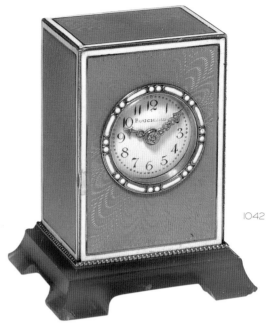

1042

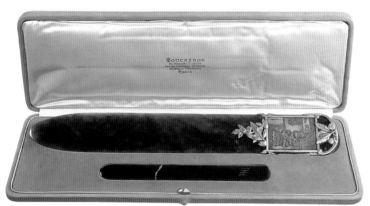

1041

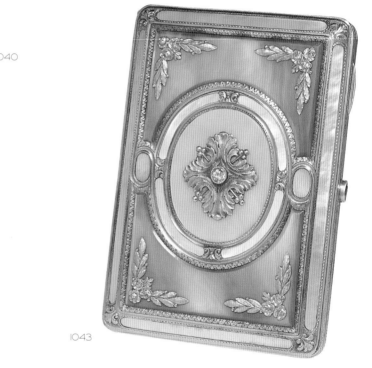

1043

1040. ENAMELED DIAMOND-SET PLATINUM FOB-WATCH the dial signed "Boucheron", with Arabic chapters and black steel hands, with a blue *guilloché* enamel border framed by rose-cut diamonds, the outer border and the reverse set with diamonds – workmaster Haas, 1911, 1$\frac{1}{16}$ sq. in. (2.75cm).
Bibliography: Néret 1992, p. 58.
Collection Boucheron, Paris (Inv. 694)

1041. SILVER AND SILVER-GILT MOUNTED NEPHRITE PAPER-KNIFE set with a silver plaque chased with a Dutch 17th century genre scene within a gilded frame chased with leaves; and a nephrite page marker – signed "Boucheron Paris", the plaque by Vicker, design by Hirtz, workmaster Canive, 1911, length of paper-knife 15$\frac{1}{8}$ in. (38.5cm). Original fitted leather case stamped "Boucheron, 69 Piccadilly London, Pont des Maréchaux Moscow, 26 Place Vendôme Paris". A case of the use of Russian nephrite by Boucheron in imitation of Fabergé, proudly displaying the firm's Russian address.
Collection Boucheron, Paris (Inv. 489)

1042. ENAMELED GOLD CLOCK of pink *guilloché* enamel with white opaque enamel borders, the white enamel dial with Arabic numerals signed Boucheron, standing on a gray agate base – by Boucheron, workmaster Bake, 1911, height 2$\frac{1}{4}$ in. (5.3cm).
Bibliography: Néret 1988 pl. 128.
A faithful rendering of a Cartier model originally inspired by Fabergé.
Collection Boucheron, Paris (Inv. 511)

1043. GOLD-MOUNTED MOTHER-OF-PEARL CIGARETTE CASE IN THE LOUIS XVI-STYLE applied with panels of opalescent shell encased in green gold borders, the cover with a central acanthus-leaf motif centered on a brilliant, navette-shaped diamond pushpiece – signed "Boucheron Paris", workmaster Bisson, 1919, length 3$\frac{5}{16}$ in. (8.4cm).
Bibliography: Boucheron 1987, p. 179; Néret 1988, pl. 125.
Exhibited: Paris 1988, cat. 150.
Collection Boucheron, Paris (Inv. 511)

LALIQUE

René Lalique was born in Ay in Marne in 1860.[1] Following the death of his father in 1876, Lalique was apprenticed to the goldsmith Louis Aucoc for two years. After a sojourn of two years in England, he returned to Paris, working as a designer for jewelers like Aucoc and Cartier. In 1884 he exhibited his own jewelry designs for the first time, attracting the attention of the jeweler Alphonse Fouquet. A year later he established his first workshop at Place Gaillon, producing diamond-set jewelry of a traditional nature for Vever, Boucheron and Cartier. In 1887 he moved to rue du Quatre Septembre and later, in 1890, to 20 rue Thérèse, where Lalique employed thirty craftsmen. As a complement to his work as jeweler, he began experimenting with enamels, glass and novel combinations of materials.

Lalique exhibited his jewels publicly for the first time in 1894 at the Salon de la Société des Artistes Français. By this time he was supplying the great actress Sarah Bernard with stage jewelry, turning his attention away from the traditional forms of diamond-set jewels. In 1895, he contributed to the opening exhibition of S. Bing's "La Maison de l'Art Nouveau", adopting for his jewelry the fluid lines and languorous figures of the incipient movement bearing the same name. In 1895 Lalique obtained an extraordinary commission for 145 jewels from millionaire-collector Calouste Gulbenkian and was given total freedom in their creation. The resulting *objets de vitrine* were "sheer flights of fantasy expressed with consummate skill and artistry." This unique series, which was completed in 1912, can in some ways be compared to Fabergé's series of 50 Imperial Easter eggs in as far as they too represent the quintessence of Lalique's creativity and craftsmanship. Crafted from "base" materials including glass and horn, as well as semi-precious stones, Lalique's jewels fit perfectly into the canon established by his contemporaries Paulding Farnham and L. C. Tiffany and Fabergé, who both eschewed the use of costly precious stones, preferring humbler materials. Even Frédéric Boucheron with his marked preference for rare woods and ivory fits into this mold.

The last years leading up to the great Exposition Universelle of 1900 mark the rapid ascent of Lalique's fame. In 1897 his first *bijoux* make their appearance: a series of ivory and horn combs which were exhibited at the Salon and which were acquired by Parisian museums. In the same year, Lalique won a Grand Prix at the Exposition Internationale in Brussels and was made a knight of the *Légion d'honneur*. The entire gamut of Lalique *bijoux* – combs, tiaras, corsage ornaments, pendants, brooches, rings and bracelets made in gold and enamels was first shown at the 1898 Salon. That same year, Lalique acquired a property at Clairefontaine, near Paris, where he set up a glass-making workshop. His first experiments include several sumptuous chalices set with plaques of molded glass (cat. 1045).

Lalique's exhibition at the 1900 Paris Exposition Universelle, which included many of the Gulbenkian jewels, was a triumphal success, obtaining for him the Grand Prix and the rank of Officer of the Legion of Honor. According to Henri Vever "Lalique triumphed in unparalleled fashion: a dense and fervent crowd gathered around to see works that were on everyone's lips." [2] One of his numerous variations on the theme of the kiss, an ivory pendant ensconced in an ivy plant dates from this highly successful year (cat. 1051), while an ivory brooch with naked female figures are a little later (cat. 1046).

Due to the 1900 Exposition, Lalique's international fame grew rapidly. Copenhagen's Kunstindustrimuseum bought a pin showing an opal surrounded by wasps; the Hamburg museum, a pendant with a winter landscape. In 1902, Baron Stieglitz bought a series of jewels for study purposes at his school, which are today preserved at the Hermitage Museum.[3] Lalique was honored with an exhibition in London at the Grafton Gallery in 1903 and another at Agnew's in 1905, where his role as innovator who has

Notes
1. Barten (1977); Vivienne Becker, The Jewellery of René Lalique, Goldsmith Hall (London, 1987); The Jewels of Lalique (Flammarion, 1998).

2. Vever (1908), p. 738.

3. See Lugano (1986).

"freed us from the tyranny of the diamond" was fully recognized.[4] He also took part in the 1904 St. Louis World Fair, at which Henry Walters, who discovered Fabergé in 1900[5] also acquired a group of eight of his jewels.

In 1902 Lalique moved to custom-made premises at 40 Cours-La-Reine, a five-storey building that housed both his family, workshops and showroom. Finally, in 1905, he opened a shop at 24 place Vendôme, where jewelry exhibitions could take place and where his glass was permanently on view. His well-known glass chalice, Apostles, dates from these years (cat. 1050).

Like Fabergé's flowers, Lalique's jewelry found numerous emulators, which dampened the great French jeweler's enthusiasm, diverting his attention to his old interest in glass. His first perfume bottle for Coty dates from 1909, the year of his patent for a glass-molding process. Following a last jewelry exhibition in 1912, Lalique acquired a glass factory at Combs-la-Ville, thereby setting out on a new career as an industrial glass maker.

In his somewhat disparaging comments on his competitors, Tiffany, Cartier and Boucheron, Fabergé did not make any mention of Lalique. He obviously held this extraordinary jeweler in high esteem. What Fabergé and his firm thought of Lalique was probably most clearly communicated by his chief designer, François Birbaum, in 1919: "We naturally acknowledge the artistic value of objects created by certain individuals, such as Lalique, but we never tried to imitate him: we thought it useless and we were right: his imitators, while unable to produce anything comparable to his masterpieces, lost their own originality."[6]

Géza von Habsburg

4. The Studio International, August 1905.

5. Habsburg (1996/7), p. 27f and cat. 1–7.

6. Fabergé/Skurlov (1992), p. 7.

1044

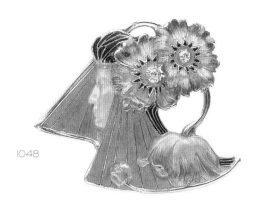

1048

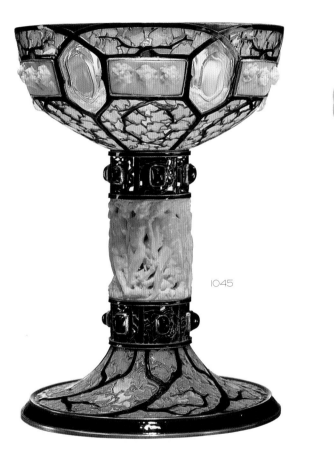

1045

1047

1044. ENAMELED GOLD-MOUNTED
DIAMOND BROOCH set with a triangular
brownish 9.65 ct. diamond encased in an
openwork gold and opaque white enamel
mount shaped as two storks – signed Lalique,
c. 1897–1898, length 1¹2 in. (3.8cm).
Provenance: Mme. Waldeck-Rousseau (1900).
Bibliography: Barten 1977, cat. 535,1 (as lost),
who also illustrates a preparatory sketch.
The illustration in Barten shows a pendant
pearl, which has been lost.
Private Collection, New York

1045. FIGURES AND GRAPEVINES
an enameled, gold-mounted ivory and glass
chalice, the cup and foot covered with greenish
plique-à-jour enamel leaves with blackened
stems, the cup also set with ivory plaques each
carved with three heads, alternating with
hexagonal glass cabochons; the stem with
an ivory frieze of naked figures held by two
openwork rings set with cabochons – signed
"Lalique", *c.* 1899–1901, height 4³4 in.
(12.2cm).
Bibliography: Beaunier 1902, p. 37; Barten
1977, cat. 1709 (as lost).
Exhibited: New York 1998, cat. 179, ill. p. 163.
Private Collection, New York

1047. LALIQUE ENAMEL AND
GOLD-MOUNTED PEARL HATPIN
the baroque pearl forming part of the head
gear of a woman's bust with raised hair,
wearing a green enamel lace collar – stamped
signature of Lalique, Paris, *c.* 1900, height
(without pin)1¹2 in (3.8cm).
Private Collection, New York

1048. ART NOUVEAU ENAMELED
GOLD PENDANT depicting an Egyptian
lady in profile, her hair arranged as a wig, her
head surrounded by large poppy blooms –
signed "Lalique", inv no. 7908, length 1³4 in.
Private Collection, New York

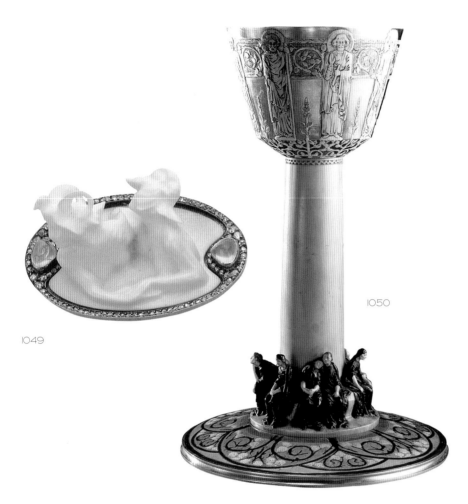

1049

1050

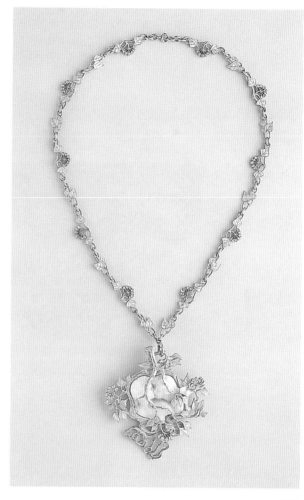

1051

1049. WOMEN IN HELMETS an oval
diamond-set silver-gilt ivory brooch carved in
high relief with two nude women wearing
helmets and holding hands, diamond-set border
set with two yellow stones – signed "Lalique",
c. 1901–1902, length 1³⁄4 in. (4.5cm).
Private Collection, New York

1050. APOSTLES an enameled,
gold-mounted ivory chalice standing on a flat
enameled gold base, the plain shaft and cup
both of ivory, the cup encrusted with eight
hieratic apostles and a band of scrolling foliage,
the shaft surrounded by nine figures of apostles
in black robes – signed "Lalique",
c. 1903–1905, height 12¹⁄2 in. (31.5cm).
Bibliography: Studio 1905, p. 128; Verneuil
1906, p. 185; Karageorgevitch 1906, p. 12;
Barten 1977, cat. 1715,1;
Exhibited: New York 1998, cat. 183.
Private Collection, New York

1051. THE KISS a diamond-set enameled
gold-mounted ivory pendant depicting an
ivory carving of two figures encased in an ivy
root with green enameled ivy leaves and pur-
ple enamel berries, suspended from a similiar
chain – signed Lalique and dated on the
reverse 18 Juillet 1900, length 2³⁄4 in. (7cm),
length of chain 19³⁄4 in. (50cm). Original fitted
case stamped Lalique 40 Cours-la Reine Paris.
Bibliography: Barten 1977, cat. 627, New York
1989, p. 7, no.3.
Exhibited: London 1987, cat. 30; Tokyo 1992,
cat.57, p. 109

1054

1055

1053

1052

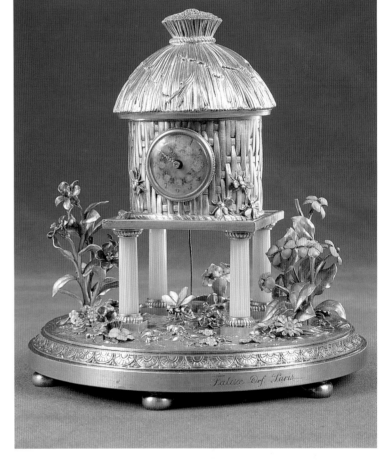

1056

1052. OBLONG SILVER-GILT AND PALE-GREEN ENAMEL CIGARETTE-CASE with match compartment of flat oval section decorated with *guilloché* enamel panels divided by chased laurel bands, with diamond-set pushpiece – engraved signature Lacloche Frères, *c.* 1910, length 4 in. (10.2cm). Exhibited: Hamburg 1995, cat. no. 250. Private Collection courtesy A. von Solodkoff

1053. BULBOUS GEM-SET SILVER-GILT VASE decorated in the Celtic style with applied interlaced filigree ribbons, a band of alternating X-shaped motifs and cornelian, further set with diamonds, pearls and turquoises, the rim similar to broken eggshell – German *c.* 1890, stamped 75,800 hallmark, diameter 2⅞ in. (7.3cm). Original fitted wooden case stamped with a Grand Dukal crown, Ph. Wondra, Hofjuwelier, Darmstadt. The box inscribed in ink "From The Queen Xmas 1892".
Provenance: Given by Queen Victoria to Sir William Henry Peregrine Carington, P.C., G.C.V.O, K.G.B, Equerry to Her Majesty 1881–1901, later extra Equerry to King Edward VII and King George V.
Private Collection courtesy A. von Solodkoff

1054. FRENCH GEM-SET GOLD-MOUNTED SMOKY QUARTZ SCENT-BOTTLE the cylindrical hardstone body inlaid with swirling foliate bands encrusted with diamonds, the hinged cover with diamond-set border and ruby pushpiece, with carved quartz stopper – maker's mark with the initials L S of Le Saché, French hallmark for gold (eagle's head), *c.* 1900, height 2⅞ in. (7.3cm).
Georges Le Saché, born in 1849, initially worked for Falize, later for all major Paris jewellers, cf. Vever, pp. 524 ff.
Private Collection

1055. FRENCH SHAPED GEM-SET ENAMELED GOLD BROOCH the center with an oval pale-blue *guilloché* enamel medallion decorated with a chased gold basket of flowers, the white enamel border set with diamonds, flanked by entwined gold laurel branches, with ribbon-tie finials and suspended pearl – signed by L. Gautraid, *c.* 1890, stamped inv no. 5095, length 1⅝ in. (4.6cm).
Private Collection

1056. FRENCH SILVER-GILT AND ENAMEL BEEHIVE CLOCK the dial painted with roses set in a naturalistically shaped beehive standing on four fluted white columns on a circular silver-gilt base decorated with enameled flowers, the pendulum with an enameled bee – engraved signature Falize Orf. Paris, *c.* 1905, height 7⅟16 in. (18cm).
Private Collection

13
"FAUXBERGÉ"

MORE FAUXBERGÉ

Copies, imitations and reproductions of Fabergé's work represent one of the most serious problems facing Fabergé research and the contemporary art market. The firm ceased to exist more than eighty years ago, but sometimes it almost seems to continue to function as intensively as it did up until 1918. Fabergé's works constantly turn up at auctions and in the hands of dealers and collectors. Among them are fakes – often obvious, and sometimes not so obvious. I have been to various artists' studios where plaster-casts of elephants, bulldogs and monkeys stand on the shelves, later to be turned into stone figures. And when I point out that these objects are similar to works by Fabergé, the artists only laugh. "And why, exactly, shouldn't they be?", they inquire.

And why indeed shouldn't they be? There have been times when jewelers have turned to the past, immersed themselves in it and made it their own. For example, jewelers of the Italian Renaissance saw classical stones with engraved designs as a criterion of quality worth of imitation. Yet forgeries have always been badly regarded, probably because people do not like being deceived. Forgeries are extremely simple to make; they are purely a matter of technique. The greater someone's technical ability, the more realistic is his forgery. To make a piece "in the style" of Fabergé is much more difficult.

The most famous name in the history of forgery in Russia is that of Mikhail Monastyrsky. I am quite certain that many of his works are now to be found in collections and are considered genuine Fabergé pieces. And it seems to me that Fabergé-lovers might be intrigued to know a little of this colossus of the forgery world, or at least to learn about those pieces that came to light after a court-case in St. Petersburg.

In the mid-1960s a student arrived in Leningrad from the provinces, intending to enter the Higher Art College and, he said, "to learn more of the beauty of art." Soon, however, he gave up all thoughts of entering the college, realizing that he was under-prepared. An energetic and sociable young man, he easily found his way into the art world, helping one artist to apply canvases to stretchers, another to set up exhibitions, or another to find profitable work. Soon he became an inspector at an art factory. The minimal salary held little attraction for him; much more important was the fact that the job gave him access to various art institutions and entitled him to sign contracts for artistic and decorating jobs. In the years that followed, Monastyrsky studied various restoration techniques and set up his own workshop where he restored and created liturgical articles – chalices, crosses, thuribles and miters. In order to carry out these highly profitable commissions, he needed to obtain the relevant materials: that is, silver, gold and precious stones. According to Soviet laws of the time, however, a private individual was not entitled to use such materials; this was the prerogative of state factories alone. This was the first time Monastyrsky came up against the law. Furthermore, to complete his "antique-style" forgeries, he bought various antique accessories on the cheap, including crystal pendants from chandeliers, bronze furniture brackets, vases, lamps and handles from display-cases. He bought them from young electricians who worked in the Hermitage, and had access to the museum's furniture, chandeliers and other treasures. The whole group was soon arrested. It is true that the court did not find that Monastyrsky had actually ordered people to steal the goods, but for buying known stolen museum valuables he was sentenced to seven years' imprisonment.

After his release from prison, Monastyrsky returned to his work in decorating and sculpture factories. In 1977 a meeting took place which was to determine his future activities. He met Albert Kheifets, or Alik, as everyone called him, a well-known second-hand dealer at the time who operated on the black antiques market. It is worth pointing out that in the Soviet era the antiques market was only ever "black", and officially banned.

Nevertheless the trade flourished. Energetic young men would travel around villages and towns in the provinces, buying up protected icons, pictures and furniture from churches and homes for next to nothing; often they would simply plunder churches or steal from old folk. Everything flowed to St. Petersburg, where it would be sold by Alik's boys for vast sums or spirited away abroad.

It seems likely that it was Alik Kheifets who suggested to Mikhail Monastyrsky that he should make stone-carved and silver objects *à la Fabergé*, and that he introduced him to Savely Shchedrin. Shchedrin was a figure of some renown in certain circles; he was later murdered, possibly by his own accomplices, for failing to share the valuables he had obtained. Monastyrsky was largely dependent on these sharp operators, since they loaned him the money he needed to get hold of his materials. He had quite a large circle of acquaintances among artists, restorers and applied artists, and was able to find the people he needed without much difficulty. He was highly persuasive, playing on the strings of the human heart – flattering, promising vast sums of money, begging for help on his knees. Stone-carvers came to work for him, as did jewelers, fasteners, filigree craftsmen, casters, pressers, enamelers, stampers and engravers – in short, all the specialists required in the jewelry-making process. He found them working for state enterprises, members of the Union of Artists and Restorers, or jewelers working with precious materials at home. Each craftsman completed his part of the work without, as a rule, knowing what it was intended for. This lack of knowledge was something of a godsend, since it was later to save many craftsmen from punishment.

The work was carried out almost exactly as it had been by Fabergé. The artist would make a sketch for an object, most often taken from a book or catalog of Fabergé's exhibitions. This would then be passed on to the sculptor, who would create a model from plasticine and cast it in plaster. The plaster-cast would then find its way into the hands of the stone-carver, and finally to the jeweler, if the piece required gold or silver details. Sometimes Monastyrsky would use the services of a faceter, an engraver, an enameler and, finally, a mounter. Everything was precisely organized, and many people were involved. They included well-known artists, jewelers and stone-carvers, as well as young men still waiting for fame. The goods were sold on the black market in a certain part of the city, and were also distributed through second-hand salesmen, or dealers as we would call them nowadays. The relevant state bodies with responsibility for the nation's moral well-being were fully aware of all this of course, but were happy to turn a blind eye until overseas buyers appeared and the goods began to leave the country. Even then the KGB was unworried about people making forgeries and deceiving buyers: their sole concern was the unlawful export of precious metals and stones. Thus it was that Monastyrsky and his accomplices were convicted of foreign currency offences, and he was imprisoned for a second time.

After the KGB case, the Hermitage took possession of nine stone figures, three plaster casts, one lead figure, three of silver and two cast in plasticine. Of course this was only the tip of the iceberg, for even the court charge said that forty-five objects had been created. People who knew about the affair and moved in such circles, however, said that many more of these figures had been made. The silver casts were reproduced in their dozens, while the stone figures were copied more than once. This was true, for example, of the figure of a dvornik caretaker, which was almost an exact copy of a work by Fabergé, and the "Man with a Tankard" (fig. 1), created from a porcelain figure from the Gardner Factory. Figures of wild beasts and animals – pigs, elephants, monkeys and bulldogs – were copied many times over.

In some cases these pieces were direct copies of works by Fabergé. They included figures of a dvornik, a rhinoceros, a pig and a seal. Others, such as the elephant, bulldog and monkey, were close to the originals. In both cases the end-products were often of a

fairly high quality, although the choice of stone was not always successful. The works composed of contemporary figures were far less interesting, although even these were sometimes distant relatives of works by Fabergé. The silver molds of a monkey (fig. 2) and a hare were exact copies.

Numerous collections were filled with these forgeries. Even such well-known St. Petersburg collectors as Valentina Golod – whose collection passed to the Theatre Museum after her death – were not able to avoid them. I have also seen works *à la Fabergé* in a major collection in London.

Monastyrsky's story is now at an end. He has long since become a "man of substance", a member of the State Duma and of Zhirinovsky's party, where he occupies an important post. But the business he started has not died; indeed, on the contrary, it continues to flourish. Now only the lazy do not make figures *à la Fabergé*. Some craftsmen who used to work with Monastyrsky continue to ply their trade. They even keep the old plaster-casts for some of the figures. They have become more skilful, and thus the quality of their creations has improved. What is more, they have been succeeded by a new generation of people no less skilled, but better educated in the field of arts and crafts and with a better understanding of the art market.

Not all contemporary jewelers, of course – even those using traditional techniques – produce hardstone and gemset works based on Fabergé; far from it. Indeed, most artists would far rather achieve fame in their own right. The St. Petersburg stone-carvers Gennady Pylin, Boris Igdalov, Vladimir Ilyushin and Alexander Levental all produce extremely high-quality work, and they are not to blame if their work sometimes becomes reminiscent of Fabergé.

Andrei Ananov for instance is quite well-known for his large Easter eggs and stone-carving work, as is Aleksei Pomelnikov for his delicate egg-pendants. Their success is testament to the demand in modern society for works in the spirit of Fabergé. So the Fabergé style lives on, and shows no sign of waning.

Marina Lopato

FIG 1. COMPOSITE HARDSTONE FIGURE of a seated toper with a tankard – with forged hallmarks, height 6⁹⁄₁₆ in. (16.9cm). Forged Cyrillic inscription: "Fabergé, St. Pb. Moskaia 24". Peterhof State Museum (PDMP 532)

FIG 2. CHALCEDONY FIGURE of a seated chimpanzee – with forged marks of Fabergé and Michael Perchin, height 4⅛ in. (10.4cm). Peterhof State Museum (PDMP 533)

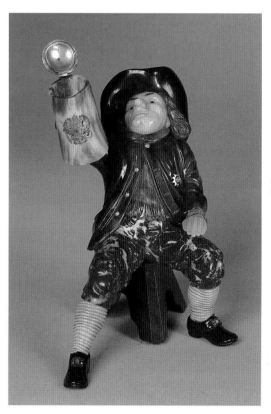
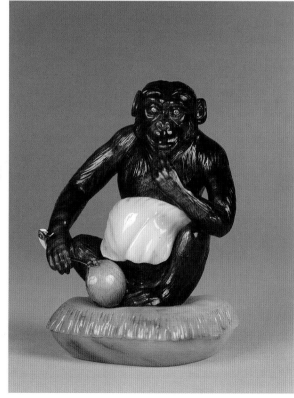

APPENDIX

THE PRIX COURANT OF 1893

"Along Kuznetsky Most interminable Frenchmen, those fashionable, artistic and literary henchmen, who burn their holes in our pockets and hearts …"

Just as it had been when Griboyedov wrote his comedy *Gore ot uma* (Woe from Wit), Kuznetsky Most remained a fashionable spot for elegant and well-to-do society in the decades that followed. Carriages and automobiles passed by, and a well-dressed and lively crowd would gaze into the shops proffering the latest fashions, rare works of art and the latest literary periodicals. At the turn of the twentieth century the Moscow street's opulent shop-windows sparkled with gold, silver, brilliant diamonds and other precious stones; an endless temptation to financial ruin. The signs above the jewelry and watch shops trumpeted the names of Suppliers to the Imperial Court: Ivan Khlebnikov, Pavel Ovchinnikov, the Bolin family and Pavel Buhré. On the corner of Kuznetsky Most and Neglinnaya Street stood a shop belonging to the firm Carl Fabergé; it was, despite the competition, one of the most popular in the ancient capital. For customers who lived in the provinces and were unable to visit the shop, a special catalog was published with illustrations and approximate prices.

Until recently, specialists in the history of Russian jewelry were familiar only with the 1899 Catalog, held in the State Museum of History. This was the second such publication and a few years ago the first catalog, published in May 1893, was discovered. It was published in Moscow by the Imperially Approved Typolithographers I.N. Kushnerev and Co. (who occupied their own premises on Pimenovskaya Street). As the introduction states, this catalog was produced "in response to the ever-increasing number of enquiries from provincial Russia concerning the firm's products." The small-scale publication could not include "the enormous variety of items available only to the personal caller"; only the most "significant and typical" examples were included. There were other factors contributing to a certain disparity between the choice of goods shown in the catalog and those available in the shop. First, the firm would frequently make changes to its products in response to the "capricious demands of fashion", and new fashions might appear on a daily basis. Second, many of the best works were not included in the catalog "for fear of imitation by our competitors." Nevertheless, the catalog contains numerous interesting and unique items, which combine to broaden our understanding of the work of Fabergé's Moscow factory in the earliest stages of its existence.

The factory opened in 1890 in the house of San Galli in Bolshoi Kiselny Lane. This date is most eloquently confirmed by the tray presented to Allan Bowe to celebrate the fifth anniversary of the workshop, and dated "1890–1895" (now in the Forbes Collection). Carl Fabergé himself resided permanently in St. Petersburg, so Allan Bowe was concerned with every aspect of the day-to-day running of the firm: accounts, the hire and dismissal of employees, purchase of materials, property insurance, rental of premises and sales contracts. The firm's capital reserves were listed in Moscow under the company name of "Carl Fabergé" at 120,000 roubles, of which one half belonged to Carl Fabergé and the other to Allan Bowe. The catalog included a picture of one of the workshops in the factory which, to judge from the items portrayed in the foreground, appears to be the silver workshop. This was one of four workshops, the others being the jewelry, metalwork and granite workshops. The jewelry workshop was on the fourth floor of the factory complex, and by the beginning of the twentieth century about forty craftsmen worked there, their specialities including mounting, setting, polishing and enameling.

The atmosphere in the workshop is well described by the daughter of Artur Ivanovich Mitkevich-Zholtko, who was head of the jewelery workshop from 1902, and

had previously worked for the firm K. E. Bolin in St. Petersburg. In an article which appeared in Vitta magazine in Ekaterinburg in 1997, Lydia remembers the extraordinary atmosphere of respect and friendship between employees, regardless of rank, that prevailed in the Moscow factory. Some of them lived in a house that overlooked the courtyard in front of the factory; they included the head of the silver workshop Mikhail Moiseevich Chepurnov, whose children were friends with the Mitkevich children, and the factory accountant, Otto Bauer. There was a great deal of socializing between the workers. For instance, the Kolbasin brothers, who worked in the setting department, often invited the Chepurnov family to lunch parties with their parents in the country, where everyone was given a most hearty welcome and all took part in the local fêtes. Lydia's father's office contained a telephone and an enormous fireproof safe, where items from all the workshops would be placed at the end of the working day. Opposite his office was a room that was the constant home of the "two Nikolais", who as well as being sent out to clients to take precise measurements – the exact size of a lady's ring finger, for example – were also entrusted with security matters such as deliveries of precious stones and artefacts from the shop to the factory and back again. Security at the factory was always carefully organized: the guards and gatekeepers were Tartars, people of "the utmost integrity." The most valuable items were not just the precious stones, metals and finished articles, but also the tools themselves, many of which were extremely rare or made to measure. Before returning home, the jewelers would wash their hands in water that gushed from a great tap in the factory courtyard. Some thrifty Germans used to buy this water, and when they appeared at the factory the children of the employees would cry out from the windows "Look! The Germans have come for the water!"

In her memoirs, Lydia Arturovna also describes some of the firm's interesting traditions. On a particular day in August, marking the beginning of the new working year, an icon of the Iverskaia Mother of God, protector of commerce in Moscow, was brought to the factory and prayers were said. Then the craftsmen and other employees would be given money to visit the nearest drinking establishment, while the factory administration and employees of the firm's shop would head off in open carriages for the fashionable restaurant Yar. Families were not invited take part in these revels, and the factory would remain, as always, under close guard. The keys to the jewelry workshop were left in the hands of the "two Nikolais".

When the firm's Moscow shop first opened in February 1887, it mainly sold pieces that had been made in St. Petersburg, as well as items from the workshops of Oskar Pihl, Feodor Rückert and other Moscow suppliers. From the end of 1888 until early 1889 the shop was closed for repairs after a fire. From the beginning of the 1890s, however, the Moscow shop began to offer articles that, in the catalog's words, had been produced "in our own factory from materials of the very highest quality." Visitors to the shop in the house of San Galli on Kuznetsky Most would thus not only find ready-made articles to suit all tastes and budgets, they could also commission articles to meet their own needs. A special assistant dealt with such commissions, and customers described their requirements to him in detail. The price would then be agreed, along with the proposed materials and design, and the customer would choose one from several sketches. The artist's studio was situated above the shop on Kuznetsky Most. As the catalog put it, "the finest artists, working exclusively for us, provide the firm with a rare selection of refined sketches which bear comparison with the most excellent works in the field by our foreign competitors." The Moscow shop's most famous customers included the ballerina Geltzer, whose benefit performance was marked by the commission of a splendid diamond and emerald necklace and diadem which went wonderfully well with her auburn hair. Grand Duchess Elizabeth Feodorovna, after she had taken holy orders and founded the Monastery of Saints Martha and Mary, presented all her family jewelry to the firm so that it could be remade into

simpler and less ostentatious pieces. The Grand Duchess then gave them to her close friends as keepsakes.

The 1893 Catalog contains a monotype showing a "view of the interior of the shop". The picture bears the signature of A. Zabiello, and was reproduced in the publication using the photomechanical technique. The interior is large and luxuriously furnished. The floors are covered with carpets and runners, and velvet benches and divans with gold braid and fringes stand all around the shop. The interior is divided into four parts by profile columns with capitols and balustrades. The show-cases and shop counters contain a wide variety of silver objects and crystal ware in silver mounts. An enormous number of ornaments in cases are on show in the low display tables. Even quite recently experts doubted whether "jewelry was manufactured in the firm's Moscow branch", but pictures such as these suggest that they were. Indeed, jewelery remained one of the most important areas of production throughout the history of the firm, and in our opinion it is wrong to suggest that Fabergé "turned his back on jewelery" as he became more interested in other products.

Ornaments take up the first section of the catalog: they constitute almost half of all the objects illustrated. The catalog contains fifty pages, of which half are illustrations and half are descriptions with prices of the items. Ninety-one ornaments and accessories are portrayed (hatpins, clasps, pencils, etc.), one *objet d'art* made of various precious stones and 126 silver articles. These include tableware, crystal and glassware in silver mounts, blotters and other writing-desk implements, cigarette-cases, ashtrays, cups, goblets, and so on. The catalog concludes with illustrations of silver services: there are various complete sets on display along with several individual items. All the illustrations are done as phototypes "taken from nature", signed by Otto Renard. Phototyping, which enabled the illustrator to reproduce items in as lifelike a way as possible, was a relatively expensive technique. For this reason it is unlikely that the print run of the catalog was very large. This is doubtless one of the reasons why only a handful exist to this day. Under each item at the bottom of each page the name of Fabergé stood alongside Renard's signature.

The illustrations of the ornaments are life-size; indeed, as the instruction at the bottom of each page says, "all the drawings will appear clearer and closer to reality if viewed through a magnifying-glass." Only a few of the objects on one page, such as the diadem, hatpins, egret-plume, diamond necklace and gold chain with diamonds are shown half-size. The accessories and precious ornaments are also shown half-size. These include a scent-bottle of matt engraved gold, an amber cigarette-holder with gold ornamentation, cuff-links, a clasp for a *sortie de bal* of matt hammered gold with six garnets in the form of cherries, pencils, a silver and garnet paper-knife, a match-box cover for Swedish matches, a convex ladies' locket with a sapphire and a ribbed men's locket with almandine. The *objet d'art* – a statuette of precious stones – is also shown half-size. The silver tableware and other silver items are reduced by three or four-and-a-half times, while some of the crystal objects such as the massive flower vases and salad bowls are reduced by seven times. The phototypes of the mirrors, candlesticks, ink-wells, frames, calling-card holders, blotters and cigarette drums are reduced by six times. Finally, the silver *objet d'art* in the form of a statue is reduced by eight times, as are the prize cup, the goblet on a marble pedestal, the flower vase, the pitcher for water or beer, the mirror in a chased frame and on chased legs, and the album with a silver plaque. The pictures of the silver service, signed with the initials "Yu. Ts.", are reproduced using the photomechanical method; all are shown reduced by either one-and-a-half or three times.

Each illustration has a caption containing a brief description of the item and the material used ("watch-chain of matt gold"), and sometimes the production technique and artistic style of the object ("salt-cellar engraved in the style of Louis XV"). Sometimes the

writer of the captions is clearly particularly taken with the object and may give a highly subjective description, for example, "Daisy Brooch with diamonds, a wonderful work of art" or "Brooch of rose-cut diamonds with two pearls, a work of delicacy and refinement." The description of the *objet d'art* is particularly fulsome and poetic, and the special significance of this work is indicated by the fact that it occupies a separate page in the catalog: "The statuette illustrated here in reduction is a gracious work of art, one of the very finest examples of the artist's craft and of refined good taste" (no. 92). The bowl with a dragon is made of nephrite and studded with pearls and small precious stones. The figure of a woman is carved "out of a quite rare and expensive stone, smoky topaz, with a silver mount around the lower part." The base consists of a column of red marble, wound around with "delicate gold open-work with small stones attached." At 4,000 roubles, the price of this elaborate work was quite high, although the brooch with a "colossal sapphire" and diamonds also shown here is priced at 4,100 roubles (no. 66).

One page in the catalog showing large-scale silver objects also contains another *objet d'art*, this time a statue with a cast oxidized figure on a marble quadrangular base with a holder for calling cards on each side (no. 120). This object clearly had a utilitarian purpose and was therefore not a "display item" in the full sense of the term. It is sometimes argued that the St. Petersburg branch of the firm concentrated on elevated "classical" styles, while the Moscow factory was oriented exclusively towards "bourgeois or heavy peasant tastes." The magnificent *objets de fantaisie* illustrated in the catalog, however, along with a number of other items of varied styles and techniques, suggest that such arguments are at best speculative. It is undoubtedly true that there were differences between the jewelry schools of St. Petersburg and Moscow; nevertheless, this only affected the work of the Moscow factory of Fabergé very slightly, since their products were often made under the direction and design of St. Petersburgers, and were aimed at a St. Petersburg and London clientele.

The variety of "designs and fashions" in the catalog is reflected in a wide variety of prices. Clients could find brooches of polished gold wire showing a single letter of the Russian or French alphabet for 3 roubles 50 kopecks – the cheapest items in the catalog – or a string of large diamonds "of equal lustre and with the splendour of pure water" for 35,000 roubles (nos. 1 and 76). Silver items ranged from a salt-cellar in the shape of half an egg on legs for 8 roubles (no. 41) to a goblet on a marble pedestal decorated with an oxidized horseman "in the classical style" for 675 roubles (no. 122, the most expensive of the silver objects). Furthermore, as the catalog explains, all of the firm's silver objects, with the exception of silver tableware, were made of 22 carat silver, although they were sold at 21 carat prices. Prices for silver tableware were determined by the average weight of the constituent pieces, although a client could commission pieces of heavier or lighter silver with a corresponding change in price.

The Moscow branch of Fabergé "treated the demands of highest society and the interests of the middle classes equally"; for this reason they were concerned to "satisfy the requirements of the most refined tastes with luxurious and expensive objects" as well as to "prepare inexpensive and accessible items for the less well-off." The quality of all the items, without exception, was governed by three golden principles. These were printed in the 1893 Catalog, and remained unchanged throughout the firm's existence. They are reproduced here in full:

1. We shall not on any account supply goods of an inferior quality; that is, every item, be its price no more than 1 rouble, shall be produced with the necessary care and durability.

2. As far as possible we shall endeavor – and our clients shall always be invited to confirm this in person – to offer a large quantity of exclusively original products. Old items that have gone out of fashion will not remain in the shop: they shall be collected up

once a year and melted down.

3. We shall endeavor to produce our goods in such a way that the value of the purchased item corresponds fully to the price paid for it; in other words we shall sell our products for as low a price as proper completion of our work allows.

These principles were reprinted in the 1899 Catalog, with the addition of a fourth one: "Thanks to our significant reserves we are in a position to maintain for the immediate satisfaction of our respected clients a large quantity of the most varied and opulent items." As far as the objects themselves are concerned, the differences between the catalogs of 1893 and 1899 are significant. This is entirely understandable as not only did the firm consistently declare its intention to update stock in response to changes in fashion, but productivity at the factory also increased. Very few items were reproduced in an absolutely identical form, and these were the brooches of polished gold wire in the form of letters of the alphabet, which were 50 kopecks cheaper in the later edition (no. 1); the "Lily-of-the-valley" brooch with a gold stem and pendent leaves of diamonds, which was reduced in price from 87 roubles in 1893 to 85 in 1899 (no. 26); the large brooch of massive matt gold with an acorn of garnet and rose-cut diamonds (no. 22) which was 9 roubles cheaper in 1899. Two variations of this last item were also available, one with a moonstone, the other with amethyst. In the 1893 Catalog bracelets consisting of a hard, often hollow band predominated, while in the 1899 edition bracelets of flexible chains were more common. The first catalog contains only two pairs of fairly simple cufflinks, while in the second a whole page is given over to such items, displaying more varied, often more elegant and elaborate examples. The second catalog contains no *objets de fantaisie*, although a whole page is given over to examples of medals, which "were produced on demand, according to designs provided by the client or by us", as well as items of church furniture and a toilet set in Louis XV style made of oxidized silver using "elaborate chasing." Overall, the 1899 Catalog contains more items than the previous one – 155 ornaments, precious accessories and medals and 166 silver objects in addition to silver services.

Everything connected with commissions, deliveries and insurance remained unchanged. Both catalogs explain that the Moscow factory is "organized in such a way that we are able to fulfill any commission provided to us." All commissions, "from the most insignificant to the most important and difficult", were carried out "as precisely as possible." If, on receipt of an order, any one of the items requested was temporarily unavailable, the client would be informed immediately of the likely date on which the order would be delivered. At the same time, employees of the firm would often send out whatever was available without waiting for the specific item to be supplied, unless the order stated otherwise. In addition to these services, the Moscow branch also undertook "repairs of gold, diamond and silver items of any kind with accuracy and without delay" and they would also take in old diamond objects and remake them "according to the latest fashions." The firm was always prepared to exchange or take back objects sold by them, with the following exceptions:

1. If an object is in a state of disrepair;
2. If so much time has elapsed since the purchase of the item that it is no longer in fashion;
3. If the object has been made to order or remade according to a commission;
4. If the object has been returned cash on delivery.

Finally, the catalog was sent free to anyone who wanted it, and the firm was "much obliged" to clients who passed on the addresses of people who might be interested in the catalog – a publication that remains a rare and valuable testament to the heyday of the Russian jewelery trade.

Tatiana N. Muntyan

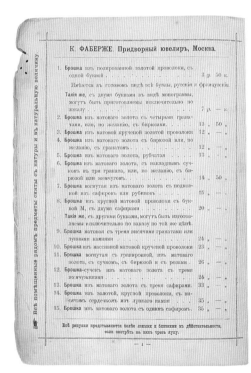

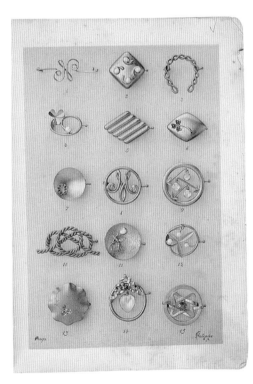

PAGE FROM THE FABERGÉ 1898
SALES CATALOG

16. Брошка изъ полированнаго золота съ висячимъ гранатомъ и съ розами 24 р.
17. Брошка сердцевидная изъ полированнаго золота съ сафирами и лунными камнемъ 33 „
18. Брошка матовая съ сучкомъ, изъ гранатъ и розъ . . 35 „
19. Брошка изъ матоваго битаго золота, съ бирюзами и жемчужинами по краямъ и съ брилліантомъ посрединѣ 35 „
20. Брошка матовая, легкой ажурной работы, съ жемчужинами и сафирами 38 „
21. Брошка изъ розъ, съ двумя жемчужинами, нѣжной, тонкой работы 38 „
22. Брошка изъ массивнаго матоваго золота, съ желудемъ изъ гранатъ и розъ 40 „
23. Брошка въ видѣ сучка съ трефомъ, съ сафирами и брилліантами 45 „
 Такая же, съ рубиномъ и брилліантами 50 „
24. Брошка съ крылышками изъ матоваго золота, съ двумя гранатами и розами 55 „
25. Брошка „Солнце" съ семью брилліантами . . . 80 „
26. Брошка „Ландышъ" съ золотымъ стебелькомъ и висячими (дрожащими) цвѣточками ландыша изъ брилліантовъ. 87 „
 Такія же, отъ 50 р. до 2000 „
27а. Брошка изъ матоваго золотого кольца и съ цвѣткомъ изъ брилліантовъ. 100 „

Всѣ рисунки представляются болѣе изящни и ближими въ дѣйствительности, если смотрѣть на нихъ чрезъ лупу.

— 3 —

К. ФАБЕРЖЕ. Придворный ювелиръ, Москва.

16. Брошка изъ полированнаго золота съ висячимъ гранатомъ и съ розами 24 р.
17. Брошка сердцевидная изъ полированнаго золота съ сафирами и лунными камнемъ 33 „
18. Брошка матовая съ сучкомъ, изъ гранатъ и розъ . . 35 „
19. Брошка изъ матоваго битаго золота, съ бирюзами и жемчужинами по краямъ и съ брилліантомъ посрединѣ 35 „
20. Брошка матовая, легкой ажурной работы, съ жемчужинами и сафирами 38 „
21. Брошка изъ розъ, съ двумя жемчужинами, нѣжной, тонкой работы 38 „
22. Брошка изъ массивнаго матоваго золота, съ желудемъ изъ гранатъ и розъ 40 „
23. Брошка въ видѣ сучка съ трефомъ, съ сафирами и брилліантами 45 „
 Такая же, съ рубиномъ и брилліантами 50 „
24. Брошка съ крылышками изъ матоваго золота, съ двумя гранатами и розами 55 „
25. Брошка „Солнце" съ семью брилліантами . . . 80 „
26. Брошка „Ландышъ" съ золотымъ стебелькомъ и висячими (дрожащими) цвѣточками ландыша изъ брилліантовъ. 87 „
 Такія же, отъ 50 р. до 2000 „
27а. Брошка изъ матоваго золотого кольца и съ цвѣткомъ изъ брилліантовъ. 100 „

Всѣ рисунки представляются болѣе изящни и ближими въ дѣйствительности, если смотрѣть на нихъ чрезъ лупу.

— 3 —

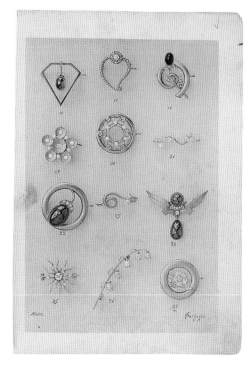

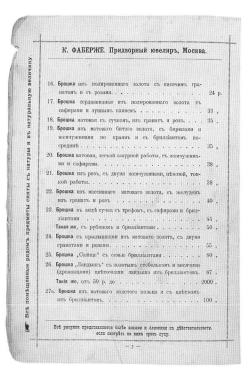

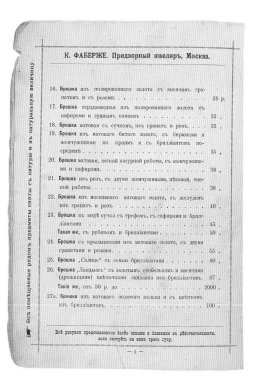

Всѣ помѣщенные рядомъ предметы сняты съ натуры и ВЪ НАТУРАЛЬНУЮ ВЕЛИЧИНУ.

63. Брошка-вѣтка, вся изъ превосходныхъ брилліантовъ. . 1750 р.
64. Брошка съ однимъ крупнымъ брилліантомъ посрединѣ и 10 меньшими по окружности. 4300 „
65. Брошка „Ландышъ" съ свободными (дрожащими) цвѣтками изъ брилліантовъ. 1100 „
 Такая-же, съ брилліантами самаго высокаго качества. 1600 „
66. Брошка съ сафиромъ громадной величины и съ брилліантами 4100 „
67. Брошь „Маргаритка" изъ брилліантовъ, прекрасной художественной работы 1800 „
 Она же можетъ служить и въ качествѣ головной шпильки.
68. Серьги съ двумя прекрасными жемчужинами и съ брилліантами. 2775 „
69. Серьги изъ крупныхъ очень чистыхъ брилліантовъ . 2650 „

Всѣ рисунки представляются болѣе изящни и ближими въ дѣйствительности, если смотрѣть на нихъ чрезъ лупу.

— 13 —

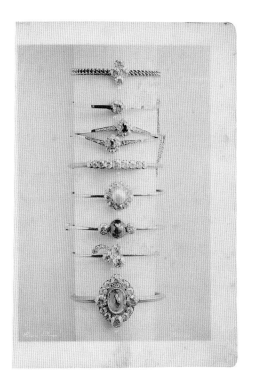

46. Браслетъ золотой полированный, проволочный съ буквой В. 8 р. — к.
 Примѣчаніе. По ошибкѣ фотографіи буква сказалась перевернутой.
 Въ магазинѣ постоянно имѣются въ готовомъ видѣ браслеты со всѣми буквами русскаго и латинскаго алфавита.
47. Браслетъ золотой матовый съ двумя сафирами и однимъ рубиномъ. 36 р. — к.
48. Браслетъ золотой матовый съ жженнымъ топазомъ и шестью розами въ видѣ трефа 38 „
49. Браслетъ золотой, матовый съ тремя подковами изъ рубиновъ, сафировъ и брилліантовъ . . . 60 „
50. Браслетъ золотой полированный съ двумя лунными камнями 33 „
51. Браслетъ золотой полированный съ сафиромъ, окруженнымъ брилліантами 100 „
52. Браслетъ матоваго золота, цѣпью, съ 3-мя лунными камнями, 2-мя сафирами, 2-мя рубинами и 2-мя брилліантами. 90 „
53. Браслетъ матоваго золота, съ сафиромъ, двумя лунными камнями на концахъ и розами 80 „
54. Браслетъ матоваго золота, съ рубиномъ, сафиромъ и 4-мя брилліантами 80 „
 Такіе же, отъ 20 руб. до 150 „
55. Браслетъ матоваго золота, панцырный 43 „
56. Браслетъ матоваго золота, гладкій, съ двумя сафирами и 6 розами 80 „
57. Браслетъ матоваго золота, гладкій, овальный . . 15 „ 75 „
 Въ магазинѣ имѣются такіе же квадратные, шести-угольные, рифованные и витые на разныя цѣны.

Всѣ рисунки представляются болѣе изящни и ближими въ дѣйствительности, если смотрѣть на нихъ чрезъ лупу.

— 9 —

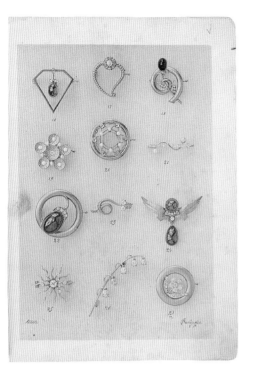

Всѣ помѣщенные рядомъ предметы сняты съ натуры
и ВЪ НАТУРАЛЬНУЮ ВЕЛИЧИНУ.

27. Брошка изъ тонкаго золотого бруска, съ двумя брил-
ліантами . 140 р.

28. Брошка изъ золотой круглой матовой проволоки, съ
сафиромъ и 2 брилліантами 115 „

29. Брошка изъ тонкой золотой изогнутой проволоки, съ
двумя брилліантами и тремя висячими жемчужинами . 175 „

30. Брошка въ видѣ кольца, съ 7 сафирами и брилліанта-
ми на окружности 215 „

31. Кулонъ (подвѣсокъ на шею), съ жемчужинами и брил-
ліантами . 290 „

32. Кулонъ изъ золотого ободка, съ тремя свободно вися-
щими крупными брилліантами 345 „

33. Кольцо золотое, съ двумя сафирами и брилліантами . 400 „

34. Кольцо золотое съ рубиномъ, окруженымъ брилліан-
тами . 400 „

35. Кольцо золотое съ сафиромъ и брилліантомъ 150 „

36. Кольцо трефъ съ рубиномъ, сафиромъ и брилліантомъ. 55 „

Большой выборъ всевозможныхъ колецъ на разныя
цѣны.

37. Браслетъ въ видѣ мягкой подвижной цѣпи изъ брил-
ліантовъ и сафировъ 1580 „

Всѣ рисунки представляются болѣе лоснщи и близкими въ дѣйствительности,
если смотрѣть на нихъ трезъ лупу.

— 5 —

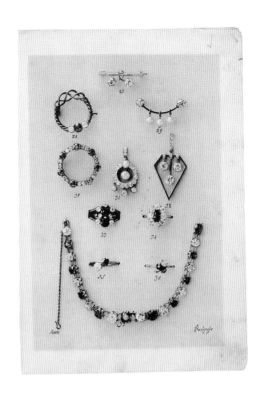

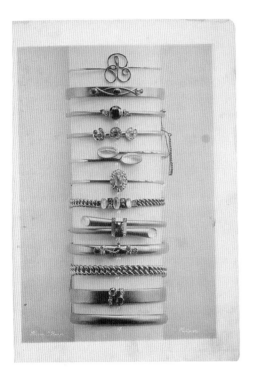

Всѣ помѣщенные рядомъ предметы сняты съ натуры
и ВЪ НАТУРАЛЬНУЮ ВЕЛИЧИНУ.

58. Цѣпочка для часовъ, короткая, изъ матоваго золота . 31 р.

59. Цѣпочка для часовъ, изъ матоваго золота 28 „

60. Цѣпочка для часовъ, изъ полированнаго золота, пан-
цырная . 80 „

61. Цѣпочка для часовъ, изъ матоваго золота 30 „

62. Цѣпочка для часовъ, короткая, изъ матоваго золота . . 30 „

Постоянно большой и разнообразный выборъ всякаго рода цѣ-
почекъ, короткихъ и длинныхъ, различныхъ фасоновъ. Послѣдніе
часто мѣняются, тѣмъ не менѣе, мы имѣемъ возможность предостав-
лять нашимъ почтеннымъ покупателямъ всегда самыя послѣднія
новости.

Всѣ рисунки представляются болѣе лоснщи и близкими въ дѣйствительности,
если смотрѣть на нихъ трезъ лупу.

— 11 —

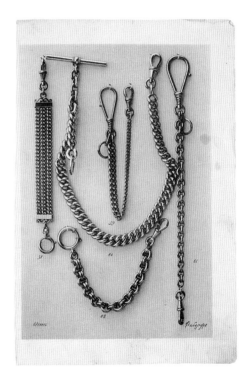

Всѣ помѣщенные рядомъ предметы сняты съ натуры и ВЪ НАТУРАЛЬНУЮ ВЕЛИЧИНУ.

38. Браслетъ изъ золотой панцырной цѣпи, съ четырмя крупными бриллiантами 440 р.

39. Браслетъ изъ полированнаго массивнаго золота, съ однимъ крупнымъ бриллiантомъ 295 „

40. Браслетъ изъ полированнаго золота, съ однимъ сафиромъ и однимъ рубиномъ, окруженными бриллiантами 515 „

41. Браслетъ изъ матоваго золота, съ 9 бриллiантами, расположенными въ одинъ рядъ 445 „

42. Браслетъ золотой полированный, съ 9 бриллiантами, окружающимъ жемчугъ 900 „

Обручъ снимается и бриллiанты могутъ быть употребляемы въ видѣ брошки.

43. Браслетъ золотой, полированный, съ однимъ сафиромъ и двумя бриллiантами 800 „

44. Браслетъ изъ тонкаго золота съ 3-мя бриллiантами . 750 „

Такой же, съ бриллiантами самаго высокаго достоинства 950 „

45. Браслетъ золотой матовый, рифованный, съ сафиромъ, окруженнымъ 4 большими и 8 бриллiантами повенше. 2.450 „

Всѣ рисунки представляются болѣе яркими и близкими къ дѣйствительности, если смотрѣть на нихъ черезъ лупу.

— 7 —

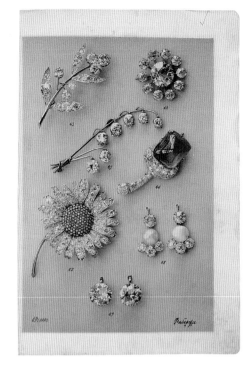

Всѣ помѣщенные рядомъ предметы сняты съ натуры и УМЕНЬШЕНЫ ВЪ ДВА РАЗА.

70. Дiадема изъ бриллiантовъ грушевидной формы, высокаго качества, тонкой, изящной работы . . 10.300 р.

71. Шпилька головная, для греческой прически, изъ черной черепахи, съ бриллiантами 2.150 „

72. Эгретъ съ перьями и семью бриллiантами . . . 600 „

73. Нитка изъ превосходныхъ бриллiантовъ 6.000 „

Бриллiантовыя нитки имѣются постоянно въ большомъ выборѣ, самыхъ разнообразныхъ цѣнъ, начиная отъ 500 „

74. Шпилька головная съ однимъ сафиромъ, 5 жемчужинами и бриллiантами 1.450 „

Можетъ быть употреблена и для греческой прически, а также на жабо.

Такiя-же шпильки можно имѣть на всѣ цѣны, отъ . 300 „

75. Нитка изъ подвижной тонкой золотой цѣпи съ 27 бриллiантами 390 „

Всѣ рисунки представляются болѣе яркими и близкими къ дѣйствительности, если смотрѣть на нихъ черезъ лупу.

— 15 —

Всѣ помѣщенные рядомъ предметы сняты съ натуры и уменьшены въ ДВА РАЗА.

77. Набалдашникъ изъ матоваго золота, тонкой чеканной работы въ стилѣ Людовика XVI 80 р.

78. Медальонъ выпуклый дамскiй изъ матоваго золота, съ сафиромъ 65 „

79. Спичечница для шведскихъ спичекъ маленькаго формата изъ матоваго золота, чеканной работы . . 40 „

80. Медальонъ мужской изъ матоваго рубчатаго золота, съ альмандиномъ 34 „

81. Шпилька головная, изъ граната, съ золотымъ бантомъ и съ жемчужиной 17 „

82. Пряжка для дамскаго пояса, оксидированнаго серебра весьма тонкой чеканной работы 45 „

83. Ножъ для разрѣзыванiя бумаги, изъ серебра съ золотыми украшенiями и гранатомъ 35 „

84. Карандашъ золотой, выдвижной 23 „

85. Перстенбрь изъ блестящаго золота, съ рубиномъ на пуговкѣ замка 160 „

86. Футляръ золотой (концехранитель) для обыкновеннаго карандаша 45 „

87. Запонки мужскiя, вогнутыя, изъ матоваго золота . . 23 „

88. Запонки мужскiя изъ матоваго битаго золота, съ сафирами 45 „

Большой выборъ золотыхъ запоновъ всевозможныхъ фасоновъ и на различныя цѣны.

89. Флаконъ для духовъ, изъ матоваго гравированнаго золота, внизу сплющенный, съ рубинами и розами . 72 „

90. Мундштукъ изъ янтаря съ золотыми накладными украшенiями, съ двумя гранатами 25 „

Мундштуки разныхъ размѣровъ, съ различными украшенiями изъ золота и драгоцѣнныхъ камней, на всевозможныя цѣны.

91. Пряжка двухсторонняя для сорти-де-баль, изъ матоваго битаго золота съ шестью гранатами въ формѣ вишенъ 75 „

Всѣ рисунки представляются болѣе яркими и близкими къ дѣйствительности если смотрѣть на нихъ черезъ лупу.

— 19 —

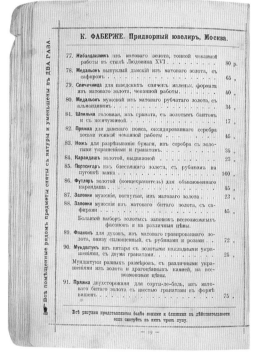
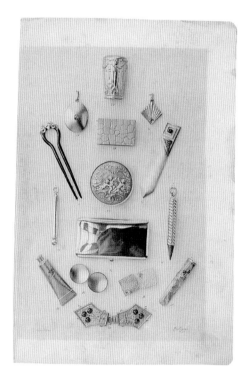

УМЕНЬШЕНО НА ПОЛОВИНУ.

92.

OBJET D'ART.

Изображенная здѣсь въ уменьшенiи статуэтка представляетъ собою грацiозное произведенiе искусства, одинъ изъ прелестнѣйшихъ образцовъ художественной работы и изящнаго вкуса.

Чаша съ дракономъ, расположенная наверху, сдѣлана изъ минерала нефрита, усыпаннаго жемчужинами и мелкими драгоцѣнными камешками. Самая фигура высѣчена изъ довольно рѣдкаго и дорогого камня — дымчатаго топаза, перехваченнаго внизу серебряными покрываломъ. Вся нижняя часть представляетъ четыреугольную колонну изъ краснаго мрамора, обвитую тонкой работы золотымъ ажуромъ, съ вкрѣпленными въ него маленькими камнями.

Уменьшена на половину.

Цѣна 4000 рублей.

Всѣ рисунки представляются болѣе яркими и близкими къ дѣйствительности, если смотрѣть на нихъ черезъ лупу.

— 21 —

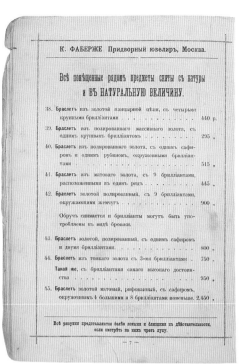
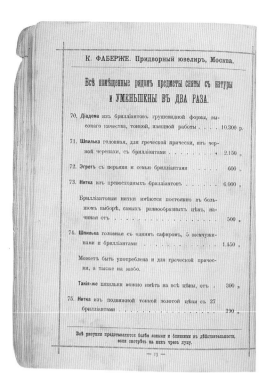

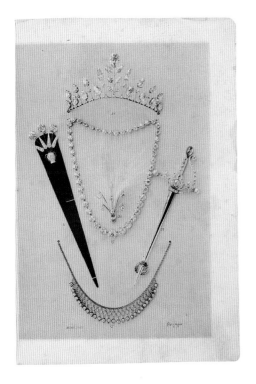

Бриллiантовая нитка снятая съ натуры
И ВЪ НАТУРАЛЬНУЮ ВЕЛИЧИНУ.

76.

Нитка изъ крупныхъ бриллiантовъ, ровнаго блеска и замѣчательно чистой воды. По величинѣ составляющихъ ея бриллiантовъ и по высокому достоинству ихъ, настоящая нитка представляетъ собою довольно рѣдкiй экземпляръ, заслуживая особеннаго вниманiя, какъ вещь, выступающая изъ ряда обыкновенныхъ.

Самый крупный нижнiй бриллiантъ, по желанiю, можетъ быть снятъ и употребленъ въ видѣ брошки.

На рисункѣ нитка воспроизведена въ ея натуральную величину.

Цѣна—35.000 рублей.

Всѣ рисунки представляются болѣе изящни и близкими къ дѣйствительности, если смотрѣть на нихъ чрезъ лупу.

— 17 —

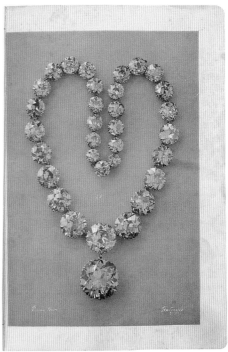

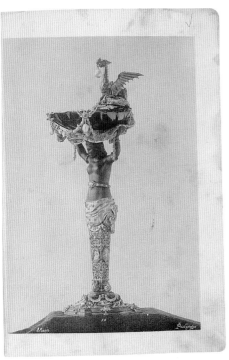

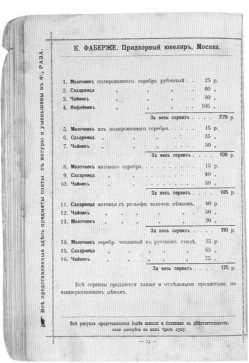

1. Молочникъ полированнаго серебра рубчатый	. .	25	р.
2. Сахарница	„	60	„
3. Чайникъ	„	80	„
4. Кофейникъ	„	105	„

За весь сервизъ 270 р.

5. Молочникъ изъ полированнаго серебра	15	р.
6. Сахарница	„	35	„
7. Чайникъ	„	50	„

За весь сервизъ 100 р.

8. Молочникъ матоваго серебра	15	р.
9. Сахарница	„	40	„
10. Чайникъ	„	50	„

За весь сервизъ 105 р.

11. Сахарница матовая съ рельефн. золочен. ѣнкомъ.		40	р.
12. Чайникъ	„	50	„
13. Молочникъ	„	20	„

За весь сервизъ 110 р.

14. Молочникъ серебр. чеканный въ русскомъ стилѣ.		35	р.
15. Сахарница	„	65	„
16. Чайникъ	„	75	„

За весь сервизъ 175 р.

Всѣ сервизы продаются также и отдѣльными предметами, по вышеуказаннымъ цѣнамъ.

Всѣ рисунки представляются болѣе изящни и близкими въ дѣйствительности, если смотрѣть на нихъ чрезъ лупу.

Всѣ представленные здѣсь предметы сняты съ натуры и уменьшены въ 4½ РАЗА.

— 23 —

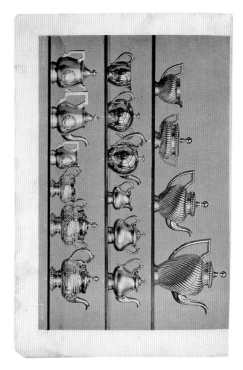

20. Спичечница глиняная въ два отдѣленія, на ножкахъ, чеканной работы 27 р.
21. Чернильница темнаго мрамора, съ оксидирован. крышкой, чеканной работы 68 „
22. Рамка плюшевая съ оксидированной накладной отдѣлкой 47 „
23. Чернильница хрустальная, рифрованная, съ оксидированной крышкой, чеканной работы 65 „
24. Пепельница глиняная, съ серебрян. оксидированной отдѣлкой, чеканной работы 32 „
25. Портъ-сигаръ матовый, серебрян. 21 „
26. Портъ-сигаръ изъ битаго серебра 26 „
27. Портъ-сигаръ серебрян, съ широкими рубцами 21 „
28. Портъ-сигаръ серебр., съ художественной отдѣлкой, съ фигурами въ античномъ стилѣ 78 „
29. Портъ-сигаръ оксидирован, чеканной работы 50 „
30. Ящикъ для марокъ чеканной работы, оксидиров. 40 „
31. Пепельница чеканной работы, оксидиров. 16 „
32. Бокалъ для папиросъ въ видѣ цилиндра, съ фигуркой амура 53 „
33. Ящикъ для папиросъ и сигаръ, въ два отдѣленія, съ накладными словами „cigares" и „cigarettes" и съ ручкой изъ слоновой кости 135 „
34. Печать въ видѣ фигурки купидона, оксидиров. 32 „
35. Пепельница оксидированн., чеканной работы 53 „

Всѣ рисунки представляются болѣе лощими и близкими къ дѣйствительности, если смотрѣть на нихъ трезъ лупу.

— 25 —

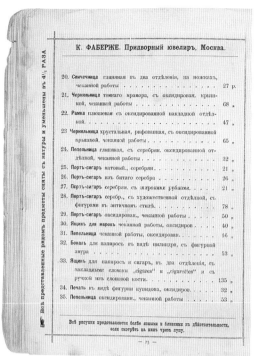

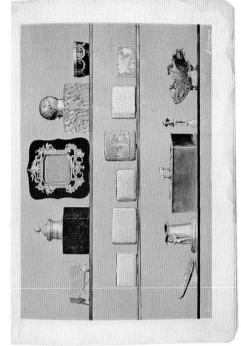

36, 45, 62 и 63. Кольца для салфетокъ серебряныя, различныхъ фасоновъ и отдѣлокъ въ большомъ выборѣ, отъ 5 р. до 25 р. — к.
37. Стаканъ-чарка съ ручкой серебр., съ гравиров. амурами. — „ —
38. Стаканъ-чарка серебр. безъ ручки, плетеный 11 „ —
39. Подстаканникъ серебр. плетеный 32 „
40, 42, 44. Сервизъ чайный большого размѣра, состоящій изъ трехъ предм.: чайника, сахарницы и молочника, художественной чеканной работы въ стилѣ Людовика XV, оксидированный, цѣна за весь сервизъ 405 „

Продается и отдѣльными предметами:
Чайникъ 190 р.
Сахарница 135 „
Молочникъ 80 „

41. Солонка въ формѣ полуутца на куриныхъ ножкахъ, матовая 8 „
43. Солонка въ видѣ цвѣтка, оксидированная 9 „
46. Солонка художеств. чеканной работы, въ стилѣ Людовика XV 25 „
47. Молочникъ серебр. матовый 18 „
48. Молочникъ серебр. полированный 20 „ 50
49. Солонка большая полированная, съ широкими рубцами 18 „
50. Солонка чеканной работы въ стилѣ Людовика XV 26 „
51. Бокалъ матовый 21 „
52. Солонка серебр. круглая, въ видѣ плетеной корзинки съ ручкой 21 „ 50
53. Солонка серебр. матовая 8 „
54. Солонка чеканной работы въ стилѣ Людовика XV 12 „
55. Молочникъ оксидирован. битаго серебра 43 „
56. Молочникъ полированный 45 „
57. Сахарница съ вогнутыми боками и съ ручкой 35 „
58. Сахарница сер. полированная съ ручкой 31 „
59. Сахарница серебр. полиров. съ вогнутыми боками и съ голубемъ на краю 45 „
60. Молочникъ матовый 18 „
61. Солонка въ видѣ утки, оксидированная, чеканной работы, съ ложкой 17 „

Всѣ рисунки представляются болѣе лощими и близкими къ дѣйствительности, если смотрѣть на нихъ трезъ лупу.

— 27 —

Всѣ помѣщенные рядомъ предметы сняты съ натуры и УМЕНЬШЕНЫ ВЪ 7 РАЗЪ.

76. Ваза матоваго серебра, съ дельфиномъ и листьями, чеканной работы, съ гладкимъ хрусталемъ 150 р.
77. Ваза оксидированнаго серебра, чеканной работы, съ гранеными хрусталемъ 235 „
78. Ваза оксидированная, чеканной работы, съ гранеными хрусталемъ 240 „
79. Ведро для чистаго льду изъ гранеаго хрусталя, ободокъ и ручка оксидированные, чеканной работы 100 „
80. Салатникъ изъ гранеаго хрусталя съ гладкимъ ободкомъ полированнаго серебра 58 „
81. Салатникъ изъ прекраснаго гранеаго хрусталя съ оксидированнымъ ободкомъ чеканной работы 98 „
82. Чайница изъ гранеаго хрусталя, съ двумя гладкими полированными крышками 75 „
83. Ваза оксидированная, чеканной работы, съ рисованными хрусталемъ 75 „
84. Ваза вся серебряная, роскошной художественной чеканки въ стилѣ Людовика XV 325 „
85. Салатникъ весь серебряный, полированный, глубоко-рифрованный, съ чеканнымъ щиткомъ 155 „

Всѣ рисунки представляются болѣе лощими и близкими къ дѣйствительности, если смотрѣть на нихъ трезъ лупу.

— 31 —

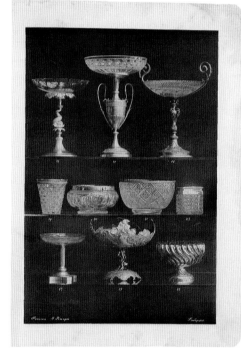

Всѣ помѣщенные рядомъ предметы сняты съ натуры и УМЕНЬШЕНЫ ВЪ 3½ РАЗА.

86. Молочникъ полиров. гравированъ 40 р. — к.
87. Сахарница 60 „
88. Чайникъ 90 „
89. Кофейникъ 110 „

За весь сервизъ 300 р. — к.

92. Молочникъ оксид. чекан, съ ручкой въ видѣ дракона 60 „
93. Сахарница 125 „
94. Чайникъ 140 р. — к.

За весь сервизъ 325 р. — к.

98. Сахарница золочен., матов., съ эмалью 65 „
99. Молочникъ 35 „
100. Чайникъ 90 р. — к.

За весь сервизъ 190 р. — к.

90. Солонка серебряная, чеканной работы 14 р. — к.
91. Подстаканникъ серебр. гладкій, матов. (безъ ложки) 15 „
такой же, гравированный 19 „
95. Подстаканникъ ажурный, чеканной работы, оксидированный 29 „
96. Солонка серебряная, золоченая, съ эмалью 21 „
такъ же, золоченая, съ эмалью 8 „ 50
97. Подстаканникъ серебряный, золоченый, съ эмалью (безъ ложки) 47 „

Всѣ рисунки представляются болѣе лощими и близкими къ дѣйствительности, если смотрѣть на нихъ трезъ лупу.

— 31 —

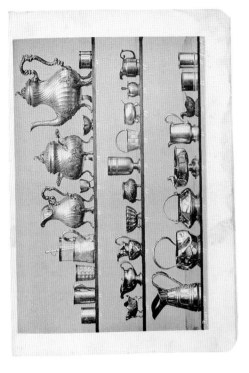

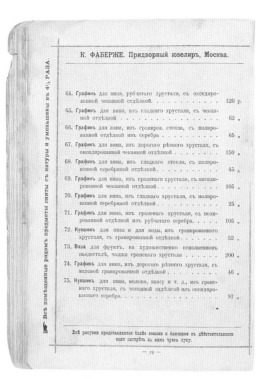

К. ФАБЕРЖЕ. Придворный ювелиръ, Москва.

64. Графинъ для вина, рубчатаго хрусталя, съ оксидированной чеканной отдѣлкой. 120 р.

65. Графинъ для вина, изъ гладкаго хрусталя, съ чеканной отдѣлкой. 62 „

66. Графинъ для вина, изъ граврен. стекла, съ полированной отдѣлкой изъ серебра. 65 „

67. Графинъ для вина, изъ дорогого рѣзного хрусталя, съ оксидированной чеканной отдѣлкой. 150 „

68. Графинъ для вина, изъ гладкаго стекла, съ полированной серебряной отдѣлкой. 45 „

69. Графинъ для вина, изъ граненаго хрусталя, съ оксидированной чеканной отдѣлкой. 105 „

70. Графинъ для вина, изъ гладкаго хрусталя, съ полированной серебряной отдѣлкой. 25 „

71. Графинъ для вина, изъ граненаго хрусталя, съ полированной отдѣлкой изъ рубчатаго серебра. 105 „

72. Кувшинъ для пива и для воды, изъ гравированнаго хрусталя, съ гравированной отдѣлкой. 52 „

73. Ваза для фруктъ, на художественно исполненномъ пьедесталѣ, чашка граненаго хрусталя. 200 „

74. Графинъ для вина, изъ дорогого рѣзного хрусталя, съ матовой гравированной отдѣлкой. 46 „

75. Кувшинъ для пива, молока, квасу и т. д., изъ граненаго хрусталя, съ чеканной отдѣлкой изъ оксидированнаго серебра. 97 „

Всѣ помѣщенные рядомъ предметы сняты съ натуры и уменьшены въ 4½ РАЗА.

Всѣ рисунки представляются болѣе лѣвши и близкими въ дѣйствительности если смотрѣть на нихъ чрезъ лупу.

— 19 —

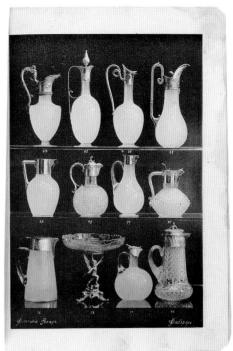

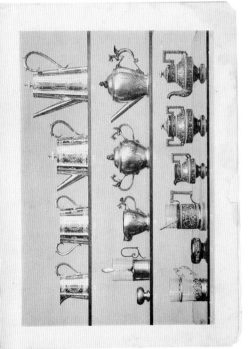

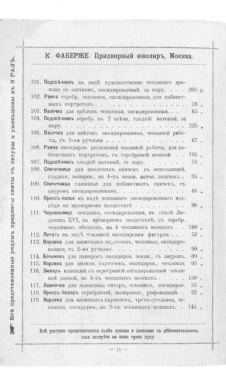

К. ФАБЕРЖЕ. Придворный ювелиръ, Москва.

101. Подсвѣчникъ въ видѣ художественно чеканнаго дракона со щиткомъ, оксидированный, за пару. . . . 260 р.

102. Рамка серебр. чеканная, оксидированная, для кабинетныхъ портретовъ. 59 „

103. Вазочка для цвѣтовъ чеканная, оксидированная. . 65 „

104. Подсвѣчникъ серебр. на 2 свѣчи, гладкій матовый, за пару. 225 „

105. Вазочка для цвѣтовъ оксидированная, чеканной работы, съ 3-мя ручками 67 „

106. Рамка оксидиров. роскошной чеканной работы, для кабинетныхъ портретовъ, съ серебряной ножкой . 195 „

107. Подсвѣчникъ гладкій матовый, за пару. 58 „

108. Спичечница для шведскихъ спичекъ съ пепельницей, гладкая, полиров., на 4-хъ чекан. матов. ножкахъ. 35 „

109. Спичечница гладкая для кабинетныхъ спичекъ, съ амуромъ оксидированнымъ. 45 „

110. Прессъ-папье въ видѣ чеканнаго оксидированнаго медвѣдя на мраморномъ пьедесталѣ 98 „

111. Чернильница чеканная, оксидированная, въ стилѣ Людовика XVI, на мраморномъ пьедесталѣ, съ серебрчеканнымъ ободкомъ, на 4 чеканныхъ ножкахъ. . . 240 „

112. Печать въ видѣ чеканной оксидиров. фигурки . . . 53 „

113. Корзина для визитныхъ карточекъ, чеканная, оксидированная, съ 2-мя ручками. 90 „

114. Боченокъ для папиросъ оксидиров. чекан., съ амуромъ. 60 „

115. Корзина для визитн. карточекъ, оксидиров. чеканная. 95 „

116. Бюваръ кожаный съ серебряной оксидированной чеканной доской, на 4-хъ чеканныхъ ножкахъ . . . 150 „

117. Лампочка для зажиганія сигаръ, чеканная, оксидиров. 35 „

118. Прессъ-бюваръ серебряный, полированн., рифленый. . 22 „

119. Корзина для визитныхъ карточекъ, трехъ-угольная, чеканная, оксидиров., на 3-хъ чеканныхъ ножкахъ. . 145 „

Всѣ представленные рядомъ предметы сняты съ натуры и уменьшены въ 6 РАЗЪ.

Всѣ рисунки представляются болѣе лѣвши и близкими въ дѣйствительности, если смотрѣть на нихъ чрезъ лупу.

— 55 —

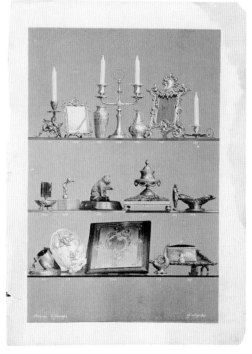

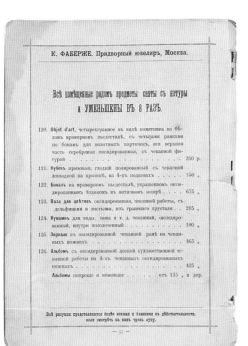

Всѣ помѣщенные рядомъ предметы сняты съ натуры
и УМЕНЬШЕНЫ ВЪ 8 РАЗЪ.

120. Objet d'art, четырехгранное въ видѣ памятника на бѣ-
ломъ мраморномъ пьедесталѣ, съ четырьмя рамками
по бокамъ для визитныхъ карточекъ, вся верхняя
часть серебряная оксидированная, съ чеканной фи-
гурой 260 р.

121. Кубокъ призовый, гладкій полированный съ чеканной
лошадкой на крышкѣ, на 4-хъ подковахъ 150 „

122. Бокалъ на мраморномъ пьедесталѣ, украшенномъ окси-
дированнымъ ѳіадокомъ въ античномъ жанрѣ . . . 675 „

123. Ваза для цвѣтовъ оксидированная, чеканной работы, съ
дельфинами и листьями, изъ гранёнаго хрусталя . . 215 „

124. Кувшинъ для воды, пива и т. д. чеканный, оксидиро-
ванный, внутри позолоченный 180 „

125. Зеркало въ оксидированной чеканной рамѣ на чекан-
ныхъ ножкахъ 465 „

126. Альбомъ съ оксидированной доской художественной че-
канной работы на 4-хъ чеканныхъ оксидированныхъ
ножкахъ 425 „

Альбомы попроще и поменьше отъ 135 „ и дор.

Всѣ рисунки представляются болѣе копіи и ближними къ дѣйствительности,
если смотрѣть на нихъ чрезъ лупу.

— 37 —

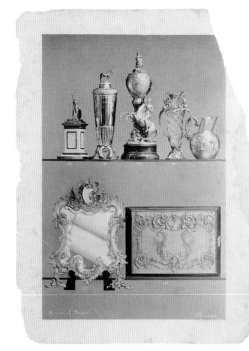

Всѣ помѣщенные рядомъ предметы сняты съ натуры
и УМЕНЬШЕНЫ ВЪ 1½ РАЗА.

Столовое серебро гладкое, обыкновеннаго фасона.

1. Ложки столовыя, гладкія, за дюжину 60 р.
2. Ножи столовые, гладкіе, со стальными лезвіями, за дюж. 57 „
3. Вилки столовыя, гладкія, „ 60 „
4. Ложки дессертныя гладкія „ 33 „
5. Ножи дессертные, съ серебр. лезвіями, „ 62 „
6. Вилки дессертныя гладкія „ 33 „
7. Ложечки чайныя, гладкія, „ 19 „
8. Ложечки кофейныя, гладкія, „ 17 „

Всѣ указанныя выше цѣны относятся ко времени пе-
чатанія настоящаго прейсъ-куранта. Цѣны эти не постоян-
ныя, такъ какъ стоятъ въ зависимости отъ колебанія кур-
са и измѣненія стоимости серебра. При опредѣленіи цѣнъ
принятъ въ разсчетъ средній вѣсъ столоваго серебра, но,
при желаніи, можно получить серебро болѣе тяжелое или
легкое, съ соразмѣрнымъ измѣненіемъ въ цѣнѣ.

Соусныя ложки и лопатки см. стр. 47 и 49.

Всѣ рисунки представляются болѣе копіи и ближними къ дѣйствительности,
если смотрѣть на нихъ чрезъ лупу.

— 39 —

Всѣ помѣщенные рядомъ предметы сняты съ натуры
и УМЕНЬШЕНЫ ВЪ 1½ РАЗА.

Столовое серебро чеканное въ стилѣ Людовика XV. № 1.

17. Ложки столовыя, чеканной работы за дюж. 118 р.
18. Ножи столовые, со стальн. лезвіями „ 69 „
19. Вилки столовыя, „ 114 „
20. Ложки дессертныя, чеканной работы, „ 76 „
21. Ножи дессертные, съ серебрянымъ лезвіями, . „ 62 „
22. Вилки дессертныя, чеканной работы, „ 62 „
23. Ложечки чайныя, чеканной работы, „ 38 „
24. Ложечки кофейныя, чеканной работы, „ 30 „

Столовое серебро въ стилѣ Людовика XV отличается
художественной отдѣлкой и тонкой работой. Всѣ пред-
меты этого серебра дѣлаются преимущественно съ поли-
рованными копьями и оксидированными ручками, что
придаетъ имъ извѣстную красоту и изящество; однако,
по желанію, можно ихъ также дѣлать и матовыми. Вѣсъ
этого серебра вообще превышаетъ обыкновенный.

Всѣ рисунки представляются болѣе копіи и ближними къ дѣйствительности,
если смотрѣть на нихъ чрезъ лупу.

— 43 —

Всѣ помѣщенные рядомъ предметы сняты съ натуры
и УМЕНЬШЕНЫ ВЪ 1½ РАЗА.

Столовое серебро чеканное, № 2.

25. Ложки столовыя, чеканныя за дюж. 123 р.
26. Ножи столовые, со стальными лезвіями . . . „ 69 „
27. Вилки столовыя, чеканныя „ 100 „
28. Ложки дессертныя, чеканныя „ 81 „
29. Ножи дессертные, съ серебрянымъ лезвіями . . „ 67 „
30. Вилки дессертныя, чеканныя „ 67 „
31. Ложечки чайныя, чеканныя „ 38 „
32. Ложечки кофейныя, чеканныя „ 30 „

Столовое серебро чеканное № 2 отличается художе-
ственной отдѣлкой и тонкой работой. Всѣ предметы это-
го серебра дѣлаются преимущественно съ полированными
копьями и оксидированными ручками, что придаетъ имъ
извѣстную красоту и изящество; однако, по желанію, мож-
но ихъ также дѣлать и матовыми. Вѣсъ этого серебра
вообще превышаетъ обыкновенный.

Всѣ рисунки представляются болѣе копіи и ближними къ дѣйствительности,
если смотрѣть на нихъ чрезъ лупу.

— 45 —

К. ФАБЕРЖЕ Придворный ювелиръ, Москва.

Всѣ помѣщенные рядомъ предметы сняты съ натуры и УМЕНЬШЕНЫ ВЪ 1½ РАЗА.

Столовое серебро гладкое, американскаго фасона.

9. Ложки столовыя, гладкія за дюж. 60 р.
10. Ножи столовые, гладкіе, со стальными лезвіями . » 57 .
11. Вилки столовыя, гладкія » 60 .
12. Ложки десертныя, гладкія » 33 .
13. Ножи десертные гладкіе съ серебр., лезвіями . . » 62 .
14. Вилки десертныя гладкія » 35 .
15. Ложечки чайныя, гладкія » 19 .
16. Ложечки кофейныя, гладкія » 17 .

Всѣ указанныя выше цѣны относятся ко времени печатанія настоящаго прейсъ-куранта. Цѣны эти не постоянныя, такъ какъ стоятъ въ зависимости отъ колебанія курса и измѣненія стоимости серебра. При опредѣленіи цѣнъ принятъ въ разсчетъ средній вѣсъ столоваго серебра, но, при желаніи, можно получать серебро болѣе тяжелое или легкое, съ соразмѣрнымъ измѣненіемъ въ цѣнѣ.

Соусныя ложки и лопатки см. стр. 47 и 49.

— 4? —

Всѣ рисунки представляются болѣе ясными и блѣдными въ дѣйствительности, если смотрѣть на нихъ сразъ близко.

RUSSIAN HALLMARKS AT THE TURN OF THE 19TH CENTURY

The Fabergé hallmark depicts a woman's head in a peasant *kokoshnik* headdress, turned to the left. Up until recently Fabergé specialists have disagreed about when the hallmark came into existence. The most authoritative reference book on the stamps of Russian masters in gold and silver by M. M. Postnikova Loseva, sets this date as January 1, 1899. Western researchers, who did not have the opportunity of either confirming or disproving this date, accepted this conclusion. Moreover, hardly anyone paid attention to the fact that the handbook describes three marks of assay for St. Petersburg with the initials of assay masters: "The stamps of the St. Petersburg assay department with the initials of assay inspectors Yakov Lyapunov, 1899–1903 [Ya. L.], A. Richter 1898–1903 and Alexander Vasilievich Romanov [A. R.]."[1]

In 1993 the researcher Ann Odom suggested reverting to 1896 as the date for the introduction of the new hallmark (with the woman's head), as it was before 1983.[2] Among other arguments, Odom referred to the authority of K. Snowman, who had suggested a date of 1896–1908 in his monograph in 1953.[3]

Recently conducted research, analyzing archive documents in the Russian assay department and the Legal Code of the Russian Empire, finally confirms that Postnikova-Loseva was correct. Precisely on January 1, 1899, a hallmark was legislatively introduced bearing a new image – "a woman's head in peasant's *kokoshnik* headdress, turned to the left". Beneath the head were the initials of the acting director of the assay district – there could only ever be one director representing each area. In August 1898 Yakov Nikolaevich Lyapunov was appointed director of the St. Petersburg assay district. In this post he replaced Nikolai Vasilevich Kulakov. If stamps with the leader's initials had been introduced in 1897 or 1898, then we would see St. Petersburg marks of assay with the initials "N. K.", but no such marks exist. Yakov Lyapunov died on March 28, 1904, and is buried in the cemetery of the St. Petersburg Novodevichii Monastery, where a year before August Holström and Michael Perchin were laid to rest – eminent master-jewelers of the House of Fabergé.

On April 1, 1904, Alexander Vasilevich Romanov, former director of the Riga assay district, was appointed to the post of director of the St. Petersburg assay district. Between 1896 and 1910 the assay department's system for the Astrakhan province was run by assay-master Anton Vasilevich Richter, but he had no directorial duties regarding St. Petersburg and so did not have his initials used in the hallmark. There was, however, Lieutenant-General Alexander Alexandrovich Richter, a Privy Councillor to the Ministry of Finance but he died at the beginning of 1899 and was no relation to the Astrakhan province Director of Assay. As a result of this it can now be confirmed that the initials A. R. only belonged to the assay-master Alexander Romanov.

On February 1, 1899, Ivan Sergeevich Lebedkin, who had until then occupied the post of director of the Warsaw Assay district, began his duties as head of the Moscow assay district. Lebedkin died in the post of director in 1915. His initials were marked on Moscow's assay marks from 1899 to 1908.

On March 1, 1908, Russian marks of assay changed. The woman's head was turned to the right, the stamps became more difficult to forge and, instead of the initials of the director of the assay districts and provinces, a system of Greek letters was introduced to identify districts. Sometimes a simplified version of the system was used, which consisted of different patterns of dots next to the head to identify each district. This system of

Notes

1. M. M. Postnikova-Loseva (ed.) (1983), p. 259.

2. Anne Odom, Fabergé – the Court Jeweler (1993).

3. Snowman (1953).

hallmarking continued until the beginning of 1920, when soviet marks of assay gradually began to be introduced.

The new assay regulations in operation from 1899 replaced the regulations used from 1882 consisting of the district's coat-of-arms, the year of stamping and the initials of the assay master. In 1896, the new system was replaced with a model which was Imperially approved on March 11, and put into practice on July 1. This is why the last hallmark-triplets were marked in 1896. The remaining question concerns which stamps were operative between July 1, 1896 and January 1, 1899 – a period of two-and-a-half years. In any case, the stamps with the heads and initials of the assay department directors were not used. A contemporary encyclopedia of 1898 states, under "Assay Business":

"The stamps applied by assay-masters consist of (a) The coat-of-arms of the town in which the article was subjected to investigation and (b) a stamp with two figures, signifying the number of zolotniks of pure metal per pound of alloy… Of the double marks (a combination of these two stamps in one hallmark) large ones (4×2mm) and small ones (3×1.5mm) are employed. Each artefact presented for investigation, must have the stamp of the master who prepared it (the name-stamp)."[4]

Precisely this sort of double assay stamp, with the coat-of-arms of St. Petersburg and the '56' assay (14-carat gold), is found on the Imperial Easter Eggs of 1897–8, while on the eggs of 1899 and later we find the St. Petersburg assay marks with initials of the director of the assay district.

The new research supports evidence provided by the Fabergé artefacts themselves. The year 1899 has now been proved to mark the start of the new hallmark. This clarification of information regarding the hallmark systems means that the chronological attribution of artefacts of Russian jewelery needs to be revisited and where necessary changed.

The stamps of the master Michael Perchin who died in 1903 cannot overlap in time with the assay marks "A. R." of Alexander Romanov only introduced on April 1, 1904. There are only a few artefacts – perhaps no more than 500 items – with the stamps of the master Wigström and previous assay director Yakov Lyapunov "Ya. L.". There should be very few artefacts of the master Viktor Aarne with the stamp of the director of the assay district, Alexander Romanov "A. R.". Aarne, as is well known, finished working with Fabergé in 1904. It would also be scarcely possible that artefacts of the master Armfeldt, who replaced Aarne, to carry the stamp "Ya. L.", Yakov Lyapunov.

Based on the above fact, a more accurate understanding of the timing of the production of Fabergé artefacts is now possible, resulting from the initials of the two St. Petersburg assay directors on the hallmark: 1899–1904 (until April 1) and 1904 (April 1) –1908 (March 1).

Valentin Skurlov

4. Brockhaus and Efron "The Assay Business" in Encyclopaedia of Brockhaus and Efron, Vol. XXV, St. Petersburg 1898.

ОТДѢЛЪ ПРОМЫШЛЕННОСТИ

сим объявляетъ о введеніи въ дѣйствіе Пробирными Установленіями, согласно ... "Правиламъ клейменія", опубликованнымъ въ "Собраніи узаконеній и распоряженій Правительства" 1899 г. № 1, ст. 9, нижеслѣдующихъ, взамѣнъ пробирныхъ клей... ...мъ прежнихъ образцовъ, новыхъ пробирныхъ клеймъ для золотыхъ и серебряныхъ издѣлій, сусальныхъ металлов... ...и слитковъ золота и серебра.

Наименованіе клеймъ.	Размѣры.	Рисунки клеймъ.	Назначеніе клеймъ.	Примѣ...нія.
а) Знакъ удостовѣренія.	Большой.		Для издѣлій внутренняго производства и заграничныхъ и для слитковъ.	Клейма: а, ...ныхъ проб... товъ отлич... никомъ (...ми буквам... и фа... миліи) У... Округомъ.
	Малый.			
б) Двойникъ	Большой.		Для издѣлій внутренняго производства (золотыхъ 56-й и 72-й пробъ и серебряныхъ 84-й и 88-й пробъ).	
	Малый.		Для издѣлій внутренняго производства (9-ти узаконенныхъ пробъ).	
в) Двойникъ	—	56ил		
г) Двойникъ	—		Для заграничныхъ издѣлій, кромѣ сусальныхъ металловъ.	Клеймо г ...ныхъ... ...личается (начально... миліи) У... Округомъ.

Рисунки клеймъ: *а, б, в, г, д, е, ж, з* ... увеличены въ шесть разъ.
 " " *и, і, к, л* увеличен... ...ъ два раза.

Подписалъ: Управляющій Отдѣломъ ... Н. Лангоовой.

Наименованіе клеймъ.	Размѣры.	Рисунки клеймъ.	Назначеніе клеймъ.	
д) Клеймо пробы	Большой.	56	Для издѣлій внутренняго производства и заграничныхъ.	
	Малый.	56		
е) Знакъ удостовѣренія	—		Для удовлетворяющихъ пробѣ издѣлій.	Предъявляемыхъ по ст. 32 и 33 Уст. Проб. (1896 г.)
ж) Условный знакъ	—		Для невышедшихъ въ пробу издѣлій.	
з) Знакъ удостовѣренія	—		Для издѣлій вывозимыхъ за границу.	
и) Двойникъ (для печатанія на сургучѣ).	—	56	Для сусальныхъ металловъ внутр. произв. и загран. (11-ти узак. пробъ).	
і) Клеймо для пломбированія (на свинцѣ)	—	56	Для часовъ и издѣлій, недопускающихъ наложенія клеймъ непосредственно на частяхъ издѣлія.	
к) Наборное клеймо	—	№ 123 С З	Для слитковъ.	

BIBLIOGRAPHY

GENERAL
BOOKS AND ARTICLES

Baer 1993
Baer, Winfried. *Punk Tabatièren Friedrichs des Grossen*. Hirmer Verlag München, 1993

Bainbridge 1949
Bainbridge, Henry Charles. *Fabergé Fabergé: Goldsmith and Jeweller to the Russian Imperial Court*. London, 1949

Bianchi 1999A
Bianchi, Robert S. *Nicholas and Alexandra – The last Imperial Family of Tsarist Russia Exhibition Album*. London, 1999

Bianchi 1999B
Bianchi, Robert S. *Splendors of the Meiji: Treasures of Imperial Japan*. Masterpieces from the Khalili Collection. Wilmington, 1999

Berniakovich 1956
Berniakovich, Z.A., Sokolova T.M., Torneus M.I. *State Hermitage. Silver in the Arts 16th–20th centuries*. Exhibition Guide (in Russian). Moscow, 1956

Berniakovich 1977
Berniakovich, Z.A. *Russian Artistic Silver. 17th–20th centuries in the Hermitage Collection*. Leningrad, 1977

Berniakovich et al. 1979
Berniakovich, Z.A., Kaliazina, N.V., Komelova G.N., et al. *State Hermitage. Monuments of Russian artistic culture 10th – early 20th centuries* (in Russian). Moscow, 1979

Broughton 1998
Broughton International Inc. *Nicholas and Alexandra, The Last Imperial Family of Tsarist Russia*. London, 1998

Buxhoeveden 1938
Buxhoeveden, Baroness Sophie. *Before the Storm*. London, 1938

Cerwinske 1990
Cerwinske, Laura. *Russian Imperial Style*. New York, 1990

Clarke 1996
Clarke, William. *The Last Fortune of the Tsars*. New York, 1996

Duncan 1994
Duncan, A. *The Paris Salons 1895–1914, Vol. II. Jewelry*. Antique Collector's Club, 1994

Duncan 1999
Duncan, A. *The Paris Salons 1895–1914, Vol. V. Objets d'Art & Metalware*. Antique Book Collectors' Club, 1999

Fersman 1924–6
Fersman, A. E. *Les Joyeaux du Trésor de Russie (Commissariat National des Finances)*. Moscow, 1924–6

Goldberg 1967
Goldberg, T.G., Mishukov F Ya., Platonova N.G. and Postnikova-Loseva, M.M. *Russian Gold and Silverwork 15th – 20th centuries*. Moscow, 1967

Gray 1962
Gray, Camilla. *The Russian Experiment in Art 1863–1922*. (revised and enlarged by Marian Burleigh-Motley). London, 1962

Habsburg 1995
von Habsburg, Géza. "When Russia Sold its Past" in *Art & Auction* March 1995, pp. 94–97, 128

Impey/MacGregor 1985/7
Impey, Oliver and MacGregor, Arthur. *The Origins of Museums*. Clarendon Press, Oxford, 1985/7

Impey/Fairley 1995
Impey, Oliver and Fairley, Malcom. *The Nasser D. Khalili Collection of Japanese Art II. Metalwork. Part I*. London, 1995

Kaliazina et al. 1987
Kaliazina, N.V., Komelova, G.N., Kostochkina, N.D. and Orlova, K.A. *Russian Enamel 12th – early 20th centuries from the State Hermitage Collection* (in Russian). Leningrad, 1987

Kirichenko 1991
Kirichenko, E. *Russian Design and the Fine Arts 1750–1917*. New York, 1991

Leningrad 1974
Applied Arts of the Late Nineteenth and Early Twentieth Century (in Russian). Leningrad, 1984

Leningrad 1987
Russian Enamels from the Twelfth to the beginning of the Twentieth Century in the Collection of the Hermitage (in Russian). Leningrad 1987

Leningrad 1991
Culture and Art Objects purchased by the Hermitage in 1988–1990 (in Russian). Leningrad, 1991

Maylunas/Mironenko 1977
Maylunas, Andrei and Mironenko, Sergei. *A Lifelong Passion. Nicholas and Alexandra, Their Own Story*. New York, 1997

M.L. "Why to no-one's sensation, the court ruled against Giuliani in the Brooklyn Museum Law Suit" in *The Art Newspaper* 99, January 2000 February 2000, p. 71, p.45

Moncrieff 2000
Moncrieff, Elspeth. "Diary of a Dealer" *The Art Newspaper* 99, January 2000, p.71

Odom 1991
Odom, Anne. *Fedor Solntsev, The Kremlin Service and the Origins of the Russian Style*. Hillwood Studies

Oman 1961
Oman, Charles. *The English Silver in the Kremlin*. London, 1961

Pollack 1999
Pollack, Barbara. "Opening Doors, and More" in *The Sunday New York Times*, 11 July 1999, *The City* section, p. 1

Postnikova-Loseva 1985
Postnikova-Loseva, M., Platonova, N., Ulyanova, B.I. and G. Smorodinova. *Historic Museum, Moscow* (in Russian). Leningrad, 1985

Romanovsky-Krassinski 1961
Romanovsky-Krassinski, HSH The Princess. *Dancing in St. Petersburg: The Memoirs of Kshessinskaya*. New York, 1961

Snowman 1966/1990
Snowman, A. Kenneth. *Eighteenth Century Gold Boxes of Europe*. London, 1966 (revised edition: Antique Collector's Club, 1990)

Snowman 1990
Snowman, A.K (ed). *The Master Jewelers*. Harry N. Abrams, 1990

Sogg 2000
Sogg, Daniel. "Fit for a Czar" in *Arts and Antiques*, January 2000, pp. 84–89

Sternin 1993
Sternin, Grigory. "Zritel I khudozhnik v Rossii na rubezhe XIX-XX vekov" in *Russkaya khudozhestvennaya kultura vtoroy poloviny XIX-nachala XX veka*. Moscow 1984, pp. 28–52 in Efimova, Alla and Manovich, Lev. (eds.). Tekstura. *Russian Essays on Visual Culture*. Chicago, 1993, pp. 89–114

Tillander-Godenhielm 1996
Tillander-Godenhielm, U. *Smycken från det Kejserliga St. Petersburg*. Hagelstam, Helsingfors, 1996

Taylor 1988
Taylor, Katrina V. H. *Russian Art at Hillwood*. Hillwood Museum, 1988

Vever 1908
Vever, H. *La Bijouterie Française au XIXe Siècle*. 3 vols, Paris 1906–1908 (re-edited Firenze, Studio Peb, Edizioni Scelte, 1975)

Williams/Ogden 1994
Williams, Dyfri and Ogden, Jack. *Greek Gold. Jewelry of the Classical World*. New York, 1994

World of Art 1991
The World of Art Movement in Early 20th Century Russia. Aurora Art Publishers, Leningrad, 1991

Youssoupoff 1927
Youssoupoff, Prince. *Rasputin: His Malignant Influence and His Assassination* (trans. Oswald Rayner). London, 1927

EXHIBITIONS

Aarhus 1990
Kunstkatte fra Zarenes Hof 1860–1917. Aarhus Kunstmuseum, 1990

Baltimore 1996
Odom, Anne. *Russian Enamels. From Kievan Rus to Fabergé*. The Walters Art Gallery, Baltimore, 1996

Belgrade 1985
Schätze aus dem Kreml. Belgrade, 1985

Bremen 1989
Das Gold aus dem Kreml. Übersee-Museum, Bremen, 1989

Copenhagen 1997
Kejserinde Dagmar. Maria Fjodorovna. Christiansborg Slot, Copenhagen, 1997

Florence 1982
Tesori del Kremlino. Firenze, 1982

Hillwood 1998/1999
Odom, Anne and Paredes Arend, Liana. *A Taste for Splendor. Russian Imperial and European Treasures from the Hillwood Museum*. (Shown at the Society of Four Arts, Palm Beach; Fresno Metropolitan Museum; Philbrook Museum of Art; Huntsville Museum of Art; Kalamazoo Institute of Arts; San Antonio Museum of Art)

Houston/Chicago 2000
Kremlin Gold. 1000 years of Russian Gems and Jewels. The Houston Museum of Natural Science/Field Museum, Chicago, 2000

Köln 1982
Russische Schatzkunst aus dem Moskauer Kreml und der Leningrader Eremitage. Wallraf- Richartz Museum, Cologne, 1982

Leningrad 1974
Applied Arts of the Late 19th Century – beginning of the 20th Century (in Russian). State Hermitage, Leningrad, 1974

Leningrad 1981
Metal in the art in Russia from the 17th to the beginning of the 20th centuries (in Russian). Leningrad, 1981

London 1935
Exhibition of Russian Art. One Belgrave Square, London, 1935

Limoges 1988
Les Émaux des Russes du 17ème au début du 20ème siècle. Limoges, 1988

London 1971
A Thousand Years of Enamel. Wartski, London, 1971

Lugano 1986
Ori e Argenti dall. Ermitage. Collection Thyssen-Bornemisza, Lugano-Castagnola, 1986

Museum of Natural History Vienna 1998
Catalogue. Museum of Natural History, Vienna, 1998

New York 1943
500 Years of Russian Art. Hammer Galleries, New York, 1943

New York 1954
Enamel. Cooper Union for Art and Decoration, New York, 1954

New York 1969
The Art of the Goldsmith & the Jeweler. A La Vieille Russie, New York, 1968

New York 1979
Treasures from the Kremlin. The Metropolitan Museum of Art, New York, 1979

Pforzheim 1990
100 Kostbarkeiten der Goldschmiedekunst aus der Staatlichen Eremitage, St. Petersburg. Schmuckmuseum, Pforzheim, 1990

Pforzheim 1996
Zarengold. 100 Kostbarkeiten der Goldschmiedekunst aus der Staatlichen Eremitage St. Petersburg. Schmuckmuseum, Pforzheim, 1996

St. Petersburg 1849
Directory of the St. Petersburg exhibition of industrial artefacts of the Russian Empire, the Kingdom of Poland and the Great Principality of Finland (in Russian). St. Petersburg, 1849

St. Petersburg 1993
Treasures of the Czars from the State Museum of the Moscow Kremlin. Florida International Museum, St. Petersburg, 1993

St. Petersburg 1996
Historic Method in Russia. Style and era in the decorative arts 1820s–1890s (in Russian). St Petersburg, 1996 Exhibitions (Competitors)

Torre Canavese 1994
Gemme e Diamanti dal Kremlino. Galleria M. Datrino, Torre Canavese, 1994

Wilmington (or Bianchi) 1999
Bianchi, Robert S. *Nicholas & Alexandra.* Riverfront Arts Center, Wilmington, Delaware, 1999

Wilmington 1999
Bianchi, Robert S. *Splendors of the Meji: Treasures of Imperial Japan.* Masterpieces from the Khalili Collection. Wilmington, 1999

FABERGÉ
BOOKS

Bainbridge 1933
Bainbridge, Henry C. *Twice Seven.* London, 1933

Bainbridge 1949/1966/1974
Bainbridge, Henry C. *Peter Carl Fabergé.* Batsford, 1949 (revised editions 1966, 1974)

Booth 1990
Booth, John. *The Art of Fabergé.* Secaucus, New Jersey, 1990

Curry 1995
Curry, David Park. *Fabergé.* Virginia Museum of Fine Arts, Richmond, 1995

Fabergé/Skurlov 1992
Fabergé, Tatiana and Skurlov, Valentin. *The History of the House of Fabergé.* St. Petersburg, 1992

Fabergé/Proler/Skurlov 1997
Fabergé, Tatiana., Proler, Lynette G. and Skurlov, Valentin V. *The Fabergé Imperial Easter Eggs.* Christie's Books, London, 1997

Fabergé/Gordinia/Skurlov 1997
Fabergé, Tatiana., Gordinia, A. S. and Skurlov, V.V. *Fabergé and the St. Petersburg Jewelers.* St. Petersburg, 1997

Fagaly/Grady 1972
Fagaly, W. A. and Grady, S. *Treasures by Peter Carl Fabergé and Other Master Jewelers: The Matilda Geddings Gray Foundation Collection.* New Orleans, 1972

Forbes 1980
Forbes, Christopher. *Fabergé Eggs, Imperial Russian Fantasies.* New York, 1980

Forbes/Hohenzollern/ Rodimtseva 1989
Forbes, Christopher., von Hohenzollern, Johann Georg Prinz and Rodimtseva, Irina. *Fabergé. Die kaiserlichen Prunkeier.* Prestel, Munich, 1989 (see also San Diego 1989/90)

Forbes/Tromeur-Brenner 1999
Forbes, Christopher and Tromeur-Brenner, Robyn. *Fabergé. The Forbes Collection.* Lauter Levin Ass., 1999. See p.404 for full listing

Ghosn 1996
Ghosn, Michel Y. *Collection Willam Kazan. Objets de Vertu par Fabergé.* Editions Dar An-Nahar, 1996

Goldberg/Platonova/ Postnikova-Loseva 1961
Goldberg, T., Mishukov, F., Platonova, N. and Postnikova-Loseva, M. *Russian Gold and Silversmithwork XV-XX Century* (in Russian). Moscow, 1961

Habsburg/Solodkoff 1979
von Habsburg, Géza, and von Solodkoff, Alexander. *Fabergé, Court Jeweler to the Tsars.* New York/Fribourg, 1979

Habsburg 1987/8
von Habsburg, Géza (et al.). *Fabergé.* Vendome Press, New York, 1988 (see also Munich 1986/7)

Habsburg 1994
von Habsburg, Géza. *Fabergé. First Impressions.* Harry N. Abrams, New York, 1994

Habsburg/Lopato 1993/4
von Habsburg, Géza, and Lopato, Marina (et al.). *Fabergé: Imperial Jeweller.* Harry N. Abrams, New York, 1994 (see also St. Petersburg/ Paris/ London 1993/4)

Habsburg 1996
von Habsburg, Géza. *Fabergé. Fantasies and Treasures.* Fabergé Co./Universe Publishing, New York, 1996

Habsburg 1996/7
von Habsburg, Géza (et al.). *Fabergé in America.* Fine Arts Museums, San Francisco/Thames & Hudson, 1996 (see also St. Petersburg/Paris/London 1996/7)

Hawley 19967
Hawley, Henry. *Fabergé and his Contemporaries.* The India Minshall Collection of the Cleveland Museum of Art. Cleveland, Ohio, 1967

Hill 1989
Hill, Gerard (et al.) *Fabergé and the Russian Master Goldsmiths.* Wings Books, New York, 1989

Keefe 1993
Keefe, John Webster. *Masterpieces of Fabergé. The Matilda Geddings Gray Foundation Collection.* New Orleans Museum of Art, 1993

Kelly 1985
Kelly, Margaret. *Highlights from the Forbes Magazine Galleries.* New York, 1985

Kostbare Ostereier 1998
Kostbare Ostereier aus dem Zarenreich aus der Sammlung Adulf Peter Goop, Vaduz. Hirmer Verlag Munich, 1998

Krairiksh
Krairiksh, B. (ed.). *Fabergé in The Thai Royal Collection.* Bangkok, nd.

Lesley 1976
Lesley, P. A. *Catalogue of the Lillian Thomas Pratt Collection of Russian Imperial Jewels.* Richmond, 1976

McCanless 1994
Fabergé and His Works. An Annotated Bibliography of the First Century of His Art. The Scarecrow Press, Metuchen, N.J., 1994

Muntyan 1996
Muntyan, T.N., in "Moscow Kremlin State Museum-Preserve of History and Culture", *The World of Fabergé.* Catalogue. Moscow, 1996

Pfeffer 1990
Pfeffer, Susanna. *Fabergé Eggs: Masterpieces from Czarist Russia.* New York, 1990

Rodimtseva 1971
Rodimtseva, I. *Fabergé's Goldsmith's Work* (in Russian). Armory Museum. The Kremlin Moscow, 1971

Ross 1952
Ross, M. *Fabergé.* Walters Art Gallery, Baltimore, 1952

Ross 1965
Ross, M. *The Art of Carl Fabergé and his Contemporaries. The Collection of Marjorie Merriweather Post, Hillwood, Washington DC.* Norman, Oklahoma, 1965

Snowman 1953/1962/8
Snowman, A.K. *The Art of Fabergé.* Faber and Faber, London, 1953 (American edition: Boston Book and Art Shop (Revised and enlarged editions 1962, 1964, 1968)

Snowman 1979
Snowman, A.K. *Carl Fabergé. Goldsmith to the Imperial Court of Russia.* Debrett, London, 1979

Snowman 1988
Snowman, A.K. *Carl Fabergé. Goldsmith to the Russian Imperial Court.* New York, Gramercy Books, 1988

Snowman 1993
Snowman, A. K. *Fabergé: Lost and Found. The Recently Discovered Jewelry Designs from the St. Petersburg Archives.* Harry N. Abrams, New York, 1993

Solodkoff 1984
von Solodkoff, Alexander (et al.). *Masterpieces from the House of Fabergé.* Harry N. Abrams, New York, 1984

Solodkoff 1984/6/9
von Solodkoff, Alexander with essays by Betteley, Roy D.R., Schaffer, Paul., Snowman, A., Swezey, Kenneth and Pfeifer, Marilyn (edited by Christopher Forbes). *Masterpieces from the House of Fabergé.* New York, Abradale Press. Harry N. Abrams Inc., Publisher, 1989

Solodkoff 1986
von Solodkoff, Alexander. *Fabergé Clocks.* London, 1986

Solodkoff 1988
von Solodkoff, Alexander. *Fabergé.* Pyramid, London, 1988

Solodkoff 1995
von Solodkoff, Alexander (et al.). *Fabergé. Juvelier des Zarenhofes.* Braus, Heidelberg, 1995 (see also Hamburg 1995)

Solodkoff 1997
von Solodkoff, Alexander. *The Jewels Album of Tsar Nicholas II.* Ermitage, London, 1997

Tillander-Godenhielm/ Schaffer/Ilich 2000
Tillander-Godenhielm, Ulla., Schaffer, Peter., Ilich, Alice and Schaffer, Mark. *Golden Years of Fabergé. Drawings from the Wigström Workshop.* A La Vieille Russie/Alain de Gourcuff, 2000 (see also New York/New Orleans 2000)

Waterfield 1973
Waterfield, Hermione. *Fabergé from the Forbes Magazine Collection.* Scribener, New York, 1973

Waterfield/Forbes 1978
Waterfield, Hermione and Forbes, Christopher. C. *Fabergé: Imperial Easter Eggs and Other Fantasies.* Scribener, New York, 1978

ARTICLES

Bainbridge 1934
Bainbridge, Henry C. "Russian Imperial Gifts: The Work of Carl Fabergé" in *Connoisseur*, May/June 1934, pp. 299–348

Bainbridge 1935
Bainbridge, Henry C. "The Workmasters of Fabergé" in *Connoisseur*, August 1935, pp. 85ff

Comstock 1936
Comstock, Helen. "Imperial Easter Egg by Fabergé, 1903" in *Connoisseur*, 98, no. 423, November 1936, pp. 284ff

Donova 1973
Donova, Kira V. "Works of the the Artist M. E. Perkhin" in Material and Research (in Russian). Moscow, 1973

Forbes 1979
Forbes, Christopher. "Fabergé Imperial Easter Eggs in American Collections" in *Antiques*, June 1979, pp. 1228–42

Forbes 1986
Forbes, Christopher. "Imperial Treasures" in *Art & Antiques*. April 1986, pp. 52–57, 86

Habsburg 1977
von Habsburg, Géza. Carl Fabergé. "Die glanzvolle Welt eines königlichen Juweliers" in *Du Atlantis*, December 1977, pp. 48–88

Habsburg 1981
von Habsburg, Géza. "Die Uhren des Peter Carl Fabergé" in *Alte Uhren*, January 1981, pp. 12–26

Habsburg 1991
von Habsburg, Géza. "Fauxbergé" in *Art & Auction*, February 1994, pp. 76–79

Habsburg (Estampille/ Objet d'Art) 1993
von Habsburg, Géza. "Les Débuts de Fabergé" in *Estampille/Objet d'Art*, Hors Série no. 7, pp. 14–19; "Fabergé contre Fauxbergé", *Ibid.*, pp. 54–61

Habsburg (Connaissance des Arts) 1993
von Habsburg, Géza. "Fabergé, Un Orfèvre d' Exception" in *Connaissance des Arts*, Hors Série, no. 45, pp. 4–31

Habsburg (Beaux Arts) 1993
von Habsburg, Géza. "Fabergé Fournisseur des Tsars" in *Beaux Arts*, Hors Série 55, pp. 34–49

Kelly 1982/3
Kelly, Margaret. "Frames by Fabergé in the Forbes Magazine Collection" in *Arts in Virginia*, 1982/3, pp. 2–13

Lopato 1984
Lopato, Marina. "New Light on Fabergé" in *Apollo*, 1984, n.s. 119, no. 263, pp. 43–49

Lopato 1991
Lopato, Marina. "Fabergé Egg. Re-dating from new evidence" in *Apollo*, February 1991, pp. 91–94

McNab Dennis 1965
McNab Dennis, J. "Fabergé's Objects of fantasy" in *Metropolitan Museum of Art Bulletin*, n.s. 23, March 1965, pp. 229ff

Solodkoff 1993
von Solodkoff, Alexander. "Fabergé, Ateliers, Art et Styles" in *Beaux Arts*, Hors Série, pp. 16–33

Truman 1977
Truman, Charles. "The Master of the Easter Egg" in *Apollo*, CI, 185, July 1977, p. 73ff

EXHIBITIONS

Hamburg 1995
Fabergé. Juwelier des Zarenhofes. Kunstgewerbemuseum, Hamburg, 1995 (see also Solodkoff 1995)

Helsinki 1980
Fabergé and his Contemporaries. The Museum of Applied Arts, Helsinki, 1980

Hillwood 1983
Fabergé at Hillwood. Washington, DC, 1983

Houston 1994
The World of Fabergé. Russian Gems and Jewels. Houston Museum of Natural Science, 1994

Lahti 1997
Fabergé – A Private Collection. Lahti, 1997

Leningrad 1992
The Fabulous Epoch of Fabergé. Catherine Palace, Pushkino, 1992

London 1949
A Loan Exhibition of the Works of Carl Fabergé. Wartski, London, 1949

London 1953
Carl Fabergé: Wartski Coronation Exhibition. London, 1953

London 1973
Fabergé at Wartski. London, 1973

London 1977
Fabergé 1984–1920. Victoria and Albert Museum, London, 1977

London 1985
Fabergé from the Royal Collection. The Queen's Gallery, Buckingham Palace, London, 1985

London 1992
Fabergé from Private Collections. Wartski 1992

London 1995
The Castle Howard Collection. Tessier, London, 1995

London (Queen's Gallery) 1996
Fabergé. The Queen's Gallery, Buckingham Palace, London, 1996

London 1996
The Maurice F. Mizzi Collection of Carl Fabergé Fragrance Bottles. Design Museum, London, 1996

London 1999
Countdown to the Millennium. Tessier, London, 1999

Lugano 1987
Fabergé Fantasies. The Forbes Magazine Collection. Collection Thyssen-Bornemisza, Lugano-Castagnola, 1987

Moscow 1992
Muntyan T. N., Nikitina, V. M. and Goncharova, I. I. *The World of Fabergé* (in Russian). Moscow–Vienna, 1992

Munich 1986/7
Fabergé, Hofjuwelier der Zaren. Kunsthalle der Hypokulturstiftung, Munich, 1986/7 (see also Habsburg 1986/7)

New York 1937
Fabergé: His Works. Hammer Galleries, New York, 1937

New York 1939
Presentation of Imperial Russian Gifts by Carl Fabergé. Hammer Galleries, New York, 1939

New York 1949
Peter Carl Fabergé: An Exhibition of His Works. A La Vieille Russie, New York, 1949

New York 1951
A Loan Exhibition of the Art of Peter Carl Fabergé. Hammer Galleries, New York, 1951

New York 1961
The Art of Peter Carl Fabergé. A La Vieille Russie, New York, 1961

New York 1962-65
Metropolitan Museum of Art. New York, 1962/65

New York 1973
Fabergé from the Forbes Magazine Collection. New York Cultural Center, New York, 1973

New York (ALVR) 1983
Fabergé. A Loan Exhibition. A La Vieille Russie, New York, 1983

New York (Cooper-Hewitt) 1983
Fabergé, Jeweler to Royalty. Cooper-Hewitt Museum, New York, 1983

New York 1988
The Josiane Woolf Fabergé Collection. Habsburg Feldman, New York, 1988

New York et al. 1996/7
Fabergé in America. Metropolitan Museum of Art, New York; Fine Arts Museums, San Francisco, Fine Arts Museum, Richmond, Virginia; Fine Arts Museum, New Orleans; Fine Arts Museum, Cleveland, Ohio, 1996/7

Paris 1987
Fabergé Orfèvre à la Cours des Tsars: The Forbes Magazine Collection. Musée Jacquemart-Andrè, Paris, 1987

Paris 1994
Quarante Flacons à Parfum de Carl Fabergé. Musée des Arts décoratifs, Paris, 1994

San Diego/Moscow 1989/90
Fabergé. The Imperial Eggs. San Diego Museumn of Art/Armory Museum; State Museums of the Moscow Kremlin, 1989/1990 (see also Forbes/von Hohenzollern/Rodimtseva 1989/90)

San Francisco 1964
Fabergé, Goldsmith to the Russian Imperial Court. M. H. de Young Memorial Museum, San Francisco, 1964

St. Petersburg 1902
Fabergé from the Imperial Collections. Von Dervis Mansion, St. Petersburg, 1902

St. Petersburg 1989
The Great Fabergé. The Art of the Jewellers of the Court Firm. Elagin Palace, St. Petersburg, 1989

St. Petersburg 1992
The Fabulous Epoch of Fabergé. Catherine Palace, Tsarskoe Selo, 1992

St. Petersburg/Paris/London 1993/4
Fabergé: Imperial Jeweler. State Hermitage Museum, St. Petersburg, Musée des Arts décoratifs, Paris, Victoria and Albert Museum, London 1993/4 (see also Habsburg/Lopato 1993/4)

St. Petersburg 1997/8
Fabergé at the Hermitage Museum. Co-curated by the Hermitage and the Fabergé Arts Foundation, St. Petersburg 1997/8

Sydney 1996
The World of Fabergé. From the Moscow Kremlin State Museum. Art Gallery of New South Wales, 1996

Tokyo 1991
K. Fabergé and the Golden Age of Russian Jewellery. Mikimoto, Tokyo, 1991

Wartski 1973
Fabergé at Wartski. London 1973

Washington 1961
Snowman, A. K. *Easter Eggs and Other Precious Objects by Carl Fabergé.* Corcoran Gallery of Art, Washington, D.C., 1961

Washington 1996
Fabergé and Finland. Corcoran Gallery of Art, Washington, D.C., 1996

Zurich 1989
Carl Fabergé. Kostbarkeiten Russischer Godschmiedekunst der Jahrhundertwende. Museum Bellerive, Zurich, 1989

FOREIGN COMPETITORS
BOOKS & ARTICLES

Barracca/Negretti/Nencini 1989
Barracca J., Negretti, G and Nencini, E.
Le Temps de Cartier. Milan, 1989
(in French 1990)

Barten 1977
Barten, Sigrid. *René Lalique, Schmuck und
Objets d'Art*. Monographie und
Werkkatalog. Prestel Verlag, Munich,
1977

Cologni/Mocchetti 1992
Cologni, E and Mocchetti, E. *Made by
Cartier. 150 Years of Tradition and
Innovation*. Milan, 1992 (French edition
1992)

Cologni/Nussbaum 1995
Cartier, Le Joaillier du Platine. Paris and
Lausanne, 1995 (English edition 1996)

Duncan 1989
Duncan, Alastair., Eidelberg, Martin and
Harris, Neil. *Masterworks of Louis Comfort
Tiffany*. Harry N. Abrams, New York,
1989

1906
*L'Art décoratif aux Expositions des Beaux
Arts 1897–1914*. 1906

Loring 1997
Loring, John. *Tiffany's 20th Century:
A Portrait of American Style*. Harry N.
Abrams, 1997

Loring 1999
Loring, John. *Tiffany Jewels*.
Harry N. Abrams, 1999

Munn 1984
Munn, Geoffrey. *Castellani and Giuliano.
Revivalist Jewellers of the Nineteenth
Century*. London, 1984

Nadelhoffer 1984
Nadelhoffer, Hans. *Cartier, Jewellers
Extraordinary*. Harry N. Abrams, New
York, 1984

Néret 1988
Néret, Gilles. *Boucheron. Histoire d'une
dynastie de joailliers*. Pont Royal, Paris
1988

Ribbing 1996
Ribbing, Magdalena; Muntyan, T.,
Skurlov, V. and L. Zavadsdkaia, *L.W.A.
Bolin 200 Years. Jewellery & Silver for Tsars,
Queens and Others*. Bolin, Stockholm,
1996

Scarisbrick 1995
Scarisbrick, Diana. *Chaumet, Master
Jewellers since 1780*. Gourcuff, Paris, 1995

Snowman 1990
Snowman, A. K. (ed.). *The Master Jewelers*.
Harry N. Abrams, 1990

Tretiack 1996
Tretiack, P. *Cartier*. Paris, 1996

Zapata 1993
Zapata, Janet. *The Jewelry and Enamels of
Louis Comfort Tiffany*. Thames & Hudson,
London, 1993

EXHIBITIONS

Chicago 1999
Cartier. Chicago, 1999

Hamburg 1999
Meisterwerke des amerikanischen Jugendstils.
Kunstgewerbemuseum, Hamburg, 1993

Hong-Kong 1995
Cartier King of Jewellers, Jewellers of Kings

Lausanne 1996
Cartier, splendeurs de la joaillerie. Fondation
de l'Hermitage, Lausanne, 1996

London 1987
Becker, Vivienne. *The Jewellry of René
Lalique*. Goldsmith Hall, London, 1987

London 1988
The Jewellery of René Lalique. Goldsmiths
Hall, London, 1987

Los Angeles 1982
*Retrospective Louis Cartier, Masterworks of
Art Deco*. Los Angeles County Museum
of Art, 1982

Mexico 1999
Cartier. Mexico City, 1999

Milan 1988
de Grada, Raffaele (ed). *Platinum
Rhinoceros. Sogni, segni e fantasie dei gioielli
Cartier*. Museo Civico di Storia Naturale
di Milano, 1988

Munich 1989
Pariser Schmuck. Bayerisches
Nationalmuseum, Munich, 1989

Naples 1988
Capolavori di Cartier. Castel Sant'Elmo,
Naples, 1988

**New Orleans/Birmingham/
Baltimore/San Diego 1988**
*Reflections of Elegance. Cartier Jewels from
the Lindemann Collection*. New Orleans
Museum of Art (also held at Birmingham
Museum of Art, Walters Art Gallery, San
Diego Museum of Art)

New York 1976
*Retrospective Louis Cartier. One Hundred
and One Years of the Jeweler's Art*. Cartier,
New York, 1976

New York 1997
Rudoe, Judy. *Cartier 1900–1939*.
Metropolitan Museum of Art, New York,
1997

New York 1998
Brunhammer, Yvonne. *The Jewels of
Lalique*. Cooper-Hewitt Museum, New
York, 1998

Paris 1988
*Boucheron. 130 Années de Création et
d'Émotion*. Musée Jacquemart-André,
Paris, 1988

Paris 1989
L'Art de Cartier. Musée du Petit Palais,
Paris, 1990

Paris 1991
René Lalique. Musée des Arts décoratifs,
Paris, 1991

Rome 1990
Chazal, G. *L'Art de Cartier*. Accademia
Valentino, Rome, 1990

St. Louis 1995
Neely, S. and Cassens, D. *The Legacy of
Elma Rumsey Cartier*. Saint Louis
University, St. Louis, 1995

St. Petersburg 1992
L'Art de Cartier. State Hermitage
Museum, St. Petersburg, 1992

Tokyo 1995
The World of French Jewelry Art. The Art
of Cartier. Tokyo Metropolitan Teien,
Tokyo, 1995

Venice 1986
*I gioielli degli anni '20–40. Cartier e i gran-
di del Deco*. Palazzo Fortuny, Venice, 1986

FORBES/TROMEUR-BRENNER 1999
Forbes, Christopher and Tromeur-Brenner, Robyn. *Fabergé: The Forbes Collection.* Hugh Lauter Levin Associates, Inc., Southport, Connecticut, 1999

The following list of objects from The Forbes Magazine Collection, New York, are given in the order they appear in this catalog, followed by their title and then the reference details for the recent Forbes/Tromeur-Brenner catalog.

140. Bogatyr Kovsh pp. 241, 291; ill. pp. 240, 291
147. Boris Godunov Desk Set pp. 242, 291; ill. p. 243
170. Big Bad Wolf Lighter pp. 176, 286; ill. p. 177
182. Pig Match Holder/Striker pp. 238, 291; ill. p. 239
200. Aesthetic Movement Brooch pp. 143, 281; ill. p. 142
200A. Aesthetic Movement Cigarette Case pp. 143, 281; ill. p. 142
252. Pair of Toilet Bottles pp. 157, 283; ill. p. 156
270. Miniature Empire-Style Table Set with Clock pp. 105, 279; ill. p. 104
271. Miniature Gueridon pp. 101, 278–279; ill. p. 100
272. Vinaigrette pp. 166, 284; ill. p. 167
273. Card-Suit Ashtrays pp. 210, 289; ill. p. 211
286. Scythian Style Bracelet pp. 10, 161, 283; ill. p. 160
297. Queen Louise Crochet Hook pp. 154, 282; ill. p. 155
307. Miniature Coin Tankard pp. 222, 289–290; ill. p. 223
320. Miniature Wastepaper Basket pp. 193, 287; ill. p. 192
321. Fish Charka pp. 222, 290; ill. p. 223
325. Vodka Cup with Sapphires p. 221, 289; ill. p. 220
339. Card Holder on Bun Feet pp. 207, 288; ill. p. 206
344. Rock Crystal Frame pp. 116, 284; ill. p. 167
354. Miniature Reliquary in the Gothic Style pp. 102, 279; ill. p. 103
362. Owl Bell Push pp. 176, 286; ill. p. 177
371. Louis XVI-Style Snuffbox pp. 144, 281; ill. p. 145
417. Amatory Frame pp. 154, 282; ill. p. 155
420. Imperial Presentation Frame pp. 106, 279; ill. p. 107
423. Louis XVI Snuffbox *by Blerzy* pp. 144, 281; ill. p. 145
429. Rocaille Opera Glasses pp. 148, 282; ill. p. 149
433. Miniature Sedan Chair p. 101, 278; ill. p. 100
437. Imperial First Egg pp. 10, 14–16, 20, 65, 269; ill. pp. 21-22
439. Imperial Heart Surprise Frame pp. 17, 42, 271; ill. pp. 43, 45
442. Imperial Coronation Egg pp. 16, 37, 270; ill. 36, 39, 271
452. Fire-Screen Frame pp. 105, 279; ill. p. 104
457. Presentation Beaker pp. 12, 259, 292; ill. p. 258
458. Art Nouveau Match Holder pp. 172, 285; ill. p. 173
459. Style-Moderne Kovsh pp. 190, 287; ill. p. 191
467. Nicholas II Nephrite Box pp. 137, 280–281; ill. p. 136
486. Lorgnette with Octagonal Lenses pp. 157, 283; ill. p. 156
487. Ostrich Feather Fan pp. 148, 282; ill. p. 149
524. Style-Moderne Clock pp. 134, 280; ill. p. 135
543. Noble Ice Egg pp. 17, 69, 273; ill. pp. 68, 71, 273
547. Imperial Fifteenth Anniversary Egg pp. 15, 56, 272; ill. pp. 13, 57, 59
549. Imperial Cross of St. George Egg pp. 16, 63, 272–273; ill. pp. 63, 273
548. Imperial Orange Tree Egg pp. 15, 61, 272; ill. pp. 60, 272
595. Coronation Box pp. 41, 271; ill. p. 40
609. Grisaille Pin pp. 165, 284; ill. p. 164
621. Amethyst and Diamond Brooch pp. 172, 285; ill. p. 173
639. Grand Duke Kirill Vladimirovich Cuff Links pp. 180, 286; ill. p. 181
685. Kaiser Wilhelm Frame pp. 115, 279; ill. p. 114
686. Pale Blue Frame pp. 116, 279; ill. pp. 117, 280
691A. Rose Trellis Frame pp. 120, 280; ill. p. 121
694. Miniature Pink Frame pp. 123, 280; ill. p. 122
695. Miniature Frame with Chamfered Edges pp. 123, 280; ill. p. 122
696. Vanderbilt Frame pp. 112, 148, 279; ill. p. 113
697. Cornflower Frame pp. 119, 280; ill. p. 118
707. Cigar Cutter and Matching Pocket Knife pp. 208, 288; ill. p. 209
711. Standing Thermometer pp. 175, 285; ill. p. 174
714. Art Nouveau Bell Push pp. 256, 292; ill. p. 257
724. Silver Anniversary Icon pp. 232, 290; ill. pp. 233, 290
725. Vieux Rose Frame pp. 123, 280; ill. p. 122
726. Pivot Frame pp. 110, 279; ill. p. 111
745. Rhodonite Dish with Rubles pp. 207, 288; ill. p. 206
756. Traveling Pencil pp. 193, 287; ill. p. 192

859. Dancing Moujik pp. 82, 277; ill. p. 83
862. Miniature Basket of Lilies of the Valley pp. 92, 278; ill. p. 93
863. Holly Spray pp. 88, 278; ill. p. 89
911. Bee Cigarette Case pp. 260, 292; ill. p. 261
912. Cupid Frame pp. 260, 292; ill. p. 261

PHOTO ACKNOWLEDGEMENTS
Boucheron, Paris
Cartier (Collection Art de Cartier); Archives Center, Paris; Nick Welsh
A.C. Cooper (Colour) Ltd., London
Prudence Cuming Associates Ltd., London
Ermitage Ltd.
André Fischer, San Francisco
The Forbes Magazine Collection, New York (Larry Stein, H. Peter Curran, Steven Mays, Joshua Mays, Joshua Nefsky, Robert Wharton, Ali Elai and Joseph Coscia Jr.)
Foto Hasse, Helsinki
Helga Photographers, New York
State Hermitage Museum, St. Petersburg (Vladimir Terebenin, Leonid Heifets, Yurii Molodkovets)
Claude Mercier, Photo Ciné, Geneva
Neumeister Photographie, Munich
Rauno Traskelin, Helsinki
André Ruzhnikov, Palo Alto
Tessier, London
Carmel Wilson Fromson, New York